THE SECRET LIFE OF SALVADOR DALI

THE SECRET LIFE
OF SALVADOR DALI

BY

DASA EDICIONS, S.A.

Translated from French by Haakon M. Chevalier
Printed by Tallers Gràfics Soler. - Esplugues de Llobregat
Dipòsit legal: B-22017/86
ISBN: 84-85814-12-6
Printed in Spain

Table of Contents

INTRODUCTION BY ENRIQUE SABATER

The talented and strange figure of Salvador Dalí goes beyond the aesthetic and revolutionary movement of surrealism.

Dalí is the very idea of the contemporary anti-hero.
"The only difference there is between a madman and me, Dalí has said, is that a madman is mad and I am not". Despite the apparent evidence of this statement, it concerns in fact a subtle distinction not always easy to understand. Does the subject always understand himself? what is certain is that the collective conscience of the country should be capable of integrating all its men, without opposing this image to the dust of ridiculing anecdotes or to the scalpel of orthodox puritans.

Salvador Dalí has broken all the myths. His behaviour accuses and at the same time attracts. The admiration of this work excites a lay adoration which goes beyond this personality. The attentive work on himself, on his own vision of painting, of being, of the world, the incurable attraction of opposites, has placed in the very zenith of creation a work dominated by the absolute vision of the real, in which whatever exists hides an enigma.

Likewise, Dalí is a spirit where multiple orthodoxies converge. His greatness makes him incoherent. He once wrote that "to believe in nothing inevitably leads you to non-objective and non-figurative painting. Of one believes in nothing one ends by painting nothing or almost nothing". * From this statement we are led to conclude that Dalí believes in everything on in almost everything.

One of his conferences which produced great stir was entitled "Why was I sacrilegious, why am I mystical?". But his genius saves him from chaos. This brush anthoritatively organises a universe in which is everything, but each thing in its place. In distintion. From contemporary geniuses, in Dalí what is obscure and macabre always feeds light and life.

Many painting of Dalí make us go to the limitless horizon, towards the infinite, starting from a very definite point, Port Lligat for example. "The secret life of Salvador Dalí", allows the reader to discover this definite point, the men, the real person from whom has emerged the abundance of hallucinatory creations which is his work.

* "Liturgical Arts" may 1952.

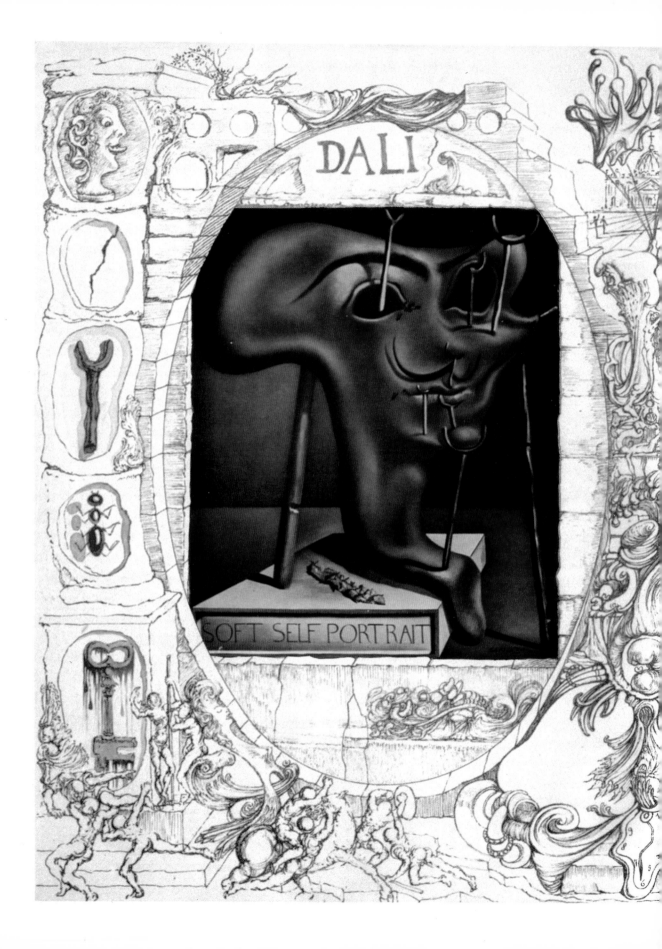

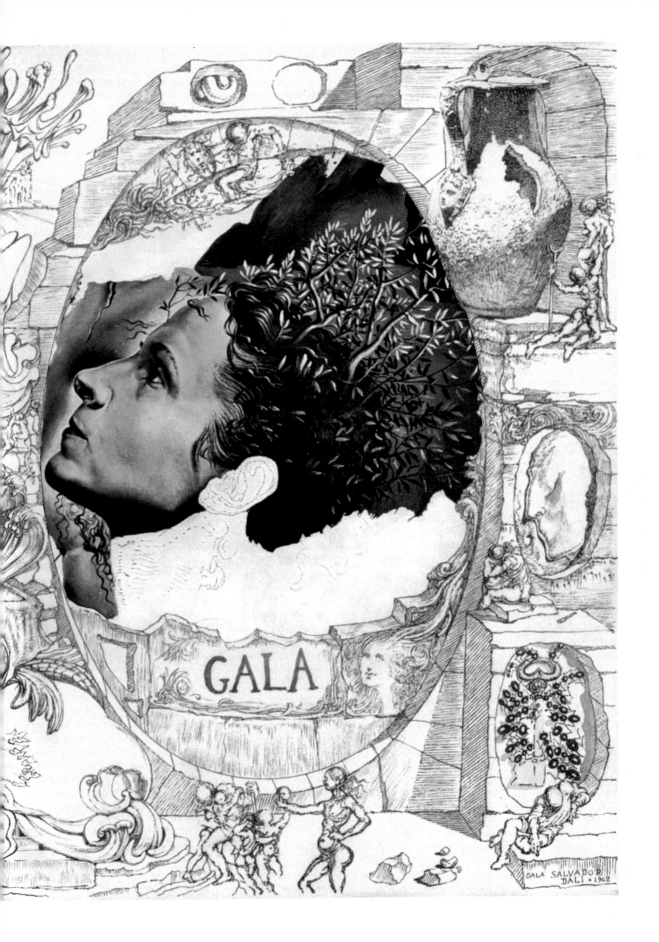

GALA

GALA SALVADOR
DALI · 1942

At the age of six I wanted to be a cook. At seven I wanted to be Napoleon. And my ambition has been growing steadily ever since.

Stendhal somewhere quotes the remark of an Italian princess who was eating ice cream with enormous relish one hot evening. "Isn't it too bad this it not a sin!" she exclaimed. When I was six, it was a sin for me to eat food of any kind in the kitchen. Going into this part of the house was one of the few things categorically forbidden me by my parents. I would stand around for hours, my mouth watering, till I saw my chance to sneak into that place of enchantment; and while the maids stood by and screamed with delight I would snatch a piece of raw meat or a broiled mushroom on which I would nearly choke but which, to me, had the marvelous flavor, the intoxicating quality, that only fear and guilt can impart.

Aside from being forbidden the kitchen I was allowed to do anything I pleased. I wet my bed till I was eight for the sheer fun of it. I was the absolute monarch of the house. Nothing was good enough for me. My father and mother worshiped me. On the day of the Feast of Kings I received among innumerable gifts a dazzling king's costume— a gold crown studded with great topazes and an ermine cape; from that time on I lived almost continually disguised in this costume. When I was chased out of the kitchen by the bustling maids, how often would I stand in the dark hallway glued to one spot—dressed in my kingly robes, my sceptre in one hand, and in the other a leather-thonged mattress beater—trembling with rage and possessed by an overwhelming desire to give the maids a good beating. This was during the anguishing hour before the sweltering, hallucinatory summer noon. Behind the partly open kitchen door I would hear the scurrying of those bestial women with red hands; I would catch glimpses of their heavy rumps and their hair straggling like manes; and out of the heat and confusion that rose from the conglomeration of sweaty women, scattered grapes, boiling oil, fur plucked from rabbits' armpits, scissors spattered with mayonnaise, kidneys, and the warble of canaries—out of that whole conglomeration the imponderable and inaugural fragrance of the forthcoming meal was wafted to me, mingled with a kind of acrid horse smell. The beaten white of egg, caught by a ray of sunlight cutting through

a whirl of smoke and flies, glistened exactly like froth forming at the mouths of panting horses rolling in the dust and being bloodily whipped to bring them to their feet. As I said, I was a spoiled child.

My brother died at the age of seven from an attack of meningitis, three years before I was born. His death plunged my father and mother into the depths of despair; they found consolation only upon my arrival into the world. My brother and I resembled each other like two drops of water, but we had different reflections. Like myself he had the unmistakable facial morphology of a genius.[1] He gave signs of alarming precocity, but his glance was veiled by the melancholy characterizing insurmountable intelligence. I, on the other hand, was much less intelligent, but I reflected everything. I was to become the prototype *par excellence* of the phenomenally retarded "polymorphous perverse," having kept almost intact all the reminiscences of the nursling's erogenous paradises: I clutched at pleasure with boundless, selfish eagerness, and on the slightest provocation I would become dangerous. One evening I brutally scratched my nurse in the cheek with a safety pin, though I adored her, merely because the shop to which she took me to buy some sugar onions I had begged for was already closed. In other words, I was viable. My brother was probably a first version of myself, but conceived too much in the absolute.

We know today that form is always the product of an inquisitorial process of matter—the specific reaction of matter when subjected to the terrible coercion of space choking it on all sides, pressing and squeezing it out, producing the swellings that burst from its life to the exact limits of the rigorous contours of its own originality of reaction. How many times matter endowed with a too-absolute impulse is annihilated; whereas another bit of matter, which tries to do only what it can and is better adapted to the pleasure of molding itself by contracting in its own way before the tyrannical impact of space, is able to invent its own original form of life.

What is lighter, more fanciful and free to all appearances than the arborescent blossoming of agates! Yet they result from the most ferocious constraint of a colloidal environment, imprisoned in the most relentless of inquisitorial structures and subjected to all the tortures of compression and moral asphyxiation, so that their most delicate, airy, and ornamental ramifications are, it seems, but the traces of its hopeless search for escape from its death agony, the last gasps of a bit of matter that will not give up before it has reached the ultimate vegetations of the mineral dream. Hence what we have in the case of the agate is not a plant transformed into a mineral, or even a plant caught and swallowed up in a mineral. On the contrary, we actually have the spectral apparition of

[1] Since 1929 I have had a very clear consciousness of my genius, and I confess that this conviction, ever more deeply rooted in my mind, has never excited in me emotions of the kind called sublime; nevertheless, I must admit that it occasionally affords me an extremely pleasurable feeling.

the plant, its arborescent and mortal hallucination: the end and form of the inquisitorial and pitiless constraint of the mineral world.

So too the rose! Each flower grows in a prison! In the aesthetic point of view freedom is formlessness. It is now known, through recent findings in

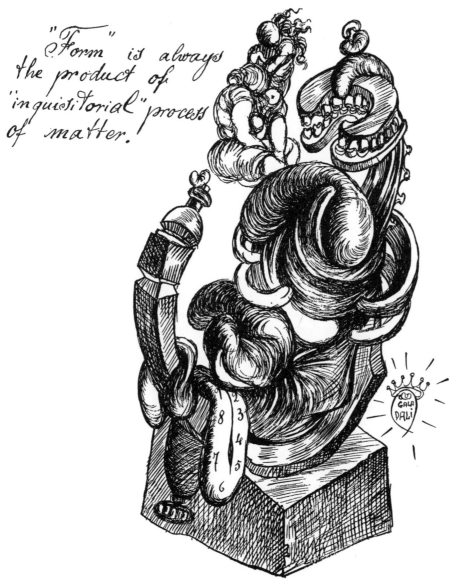

"Form" is always the product of "inquisitorial" process of matter.

morphology (glory be to Goethe for having invented this word of incalculable moment, a word that would have appealed to Leonardo!) that most often it is *precisely* the heterogeneous and anarchistic tendencies offering the greatest complexity of antagonisms that lead to the triumphant reign of the most rigorous hierarchies of form.

Even as men with unilateral, one-way minds were burned by the fire of the Holy Inquisition, so multiform, anarchistic minds—precisely because they were such—found in the light of these flames the flowering of their most individual spiritual morphology. My brother, as I have already said, had one of those insurmountable intelligences with a single direction and fixed reflections that are consumed or deprived of form. Whereas I was the backward, anarchistic polymorphous perverse. With extreme mobility I reflected all objects of consciousness as though they were sweets, and all sweets as though they were materialized objects of consciousness. Everything modified me, nothing changed me; I was soft, cowardly, and resilient; the colloidal environment of my mind was to find in the unique and inquisitorial rigor of Spanish thought the definitive form of the bloody, jesuitical, and arborescent agates of my curious genius. My parents baptized me with the same name as my brother—Salvador—and I was destined, as my name indicates, for nothing less than to rescue painting from the void of modern art, and to do so in this abominable epoch of mechanical and mediocre catastrophes in which we have the distress and the honor to live. If I look toward the past, beings like Raphael appear to me as true gods; I am perhaps the only one today to know why it will henceforth be impossible even remotely to approximate the splendors of Raphaelesque forms. And my own work appears to me a great disaster, for I should like to have lived in an epoch during which nothing needed to be saved! But if I turn my eyes toward the present, although I do not underestimate specialized intelligences much superior to my own— yes, I shall repeat it a hundred times—I would for nothing in the world change places with anyone, with anyone whomsoever among my contemporaries. But the ever-perspicacious reader will already have discovered without difficulty that modesty is not my specialty.

One single being has reached a plane of life whose image is comparable to the serene perfections of the Renaissance, and this being happens to be precisely Gala, my wife, whom I had the miracle to choose. She is composed of those fleeting attitudes, of those Ninth-Symphony-like facial expressions, which, reflecting the architectonic contours of a perfect soul, become crystallized on the very shore line of the flesh, at the skin's surface, in the sea foam of the hierarchies of her own life, and which, having been classified, clarified by the most delicate breezes of the sentiments, harden, are organized, and become architecture in flesh and bone. And for this reason I can say of Gala seated that she resembles perfectly, that she is posed with the same grace as, Il Tempietto di Bramante near the church of San Pietro in Montorio at Rome; for, like Stendhal in the Vatican, I too can measure exactly the slim columns of her pride, the tender and stubborn banisters of her childhood, and the divine stairways of her smile. And so, as I watch her from the corner of my eye during the long hours I spend huddled before my easel, I say to myself that she is as well painted as a Raphael

Tabernacle.

or a Vermeer. The beings around us look as though they were not even finished, and so badly painted! Or rather, they look like those sordid caricatural sketches hastily drawn on café terraces by men with stomachs convulsed by hunger.

I have said that at the age of seven I already wanted to be Napoleon, and I must explain this. On the third floor of our house lived an Argentine family named Matas, one of whose daughters, Ursulita, was a renowned beauty. It was whispered in the Catalonian oral mythology of 1900 that she had been selected by Eugenio d'Ors as the archetype of Catalonian womanhood, in his book *La Ben Plantada* (The Well-Planted One).

Shortly after I reached the age of seven, the all-powerful social-libidinal attraction of the third floor began to exercise its sway over me. In the sultry twilights of early summer I would sometimes abruptly interrupt the supreme pleasure of drinking from the terrace faucet (delightfully thirsty, my heart beating fast) when the almost imperceptible creaking of the third-floor balcony door made me hope it would perhaps open. On the third floor I was worshiped as I was at home. There, every day at about six, around a monumental table in a drawing room with a stuffed stork, a group of fascinating creatures with the hair and the Argentine accent of angels would sit and take *maté*,[1] served in a silver sipper which was passed from mouth to mouth. This oral promiscuity troubled me peculiarly and engendered in me whirls of moral uneasiness in which the blue flashes of the diamonds of jealousy already shone. I would in turn sip the tepid liquid, which to me was sweeter than honey, that honey which, as is known, is sweeter than blood itself—for my mother, my blood, was always present. My social fixation was sealed by the triumphal and sure road of the erogenous zone of my own mouth. I wished to sip Napoleon's liquid! For Napoleon too was there, in the third-floor drawing room; there was a picture of him in the centre of the circle of glorious polychromes that adorned one end of a tin keg; this little keg was painted to look like wood and contained the voluptuous substance of the *maté*. This object was preciously placed on a centrepiece in the exact middle of the table. Napoleon's image, reproduced on the *maté* keg, meant everything to me; for years his attitude of Olympian pride, the white and edible strip of his smooth belly, the feverish pink flesh of those imperial cheeks, the indecent, melodic, and categorical black of the spectral outline of his hat, corresponded exactly to the ideal model I had chosen for myself, the king.

At that time people were singing the stirring song:

Napoleón en el final
De un ramillette colosal.

This little picture of Napoleon had forcefully taken hold of the very

[1] An Argentinian tea.

core of the still nonexistent contours of my spirit, like the yolk of an egg fried in a pan (without the pan, and yet already in the centre of the pan).

Thus I frantically established hierarchies in the course of a year; from wanting to be a cook I had awakened the very person of Napoleon from my impersonal costume of an obscure king. The furtive nutritive delights had assumed the architectural form of a small tabernacle—the keg containing the *maté*. The swarming erotic emotions aroused by the confused visions of the creatures, half women, half horses, who inhabited the kitchen below had given way to those of the third-floor drawing room, provoked by the serene image of a true lady, Ursulita Matas, the 1900 archetype of beauty.

Later on I shall explain and minutely describe several thinking machines of my invention. One of these is based on the idea of the wonderful "edible Napoleon," in which I have materially realized those two essential phantoms of my early childhood—nutritive oral delirium and blinding spiritual imperialism. It will then become clear as daylight why fifty small goblets filled with lukewarm milk hung on a rocking chair are to my mind exactly the same thing as the plump thighs of Napoleon. Since this may become true for everyone, and since there are all sorts of advantages in being able to look upon things in this way, I shall explain these and many other enigmas, even stranger and no less exact, in the course of this sensational book. One thing, at least, is certain: everything, absolutely everything, that I shall say here is entirely and exclusively my own fault.

PART I

C H A P T E R O N E

Anecdotic Selfportrait

I know what I eat
I do not know what I do

Fortunately I am not one of those beings who when they smile are apt to expose remnants, however small, of horrible and degrading spinach clinging to their teeth. This is not because I brush my teeth better than others; it is due to the much more categorical fact that I do not eat spinach. It so happens that I attach to spinach, as to everything more or less directly pertaining to food, essential values of a moral and esthetic order. And of course the sentinel of disgust is ever on hand, vigilant and full of severe solicitude, ceremoniously attentive to the exacting choice of my foods.

I like to eat only things with well-defined shapes that the intelligence can grasp. I detest spinach because of its utterly amorphous character, so much so that I am firmly convinced, and do not hesitate for a moment to maintain, that the only good, noble and edible thing to be found in that sordid nourishment is the sand.

The very opposite of spinach is armor. That is why I like to eat armor so much, and especially the small varieties, namely, all shell-fish. By virtue of their armor, which is what their exoskeleton actually is, these are a material realization of the highly original and intelligent idea of wearing one's bones outside rather than inside, as is the usual practice.

The crustacean is thus able, with the weapons of its anatomy, to protect the soft and nutritive delirium of its insides, sheltered against all profanation, enclosed as in a tight and solemn vessel which leaves it vulnerable only to the highest form of imperial conquest in the noble war of decortication: that of the palate. How wonderful to crunch a bird's tiny skull![1] How can one eat brains any other way! Small birds are very much like small shell-fish. They wear their armor, so to speak, flush with their skin. In any case Paolo Uccello painted armor that looked like little ortolans and he did this with a grace and mystery worthy of the true bird that he was and for which he was named.

[1] The bird always awakens in man the flight of the cannibal angels of his cruelty. Della Porta in his *Natural Magic* gives the recipe for cooking turkey without killing it, so as to achieve that supreme refinement: to make it possible to eat it cooked and living.

I have often said that the most philosophic organs man possesses are his jaws. What, indeed, is more philosophic than the moment when you slowly suck in the marrow of a bone that is being powerfully crushed in the final destructive embrace of your molars, entitling you to believe that you have undisputed control over the situation?—For it is at the supreme moment of reaching the marrow of anything that you discover the very taste of truth, that naked and tender truth emerging from the well of the bone which you hold fast between your teeth.

Having once overcome the obstacle by virtue of which all self-respecting food "preserves its form," nothing can be regarded as too slimy, gelatinous, quivering, indeterminate or ignominious to be desired, whether it be the sublime viscosities of a fish-eye, the slithery cerebellum of a bird, the spermatozoal marrow of a bone or the soft and swampy opulence of an oyster.[1] I shall undoubtedly be asked: In that case, do you like Camembert? Does it preserve its form? I will answer that I adore Camembert precisely because when it is ripe and beginning to run it resembles and assumes exactly the shape of my famous soft watches, and because being an artificial elaboration its original form, though honorable, is not one for which it is entirely responsible. Furthermore I would add that if one were to succeed in making Camembert in the shape of spinach I should very probably not like it either.

But do not forget this: a woodcock, properly high and over which a fine grade of brandy has been burned, served in its own excrement with all the ritual of the best restaurants of Paris, will always represent for me, in this grave domain of food, the most delicate symbol of an authentic civilization. And how beautiful a woodcock is to look upon as it lies naked in the dish! Its slender anatomy achieves, one might say, the proportions of Raphaelesque perfection.

Thus I know exactly, ferociously, what I want to eat! And I am all the more astonished to observe habitually around me creatures who will eat anything, with that sacrilegious lack of conviction that goes with the accomplishment of a strict necessity.

But while I have always known exactly and with premeditation what I wished to obtain of my senses, the same is not true of my sentiments, which are light and fragile as soap-bubbles. For, generally speaking, I have never been able to forsee the hysterical and preposterous course of my conduct, and even less the final outcome of my acts, of which I am often the first astonished spectator and which always acquire at their climax the heavy, categorical and catastrophic weight of leaden balls. It is as if each time one of these thousand iridescent bubbles of my sentiments strays from the course of its ephemeral life and miraculously reaches the earth—reaches reality—it is at that moment transformed

[1] I have always refused to eat a shapeless mess of oysters detached from their shells and served in a soup-dish, even though they were the freshest and best in the world.

into an important act, suddenly changed from something transparent and ethereal into something opaque, metallic and menacing as a bomb. Nothing can better illuminate this than the kinds of stories which are to follow, selected for this chapter without chronological order from the anecdotic stream of my life. When they are strictly authentic and bluntly told, as these are, such anecdotes offer their colors and contours with the guarantee of an unmistakable resemblance that is essential to any honest attempt at self-portraiture. They would have been, I know, secrets forever sealed for many. My fixed idea in this book is to kill as many of these secrets as possible, and to kill them with my own hands!

I

I was five years old, and it was springtime in the village of Cambrils, near Barcelona. I was walking in the country with a boy smaller than I, who had very blond curly hair, and whom I had known only a short time. I was on foot, and he was riding a tricycle. With my hand on his back I helped to push him along.

We got to a bridge under construction which had as yet no railings of any kind. Suddenly, as most of my ideas occur, I looked behind to make sure no one was watching us and gave the child a quick push off the bridge. He landed on some rocks fifteen feet below. I ran home to announce the news.

During the whole afternoon bloodstained basins were brought down from the room where the child, with a badly injured head, was going to have to remain in bed for a week. The continual coming and going and the general turmoil into which the house was thrown put me in a delightful hallucinatory mood. In the small parlor, on a rocking chair trimmed with crocheted lace that covered the back, the arms and the cushion of the seat, I sat eating cherries. The lace was adorned with plump plush cherries. The parlor looked out on the hall, so that I could observe everything that went on, and it was almost completely dark, for the shutters had been drawn to ward off the stifling heat. The sun beating down on them lit up knots in the wood, turning them to a fiery red like ears lighted from behind. I don't recall having experienced the slightest feeling of guilt over this incident. That evening while taking my usual solitary walk I remember having savored the beauty of each blade of grass.

II

I was six years old. Our drawing-room was full of people. They were talking about a famous comet that would be visible that same evening if there were no clouds. Someone had said it was possible that its tail might touch the earth, in which case the world would come to an end. In spite of the irony registered on most of the faces I was seized with a growing agitation and fright. Suddenly one of my father's office clerks appeared in the drawing-room doorway and announced that the comet could be seen

from the terrace. Everyone ran up the stairs except myself; I remained sitting on the floor as if paralyzed with fear. Gathering a little courage I in turn got up and dashed madly toward the terrace. While crossing the hall I caught sight of my little three-year-old sister crawling unobtrusively through a doorway. I stopped, hesitated a second, then gave her a terrible kick in the head as though it had been a ball, and continued running, carried away with a "delirious joy" induced by this savage act. But my father, who was behind me, caught me and led me down into his office, where I remained for punishment till dinner time.

The fact of not having been allowed to see the comet has remained seared in my memory as one of the most intolerable frustrations of my life. I screamed with such rage that I completely lost my voice. Noticing how this frightened my parents, I learned to make use of the stratagem on the slightest provocation. On another occasion when I happened to choke on a fish-bone my father, who couldn't stand such things, got up and left the dining room holding his head between his hands. Thereafter on several occasions I simulated the hacking and hysterical convulsions that accompany such choking just to observe my father's reaction and to attract an anguished and exclusive attention to my person.

At about the same period, one afternoon, the doctor came to the house to pierce my sister's earlobes. My feeling for her was one of delirious tenderness, which had only grown since the incident of my kicking her. This ear-piercing appeared to me an act of outrageous cruelty which I decided to prevent at all costs.

I waited for the moment when the doctor was already seated, had adjusted his glasses, and was ready to perform the operation. Then I broke into the room brandishing my leather-thonged mattress beater and whipped the doctor right across the face, breaking his glasses. He was quite an old man and he cried out with pain. When my father came running in he fell on his shoulder.

"I would never have thought he could do a thing like that, fond of him as I was!" he exclaimed in a voice finely modulated as a nightingale's song, broken by sobs. Since then I loved to be sick, if only for the pleasure of seeing the little face of that old man whom I had reduced to tears.

III

Back to Cambrils again, and to my fifth year. I was taking a walk with three very beautiful grown women. One of them especially appeared to me miraculously beautiful. She held me by the hand and she was wearing a large hat with a white veil twisted round it and falling over her face, which made her extremely moving. We reached a deserted spot, whereupon they began to titter and to whisper among themselves in an ambiguous way. I became troubled and jealous when they began to insist on my running off somewhere to play by myself. I finally left them, but only in order to find a point of vantage from which to spy on them. Suddenly I saw them get into odd postures.

The most beautiful one was in the center, curiously observed from a distance of a few feet by the other two who had stopped talking. With a strange look of pride, her head slightly lowered, her legs very rigid and outspread, her hands by her hips delicately and imperceptibly raised her skirt, and her immobility seemed to convey the expectation of something that was about to happen. A stifling silence reigned for half a minute, when suddenly I heard the sound of a strong liquid jet striking the ground and immediately a foaming puddle formed between her feet. The liquid was partially absorbed by the parched earth, the rest spreading in the form of tiny snakes that multiplied so fast that her white-colored shoes did not escape them in spite of her attempts to extend her feet beyond their reach. A grayish stain of moisture rose and spread on the two shoes, on which the whiting acted as blotting paper.

Intent on what she was doing, the "woman with the veil" did not notice my paralyzed attention. But when she raised her head and found herself looking right into my face she tossed me a mocking smile and a look of unforgettable sweetness, which appeared infinitely troubling, seen through the purity of her veil. Almost at the same moment she cast a glance at her two friends with an expression that seemed to say: "I can't stop now, it's too late." Behind me the two friends burst out laughing, and again there was silence. This time I immediately understood, and my heart beat violently. At almost the same moment two new streams struck hard against the ground; I did not turn my head away; my eyes were wide open, fixed on those behind the veil. A mortal shame welled into my face with the ebb and flow of my crazed blood, while in the sky the last purples of the setting sun melted into the twilight, and on the calcinated earth these three long-confined, hard and precious jets resounded like three drums beneath cascades of wild topazes in ebullition.

Night was falling as we started back, and I refused to give my hand to any of the three young women. I followed them at a short distance, my heart torn between pleasure and resentment. In my shut fist I was carrying a glow-worm which I had picked up by the roadside, and from time to time I gently half-opened my hand to watch it glow. I kept my hand so carefully contracted that it dripped with perspiration, and I would shift the glow-worm from one hand to the other to keep it from getting drenched. Several times in the course of these operations it fell out of my grasp, and I had to look for it in the white dust over which the faint moonlight cast a bluish tinge. And once as I stooped a drop of sweat fell from my hand, making a hole in the dust. The sight of this hole made me shiver. I felt myself tingling with goose flesh. I picked up my glow-worm and, seized with a sudden fright, ran toward the three young women who had left me far behind. They were waiting for me, and the one with the veil vainly held out her hand to me. I wouldn't take it. I walked very close to her, but without giving her my hand.

When we had almost reached the house my twenty-year old cousin

came out to meet us. He was carrying a small rifle slung across his shoulder and his other hand held up some object for us to see. Upon coming nearer we saw that it was a small bat that he held dangling by the ears and that he had just shot in the wing. When we got home he put it in a little tin pail and made me a present of it, when he saw that I was dying to have it. I ran back to the wash-house, which was my favorite spot. There I had a glass under which I kept some ladybugs, with green metallic gleams, on a bed of mint leaves. I put my glow-worm inside the glass, which I placed inside the pail, where the bat remained almost motionless. I spent an hour there before dinner deep in revery. I remember that I spoke aloud to my bat, which I suddenly adored more than anything in the world, and which I kissed again and again on the hairy top of its head.

The next morning a frightful spectacle awaited me. When I reached the back of the wash-house I found the glass over-turned, the ladybugs gone and the bat, though still half-alive, bristling with frenzied ants, its tortured little face exposing tiny teeth like an old woman's. Just then I caught sight of the young woman with the veil passing within ten feet of me. She paused to open the garden gate. Without a moment's reflection I found myself picking up a rock and throwing it at her with all my might, possessed by a mortal hate, as though she were the cause of my bat's condition. The stone missed its mark, but the sound of it made the young woman turn around, and she gave me a look full of maternal curiosity. I stood trembling, overcome by an indescribable emotion in which shame quickly got the upper hand.

Suddenly I committed an incomprehensible act that drew a shrill cry of horror from the young woman. With a lightning movement I picked up the bat, crawling with ants, and lifted it to my mouth, moved by an insurmountable feeling of pity; but instead of kissing it, as I thought I was going to, I gave it such a vigorous bite with my jaws that it seemed to me I almost split it in two. Shuddering with repugnance I flung the bat into the wash-house and fled. The opalescent water in the wash-house was bestrewn with black over-ripe figs that had fallen from a large fig-tree shading it. When I went back to within a few feet of there, my eyes filled with tears. I could no longer distinguish the bat's dark little body, which was lost among the other black specks of the floating figs. Never again did I have a desire even to go near the wash-house, and still today, each time some black spots recall the spatial and special arrangement (which remains quite clear in my memory) of the figs in the tub where my bat was drowned, I feel a cold shudder run down my back.

IV

I was sixteen. It was at the Marist Brothers' School in Figueras. From our classrooms we went out into the recreation yard by a nearly vertical stone stairway. One evening, for no reason at all, I got the idea of flinging myself down from the top of the stairs. I was all set to do this,

when at the last moment fear held me back. I was haunted by the idea, however, secretly nursing the plan to do it the following day. And the next day I could in fact no longer hold back, and at the moment of going down with all my classmates I made a fantastic leap into the void, landed on the stairs, and bounced all the way to the bottom. I was violently bumped and bruised all over, but an intense and inexplicable joy made the pain entirely secondary. The effect produced upon the other boys and the superiors who came running to my aid was enormous. Wet handkerchiefs were applied to my head.

I was at this time extremely timid, and the slightest attention made me blush to the ears; I spent my time hiding, and remained solitary. This flocking of people around me caused in me a strange emotion. Four days later I re-enacted the same scene, but this time I threw myself from the top of the stairway during the second recreation period, at the moment when the animation in the yard was at its height. I even waited until the brother superior was also outdoors. The effect of my fall was even greater than the first time: before flinging myself down I uttered a shrill scream so that everyone would look at me. My joy was indescribable and the pain from the fall insignificant. This was a definite encouragement to continue, and from time to time I repeated my fall. Each time I was about to go down the stairs there was great expectation. Will he throw himself off, or will he not? What was the pleasure of going down quietly and normally when I realized a hundred pairs of eyes were eagerly devouring me?

I shall always remember a certain rainy October evening. I was about to start down the stairs. The yard exhaled a strong odor of damp earth mingled with the odor of roses; the sky, on fire from the setting sun, was massed with sublime clouds in the form of rampant leopards, Napoleons and caravels, all dishevelled; my upturned face was illuminated by the thousand lights of apotheosis. I descended the stairway step by step, with a slow deliberation of blind ecstasy so moving that suddenly a great silence fell upon the shouting whirlwind in the play-yard. I would not at that moment have changed places with a god.

V

I was twenty-two. I was studying at the School of Fine Arts in Madrid. The desire constantly, systematically and at any cost to do just the opposite of what everybody else did pushed me to extravagances that soon became notorious in artistic circles. In the painting class we had the assignment to paint a Gothic statue of the Virgin directly from a model. Before going out the professor had repeatedly emphasized that we were to paint exactly what we "saw".

Immediately, in a dizzy frenzy of mystification, I went to work furtively painting, in the minutest detail, a pair of scales which I copied out of a catalogue. This time they really believed I was mad. At the end of the week the professor came to correct and comment on the progress of

our work. He stopped in frozen silence before the picture of my scales, while all the students gathered around us.

"Perhaps you see a Virgin like everyone else," I ventured, in a timid voice that was not without firmness. "But I see a pair of scales."[1]

VI

Still at the School of Fine Arts.

We were assigned to do an original picture in oil for a prize contest in the painting class. I made a wager that I would win the prize by painting a picture without touching my brush to the canvas. I did in fact execute it by tossing splashes of paint from a distance of a metre, and I succeeded in making a *pointilliste* picture so accurate in design and color that I was awarded the prize.

VII

The following year I came up for my examination in the history of art.

I was anxious to be as brilliant as possible. I was wonderfully well pre-

[1] It is only in writing down this anecdote that I am struck by the obvious connection, if only as a pure association of ideas, between the Virgin and the scales in the signs of the Zodiac. As she now appears in my memory, moreover, the Virgin was standing on a "celestial sphere." This would-be mystification was therefore nothing more nor less than an anticipation, the first realization of the future Dalinian philosophy of painting; that is to say the sudden materialization of the suggested image; the all-powerful fetishistic corporeality of virtual phantoms which are thereby endowed with all the attributes of realism belonging to tangible objects.

pared. I got up on the platform where the examining committee of three sat, and the subject of my oral thesis was drawn by lot. My luck was unbelievable: it was exactly the subject I should have preferred to treat. But suddenly an insurmountable feeling of indolence came over me, and almost without hesitation, to the stupefaction of my examiners and the people who filled the hall, I got up and declared in so many words,

"I am very sorry, but I am infinitely more intelligent than these three professors, and I therefore refuse to be examined by them. I know this subject much too well."

As a result of this I was brought before the disciplinary council and expelled from the school.

This was the end of my scholastic career.

VIII

I was twenty-nine, and it was summer, in Cadaques. I was courting Gala, and we were having lunch with some friends at the seashore, in a vine-covered arbor over which hung the deafening hum of bees. I was at the peak of my happiness although I bore the ripening weight of a new-born love clutching my throat like a veritable octopus of solid gold sparkling with a thousand precious stones of anguish. I had just eaten four broiled lobsters and drunk a bit of wine—one of those local wines that are unpretentious but in their own right one of the most delicate secrets of the Mediterranean, for they have that unique bouquet in which, along with a great, great deal of unreality, one can almost detect the sentimental prickling taste of tears.

It was very late as we were finishing the meal, and the sun was already low on the horizon. I was barefoot, and one of the girls in our group, who had been an admirer of mine for some time, kept remarking shrilly how beautiful my feet were. This was so true that I found her insistence on this matter stupid. She was sitting on the ground, with her head lightly resting against my knees. Suddenly she put her hand on one of my feet and ventured an almost imperceptible caress with her trembling fingers. I jumped up, my mind clouded by an odd feeling of jealousy toward myself, as though all at once I had become Gala. I pushed away my admirer, knocked her down and trampled on her with all my might, until they had to tear her, bleeding, out of my reach.

IX

I seem destined to a truculent eccentricity, whether I wish it or no.

I was thirty-three. One day in Paris I received a telephone call from a brilliant young psychiatrist. He had just read an article of mine in the review *Le Minotaure* on *The Inner Mechanism of Paranoiac Activity*. He congratulated me and expressed his astonishment at the accuracy of my scientific knowledge of this subject, which was so generally misunderstood. He wished to see me to talk over this whole question. We agreed

to meet late that very afternoon in my studio on Rue Gauguet. I spent the whole afternoon in a state of extreme agitation at the prospect of our interview, and I tried to plan in advance the course of our conversation. My ideas were so often regarded even by my closest friends in the surrealist group as paradoxical whims—tinged with genius, to be sure— that I was flattered finally to be considered seriously in strictly scientific circles. Hence I was anxious that everything about our first exchange of ideas should be perfectly normal and serious. While waiting for the young psychiatrist's arrival I continued working from memory on the portrait of the Vicomtesse de Noailles on which I was then engaged. This painting was executed directly on copper. The highly burnished metal cast mirror-like reflections which made it difficult for me to see my drawing clearly. I noticed as I had before that it was easier to see what I was doing where the reflections were brightest. At once I stuck a piece of white paper half an inch square on the end of my nose. Its reflection made perfectly visible the drawing of the parts on which I was working.

At six o'clock sharp—the appointed time of our meeting—the doorbell rang. I hurriedly put away my copper, Jacques Lacan entered, and we immediately launched into a highly technical discussion. We were surprised to discover that our views were equally opposed, and for the same reasons, to the constitutionalist theories then almost unanimously accepted. We conversed for two hours in a constant dialectical tumult. He left with the promise that we would keep in constant touch with each other and meet periodically. After he had gone I paced up and down my studio, trying to reconstruct the course of our conversation and to weigh more objectively the points on which our rare disagreements might have a real significance. But I grew increasingly puzzled over the rather alarming manner in which the young psychiatrist had scrutinized my face from time to time. It was almost as if the germ of a strange, curious smile would then pierce through his expression.

Was he intently studying the convulsive effects upon my facial morphology of the ideas that stirred my soul?

I found the answer to the enigma when I presently went to wash my hands (this, incidentally, is the moment when one usually sees every kind of question with the greatest lucidity). But this time the answer was given me by my image in the mirror. I had forgotten to remove the square of white paper from the tip of my nose! For two hours I had discussed questions of the most transcendental nature in the most precise, objective and grave tone of voice without being aware of the disconcerting adornment of my nose. What cynic could consciously have played this rôle through to the end?

X

I was twenty-three, living at my parents' house in Figueras. I was inspired, working on a large cubist painting in my studio, I had lost the belt to my dressing gown, which kept hampering my movements. Reach-

ing for the nearest thing to hand I picked up an electric cord lying on the floor and impatiently wound it round my waist. At the end of the cord, however, there was a small lamp. Not wanting to waste time by looking further, and as the lamp was not very heavy, I used it as a buckle to knot the ends of my improvised belt together.

I was deeply immersed again in my work when my sister came to announce that there were some important people in the living-room who wanted to meet me. At this time I had considerable notoriety in Catalonia, less because of my paintings than because of several cataclysms that I had unwittingly precipitated. I tore myself ill-humoredly from my work and went into the living-room. I was immediately aware of my parents' disapproving glance at my paint-spattered dressing-gown, but no one yet noticed the lamp which dangled behind me, right against my buttocks. After a polite introduction I sat down, crushing the lamp against the chair and causing the bulb to burst like a bomb. An unpredictable, faithful and objective hazard seems to have systematically singled out my life to make what are normally uneventful incidents violent, phenomenal and memorable.

XI

In 1928 I was giving a lecture on modern art in my native town of Figueras, with the mayor acting as chairman and a number of local notables in attendance. An unusual crowd had gathered to hear me. I had come to the end of my speech, which had apparently been followed with polite puzzlement, and there was no indication from the audience that the conclusive nature of my last paragraph had been grasped. In a sudden hysterical rage, I shouted, at the top of my lungs:

"Ladies and gentlemen, the Lecture is FINISHED!"

At this moment the mayor, who was very popular, who was indeed loved by the whole town, fell dead at my feet. The emotion was indescribable and the event had considerable repercussions. The comic papers claimed that the enormities expressed in the course of my lecture had killed him. It was in fact simply a case of sudden death—angina pectoris, I believe—fortuitously occurring exactly at the end of my speech.

XII

In 1937 I was to give a lecture in Barcelona on the subject: "The Surrealist and Phenomenal Mystery of the Bedside Table". On the very day scheduled for the lecture an anarchist revolt broke out. A part of the public which had come to hear me in spite of this was kept prisoner in the building, for the metal doors to the street had to be hastily lowered in case of shooting. Intermittently could be heard the bursting bombs of the F. A. I.[1]

[1] Iberian Anarchist Federation.

XIII

When I arrived in Turin on my first trip to Italy the sky was blackened by a spectacular aerial display. Through the streets marched torchlight parades: war had just been declared on Abyssinia.

XIV

Another lecture in Barcelona. The theatre in which I was to talk caught fire that same morning. It was quickly put out, but the conflagration was more than enough to give a light of immediacy to the evening lecture.

XV

At still another lecture, also in Barcelona, a doctor with a white beard was seized with a kind of mad fit and tried to kill me. It took several people to subdue him and drag him out of the hall.

XVI

, In 1931, in Paris, in the course of the showing of the surrealist film *L'Age d'Or*, on which I had collaborated with Bunuel, the *Camelots du Roi* (King's Henchmen) threw ink-bottles at the screen, fired revolvers in the air, assaulted the public with bludgeons and wrecked the exhibition of surrealist paintings on display in the theatre lobby. As this was one of the greatest Parisian events of the period I shall relate it in full detail in its proper place in this book.

XVII

At the age of six, again, I was on the way to Barcelona with my parents. Midway there was a long stop, at the station of El Empalme. We got out. My father said to me: "You see, over there, they're selling rolls—let's see if you're smart enough to buy one. Run along, but don't get any of the ones with an omelet inside; I just want the roll."

I went off and came back with a roll. My father turned pale when he saw it.

"But there was an omelet inside!" he exclaimed, highly aggravated.

"Yes, but you told me you only wanted the roll. So I threw away the omelet."

"Where did you throw it?"

"On the ground."

XVIII

In 1936 in Paris in our apartment at number 7 Rue Becquerel, near the Sacré-Coeur. Gala was to undergo an operation the following morning and had to spend the night at the hospital for preparatory treatments. The operation was considered very serious. Nevertheless, Gala, with her unfailing courage and vitality, seemed not at all worried, and we spent

that whole afternoon constructing two surrealist objects. She was happy as a child: with graceful arched movements, reminiscent of Carpaccio's figures, she was assembling an astounding collection of items which she subjected to the little catacylsms of certain mechanical actions. Later I realized that this object was full of unconscious allusions to her impending operation. Its eminently biological character was obvious: membranes ready to be torn by the rhythmic movement of metal antennae, delicate as surgical instruments, a bowl full of flour serving as a shock-absorber for a pair of woman's breasts so placed as to bump against it...The breasts had rooster-feathers budding out of the nipples, so that by brushing against the flour the feathers softened the impact of the breasts, which thus barely grazed the surface and left only an infinitely soft, almost imperceptible imprint of their contours upon the immaculate flour.

I, meanwhile, was putting together a "thing" which I called the "hypnagogic clock." This clock consisted of an enormous loaf of French bread posed on a luxurious pedestal. On the back of this loaf I fastened a dozen ink-bottles in a row, filled with "Pelican" ink, and each bottle held a pen of a different color. I was highly enthusiastic over the effect which this produced. At nightfall Gala had completely finished her object, and we decided to take it to André Breton to show to him before going to the hospital. (The making of this kind of object had become an epidemic and was then at its height in surrealist circles.) We hurriedly carried Gala's object into a taxi, but no sooner had we got under way than a sudden stop caused the object, which we were cautiously carrying on our laps, to fall apart, and the pieces scattered all over the floor and seat of the taxi. Worst of all, the bowl containing two pounds of flour was upset along with the rest. We were entirely covered with it. We tried to gather up some of the spilt flour, but it had already become dirty. From time to time the taxi-driver glanced back at us in our agitation with an expression of profound pity and bewilderment. We stopped at a grocery store to buy another two pounds of fresh flour.

All these incidents almost made us forget the hospital, where we arrived very late. Our appearance in the courtyard, which was steeped in a mauve May twilight, must have seemed strange and alarming, to judge from the effect we produced on the nurses who came out to meet us. We kept dusting ourselves, each time raising clouds of flour, especially I, who was covered with it even to my hair. What was one to make of a husband stepping out of a perfectly conventional taxi and bringing in his wife for a serious operation, with his clothes saturated with flour, and seeming to take it all as a lark? This is probably still an unfathomed mystery to those nurses of the clinic on Rue Michel-Ange who witnessed our bizarre appearance, which only the chance reading of these lines is likely to clear up.

I left Gala at the hospital and hurried back home. From time to time and at increasing intervals I continued absentmindedly to dust off

the stubborn flour sticking to my clothes. I dined on a few oysters and a roast pigeon, which I ate with an excellent appetite. After three coffees I went back to work on the object I had begun in the afternoon. As a matter of fact I had cherished this moment the whole time I was gone, and the interruption of taking Gala to the hospital had only heightened the anticipation and increased its delight. I was a little surprised at my almost complete indifference to my wife's operation, which was to be performed the following morning at ten. But I found myself unable, even with a little effort, to bring myself to feel the slightest anxiety or emotion. This complete indifference toward the being whom I believed I adored presented to my intelligence a very interesting philosophical and moral problem to which, however, I found it impossible to give my attention immediately.

Indeed I felt myself inspired, inspired like a musician: new ideas sparkled in the depth of my imagination. To my loaf of bread I added sixty pictures of ink-bottles with their pens respectively painted in water-color on little squares of paper which I hung by sixty strings under the loaf. A warm breeze blowing in from the street set all these pictures swinging back and forth. I contemplated the absurd and terribly real appearance of my object with genuine ecstacy. Still engrossed in the importance of the object I had just constructed, I finally went to bed at about two in the morning. With the innocence of an angel I fell immediately into deep, peaceful slumber. At five I awoke like a demon. The greatest anguish I had ever felt held me riveted to my bed.

With painfully slow movements which seemed to me to last two thousand years, I threw back the blankets that were choking me. I was covered with that cold perspiration of remorse which is like the dew that has formed on the landscapes of the human soul since the first gleams of the dawn of morality. Day needled the sky, the shrill and frenzied song of birds, suddenly awakened, pecked, as it were, at the very pupils of my eyes opening to misfortune, deafening my ears, and constricting my heart with the tense and growing web of all the buds bursting with the sap of springtime.

Gala, Galuchka, Galuchkineta! Burning tears welled up one by one into my eyes, awkwardly at first, with spasms and the pangs of childbirth. Presently they flowed—with the sureness and impetuosity of a rushing cavalcade—with sorrow for the beloved one, seen in profile seated in the pearl-studded chariot of despair, swept along triumphantly. Each time the flow of my tears began to subside there would immediately arise before me an instantaneous vision of Gala—Gala leaning against an olive-tree in Cadaques, beckoning to me; Gala in late summer stooping to pick up a gleaming mica pebble amid the rocks of Cape Creus; Gala swimming out so far that I can distinguish only the smile of her little face—and these fleeting images sufficed to provoke by their painful pressure a fresh jet of tears, as though the hard mechanism of feeling were compressing the muscular diaphragm of my orbits, squeezing and press-

ing out to the last drop each one of those luminous visions of my love, contained in the acid and livid lemon of memory.

Like one possessed I ran to the hospital, and I clutched at the surgeon's uniform with such a display of animal fear that he treated me with exceptional circumspection, as though I had been myself a patient. For a week I was in an almost constant state of tears and wept in every circumstance in which I found myself, to the complete astonishment of my close friends among the surrealists. A Sunday came when Gala was definitely out of danger, and the hour of death in holiday-clothes respectfully backed away on tiptoe. Galuchka was smiling, and at last I held her hand pressed against my cheek. And with tenderness I thought: "After all this, I could kill you!"

XIX

My three voyages to Vienna were exactly like three drops of water which lacked the reflections to make them glitter. On each of these voyages I did exactly the same things: in the morning I went to see the Vermeer in the Czernin Collection, and in the afternoon I did *not* go to visit Freud because I invariably learned that he was out of town for reasons of health.

I remember with a gentle melancholy spending those afternoons walking haphazardly along the streets of Austria's ancient capital. The chocolate tart, which I would hurriedly eat between the short intervals of going from one antiquary to another, had a slightly bitter taste resulting from the antiquities I saw and accentuated by the mockery of the meeting which never took place. In the evening I held long and exhaustive imaginary conversations with Freud; he even came home with me once and stayed all night clinging to the curtains of my room in the Hotel Sacher.

Several years after my last ineffectual attempt to meet Freud, I made a gastronomic excursion into the region of Sens in France. We started the dinner with snails, one of my favorite dishes. The conversation turned to Edgar Allan Poe, a magnificent theme while savoring snails, and concerned itself particularly with a recently published book by the Princess of Greece, Marie Bonaparte, which is a psychoanalytical study of Poe. All of a sudden I saw a photograph of Professor Freud on the front page of a newspaper which someone beside me was reading. I immediately had one brought to me and read that the exiled Freud had just arrived in Paris. We had not yet recovered from the effect of this news when I uttered a loud cry. I had just that instant discovered the morphological secret of Freud! Freud's cranium is a snail! His brain is in the form of a spiral—to be extracted with a needle! This discovery strongly influenced the portrait drawing which I later made from life, a year before his death.

Raphael's skull is exactly the opposite of Freud's; it is octagonal like a carved gem, and his brain is like veins in the stone. The skull of

Leonardo is like those nuts that one crushes: that is to say, it looks more like a real brain.

I was to meet Freud at last, in London. I was accompanied by the writer Stefan Zweig and by the poet Edward James. While I was crossing the old professor's yard I saw a bicycle leaning against the wall, and on the saddle, attached by a string, was a red rubber hot-water bottle

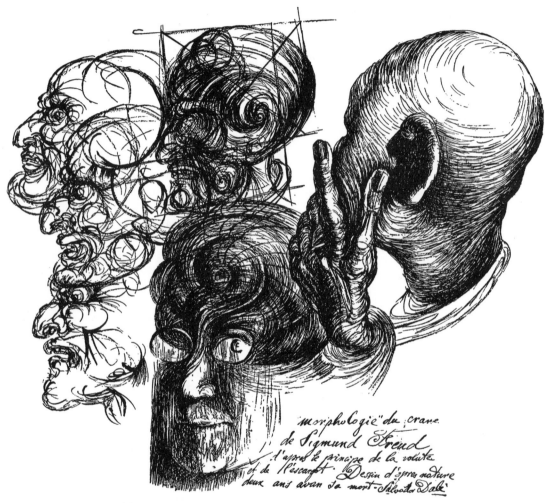

which looked full of water, and on the back of the hot-water bottle walked a snail! The presence of that assortment seemed strange and inexplicable in the yard of Freud's house.

Contrary to my hopes we spoke little, but we devoured each other with our eyes. Freud knew nothing about me except my painting, which he admired, but suddenly I had the whim of trying to appear in his eyes as a kind of dandy of "universal intellectualism." I learned later that the effect I produced was exactly the opposite.

Before leaving I wanted to give him a magazine containing an article I had written on paranoia. I therefore opened the magazine at the page of my text, begging him to read it if he had time. Freud continued to stare at me without paying the slightest attention to my magazine. Trying to interest him, I explained that it was not a surrealist diversion, but was really an ambitiously scientific article, and I repeated the title, pointing to it at the same time with my finger. Before his imperturbable indifference, my voice became involuntarily sharper and more insistent. Then, continuing to stare at me with a fixity in which his whole being seemed to converge, Freud exclaimed, addressing Stefan Zweig, "I have never seen a more complete example of a Spaniard. What a fanatic!"

Intra-Uterine

Memories

I presume that my readers do not at all remember, or remember only very vaguely, that highly important period of their existence which anteceded their birth and which transpired in their mother's womb. But I—yes, I remember this period, as though it were yesterday. It is for this reason that I propose to begin the book of my secret life at its real and authentic beginning, namely with the memories, so rare and liquid, which I have preserved of that intra-uterine life, and which will undoubtedly be the first of this kind in the world since the beginning of literary history to see the light of day and to be described systematically.[1]

In doing this I am confident of provoking the apparition of similar recollections that will begin timidly to people the memories of my readers, or at least of localizing in their minds a host of sentiments, of ineffable and indefinable impressions, images, moods and physical states which will progressively become incorporated into a kind of adumbration of their memories of pre-natal life. On this subject the quite sensational book by Doctor Otto Rank entitled *The Traumatism of Birth* cannot fail to enlighten the reader really curious about himself who desires to approach this question more scientifically. As for me, I must declare that my personal memories of the intra-uterine period, so exceptionally lucid and detailed, only corroborate on every point Doctor Otto Rank's thesis, and especially the most general aspects of this thesis, as it connects and identifies the said intra-uterine period with paradise, and birth—the

[1] While engaged in the translation of my book Mr. Chevalier has called my attention to another chapter of "intra-uterine" memories discovered by his friend Mr. Vladimir Pozner in Casanova's *Memoirs*.

traumatism of birth—with the myth, so decisive in human life, of the "Lost Paradise."

Indeed if you ask me how it was "in there", I shall immediately answer, "It was divine, it was paradise." But what was this paradise like? Have no fear, details will not be lacking. But allow me to begin with a short general description: the intra-uterine paradise was the color of hell, that is to say, red, orange, yellow and bluish, the color of flames, of fire; above all it was soft, immobile, warm, symmetrical, double, gluey. Already at that time all pleasure, all enchantment for me was in my eyes, and the most splendid, the most striking vision was that of a pair of eggs fried in a pan, without the pan; to this is probably due that perturbation and that emotion which I have since felt, the whole rest of my life, in the presence of this ever-hallucinatory image. The eggs, fried in the pan, without the pan, which I saw before my birth were grandiose, phosphorescent and very detailed in all the folds of their faintly bluish whites. These two eggs would approach (toward me), recede, move toward the left, toward the right, upward, downward; they would attain the iridescence and the intensity of mother-of-pearl fires, only to diminish progressively and at last vanish. The fact that I am still able today to reproduce at will a similar image, though much feebler, and shorn of all the grandeur and the magic of that time, by subjecting my pupils to a strong pressure of my fingers, makes me interpret this fulgurating image of the eggs as being a phosphene,[1] originating in similar pressures: those of my fists closed on my orbits, which is characteristic of the foetal posture. It is a common game among all children to press their eyes in order to see circles of colors *which are sometimes called angels.* The child would then be seeking to reproduce visual memories of his embryonic period, pressing his already nostalgic eyes till they hurt in order to extract from them the longed-for lights and colors, in order approximately to see again the divine aureole of the spectral angels perceived in his lost paradise.

It seems increasingly true that the whole imaginative life of man tends to reconstitute symbolically by the most similar situations and representations that initial paradisial state, and especially to surmount the horrible "traumatism of birth" by which we are expulsed from the paradise, passing abruptly from that ideally protective and enclosed environment to all the hard dangers of the frightfully real new world, with the concomitant phenomena of asphyxiation, of compression, of blinding by the sudden outer light and of the brutal harshness of the reality of the world, which will remain inscribed in the mind under the sign of anguish, of stupor and of displeasure.

It would seem that the death-wish is often explained by that imperialist and constant compulsion to return where we came from, and that suicides are generally those who have not been able to overcome that

[1] Phosphene: a luminous sensation resulting from pressure on the eye when the eyelids are shut.

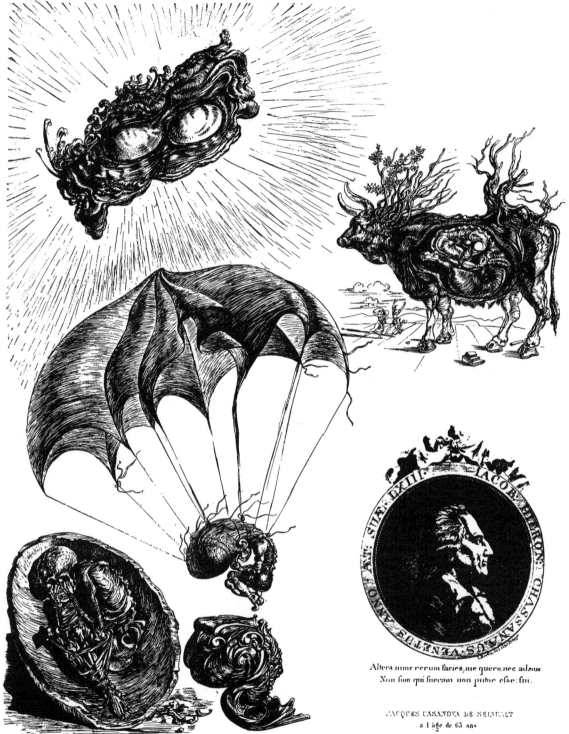

Altera nunc rerum facies, me quero, nec adsum
Non sum qui fueram non putor esse: fui.

JACQUES CASANOVA DE SEINGALT
a l'âge de 65 ans

traumatism of birth, who, even in a brilliant social midst, and while all the candelabra are sparkling in the drawing room, suddenly decide to return to the house of death. In the same way the man who dies from a bullet on the field of battle with the cry of "Mother!" on his lips expresses with truculence that wish to be born again backwards, and to return to the place from which he emerged. Nothing better illustrates all this than the burial customs of certain tribes, who inter their dead crouching and bound in the exact attitudes of the foetus.

But without requiring this categorical experience of the hour of death, man periodically recovers in sleep something of this artificial death, something of that paradisial state, which he tries to recapture in the minutest details. The attitudes of sleepers are in this regard most instructive: in my own case my attitudes of pre-sleep offer not only the characteristic curling up, but also they constitute a veritable pantomime composed of little gestures, tics, and changes of position which are but the secret ballet required by the almost liturgical ceremonial initiating the act of delivering oneself body and soul to that temporary nirvana of sleep by which we have access to precious fragments of our lost paradise. Before sleep I curl up in the embryonic posture, my thumbs pressed by the other fingers so tightly as to hurt, with a tyrannic necessity to feel my back adhere to the symbolic placenta of the bedsheets, which I try, by successive efforts more and more closely approximating perfection, to mould to the posterior part of my body, irrespective of the temperature; thus even during the greatest heat I must be covered in this fashion, however slight the thickness of my envelope. Also my definitive posture as a sleeper must be of a rigorous exactitude. It is necessary, for instance, that my little toe be more to the left, or to the right, that my upper lip be almost imperceptibly pressed to my pillow, in order that the god of sleep, Morpheus, shall have the right to seize me, to possess me completely; as he wins me my body progressively disappears and becomes localized, so to speak, entirely in my head, invading it, filling it with all its weight.

This representation of myself approximates the memory of my intra-uterine person, which I might define as: a certain weight around two roundnesses—my eyes, very likely. I have often imagined and represented the monster of sleep as an immense and very heavy head, with a single thread-like reminiscence of the body, which is prodigiously maintained in equilibrium by the multiple crutches of reality, thanks to which we remain in a sense suspended above the earth during sleep. Often these crutches give way and we "fall." Surely most of my readers have experienced that violent sensation of feeling themselves suddenly fall into the void just at the moment of falling asleep, awakening with a start, their hearts tumultuously agitated by a paralyzing fear. You may be sure that this is a case of a brutal and crude recall of birth, reconstituting thus the dazed sensation of the very moment of expulsion and of falling outside. Pre-sleep reconstituting the pre-natal memory, characterized by

the absence of movement, prepares the unfolding of that traumatic memory of a fall into the void. These falls of pre-sleep take place each time the individual either by excess of fatigue or by the paroxysmal need for escape from the day's cares prepares for the most delightfully and exceptionally longed-for and refreshing sleep.

We have learned, thanks to Freud, the symbolic significance charged with a well determined erotic meaning that characterizes everything relating to aviation, and especially to its origins.[1] Nothing, indeed, is clearer than the paradisial significance of dreams of "flight",[2] which in the unconscious mythology of our epoch only mask that frenzied and puerile illusion of the "conquest of the sky," the "conquest of paradise" incarnated in the messianic character of elementary ideologies (in which the airplane takes the place of a new divinity), and in the same way that we have just studied in the individual pre-dream the frightful fall that awakens us with a start—as a brutal recall of the precise moment of our birth—so we find in the pre-dream of the present day those parachute jumps which I affirm without any fear of being mistaken are nothing other than the dropping from heaven of the veritable rain of new-born children provoked by the war of 1914, nothing other than the fall of all those who, unable to surmount the frightful traumatism of their first birth, desperately attempt to hurl themselves into the void, with the infantile desire to be reborn at all costs, "and in another way", all the while remaining attached to the umbilical cord which holds them suspended to the silk placenta of their maternal parachute. The stratagem of the parachute is of the same nature as that which is utilized by marsupials; in effect the kangaroo's pocket serves as a shock-absorber for the brusk transition of birth by which one is cruelly expulsed from paradise.

The marsupial centauresses recently invented by Salvador Dali also have this meaning of the parachutes of birth—"parabirths"—for thanks to the "holes"[3] which the centauresses have in the middle of their stomachs their sons can at will enter and leave their own mother, their own paradise, so as to be able to become gradually habituated to the environmental reality, while consoling themselves in the most progressive manner for the memory, unconscious but incrusted in their soul,

[1] Leonardo da Vinci's preoccupations in this regard (which became crystallized in the invention of his flying machines) are most instructive from the psychological point of view.

[2] A symbol of erection by the contradiction which this phenomenon offers in relation to the laws of gravity: the bird a very frequent popular synonym for the penis, the winged phallus of antiquity—Pegasus, Jacob's ladder, angels, Amor and Psyche, etc.

[3] In my last exhibition a lady asked me, "Why those holes in the stomachs of your centauresses?" To which I answered, "It's exactly the same as a parachute, but it's less dangerous." This, as might have been expected, was loudly greeted as a mystification, but I am convinced that the reader who has attentively read the preceding lines will judge my answer otherwise, while readily understanding that it was not so eccentric as it seemed.

of that wonderful pre-natal lost paradise, which only death can partly restore to them.

External danger [1] has the virtue of provoking and enhancing the phantasms and representations of our intra-uterine memories. When I was small I remember that at the approach of great summer storms we children would all run frantically with one accord and hide under the tables covered with cloths, or else we would hastily construct huts by means of chairs and blankets that were meant to hide and protect our games. What a joy it was then to hear the thunder and the rain out- side! What a delightful memory of our games! All curled up in there, we especially liked to eat sweets, to drink warm sugar-water, all the while trying to make believe our life was then transpiring in another world. I had named that stormy weather game "Playing at making grottoes," or else "Playing at Padre Patufet," and this is the reason for the last appella- tion: Padre Patufet has been since olden times the most popular child- hood hero of Catalonia; he was so small that one day he got lost in the country. An ox swallowed him to protect him. His parents looked for him everywhere, calling, "Patufet, Patufet! Where are you?" And they heard the voice of Patufet answering, "I am in the belly of the ox where it does not snow and it does not rain!"

It was in these artificial ox-belly-grottoes, constructed in the electric tension of stormy days that my Patufet imagination reproduced most of the images corresponding in an unequivocal way to my pre-natal memories. These memory-images that had so determining an influence on the rest of my life would always occur as a consequence of a curious game consisting of the following: I would get down on all fours and in such a way that my knees and hands would touch; I would then let my head droop with its own weight while swinging it in all directions like a pendulum, so as to make all my blood flow into it. I would prolong this exercise until a voluptuous dizziness resulted; then and without having to shut my eyes I would see emerging from the intense darkness (blacker than anything one can see in real darkness) phosphorescent circles in which would be formed the famous fried eggs (without the pan) already described in these pages. These eggs of fire would finally blend with a very soft and amorphous white paste; it seemed to be pulled in all directions, its extreme ductility adapting itself to all forms seemed to grow with my growing desire to see it ground, folded, refolded, curled up and pressed in the most contradictory directions. This appeared to me the

[1] The present war has furnished me several striking examples on this subject: during the air-raid alarms in Paris I would draw the curled-up and foetus-like attitudes that people would adopt in the shelters. There the external danger was further augmented by the intra-uterine evocations inherent in the darkness, the dimensions, etc. of the cellars. People would often go to sleep with ecstasies of happiness, and a secret illusion was constantly betrayed by smiles appropriate to a satisfaction abso- lutely unjustified by logic, if one did not admit the presence of secret activities characteristic of unconscious representations.

height of delight, and I should have liked everything *to be always like that!*

The mechanical object was to become my worst enemy, and as for watches, they would have to be soft, or not be at all!

A Gala-Gradiva,

celle qui avance

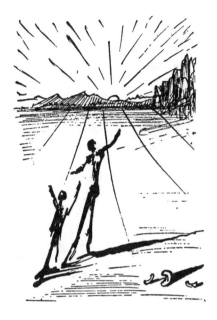

Birth of Salvador Dali

In the town of Figueras at eleven o'clock on the thirteenth day of the month of May, 1904, Don Salvador Dali y Cusi, native of Cadaques, province of Gerona, 41 years of age, married, a notary, residing in this town at 20 Calle de Monturiol, appeared before Senor Miguel Comas Quintana, the well-read municipal judge of this town, and his secretary, D. Francisco Sala y Sabria, in order to record the birth of a child in the civil register, and to this effect, being known to the aforementioned judge, he declared:

THAT the said child was born at his domicile at forty-five minutes after eight o'clock on the eleventh day of the present month of May, and that he will be given the names of Salvador Felipe y Jacinto; that he is the legitimate son of himself and of his wife, Doña Felipa Dome Domenech, aged thirty, native of Barcelona and residing at the address of the informant. His paternal grandparents are: Don Galo Dali Vinas, native of Cadaques, defunct, and Doña Teresa Cusi Marco, native of Rosas; and his maternal grand-parents: Doña Maria Ferres Sadurne and Don Anselmo Domenech Serra, natives of Barcelona.

The witnesses were: Don José Mercader, native of La Bisbal, in the province of Gerona, a tanner residing in this town, at 20 Calzada de Los Monjes, and Don Emilio Baig, native of this town, a musician, domiciled at 5 Calles de Perelada, both having attained the age of their majority.

Let all the bells ring! Let the toiling peasant straighten for a moment the ankylosed curve of his anonymous back, bowed to the soil like the trunk of an olive tree, twisted by the tramontana, and let his cheek, furrowed by deep and earth-filled wrinkles, rest in the hollow of his calloused hand in a noble attitude of momentary and meditative repose.

Look! Salvador Dali has just been born! No wind blows and the May sky is without a single cloud. The Mediterranean sea is motionless and on its back, smooth as a fish's, one can see glistening the silver scales of not more than seven or eight sunbeams by careful count. So much the better! Salvador Dali would not have wanted more!

It is on mornings such as this that the Greeks and the Phoenicians must have disembarked in the bays of Rosas and of Ampurias, in order to come and prepare the bed of civilization and the clean, white and theatrical sheets of my birth, settling the whole in the very centre of this plain of Ampurdán, which is the most concrete and the most objective piece of landscape that exists in the world.

Let also the fisherman of Cape Creus slip his oars under his legs, keeping them motionless; and while they drip let him forcefully spit into the sea the bitter butt of a cigar a hundred times chewed over, while with the back of his sleeve he wipes that tear of honey which for several minutes has been forming in the corner of his eye, and let him then look in my direction!

And you, too, Narciso Monturiol, illustrious son of Figueras, inventor and builder of the first submarine, raise your gray and mist-filled eyes toward me. Look at me!

You see nothing? And all of you—do you see nothing either?

Only...

In a house on Calle de Monturiol a new-born babe is being watched closely and with infinite love by his parents, provoking a slight and unaccustomed domestic disorder.

Wretches that you all are! Remember well what I am about to tell you: It will not be so the day I die!

False
Childhood
Memories

When I was seven years old my father decided to take me to school. He had to resort to force; with great effort he dragged me all the way by the hand, while I screamed and raised such a commotion that all the shopkeepers on the streets we passed through came out on their doorsteps to watch us. My parents had succeeded by this time in teaching me two things: the letters of the alphabet and how to write my name. At the end of one year of school they discovered to their stupefaction that I had totally forgotten these two things.

This was by no means my fault. My teacher had done a great deal to achieve this result—or rather, he had done nothing at all, for he would come to school only to sleep almost continually. This schoolmaster's name was Senor Traite, which in Catalonian is something like the word for "omelet," and he was truly a phantastic character in every respect. He wore a white beard separated into two symmetrical plaits that were so long that when he sat down they hung below his knees. The ivory tint of this beard was stained with yellowish spots shading into brown like those that form a patina on the fingertips and nails of great smokers, and also the keys of certain pianos—which, of course, have never smoked in their lives.

As for Senor Traite, he did not smoke either. It would have interfered with his sleeping. But he made up for this by taking snuff. At each brief awakening he would take a pinch of criminally aromatic snuff, which made him sneeze wholeheartedly, bespattering an immense handkerchief, which he rarely changed, with ochre stains. Senor Traite had a very handsome face of the Tolstoyan type to which something of a Leonardo had been grafted; his blue eyes, very bright, were surely peopled with dreams and a good deal of poetry; he dressed carelessly, he was foul-smelling, and from time to time he wore a top-hat, which was altogether unusual in the region. But with his imposing appearance

he could allow himself anything: he lived surrounded by a legendary aureole of intelligence which made him invulnerable. Now and then he would go off on a Sunday excursion and return with his cart filled with bits of church sculpture, Gothic windows and other architectural pieces which he stole from the churches of the countryside or which he bought for next to nothing. Once he discovered a Romanesque capital which particularly appealed to him and which was set in a belltower. Senor Traite managed to find his way in at night and break it loose from the wall. He dug and dug so hard that a part of the tower collapsed, and with a noise easy to imagine two large bells fell through the roof of an adjoining house, leaving a gaping hole. By the time the awakened village was able to realize what had happened Senor Traite was already galloping away in his cart, though it is true that he did not escape a few inhospitable rocks. Although the incident aroused the people of Figueras, it rather enhanced his glory, for he became on this account a kind of martyr to the love of Art. What is certain in this story is that bit by bit Senor Traite was building in the vicinity an outlandish villa in which he lumped together the whole heterogeneous archeological collection gathered in the course of his Sunday pillagings, which had assumed the endemic form of a veritable devastation of the artistic treasures of the countryside.

Why had my parents chosen a school with so sensational a master as Senor Traite? My father, who was a free-thinker, and who had sprung from sentimental Barcelona, the Barcelona of "Clavé choirs," [1] the anarchists and the Ferrer trial,[2] made it a matter of principle not to put me into the Christian schools or those of the Marist brothers, which would have been appropriate for people of our rank, my father being a notary and one of the most esteemed men of the town. In spite of this he was absolutely determined to put me into the communal school— Senor Traite's school. This attitude was regarded as a real eccentricity, only partly justified by the mythical prestige of Senor Traite, of whose pedagogical gifts none of my parents' acquaintances had the slightest personal experience, since they had all raised their children elsewhere.

I therefore spent my first school year living with the poorest children of the town, which was very important, I think, for the development of my natural tendencies to megalomania. Indeed I became more and more used to considering myself, a rich child, as something precious, delicate, and absolutely different from all the ragged children who surrounded me. I was the only one to bring hot milk and cocoa put up in a magnificent thermos bottle wrapped in a cloth embroidered with my initials. I alone had an immaculate bandage put on the slightest scratch, I alone wore a sailor suit with insignia embroidered in thick gold on the sleeves,

[1] José Anselmo Clavé, a Catalan musician, founded choral societies in Barcelona which developed into important musical institutions.

[2] A famous anti-anarchist trial.

and stars on my cap, I alone had hair that was combed a thousand times and that smelt good of a perfume that must have seemed so troubling to the other children who would take turns coming up to me to get a better sniff of my privileged head. I was the only one, moreover, who

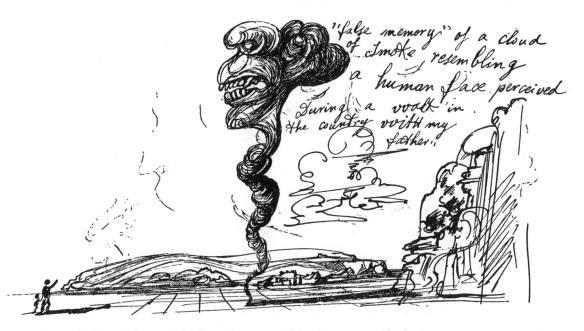

"false memory" of a cloud of smoke resembling a human face perceived during a walk in the country with my father.

wore well-shined shoes with silver buttons. These became, each time one of them got torn off, the occasion of a tussle for its possession among my schoolmates who in spite of the winter went barefoot or half shod with the gaping remnants of foul, unmatched and ill-fitting *espadrilles*. Moreover, and especially, I was the only one who never would play, who never would talk with anyone. For that matter my schoolmates, too, considered me so much apart that they would only come near me with some misgivings in order to admire at close range a lace handkerchief that bloomed from my pocket, or my slender and flexible new bamboo cane adorned with a silver dog's head by way of a handle.

What, then, did I do during a whole year in this wretched state school? Around my solitary silence the other children disported themselves, possessed by a frenzy of continual turbulence. This spectacle appeared to me wholly incomprehensible. They shouted, played, fought, cried, laughed, hastening with all the obscure avidity of being to tear out pieces of living flesh with their teeth and nails, displaying that common and ancestral dementia which slumbers within every healthy biological specimen and which is the normal nourishment, appropriate to the practical and animal development of the "principle of action." How far I was from this development of the "practical principle of action"— at the other pole, in fact! I was headed, rather, in the opposite direc-

tion: each day I knew less well how to do each thing! I admired the ingenuity of all those little beings possessed by the demon of all the wiles and capable of skillfully repairing their broken pencil-boxes with the use of small nails! And the complicated figures they could make by folding a piece of paper! With what dexterity and rapidity they would undo the most stubborn laces of their *espadrilles,* whereas I was capable of remaining locked up in a room a whole afternoon, not knowing how to turn the door-handle to get out; I would get lost as soon as I got into any house, even those I was most familiar with; I couldn't even manage by myself to take off my sailor blouse which slipped over the head, a few experiments in this exercise having convinced me of the danger of dying of suffocation. "Practical activity" was my enemy and the objects of the external world became beings that were daily more terrifying.

Senor Traite, too, seated on the height of his wooden platform, wove his chain of slumbers with a consciousness more and more akin to the vegetable, and if at times his dreams seemed to rock him with the gentleness of reeds bowing in the wind, at other moments he became as heavy as a tree-trunk. He would take advantage of his brief awakenings to reach for a pinch of snuff and to chastise, by pulling their ears till they bled, those going beyond the limit of the usual uproar who either by an adroitly aimed wad of spittle or by a fire kindled with books to roast chestnuts managed to anticipate his normal awakening with a disagreeable jolt.

What, I repeat, did I do during a whole year in this wretched school? One single thing, and this I did with desperate eagerness: I fabricated "false memories." The difference between false memories and true ones is the same as for jewels: it is always the false ones that look the most real, the most brilliant. Already at this period I remembered a scene which, by its improbability, must be considered as my first false memory. I was looking at a naked child who was being washed; I do not remember the child's sex, but I observed on one of its buttocks a horrible swarming mass of ants which seemed to be stationary in a hole the size of an orange. In the midst of the ablutions the child was turned round with its belly upward and I then thought that the ants would be crushed and that the hole would hurt it. The child was once more put back into its original position. My curiosity to see the ants again was enormous, but I was surprised that they were no longer there, just as there was no no longer a trace of a hole. This false memory is very clear, although I cannot localize it in time.

On the other hand, I am perfectly sure that it was between the ages of seven and eight while I was at Senor Traite's school, forgetting the letters of the alphabet and the way to spell my name, that the growing and all-powerful sway of revery and myth began to mingle in such a continuous and imperious way with the life of every moment that later it has often become impossible for me to know where reality begins and the imaginary ends.

My memory has welded the whole into such a homogeneous and indestructible mass that only a critically objective examination of certain events that are too absurd or clearly impossible obliges me to consider

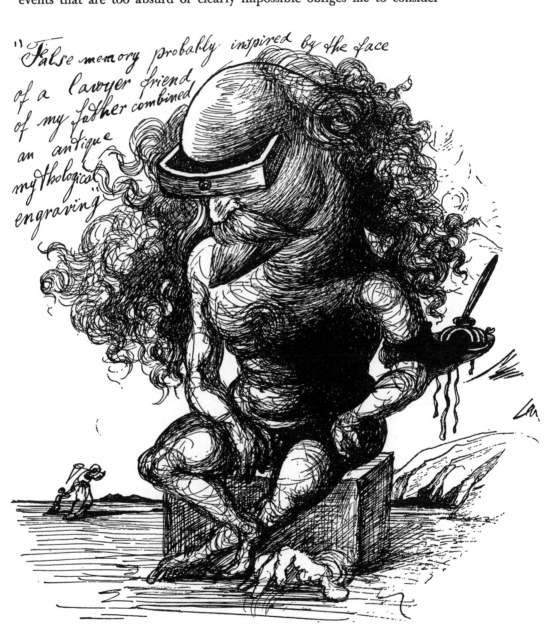

"False memory probably inspired by the face of a lawyer friend of my father combined an antique mythological engraving"

them as authentic false memories. For instance, when one of my memories pertains to events happening in Russia I am after all forced to catalogue it as false, since I have never been in that country in my life. And it is indeed to Russia that certain of my false memories go back.

It was Senor Traite who revealed to me the first images of Russia, and this is how it happened:

When the so-called study-day was over, Senor Traite would sometimes take me to his private apartment. This has remained for me the most mysterious of all the places that still crowd my memory. Such must have been the room where Faust worked. On the shelves of a monumental bookcase, spasmodically depleted, great dusty volumes alternated with incongruous and heterogeneous objects. Some of the latter were covered or half-concealed by cloths, sometimes exposing a part of their enigmatic complexities, which was often just the detail necessary to set off at a gallop the ever-ready Arab cavalry [1] of my "phantastic interpretations," holding themselves in with frenzied impatience, and waiting only for the silver spurs of my mythomania to prod their bruised and bloody flanks in order to dash into an unbridled race.

Senor Traite would seat me on his knees [2] and awkwardly stroke my chin with its fine, glowing skin, grasping it with the forefinger and large thumb of his hand which had the lustreless skin, the smell, the color, the temperature and the roughness of a potato wrinkled and warmed by the sun and already a little rotten.

Senor Traite always began by saying to me:

"And now I'm going to show you something you have never seen."

Then he would disappear into a dark room and presently return loaded with a gigantic rosary which he could barely carry on his shoulders and which hung down the whole length of his bent body and trailed two metres behind him on the floor, making an infernal din and raising a cloud of dust.

"My wife (God save her!) asked me to bring her back a rosary as a present from my trip to Jerusalem. I bought her this one, which is the largest rosary to be found in the whole world, besides which it is carved out of real olive wood from the Mount of Olives."

So saying, Senor Traite would smile slyly.

Another time Senor Traite pulled out of a large mahogany box lined with garnet-red velvet a statuette of Mephistopheles of a wonderful red color, as shiny as a fish just out of water, and he lighted an ingenious contrivance in the form of a trident which the demon brandished with his movable arm, and sheafs of multicolored fireworks rose to the ceiling while in the almost complete darkness Senor Traite, stroking his immense beard, paternally observed the effects of my amazement.

In Senor Traite's room there was also a desiccated frog hanging from a thread, which he waggishly called *"La meva pubilla"* (my pupil), and at other times, "my dancer." He was fond of saying:

Méphistophélès.

[1] In my family tree my Arab lineage, going back to the time of Cervantes, has been almost definitely established.

[2] At about the same time in Russia, in the "Lighted Glade," Tolstoy's country place, another child, Galuchka, my wife, was seated on the lap of another potato, of another specimen of that kind of earthy, rugged and dreamy old man—Count Leo Tolstoy.

"With her all I have to do to know what the weather is going to be is to look at her."

I would find this frog each day stiffly contracted in a different pose. It gave me an indefinable sickish feeling which nevertheless did not prevent an irresistible attraction, for it was almost impossible for me to detach my eyes from the horrid little thing. Besides the giant rosary, the explosive Mephistopheles and the dried frog there was a large quantity of objects which were probably medical paraphernalia, whose unknown use tormented me by the scabrous ambiguity of their explicit shapes. But over all this reigned the irresistible glamor of a large square box which was the central object of all my ecstasies. It was a kind of optical theatre, which provided me with the greatest measure of illusion of my childhood. I have never been able to determine or reconstruct in my mind exactly what it was like. As I remember it one saw everything as if at the bottom of and through a very limpid and stereoscopic water, which became successively and continually colored with the most varied iridescences. The pictures themselves were edged and dotted with colored holes lighted from behind and were transformed one into another in an incomprehensible way that could be compared only to the metamorphoses of the so-called "hypnagogic" images which appear to us in the state of "half-slumber." It was in this marvelous theatre of Senor Traite that I saw the images which were to stir me most deeply, for the rest of my life; the image of a little Russian girl especially, which I instantly adored, became engraved with the corrosive weight proper to nitric acid in each of the formative moulds of my child's flesh and soul, in an integral way, from the limpid surface of the crystalline lenses of my pupils and my libido to the most delicate murmur of the "chrysalid caress" sleeping hidden behind the silky protection of the pink and ridged skin of my tender fingertips. The Russian girl appeared to me swathed in white furs and deeply ensconced in a sled, pursued by wolves with phosphorescent eyes. This girl would look at me fixedly and her expression, awe-inspiringly proud, oppressed my heart; her little nostrils were as lively as her glance, which gave her something of the wild look

Troika.

of a small forest animal. This extreme vivacity provided a moving contrast to the infinite sweetness and serenity conveyed by an oval face and a combination of features as miraculously harmonious as those of a Madonna of Raphael. Was it Gala? I am certain it was.

In Senor Traite's theatre I also saw a whole succession of views of Russia and I would remain startled before the mirage of those dazzling cupolas and ermine landscapes in which my eyes "heard," so to speak, beneath each snowflake, the crackling of all the precious fires of the Orient. The visions of that white and distant country corresponded exactly to my pathological desire for the "absolutely extraordinary," progressively assuming reality and weight to the detriment of those streets of Figueras which, on the other hand, each day lost a little more of their everyday corporeality.

Moreover, as on each occasion in my life when I have wanted something with passionate persistence, an obscure but intense expectation that hovered in my consciousness was materialized: it snowed. It was the first time I witnessed this phenomenon. When I awoke, Figueras and the whole countryside appeared before me covered by that ideal shroud, under which everyday reality was indeed buried, and it was as though this were due to the sole and unique autocratic magic of my will. I felt not the slightest astonishment, so intently had I expected and imagined this transformation. But from this moment a calm ecstasy took hold of me, and I lived the moving and extraordinary events which are to follow in a kind of waking dream that was almost continual.

Toward the middle of the morning it stopped snowing. I left the clouded window-pane, against which I had kept my face obstinately flattened during this whole time, to go walking with my mother and sister. Each crunching step in the snow appeared to me to be a miracle, though I was a little angry over the traffic, which continued as usual and which had already stained the whiteness of the streets—I should have liked no one to have the right to touch it except myself.

As we approached the outskirts of town the whiteness became absolute; we went through a small forest and soon reached a glade. I stood motionless before that immaculate expanse. But I had stopped especially because of a small, round brown object that lay exactly in the centre of this expanse of snow. It was a small seed-ball which had fallen there from a plane tree. The outer envelope of this ball had been partly split open and from where I saw it I clearly distinguished a bit of the kind of yellow down which is inside. Suddenly the sun broke through the clouds and everything was illuminated with a maximum of intensity. My eyes remained riveted to the seed-ball which now cast a precise blue shadow on the snow. Its yellow down, especially, seemed to have caught fire and to have become as if "alive." The sudden dazzle mingled with a great emotion filled my eyes with tears. I went over and with infinitely gentle care picked up the little bruised ball. I kissed it in the broken place with the tenderness one owes to something animate, suffering and cherished. I wrapped it in my handkerchief and said to my sister:

"I have found a dwarf monkey, but I won't show it to you!"

I could feel it moving inside my handkerchief! A sentiment stronger than all else guided me toward a single spot: "the Discovered Fountain."

Platane.

I had to insist with the unflinching exactingness of my tyrannical obsti-
nacy to force the direction of our walk toward this spot. When we had
almost reached it (the Discovered Fountain was just to one side; one
had to go down several steps and then turn to the right), my mother,
meeting some friends, said to me:

"moi et ma mère" Salvador Dalí 1936

"Run along and play for a while. Go as far as the fountain, but be
careful not to get hurt. I'll wait for you here."

The friends made room for my mother on a stone bench, which just
a while ago had been covered with snow and was still all damp. I looked
with ferocious contempt at these friends who dared to offer "that" to my
mother, for whom I could imagine only the most exceptionally selected
comfort, and I found a great satisfaction in the fact that my mother did
not sit down, but remained standing on the pretext that she would be
able to watch me more easily. I went down the steps and turned to the
right: there she was!—the little Russian girl I had seen inside Senor
Traite's magic theatre. I shall call her Galuchka, which is the diminutive
of my wife's name, and this because of the belief so deeply rooted in my
mind that the same feminine image has recurred in the course of my
whole love-life, so that this image having, so to speak, never left me,
already nourished my false and my true memories. Galuchka was sitting
there, facing me, on a stone bench, in the same attitude as in the sled
scene, and she seemed to have been looking at me for a long time. The
moment I perceived her I instinctively drew back; my heart was so agi-
tated that I thought it would jump out of my mouth. The little seed-ball,
too, began to pulsate in my hand, strengthening my feeling that it was
alive.

My mother, seeing me come back and noticing my perturbation,
exclaimed:

"What is there at the fountain?" And she explained to her friends:

"See how capricious he is: The whole day he's done nothing but ask to come to the fountain, and now that we've reached it he doesn't want to go there any more."

I said I had forgotten my handkerchief, and seeing my mother look at the one I was carrying in my hand I added:

"I'm using this one to wrap up my monkey. I need one to blow my nose."

My mother blew my nose with her handkerchief and I went off again. This time I tried to go down to the fountain from the opposite direction, so as to be able to see Galuchka from behind without being seen myself. In order to do this I had to climb over a tangled clump of prickly shrubs. My mother commented, as usual:

"He's always got to do just the opposite of everyone else—going down the steps was too easy for him!"

On all fours I scrambled over the top of the clump, and there I did in fact see Galuchka from behind. This reassured me as to her reality, for I was almost convinced that she would no longer be there on my return. The dorsal fixity of her attitude paralyzed me anew, but this time I did not back away—I kneeled in the snow both to affirm my decision to remain and in order to hide myself behind the trunk of an old olive tree; my movement coincided with that of a man leaning over to fill a water jug at the fountain. While the sound of the water re-echoed within the jug I had an "astonishing" impression:[1] it seemed to me that I lived an "infinite time," during which every kind of precise thought or emotion left me. I became like the Biblical statue of salt. But though my mind was as if absent, I nevertheless saw and heard with an acuteness that I have never again experienced. Galuchka's silhouette against the background of snow had contours as curiously and furiously precise as a key hole. I could hear even the faintest syllable of the conversation between my mother and her friends, in spite of the distance that separated me from them.

At the precise moment when the full jug began to overflow my strange enchantment instantaneously came to an end. Time, as if suspended until then, resumed its habitual prerogatives and its normal limits. I got up again, as if cured of all timidity. My knees were completely benumbed from their long contact with the snow; and I felt a new sensation as of "lightness," without knowing whether it came from the emotion of being in love or from my benumbed knees. A precise idea assailed me: I was going to go up and kiss Galuchka on the back of her head with all my might. But instead of realizing this desire I quickly drew a small knife from my pocket, deciding to carry out another idea instead of that of the kiss—the idea which I had already caressed in

[1] Picasso one day related to me a similar impression which had greatly struck him. In his chateau near Paris he went down to the fountain and filled a jug with water; there was a magnificent moonlight. During the time the jug was filling, he had the impression of "living several years," without preserving any precise memory of it.

the course of my walk: with the pocket knife I would completely peel the seed-ball so that it would be all downy, and then I would make a present of it to Galuchka.

But I had not yet had time to begin my operation when already the adored girl got up and in turn ran to the fountain to fill a little jug. I dashed over to the bench to leave my present, just as it was, on a news-paper lying on the seat. But at this moment I was again seized with a mortal shame and I hid my ball under the paper. The possibility and suddenly the hope, more and more violent, that the little girl would come and perhaps sit down again on the newspaper which now concealed my little ball became for me something so upsetting that I was seized by a slight trembling which would not leave me. My mother came down to fetch me. She had been shouting for me for some time without my hearing her in the least. She was afraid I had caught cold and she rolled a great scarf around my neck and chest. She was terrified. When I tried to speak my teeth chattered; at first I followed her, holding her hand, dazed, resigned, although the regret at leaving this spot, just at this moment, devoured my bowels.

But the story of my beloved little ball has but just begun. Listen patiently, therefore, to the account of the amazing and dramatic circum-stances which surrounded the new encounter with the fetish of my deliria. It is well worth your while.

The snow disappeared and with it the enchantment of that trans-figuration of the town and the landscape which accompanied those three exceptional days when I did not go to school and during which I lived in a kind of waking dream—through the adventures that have already been described so passionately and minutely. The return to the soporific monotony of Senor Traite's school appeared agreeable to me as a rest after all these vicissitudes, but at the same time the return to reality wounded me with the birth of a sadness which, I felt, would be slow to heal and which the loss of my dwarf-monkey, of my beloved little ball, rendered poignant in the extreme.

The great vaulted ceiling which sheltered the four sordid walls of the class was discolored by large brown moisture stains, whose irregular contours for some time constituted my whole consolation. In the course of my interminable and exhausting reveries, my eyes would untiringly follow the vague irregularities of these mouldy silhouettes and I saw rising from this chaos which was as formless as clouds progressively con-crete images which by degrees became endowed with an increasingly pre-cise, detailed and realistic personality.

From day to day, after a certain effort, I succeeded in recovering each of the images which I had seen the day before and I would then continue to perfect my hallucinatory work; when by dint of habit one of the dis-covered images became too familiar, it would gradually lose its emotive interest and would instantaneously become metamorphosed into "some-thing else," so that the same formal pretext would lend itself just as read-

ily to being interpreted successively by the most diverse and contradictory figurations, and this would go on to infinity.

The astonishing thing about this phenomenon (which was to become the keystone of my future esthetic) was that having once seen one of these

"False memory of a vast ornamental visage in a state of decomposition"

images I could always thereafter see it again at the mere dictate of my will, and not only in its original form but almost always further corrected and augmented in such a manner that its improvement was instantaneous and automatic.

The sled in which Galuchka was seated became the panoramic view of a Russian city, bristling with cupolas, which would change into the bearded and somnolent face of Senor Traite, which in turn would be transformed into a fierce battle of furiously famished wolves in the middle of a clearing of virgin forest, and so on, the stains becoming metamorphosed into a cavalcade of ever-renewed apparitions which served as an illustrative background to the copious and dreamy course of my violent imagination, which would project itself upon the wall with the maximum of its force of luminous materialization, all as if my head had been a real motion picture projector by virtue of which everything that occurred within me was simultaneously seen externally by my own eyes, astonished and absorbed by that great hallucinatory stain from a leaking gut-

ter produced by the melting of the snow of my fairytale ball in the ruin-menaced vault which protected Senor Traite's dreams and mine within the mouldy curve of its thick walls.

One evening as I was even more absorbed than usual in the contemplation of the spots of moisture, I felt two hands gently placed on my shoulders. I jumped, swallowing my saliva the wrong way, which made me cough convulsively. I welcomed this cough, for it excused my agitation and made it less noticeable. I had in fact just blushed with crimson on identifying the child who was touching me as Buchaques.

He was considerably taller than I and he was nick-named Buchaques because of his extravagant costume which had an exaggerated and unusual number of pockets—pockets in Catalonian being called *buchaques*. For a long time I had noticed Buchaques as being the handsomest of all the boys, and I had only dared to look at him furtively; but each time our glances accidentally crossed, I felt my blood congeal within my veins. Without any doubt I was in love with him, for nothing could justify the emotional disturbance that his presence caused me, much less the preponderant place which his image had occupied for some time in the flow of my reveries, appearing to me now confused with Galuchka and now as her antithesis.

I was not quite aware of what Buchaques said to me because of my dizziness, which filled my ears with that delightful buzzing whose mission it is to efface all the sounds of the surrounding world in order that you may hear more clearly the accelerated beating of your own heart.

Certain it is that Buchaques immediately became my sole friend and that each time we separated we exchanged a long kiss on the mouth.

He was the only one to whom I felt capable of revealing my secret of the dwarf-monkey. He believed, or pretended to believe, in it, taking an interest in my story; and we went on several occasions, at nightfall, to the Discovered Fountain, to try again to "hunt" my dwarf-monkey, my beloved little ball, which in my imagination now appeared endowed with all the most minute attributes of a genuine little living being.

Buchaques was fairhaired (I brought home one of his hairs, which I kept preciously between the pages of a book and which seemed to me to be a thread of real gold), his eyes were blue, very bright, and his pink and smiling flesh contrasted violently with my olive and meditative palor over which seemed to hover the shadow of that dark bird of meningitis which had already killed my brother.

Buchaques appeared to me beautiful as a little girl, yet his excessively chunky knees gave me a feeling of uneasiness, as did also his buttocks too tightly squeezed into pants that were too excruciatingly narrow. Yet in spite of my embarrassment an invincible curiosity impelled me to look at these tight pants each time a violent movement threatened to split them wide open.

One night I told Buchaques all about my feelings toward Galuchka. His reaction was totally devoid of jealousy and his attitude in regard

to her was absolutely similar to the one he had adopted toward my little ball; like myself, he was going to adore both it and Galuchka.

We spoke constantly and endlessly of these two creatures of delirium, while embracing each other with our caressing arms, but our kiss was always reserved for the end and the very moment of taking leave of each other.

We would await this delightful moment with a growing emotion which we tried to exasperate to the extreme by the tacit conspiracy of our prolonged chatting. Buchaques became everything to me: I began to make him presents of my dearest and most precious toys, which progressively disappeared from my house to go and enhance the stock of my presents which Buchaques amassed with a growing avidity. When my toys were liquidated in this fashion I undertook a veritable rifling of all sorts of other objects, beginning timidly with my father's pipes and a silver medal adorned with a moiré silk ribbon which my father had won in an Esperanto congress; the following day I brought a porcelain canary which adorned one of the cabinets of the living room. Buchaques, becoming very quickly accustomed to my generous offerings, began to exact them. Thus one day I ended by bringing him a large china soup-bowl which appeared to me wonderfully poetic—it was adorned with an image of two blue-gray swallows in full flight.

Buchaques' mother must have judged that my gift exceeded the volume that could be allowed to pass unnoticed and brought it back to my mother, who thus discovered the cause of the disappearance of so many objects, until then inexplicable, and which had been stripping our house in such a disturbing and accelerated fashion. I was profoundly unhappy and vexed at having to stop my presents and I wept bitter tears, and cried: "I love Buchaques! I love Buchaques!"

My mother, who was always of an angelic tenderness, consoled me as best she could, then bought me a sumptuous album in which we pasted hundreds of transfer pictures, so that as soon as we had filled it we could make a present of it to my friend, my lover, Buchaques.

Later my mother drew astonishing pictures of fantastic animals on a long strip of paper with colored pencils. She then carefully folded this strip where each picture stopped, so that the whole could be reduced to a small book which unfolded like an accordion. This was another present for Buchaques!

But the increasing intervals between my gifts, and their diminishing material value, cooled Buchaques' attitude toward me, and he again began to play with all the other children and devoted to me only brief spells between his turbulent games. I felt that I was losing forever the sweetness of my former idyllic confidant who at each new recreation period became as if possessed by the frenzy of the most noisy and violent games; the germinating force of his exuberant health seemed no longer capable of being contained within the limits of that flesh, which was so smooth but which the slightest agitation caused to become quickly con-

gested and disagreeably bloodshot. On the slightest pretext he would come and push me over or brutally pull me by the sleeve to make me run with him. One evening I pretended I had rediscovered my little ball, my dwarf-monkey! I thought that perhaps by this stratagem I would succeed in winning back his interest. And indeed he absolutely insisted on my showing him my monkey and accompanied me as far as to the entrance to my house where we hid behind the large door in the stairway where it was already dark. With infinite care, and with trembling hands, I unwrapped a plane ball which I had picked up at random in the street and which I had kept hidden inside a handkerchief.

With a single brutal gesture Buchaques tore the ball and the handkerchief from me. He was so much stronger than I that I could never have resisted him. Then, with an abominably mocking gesture, holding up to me the little ball hanging by the tail, he went out into the middle of the street. Whereupon he threw the ball into the air as high as he could. I did not even make an effort to go and pick it up, because I knew perfectly well that it was not my "real" ball. From this time on, however, Buchaques became my enemy. He went off spitting several times into the air in my direction. Painfully I swallowed my saliva and I ran to my room to have a cry. I would show him!

"False memori.
of a lady
in the shape of a
Spoon"

I was convinced that I was in Russia, yet there was no snow. The absence of this phenomenon, which until then seemed to characterize all the visions I had had of that country, did not astonish me. It must have been toward the end of a hot summer afternoon, for they were sprinkling the central avenue of a great park where a fashionable crowd, in which the feminine element predominated, was lining up on either side, settling down slowly and laboriously in the complicated labyrinth of chairs to watch the scheduled military parade.

Myriad-colored towers and cupolas [1] (like those I had seen inside Senor Traite's theatre) emerged from the great, dark masses of trees, sparkling with all their teeth and with all their gleaming polychrome in the progressively oblique rays of a sun that was beginning to set.

On a platform that seemed to be made entirely of stonework, a military band was parsimoniously beginning to tune its instruments; the brasses intermittently cast savage flashes, blinding as those of the monstrance in country Masses.

Already one heard the cry, now rending, now muffled, of those disparate preliminary notes which with their perfidious prodding have the virtue of exasperating the anticipation of the imminent beginning of the music which cannot delay much longer.

If this anxious expectation is prolonged indefinitely, the bitter-sweet which each new stridence provokes has the purpose of maintaining each heart, with the terribly delicate torture of its repetition, in increasing suspense on the edge of the great crystal of the afternoon silence which begins to form as the uneasiness spreads through the crowd.

If at this moment the fragrance of linden trees is wafted over you in gusts to add to your anguish, you will appreciate that what may have been merely a touch of dizziness will have reached the category of nausea and your eyes will be forced to show their whites.

In my case and at the age when all this happened, this anxious state of mind would reach the fainting-point and always resolved itself into a sudden urge to urinate which culminated at the moment when the first inaugural paso doble finally came and tore the evening glow into bloody shreds. A tear impossible to hold back would burn in the corner of my eye, seeming to be the same, as irrepressible and hot, as what I felt was at that very moment wetting my pants. That day the sensation, which took hold of me just as the military fanfare struck its first martial notes, was redoubled by the sudden discovery of Galuchka's presence. She had just stood up on a chair to observe the arrival of the parade,

[1] These multicolored cupolas which in my false remembrances correspond to Russia or at least to the mirages I had of that country, thanks to Senor Traite's theatre (unless the latter too is a false remembrance), must in all likelihood be localized in the Guell de Gaudi Park in Barcelona, a spot which consists largely of architecture incrusted with violently multicolored and fairylike tiles. I must have attended an open-air festival there. Or, it is possible that my imagination blended a military celebration that took place at the fortified castle of Figueras with the fantastic setting of Guell Park.

placing herself just in front of me ten metres away and on the other side of the avenue.

I was sure that she in turn had just discovered me in the crowd. Seized with an insurmountable shame I immediately hid behind the plump back of a big nurse sitting monumentally on the ground, whose corpulence offered me refuge from Galuchka's unendurable glance.

I felt myself stunned and dumbfounded by the shock of the unforeseen encounter, a shock which the lyrical impact of the music amplified to a state of paroxysm. Everything seemed to melt and vanish around me and I had to lean my little head against the nurse's broad insensitive back, a parapet of my desire.

I shut my eyes. When I reopened them they were fixed on the bare arm of a lady sitting beside me who was parsimoniously lifting a cup of chocolate to her lips. The strange sentiment of absence and of nothingness, which seemed to envelop me more and more, formed a vivid contrast to the sharpness with which I perceived the tiniest details of the skin on the wrist of the lady in question. It was as if my eyes, having become powerful lenses, were exercising their amplifying power on a field of vision that was limited, but endowed with a delirious quality of concreteness; and all this to the detriment of the rest of the world, which was becoming effaced in a more and more total absence, mingling, so to speak, with the music which filled the whole.

This phenomenon of hypervisuality has recurred in a number of diverse circumstances in the course of my life, but always as a consequence of the stupor provoked by a too powerful emotion suddenly taking me unawares. In 1936, among hundreds of photographic documents which I was selecting in a shop on Rue de Seine in Paris, I came across a photo that paralyzed me: it showed a woman lifting a cup to her lips; I recognized her instantly, for she corresponded exactly to the image of my memory. The impression of the "already seen" was so poignant that I remained haunted for several days by the magic of this picture, convinced that it was exactly the same that I had seen with such great and strange precision as a child, and which still today stands out with a photographic minuteness of detail among the blurred mists of my most remote false remembrances mingled with lightning images.

I pressed myself closer and closer against the infinitely tender, unconsciously protective, back of the nurse, whose rhythmic breathing seemed to me to come from the sea, and made me think of the deserted beaches of Cadaques...

My cheek crushed against her white uniform, that stretched over the warm flood of her nutritive flesh, became filled with those thousand ants which a long and dreamy revery provokes. I wanted, I desired only one thing, which was that evening should fall as quickly as possible!

At twilight and in the growing darkness I would no longer feel ashamed. I could then look Galuchka in the eye, and she would not see me blush.

Each time I stole a furtive glance at Galuchka to assure myself with delight of the persistence of her presence I encountered her intense eyes peering at me. I would immediately hide; but more and more, at each new contact with her penetrating glance, it seemed to me that the latter, with the miracle of its expressive force, actually pierced through the nurse's back, which from moment to moment was losing its corporeality, as though a veritable window were being hollowed out and cut into the flesh of her body, leaving me more and more in the open and gradually and irremissibly exposing me to the devouring activity of that adored though mortally anguishing glance. This sensation became more and more acute and reached the point of a hallucinatory illusion. In fact I suddenly saw a real window transpierce the nurse. Yet through this maddening aperture, of frantically material and real aspect, I no longer saw the crowd which ought to have been there and in the midst of which Galuchka standing on a chair ought to have been in the act of looking at me. On the contrary, through this window opened in the nurse's back, I distinguished only a vast beach, utterly deserted, lighted by the criminally melancholy light of a setting sun.

I suddenly returned to reality, struck by a horrible sight: before me there was no longer a nurse, but in her place a horse in the parade, happening to slip, fell to the ground. I barely had time to draw back and press myself against a wall to avoid being trampled. At each new convulsion of the horse I was in fear of being crushed by one of its furious hooves. One of the metallic shafts of the chariot to which the animal was harnessed had plunged into its flank and a thick spurt of blood splashed in all directions like a wild jet of water dishevelled by the wind.

Two little soldiers fell on the great prostrate body, one of them trying to hold its head still while the other carefully placed a small knife in the center of its brow; after which, with a quick, vigorous thrust of his two hands, he drove the blade of his weapon home.

The horse gave a final quiver and remained motionless, one of its stiffened legs swaying and pointing to the sky, in which I perceived stars beginning to pierce through.

Across the avenue Galuchka was beckoning to me energetically with her arm; I distinctly saw a small brown object in the clenched hand which she held out to me; I could not believe this new miracle, and yet it was true; she was showing me my plane ball! My beloved plane ball which I had lost in the "Discovered Fountain"! [1] Overwhelmed with confusion I lowered my eyes. My white sailor suit was already blue-tinged

[1] At the time when I chose the *delirious fetish* of my plane ball, Galuchka in Moscow projected her whole passion on another fetish, but of a different type; it was a small box of wax matches on the back of which could be seen a glossy picture in color representing the cathedral in Florence where Galuchka had once been on a short voyage with her father.

Each time she wished to console herself for her hyperesthetic desire to return to Italy, she would light one of her precious matches.

by the deepening twilight, and all spangled with tiny, almost invisible splashes of blood from the dead horse at my feet.

I scratched the spots with my fingernail. The blood was already dry. A warm, heavy air violently exasperated my thirst. The excitement which the brutal and extraordinary violence of the preceding scene had produced in me, and the new situation of feeling myself exposed, looked at by Galuchka, who moreover was motioning to me, all this plunged me into such an unbearable perplexity that I suddenly felt it necessary to resolve my situation by a heroic and utterly incomprehensible act: what I did was to stoop down to the horse's great face and kiss it with my whole soul on the teeth of its half-open mouth contracted in the convulsions of death. Then I climbed nimbly over the animal's body and ran across the avenue that separated me from Galuchka. I headed straight for her, but just as I was one metre away I was seized by a new crisis of timidity even more insurmountable than the previous ones, turning me aside from my objective.

I darted into the crowd, waiting with a more and more frenzied impatience for complete darkness to favor a new plan of approach which I had just conceived.

But this time Galuchka herself came toward me. Again I tried to run away, but she was too near.

Mortally vexed, for I could no longer do anything to conceal my timidity, I nevertheless hid my face in my sailor cap, thinking as I did so that I would choke from the strong odor of violets with which it was soaked. A flush of irritation and indignation rose to my head. I could feel Galuchka brushing against my clothes. Then without looking I kicked her with all my might. She uttered a plaintive cry and reached both hands to one of her knees. I saw her go off limping and sit down at the end of the park between the last row of chairs and an ivy-covered wall. Soon we were sitting face to face, our cold, smooth knees pressing one another with such violence that they hurt; our hurried breathing prevented us from uttering a single word.

From the place where we were seated rose a rather steep ramp which communicated with an upper walk. Children carrying scooters would walk up this ramp, and then come down at a dizzy speed on their grinding and horrible contraptions. The menacing din as they periodically came down made us edge closer and closer together. But what was my distress to discover, among those turbulent boys, the red and sweating face of Buchaques! He was ugly, I thought, and I looked at him with mortal hatred. As for Buchaques, he seemed to feel the same hatred for me; he rushed upon me with his scooter and flung himself heavily against my chair, accompanying this act with loathsome little cries and laughs. Galuchka and I tried to barricade ourselves between the wall and the trunk of a large plane tree. She could thus shield herself from the brutal batterings. I, however, who was only half protected, continued to be vulnerable to the malevolent assaults of Buchaques, who after

each interval of climbing the slope on foot would come down again at a furious pace with the sole idea of ramming me again with systematic and growing relentlessness. Each of Buchaques' departures was for Galuchka and me a glimpse of heaven; we would immediately take advantage of it to plunge back into the infinitely sweet melancholy of our two glances, united in an inexplicable communion in which the most diverse sentiments were born and melted on the threshold of our souls in an unbroken succession of divine ecstasies. Each sudden new interruption of our romance by the clattering onrush of Buchaques on his scooter would only increase the purity and the passion of our ecstatic contemplation and redouble its delightfully agonizing peril.

As if absentmindedly Galuchka began to toy with a very delicate chain that she wore round her neck, but soon she seemed to want to indicate to me with gestures of passionate and malicious coquettishness that something precious must be attached to the end of this chain.

Indeed, under her blouse an object sufficiently voluminous to be guessed at would slowly rise toward the delicate white skin above the low neck line on which my eyes remained fastened, hoping to see emerge what I understood was being promised me. But it did not come, for Galuchka, purposely pretending that her toying was involuntary, would let go the chain which again would slip far down into her blouse with the agility of a snake. After which Galuchka would begin the game all over again, and this time she proceeded to pull the chain up with her teeth, lifting her head slowly so that the object attached to the end of the chain would rise from the well of her bosom and at any moment be on the point of

emerging from her blouse. At the culminating moment, holding the chain between her clenched teeth, she said to me, "Shut your eyes!" I obeyed, secretly knowing what I would see on reopening them. And there indeed, attached to a handful of tiny medals, hung the beloved ball of my deliria! My dwarf monkey! But Galuchka let it slip back into her blouse as an instinctive reaction to the move I had just made to take it. She then ordered me once again and with increased energy to shut my eyes. Again I obeyed, shutting my eyes so hard that they hurt and trembling with emotion like a leaf, while Galuchka seizing one of my hands drew it firmly toward her and slipped it, in spite of my resisting stupor, all the way down her bosom. I felt a button of her blouse break loose and my hand, benumbed by the giddiness provoked by the sudden warmth of an infinitely soft flesh, began to make slow, heavy and clumsy gestures, like those of a drowsy, slumber-swollen lizard.

Finally I seized the handful of burning hot medals among which I could feel the rugged and unmistakable presence of my longed-for ball.

I had not yet had time to savor the miracle of possession with my sense of touch when the grinding noise of Buchaques' lightning approach again made me violently shut my eyes, convulsed this time by rage.

A bestial blow knocked me off the chair and I found myself on the ground next to Galuchka who was on all fours. In my fall I had torn off the chain, which had deeply marked her neck, and whose white and indented traces I could see gradually vanish.

I pretended to be looking for the handful of medals and the ball under the chairs, but an inquisitorial look from Galuchka made me understand that she had guessed my deception and I handed over to her my treasure which I had kept hidden until then in the folds of my sailor collar which I clutched tightly in my hand.

Galuchka walked away from me, went and sat down on the ground near a plane-tree, making believe she was caressing my ball with gestures in which malice mingled with the purest maternal cajoleries.

Cretinized, exhausted by so many moving events, I remained leaning on my elbow against a chair copiously piled with clothes and accessories belonging to two very beautiful ladies sitting beside me, who were laughing gaily and chatting with a soldier who was obviously paying court to one of them. On the same chair there was also, folded several times, the soldier's bright red cape, under which his sword lay flat, partially emerging from the heterogeneous pile of materials, exposing its glittering hilt which in spite of myself insistently drew my attention.

An atrocious idea of vengeance instantly dawned in my brain, appearing with such force that I immediately felt nothing in the world would henceforth be able to prevent the execution of my abominable act; possessed by the unperturbed coolness characteristic of irrevocable verdicts and without the slightest trace of visible emotion, I calmly turned my head toward the top of the ramp to look at Buchaques who had just reached it, painfully dragging his scooter behind him.

At the same moment I slipped my hand on to the hilt of the sword, trying imperceptibly to unsheathe it. The sword slid gently out from its sheath in obedience to my movement; with a furtive glance I saw a piece of its sharp blade glisten. It would work! Buchaques would be horribly punished! !

To succeed in realizing my design it would be necessary to act with an economy of gesture and a dissimulation so monstrous that only my passion for vengeance mingled with the controlled tumult of jealousy could make it possible. To accomplish this frightful chastisement with the maximum of rigor I had to unsheathe the sword entirely without being seen and afterward conceal its naked blade under the clothes. This pre-liminary operation would have to be performed without being perceived, especially by Galuchka who would have been horrified to discover my plan; she was the last person to whom I should have wanted to reveal the least of my intentions regarding my cruel decision, and this was all the more difficult as she did not avert her eyes from me for a single moment.

Even when I should succeed in holding this bare weapon in readiness, I would still have to take advantage of a favorable moment just before Buchaques' swift onrush to slip the sword between two chairs in such a way that he would be horribly and irremediably wounded. It was already night, so that Buchaques, with the accelerating speed of his descent and the prevailing darkness, would not be aware of my criminal obstacle. Even if he should catch a momentary glimpse of the shining sword in the dark he would not be able to stop at the last moment. It would be too late!

But I realized that in order to carry through my bloody plan systemati-cally I would first have to distract the attention of Galuchka, who was too much absorbed in looking at me and who could not fail to perceive my slightest move. I therefore got down again, walking on all fours, as though bent on seizing my ball at all costs.

Surprised by my resolute attitude, Galuchka hastily interposed a chair between us. This obstacle rekindled my true desires. I introduced my head and torso between the bars of the chair, pretending that I was going to pass between them, but immediately I felt myself a prisoner in this kind of skeleton shield, which had suddenly become a real and painful trap.

Nevertheless this idyll in the heightened darkness under the chairs appeared to me more and more pleasurable in spite of the growing dis-comfort of my imprisonment, and I would have been willing to live the rest of my days in this dangerous and confused labyrinth that exasperated my desire to such a point. I had a growing horror of the moment when our unsatisfied romance might come to an end.

Galuchka, visible and invisible, vague in detail but precise in her expression as a whole and tinged more and more with troubling demoniac gleams, became almost immaterial because of the effacement of all the

details which presented her to me as if each dimple of her smile, of her elbows or her knees had already been devoured by the supreme softness of the nocturnal shadows in whose depths, through the accents of the dwindling music, I heard the insistent and solitary hooting of an owl. During the intervals in the music both of us suddenly grew more timid. We would then listen to the lazy sound of the footsteps dragging on the wet sand, which became more deafening than the most lyric and strident instrumental sighs which, in turn, inaugurating the ever fresh melancholy of new melodies, would dissolve our shame in the more and more violent audacities of our progressively unequivocal exhibitionist efforts. Galuchka, on the pretext of showing and hiding my ball, ended by entirely unbuttoning her blouse, and her hair, dishevelled by the disorder of her jerky gestures, masked her face where I could half-imagine the gleaming saliva in a mouth deliciously half-opened by the breathing which her bizarre emotional state accelerated from second to second. As for me, my efforts to approach Galuchka finally brought me forward a few centimetres between the bars as I dragged the chair in her direction. The bars painfully squeezed my sides, bared by the pulling up of my sailor blouse.

Galuchka, who with an exquisite tenderness had reached out the beloved ball till it brushed against my lips suddenly pulled it back cautiously as I made another painful effort to edge forward a little, and a burning pain now bit me to the blood in the hip-bone; my lips were already about to reach my ball once more, but Galuchka pulled it back imperceptibly once more with a gesture so parsimoniously cruel that my eyes drowned in large tears. She remained fixed at that moment in an almost absolute immobility; only the grin of her malicious smile did not vanish from her mouth, but on the contrary it seemed to settle there permanently, assuming a place of honor in the divine oval of her adored face.

However, in spite of her apparent expressive immobility, one would have said that it was rapidly becoming corruptible and without anything external coming to trouble her look of cynical assurance I saw the persistent smile of triumph fade with a rapidity which can only be compared to a reversed and speeded up motion picture of the ephemeral unfolding of a flower.

Galuchka remained thus with the ball dangling from her hand; she was not going to withdraw it, nor was she going to make the slightest movement to bring it closer to me. I knew it. In her fixed glance I read the sureness of a promise, but for this I had to advance still further.

I stretched forward furiously, mad with desire, and by dint of a supreme convulsion I finally succeeded in biting the handful of medals among which my ball was hanging.

At this moment I felt Galuchka's little hand clench like a little bird's tightening claw, enfolding the precious cluster and this time pressing it violently, ferociously even, against my avid mouth in which, mingled

with the knife-taste of the medals, I immediately felt the beginning of
that other strong metallic savor, bitter and bloody, of my own wounded
gums.

Suddenly a new jolt, more brutal and unforeseen than the preceding
ones—for the paroxysm of my sentiments had completely deafened me to
Buchaques' arrival—dashed my head to the ground with a bang; my
cheek was chafed raw on the sand, my body caught between the bars
of the chair seemed to break in two, I uttered a cry of pain and I
furiously raised my head toward Buchaques whose purple-stained face,
almost on top of me now, was illuminated by jealousy, and had attained
the congested ugliness of a cockscomb.

He backed away from me and was about to climb the ramp once
more when suddenly, retracing his steps, he sent a contemptuous kick in
my direction, raising a clod of earth which struck me and blinded me for
a moment. Then he again started off. Galuchka, too, had received a blow
from my chair and had been thrown a metre away from me.

There was a bloody smudge in the exact centre of her brow. She was
wholly given over to feeling this painful spot, dazed by the recent com-
motion; the abandoned attitude of her half-open legs no longer knew any
modesty, and I discovered then for the first time that she was not wearing
any pants.

A shadow soft as a dream submerged the upper end of her thighs
which were obliterated in the absolute black beneath her little white
skirt and in spite of the darkness in which her anatomy completely
vanished I felt that she was naked underneath.

She smiled at me, and I got up; this time my vengeance was decided.

I went and sat down on the chair near the one where the sword lay
buried between the soldier's cape and the other accessories belonging to
the two ladies with whom he continued to chat while he kept looking
deep into the eyes of one of them. The other lady, pretending not to
take any interest, was directing her attention elsewhere, intervening
in the conversation with quick, disconnected remarks. She wore an imper-
ceptible smile of malicious complicity which seemed to me very troubling;
from time to time and without apparent reason she would drop back her
head heavy with hair, and would then smile with all her teeth at the
soldier who at the same moment cast her a polite glance of gratitude, as
brief as possible.

I took advantage of the distraction of this absorbing sentimental
game that kept these three beings chained to one another to work my
way, without being seen by them, by a series of little sliding moves,
toward the chair where the sword reposed.

I had to do this in order to reach it from where I was, for I could
not change my position without the risk of losing sight of Galuchka who
would then be intercepted from me by the plane tree. This tree in turn
hid the manipulations full of wile and of sudden skill which I was
effecting with my left hand and thanks to which I slowly and by suc-

cessive stages unsheathed the weapon of my vengeance destined for Buchaques' impending and frightful martyrdom.

I took the precaution of wrapping a handkerchief around my hand so as not to wound myself. I hid the sword behind my back with a slight trembling which did not exclude sureness in my movements, and I used my cap to prevent Galuchka from seeing the hilt project from the other side of my body.

After the success of this first operation, which enabled me to unsheathe the sword without being seen by anyone, I cautiously slipped it back under the materials, but with the blade now bare and pointed in the right direction. All I had left to do was to push it as I wished so that at the right moment the sword would intercept Buchaques' descent.

But my preparations were not yet absolutely completed. A dizzying fever of calculation and of ceremonial in the minutest details took hold of my brain as I felt the irremediable moment approaching. I redoubled the intensity of my amorous gaze in Galuchka's direction to keep her rooted to her place; after the blow she had received in the forehead she remained crouching in a posture of such chilled weariness that my fervent glance, reinforced by the sway which the voluptuous approach of my cruel act gave it, succeeded in maintaining my Galuchka in a kind of paralysis of which I felt myself the more and more absolute master as the moments passed.

Without moving my sword one millimetre I waited for Buchaques' imminent descent. Against all anticipations, though he came at the same dizzying speed as usual, he did not come crashing against me this time, but got off his scooter and, going over to the plane tree without

daring to look at me, asked me, "Where is she?" I did not answer. He knew perfectly well. He went behind the plane tree and for a long time stood stupidly looking at Galuchka.

Without changing her posture, her eyes riveted to mine, she seemed not to see him.

Finally Buchaques said to Galuchka, "If you show me Dali's dwarf monkey I won't do it any more." She shuddered and pressed my beloved ball with the handful of medals against her bosom. Buchaques then said, "Let's play!" "Play what?" I answered. He turned toward me and with a repugnant look of gratitude, assuming from my question that I had forgiven him, said, almost joyously, yet with something of the social climber's sugar-coated fear, "Let's all three play robbers and civil guard!" I answered "Yes, let's!" And while with one hand I pressed his, with the other I pressed the sword's cold hilt. "Who'll begin?" asked Buchaques. "The taller one of us." Buchaques accepted this absurd condition, for he was clearly taller than I. And suddenly he became very weak, with a weakness which continued to grow in direct ratio to my power of domination.

We measured ourselves against the trunk of the plane tree, marking our heights in the bark by means of a notch made with a pebble.

It was he, then, who would have to go; he would walk up the ramp very slowly in order to give Galuchka and myself time to go and hide.

Once he reached the top he would come down full speed on his scooter and I challenged him to do it faster than he had done the previous times, goading the living and congested flesh of his pride with infallible sureness.

I saw Buchaques start off nonchalently, dragging his scooter behind him and climbing the ramp which was to be fatal to him. At each new furtive glance that I cast in his direction I saw the volume of his buttocks progressively diminishing, with their ungainly movements outlined by his tight-fitting pants. My antipathy toward my former lover grew with each of his awkward steps, in whose beatific and nauseating succession I could read the progressive revival of his good conscience, after the troubled waters of remorse which my hypocritical and perverse reconciliation had just calmed.

In my mind there was present the maxim of Philip II, who said one day to his valet, "Dress me slowly because I'm in a great hurry."

I hurried without haste in order to give the last indispensable touches to the scrupulous "finish" of the brilliant painting of my imminent sanguinary creation toward which, with exclusive delight, all the representative force of my imperial imagination was converging.

I absorbed myself in a rigorous calculation which called for my utmost powers of dissimulation so that Galuchka would continue to believe me to be imbued with the simulated ecstasy of my contemplation, when in reality I was occupied solely in coldly calculating Buchaques' stature from the mark of his height in the plane-tree bark, while taking into account the approximate elevation of his scooter, since after all the only thing I wanted to know was the exact location in space of the middle of my rival's throat, in order to be able to dispose my sword in a fashion adequate to a categorical, Doric and pitiless slitting of his throat.

I had to assure myself also of the resistance of the chairs which were to serve as pillars to the sharp-pointed bridge of my sword. For this I brought together several additional chairs which would serve as reinforcement, thus redoubling the fearful efficacy of my trap.

I said to Galuchka, "Buchaques is coming down!" She came up to me so quickly that I did not have time to accomplish my decisive act. I cast an anxious glance toward the top of the ramp which Buchaques was just reaching, already preparing for his run.

I pressed Galuchka against my chest with a tyrannic will, ordering her not to look. While I profited by her obedience to slip the sword between the bars of two chairs, a last glance reassured me as to my task; almost invisible, the weapon shone feebly in the night with all the cold and inhuman nobility of justice.

We could already hear the din of Buchaques' scooter launched on its mad descent. We must run! I dragged Galuchka by the hand in a frenzied chase through the crowd; we struggled like blinded butterflies

against the river current of the crowd, which at this moment was slow-
ing its rhythm, obeying the force of the melancholy regret that succeeds
the ending of a feast.

A last paso doble, executed without conviction, had come to a
close. We stopped for a moment just at the spot where, at sunset, I had
seen the horse die. On the asphalt sprawled an enormous blood-stain in
the form of a great black bird with outspread wings.

Suddenly it was cold and our perspiration made us shiver. We were
indescribably dirty, and our clothes were all torn.

I could feel my heart beat in the burning wound of my raw cheek.
I touched my head covered with bumps which procured me a sweet
and agreeable pain. Galuchka was livid; the clot of blood on her fore-
head now appeared surrounded by a mauve aureole.

And Buchaques? Where was *his* blood? I shut my eyes.

True

Childhood

Memories

I shut my eyes and I turn my mind to my most distant memories in order to see the image that will appear to me most spontaneously, with the greatest visual vividness, in order to evoke it as the first and inaugural image of my true remembrances. I see...

I see two cypresses, two large cypresses of almost equal height. The one on the left is the smaller, and its top leans slightly toward the one on the right which is impressively vertical; I see these two cypresses through the window of classroom 1 of the Christian Brothers' School of Figueras, the school which immediately followed my supposedly harmful pedagogical experience at Senor Traite's. The window which served as a frame to my vision was opened only in the afternoon, but from then on I would absorb myself entirely in the contemplation of the changes of light on the two cypresses, along which the slightly sinuous shadow of the rectilinear architecture of our school would slowly rise; at a given moment, just before sunset, the pointed tip of the cypress on the right would appear strongly illuminated with a dark red, as though it had been dipped in wine, while the one on the left, already completely in the shadow, appeared to me to be a deep black. Then we heard the chiming of the Angelus, and the whole class would stand up and we would repeat in chorus the prayer recited with bowed head and folded hands by the superior.

The two cypresses outside, which during the whole afternoon seemed to be consumed and to burn in the sky like two dark flames were for me the infallible clock by which I became in a sense aware of the monotonous rhythm of the events of the class; for as had been the case at Señor Traite's, I was likewise completely absent from this new class, where far from being allowed to enjoy the advantages of my first teacher Senor Traite's blessed sleep to my heart's content, I had now every moment to overcome the resistance which the Brothers of the Christian School with unequalled zeal, and resorting to the cruellest ruses and stratagems, vainly exerted to attract and solicit my attention. But these

only accentuated my capacity for annihilating my outer world: I did not want anyone to touch me, to talk to me, to "disturb" what was going on within my head. I lived the reveries begun at Senor Traite's with heightened intensity, but feeling these now to be in peril I clutched at them even more dramatically, digging my nails into them as into a rescue plank.

After the Angelus the two cypresses became almost obliterated in the dark. But if their outlines finally disappeared completely in the night, the immobile presence of their invisible personalities remained firmly localized and their spatial situation, drawing me like a magnet, would force my little dream-filled head to turn from time to time to look in their exact direction even though I could not see them. After the Angelus and almost at the same moment that the window became black with night, the corridor leading to the classroom would be lighted, and then through the glass-paneled door I could observe the oil paintings which decorated this corridor, wholly covering its walls. From my seat I could see only two of them distinctly: one represented a fox's head emerging from a cavern, carrying a dead goose dangling from its jaws; the other was a copy of Millet's *Angelus*.[1] This painting produced in me an obscure anguish, so poignant that the memory of those two motionless silhouettes pursued me for several years with the constant uneasiness provoked by their continual and ambiguous presence. But this uneasiness was not "all". In spite of these feelings that the *Angelus* aroused in me I had a sense of being somewhat under their protection and a secret and refined pleasure shone in the depth of my fear like a little silvery knife blade gleaming in the sunlight.

During those long winter evenings, while I waited for the bell to announce that the school day was about to come to a close, my imagination was in fact constantly guarded by five sentinels, faithful, frightful and sublime: outside to my left, the two cypresses; to my right the two silhouettes of the *Angelus;* in front of me, God in the person of Jesus Christ—yellow, nailed to a black wooden cross standing on the brother's table. The Redeemer had two horrible wounds, one on each knee, wonderfully imitated by means of a very shiny enamel which revealed the bone through the flesh. The feet of the Christ were dirty with a sickening gray produced by the daily contact of the children's fingers, for after having kissed our superior's hairy hand and before crossing ourselves as

[1] This painting which made such a deep impression upon me as a child disappeared completely, so to speak, from my imagination for years, its image ceasing to have the same effect upon me. But suddenly in 1929, upon seeing a reproduction of the *Angelus* again, I was violently seized by the same uneasiness and the original emotional upset. I undertook the systematic analysis of a series of the "phenomena" that began to occur around the image referred to, which assumed for me a clearly obsessive character; and after having utilized this image of the *Angelus* in the most diverse forms, such as objects, paintings, poems, etc., I finally wrote an essay of paranoiac interpretation called *The Tragic Myth of Millet's Angelus,* a book soon to be published and which I consider one of the fundamental documents of the Dalinian philosophy.

we left, each one of us had to touch the pierced feet of the Christ with his ink-blackened fingers.

The brothers of the Christian School noticed the absorption with which I would sit and look out; I was the only child in the class upon whom the window exercised such an absolutist power of fascination. They therefore changed my seat, thus depriving me of the view of my two cypresses; but I continued stubbornly to look in their direction, sensing exactly the spot where they were located! And as if the intensity of my will had endowed my eyes with the power of seeing right through the walls, I was eventually able in my imaginative effort to reconstruct everything according to the hour of the day, which I now had to gauge by what went on in class. I would say to myself, "Now we're about to begin the catechism, so that the shadow on the right-hand cypress must have reached that burnt hole with a dry branch coming out of it, from which hangs a bit of white rag; the mountains of the Pyrenees must be mauve, and it is also at this moment, as I noticed several days ago, that a window must be shining in the distant village of Villa Bertran!" And this flash of light would suddenly sparkle with the reality of a fiery diamond in the annihilating darkness produced in my brain by the torture of not being allowed to see that beloved plain of Ampardán, whose unique geology with its utter vigor was later to fashion the entire esthetic of the philosophy of the Dalinian Landscape.

It was soon realized that moving me to a seat out of sight of the window had not been so effective as might have been expected. Quite to the contrary, my inattention remained so incorruptibly anchored to my pleasure that they began to despair of my case.

One day at dinner, my father created a general consternation by

reading aloud a report from my teachers. They alluded to my exemplary discipline and gentleness; they mentioned approvingly that I would spend my recreation periods far from the noisy games, lost in the contemptation of a colored picture (I knew which one)[1] found in a chocolate wrapping. But they concluded by saying that "I was dominated by a kind of mental laziness so deeply rooted that it made it almost impossible for me to achieve any progress in my studies." I remember that my mother wept that evening. The truth is that after almost a whole additional year of school I had not even learned one-fifth of what all my schoolmates had already devoured during this time. I was forced to remain indefinitely in the same class while the others scurried ahead with the gluttonous frenzy of competition to seize new rungs on the slippery and viscous ladder of hierarchy. My isolation became such a systematic fixed idea that I pretended not to know even the things which, in spite of myself, eventually and little by little became incorporated in my mind. For instance, I still wrote nonchalantly, with thousands of blots and characters of bewildering irregularity. This was done on purpose, for I really knew how to do it well.

One day when I was given a notebook with very silky paper I suddenly discovered the pleasure of writing properly. With a pounding heart, after wetting the new pen-point with my saliva for several minutes, I began, and proceeded to execute a marvel of regularity and elegance, winning the prize in penmanship, and my page was framed and put under glass.

The astonishment which the sudden, miraculous change in my handwriting produced encouraged me in the path of mystification and simulation, which were my first methods of "social contact." In order to avoid a recitation when I felt that the Brother would inevitably question me during the lesson, I would leap up and fling away my book which for the past hour I had been pretending to study with the deepest attention, though I really had not read a single line.

After this act which appeared to proceed from an unshakable decision, I would stand up on the bench, then get down again as if seized with panic and while protecting myself with my arms extended before me from some invisible danger, I would fall back on my desk, my head pressed between my hands, seemingly shaken with fright. This pantomime won me the permission to go out all by myself and walk in the garden. When I returned to the classroom I was given a drink of hot herb tea with highly aromatic drops that smelled of pine oil. My parents, who had apparently been informed of this false hallucinatory phenomenon, must have recommended to the superiors of the school redoubled and very special attentions to my person. Thus a more and more exceptional atmosphere surrounded my school days and finally the superiors ceased altogether to attempt to teach me anything.

[1] A religious picture representing the martyrdom of the Maccabees.

I was, moreover, frequently taken to the doctor's (the same one whose glasses I had broken several years before when he was about to pierce my sister's ears). At this time I was subject to real dizzy spells after having run up or down the stairs too fast. Also I had frequent nosebleeds, and was periodically confined to my bed with angina. This always took the same course: one day of fever and a week of convalescence with slightly abnormal temperatures. During this time I would perform my natural functions in my room, after which a purple-colored Armenian paper redolent of incense would be burned to remove the bad smell; sometimes the Armenian paper ran out and then they would burn sugar, which was even more delicious. I loved to have angina! I would look forward impatiently to its recurrence—what paradises those convalescences were! Llucia, my old nurse, would come and keep me company every afternoon, and my grandmother would come and settle down to her knitting near the window of my room: my mother herself would also sometimes have her visiting acquaintances sent into my room, and I would listen with one ear to Llucia's stories while with the other I would follow the more measured background of the murmurs and conversations of the "grown-ups," continuous as a well-fed fire. And if the fever rose a little all this would mingle in a kind of foggy reality which merely lulled my heart and benumbed my head within which that white-winged Angel in silvery robes who, according to Llucia's song, was none other than the angel of sleep began to gleam with a tired splendor.

Llucia and my grandmother were two of the neatest old women, with the whitest hair and the most delicate and wrinkled skin I have ever seen. The first was immense in stature and looked like a pope. The second was tiny and resembled a small spool of white thread. I adored old age! What a contrast between these two "fairy-tale" creatures, between that parchment-like flesh on which the effaced and complete manuscripts of their life were written and that other crude, brand new and apathetically unconscious flesh of my schoolmates, who no longer even remembered that they too had already been old a while ago when they were embryos; old people, on the other hand, had learned how to become old again by their own experience and, moreover, they also remembered having been children.

I became, I was and I continue to be the living incarnation of the Anti-Faust. As a child I adored that noble prestige of old people, and I would have given all my body to become like them, to grow old immediately! I was the Anti-Faust. Wretched was he who, having acquired the supreme science of old age, sold his soul to unwrinkle his brow and recapture the unconscious youth of his flesh! Let the labyrinth of wrinkles be furrowed in my brow with the red-hot iron of my own life, let my hair whiten and my step become vacillating, on condition that I can save the intelligence of my soul—let my unformed childhood soul, as it ages, assume the rational and esthetic forms of an architecture, let me learn just everything that others cannot teach me,

what only life would be capable of marking deeply in my skin! The smooth-skinned animal of my childhood was repugnant to me and I should have liked to crush it with my own feet provided with little bluish metallic heels. For in my mind desire and science were but one single and unique thing and I already knew that only the wear and decline of the flesh could bring me illuminations of resurrection. In each of Llucia's or my grandmother's wrinkles I read this force of intuitive knowledge brought to the surface by the painful sum of experienced pleasures and which was already the force of those germs of premature old age that crumples the embryo, an unfathomable force, a subterranean and Bacchic force of Minerva, a force that twists the hundreds of tendrils of the shoots of old age on the young vine-stalk and that soon effaces the strident laughter of the ageless and retarded face of the child of genius.

To be sure, I did not advance in that painful upward climb of arithmetic, I did not succeed in the sickly and exhausting calculation of multiplications. On the other hand I, Salvador Dali, at the age of nine, discovered not only the phenomenon of mimesis,[1] but also a general and complete theory to explain it!

At Cadaques that summer I had observed a species of plant that grows in great profusion along the seashore. These plants when seen at close range are composed of small, very irregular leaves supported on stems so fine that the slightest breath of air animates them in a kind of constant quivering. One day, however, some of these leaves struck me as moving independently of the rest, and what was not my stupor when

[1] Mimesis: a resemblance which certain living beings assume, either to the environment in which they find themselves, or to the better protected species or to those at whose expense they live.

I perceived that they walked! Thereupon I isolated that curious and tiny leaf-insect from the rest to observe it at leisure and examine it minutely. Seen from behind it was impossible to distinguish from the other leaves among which it lived, but if one turned it over its abdomen appeared no different from that of any other beetle, except for its legs which were perhaps unusually delicate and were in any case invisible in their normal position. The discovery of this insect made an inordinate impression on me for I believed I had just discovered one of the most mysterious and magic secrets of nature.[1] And there is no shadow of a doubt that this sensational discovery of mimesis influenced from then on the crystallization of the invisible and paranoiac images which people most of my present paintings with their phantasmal presence. Proud, haughty, ecstatic even over my discovery, I immediately utilized it for purposes of mystification. I proceeded to claim that by virtue of my personal magic I had acquired the ability to animate the inanimate. I would tear a leaf from a mass of these plants, I would substitute my leaf-insect for the leaf by a sleight-of-hand and, placing it on the dining-room table, I would begin to strike violently all around it with a rounded stone which I presented as the object endowed with magic virtue which was going to bring the leaf to life.

At the beginning of my performance everyone thought the little leaf moved solely because of the agitation which I created around it. But then I would begin to diminish the intensity of my blows until I reduced them to such feeble taps that they could no longer account for the movements of the little leaf-insect which were already clearly independent and differentiated.

At this moment I completely stopped knocking the table and people then uttered a cry of admiration and general stupefaction upon seeing the leaf really walk. I kept repeating my experiment, especially before fishermen. Everyone was familiar with the plant in question, but no one had ever noticed the phenomenon discovered by me, in spite of the fact that this kind of leaf-insect is to be found in profusion on the plant. When, much later, at the outbreak of the war of 1914, I saw the first camouflaged ships cross the horizon of Cadaques, I jotted down in my notebook of personal impressions and reminiscences something like the following—"Today I found the explanation of my 'morros de con'[2], [for this was what I called my leaf-insect] when I saw a melancholy convoy of camouflaged ships pass by. Against what was my insect protecting himself in adopting this camouflage, this disguise?"

Disguise was one of my strongest passions as a child. Just as there had

[1] The invisible image of Voltaire may be compared in every respect to the mimesis of the leaf-insect rendered invisible by the resemblance and the confusion established between Figure and Background.

[2] This name in Catalonian has a highly pornographic meaning, impossible to translate. It designates a part of the female pudenda and is used by fishermen and peasants to refer to someone or something prodigiously cunning and sly.

been a snowfall on the day when I wished so hard that the landscape of Figueras would be transformed into that of Russia, so on the day when I intensely longed to grow old quickly I received (as if by chance) a gift from one of my uncles in Barcelona—a gift which consisted of a king's ermine cape, a gold sceptre and a crown from which hung a solemn and abundant white wig.

That evening I looked at myself in the mirror, wearing my crown, the cape just draped over my shoulders, and the rest of my body completely naked. Then I pushed my sexual parts back out of sight and squeezed them between my thighs so as to look as much as possible like a girl. Already at this period I adored three things: weakness, old age and luxury. But above these three representations of the "ego", the "imperialist sentiment of utter solitude" held sway, more and more powerful, and always accompanied by that other sentiment which was to serve as its frame, its ritual, so to speak—the sentiment of "height," of the "summit."

For some time my mother had been asking me, "Sweetheart, what do you wish? Sweetheart, what do you want?" I knew what I wanted. I wanted one of the two laundry rooms located on the roof of our house, which opened on the terrace and which, as they were no longer being used, merely served as storage rooms. And one day I got it, and was allowed to use it as a studio. The maids went up and took out all the things, putting them in a nearby chicken-coop. And the following day I was able to take possession of the little laundry room which was so small that the cement tray took up almost all the space except for the area strictly indispensable for the woman who washed the clothes to stand in. But the extremely restricted proportions of my first studio corresponded perfectly to those reminiscences of the intra-uterine pleasures which I have already described in my memories of this period.

I accordingly installed myself there in the following fashion: I placed my chair inside the cement tray, and the vertical wooden board (serving to protect the washerwoman's dress from the water) I put horizontally across the top so that it half covered the tray. This was my work table! Occasionally on very hot days I would take off my clothes. I then had only to open the faucet and the water filling the tray would rise along my body high up my waist. This water, coming from a reservoir on which the sun would beat down all day long, was tepid. It was somewhat like Marat's bathtub. The whole empty space between the laundry tray and the wall was given over to the arrangement of the most varied objects and the walls were covered with pictures that I painted on the covers of hat boxes of very pliable wood which I stole from my aunt Catalina's millinery shop. The two oil paintings which I did sitting in the tray were the following: one represented the scene of "Joseph meeting his Brethren," and was entirely imaginary; the second was to a certain extent plagiarized from an illustration in a little book in colors which

Robinet.

I. Intra-Uterine Memories

Ingres' "The Turkish Bath" is a preeminent unconscious expression of the intra-uterine paradise.

Dali photographed in a sleeping pose, within the form of an egg, by F. Halsman.

The Child Jesus is situated like an unhatched chick, within the divine egg shape formed by the Raphaelesque curves.

Dali's 1942 "Family of Marsupial Centaurs"; the children can come out of, and go back into, the maternal uterine paradise.

Most pictures of rounded form are dominated by intrauterine and paradisiac elements of the consciousness.

II. Child Heredity

The Monastery of El Escorial, the inquisitorial beauty of whose architecture exercised a powerful influence on Dali's child mind.

Dali as a child photographed by Mr. Pitchot.
Felipa Domenech, mother of Salvador Dali.
Salvador Dali Cusi, father of Salvador Dali.
Salvador Dali Domenech as an infant.

was a summary of the *Iliad* and showed Helen[1] of Troy in profile looking at the horizon. The title was "And the slumbering heart of Helen was filled with memories..." In this picture (about which I dreamed a great deal), almost on the edge of the horizon I painted an infinitely high tower with a tiny figure on its summit. It was surely myself! Aside from the paintings there were also objects which already were embryos of those surrealist objects invented later on in 1929 in Paris. I also made at this period a copy of the *Venus of Milo* in clay; I derived from this my first attempt at sculpture an unmistakable and delightful erotic pleasure.

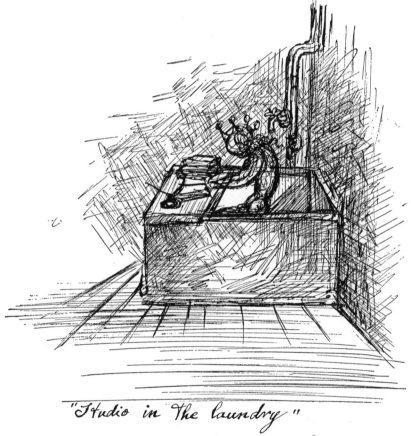

"Studio in the laundry"

I had brought up to my laundry the whole collection of "Art Govens"; these little monographs which my father had so prematurely given me as a present produced an effect on me that was one of the most decisive in my life. I came to know by heart all those pictures of the history of art, which have been familiar to me since my earliest childhood, for I would spend entire days contemplating them. The nudes attracted me above all else, and Ingre's *Golden Age* appeared to me the most beautiful picture in the world and I fell in love with the naked girl symbolizing the fountain.

[1] Helen was to be the name of my wife.

It would be interminable for me to narrate all that I lived through inside my laundry tray, but one thing is certain, namely that the first pinches of salt and the first grains of pepper of my humor were born there. I began already to test and to observe myself while accompanying my voluptuous eye-winks with a faint malicious smile, and I was vaguely, confusedly aware that I was in the process of playing at being a genius. O, Salvador Dalí! You know it now! If you play at genius you become one!

My parents did not tire of answering the invariable question which their friends would ask in the course of a visit, "And Salvador?" "Salvador has gone up on the roof. He says he has set up his painter's studio in the laundry! He spends hours and hours up there by himself!" "Up there!" That is the wonderful phrase! My whole life has been determined by those two antagonistic ideas, the top and the bottom. Since my earliest childhood I have desperately striven to be at the "top." I have reached it, and now that I am there I shall remain there till I die.

I have always felt the greatest moral uneasiness before the anonymity of names in cemeteries, engraved as far as the eye can see in a symmetrical vista to be found only in cemeteries.

What a palpitating magic it was to be able to escape the parental dining-room and run madly up the stairs leading to the roof of the house and, having arrived, to lock the door behind me and feel invulnerable and protected in the total refuge of my solitude. Once I had reached the roof I felt myself become unique again; the panoramic view of the town of Figueras, outstretched at my feet, served in the most propitious way to stimulate the limitless pride and ambition of my ruling imagination. My parents' house was one of the highest in the town. The whole panorama as far as to the Bay of Rosas seemed to obey me and to depend upon my glance. I could also see coming out of the College of the French Sisters those same little girls who gave me feelings of shame when I passed them on the street, and who now did not intimidate me, even if they were there before me, looking straight at me.

There were times when I would bitterly long to run out into the streets and participate in the confused aphrodisiac mingling of night games. I could hear the joyous cries of all the other children, of those anonymous ones, fools, ugly and handsome, of the boys and especially the girls, rising toward me from below and fastening like a martyr's arrow in the center of the hot flesh of my chest composed of massive pride! But no! no! and again NO! Not for anything in the world! I, Salvador, knew that I must remain there, sitting in the damp interior of my laundry tray, I, the most solitary child, surrounded only by the wavering and embittered chimera of my forbidding personality. Besides, I was already so old! And to prove it to myself I would forcibly pull down that king's crown with its fringe of white hair upon my head, seaming my brow with blood-red dents, for I would not admit that my head was growing!

When twilight had fallen I would come out of my laundry, and this was my favorite moment! The smooth and soundless flight of the swallows was already interwoven with that other antagonistic flight, awkward and vacillating—the flight of the bats; I would further wait for the voluptuous moment when I would remove my crown which was becoming so tight that a violent pain on my temples would be added to the real headache produced by that pitiless continual pressure. I would walk up and down the length of the terrace saying to myself, "Just a little longer!" trying to prolong the course of my meditations by some sublime thought. In such moments, exasperated by pain, I would deliver speeches aloud with such grandiloquent verve and intonation that I became imbued with a fantastic and passionate tenderness toward myself.[1]

My speeches would succeed one another in a purely automatic fashion and often my words would in no way correspond to the stream of my thoughts. The latter would seem to me to attain the summit of the sublime and I had the impression of discovering each second, in a more and more inspired and unerring fashion, the enigma, the origin and the destiny of each thing. The city lights would progressively turn on, and for each new star a tiny flute would be born. The monotone and rhythmic song of the crickets and the frogs would stir me sentimentally by superposing upon the present twilight anguish evocative memories of former springtimes. The sudden apparition of the moon only served to exacerbate my ecstasy to a paroxysm and the megalomaniac tumult would reach such a height of delirious egocentricity that I felt myself rising to the very summit of the most inaccessible stars, the whirl of my narcissism having attained the proportions of a cosmic revery; at this moment a calm, ungrimacing, intelligent flow of tears would come and appease my soul. For some time I had felt within my caressing hand something small, moist, bizarre. I looked in surprise: it was my penis.

Grillon.

I finally removed my crown and pleasurably rubbed the quickly soothed pain of the bruise which the crown had made with its long embrace. I went down to the dining room dead with fatigue, I was not hungry and I looked so ill that my parents were terrified. My mother looked at me questioningly. "Why aren't you hungry? What does my darling want? I can't bear to look at the little darling! He isn't yellow, he's green!"

Green or not, I would go up again on all occasions to the top of the roof, and one day I even went up on the roof of the little laundry where I felt for the first time in my life the sensation of dizziness when I realized that nothing stood between me and the empty space below. I had to remain for several minutes flat on my belly with my eyes shut to resist

Grenouille.

[1] Subsequently I have realized that in all my lectures I would seat myself in such a way as to have my foot so uncomfortably twisted that it hurt and that this pain could be accentuated at will. One day when this characteristic contraction coincided with my wearing of shoes that were painfully tight my eloquence reached its height. In my own case physical pain certainly augments eloquence; thus a tooth-ache often releases in me an oratorical outburst.

the almost invincible attraction that I felt sucking me toward the void.

Since then I never again repeated this experiment; but my long sessions within the laundry tray were enhanced by that sensation of dizziness which I felt localized just above my head and from which the laundry ceiling protected me while at the same time reinforcing in a royal fashion the vertiginous awareness of the height of my cement throne which I felt to be even higher above everything since my experience with dizziness.

And what is the high? The high is exactly the contrary of the low: and there you have a fine definition of dizziness! What is the low? The low is: chaos, the mass, the collective, promiscuity, the child, the common fund of the obscure folly of humanity, anarchy; the low is the left. To the right, above, one finds monarchy, the cupola, hierarchy, architecture and the angel. All poets have sought one single thing: the angel. But their vice of congenital negativism has confused and perverted their taste and turned them to evil angels, and if it is true that it is always the spirit of evil that animates the Rimbaudian and Maldororian angels this is due to the sole and unique fact of the inadaptation to reality that is consubstantial with poets. Painters, on the other hand, having their feet much more securely on the ground, do not need to grope blindly and, possessing a means of inspiration far superior to that of poets—namely the eye—do not need to have recourse to the viscous confusion of the mental collapse into which poets must inevitably fall. This is why only painters are and will be able to show you true angels and true gods, as Raphael did with so much reality and good sense from the height of his imperial Olympus of divine genius. As for me, the more delirious I became the more alert was my eye.

Thus, to summarize what I have said, there I was at the beginning of my ninth year, I, a solitary child, a King, seated within the tray and frequently bleeding from the nose, at the top of the roof, on the summit! Below, all the rest, all that cannon-flesh composed of biology devoid of anguish, all the nose-hairs, the mayonnaise, the spinning tops, the souls of purgatory, the imbecile children that learned anything you please, boiled fish, etc. etc. I would never again go down into the street of the spirit to learn anything whatever. For that matter, I too was mad ages ago, and even this confounded spelling, why learn it again when I already forgot it at least two thousand years ago![1]

I was persevering and I still am. My mania for solitude grew, with pathological flashes, my eagerness to climb up to the roof became so

[1] Mr. Dali's manuscript, as to handwriting, spelling and syntax, is probably one of the most fantastically indecipherable documents ever to have come from the pen of a person having a real feeling for the value and the weight of words, for verbal images, for style. The manuscript is written on yellow foolscap in a well-nigh illegible hand-writing, almost without punctuation, without paragraphing, in a deliriously fanciful spelling that would bring beads of perspiration to a lexicographer's brow. Gala is the only one who does not get lost in the labyrinthian chaos of this manuscript. —*Translator's Note*.

intense that before the end of the meals, unable to remain in my seat any longer, I would have to run out several times and lock myself in the toilet on the pretext that I had a stomach-ache. My sole object in doing this was to remain a few moments alone, which lightened the torture of having to wait until dinner was over and I was allowed to rush upstairs and shut myself up in the laundry.

In school my state of mind became aggressive toward anything or anyone who deliberately or otherwise challenged my solitude. The children who ventured to come near me—growing progressively fewer to be sure—I received with a look and an attitude so hateful that I was safe from intrusion during the long recreation periods from then on, plunged in an intact and untroubled world of my own. But it so happened that the immaculate purity of this world was destroyed with a single stroke, and this came about, as might easily have been foreseen, by the intervention of that feminine image which is always there to demolish every cerebral construction from which one tries, at nightfall, to spirit away the anguishing presence of the soft and smiling butterfly of the flesh because of which man begins to fear death and by virtue of which he will end by believing in the Catholic myth *par excellence* of the triumphant resurrection of his own body.

It was a little girl whom I saw one day from behind, walking in front of me the whole length of the street, on my way home from school. She had a waist so slender and so fragile that it seemed to separate her body into two independent parts and her extremely arched manner of walking threatened to break her in two; she wore a very tight silver belt. This little girl was accompanied by two girl friends, one on each side, who had their arms around her waist while they caressed and cajoled her with the most seductive smiles that they were capable of offering her. The two girls turned their heads several times to look back. I walked very close to them and was able to pick up the remnants of those smiles, that were slow to vanish from their faces. The one in the middle did not turn round and I knew, though seeing her only from behind, walking so proudly, that she was different from all other girls in the world, that she was a queen. The same sentiment of never-extinguished love that I had had for Galuchka was born anew; her name was Dullita, for that is what her two fervent and adoring friends called her ceaselessly and in every tone of tenderness and passion. I returned home without having seen her face and without its having occurred to me to look at it. It was indeed she—Dullita, Dullita! Galuchka "Rediviva"!

I went directly up to my rooftop, feeling my aching ears tightly imprisoned in my sailor cap as if ready to catch on fire; I released them and the cool twilight air came and caressed them delightfully; I felt the whole invincible power of love take hold of me anew, and this time it began with my ears.

Since this encounter I had but one single desire, which was that Dullita should come and find me up there in my laundry, that Dullita

should come up to me on the roof! And I knew that this must inevitably happen—but how? And when? Nothing would appease my mad impatience and the boiled potatoes became a torture to swallow. One afternoon I had such a violent nosebleed that the doctor was called and I remained several hours with my head down, looking up toward the ceiling, with napkins dipped in vinegar, the shutters drawn. At the beginning of my hemorrhage the maid placed a large cold key at the nape of my neck, and now it dug into my flesh, causing me great pain; but I was so exhausted that I did not even try to lift myself up.

I saw reduced images pass back and forth—carts and people walking along the street—projected upside down on the ceiling,[1] and I knew that these images corresponded to real people who were in the street in the bright glare of the sun. But in my weak state these distorted figures which came into focus only for a moment all appeared to me to be real

Moulí de la Torre

[1] I had on other occasions observed and reproduced at will this phenomenon due to small holes in the shutters which made my room act as a photographic camera.

angels. I then thought: if Dullita with her two friends should happen to pass by I would see her on my ceiling. This, however, was very unlikely, for she always or almost always came home from school by way of the street running parallel to ours; but even the slightest glimmer of the possibility that she might pass by deeply stirred me by the most contradictory representations, in which displeasure, expectation, hope, pride and illusion dimly mingled in an agony of uneasiness. Two thoughts stronger than the rest came to light, nevertheless, in the chaos of my anxiety:

1. If she should happen to pass across the ceiling I would be the one to be below.

2. If her head was down she would fall down into empty space.

I always saw her from behind, with her delicate waist, fall back into the black void, where she would break in two, like a white porcelain egg-cup. She deserved this, for not having been willing to come up to my roof top, but at the last moment I wanted to save her. I stirred on my bed, torn by a frightful remorse, and I then felt the burning pain of the key of torture incrusted with all the force of my weight in the bones of my neck, and I then felt my love for Dullita, for Galuchka Rediviva, once more become localized there, just where I felt the pain!

The following day my parents decided to send me to the country for a rest; I was to visit the Pitchot family [1] who had a property situated in the plain, two hours from Figueras. The property was called "El Muli de la Torre" (The Tower Mill). I had never yet been there, but this name struck me as wonderful. I accordingly consented to go, with a stoic resignation in which the image of the Tower, one of my favorite myths, played a tempting role.

Also my departure for the Muli de la Torre would serve me as a means of vengeance against Dullita, since she did not come up to my roof as I had hoped, and as I still expected her to every evening; at the same time my trip would enable me to soften my rancor, while encouraging my hope of recovering with all my former fanaticism that beloved solitude which had just been shaken and compromised by the encounter with Dullita in a way so disconcerting to my spirit.

I started off in a cart with Señor and Señora Pitchot and Julia, their adopted daughter of sixteen, who had long black hair. Señor Pitchot

[1] This family has played an important role in my life and has had a great influence on it; my parents before me had already undergone the influence of the personality of the Pitchot family. All of them were artists and possessed great gifts and an unerring taste. Ramon Pitchot was a painter, Ricardo a cellist, Luis a violinist, Maria a contralto who sang in opera. Pepito was, perhaps, the most artistic of all without, however, having cultivated any of the fine arts in particular. But it was he who created the house at Cadaques, and who had a unique sense of the garden and of life in general. Mercedes, too, was a Pitchot one hundred per cent, and she was possessed of a mystical and fanatical sense of the house. She married that great Spanish poet, Eduardo Marquina, who brought to the picturesque realism of this Catalonian family the Castillian note of austerity and of delicacy which was necessary for the climate of civilization of the Pitchot family to achieve its exact point of maturity.

drove the cart himself. He was one of the handsomest men I have ever seen, with an ebony beard and moustache and long curly hair. To enliven the horse at the moment when the latter seemed about to sink into laziness, he had merely to produce a curious sound with his tongue, and for this he had to keep his teeth pressed together while at the same time opening and distending his lips as much as possible with a grimacing contraction of his cheeks.

The sun glistened on his perfect white teeth as on petrified gardenias moistened with saliva. The horse, responsive to the noise Señor Pitchot made with his mouth, would start off again at a gentle gallop, giving a new note to the monotonous tinkling of the bells. We arrived just after sunset. The Muli de la Torre [1] impressed me as a magic spot, it was "made on purpose" for the continuation of my waking fantasies and dreams.[2] I felt as if I had miraculously recovered my health in a single

instant, and nothing remained of my anxious and melancholy lassitude of the preceding days. On the contrary, a delirious joy unpredictably and repeatedly took hold of me. The boiled potato, well sprinkled with olive oil and a rapid pinch of salt, made my mouth water, and a sentiment of uninterrupted satisfaction gave me a constant thrill of well-being that each of the minute events inherent in the progressive adaptation to and discovery of the place only accentuated, with the marinated red pimento that this kind of small surprise always constitutes when the place to which you have arrived gives you the certainty that it is "for you" and that reciprocally, for your part, your loyalty toward it, from the first decisive contact of the threshold, can never henceforth know any limits.

The next day the sun rose, the countryside was deafening with greenery and the song of insects. The month of May beat in my temples the "caressing and fluorescent drums" of nuptial palpitations. My love for Dullita, while it grew, mingled with the frenzied pantheism of the landscape and became impregnated with that viscous and digestive sap which is the very same that lifts toward the summer sky the slow and convulsed

[1] This spot was objectively one of the richest properties in the country-side, and contained a large number of pictures painted by Senor R. Pitchot.

[2] It is in this spot of the Muli de la Torre that most of my reveries during the whole rest of my life have taken place, especially those of an erotic character, which I wrote down in 1932; one of these having as protagonists Gala and Dullita was published in *Le Surréalisme au Service de la Révolution*. But the very special character of the text prevents including it in the present work.

stalk of the plant, forming a transparent drop upon its uttermost tip, tense with the glorious pain of growth.

My love for Dullita (whose face I had not yet seen) spread over all things and became a sentiment so general that the idea of the slightest possibility of her real presence would have horrified and disappointed me; I would adore her, and at the same time remain more alone, more ferociously alone than ever!

The mechanical side of the Mill interested me very little, but its monotonous noise quickly became assimilated to my imagination, and I immediately considered it as the continual presence of the memory of something absent serving, with its majestic recall, to protect the solemn side of my solitude. The tower, on the other hand, as the reader of this book already initiated to my tastes will readily understand, became the sacred spot, the tabernacle, the "mansion of sacrifice"—and it was, in fact, up in the tower that I perpetrated the sacrifice!

This will be recounted minutely and as well as my own emotion will allow me, at the exact end of this chapter. I had to wait two days before I was able to climb "up there." Someone was always going to bring the key. Finally on the third day they opened the door which gave access to the upper terrace of the tower, and from this moment the clear and rotting water of my impatience could flow tumultuously, just as cascades of dizziness succeed stagnant emotions, long contained by the dam of censorship which regulates the melancholy course of the majestic canal of life. The height of the summit of the tower where I found myself exceeded everything I had imagined; I leaned over the edge and spat; I saw my spittle become smaller and disappear in a mass of dark vegetation from which emerged the remnants of an old chicken-coop. Beyond one saw the slow course of a little stream running into the mill-dam; still farther on began the limits of those earthly paradises of kitchen gardens which served as foreground and were like garlands to a whole theory of landscape which was crowned by the successive planes of the mountains, whose Leonardoesque geology rivaled in rigor of structure the hard analytical silhouettes of the admirably drawn clouds of the Catalonian sky.

If Dullita had been there I would have made her lean very far over the edge, at the same time holding her back so she would not fall. This would have given her an awful scare.

The following day I determined the methodical distribution of the events of my future days, for with my avidity for all things, resulting from my new and bubbling vitality, I felt that I needed a minimum of order so as not to destroy my enthusiasm in contradictory and simultaneous desires. For I now wanted to take frenzied advantage of everything all at once, to be everywhere at the same moment. I understood very quickly that with the disorder in which I went about wanting to enjoy and bite and touch everything I would in the end not be able to taste or savor anything at all and that the more I clutched at pleasure,

attempting to profit by the gluttonous economy of a single gesture, the more this pleasure would slip and escape from my too avid hands.

The systematic principle which has been the glory of Salvador Dali began thus to manifest itself at this time in the meditated program in which all my impulses were weighed, a jesuitical and meticulous program whereby I traced out for myself in advance the plan not only of the events but also of the kind of emotion I was to derive from them during the whole length of my days to follow that promised to be so substantial. But my systematic principle of action consisted as much in the perverse premeditation of this program as in the rigor and discipline which, once the plan was adopted, I devoted to making its execution strictly and severely exacting.

Already at this age I learned an essential truth, namely, that an inquisition was necessary to give a "form" to the bacchic multiplicity and promiscuity of my desires. This inquisition I invented myself, for the sole use of the discipline of my own spirit. Here in its main outlines, is the program of my auto-inquisitorial days of the Muli de la Torre.

My rising had always to involve an exhibitionistic ritual, inspired by my nakedness. To carry this out I always had to be awake before Julia came into my room to open my window in the morning. This awakening, which I effected by the sheer force of my will, was a torture because of the exhausting events that filled my days. Every morning I was devoured by sleep. I succeeded nevertheless in waking up with great punctuality, that is to say fifteen minutes before Julia came in. I used this interval to savor the erotic emotion which I was going to derive from my act, and especially to invent the pose which varied daily, and which each morning had to correspond to the renewed desire of "showing myself naked," in the attitude that would appear most troubling to myself and at the same time be capable of producing the greatest effect upon Julia. I tried out my gestures until the last moment when I heard Julia's approaching footsteps. Then I definitely had to make up my mind, and this last moment of bewilderment was one of the most voluptuous in my incipient exhibitionism. The moment I heard the door open I remained frozen in a tense immobility, simulating peaceful slumber. But anyone who had looked at me attentively would readily have noticed my agitation; for my body was seized with such violent trembling that I had to clench my teeth firmly to prevent them from chattering. Julia would open the two shutters of the window, come over to my bed, and cover my nakedness with the sheets which I had let drop to the floor or piled at my feet as if by the restless movements I might have made in the course of my sleep. Having done this she would kiss me on the brow to wake me up. At that age I thought myself ideally beautiful, and the pleasure which I experienced at feeling myself looked at was so vivid that I could not resign myself to getting dressed before this pleasure had been repeated once more. To this end I had to invent a new pretext and I would frantically review in my mind the list of such projects carefully

worked out the previous evening before going to sleep and which con-
stituted the thousand and one manners of my morning exhibitionism.
"Julia, these buttons are all gone! Julia, put some iodine here on my
upper thigh! Julia!..."

After which came breakfast, which was served on the large table of
the dining room, for me alone. Two large pieces of toast drenched with
honey and a glass of very hot coffee and milk. The walls of the dining
room were entirely covered with oil paintings and colored etchings, most
of them originals, by Ramon Pitchot, who at this time lived in Paris, and
who was the brother of Pepito Pitchot.

These breakfasts were my discovery of French impressionism, the
school of painting which has in fact made the deepest impression on me
in my life because it represented my first contact with an anti-academic
and revolutionary esthetic theory. I did not have eyes enough to see all
that I wanted to see in those thick and formless daubs of paint, which
seemed to splash the canvas as if by chance, in the most capricious and
nonchalant fashion. Yet as one looked at them from a certain distance
and squinting one's eyes, suddenly there occurred that incomprehensible
miracle of vision by virtue of which this musically colored medley became
organized, transformed into pure reality. The air, the distances, the
instantaneous luminous moment, the entire world of phenomena sprang
from the chaos! R. Pitchot's oldest painting recalled the stylistic and
iconographic formulae characteristic of Toulouse-Lautrec. I squeezed
from these pictures all the literary residue of 1900, the eroticism of
which burned deep in my throat like a drop of Armagnac swallowed the
wrong way. I remember especially a dancer of the Bal Tabarin dress-
ing. Her face was perversely naïve and she had red hairs under her arms.

But the paintings that filled me with the greatest wonder were the
most recent ones, in which deliquescent impressionism ended in certain
canvases by frankly adopting in an almost uniform manner the *poin-
tilliste* formula. The systematic juxtaposition of orange and violet pro-
duced in me a kind of illusion and sentimental joy like that which I had
always experienced in looking at objects through a prism, which edged
them with the colors of the rainbow. There happened to be in the dining
room a crystal carafe stopper, through which everything became "impres-
sionistic." Often I would carry this stopper in my pocket to observe the
scene through the crystal and see it "impressionistically."

Suddenly I would realize that I had exceeded the time allotted to
breakfast, and my contemplation would always end with a "shock of vio-
lent remorse" which caused me to swallow my last mouthful of coffee-
and-milk the wrong way, and it would spill down my neck and wet my
chest inside my clothes. I found a singular pleasure in feeling this hot
coffee dry on my skin, cooling slowly and leaving a slight sticky and
agreeable moisture. I became so fond of this moisture that I finally pur-
posely produced it. With a quick glance I would assure myself that Julia
was not looking, and then just before she went out I would pour directly

from the cup a sufficient quantity of coffee-and-milk, which would wet me down to my belly. One day I was caught red-handed doing this, and for years the story was told by Señor and Señora Pitchot as one of the thousand bizarre anecdotes relating to my alarming personality which they adored to collect. They would always begin by asking, "Do you know what Salvador has done now?" Everyone would prick up his ears, prepared to hear about one of those strange fantasies which were utterly incomprehensible, but always had the power to make everyone laugh till the tears rolled. The sole exception was my father, who by his worried smile could not but betray the anguish of menacing doubts about my future.

After the honey and the café-au-lait poured inside my shirt I would run over to a large white-washed room where ears of corn and rows of sacks filled with grains of corn were drying on the floor. This room was my studio, and it was Señor Pitchot himself who had decided this, because, he said, "the sun came in the whole morning." I had set up a big box of oil colors on a large table where each day a pile of drawings would accumulate. The walls too, before long, were soon filled with my paintings which I put up with thumb tacks as soon as they were finished.

One day when I had finished my roll of canvas I decided to do something with a large unmounted old door which was not in use. I placed it horizontally on two chairs, against the wall. It was made of very handsome old wood, and I decided to paint only the panel so that the doorframe would serve as the frame for my picture. On it I started to paint a picture which had obsessed me for several days—a still life of an immense pile of cherries. I spilled out a whole basket of them on my table to use as a model. The sun, streaming through the window, struck the cherries, exalting my inspiration with all the fire of their tantalizing uniformity. I set to work, and this is how I proceeded: I decided to paint the whole picture solely with three colors, which I would apply by squeezing them directly from the tube. For this I placed between the fingers of my left hand a tube of vermilion intended for the lighted side of the cherries, and another tube of carmine for their shade. In my right hand I held a tube of white just for the highlight on each cherry.

Thus armed I began the attack on my picture, the assault on the cherries. Each cherry—three touches of color! Tock, tock, tock—bright, shade, highlight, bright, shade, highlight...Almost immediately I adjusted the rhythm of my work to that of the sound of the mill—tock, tock, tock... tock, tock, tock...tock, tock, tock...My picture became a fascinating game of skill, in which the aim was to succeed better at each "tock, tock, tock," that is to say with each new cherry. My progress became so sensational, and I felt myself at each "tock" becoming master and sorcerer in the almost identical imitation of this tempting cherry. Growing quickly accustomed to my increasing skill, I tried to complicate my game, inwardly repeating to myself the circus phrase, "Now something even more difficult."

And so, instead of piling my cherries one on top of another as I had done so far, I began to make isolated cherries, as far separated from one another as possible, now in one corner, now in the most distant opposite

corner. But as the severe rules of my new experiment required that I continue to follow the same rhythm of the sound of the mill, I was forced to rush from one spot to another with such agility and rapidity of gestures that one would have thought that, instead of painting a picture I was being carried away by the most disconcerting kind of dancing incantation, making agile leaps for the cherries above and falling back on my knees for the cherries below; "tock" here, "tock" there, "tock" here...tock, tock, tock, tock, tock, tock. And I kept lighting up the old door which served as my canvas with the new and fresh fires of my painted cherries which were joyously born at each monotonous "tock" of the mill as if by an art of enchantment of which "in reality of truth" I was the sole master, lord and inventor.

This picture really astonished everyone who saw it, and Señor Pitchot bitterly regretted that it was painted on an object so cumbersome, so heavy and difficult to transport as a door, and which moreover was riddled with wormholes in certain places.

All the peasants came and stared in open-mouthed admiration at my monumental still life, in which the cherries stood out in such relief that it seemed as though one could pluck them. But it was pointed out to me that I had forgotten to paint the stems of the cherries. This was true— I had not painted a single one. Suddenly I had an idea. I took a handful of cherries and began to eat them. As soon as one of them was swallowed I would glue the stem directly to my painting in the appropriate place. This gluing on of cherry stems produced an unforeseen effect of startling "finish" which chance was once more to heighten with a delirious effect of realism. I have already said that the door on which I painted my picture was riddled with worms. The holes these had made in the wood now looked as though they belonged to the painted pictures of the cherries. The cherries, the real ones, which I had used as models, were also filled with worm-infested holes! This suggested an idea which still today strikes me as unbelievably refined: armed with a limitless patience, I began the minute operation (with the aid of a hairpin which I used as tweezers) of picking the worms out of the door—that is to say, the worms of the painted cherries—and putting them into the holes of the true cherries and vice versa.

I had already effected four or five of these bizarre and mad transmutations, when I was surprised by the presence of Señor Pitchot, who must have been there behind me for some time, silently observing what I was doing. The effect of the cherry stems must have struck him as quite astonishing, but I understood immediately that it was my manipulations with the worms that kept him standing there so motionless and absorbed. This time he did not laugh, as he usually did about my things; after what appeared to be an intense reflection, I remember that he finally muttered between his teeth, and as if to himself, "That shows genius," and left.

I sat down on the floor on a pile of ears of corn, feeling very hot in

the sun and thinking over Señor Pitchot's words, which remained deeply engraved in my heart. I was convinced that I could really achieve "extraordinary" things, much more extraordinary than "that." I was determined to achieve them, and I would, at no matter what cost! One day everyone would be astonished by my art! And you, too, Dullita, Galuchka Rediviva, even more than all the rest!

The contact with the hot ears of corn had felt very agreeable, and I changed places to find another hotter pile. I dreamt of glory, and I should have liked to put on my king's crown. But I would have had to go up to my room and fetch it, and it was so comfortable here on the corn! I took my crystal carafe stopper out of my pocket, and looked through the prismatic facets at my picture, then at the cherries, then at the ears of corn scattered on the floor. The ears of corn especially produced an extremely langorous effect seen in this manner, set off by all the colors of the spectrum. An infinite laziness came over me, and with slow movements I took off my pants. I wanted my flesh to touch the burning corn directly. I slowly poured a sack of grain over myself. The grains trickled over my body, soon forming a pyramid that entirely covered my belly and my thighs.

I was under the impression that Señor Pitchot had just started off on his morning inspection tour and would as usual not be back before the lunch hour. I therefore had plenty of time to put back all the spilled corn in the sack. This thought encouraged me and I poured out still another sack of corn in order to feel the weight of the pyramid of grain progressively increase on top of me. But I had erred in my calculations as to the duration of Señor Pitchot's walk, for the latter suddenly reappeared on the threshold. This time I thought I would die of shame at seeing myself caught in my voluptuous attitude. I saw consternation contract his features and, backing away without saying a word, he disappeared, this time for good. I did not see him again before lunch time.

At least an hour must have gone by meanwhile, for the sun had long since left the spot where I remained without moving from the moment of Señor Pitchot's unexpected reappearance. I was stiff and ached all over from having kept the same half-lying position for so long. I began to pick up all the corn I had spilled, putting it back in the sack. This operation took a long time, for I was only using my two hands. Because of the unusual size of the sacks I did not seem to be making any headway; I was several times tempted to leave my work unfinished, but immediately a violent sense of guilt seized me in the center of my solar plexus, and then I would begin again with fresh courage to put the grains of corn back into the sack. As I neared the end my work became more painful because of the constant temptation to leave everything as it was. I would say to myself, "It's good enough as it is," but an insuperable force pressed me to keep right on. The last ten handfuls were a real torture, and the last grain seemed almost too heavy to lift from the ground. Once my task was finished to the end I felt my spirit suddenly calmed, but the

weariness that had come over my body was even greater. When I was called to lunch I thought I would never be able to climb the stairs.

An ominous silence greeted me as I entered the dining room, and I immediately realized that I had just been the subject of a long conversation. Señor Pitchot said to me in a grave tone,

"I have decided to speak to your father, so that he will get you a drawing teacher." As though I felt outraged by this idea, I indignantly answered,

"No! I don't want any drawing teacher, because I'm an 'impressionist' painter!"

I did not know very well the meaning of the word "impressionist" but my answer struck me as having an unassailable logic. Señora Pitchot, dumfounded, broke into a great peal of laughter.

"Well, will you look at that child, coolly announcing that he's an 'impressionist' painter!"

And with this she went off into an immense, fat and generous laugh. I became timid again, and continued to suck the marrow of the second joint of a chicken, noticing that the marrow had exactly the color of Venetian red. Señor Pitchot launched into a conversation on the necessity of picking the linden blossoms toward the end of the week. This linden blossom picking was to have consequences of considerable moment for me.

But before I enter into the absorbing, cruel and romantic story which is to follow, let me first continue, as I had promised, to describe the rigorous apportioning of the precious time of my days lived in that unforgettable Muli de la Torre. This is necessary, moreover, to situate precisely, against a chronological, ordered and clear setting, the vertiginous love scenes which I am about to unfold to you. Here, then, is the neurotic program of my intense spring days.

I excuse myself for repeating once more in summary the manner in which these began, so that the reader may more readily connect this part with the rest of my program and be in a position to obtain the necessary view of the whole.

Ten o'clock in the morning—awakening, "varied exhibitionism," esthetic breakfast before Ramon Pitchot's impressionistic paintings, hot coffee-and-milk poured down my chest before leaving for the studio. Eleven to half past twelve—pictorial inventions, reinvention of impressionism, reaffirmation and rebirth of my esthetic megalomania.

At lunch I collected all my budding and redoubtable "social possibilities," in order to understand everything that was going on at the Mill through the conversations sprinkled with euphemisms of Señor and Señora Pitchot and Julia. This information was precious in that it revealed to me plans of future events by which I could regulate the delights of my solitude while establishing an opportunistic compromise between these and the marvels of seduction offered me by the whole series of activities connected with the agricultural developments of the

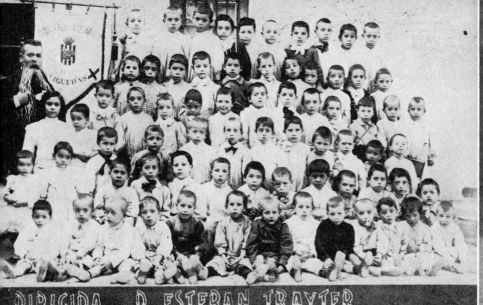

DIRIGIDA por D. ESTEBAN TRAYTER.
15—9—1908.

III. Thirty Years Before—Thirty Years After

As a little boy at school, I stole an old slipper belonging to the teacher, and used it as a hat in the games I played in solitude.

In 1936, I constructed a Surrealist object with an old slipper of Gala's and a glass of warm milk.

Years after my school-boy prank, a photo of Gala crowned by the coupolas of Saint Basil revived my early fantasy of the "slipper-hat."

Finally Madame Schiaparelli launched the famous slipper-hat. Gala wore it first; and Mrs. Reginald Fellowes appeared in it during the summer, at Venice.

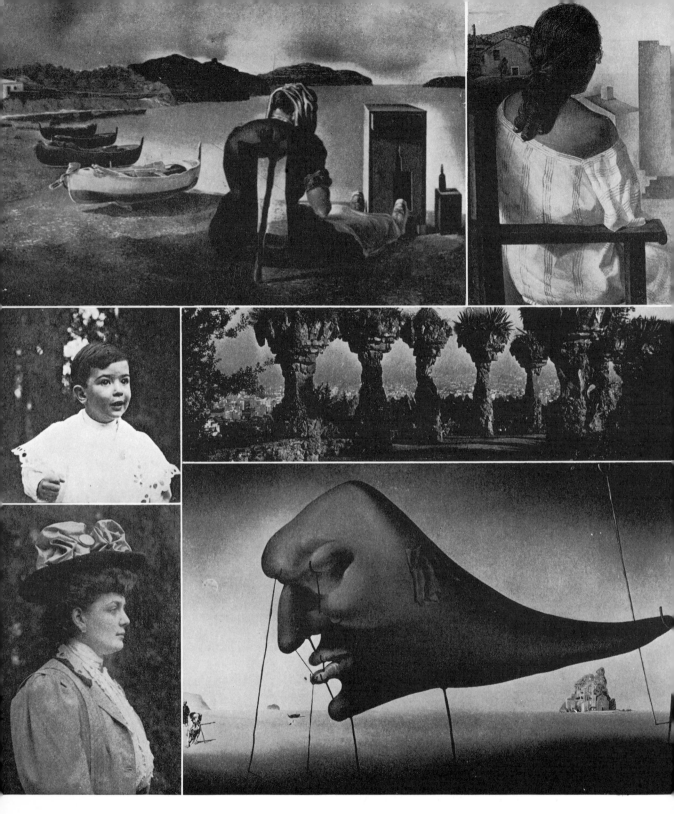

IV. The Orifice Enigma

"Weaning of Alimentary Furniture": my nurse, from whose back a night table has been extracted.

"Portrait of My Sister." During the execution of this picture, I had an instantaneous vision of a terrifying rectangular hole in the middle of her back.

Photo of Dali at the time he visited the Park Guell in Barcelona.

Avenue in the Park Guell. The open spaces between the artificial trees gave me a sensation of unforgettable anguish.

Ursulita Matas, who took me to visit the Park Guell.

"Sleep," 1939 painting in which I express with maximum intensity the anguish induced by empty space.

place. These events always brought with them not only the flowering of new myths but also the apparitions (in their natural setting) of their protagonists who were heretofore unknown to me—the linden blossom picking (in this connection only women were mentioned), the wheat threshing, performed by rough men who came from far away, the honey gathering, etc.

Hérisson.

The afternoon was dedicated almost exclusively to my animals which I kept in a large chicken coop, the wire mesh of which was so fine that I could even confine lizards there. The animals in my collection included two hedgehogs, one very large and one very small, several varieties of spiders, two hoopoes, a turtle, a small mouse caught in the wheat bin of the Mill where it had fallen, unable to get out. This mouse was shut up inside a tin biscuit box on which there happened to be a picture of a whole row of little mice, each one eating a biscuit. For the spiders I had made a complicated structure out of cardboard shoe boxes so as to give each kind of spider a separate compartment, which facilitated the course of my long meditative experiments. I managed to collect some twenty varieties of this insect, and my observations on them were sensational.

Araignée!

The monster of my zoological garden was a lizard with two tails, one very long and normal and the other shorter. This phenomenon was connected in my mind with the myth of bifurcation, which appeared to me even more enigmatic when it manifested itself in a soft and living being—for the bifurcated form had obsessed me long before this. Each time chance placed me in the presence of a fine sample of bifurcation, generally offered by the trunk or the branches of a tree, my spirit remained in suspense, as if paralyzed by a succession of ideas difficult to link together, that never succeeded in crystallizing in any kind of even poetically provisional form. What was the meaning of that problem of the bifurcated line, and especially of the bifurcated object? There was something extremely practical in this problem, which I could not take hold of yet, something which I felt would be useful for life and at the same time for death, something to push with and to lean on: a weapon and a protection, an embrace and a caress, containing and at the same time contained by the thing contained! Who knows, who knows! Wrapped in thought, I would caress it with my finger in the middle where the two tails of the lizard bifurcated, went off in two different directions, leaving between them that void which alone the madness peculiar to my imagination would perhaps some day be able to fill. I looked at my hand with its fingers spread out, and their four bifurcations disappeared in the imaginative and infinite prolongation of my fingers which, reaching toward death, would never be able to meet again. But who knows? And the resurrection of the flesh?

. Huppe.

Suddenly I became aware that the afternoon was vanishing in the ritualistic apotheosis of a bloody glow. These philosophic meditations had as their principal virtue that of devouring time, while leaving at

Pyxide.

the bottom of its empty bottle the reddish, thick and wine-smelling lees of the setting sun.

Sunset, the time for running out to the kitchen-garden! The time propitious for pressing out the guilty juices of terrestrial gardens invaded by the evening breezes of original sins. I would bite into everything—sugar beets, peaches, onions tender as a new moon. I was so fearful of becoming satiated, of letting my temptations lose their edge too quickly by the debauched prodigality of my gluttony, that I would only bite the desired fruit with a single impatient crunch of my teeth, and after having extracted from it the strict taste of desire, I would throw away the object of my seduction, the more quickly to grasp the rest of these fruits of the moment, whose taste was for my palate as ephemeral as the fugitive flicker of the fireflies that already began to shine in the deepest shadows of the growing vegetational darkness. At times I would take a fruit and be content to touch it with my lips or press it softly against my burning cheek. I liked to feel on my own skin the serene calm of the temperature of that other taut, cool-steeped skin, especially that of a plum, black and wet like a dog's nose having the texture of a plum rather than that of a truffle. I had allowed myself the possible prolonging of this whole gustatory and vegetal promiscuity of the kitchen garden until mid-twilight, but I had anticipated exceptions to this. That is to say, I could linger on there a little if the gathering of glow-worms with which I concluded the delights of the kitchen garden promised to be fruitful. I wanted in fact to make a necklace [1] of glow-worms strung on a silk thread, which in the prophorescent convulsions of their death agony would produce a singular effect on Julia's neck. But she would be horrified by this. Perhaps Dullita, then? I could imagine her standing thus adorned, consumed with pride.

When twilight deepened, the Muli de la Torre was already calling me with the whole irresistible attraction of its dizzy height, and I raised my eyes toward the top of this tower with an ardent gaze of promise and fidelity. I said to it in a low voice, "I'm coming!" It was still flushed with a faint rose tinge, even though the sun had long since set. And always above those proud walls three great black birds hovered majestically. My daily twilight visit to the terrace at the top of the Tower was by all means the most eagerly awaited and the most solemn moment of my days. Nevertheless, as the hour of my ascent approached, the impatience which I felt growing within me blended with a kind of indeterminate and infinitely voluptuous fear. On reaching the top of the tower my glance would delight in losing its way as it wandered along the mountain tops, whose successive planes appeared still at this late hour to be etched with the gold and scarlet line of the last glimmer of daylight which by

[1] The making of this kind of necklace is not a Dalinian invention as it seems, but on the contrary was a frequent game among the peasant children in the region where the Muli de la Torre was located.

virtue of the limpidity of the air rendered that prenocturnal landscape precise and stereoscopic.

From the summit of this tower I was able to continue to develop the kinds of grandiose reveries which I had begun previously on the roof of my parents' house in Figueras. But now my exhausting imaginings assumed a much clearer "social and moral" content, in spite of the persistence of a continually paradoxical ambiguity. My moral ideas in fact constantly plunged from one extreme to the other. Now I would imagine myself set up as a bloody tyrant, reducing all contemporary peoples to slavery for the sole satisfaction of my luxurious and fantastic egocentric caprices; again, on the other hand, I would abase myself to the humble and degrading condition of the pariah, animated by an inextinguishable thirst for cosmic redemption and justice, who would uselessly sacrifice himself in the most romantic of deaths. From the cruel demi-god to the humble worker, passing through the stages of the artist to the total genius, I have always arrived at the savior ... Salvador, Salvador, Salvador! I could repeat my own name tirelessly ... I knew that a sacrifice was inevitable, and with a repugnant cowardice I would look around me in the dark. For of only one thing was I absolutely sure: I was not going to be the one sacrificed!

In the large dining room bathed in a very feeble light, dinner was a kind of gentle convalescence after the great nocturnal eloquence at the top of the Tower. Sleep was there, right close to me, seated in the empty chair at my side; sometimes it would take hold of my foot under the table, and then I would let it rise along the whole length of my body, just as coffee rises in a lump of sugar. One evening, almost asleep at the end of the meal, I heard Señor Pitchot bring up again the subject of the linden blossom picking. It was finally set for the day after the following. This day arrived, and here now is the story that you have been waiting for so impatiently.

The Story of the Linden Blossom Picking and the Crutch

A story filled with burning sun and tempest, a story seething with love and fear, a story full of linden blossoms and a crutch, in which the spectre of death does not leave me, so to speak, for a single moment.

Shortly after dawn, having got up earlier than usual, I went up with Julia and two men to the Tower attic to fetch the ladders needed for the linden blossom picking. This attic was immense and dark, cluttered with miscellaneous objects. It had been locked before this, so that I entered it now for the first time. I immediately discovered two objects which stood out with a surprising personality from the indifferent and anonymous pile of the remaining things. One was a heavy crown [1] of

[1] I learned much later that far from having the mortuary character which I attributed to it, this crown was a gift that had been offered as a tribute to Maria Gay at the Moscow Opera after one of her successes in the role of Bizet's *Carmen*.

golden laurel that stood as high as my head, and from which hung two immense faded silk ribbons on which were embroidered inscriptions in a language and characters unknown to me. The second object, which struck me as being terribly personal and overshadowing everything else, was a crutch! It was the first time in my life that I saw a crutch, or at least I thought it was. Its aspect appeared to me at once as something extremely untoward and prodigiously striking.

Béquilles.

I immediately took possession of the crutch, and I felt that I should never again in my life be able to separate myself from it, such was the fetishistic fanaticism which seized me at the very first without my being able to explain it. The superb crutch! Already it appeared to me as the object possessing the height of authority and solemnity. It immediately replaced the old mattress beater with leather fringes which I had adopted a long time ago as a scepter and which I had lost one day on dropping it behind a wall out of my reach. The upper bifurcated part of the crutch intended for the armpit was covered by a kind of felt cloth, extremely fine, worn, brown-stained, in whose suave curve I would by turns pleasurably place my caressing cheek and drop my pensive brow. Then I victoriously descended into the garden, hobbling solemnly with my crutch in one hand. This object communicated to me an assurance, an arrogance even, which I had never been capable of until then.

They had just set up the double ladders under the tall linden trees growing in the centre of the garden. At their bases large white sheets had been stretched out to receive the flowers that were to be gathered and on which a few blossom-laden branches were already beginning to drop. Three ladders had been set up, and on each one stood an unknown woman, two of whom were very beautiful and greatly resembled each other. One of these had large breasts, extremely beautiful and turgescent, of which the eye could follow the slightest details beneath her white knitted wool sweater that was perfectly molded to their curves. The third girl was ugly. Her teeth were the color of mayonnaise and so large that they overflowed from her tumefied gums, making her look as though she were constantly laughing. There was also a fourth person with one foot on the ground, her back arched on one of her hips. This was a little girl of twelve, who stood looking up and motioning to her mother, who was precisely the one with the beautiful breasts. This girl had also come to help with the gathering. I fell in love with her instantly, and I think that the view of her from behind, reminding me of Dullita, was very favorable to this first impulse of my heart. Besides, never having seen Dullita face to face, it was extremely easy for me to blend these two beings, just as I had already once done with Galuchka, of my false memories, and Dullita Rediviva! With my crutch I imperceptibly touched the girl's back. She quickly turned round, and I then said to her, with a sureness and a force of conviction that came close to rage, "You shall be Dullita!"

The condensed images of Galuchka and of Dullita had just become

incorporated and fused by the force of my desire for this new child whose
sun-blackened but angelically beautiful face I had just discovered. This
face instantly took the place of Dullita's, which I had never seen, so that
the three images of my delirium mingled in the indestructible amalgam

"Dullita"

of a single and unique love-being. My passion charged the enhanced
reality of the reincarnated image of my love with a new potential, more
irresistible than ever. And my libidinous anxiety, stored up in the course
of several years of solitary and anxious waiting, now became crystallized
into a kind of precious stone, transparent, homogeneous and hard, cut
into a tetrahedron, and in whose facets I saw the virginal splendor of
my three unassuaged loves sparkling beneath the sun of the most radiant
day of the year.

Besides, was I quite sure that she was not Dullita herself in reality?
I tried to find in this country girl's calcinated face the vestiges of
Galuchka's former pallor, whose face seemed to begin to resemble hers
from minute to minute. I struck a violent blow with my crutch on the
ground and repeated to her in a hoarse voice choking with emotion at
the very start, "You shall be Dullita." She drew back, startled by the
uncouthness of my emotional state, and did not answer. The exterioriza-
tion of my first urge toward her must indeed have betrayed such
tyrannical intentions that I understood it would be difficult for me now
to regain the child's confidence. I drew one step nearer to her. But she,
dominated by an almost animal-like fear, climbed as if for protection

up two rungs of the ladder on which her mother was perched, and did this with such lightness and agility that I did not have time gently to touch her head with the tip of my crutch as I had intended to do to calm her fear, and to prove to her the gentleness of my sentiments.

But my beautiful Dullita was quite right in being afraid of me. She would realize it only too well later, for all this had but just begun! I myself at that age already felt the clutch of a vague presentiment of the danger that was involved in the more and more pronounced features of my impulsive character. How many times, walking peaceably in the country, lulled by the nostalgic weaving back and forth of my reveries, had I suddenly felt the irresistible desire to jump from the top of a wall or a rock whose height was too great for me; but knowing that nothing could prevent this impulse I would shut my eyes and throw myself into the void.[1] I would often remain half stunned, but with a calmed heart I said to myself, "The danger is past for today," and this would give me a new and frenzied taste for the most trivial surrounding realities.

Understanding that for the moment I could not regain my new Dullita's confidence I decided to leave, but not without having cast her a glance of infinite tenderness by which I wanted to tell her, "Don't worry, I'll come back again." Then I left and I wandered at random in the garden. It was just the time when I should have devoted myself to painting, shut up in my studio with the ears of corn. But the day had begun in such an unaccustomed way, and with such exceptional encounters, like that of my crutch, and of Dullita, that I said to myself, dizzy with the whirl of the magic of the linden-blossom gathering, "I might perhaps make an exception to the pre-established plan of my habits," for already at this period these reigned as supreme mistresses of my destiny, and every infraction of these rules had to be paid for immediately by a dose of anguish and of guilty feeling so painful that when I felt them already begin to gnaw at the root of my soul I made an about-face and went back and shut myself up in my studio. There my unhappiness was not appeased, for I wanted to be elsewhere that morning, and after the short but intense scene of my encounter with Dullita I should have liked to walk about freely in the most out-of-the-way corners of the garden in order to be able to think of her without any other distraction and at the same time to begin to build the imaginary and idyllic foundations of my impending encounter.

But no! My self-inquisition imprisoned me there! And as time passed without any brilliant ideas springing forth in my head, which was supposed to happen each morning at that hour for the satisfaction of my ego, feelings of guilt clutched me more and more tightly in the spiny irons of a horrible moral torture.

[1] A farmer who witnessed one of these voluntary falls reported the event to Señor Pitchot. But no one would believe that I was able to jump thus without being killed. I became, indeed, extremely accomplished in high jumping. Later on in the gymnastics class of Figueras, I was to win the championship in high and broad jumping almost without effort. Still today I am a rather remarkable jumper.

I was assailed without respite by seductive representations of my Dullita. But at the same time an invisible rancor against her rumbled in the blue cloudless sky, with dull reverberations of a storm. Again, and for the second time, Dullita with a single moment of her presence had come to trouble, annihilate and ruin the architecture of the narcissistic temple of my divine solitude which I had been engaged in rebuilding with so much rigor and cerebral intensity since my arrival at the Muli de la Torre. I felt that only a bold stratagem, based on a lie capable of fooling myself, could liberate me for a few moments from the four walls of my studio where I felt myself so pitilessly shut in. I therefore convinced myself that it was urgent for me to begin today, and no later, my long projected drawings from life of animals in movement. There was no better way to start than to go and fetch my little mouse, which would make an ideal model. With it I could undertake to do a large picture in the style of the one with the cherries. But instead of representing the same static element I would repeat it to infinity in different movements. It occurred to me that since mice also had tails, I might perhaps find an original idea for effecting a *collage* on this subject.

Souris.

Although the project for my new work did not greatly interest me, and I felt that I was going to repeat the picture of the cherries, I tried nevertheless to convince myself by a thousand arguments that I must at all costs go to the chicken coop in the garden and fetch my box containing the gray mouse which was to be my model. I thought I might perhaps take advantage of the state of anxiety and nervousness in which I had been submerged since the vision of Dullita and attune it to the extremely febrile movements and attitudes of the mouse, thus making the most of my anguish and canalizing it toward the success of my projected work of art and thereby sublimating the "anecdote" of my state of anxiety to the "category" of an esthetic fulfillment.

I accordingly ran to the chicken coop to fetch my little model of the gray mouse. But the moment I arrived I found the latter in a curious state. It was as if swollen; its body usually so slim and agile was now completely round, as round as a cherry miraculously turned gray and hairy. Its unwonted immobility frightened me. It was alive, since I could see it breathe, and I would even have said that its breathing had an accelerated and unusual rhythm. I lifted it cautiously by its tail and the resemblance to my cherry was complete, with its paws all folded up and making no movement. I put it back with the same precaution in the bottom of the box, when all at once it made a single vertical bound, hitting my face that was maternally bowed over it. Then it fell back into the same motionless attitude. This unforeseen leap provoked in me such a frightful start that it took my heart a long time to recover its rhythm.

An intolerable moral uneasiness made me cover my mouse's box with the top, leaving a little space for it to breathe. I had not yet had time to recover from these painful impressions when I made a new discovery which is one of the most fearful of its kind that people my memories.

The large hedgehog, which I had been unable to find for more than a week, and which I thought had miraculously escaped, suddenly appeared to me in a corner of the chicken-coop behind a pile of bricks and nettles: it was dead. Full of repulsion I drew near it. The thick skin of its bristle-covered back was stirring with the ceaseless to-and-fro movement of a frenzied mass of wriggling worms. Near the head this crawling was so intense that one would have said that a veritable inner volcano of putrefaction was at any moment about to burst through this skin torn by the horror of death in an imminent eruption of final ignominy. A

..."*Eruption of final ignominy!*"

slight trembling accompanied by an extreme feebleness seized my legs, and delicate cold shudders rising vertically along my back spread fan-wise in the back of my neck, from which they fell back, branching outward through my whole body like a veritable burst of fireworks at a feast of the apotheosis of my terror. Involuntarily I drew still closer to this foul ball which continued to attract me with a revolting fascination. I had to get a really good look at it.

But a staggering whiff of stench made me draw back. I ran from the chicken coop as fast as my legs would carry me; coming close to the linden blossoms I took a deep breath of the fragrance with the idea of purifying my lungs; but presently I retraced my steps to continue the attentive observation of my putrefied hedgehog. During the time that I remained near it I completely stopped breathing, and when I could no longer hold my breath I dashed off again toward the linden blossom pickers, who by this time had accumulated great piles humming with bees. I took advantage of these breathing-spells to pour out the dark water of my glance into the sunny well of Dullita's celestial eyes. Once more I

rushed back to my horror-bristling ball, and again came back to breathe the perfumed air that surrounded my Dullita.

These goings and comings between Dullita and the dead hedgehog became so exalted and hysterical that I felt myself gradually losing control of my movements, and indeed at each new approach to the hedgehog I found myself almost on the point of committing an irreparable act, seized with a more and more irresistible longing to throw myself upon it and touch it, just as each time I returned toward the lindens, at the very last limit of the asphyxiating retention of my breath, it seemed as though it would be impossible for me to repress the decisive gesture of embracing Dullita with all my might, to tear the salivary savor of her soul and of her rustic and timid angel's face from her mouth half-opened like a wound.

In one of my dizzy returns toward the hedgehog I came so fast and so close to it that just at the last second, no longer able to control the inertia of my blind chase, I decided to jump on its body. I stumbled at the last moment with a clumsiness so skillful from the point of view of my subconscious intentions that I came within a millimetre of falling on the dark and repugnant mass.

After this awkward act, which sharpened the fevered stimulant of my desire while it redoubled my disgust, I finally had an idea which was provisionally to procure me a deep satisfaction: I would touch the stinking ball of my hedgehog with my crutch. I could in this manner move the foul ball at will, and without having to come too close to it. I had already tried, before this, to toss several stones in order to observe the mechanical effects of their impact on the decomposed softness of the nauseating body. But these experiments, in spite of the emotion which I derived from them, especially at the moment of throwing the stone, did not appear to me to assume the expected frightful character which I could consider altogether satisfying. Accordingly I advanced, holding my crutch by its lower end, and pressed its other "bifurcated" end against the roundness of the hedgehog's black heart ripe with death. My crutch's bifurcation adapted itself so well to the stiffened and pasty ball that one would have thought they were made for each other, so much so that it was impossible to tell whether it was the crutch that held the hedgehog or the hedgehog that held the crutch.

I stirred this nightmare-bristling pile with such terrifying intensity and such morbid voluptuousness that for a moment I thought I was going to faint. Especially when, under the exploratory proddings of my crutch impelled by my curiosity, the hedgehog was finally turned upside down. Between its four stiffened paws I saw a mass of gesticulating worms, big as my fist, that oozed in an abominable fashion after having burst and pierced through the very delicate and violet-colored ventral membrane which until then had maintained them in a compact, devouring and impatient mixture. I fled, leaving my crutch on the spot. This time it was more than I could stand.

Sitting on the ground I watched the linden blossoms fall. I realized that because of the momentary waywardness of my desire I had just doomed my crutch, and I could no longer be attended by the security which it afforded me. For, contaminated as it now was by the gluey contact of the hedgehog's mass of worms, from being a favorable fetish it had become transformed into a frightful object synonymous with death.

But I could not resign myself to the idea of getting along wholly and forever without my crutch, toward which my fetishistic sentiments had only grown and become consolidated in the course of the morning. I finally found a fairly satisfying solution, which would allow me to resume possession of my crutch after performing some preliminary ceremonies. I would go back and, without looking at the hedgehog this time, rescue my crutch. I would go and dip its soiled end in the clear water of the mill-stream, at the point where the current was strongest and formed little whirls of white foam. After a prolonged immersion I would let my crutch dry, and finally after laying it horizontally on the great pile of linden blossoms warmed with sunshine, I would take my crutch up to the top of the tower at twilight, so that night, and dawn with the heavy dew of my repentance, would effect its complete purification.

I proceeded to carry out this plan, and already my crutch was resting buried under the blossoms while in my calm spirit I could feel the black ball of death still stirring. After an unmemorable lunch came the afternoon. Now my listless glance followed the various incidents of the blossom gathering. Dullita, on the other hand, was looking continually at me, just like Galuchka. Her fixed eyes did not leave me a single moment, and I was so sure that she would now obey me in all that my will was prepared to command her that I could savor with delight that voluptuousness which is the whole luxury of love, and which consists in being able nonchalantly to direct your attention and your glance elsewhere while feeling the passionate proximity of the unique being, thanks to whom each minute becomes a bit of paradise, but whom your perversity commands you to ignore, while keeping him in leash like a dog; and before whom, nevertheless, you would be ready to grovel with the cowardice and the fawning of a real dog the moment you found yourself in danger of losing that loved being whom you pretended up to that point to treat with the inattentive dandyism characteristic of morbid sentimentalism.

Knowing my Dullita to be solidly attached to the end of the shiny yellow leather leash of my seduction, I looked elsewhere, I looked especially up at the under part of the naked arm of the woman with the turgescent breasts. Her arm-pit presented a hollow of great softness; the untanned skin of this part of her body was of an extreme paleness, pearly and glorious, serving as a dream frame to the burst of sudden blackness of the hairs. My glance was engaged in straying alternately from this strange nest of ebony hair surrounded by pearly flesh to her two plethoric breasts, whose divine volume I felt weighing upon each of

my eyelids half closed with the mingled voluptuousness of my visions and my digestion. And presently, through my benumbed laziness, I felt the budding of a new invincible fantasy, and once again the little quicksilver horses of my anguish galloped within my heart. This is what Salvador wanted now! I wanted to disinter my crutch from its tomb beneath the linden blossoms, and with this same "bifurcation" with which I had touched and stirred the hedgehog I now wanted delicately to touch the breasts of the blossom-picker, while adapting the perfumed bifurcation of the crutch with infinite precaution, and with an ever so slight pressure, the carnal globes of those sun-warmed breasts.

All my life has been made up of caprices of this kind, and I am constantly ready to abandon the most luxurious voyage to the Indies for a little pantomime as childish and innocent as the one I have just described. Yet are these things as simple as they appear? My experience had convinced me of exactly the contrary, and my head was crowded with competing strategic plans by the force, skill, hypocrisy and ruse of which I might perhaps win this preliminary battle against reality which, with victory, would bring me the heroic realization of my fantasy: to touch those breasts with the bifurcation of my crutch. After that, my crutch could again become my kingly sceptre!

The sun was setting, the pyramid of flowers was growing, the moon "mooned," Dullita lay on the flowers. The fantasy of touching the breasts with my crutch grew sharper, became a desire so strong that I would have preferred to die rather than deny it to myself. In any case

the best thing would be to go quickly and put on my kingly disguise; when I was thus clad, my plans always became colored with a new and inspiring audacity. I would come out again in this garb and lie down

beside Dullita on the pile of linden blossoms, and I could then continue to look at the blossom-picker's breasts. Dullita seeing me thus bedecked, with all the trappings of a king, would feel herself dying of love.

I went quickly up to my room, took the ermine cape out of the closet, placed my crown on my head, with the long white "anti-Faustian" wig falling delicately over my shoulders. Never in my life had I thought myself so handsome as that afternoon. A waxen pallor pierced through my browned skin, and the circles around my eyes had that same enticingly bruised brown color that I had just observed wearilessly for over an hour in the folds of the linden-blossom-picker's armpit just where three little creases formed each time she lowered her arm. I left my room intending to go down again into the garden, animated with the serene calm that comes with the feeling of being irresistibly handsome.

Just before reaching the main stairway I had to cross a kind of closed vestibule situated on the second floor and overlooking the garden through a small window brightly lighted by the sun. In this window there were three melons in the process of ripening, hanging from the ceiling by strings. I stopped to observe them, and with the rapidity and the blinding luminousness of lightning I had an idea which was going to solve and render possible my new fantasy involving the blossom-picker's breasts. The vestibule was steeped in semi-darkness, in spite of the strong light from the small window. If the blossom-picker were to set up her ladder close to this window and climb up to a given height, I should be able to see her breasts set in the frame of the window as if altogether isolated from the rest of her body, and I would then be in a position to observe them with all the voracity of my glance without feeling any shame lest my desire be discovered or observed by anyone. While I looked at the breasts I would exercise a caressing pressure by means of my crutch's bifurcation upon one of the hanging melons, while attempting to have a perfect consciousness of its weight by slightly lifting it. This operation suddenly appeared to me as a hundred times more distracting and desirable than the first version of my fantasy, which simply consisted in directly touching the breasts. Indeed the weight of this hanging melon seemed to me now to have absorbed all the ripening gravity of my desire, and the supposition that this melon must be marvelously sweet and fragrant blended in my imagination in so paradisial a fashion with the turgescence of the blossom-picker's real breasts that it already seemed to me that by virtue of the subterfuge of my substitution I could now not only press them tenderly with my crutch's bifurcation, but also and especially I could "eat" them and press from them that sugared and fragrant liquid which they too, like the melons, must have within them.

To bring the blossom-picker close to the window, as much as was necessary for the realization of my stratagem, I went up to the third floor and then out on the balcony. I accomplished the difficult feat of letting my "diabolo" game fall in such a way that its string got caught in a given spot on the rose vine climbing up the front of the house. Where-

upon, using a reed-stalk, I tried to tangle this string as much as possible among the thorny branches in order to make its removal as long and painful as possible. This operation was most successful, and I took all the necessary time. Anyone observing me from the garden might have thought what I was doing was precisely to try to get it free.

Having prepared the bait of my trap, I ran out into the garden. I went over to the ladder on which the blossom-picker with the beautiful breasts was perched, and in a whimpering voice begged her to go and untangle my "diabolo." And I pointed to it with the tip of my crutch which I had previously unearthed from the pile of flowers where it had been purifying since noon. The blossom-picker stopped her work and looked in the direction where my diabolo was caught. In doing so she assumed an attitude expressing the pleasurable relief that goes with a long awaited rest; she distributed the whole weight of her body between the support of one of her robust elbows and the opposite leg in such a way that her hips were violently arched, in a divinely beautiful pose which was further enhanced by the motions of her free arm which she lifted to tidy her dishevelled hair. Just then a drop of sweat fell from her moist arm pit and struck me right in the middle of my forehead, like one of those large warm raindrops that usher in the great summer storms, a drop of sweat which was "in reality of truth" like the oracle and the harbinger of the storm of nature combined with that of my soul, which destiny held in store for me the next day at about the same hour.

The peasant woman did not have to be asked a second time, for in the domain of the Muli de la Torre it was well known (by the express orders of Señor Pitchot himself) that my slightest whims were to be obeyed on the spot, and that the carrying out of my desires was a law for everyone. After having savored a short rest, during which she abandoned her whole body to the light, like a piece of sculpture, she came down from her ladder and with Dullita's help dragged it to the foot of the wall beneath the window, which was the place I had chosen. This operation was a rather long one, for the ladder was some distance away and it had to be pushed to the designated spot in short spurts. In addition it was necessary, once it was near the wall, to brace it well before venturing to climb up on it.

I took advantage of the delay to run into my room and strip to the skin. This was the occasion in my life on which I remember thinking myself most handsome as I looked at my reflection in the mirror. I ardently wished at that moment that the whole world could have admired my supreme beauty, or at least that the lovely blossom picker and my new Dullita could have done so. But I could not think of appearing thus all of a sudden, and I covered my nakedness with the ermine cape. In spite of the fact that it was deeply tanned by the sun, my face now revealed a spectral pallor which was due to the greenish light, reflected by the linden trees in the garden. I went down into the dark vestibule where the melons hung, and almost as soon as I reached it the body of the

blossom-picker appeared behind the frame of the little window. I had taken good measurements! The lower part of the window intercepted her body just where the thighs began, while her upper part was entirely cut off at the head. By the movements of her shoulders with her arms uplifted I could judge the fruitless and absorbed efforts that she was making to undo the tangled string of my diabolo which I had deliberately entwined in the thorny interlaced branches of wild rose that climbed up the front of the Muli de la Torre.

The woman's body, as I have just described, filled the entire space of the window and threw the feebly lighted vestibule in which I stood into greater shadow. The heat under my thick ermine cape was stifling. Wringing wet, I let the cape slip to the floor, and a soft warmth barely touched with coolness came over my body and caressed its nakedness. I thought: she cannot see me thus, and the moment she gets ready to come down the ladder I shall know it and be able to dress hurriedly or run and hide against the wall.

For the moment I could give myself over fearlessly to the fantasy of my game. Delicately I placed the bifurcation of my crutch under the lower

part of the hanging melon, pressing it with all the sentimental tender-
ness of which I was capable. An acute lyricism drowned my eyes with
tears. The softness of the melon exceeded all my hopes. It was so ripe
that in spite of the gentleness of my pressure my crutch sank into it
with a delightful lapping sound. Then I turned my glance upward to
glue it to the bosom of the woman who was struggling to untangle the
labyrinthian snares of my diabolo. I could not see her breasts very
clearly, but their confused mass, seen against the light, only exasperated
my unsatisfied libido. I accentuated my proddings while communicating
a special rhythm to my crutch. Soon the juice of the melon began to
drip on me, sprinkling me with its sticky fluid, at first only in occa-
sional drops, but presently more and more copiously. At this moment
I placed my face beneath the melon, opening my mouth and reaching
out my tongue, which was thirsty, dry with heat and desire; in this
manner I caught the spatterings of the juice, which was prodigiously
sweet, but with prickling accents of ammonia interspersed. These few
drops, quickly annihilated in my mouth, made me mad with thirst,
while my glance ran dizzily from the melon to the window, from the
window to the melon, and back again, and so on, in a veritable growing
frenzy which soon culminated in a kind of delirium in which the whole
consciousness of my acts and movements seemed to become obliterated.
To my crutch I imparted gestures of increasing brutality, calculated to
dig it in the most effective and deeply anchored way into the melon's
flesh, in order to make the maximum of its life and its juice burst forth
from the depths of its bowels. Toward the end the alternate rhythm
of my glance became accentuated: Melon, window! Melon, window! Win-
dow, melon!...

My gestures had by now become so deeply and hysterically tumultuous
that suddenly the melon broke loose and fell on my head, almost at the
same time that the beautiful blossom-picker, having finally succeeded in
untangling my diabolo, began to come down the ladder. I barely had
time to throw myself to the floor and get out of her sight when her face
appeared. I fell on my ermine cape which lay at my feet, drenched with
the melon's yellow liquid. Panting, weary, trying to hold my breath,
I waited for the peasant woman, upon discovering me naked, to climb
up again a few rungs to look at me; without needing to turn my head I
would be able to tell whether she came up again by the shadow
which her body would produce, just as it had a while ago when it
intercepted the window-frame.

But this maddening and tensely awaited moment did not come.
Instead of the cherished shadow of eclipse, the oblique and orange light
of the setting sun slowly penetrated and rose the whole length of the
thickly whitewashed wall, on which the shadow of the two intact hang-
ing melons now stood out. But I had no inclination to play with them.
My enchantment had passed. This could not be repeated. An extreme
weariness took hold of all my muscles, making my movements painful.

The two black shadows of the melons appeared to me as a sinister symbol, and they no longer evoked the beautiful blossom-gatherer's two breasts, sunny with afternoon. Instead they too now seemed to stir like two dead things rolled into balls, like two putrefied hedgehogs. I shuddered. I went up into my room and slowly put on my clothes again, stopping several times to take a rest, during which I would stretch out on the bed with my eyes shut. Darkness overtook me thus, in my room.

I had to hurry if I still wanted to take advantage of the summit of the tower. I went up, holding my crutch. The sky was all starry and I felt it weigh so heavily on my weariness that I did not have the courage to undertake any of the grandiose reveries which the place usually had the virtue of provoking in my mind. Just in the centre of the terrace of this tower there was a small cement cube provided with a hole which was presumably intended to hold a banner or a weather-vane. The base of my crutch was a little too slender to fit it perfectly. Nevertheless I placed it there, upright, slightly leaning toward the right. This attitude of my crutch was much more satisfying to me than a perfect vertical, and I went away, leaving it thus placed. If I should wake up in the night I would immediately think of my crutch, motionless at the top of the tower, and this would fill me with a protective illusion. But would I wake up? A sleep heavy as lead already hummed in my head, after a day so filled with emotions that I no longer wanted to think of anything. I wanted before and above all to sleep!

I went down the stairs like a somnambulist, bumping myself several times against the walls at the turns, and each time I uttered in a low voice, through which pierced the whole force of my will,

"You shall be Dullita! You shall be Dullita! Tomorrow!"

I knew that the linden blossom picking was to last another day. The following morning Dullita was again there. The sun rose, the blossom-picker picked, the breasts hung, and the melons hung, but this morning it was as though all the attraction I had felt for the breasts the day before had totally disappeared, thanks to the realization of my fantasy with the melon. Not only could I not recapture even the traces of a desire which after all had been extremely vivid, but a real disgust seized me as I reconstructed the scene in my mind. The ermine cape soiled with melon juice, the prickly and excessively sweet taste of the latter, and even the breasts no longer seemed so beautiful as I looked at them again, and in any case I was far indeed from according them that element of sentimental poetry which on the previous afternoon had made the mere sight of them bring tears to my eyes.

Today I felt myself fascinated exclusively by the slimness of Dullita's waist, which seemed to diminish in diameter as the sun advanced toward the zenith, the increasingly vertical shadows accentuating the vulnerable fragility of the hour-glass whose form her body was assuming for me—the slimmest and proudest body of them all, the body of my new Dullita, of my Galuchka Rediviva.

I said nothing to her in the morning on seeing her again, but to myself I said, "Today there shall be no one but she! I have all the time I want!"

And I began to play with my diabolo. I was extremely skilful at this game. After having made it whirl and glide in all directions, with a most capricious dexterity, I tossed it up into the air to great heights, always catching it on the string drawn taut between my two sticks. I felt myself admired by Dullita, and the ease with which I played allowed me to adopt attitudes which I was sure must be of great beauty to Dullita's eyes. I tossed my diabolo higher and higher, and finally it got away from me and fell on a flowery shrub. Dullita, amused and smiling, ran to pick it up, and she hesitated a little to give it back to me, asking me to let her play too. I took back my diabolo, without answering her, and went on with my game.

Diabolo.

But each time I tossed it into the air I felt myself seized with a violent anguish, arising from the sudden fear of missing my catch (which in fact happened quite frequently from then on), and Dullita's attempts to recover my diabolo each time occasioned little races between us, leading to hostile demonstrations on my part. Dullita would always yield smilingly, but with her demand to which I had not acceded and which my pride rendered each time more unacceptable, she had created in my mind a germ of remorse which I quickly transformed into rancor. Instead of admiring me play, instead of watching the prodigies of my movements addressed exclusively to her, Dullita preferred to play herself! Violently I whirled my diabolo up into the sky, which was an "immaculate conception" blue, and the anguishing fear of not catching it made me tremble. But again this time I victoriously caught it. And no sooner had I caught it than I threw it up once more and with greater force, but so clumsily this time that it landed far away.

Dullita promptly broke into a laugh that wounded me in all the fibres of my being. She ran to pick up my diabolo, and I let her, since I still had the sticks and she could not play without them. I went slowly toward her, my eyes charged with repressed anger. She immediately understood my attitude, and seemed this time to be preparing for a long resistance. We walked one behind the other in a calm persecution, and as soon as I increased my pace she would increase hers, but just enough to keep herself always at the same distance; we went round the garden in this way several times.

Finally she went and lay down on one of the piles of linden blossoms which had been sorted out as bad, for the flowers were yellow, bruised, and consumed by bees. Mollified, I went up close to Dullita, thinking she was going to give me back my diabolo. I took a large pile of white, fresh linden blossoms in my arms, and let them fall on Dullita. She turned over on her stomach at this moment, hiding the diabolo under her body, showing me in this manner that she wanted to keep it at all costs. Seen thus from behind, Dullita was extraordinarily beautiful. Between

her round, delicate buttocks and her back one saw hollowed out the abyss of her deep waist half-buried in flowers. I got down on my knees on top of her, and encircling her queenly waist with an almost imperceptible gentleness, with the caressing embrace of my two arms I said to her in a low voice,

"Give me the diabolo!..."

"No!" she answered, already suppliant...

"Give me the diabolo!..."

"No!" she repeated.

"Give me the diabolo!" And I pressed her tighter. "Give me the diabolo!..."

"No!"

"Give me the diabolo!..."

"No!"

I then pressed her with all the savage might of which I was capable. "Give me the diabolo!..."

"Aïe!"

An incipient sob already shook her little shoulders, and pulling out my diabolo, which she was holding clutched to her bosom, she let it drop. I picked it up and went away a short distance. Dullita too got up and went to seek refuge under the ladder where her mother was working. The two slopes of this ladder were united by a taut cord which prevented them from slipping apart. With angelic grace Dullita went over and, holding on to the two slopes of the ladder with her arms, leaned against the ladder's taut cord with the slenderest portion of her waist which I had just so savagely squeezed. I could feel burning into my own flesh the pain which I assumed the pressure of this cord must produce on Dullita's back. She was weeping without grimacing, and with absolute nobility; I could see very well that she was holding back even this so that no one would notice anything. But I felt ashamed and was looking for a way to escape Dullita's tear-drenched glance.

A hegemonic desire for total solitude took violent hold of me, and I felt myself ready to run away no matter where, when a mad plan assailed my brain with that tyrannic force which already then no power in the world could modify. What I planned to do was to go up and play with my diabolo at the top of the Tower, so as to throw it as high up as possible; and if it should fall outside the Tower, it would be lost! This danger made my heart beat wildly.

Just then I heard Julia come and call me to lunch. I pretended not to have heard and ran full speed up into the Tower, for I absolutely had to experience the emotion of my game at least once before going down into the dining room.

As soon as I had reached the top of the Tower I tossed my diabolo with all my might into the air, and it fell beyond the edge of the Tower. But by a miracle of skill and a gesture of great suppleness, I leaned over the rampart, with half my body over the edge of the sheer drop. Thus

I was able to catch my diabolo. The mortal danger of this act to save my diabolo made me so dizzy that I had to sit down on the terrace to recover myself. The whole flag-stone terrace of the tower, and the crutch itself, planted in the centre, seemed to reel around me. Someone below kept calling me. I went down into the dining room feeling a kind of seasickness which had robbed me of all inclination to eat. Señor Pitchot too had a severe head-ache, and he had wrapped a tight white band around his head. In spite of the terror I had just undergone I promised myself to go back, after eating, and get my diabolo which I had left on the tower terrace, so that I could continue the same game. I promised myself, however, that I would be more careful next time. I would go and play immediately after lunch, and again in the evening, and I was already thinking of the sunset. I wanted to avoid Dullita this afternoon, I wanted evening to come quickly!

Do not be impatient, Salvador, this evening there will occur one of the most moving experiences in your life, aureoled by a fantastic sunset—wait, wait!

When luncheon was over Señor Pitchot headed for the balcony and, drawing the shutters himself, ordered that the same be done for all the rest of the windows and balconies of the Muli de la Torre. He added, "We are in for a storm." I looked with astonishment at the sky, which appeared as blue and smooth as before. But Señor Pitchot took me out on the balcony and pointed out to me, far down on the horizon, some tiny cumulus clouds, white as snow, and which seemed to be rising vertically. He said, pointing to them with his finger,

"You see those 'towers'? Before tea-time we're going to have lightning and thunder, if it doesn't hail."

I remained clutching the iron railing of the balcony, watching those clouds grow in a steady absorption and wonderment. It was as though the spots of moisture on the vaulted ceiling of Señor Traite's school where I had seen the procession of all the first fantasies of my childhood, which had since been obliterated by my memory's layers of forgetfulness, had suddenly revived in the glory of the flesh and of the immaculate foam of those towers of flashing clouds which rose on several points of the horizon.

Winged horses swelled their chests, from which began to bloom all the breasts, all the melons and all the wasp-waisted diabolos of my delirious desire. Presently one of the clouds, which had rapidly swollen to the point of assuming the form of a colossal elephant with a human face, would divide into two big pieces, which in turn would quickly, before one had time to anticipate it, be transformed into the muscle-bound bodies of two immense bearded wrestlers, one of whom bore an enormous rooster attached to his back. These two fighters now came together violently, and the space of cobalt-blue sky which still separated them in their definitive struggle rapidly diminished. The shock was of such ferocity that the slow motion of the gestures which they adopted made

their clinch only more inhuman. I saw the two bodies simultaneously penetrate each other with an unconscious force of inertia which destroyed them instantly, mingling them in a single and unique conglomeration, in which both of them obliterated their personalities now confused in formlessness.

"Beethoven's cranium"

Immediately the latter began to reorganize itself into the whirl of a new image! I recognized it right away! It was the bust of Beethoven, an immense bust of Beethoven which grew so fast that it seemed presently to fill the entire sky. Beethoven's cranium, bowed in melancholy over the plain, augmented in volume while at the same time it turned gray, that dirty "storm" color which is proper to and characteristic of the deposits of dust that darken pieces of plaster sculpture that have long been forgotten. Soon Beethoven's entire face was reabsorbed by his immense brow which, growing at an accelerated speed, became an incommensurable and apotheotic leaden skull. A streak of lightning flashed, splitting it in two, and it was as though for the duration of a second one had seen the quicksilver brain of the sky itself through the suture of the frontal lobes of his skull.

Almost simultaneously a clap of thunder shook the Muli de la Torre to its foundations for a half minute. The leaves and the linden blossoms were lifted by a whirl of dry and choking wind. The swallows grazed the earth, uttering cries of paroxysm, and all at once, after a few heavy drops of rain, like great Roman coins, a compact and pitiless downpour flagellated the fearful and avid garden, from which rose a fragrant gust of moss and wet bricks, a gust which seemed already to pacify the fury of the first brutal shock, the erotic, long-contained consequence of the prolonged, anxious, electrified and unsatisfying Platonic contemplation of the sky and the earth which had lasted for two long months! The propitious darkness in which that afternoon of continuous rain remained plunged was one of the accomplices in the drama of which Dullita and I were destined to become the protagonists at the end of that long day marked by the unleashed violence of the elements mingled with that of our own souls.

Dullita and I had run, suddenly and tacitly in accord, to lie down together and play in the tower attic where almost total darkness reigned. The very low ceiling, the solitary location of the spot and the absence of light were most propitious to the anxiously awaited unfolding of our dangerous intimacy. The fear with which the place usually inspired me (even when I merely stood before the door, and especially since I had discovered two days previously the huge laurel crown given to Nini Pitchot), this fear had completely vanished, and in the company of Dullita, whom I felt at last to be quite alone with me, with the torrential rain outside, which isolated us from the rest of the world, this attic which had appeared lugubrious to me until then, became suddenly the most desirable place in the world. The gilded laurel of the crown itself, in spite of the mortuary sense which I continued to attach to it, glowed with a kind of appetizing coquettishness at each new flash of lightning which blinded us intermittently through the heavy closed shutters. My new Dullita, my Galuchka Rediviva, stepped into the hole of the crown and lay down inside it like a corpse; she shut her eyes. The bursts of thunder and lightning succeeded one another around our tower in a grow-

ing din, while a swelling presentiment oppressed my chest. Something—I did not know what—but something frightful was about to happen between us.

I kneeled before her, and looked at her fixedly. Becoming gradually accustomed to the half-light, and holding myself so near her that I could see her face in the tiniest detail, pressed on all sides by blackness, I drew even closer and leaned my head on hers. Dullita opened her eyes and said, "Let's play at touching each other's tongues," and she raised her head slightly, bringing it even a little closer to me, while sticking out the tip of her tongue from her deliciously moist, half-opened mouth. I was paralyzed by a mortal fear, and in spite of my desire to kiss her I pulled back my head and with a brutal gesture of my hand I threw her head back, causing it to strike the laurel crown noisily. I got to my feet again, and my attitude must have struck her as so menacing and resolute that I could feel by her absent look that she was ready to submit to any kind of treatment without offering the slightest resistance. This stoicism in which I felt in addition the presence of a principle of acquiescence on her part accentuated my growing desire to hurt her. With a bound I got behind her; Dullita raised herself up, lifted by the springs of an instinctive fear, but immediately repressing this first gesture of alarm did not turn toward me and remained immobilized in her attitude, proudly seated in the centre of the crown.

At this moment a flash of lightning longer and more penetrating than the others sharply illuminated and pierced through the slits of the closed shutters, and for the space of a second I saw the slim silhouette of Dullita's back outlined in black against that sudden blinding light. I threw myself on Dullita's body and I again squeezed her waist with all my might, as I had done in the morning on the pile of flowers. She resisted my brutality feebly and all at once our struggle became slow, for I suddenly began to calculate everything. Dullita interpreted the gentleness which I now imparted to my gestures as a symptom of tenderness, and in turn wound her caressing arms all around my waist.

We lay thus sprawling on the floor, mingled in a more and more indolent embrace. I felt that it would be easy for me to choke the least of her cries, crushing her little face against my chest. But her attitude did not correspond to my fantasy. What I wanted to do was precisely to turn her over completely on her other side, for it was just in the hollow of her back that I wanted to hurt her; I might, for example, have crushed her, just there, with the crown; the leaves of those metallic laurels would have nailed themselves like blades into her smooth skin. I could then have brought progressively heavier objects to keep her pinned down there. And when I finally freed her from this torture I would kiss her on the mouth and on her bruised back, and we would weep together. I therefore continued to feign more and more gentle caresses while I recovered my breath for the coming struggle, and I looked around avidly at the heaviest objects, establishing a quick choice

among those which crowded the half-light of the attic with their phantasmal contours. My eyes were finally caught by an immense decrepit chest of drawers towering above us and slightly tilted forward. But was I capable of budging it? I felt an intense pain clutching me behind my legs, the back of my neck and my calves. A violent gust of wind caused the attic door to bang open, revealing at the other end of the tower stairway another door, likewise open. It stopped raining and a brand new sky appeared, yellow and livid as a dream lemon.

My fantasy of "Dullita's crushing" instantly melted away in that sky in which I felt the gleams of a delirious sunset flutter.

"Let's go up to the top of the tower!"

And already I was climbing the stairway. Dullita, probably disappointed at the sudden interruption of our caresses, did not obey me instantly. I was forced to interpret her delay as a refusal, and in a fury I went down again to fetch her. She seemed to want to run away. Then, seized with an all-powerful anger, I felt the blood rise to my head, unleashing the wild beast of my wrath. With my two hands I seized Dullita's hair and dragged her toward me. She fell on her knees on the edge of one of the steps and uttered a little plaintive cry of pain; pulling her with all my might, I succeeded in raising her and I dragged her up three or four steps. I let go of her hair for a moment to rest, prepared to continue right on pulling her thus. Then, with a determined movement, she got to her feet, ran up the rest of the steps, and disappeared on the terrace of the tower.

Recovering a supernatural calm and poise I continued slowly up the stairs, making this last as long as I could, for now I knew that she could no longer escape me! This long, persevering and fanatical desire that the Dullita of Figueras should come up to my laundry on the roof-top had just been fulfilled by this new Dullita, Galuchka Rediviva, whom I saw with my own eyes at this very moment crossing the threshold of that dizzy summit of the Muli de la Torre! I should have liked my ascension never to end, so that I might prolong and profit by each of the unique hallucinating moments which I felt I was about to live. For my happiness to have been perfect I would only have had to be wearing my king's crown on my head; for a second I thought of going down to fetch it, but my climb, though deliberately slow, could not be turned aside by anything, not even by death.

I reached the threshold of the door at the top! In the centre of the terrace was standing, slightly leaning toward the right, my rain-soaked crutch which now projected an elongated and sinister shadow on the tiling lighted by red sun-rays. Beside the crutch, my upright diabolo also projected a disturbing shadow strangulated at the centre; across the fine waist of the diabolo a little metal ring shone savagely. At the very top of the sky before me the immense silhouette of a mauve cloud lined with flashing gold was vanishing, resembling an imposing storm-Napoleon; still higher yet, a rainbow cut in two showed in its centre a large piece of Prussian blue sky, which corresponded to the space on the Tower that separated me from Dullita. No longer weeping she was waiting for me, seated on the ramparts of the Tower.

With an inspired hypocrisy, which never fails me in the supreme moments of my life, I said to her,

"I shall make you a present of my diabolo on condition that you don't lean over the edge of the Tower any more, for you might fall."

She immediately came and picked up the diabolo, after which she went back and once more leaned over the edge, exclaiming,

"Oh, how pretty it is!" She turned her face toward me and looked at me with a mocking smile, thinking I had finally become gentle and dominated by her recent tears. I made a gesture of terror and hid my face, as though unable to stand seeing her lean over in this way. This stimulated her coquettishness, as I had foreseen, and straddling the ramparts of the Tower, she let her two legs hang over the edge. I said to her then,

"Wait a minute and I'll go and get you another present!"

And taking my crutch with me I pretended to leave. But I immediately came up again on tip-toe the few steps I had just gone down. My emotion reached its climax. I said to myself, "Now it's up to me!" On all fours I began to crawl toward her, without making any noise, preceded by my crutch which I held by its tip. There was Dullita, still seated with her back to me, her legs over the drop, the palms of her hands resting on the rampart, and completely absorbed in the contem-

Sablier.

plation of the clouds, torn by the rain, broken up into fantastic fragments of the great vertical Napoleon of a while ago, now transformed into a kind of immense and horizontal sanguinary crocodile.

Soon it would be dark. With infinite precautions I advanced the bifurcation of my crutch toward just the slenderest part of Dullita's waist; I effected this operation with such attention that as I approached I bit my lower lip hard, and a tiny trickle of blood began to flow down my chin. What was I going to do? As though sensing in advance the contact of my crutch, Dullita turned toward me, in no wise frightened, and of her own accord leaned her back against my crutch. At this moment her face was the face of the most beautiful angel in heaven, and then I felt the rainbow of her smile form a bridge to me across the whole distance by which the crutch separated us. I lowered my eyes and pretended to prop the end of my crutch in the space between two paving-tiles. Rising abruptly, with my eyes full of tears, I approached Dullita, tore the diabolo from her hand and screamed with a hoarse tear-choked voice,

"Neither for you nor for me!"

And I hurled our diabolo into empty space.

The sacrifice was at last accomplished![1] And since then that anonymous crutch was and will remain for me, till the end of my days, the "symbol of death" and the "symbol of resurrection!"

[1] The diabolo in my story assumed in every respect the substitutive role typical of sacrifices, and takes the place of Abraham's sacrificial ram. In my case it symbolizes without euphemism the death of Dullita, of Galuchka Rediviva, and also the possibility of their resurrection.

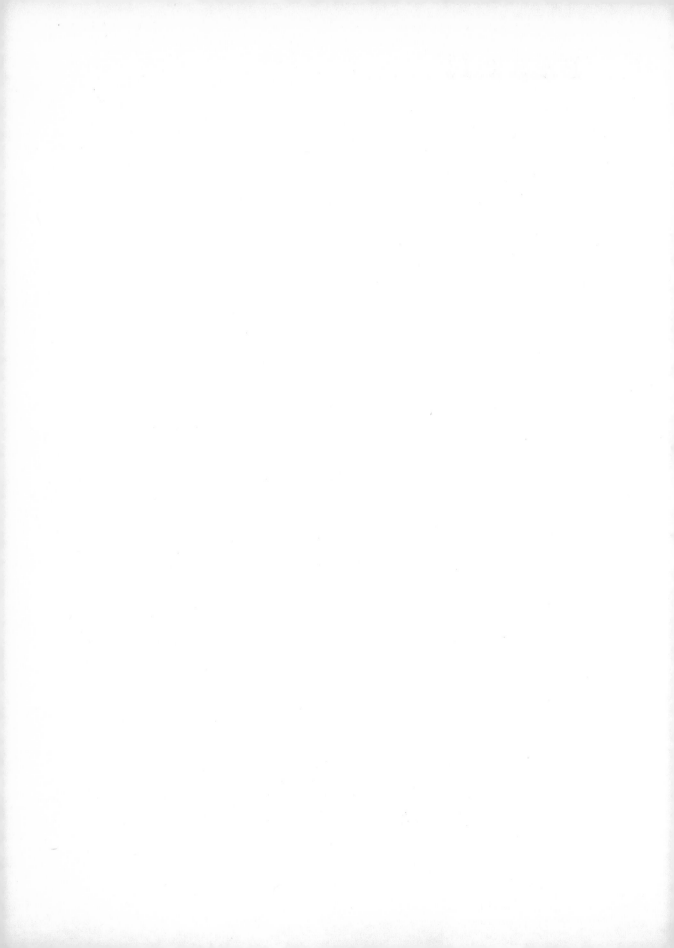

PART II

C H A P T E R S I X

Dali in an anarchistic mood, walking in the country of Figueras at Sundown.

1922

Adolescence

Grasshopper

Expulsion from School

End of the

European War

Adolescence is the birth of body hairs. In my case this phenomenon seemed to occur all at once, one summer morning, on the Bay of Rosas. I had been swimming naked with some other children, and I was drying myself in the sun. Suddenly, on looking at my body with my habitual narcissistic complacency, I saw some hairs unevenly covering the very white and delicate skin of my pubic parts. These hairs were very slender and widely scattered, though they had grown to their full length, and they rose in a straight line toward my navel. One of these, which was much longer than the rest, had grown on the very edge of my navel.

I took this hair between my thumb and forefinger and tried to pull it out. It resisted, painfully. I pulled harder and when I at last succeeded, I was able to contemplate and to marvel at the length of my hair.

How had it been able to grow without my realizing it on my adored body, so often observed that it seemed as though it could never hide any secret from me?

A sweet and imperceptible feeling of jealousy began to bud all around that hair. I looked at it against the sky, and brought it close to the rays of the sun; it then appeared as if gilded, edged with all the colors, just as when, half shutting my eyelids, I saw multitudes of rainbows form between the hairs of my gleaming eyelashes.

While my mind flew elsewhere, I began automatically to play a game of forming a little ring with my hair. This little ring had a tail which I formed by means of the two ends of the hair curled together into a single stem which I used to hold my ring. I then wet this ring, carefully introducing it into my mouth and taking it out with my saliva clinging to it like a transparent membrane and adapting itself perfectly to the empty circle of my ring, which thus resembled a lorgnette, with my pubic hair as the frame and my saliva as the crystal. Through my hair thus transformed I would look with delight at the beach and the distant landscape. From time to time I would play a different game.

With the hand which remained free I would take hold of another of my pubic hairs in such a way that the end of it could be used as the pricking point of a needle. Then I would slowly lower the ring with my saliva stretched across it till it touched the point of my pubic hair. The lorgnette would break, disappear and an infinitesimal drop would land with a splash on my belly.

I kept repeating this performance indefinitely, but the pleasure which I derived from the explosion of the fabric of my saliva stretched across the ring of my hair did not wear off—quite the contrary. For without knowing it the anxiety of my incipient adolescence had already caused me to explore obscurely the very enigma of the semblance of virginity in the accomplishment of this perforation of my transparent saliva in which, as we have just seen, shone all the summer sunlight.

My adolescence was marked by a conscious reinforcement of all myths, of all manias, of all my deficiencies, of all the gifts, the traits of genius and character adumbrated in my early childhood.

I did not want to correct myself in any way, I did not want to change; more and more I was swayed by the desire to impose and to exalt my manner of being by every means.

Instead of continuing to enjoy the stagnant water of my early narcissism, I canalized it; the growing, violent affirmation of my personality soon became sublimated in a new social content of action which, given the heterogeneous, well characterized tendencies of my mind, could not but be anti-social and anarchistic.

The Child-King became an anarchist. I was against everything, systematically and on principle. In my childhood I always did things "differently from others," but almost without being aware of it. Now, having finally understood the exceptional and phenomenal side of my pattern of behavior I "did it on purpose." It was only necessary for someone to say "black" to make me counter "white!" It was only necessary for someone to bow with respect to make me spit. My continual and ferocious need to feel myself "different" made me weep with rage if some coincidence should bring me even fortuitously into the same category as others. Before all and at whatever cost: myself—myself alone! Myself alone! Myself alone!

And in truth, in the shadow of the invisible flag on which these two words were ideally inscribed my adolescence constructed walls of anguish and systems of spiritual fortifications which for long years seemed to me impregnable and capable until my old age of protecting the sacred security of my solitude's bloody frontiers.

I ran away from girls, for since the criminal memory of the Muli de la Torre, I felt in them the greatest danger for my soul, so vulnerable to the storms of passion. I made a plan, nevertheless, for being "uninterruptedly in love"; but this was organized with a total bad faith and a

refined jesuitical spirit that enabled me to avoid beforehand every material possibility of a real encounter with the beings whom I took as protagonists of my loves.

I always chose girls whom I had seen only once, in Barcelona or in

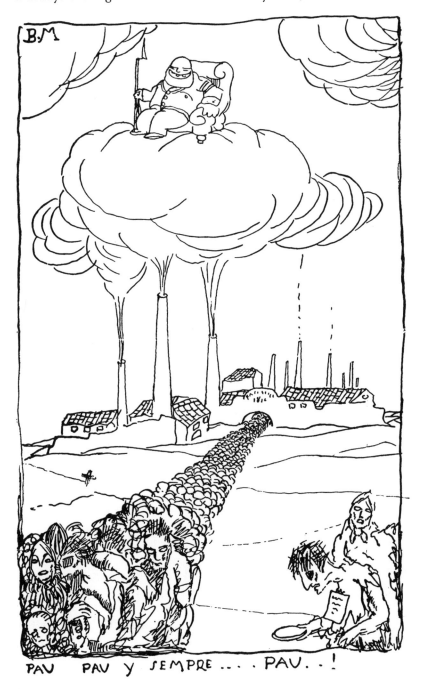

PAU PAU Y SEMPRE.... PAU..!

nearby towns, and whom it was doubtful or impossible that I should ever see again. The unreality of these beings, becoming accentuated with the fading of my recollections, made it easy to transmute my passion into new protagonists.

One of my greatest loves of this kind was born in the course of a traditional picnic in the country near Figueras. The little hills were sprinkled with clusters of people preparing their meals under the olive trees. Immediately I chose as the object of my love a young girl who was lighting a fire on the opposite hill. The distance that separated me from her was so great that I could not clearly make out her face; I knew already, however, that she was the incomparable and most beautiful being on earth. My love burned in my bosom, consuming my heart in a continual torment.

And each time a festival gathered together a multitude of people, I would imagine I caught glimpses of her in the milling throng.

This kind of apparition, in which doubt played the leading role, would come and cast fresh branches on the fire which the chimerical creature of my passion had lighted on the opposite hill-slope that first day when I had seen her from afar.

Loves of this kind, ever more unreal and unfulfilled, allowed my feelings to overflow from one girl's image to another, even in the midst of the worst tempests of my soul, progressively strengthening my idea of continuity and reincarnation which had come to light for the first time in my encounter with my first Dullita. That is to say, I reached by degrees the conviction that I was really always in love with the same unique, obsessing feminine image, which merely multiplied itself and successively assumed different aspects, depending more and more on the all-powerful autocracy of my royal and anarchic will.

Just as it had been easy for me, since Señor Traite's school, to repeat the experience of seeing "anything I wished" in the moisture stains on the vaults, and as I was able later to repeat this experience in the forms of the moving clouds of the summer storm at the Muli de la Torre, so even at the beginning of my adolescence this magic power of transforming the world beyond the limits of "visual images" burst through to the sentimental domains of my own life, so that I became master of that thaumaturgical faculty of being able at any moment and in any circumstance *always, always to see something else,* or on the other hand—what amounts to the same—"always to see the identical thing" in things that were different.

Galuchka, Dullita, second Dullita, Galuchka Rediviva, the fire-lighter, Galuchka's Dullita Rediviva! Thus in the realm of sentiment, love was at the dictate of the police of my imagination!

I have said at the beginning of this chapter that the exasperated hyper-individualism which I displayed as a child became crystallized in my adolescence in the development of violently anti-social tendencies. These became manifest at the very beginning of my study for the bac-

calaureate, and they took the form of "absolute dandyism," based on a spirit of irrational mystification and systematic contradiction.

I must confess that the most catastrophic hazards kept occurring to enhance the theatrical character of my most trivial actions, contributing in a decisive way to the myth which already at the time of my adolescence began to surround the initial obscurity of my person with its mists of divine renown.

I was to begin my secondary studies, and for this I was sent to another religious school, that of the Marist Brothers. At this time I claimed to have made sensational discoveries in the field of mathematics which would enable me to make money. My method was simple. It was this: I would buy five-*centimo* pieces with ten-*centimo* pieces—for each five that I was offered I would give ten in exchange! All the money that I could obtain from my parents I would immediately spend in this way, taking a frenzied delight in the game which was incomprehensible to everyone and inevitably ruinous. One day when my father made me a present of a *duro* (five *pesetas*), I rushed out to change it into ten-*centimo* pieces, which made several marvelous piles! As soon as I got to school I triumphantly announced that on this very day I would open my market to buy five-*centimo* pieces on my usual conditions.

Duro, coin worth five pesetas

So at the first recreation period I took up my post behind a little table, and with great delight I arranged the coins in several piles. All my schoolmates gathered round me, eager to realize the promised exchange. To the consternation of everyone I actually gave back ten *centimos* for every five I was offered! My money spent, I pretended to go over my accounts in a secret little book which I put back preciously in my pocket, securing it with several safety pins. After which I exclaimed, rubbing my hands with satisfaction, "Again I've made a profit!" I then got up from my counter table and strode off, not without having first cast a contemptuous glance around at my schoolmates, with an expression which poorly concealed my joy, as if to say, "Once more I've put one over on you! What idiots!"

This money-buying game began to fascinate me in an obsessing way, and from then on I canalized all my activity toward obtaining as much money as possible from my parents on the most varied pretexts—for buying books or paint; or else, by displaying such exemplary and unusual conduct that it warranted my asking for some monetary reward. My financial needs grew, for in order to consolidate my prestige it was necessary for me to exchange more and more considerable sums: it was the only sure way of amplifying the sensational astonishment which steadily spread around me at each new exchange.

One day I arrived at school, out of breath, barely holding back my joy—I was bringing fifteen *pesetas* which I had finally got together after a thousand tortures and sacrifices of sweetness toward my parents! I was going to be able to exchange fifteen *pesetas* all at once. I went about this with the utmost ceremony and deliberation, interrupting my exchanges

from time to time to consult my account book. I succeeded in making my pleasure last several hours, and my success exceeded all my ambitions. My schoolmates repeated from mouth to mouth, "You know how much money Dali has just exchanged? Fifteen *pesetas!*..." "Not really!" Everyone was amazed, and they kept exclaiming, "He is really mad!"

For as long as I could remember I had savored that phrase with delight. In the evenings after school I would go strolling about the town all by myself; it was then that I thought up what I would do the next day to astonish my schoolmates. But I also took advantage of these strolls to indulge in my "aggressions," for I usually came upon suitable victims, which this "sport" required, and whom I chose among children smaller than myself. My first aggression was perpetrated on a boy of thirteen. I had been watching him for some time stupidly eating a large piece of bread with some chocolate—a mouthful of bread, a mouthful of chocolate. These alternate, almost mechanical gestures, appeared to me to reveal a profound lack of intelligence. Moreover he was ugly, and the chocolate he was eating, which was of atrocious quality, inspired me with an immense contempt for its consumer. I approached the boy furtively, pretending to be absorbed in the reading of a book by Prince Kropotkin [1] which I always carried with me on my walks. My victim saw me coming, but he had no suspicions of me and continued to devour his bread and his chocolate while looking in another direction. I sized him up and planned what I was going to do, indulging at leisure in the great luxury of premeditation as I approached him. After having closely observed his horrible, idiotic, uncouth manner of eating, and especially of swallowing, I slapped him hard right in the face, making his bread and chocolate fly into the air. After which I dashed off in frenzied flight as fast as my legs would carry me. It took the lad a long time to realize what had happened to him, and when he understood it and tried to run after me I was already so far away that he immediately abandoned his angry impulse to dash after me. I saw him stoop down and pick up his piece of bread and his chocolate.

My unpunished success immediately caused such acts of aggression to assume the endemic character of a real vice which I could no longer forego. I would be on the look-out for every propitious occasion to commit similar acts, and I grew more and more reckless. Soon I noticed that the sympathetic or antipathetic character of my victims no longer played an essential role, and that my pleasure arose solely from the anguish inherent in the execution and the vicissitudes of the assault itself.

On one occasion I chose as my victim a violin student whom I knew very slightly and toward whom I had rather a feeling of admiration because of his artistic vocation. He was very tall, much bigger than I,

[1] I have never read this book, but Kropotkin's portrait on the cover, and the title, *The Conquest of Bread,* appeared to me of great subversive value, and were intended to make me appear interesting in the eyes of the people who saw me pass through the streets of the town.

but so thin, so pale and sickly that his look of frailness made me regard him as unlikely to react violently to what I would do. I had been following him for several minutes, but no favorable occasion arose: he was still in the midst of several groups of students, busily chatting. Presently he left one of these groups, put his violin on the ground, and kneeled down to tie a shoelace that had come undone. His posture at this moment could not have been more propitious. Without hesitating, I went up to him and gave him a terrific kick on the buttocks. After which I jumped with both feet upon his violin, crushing it into a hundred pieces and immediately after dashed away like a rabbit. But this time my victim, recovering quickly from my attack, ran after me and did not give up the chase. His legs were so long, and he ran so well that I immediately felt I was lost. Then, judging all resistance useless, and seized with an insurmountable fit of cowardice, I stopped short, got down on my knees, and begged him tremblingly to forgive me. I immediately thought of offering him money, and with my eyes full of tears volunteered to give him twenty-five *pesetas* if he did not touch me, if he did not hurt me. But the boy violinist's lust for vengeance was so aroused that I understood my pleas were in vain and that no amount of wailing could stop him. Then I concealed my head between my arms to protect myself from the blows I was about to receive. With a savage kick in my chest he knocked me over, punched me several times, seized a lock of my long hair, and pulled and twisted it at the same time, tearing out several handfuls. I uttered piercing and hysterical shrieks of pain and my terror was so theatrically manifest in the quivering of my whole body, by which I made it seem that I was about to succumb to a kind of attack, that the boy violinist, suddenly startled, stopped beating me and fled in turn.

A compact group of students had just gathered round us; the professor of literature who happened to be nearby asserted his authority to intervene, and breaking his way through the crowd he asked for an explanation of what had occurred. Then an astonishing lie was suddenly born in my head, and I said to him all in one breath,

"I have just crushed his violin to give a final irrefutable proof of the superiority of painting over music!"

My explanation was greeted with mingled murmurs and laughter. The professor, indignant though his curiosity was aroused, said,

"How did you do this?"

"With my shoes," I answered, after a moment's pause.

Everyone laughed, this time, creating a great hubbub. The professor restored silence, came over to me, put one hand on my shoulder and said in an almost paternal tone of reproach,

"That doesn't prove anything. It makes no sense!"

Looking him straight in the eye, with an assurance that verged on solemnity, and hammering out each syllable with the utmost dignity of which I was capable, I answered,

"I know very well that it makes no sense for most of my schoolmates

and even for most of my professors; on the other hand I can assure you that my shoes [1] [and I pointed to them with my finger] have quite a different view of the matter!"

A stifling silence fell around us after I had finished uttering my last words. All my schoolmates expected a dressing down and a severe punishment for my stupefying insolence. On the contrary the literature professor became suddenly meditative and made, to the surprise and disappointment of everyone, an impatient and categorical gesture with his arm indicating that he considered the incident closed, at least for the moment.

From that day on there began to grow around my personality an aureole of "audacity," which the events I am now about to describe were only to consolidate and raise to the status of a legendary category. None of my companions had ever dared to answer a professor with the assurance which I had shown, and all were agreed in recognizing that the vigor of my tone had left the professor breathless. This sudden energy which flashed like a streak of lightning through the haze of my habitual timidity brought me a certain prestige, which happily counterbalanced the mingled contempt and stupefaction which my monetary exchanges and other continual eccentricities had eventually attached to my reputation.

I began now to be a subject of intriguing controversy: Is he mad? Is he not mad? Is he half-mad? Does he show the beginnings of an extraordinary but abnormal personality? The last opinion was shared by several professors—those of drawing, handwriting and psychology. The mathematics professor, on the other hand, maintained that my intelligence was much below the average. One thing at any rate was more and more certain: everything abnormal or phenomenal that occurred was automatically attributed to me; and as I became more "alone" and more "unique," I became by that very fact each day more "visible"— the more occult I made myself the more I was noticed. For that matter I began to exhibit my solitude, to take pride in it as though it were my mistress whom I was cynically parading, loaded with all the aggressive jewels of my continual homage.

One day a skull from a "mounted skeleton" which was used in the natural history class disappeared. I was immediately suspected, and they came to search my desk which, since it was locked, was forced open.

[1] All my life I have been preoccupied with shoes, which I have utilized in several surrealist objects and pictures, to the point of making a kind of divinity of them. In 1936 I went so far as to put shoes on heads; and Elsa Schiaparelli created a hat after my idea. Daisy Fellowes appeared in Venice with this shoe-hat on her head. The shoe, in fact, appears to me to be the object most charged with realistic virtues as opposed to musical objects which I have always tried to represent as demolished, crushed, soft—cellos of rotten meat, etc. One of my latest pictures represents a pair of shoes. I spent two long months copying them from a model, and I worked over them with the same love and the same objectivity as Raphael painting a Madonna.

It is therefore extremely instructive to observe how in an improvised lie, produced in ultra-anecdotic circumstances, I anticipated the formulation of a durable and integrated philosophic platform, which was only to become consolidated with time.

Already at that time skeletons filled me with a horrible uneasiness, and for nothing in the world would I have touched one. How little they knew me! The next day the enigma was solved: it was simply the professor him-

143. Cette poule n'a pas de queue. 144. Cet arbre n'a pas de feuilles.

145. Une plume. 146. Une montre.

147. Une clef. 148. Un encrier.

147 Une clef.

self who had needed the skull and who had unmounted it to take it home with him.

One morning, after I had been absent from the institute several days because of my habitual anginas, I went back to resume my studies. When I arrived I noticed an excited crowd of students gathered in a circle, all shouting at the top of their lungs. Suddenly I saw a flame dart up from the centre of their excited group, followed by a whirl of black smoke. This is what had happened: at this time there was developing an important separatist movement connected with certain contemporary political events which had just been announced in the newspapers of the day before, and the students had done nothing less than to burn a Spanish flag!

Just as I was heading toward the group to try to find out what was happening I was surprised to see everyone suddenly scatter, and for a moment I thought my hurried arrival might have caused this. Before I knew, I was left standing alone with the remnants of the burned and smoking flag at my feet; the runaways looked at me from a distance with an expression both of terror and admiration which puzzled me. Yet the reason for the sudden dispersal was perfectly obvious, for it was motivated simply by the arrival of a group of soldiers who happened to be passing by the scene of the incident and to have witnessed what had occurred, and who now were already beginning to investigate the anti-patriotic sacrilege which had just been perpetrated. I declared repeatedly that my presence here was purely accidental, but no one paid the slightest attention to my protests of innocence; on the contrary, the picture that everyone had already formed of me required that I become the principal hero of this demonstration in which I had not even participated. The story immediately went round that the moment the soldiers appeared on the scene everyone had run away except myself, who in remaining glued to the spot had given a proof and example of revolutionary stoicism and admirable presence of mind. I had to appear before the judges, but fortunately I was not yet old enough to be held responsible for acts of a political nature; I was acquitted without being brought to trial. Nevertheless the event made a deep impression on public opinion, which was beginning to have to take notice of my person.

I had let my hair grow as long as a girl's, and looking at myself in the mirror I would often adopt the pose and the melancholy look which so fascinated me in Raphael's self-portrait, and whom I should have liked to resemble as much as possible. I was also waiting impatiently for the down on my face to grow, so that I could shave and have long side-whiskers. As soon as possible I wanted to make myself "look unusual," to compose a masterpiece with my head; often I would run into my mother's room—very fast so as not to be caught by surprise—and hurriedly powder my face, after which I would exaggeratedly darken the area around my eyes with a pencil. Out in the street I would bite my lips very hard to make them as red as possible. These vanities became accen-

tuated after I became aware of the first curious glances directed toward me, glances by which people would attract one another's attention to me, and which said, "That's the son of Dali the notary. He's the one who burned the flag!"

The ideas which had made me into a hero were deeply repugnant to me. To begin with, they were those of most of my schoolmates and because of my irrepressible spirit of contradiction were disqualified by that very fact; besides, the lack of universality of that small and wretched local patriotism appeared unendurably mediocre to my eyes which thirsted for sublimity. At this period I felt myself to be an "integral anarchist," but it was an anarchy of my own, quite special and anti-sentimental, an anarchy in which I could have reigned as the supreme and capricious disorganizer—an anarchic monarchy,[1] with myself at the head as an absolute king; I composed at this time several hymns that could be sung to tunes currently popular, in which the incoherent praises of anarchic and Dalinian monarchy were described in a dithyrambic manner. All my schoolmates knew songs of this kind, and they tried unsuccessfully to imitate them; the idea of influencing my schoolmates began to appeal to me and the "principle of action" gradually awakened in my brain.

On the other hand I was utterly backward in the matter of "solitary pleasure," which my friends practiced as a regular habit. I heard their conversations sprinkled with allusions, euphemisms and hidden meanings, but in spite of the efforts of my imagination I was unable to understand exactly whereof "it" consisted; I would have died of shame rather than dare to ask how one went about doing "it," or even to broach the matter indirectly, for I was afraid it might be found out that I did not know all about "it," and had never done "it." One day I reached the conclusion that one could do "it" all by oneself, and that "it" could also be done mutually, even by several at a time, to see who could do it fastest. I would sometimes see two of my friends go off after exchanging a look that haunted me for several days. They would disappear to some solitary spot, and when they came back they seemed transfigured—they were more handsome! I meditated for days on what "it" might well be and would lose my way in the labyrinth of false and empty childish theories, all of which constituted a gross anomaly in view of my already advanced adolescence.

I passed all my first year examinations without distinction, but I failed in none—this would have spoiled my summer, for I should have had to prepare to take the examinations over again in the fall. My summers were sacred, and I imposed a painful constraint upon myself in order to keep them free from the blemish of displeasure.

[1] In 1922, in Madrid, I developed this idea of an anarchic monarchy, mingling the most caustic humor with a whole series of anti-social and a-political paradoxes which at least had the virtue of being a convincing polemic weapon by which I could amuse myself, scattering seeds of doubt and ruining my friends' political convictions.

I was waiting frantically for vacation to begin. This was always a little before Saint John's Day; and since my earliest childhood I remembered having always spent this day in the same place, in a white-washed village on the edge of the Mediterranean, the village of Cadaques! This is the spot which all my life I have adored with a fanatical fidelity which grows with each passing day. I can say without fear of falling into the slightest exaggeration that I know by heart each contour of the rocks and beaches of Cadaques, each geological anomaly of its unique landscape and light, for in the course of my wandering solitudes these outlines of rocks and these flashes of light clinging to the structure and the esthetic substance of the landscape were the unique protagonists on whose mineral impassiveness, day after day, I projected all the accumulated and chronically unsatisfied tension of my erotic and sentimental life. I alone knew the exact itinerary of the shadows as they traced their anguishing course around the bosom of the rocks, whose tops would be reached and submerged by the softly lapping tides of the waxing moon when the moment came. I would leave signals and enigmas along my trail. A black, dried olive placed upright on a piece of old cork served to designate the limit of the setting sun—I placed it on the very tip of a rock pointed like an eagle's beak. By experimenting I found that this stone beak was the point that received the sun's last rays and I knew that at a given moment my black olive would stand out alone in the powerful flood of purple light, just as the whole rest of the landscape appeared suddenly submerged in the deep shadow of the mountains.

As soon as this effect of light occurred, I would run and get a drink out of a fountain from which I could still see the olive, and without letting it out of my sight for a second I would slowly swallow the cold water from the spring, quenching my thirst which I had held back until this long anticipated moment in obedience to an abscure personal liturgy which enabled me, as I quenched my thirst, to observe that black olive, poised upon the ultimate point of day, which the blazing sunset rendered for a moment as vivid as an ephemeral twilight cherry! After this I went and fetched my miraculous olive and, inserting it in one of my nostrils, I continued on my way. As I walked, and occasionally broke into a run, I liked to feel my more and more accelerated breathing encounter the resistance of my olive; I would purposely blow harder and harder, stopping up my other nostril until I succeeded in expelling it, with considerable force. Then I would pick it up, carefully brushing off the little grains of dirt and sand which had fastened themselves on its sweating surface, and would even put it in my mouth, sucking its faint taste of rancid oil with delight. Then I would put it back in my nostril and begin all over again the respiratory exercises that were to result in its expulsion. I could not decide which I liked better, the smell of the rancid oil or its taste when I sucked it.[1]

[1] In this game with my olive I frequently ended by repeatedly inserting or pressing it into other parts of my body, under my arms, etc., after first wetting it with my saliva.

My summers were wholly taken up with my body, myself and the landscape, and it was the landscape that I liked best. I, who know you so well, Salvador, know that you could not love that landscape of Cadaques so much if in reality it was not the most beautiful landscape in the world —for it is the most beautiful landscape in the world, isn't it?

I can already see the sceptical though kindly smile of most of my readers. Nothing can put me into such a rage as that smile! The reader thinks: the world is so big, there are so many beautiful and varied landscapes everywhere, on every continent, in every latitude. Why does Dali try to convince us by a mere gratuitous statement that he cannot prove (except on the subjective ground of his own taste)? For this would require an experiment, which is humanly impossible, especially for Dali who, not having travelled very extensively, is and will continue to be ignorant of considerable areas of the terrestrial globe, and cannot judge and deliver an opinion of such unqualified finality.

I am sorry for anyone who reasons in this way, giving flagrant proof of his esthetic and philosophic shortsightedness. Take a potato in your hands, examine it carefully. It may have a spot that has rotted, and if you bring your nose close to it it has a different smell. Imagine for a moment that this spot of decomposition is the landscape—then on this potato that I have just respectfully offered you to hold between your fingers there would be one landscape, a single one and not thirty-six. Now on the other hand imagine that there are no moldy spots at all on the potato in question—then, if we continue to assume that the above-mentioned spot is the equivalent of the landscape, there will result the fact that the potato now has no landscape at all. This may very well happen! And this has happened to planets like the moon, where I assure you there is not a single landscape worth seeing—and I can affirm this, even though I have never been there, and even though the moon is not exactly a potato.

Just as on a human head, which is more or less round, there is only one nose, and not hundreds of noses growing in all directions and on all its surfaces, so on the terrestrial globe that phenomenal thing which a few of the most cultivated and discriminating minds in this world have agreed to call a "landscape," knowing exactly what they mean by this word, is so rare that innumerable miraculous and imponderable circumstances—a combination of geological mold and of the mold of civilization—must conspire to produce it. That thing, then—and I repeat it once again—that thing which is called and which I call a "landscape," exists uniquely on the shores of the Mediterranean Sea and not elsewhere. But the most curious of all is that where this landscape becomes best, most beautiful, most excellent and most intelligent is precisely in the vicinity of Cadaques, which by my great good fortune (I am the first to recognize it) is the exact spot where Salvador Dali since his earliest childhood was periodically and successively to pass the "esthetic courses" of all his summers.

And what are the primordial beauty and excellence of that miracu-

lously beautiful landscape of Cadaques? The "structure," and that alone! Each hill, each rocky contour might have been drawn by Leonardo himself! Aside from the structure there is practically nothing. The vegetation is almost nonexistent. Only the olive-trees, very tiny, whose yellow-tinged silver, like graying and venerable hair, crowns the philosophic brows of the hills, wrinkled with dried-up hollows and rudimentary trails half effaced by thistles. Before the discovery of America this was a land of vines. Then the American insect, the phyloxera, came and devastated them, contributing by its ravages to make the structure of the soil emerge again even more clearly, with the lines formed by the retaining walls that terraced the vines accentuating and shading it, having esthetically the function of geodetic lines marking, giving emphasis and architectonic compass to the splendor of that shore, which seems to descend in multiple and irregular stairways adapted to the soil; serpentine or rectilinear tiers, hard and structural reflections of the splendor of the soul of the earth itself; tiers of civilization encrusted on the back of the landscape; tiers now smiling, now taciturn, now excited by Dionysian sentiments on the bruised summits of divine nostalgias; Raphael-esque or chivalric tiers which, descending from the warm and silvery Olympuses of slate, burst into bloom on the water's fringe in the svelte and classic song of stone, of every kind of stone down to the granite of the last retaining walls of that unfertilized and solitary earth (its teeming vines having long since disappeared) and on whose dry and elegiac roughness, even today, rest the two bare colossal feet of that grandiose phantom, silent, serene, vertical and pungent, which incarnates and personifies all the different bloods and all the absent wines of antiquity.

When you are thinking of it least, the grasshopper springs! Horror of horrors! And it was always thus. At the heightened moment of my most ecstatic contemplations and visualizations, the grasshopper would spring! Heavy, unconscious, anguishing, its frightfully paralyzing leap reflected in a start of terror that shook my whole being to its depths. Grasshopper—loathsome insect! Horror, nightmare, martyrizer and hallucinating folly of Salvador Dali's life.

I am thirty-seven years old, and the fright which grasshoppers cause me has not diminished since my adolescence. On the contrary. If possible I should say it has perhaps become still greater. Even today, if I were on the edge of a precipice and a large grasshopper sprang upon me and fastened itself to my face, I should prefer to fling myself over the edge rather than endure this frightful "thing."

The story of this terror remains for me one of the great enigmas of my life. When I was very small I actually adored grasshoppers. With my aunt and my sister I would chase them with eager delight. I would unfold their wings, which seemed to me to have graduated colors like the pink, mauve and blue-tinted twilight skies that crowned the end of the hot days in Cadaques.

One morning I had caught a very slimy little fish, called a "slobberer" because of this. I pressed it very hard in my hand so as to be able to hold it without its slipping away, and only its small head emerged from my hand. I brought it close to my face to get a good look at it, but immediately I uttered a shrill cry of terror, and threw the fish far away,

while tears welled into my eyes. My father, who was sitting on a rock nearby, came and consoled me, trying to understand what had upset me so. "I have just looked at the face of the 'slobberer,'" I told him, in a voice broken by sobs, "and it was exactly the same as a grasshopper's!" Since I found this association between the two faces, the fish's and the grasshopper's, the latter became a thing of horror to me, and the sudden and unexpected sight of one was likely to throw me into such a spectacular nervous fit that my parents absolutely forbade the other children to throw grasshoppers at me, as they were constantly trying to do in order to enjoy my terror. My parents, however, often said, "What a strange thing! He loved them so much before!"

On one occasion my girl cousin purposely crushed a large grasshopper on my neck. I felt the same unnamable and slobbery sliminess that I had noticed in the fish; and though it was eviscerated and abundantly sticky with a loathsome fluid, it still stirred, half destroyed, between my shirt-collar and my flesh, and its jagged legs clutched my neck with such force that I felt they would be torn off sooner than relax their death-grip. I remained for a moment in a half faint, after which my parents succeeded in detaching that "horrible half-living nightmare" from me. I spent the afternoon frantically rubbing my neck and washing it with sea-water. Still tonight, as I write these lines, shudders of horror shoot through my back, while in spite of myself my mouth keeps con-

tracting into a grimace of repugnance mingled with the bitterest moral malaise, which (to the eyes of an imaginary observer) must make my facial expression as sickly and horrible to behold as that of the half-crushed grasshopper which I have just described and which I am probably imitating, identifying myself with its martyrdom by the irresistible reflexes and mimicry of my facial muscles.

But my own martyrdom awaited me on my return to Figueras. For there, once my terror was discovered, and my parents not being constantly present to protect me, I was the victim of the most refined cruelty on the part of my schoolmates, who would think of nothing but catching grasshoppers to make me run—and how I ran!—like a real madman, possessed by all the demons. But I rarely escaped the sacrifice—the grasshopper would land on me, half-dead, cadaverous, hideous! At times it was on opening my book that I would find it, crushed, bathed in a yellow juice, its heavy horse-head separated from its body, its legs still stirring, hi hi hi hi! !

Even in this state it was still capable of jumping on me! Once after such a discovery I flung my book away, breaking a pane of glass in the door, right in the midst of class while everyone was listening to the teacher expounding a geometry problem. That day the teacher made me leave class, and for two days I was afraid that my parents would receive a communication on the subject.

In Figueras the grasshoppers attain much greater dimensions than those of Cadaques, and this species terrified me much more. Those horrible grasshoppers of Figueras, half-crushed on the edges of the sidewalks, dragging a long foul string tied to their legs and subjected to the slow and fierce martyrdom of the games which the children inflict on them— I can see them now! There they are, there they are, those grasshoppers —motionless, convulsed with pain and terror, covered with dust like loathsome croquettes of pure fear. There they are, clutching at the edge of the sidewalk, their heads lowered, their heavy horse-heads, their inexpressive, impassive, unintelligent, frightful heads, with their blind, concentrated look, swollen with pain; there they are, motionless, motionless ...And suddenly—hi hi hi hi hi!—they jump, released with all the explosive unconsciousness of their long contained waiting, as if all of a sudden the spring of their capacity for suffering had reached the breaking-point, and they had to fling themselves, no matter where—on me!

In school my fear of grasshoppers finally took up all the space of my imagination. I saw them everywhere, even where there were none: a grayish paper, suddenly seen, and looking to me like a grasshopper, would make me utter a shrill cry which delighted everyone; a simple pellet of bread or gum thrown from behind that struck me in the head would make me jump up on my desk with both feet, trembling, looking around me, mortally anguished by the fear of discovering the horrible insect, ever ready to spring.

My nervous state became so alarming that I decided on a stratagem

Cocottes.

in order to liberate myself, not of this fear, which I knew to be all-powerful, but at least of my schoolmates' plaguing. I accordingly invented the "counter-grasshopper." This consisted of a simple *cocotte* made by folding a sheet of white paper into the shape of a rooster, and I pretended one day that this paper rooster frightened me much more than grasshoppers, and begged everyone never to show me such a thing. When I saw a grasshopper I did my utmost to repress the display of my fear. But when they showed me a *cocotte* I would utter screams and simulate such a wild fit that one might have thought I was being murdered. This false phobia had an immense success, not only by its novelty and its doubly scandalous effect but also and especially because it was infinitely easier to make a little *cocotte* of white paper than to go and hunt a grasshopper; moreover the fear produced by the white *cocotte* appeared more spectacular. Thanks to this stratagem I was almost freed of the grasshoppers, to which I was less and less exposed as they were replaced by the white *cocottes*. For a real terror I had thus succeeded in substituting its simulation, which amused and tyrannized me at the same time, for I had constantly to play my role to perfection, otherwise I risked being assailed again by a new period of real grasshoppers, and consequently of authentic terrors.

But the disorder into which my hysterical reactions to each apparition of the white *cocottes* plunged the class became so spectacular and constant that the teachers began to be seriously concerned about my case; they decided to punish the pupils severely each time they showed me one of those white *cocottes*, explaining to them that my reaction was the result of a nervous state which was peculiar to me and which it was criminal to exasperate.

Not all the teachers, however, interpreted my simulation so generously. One day we were in a class with our Superior, who did not know very much about my case, when I found a large white paper *cocotte* inside my cap. I knew that all the pupils were just waiting for my reaction, and I therefore had to utter a cry that would measure up to my supposed irremediable repugnance. Outraged by my scream, the teacher asked me to bring him the *cocotte* that had created the disturbance, but I answered, "Not for all the world!" His patience getting out of bounds, he began to insist and peremptorily called upon me to obey him. Then, going up to a stand on which stood an immense bottle of ink from which all the inkwells in the class were periodically filled, I took the bottle with both hands and let it drop on the paper *cocotte*. The bottle shattered into a thousand pieces and the flood of ink dyed the *cocotte* a deep blue. Delicately picking up the soaked *cocotte* still dripping with ink between my thumb and forefinger, I threw it on the teacher's desk, and said, "Now I can obey you. Since it isn't white it doesn't frighten me any more!"

The consequence of this new Dalinian performance was that I was expelled from school the following day.

My memories of the war were all agreeable memories, for Spain's neutrality led my country into a period of euphoria and rapid economic prosperity. Catalonia produced a truculent and succulent flora and fauna of *nouveaux-riches* who, when they grew in Figueras, "an agricultural region of Ampurdán where madness blends most gracefully with reality," produced a whole harvest of picturesque types whose exploits blossomed forth in a living and burning folklore and constituted a kind of piping-hot spiritual nourishment for the elite of our fellow-citizens which supplemented, and was served together with, the everyday terrestrial nourishment—which, it must be said, was very good. I remember well that during this war of 1914 everyone in Figueras was deeply concerned over the question of cooking. There was a French family that was very intimate with my parents and whose members were confirmed *gourmets;* hence a woodcock, served "high" with brandy burned over it, had no secrets for me, and I knew by heart the whole ritual for drinking a good Pernod out in the sun with a sugar-lump dipped into it, while listening to the thousand and one comic anecdotes about our *nouveaux-riches.* These anecdotes became as famous as those of Marseille. But in crossing the frontier they lose their fine effervescent flavor. They have to be consumed on the spot.

Every evening there was a large gathering of grown-ups in the back of the French family's shop. People came there ostensibly to talk about the war and the European situation, but mostly they told endless anecdotes. Looking out on the street through the shop-window they could watch their fellow-citizens passing by, the sight of whom was a lively stimulant that kept the conversation welded to the immediacy of happenings in the town. Hilarity hovered over this predominantly masculine gathering like a whirlwind of hysteria. At times the strident roar of their paroxysms of laughter could even be heard out in the street, mingled with the choking coughs and the plaintive screams of those who exceeded all bounds and went into such convulsions that one might have thought they would die of laughing, and, with tears rolling down their cheeks, shrieked, Ay, Ay, Ay!...

The song "Ay, Ay, Ay" was being sung at that time, and one heard everywhere the sighs of Argentine tangos which had come from Barcelona by way of traveling salesmen who told tales of the Thousand and One Nights of roulette and baccarat, that had just been legalized in the Catalonian capital. A German painter, Siegfried Burman, who painted exclusively with knives, using enormous daubs of color, spent the whole period of the war in Cadaques teaching ladies the steps of the Argentine tango and singing German songs to the accompaniment of the guitar. A rich gentleman giving a flower party had the idea of harnessing to his flower-decked chariot two horses completely covered with confetti. For this he first had the horses coated with hot glue, several men simultaneously pouring pails of it on the animals. Then the horses were made to roll on an immense pile of confetti in which they were completely

submerged. In less than an hour the two horses were dead. Ay, ay, ay—
Ay, ay, ay!...

Peace burst like a bomb. The armistice had just been signed, and
preparations were made for a great celebration. The repercussions of the
armistice were almost as joyous in this countryside of Catalonia as in
France, for the country was unanimously Francophile. It had a pleasant,
splendid and golden memory of the war, and here was victory, besides,
right next door, with all its seductiveness: it was going to make the most
of it, right down to the bone. A public demonstration was planned in
the streets of Figueras, in which there would be popular and political
representatives of all the small towns and villages of the region—flags,
posters, meetings, *sardanas* [1] and balls. The students formed an organi-
zation of a "progressive" type, which it was decided to name "Grupo
Estudiantil," and which was to adopt a platform and elect a committee
charged with organizing the students' participation in the "victory
parades" that were being prepared.

The president of the "Grupo Estudiantil" came to me to ask me
to make the opening speech. I had one day in which to prepare it.

"You are the only student who can do this," he said, "but be sure
to make it powerful, stirring—something in your own line." He shook
my hand vigorously.

I agreed, and immediately set myself to preparing my speech, which
began something like this: "The great sacrifice of blood which has just
been made on the field of battle has awakened the political conscience
of all oppressed peoples! etc. etc." I was extremely flattered at having
been chosen to make the speech, which I rehearsed melodramatically
before the mirror. But as time passed an encroaching and destructive
timidity took hold of me, becoming so extreme that I was beginning to
think it might get out of control. This was my first public speech, how-
ever, and with the legend that had already grown up around me it would
be a shame to disappoint my audience at the last moment by a stupid
childish timidity! If my "funk" continued I might be able to plead ill-
ness, but I could not resign myself to giving up my speech, which
swelled in rhetorical splendor and profundity of ideas as my timidity
grew more paralyzing. Already it prevented me from delivering my
memorized speech, even without witnesses, confusing my memory, mix-
ing up all the words, and blurring the letters of my own handwriting
as with a beating heart and flushed cheeks I tried to decipher what I
had written, my eyes gaping as though the letters had suddenly become
an inexplicable hieroglyph! No! I could not! I could not! There was
nothing to be done! And I stamped my foot with rage, burying my face
devoured by shame and rancor at myself in the rumpled papers on which
I had traced the brilliant path of my first speech with so much elo-
quence and assurance! No, no, no! I would not be capable of delivering

[1] Catalonian popular dance.

my speech! And I went out to roam through the outskirts of town, to try to recover courage in the contemplation of the communicative serenity of the landscape.

The speech was scheduled for the following day. Before returning home in the late afternoon I mingled with a group of students who were all making fun of the speech I was going to give, and the slight amount of courage which I had recovered in the course of my solitary walk fell back to below zero.

The following day I awoke with my heart constricted by a mortal anguish. I could not swallow my *café-au-lait*. I took my speech, which I rolled up and secured with an elastic, combed my hair as best I could, and left for the Republican Centre, where the meeting was to take place.

I walked down the street as though I were going to my execution. I arrived on purpose an hour ahead of time, for I thought that by familiarizing myself with the place and the audience as it gradually foregathered, I would perhaps succeed in lessening the brutal shock of finding myself suddenly facing a crowded hall, in which as you appear silence suddenly falls with the sole aim of sucking in, as through a syphon, the speech which you bear within you. But as I reached the Republican Centre my discouragement reached its peak. The grown-up people were terribly intimidating, and there were even girls! As I entered I blushed so violently that everything became blurred before my eyes, and I had to sit down. Someone immediately brought me a glass of water. The people were pouring in in great numbers, and the sound of voices was deafening. A platform had been erected and dressed with the republican flags, and I had to take my place on it. On this platform there were three chairs. The one in the middle was reserved for me; to my right was the chairman, to my left the secretary. We sat down and were received with scattered applause and a few mocking laughs (which remained seared in my flesh like brands). I put my head between my hands as though I were studying my speech, which I had just unfolded with a firmness which I would not have thought myself capable of a moment before. The secretary got up and began a long explanation of the reasons for the meeting. He was being constantly interrupted by the more and more numerous members of the audience who took our meeting as a joke.

My eyes, unable to see a thing, were glued to my speech, and my ears could register only a confused hum amid which the only distinct notes were the clear, cruel and brutal stridences of the sarcasms directed at us. The secretary hurriedly concluded his introduction because of the audience's lack of interest, and gave me the floor, not without alluding to my heroism on the occasion of the burning of the flag. An impressive silence fell over the hall, and I had for the first time the consciousness that the people in the audience were there only to hear me. Then I experienced that pleasure which I have since prized so highly: feeling myself the object of an "integral expectation." Slowly I rose to my feet,

without having the slightest idea what I was going to do. I tried to remember the beginning of my speech. But unable to do so, I did not open my mouth. The silence around me became even thicker, until it became an asphyxiating embrace: something was going to happen—I knew it! But what? I felt my blood rise to my head and, lifting my arms in a gesture of defiance, I shouted at the top of my lungs, "Long live Germany! Long live Russia!" After which, with a violent kick, I flung the table at the audience. Within a few seconds the hall became a scene of wild confusion, but to my surprise nobody paid any further attention to me. The members of the audience were all arguing and fighting among themselves. With sudden self-possession I slipped out and ran home.

"What about your speech?" my father asked.

"It was fine!" I answered.

And it was true. Without my realizing it, my act had led to a result of great political originality and immediacy. Martin Villanova,[1] one of the agitators of the region, undertook to explain my attitude in his own way.

"There are no longer allies or vanquished," he said. "Germany is in revolution, and must be considered on the same basis as the victors. This is especially true of Russia, whose social revolution is the only fruit of this war that offers a real hope."

The kick that had overturned the table was just what was needed to awaken a public too slow to become alive to historic facts.

The next day I took part in the parade, carrying a German flag, which was greeted with applause, and Martin Villanova carried another, bearing the name of the Soviets, the U.S.S.R. These were certainly the first of their kind to be borne in a Spanish street.

Some time later, Martin Villanova and his group decided to baptize one of the streets of Figueras President Wilson. Villanova came to my house bringing a long canvas like a ship's sail, and asked me to paint on it in large "artistic" letters the words, "The City of Figueras Honors Woodrow Wilson, Protector of the Liberties of Small Nations." We climbed up on the roof of the house and hung the canvas by its four corners to rings which usually served to hang the laundry. I promised him I would go and buy pots of paint and begin the work that very afternoon so that all would be ready the next day for the unveiling of the marble plaque which would give the new illustrious name to the street.

The following morning I awoke very early, gnawed by a feeling of guilt, for I had not yet begun my work. It was probably already too late for my letters to dry in time, even if I should begin work right away. Then I had an idea. Instead of painting the letters with paint, I would cut them out, so that the motto would be made by the blue of the sky that would show through. With the lack of practical sense which char-

[1] Martin Villanova is one of the few revolutionaries of "good faith" whom I have known in the course of my life. He was immeasurably naïve, but also immeasurably generous and prepared to make any sacrifice.

acterized me at this time, I did not realize how difficult this would be and I went down to fetch some scissors. The canvas was so tough that I was not even able to puncture it. I then went and fetched a large kitchen knife. But after many efforts I succeeded only in cutting out a formless hole, which completely discouraged me from pursuing this method further. After all sorts of reflections, I decided on a new technique, even madder and more impracticable—I would burn holes in the canvas following roughly the forms of the letters, after which I would even them out with the scissors, and I would have several pails of water handy in case the canvas should start to burn beyond the edges of the letters. But this was an even more categorical failure than the last effort: the canvas caught fire, and though I managed to put it out there remained of all my labors of two hours only a blackish hole and another smaller hole which I had previously pierced with the knife.

I now felt that it was definitely too late to make any further attempt. Discouraged, dead tired, I lay down on the canvas that hung like a hammock. Its swinging seemed very pleasant, and I immediately felt like going to sleep. I was about to doze off, but I suddenly remembered my father's telling me that one could get a sunstroke from going to sleep in the sun. I felt my head benumbed both by the sun and sleepiness, and in order to arouse myself from this state I decided to undress completely, after which I placed one of the buckets just below the burned hole. I had just invented a new fantasy by which, in the most unexpected and innocent manner in the world, I was going to risk an almost certain death! Lying flat on my belly on the great suspended cloth which served as a hammock, I passed my head through the burned hole [1] in such a way as to be able to plunge it into the cool water. But to get my head in and out of the water it was not enough merely to contract my shoulders, for the hole had widened and one of my shoulders was already halfway through. Then my foot found the solution, making my plan extremely easy to execute. For the second hole, the one I had made with the kitchen knife, happened to be just at the level of my foot; I introduced my foot into this hole, and all I had to do to bring my head up was slightly to contract my leg.

I immersed my head several times satisfactorily, deriving an im-

[1] In my intra-uterine memories I have already told about the games which consisted in making my blood go to my head by hanging and swinging it, which eventually provoked certain retinal illusions similar to phosphenes. This new fantasy which occurred just at the end of the war must be related to the same kind of intra-uterine fantasy. Not only the fact that I had my head down, but also that I passed it through a hole, as well as everything that follows, are exemplary in this regard. The "frustrated acts," the "unsuccessful holes," made with great expenditure of effort and means, clearly revealed the principle of displeasure provoked by real mechanical obstacles. Also the fear of the external world incarnated in the people participating in the celebration who were looking forward to seeing my poster, which I knew could not be finished in time, provoked in me the need to seek refuge in the prenatal world of sleep. But the fear of death assailed me, unconsciously evoking for me the traumatism of birth by the agreeable symbolism of the hanging parachute simulacrum of my counter-submarine!

mense voluptuous pleasure from the performance. But during one of
these operations there occurred an accident which might well have been
fatal. After having held my breath for a long time and wishing to pull
my head out of the pail of water I exerted the necessary pressure with
my leg. Just then the hole in which my foot was caught tore, and instead

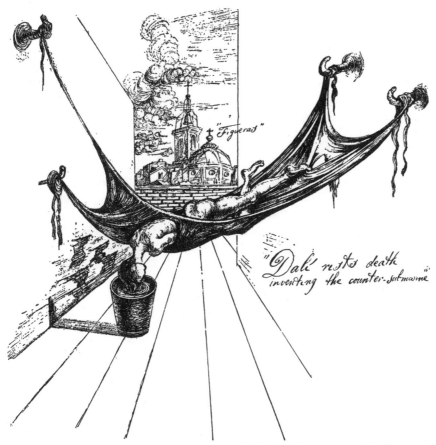

of coming out of the water my head sank all the way to the bottom.
I found myself suddenly in a critical situation, unable to make any
movement, or even to upset the pail in which my head was now thor-
oughly caught and which immobilized me by its weight. The twisting
and squirming of my body only made me swing on the hammock in a
futile way, and it is thus that I found myself with no alternative but to
wait for death.

It was Martin Villanova who came to my rescue; seeing that I did
not appear with my poster, he came to my house, all out of breath, to
find out what had happened to me. And what was happening was simply
this, that Salvador Dali was in the act of dying of asphyxiation on the
heights, on those same dangerous heights on the roof of the house where
as a child-king he had experienced for the first time the sensation of

vertigo. It took me some time to recover after I had been delivered from the pail. Martin Villanova looked at me, stupefied.

"What in the world were you doing here, stark naked, with your head inside the bucket—you might have drowned! And the mayor has already arrived, and the whole crowd is there, we've been waiting for more than half an hour for you to arrive! Tell me what you were doing here."

I have always had an answer for everything, and this time I also had one. "I was inventing the counter-submarine [1]," I said.

Martin Villanova was never able to forget this scene, and he told it that very evening on the *rambla*.[2] "What do you think of Dali, isn't he great! While we were waiting with all the notabilities and the band was there, and everything, there he was stark naked on the roof inventing the 'counter-submarine,' with his head plunged into a bucket of water. If by some misfortune I had not arrived in time, he would be good and dead right now! Isn't he great! Isn't Dali great!"

The following evening they were playing *sardanas* [3] on President Wilson Street, and the poster, which I had finally succeeded in painting in his honor, floated across the street, fastened to two balconies. Two sinister, torn holes could be seen in the canvas, and it was only Martin Villanova and I who knew that one of them corresponded to Salvador Dali's neck and the other to his foot. But Salvador Dali was there, alive, quite alive! And we shall still hear many strange things of him. But patience! We must proceed methodically.

Thus, let us summarize Dali's situation at the outset of this decisive post-war period: Dali, thrown out of school, is to continue his baccalaureate studies at the institute; martyrized by the anguishing grasshoppers, running away from girls, always imbued with the chimerical love of Galuchka, he has not yet experienced "it"; he has grown pubic hair; he is an anarchist, a monarchist, and an anti-Catalonian; he has been under criminal indictment for a supposed antipatriotic sacrilege; at a pro-Ally meeting he has shouted, "Long live Germany! Long live Russia!," kicking over the table at the audience; finally he has been within a hair's breadth of meeting death in the invention of the counter-submarine! How great he is! Look how great Salvador Dali is!

[1] Narciso Monturiol is the inventor of the first submarine that ever navigated under water. An illustrious son of Figueras, he has his monument in the town and for as long as I can remember I have felt a strong jealousy toward him, for my ambition was to make a great invention of this kind, too.

[2] A walk.

[3] A Catalonian popular dance.

CHAPTER SEVEN

"It"

Philosophic Studies

Unassuaged Love

Technical Experiments

My "Stone Period"

End of Love Affair

Mother's Death

I was growing. On Señor Pitchot's property, at Cadaques, there was a cypress planted in the middle of the courtyard; it too was growing. I now wore sideburns that reached below the middle of my cheek. I liked dark suits, preferably of very soft black velvet, and on my walks I would smoke a meerschaum pipe of my father's on which was carved the head of a grinning Arab showing all his teeth. On my father's excursion to the Greek ruins of Ampurias the curator of the museum made him a present of a silver coin with the profile of a Greek woman. I liked to imagine that she was Helen of Troy. I had it mounted into a tie-pin which I always wore, just as I always carried a cane. I have had several famous canes, but the most beautiful one had a gold handle in the shape of a two-headed eagle—an imperial symbol whose morphology adapted itself in a happy way to the possessive grip of my ever-dissatisfied hand.

I was growing, and so was my hand. "It" finally happened to me one evening in the outhouse of the institute; I was disappointed, and a violent guilt-feeling immediately followed. I had thought "it" was something else! But in spite of my disappointment, overshadowed by the delights of remorse, I always went back to doing "it," saying to myself, this is the last, last, last time! After three days the temptation to do "it" once more took hold of me again, and I could never struggle more than one day and one night against my desire to do it again, and I did "it," "it," "it," "it" again all the time.

"It" was not everything... I was learning to draw, and I put into this other activity the maximum of my effort, of my attention and of my fervor. Guilt at having done "it" augmented the unflagging rigor

of my work on my drawings. Every evening I went to the official drawing school. Señor Nuñez was a very good draftsman and a particularly good engraver. He had received the Prix de Rome for engraving; he was truly devoured by an authentic passion for the Fine Arts. From the beginning he singled me out among the hundred students in the class, and invited me to his house, where he would explain to me the mysteries of chiaroscuro and of the "savage strokes" (this was his expression) of an original engraving by Rembrandt which he owned; he had a very special manner of holding this engraving, almost without touching it, which showed the profound veneration with which it inspired him. I would always come away from Señor Nuñez' home stimulated to the highest degree, my cheeks flushed with the greatest artistic ambitions. Imbued with a growing and almost religious respect for Art, I would come home with my head full of Rembrandt, go and shut myself up in the toilet and do "it." "It" became better and better, and I was beginning to find a psychic technique of retardation which enabled me to do "it" at less frequent intervals. For now I no longer said, "This is the last time." I knew by experience that it was no longer possible for me to stop. What I would do was to promise myself to do "it" on Sunday, and then "occasionally on Sunday." The idea that this pleasure was in store for me calmed my erotic yearnings and anxieties, and I reached the point of finding a real voluptuous pleasure in the fact of waiting before doing it. Now that I no longer denied it to myself in the same categorical way, and knew that the longer I waited the better "it" would be when it came, I could look forward to this moment with more and more agreeable and welcome vertigoes and agonies.

My studies at the institute continued to progress in a mediocre way, and everyone advised my father to let me become a painter, especially Señor Nuñez, who had complete faith in my artistic talent; my father refused to make a decision—my artistic future frightened him, and he would have preferred anything to that. Nevertheless he did everything to complete my artistic education, buying me books, all kinds of reviews, all the documents, all the tools I needed, and even things that constituted only a pure and fugitive caprice. My father kept repeating, "When he has passed his baccalaureate we shall see!"

As for myself, I had already made up my mind. I turned to silence, and began to read with real frenzy and without order of any kind. At the end of two years there was not a single book left for me to read in my father's voluminous library. The work which had the greatest effect on me was Voltaire's *Philosophical Dictionary*. Nietzsche's *Thus Spake Zarathustra,* on the other hand, gave me at all times the feeling that I could do better in this vein myself. But my favorite reading was Kant. I understood almost nothing of what I read, and this in itself filled me with pride and satisfaction. I adored to lose myself in the labyrinth of reasonings which resounded in the forming crystals of my young intelli-

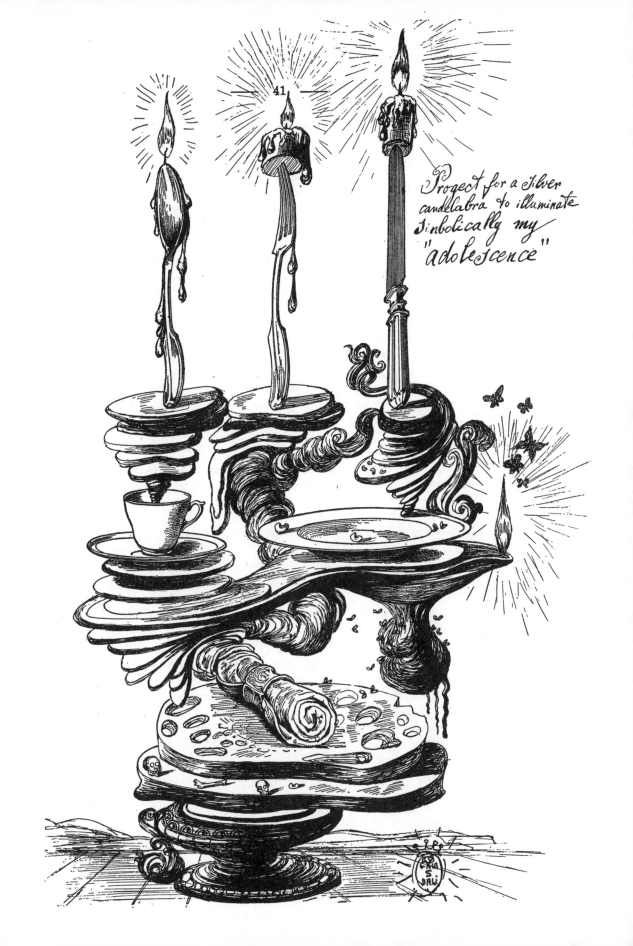

Project for a silver
candelabra to illuminate
simbolically my
"adolescence"

41

gence like authentic celestial music. I felt that a man like Kant, who wrote such important and useless books, must be a real angel! My eagerness to read what I did not understand, stronger than my will, must have obeyed a violent necessity for the spiritual nourishment of my soul, and just as a calcium deficiency in certain weakened organisms of children causes them blindly and irresistibly to break off and eat the lime and plaster on walls, so my spirit must have needed that categorical imperative, which I chewed and rechewed for two consecutive years without succeeding in swallowing it. But one day I did swallow it. In a short time I actually made unbelievable progress in understanding the great philosophical problems. From Kant I passed on to Spinoza, for whose way of thinking I nourished a real passion at this time. Descartes came considerably later, and him I used to build the methodical and logical foundations of my own later original researches. I had begun to read the philosophers almost as a joke, and I ended by weeping over them. I who have never wept over a novel or over a play, no matter how dramatic or heart-rending, wept on reading a definition of "identity" by one of these philosophers, I don't remember which. And even today, when I am interested in philosophy only incidentally, each time I find myself in the presence of an example of man's speculative intelligence, I feel tears irresistibly spring to my eyes.

One of the younger professors at the institute had organized a supplementary course in philosophy, which was completely outside the curriculum, and which met in the evening, from seven to eight. I immediately enrolled in this course, which was to be devoted specially to Plato. It was spring, late spring, when these sessions began, and the night air was balmy. We brought our chairs out-of-doors and sat around a well overgrown with ivy, with a bright moon shining overhead. There were several girls among us whom I did not know and whom I found very beautiful. Immediately I chose one of them with a single glance—she had just done the same with me. This was so apparent to both of us that we both stood up almost at the same moment, our attitudes exactly expressing, "Let's leave! Let's leave!" And we left. When we got outside the institute our emotion was so great that neither one of us could utter a word. So we began to run, holding each other by the hand. The institute was situated near the outskirts of town, and we had only to climb a few blocks of poor unlighted streets to be right out in the country; with one mind we turned our steps toward the most solitary spot, a little road between two fields of wheat that already grew very high. It was completely deserted and auspicious at this hour...

The girl looked into my eyes with a fiery and provocative sweetness; she would laugh from time to time and start off again at a run. But if I had been at a loss for words to begin with, I was even more so now. I thought I should never be able to utter a word again. I tried, and

nothing came. I attributed this phenomenon now more to my paroxysmal fatigue than to my emotional state. She was trembling with every breath, which made her doubly, triply desirable to me. Pointing with my finger to a slight hollow in the field of wheat, I said with a supreme effort, "There!" She ran to the spot and when she reached it lay down, disappearing completely in the wheat. I arrived there in turn; there the girl lay, stretched out full length, appearing much taller than she had before. I saw then that she was very blonde, and had extremely beautiful breasts which I felt wriggling under her blouse like fish caught in my hands. We kissed each other on the mouth for a long time. At times she would half open her mouth, and I would press my lips against her teeth, kissing them till it hurt me.

She had a severe cold and she held a little handkerchief in her hand, with which she vainly tried to blow her nose, as the handkerchief was already completely soaked. I had no handkerchief of my own to offer her, and I did not know what to do... She was constantly sniffing up her mucus, but it was so copious that it would immediately reappear. Finally she turned her head away in shame and blew her nose with the edge of her skirt. I hastened to kiss her again, to prove to her that I was not disgusted by her mucus, which was indeed the case, for it was so fluid, colorless and runny that it rather resembled tears. Moreover, her bosom was continually quivering with her breathing which gave me the illusion that she was weeping. Then I looked at her hard. "I don't love you!" I said. "And I shall never love any woman. I shall always live alone!" And as I spoke I could feel the skin on my cheek contract with the beautiful girl's drying mucus. A complete calm possessed my mind, and again I was working out my plans in the minutest detail, with such calculating coldness that I felt my own soul grow chill.

How had I been able in such a short time to become master of myself again? The girl, on the other hand, felt more and more embarrassed. Obviously her cold had a good deal to do with this. I held her enveloped in my two arms, which had suddenly become sure of their movements, keeping her enfolded in a strictly friendly pose. I suddenly felt the contractions of the dry mucus on my cheek pricking me in an irresistible way. But instead of scratching myself with one of my hands, I lowered my head and pretended to caress my mistress's shoulder with concentrated tenderness, my nose happening to strike just the level of the fold of her armpit. She had perspired profusely during our running about, and I was thus calmly able to breathe in a sublime fragrance compounded of heliotrope and lamb, to which a few burnt coffee-beans might have been added. I raised my head. She looked at me, bitterly disenchanted, and with a vexed, contemptuous smile, said,

"Then you won't want to come back again tomorrow evening?"

"Tomorrow evening, yes," I answered, ceremoniously helping her up, "and for another five years, but not a day longer!" I had my plan—it was my five-year plan!

And so she was my mistress for five years, not counting the summers, which I spent in Cadaques. During this time she remained faithful to me to the point of mysticism. I never saw her except at different times during the twilight hours; on the days when I wished to remain alone I communicated this fact to her by a little note which I sent her by a street urchin. Otherwise we would meet in the open countryside as if by chance. In order to do this she had to resort to a thousand ruses, even to bringing some of her girl friends along, who in turn were sometimes accompanied by boys. But I disliked this, and on most of our walks we were alone.

It was in the course of this five-year romance that I put into play all the resources of my sentimental perversity. I had succeeded in creating in her such a need of me, I had so cynically graduated the frequency of our meetings, the kinds of subjects I would talk about, the sensational lies about supposed inventions, which I had not made at all, and which for the most part were improvised on the spur of the moment, that I could see the sway of my influence growing day by day. It was a methodical, encircling, annihilating, mortal fascination. A time came when I considered my girl "ripe," and I began to demand that she perform acts, sacrifices for me—had she not often told me she was ready to give her life, to die for me? Well, then! I would see about that! We still had—how much time? Four years? I have to mention—in order that the ever-growing passion which I unleashed in this woman's soul may be better understood and not solely attributed to my gifts as a Don Juan—that nothing more occurred between us two, in an erotic way, than has been described on the first day: we kissed each other on the mouth, we looked into each other's eyes, I caressed her breasts, and that was all. I think also that the sense of inferiority which she felt the day we met, because of her cold and her lack of a dry handkerchief, created in her mind such a dissatisfaction, such a violent continued desire to rehabilitate herself in my eyes, that in the sequel of our relationship, never being able to obtain more from me in the way of passion than what I had shown her on that occasion—rather less on the contrary (for the simulation of coldness was one of my most formidable weapons)—her own constantly prodding love undoubtedly contributed to maintaining that state of growing amorous tension which, far from suffering the decline that goes with satiated sentiments, each day grew with alarming, dangerous and unhealthy wishes, more and more sublimated, more and more unreal, and at the same time more and more vulnerable to the terribly material crises of crime, suicide, or nervous collapse.

Unconsummated love has appeared to me since this experience to be one of the most hallucinatory themes of sentimental mythology. Tristan and Isolde are the prototypes of one of those tragedies of unconsummated love which in the realm of the sentiments are as ferociously cannibalistic as that of the praying mantis actually devouring its male on their wedding day, during the very act of love. But the keystone of this cupola

of moral torture which I was building to protect the unconsummated
love of my mistress was without doubt the fully shared realization that
I did not love her. Indeed I knew and she knew that I did not love her;
I knew that she knew I did not love her; she knew that I knew that she
knew that I did not love her. Not loving her, I kept my solitude

intact, being free to exercise my "principles of sentimental action"
on a very beautiful creature, hence on an eminently esthetic and experi-
mental form. I knew that to love, as I should have adored my Galuchka,
my Dullita Rediviva, was something altogether different, calling for the
annihilation of the ego in an omnipotent confusion of all sentiments, in
which all conscious discrimination, all methodical choice of action per-
petually threatened to break down, in the most paradoxically unforesee-
able fashion. Here, on the contrary, my mistress became the constant tar-
get of my trials of skill, which I knew were going to "serve" me later.
I was quite aware that love is receiving the arrow, not shooting it; and
I tried out upon her flesh that Saint Sebastian whom I bore in a latent
state in my own skin, which I should have liked to shuffle off as a ser-
pent does. Knowing that I did not love her, I could continue at the same
time to adore my Dullitas, my Galuchkas, and my Redivivas with a love
more idealized, absolute and pre-Raphaelitic, since now I had a mistress
of flesh and blood, with breasts and saliva, whom I cretinized with love
for me, whom I pressed violently against my flesh, not loving her...
Knowing that I did not love her I would not have with her, either,
that always unsatisfied yearning to mount to the summit of a tower!
She was earthy, real, and the more her thirsty desire devoured her flesh,
and the more sickly she looked—the less she appeared to me to be fit
to mount my tower; I would have liked her to croak!

I would sometimes say to her, as we lay somewhere out in the fields, "Make believe you are dead." And she would cross her two hands on her chest and stop breathing. Her two little nostrils became so motionless, she would stop breathing so long that sometimes, becoming frantic, I would pat her cheeks, believing her to be really inanimate. She derived

an unmistakable pleasure from her growing pallor, which I guided with bridles of delicate anguish like an exhausted moon-white horse with a dishevelled mane.

"Now we'll run together without stopping, as far as to the cypress tree." She was afraid of my anger and would obey me, dropping at the foot of the cypress at the end of the race, almost fainting with fatigue. "You want me to die," she would often say, knowing that I liked her to say this, and that I would reward her by kissing her on the mouth.

Summer came, and I left for Cadaques. Señor Pitchot announced that the cypress planted in the centre of the patio had grown another two feet. I made a very detailed drawing of this cypress from life. I had observed its seed balls and been struck by their resemblance to skulls, especially because of the jagged sutures between the two parietal bones.

The letters that I received from my mistress were more exalted in tone than ever, and I answered her only rarely, always with a barb of venom which I knew could not fail to poison her and make her yellow as wax.

At the end of the summer it rained for a whole day. We were one of the last families to leave, and on the last day I went for a walk around the property of the Pitchots, which was · already deserted. I picked up my jacket which had been left out in the rain and was soaked; exploring the pockets, I pulled out a sheaf of letters from my mistress, which I used to keep and take with me on my walks. They were all drenched, and the bright blue handwriting on them was almost effaced. I sat down before my cypress, thinking of her. Mechanically I began to squeeze and compress the letters between my hands, so that they became like paste, and soon I made a kind of ball by rolling together several wads of these wet papers. I suddenly realized that in doing so I was involuntarily imitating the cypress balls, for mine was exactly the same size, and similarly made up of several sections joined by lines like the sutures between the parietal bones. I went over to the cypress and replaced one of its balls

by the white conglomerate ball of my letters, and with the rest of these I made a second ball which I placed symmetrically in relation to the first. After which I continued on my walk, becoming absorbed in meditation upon the most varied subjects. I remained seated for more than an hour on the extreme point of a rock so close to the breaking waves that when I left my face and hair were all wet; the taste of sea salt which was on my lips evoked in my mind the myth of incorruptibility, of immor-

tality, so obsessing to me at the time. Night had come, and I no longer saw where I was walking. Suddenly I shuddered and put my hand on my heart, where I felt a twinge as though something had just bitten it—in passing I had been startled by the two motionless white balls which I had left in the cypress tree and which loomed out of the dark as I came almost close enough to touch them. A lightning presentiment flashed through my mind: is she dead? I broke into a cold sweat, which did not leave me till I got to the house where a letter from my mistress awaited me, which she concluded by saying, "I am getting fatter, and everyone thinks I look very well. But I am only interested in what you will think of me when you see me again. A thousand kisses, and again, I could never forget you, etc. etc."... The idiot!

I was preparing myself. My father was beginning to yield, and I knew that after my six years of the baccalaureate I was going to be a painter! This would not be before three more years, but there was already talk of the School of Fine Arts of Madrid, and perhaps, if I won prizes, I would go and complete my studies in Rome. The thought of attending "official courses" again, even if these were courses in painting, deeply revolted me at first, for I should have liked to be given full freedom of action, without anyone's being able to interfere with what went on inside my head. I was already planning a desperate struggle, a struggle to the death, with my professors. What I intended to do had to happen "without witnesses." Besides, the sole present witness of my artistic inventions, Señor Nuñez, no longer had any peace with me. Each day I flabbergasted him, and each day he had to acknowledge that I was right.

I was making my first technical discoveries, and they all had the same origin: I would start out by doing exactly the contrary of what my professor told me. Once we were drawing an old man, a beggar, who had a beard of very curly, fine hair—almost like down, and absolutely white. After looking at my drawing Señor Nuñez told me that it was too much worked over with pencil strokes to make it possible to get the effect of that very delicate white down; I must do two things—begin again with an absolutely clean sheet of paper, and respect its "whiteness," which I could then utilize; and also, in order to get the effect of the extremely fine down of his hair I would have to use a very soft pencil, and make strokes that would barely brush the paper. When my professor had left, I naturally began to do the opposite of what he had just advised, and continued to work away with my pencil with extreme violence, using the blackest and heaviest pencils. I put such passion into my work that all the pupils gathered around to watch me work. I was eventually able, by the cleverness of my contrasts, to create an illusion suggestive of the model. But still dissatisfied, I continued to blacken my drawing still more, and soon it was but an incoherent mass of blackish smudges which became more and more homogeneous, and finally covered the whole paper with a uniform dark tone.

The next day when the professor came and stood in front of my work he uttered a cry of despair.

"You've done just the opposite of what I told you to do, and this is the result!"

To which I answered that I was on the verge of solving the problem. And, taking out a bottle of India-ink and a brush, I began to daub my drawing with pitch black precisely where the model was whitest. My professor, thinking he understood, exclaimed,

"Your idea is to make the negative!"

"My idea," I answered, "is to paint exactly what I see!"

The professor went off again, shaking his head, saying, "If you think you can finish it with chalk you're mistaken, because your India-ink won't take chalk!"

Left to myself I took out a little pen knife and began to scratch my paper with a special stroke, and immediately I saw appear the most dazzling whites that one can obtain in a drawing. In other parts of the drawing where I wanted my whites to emerge more subdued, I would spit directly on the given spot and my rubbing then produced peelings that were more grayish and dirty. The beard of the old beggar who sat as the model emerged from the shadows of my drawing with a paralyzing realism. Soon I mastered the operation of bringing out the pulp of the paper in such a way as really to look like a kind of down, which was made by scratching the paper itself,[1] and I almost went to the length of pulling out the fibres of the paper with my fingernails, and curling them to boot. It was, so to speak, the direct imitation of the old man's beard. My work completed, I lighted my drawing with a slanting light, placed close to the edge of the paper. When Señor Nuñez came to see it he could say nothing, so greatly did his perplexity overflow the habitual frame of his admiration. He came over to me, pressed me hard against his chest with his two robust arms in an embrace which I thought would choke me, and repeated approximately what Martin Villanova had said (on the occasion of my invention of the counter-submarine), "Look at our Dali— isn't he great!" Deeply moved, he patted me on the shoulder. This experiment of scratching the paper with my pen knife made me ponder a great deal upon the peculiarities of light and its possibilities of imitation. My researches in this field lasted a whole year, and I came to the conclusion that only the relief of the color itself, deliberately piled on the canvas, could produce luminous effects satisfying to the eye.

This was the period which my parents and myself baptized "The Stone Period." I used stones, in fact, to paint with. When I wanted to

[1] Later, in studying the water-colors of Mariano Fortuni, the inventor of "Spanish colorism" and one of the most skilful beings in the world, I realized that he utilizes similar scratchings to obtain his most luminous whites, taking advantage like myself of the relief and irregularity of the whites in question to catch the light in the tiny particles of the surface and thus heighten the effect of stupefying luminousness.

obtain a very luminous cloud or an intense brilliance, I would put a small stone on the canvas, which I would thereupon cover with paint. One of the most successful paintings of this kind was a large sunset with scarlet clouds. The sky was filled with stones of every dimension, some of them as large as an apple! This painting was hung for a time in my parents' dining room, and I remember that during the peaceful family gatherings after the evening meal we would sometimes be startled by the sound of something dropping on the mosaic. My mother would stop sewing for a moment and listen, but my father would always reassure her with the words, "It's nothing—it's just another stone that's dropped from our child's sky!" Being too heavy and the coat of paint too thin to keep them attached to the canvas, which eventually would crack, these stones which served as kernels to large pieces of clouds illuminated by the setting sun would come tumbling down on the tiled floor with a loud noise. With a worried look, my father would add, "The ideas are good, but who would ever buy a painting which would eventually disappear while their house got cluttered up with stones?"

In the town of Figueras my pictorial researches were a source of constant amusement. The word would go round that "now Dali's son is putting stones in his pictures!" Nevertheless, at the height of the stone period, I was asked to lend some of my paintings for an exhibition that was to take place in the hall of a musical society. There were represented about thirty local and regional artists, some of them from as far away as Gerona and even Barcelona. My works were among the most noticed, and the two intellectuals of the town who carried the most weight, Carlos Costa and Puig Pujades, declared that without the slightest doubt a brilliant artist's career lay before me.

This first consecration of my glory produced a powerful impression on my mistress's amorous imagination, and I took desperate advantage of this to enslave her to me more and more. Above all I did not want her to have any friends, whether girls or boys, children or grown-ups. She had to remain always alone, like myself, and when I wanted to she could see me—me, the only one who had intelligence, who understood everything differently from others, and whom the very newspapers were surrounding with clouds of glory. As soon as I learned that she had made a new acquaintance, or if she spoke to me of someone in a sympathetic way, I immediately tried to deprecate, ruin and annihilate this person in her mind, and I always succeeded. I invariably found just the right observation, the prosaic simile that defined the person with such realism that she could no longer see him in any other manner than the one which I dictated to her. I exacted the subservience of her sentiments in a literal way, and every infraction of my pitiless sentimental inquisition had to be punished by her bitter tears. A contemptuous tone directed at her, slipped as if unintentionally into a casual conversation, was enough to make her feel as though she were dying. She no longer expected me to

be able to love her, but she clutched at my esteem like a drowning woman. Her whole life was concentrated into the half-hour of our walk, which I granted her more and more rarely, for this was all going to end! The temple of the Academy of Fine Arts of Madrid already loomed before me, with all its stairways, all its columns and all its pediments of glory. I would say to my mistress, "Profit while you may; you still have another year." She spent her life making herself beautiful for our half-hour. She had overcome her sickliness, and she now possessed a violent health which only her tears could make acceptable to me.

I would carry with me on my walks numbers of "L'Esprit Nouveau" (The New Spirit) which I received; she would humbly bow her fore-head in an attentive attitude over the cubist paintings. At this period I had a passion for what I called Juan Gris' "Categorical imperative of mysticism." I remember often speaking to my mistress in enigmatic pro-nouncements, such as, "Glory is a shiny, pointed, cutting thing, like an open pair of scissors." She would drink in all my words without under-standing them, trying to remember them... "What were you saying yesterday about open scissors?"

On our walks we would often see the mass of the Muli de la Torre rising from the dark greenery in the distance. I liked then to sit down to look at it. "You see that white smudge over there? That's just where Dullita sat." She would look without seeing what I was pointing at. I would hold one of her breasts in my hand. Since the first time I had met

her her breasts had gradually hardened, and now they were like stone. "Show them to me," I said. She undid her blouse and showed them to me. They were incomparably beautiful and white; their tips looked exactly like raspberries; like them they had a few infinitely fine and minute hairs. She was about to button up her blouse again, but I commanded, with a trace of emotion in my voice, "No. Stay the way you are!" She let her hands fall along her body, inclined her head slightly to one side, and lowered her eyes. A violent breathing shook her bosom. Finally I said, "Come on." She buttoned up her blouse again and got up, smiling feebly. I took her tenderly by the hand and began the walk home. "You know," I said, "when I go to Madrid I won't ever write to you again."

And I walked on another ten steps. I knew that this was exactly the length of time it would take for her to start crying. I was not mistaken. I then kissed her passionately, feeling my cheek burn with her boiling tears, big as hazel-nuts. In the center of my brain glory shone like a pair of open scissors! Work, work, Salvador; for if you were endowed for cruelty, you were also endowed for work.

This capacity for work always inspired everyone with respect, whether I fastened stones to my canvases or worked minutely at my painting for hours on end, or spent my day taking notes to try to untangle a complicated philosophic text. The fact is that from the time I arose, at seven in the morning, my brain did not rest for a single moment in the course of the entire day. Even my idyllic walks I considered a laborious and exacting labor of seduction. My parents would always remark, "He never stops for a second! He never has a good time!" And they would admonish me, "You're young, you must make the most of your age!" I, however, was always thinking, "Hurry up and grow old—you are horribly 'green,' horribly 'bitter.'" How, before I reached maturity, could I rid myself of that dreamy and puerile infirmity of adolescence? I was supremely conscious of one thing—I had to go through cubism in order to get it out of my system once and for all, and during this time perhaps I could at least learn to draw!

But this could not appease my avid desire to do everything. I still had to invent and write a great philosophic work, which I had begun a year before, and which was called, "The Tower of Babel." I had already written five hundred pages of it, and I was still only on the Prologue! At this period my sexual anxiety disappeared almost completely, and the philosophic theories of my book took up all the room in my psychic activity. The bases of my "Tower of Babel" began with the exposition of the phenomenon of death which was to be found, according to my view, at the inception of every imaginative construction. My theory was anthropomorphic, for I always considered that I was not so much alive as in the process of resuscitating from the "amorphous unintelligence" of my origins and, moreover, I considered a premature old age as the price I would pay for a promise of immortality. That which at the base of the tower was "comprehensible life" for everyone was for me only death and chaos; on the other hand everything on the summit of the tower that was confusion and chaos for everyone else was for me, the anti-Faust, the supreme thaumaturge, only "logos" and resurrection. My life was a constant and furious affirmation of my growing and imperialistic personality, each hour was a new victory of the "ego" over death. On the other hand, I observed around me only continual compromises with this death. Not for me! With death I would never compromise.

My mother's death supervened, and this was the greatest blow I had experienced in my life. I worshipped her; her image appeared to me unique. I knew that the moral values of her saintly soul were high above

all that is human, and I could not resign myself to the loss of a being on whom I counted to make invisible the unavowable blemishes of my soul—she was so good that I thought that "it would do for me too." She adored me with a love so whole and so proud that she could not be wrong—my wickedness, too, must be something marvelous! My mother's death struck me as an affront of destiny—a thing like that could not happen to me—either to her or to me! In the middle of my chest I felt the thousand-year-old cedar of Lebanon of vengeance reach out its gigantic branches. With my teeth clenched with weeping, I swore to myself that I would snatch my mother from death and destiny with the swords of light that some day would savagely gleam around my glorious name!

CHAPTER EIGHT

Project for a cosk, for "mad Tristan"

Apprenticeship of Glory

Father Consents to
Artistic Career

Entrance Examination

Suspension from the
School of Fine Arts
of Madrid

Dandyism and Prison

The profusion of articles that were beginning to flood the house made my father decide to start a large notebook in which he would collect and paste everything that he had and everything that appeared about me. He wrote a preface to this collection for the benefit of posterity, of which the following is a complete and faithful translation:

Salvador Dali y Domenech, Apprentice Painter

After twenty-one years [1] of cares, anxieties and great efforts I am at last able to see my son almost in a position to face life's necessities and to provide for himself. A father's duties are not so easy as is sometimes believed. He is constantly called upon to make certain concessions, and there are moments when these concessions and compromises sweep away almost entirely the plans he has formed and the illusions he has nourished. We, his parents, did not wish our son to dedicate himself to art, a calling for which he seems to have shown great aptitude since his childhood.

I continue to believe that art should not be a means of earning a livelihood, that it should be solely a relaxation for the spirit to which one may devote oneself when the leisure moments of one's manner of life allow one to do so. Moreover we, his parents, were convinced of the difficulty of his reaching the preeminent place in art which is achieved only by true heroes conquering all obstacles and reverses. We knew the

[1] This belongs chronologically a few years later in my biography.

bitterness, the sorrows and the despair of those who fail. And it was for these reasons that we did all we could to urge our son to exercise a liberal, scientific or even literary profession. At the moment when our son finished his baccalaureate studies, we were already convinced of the futility of turning him to any other profession than that of a painter, the only one which he has genuinely and steadfastly felt to be his vocation. I do not believe that I have the right to oppose such a decided vocation, especially as it was necessary to take into consideration that my boy would have wasted his time in any other discipline or study, because of the "intellectual laziness" from which he suffered as soon as he was drawn out of the circle of his predilections.

When this point was reached, I proposed to my son a compromise: that he should attend the school of painting, sculpture and engraving in Madrid, that he should take all the courses that would be necessary for him to obtain the official title of professor of art, and that once he had completed his studies he should take the competitive examination in order to be able to use his title of professor in an official pedagogical center, thus securing an income that would provide him with all the indispensable necessities of life and at the same time permit him to devote himself to art as much as he liked during the free hours which his teaching duties left him. In this way I would have the assurance that he would never lack the means of subsistence, while at the same time the door that would enable him to exercise his artist's gifts would not be closed to him. On the contrary, he would be able to do this without risking the economic disaster which makes the life of the unsuccessful man even more bitter.

This is the point we have now reached! *I* have kept my word, making assurance for my son that he shall not lack anything that might be needed for his artistic and professional education. The effort which this has implied for me is very great, if it is considered that I do not possess a personal fortune, either great or small, and that I have to meet all obligations with the sole honorable and honest gain of my profession, which is that of a notary, and that this gain, like that of all notaryships in Figueras, is a modest one. For the moment my son continues to perform his duties in school, meeting a few obstacles for which I hold the pupil less responsible than the detestable disorganization of our centers of culture. But the official progress of his work is good. My son has already finished two complete courses and won two prizes, one in the history of art and the other in "general apprenticeship in color painting." I say his "official work," for the boy might do better than he does as a "student of the school," but the passion which he feels for painting distracts him from his official studies more than it should. He spends most of his hours in painting pictures on his own which he sends to expositions after careful selection. The success he has won by his paintings is much greater than I myself could ever have believed possible. But, as I have already mentioned, I should prefer such success to come later, after he had

finished his studies and found a position as a professor. For then there would no longer be any danger that my son's promise would not be fulfilled.

In spite of all that I have said, I should not be telling the truth if I were to deny that my son's present successes please me, for if it should happen that my son would not be able to win an appointment to a professorship, I am told that the artistic orientation he is following is not completely erroneous, and that however badly all this should turn out, whatever else he might take up would definitely be an even greater disaster, since my son has a gift for painting, and only for painting.

This notebook contains the collection of all I have seen published in the press about my son's works during the time of his apprenticeship as a painter. It also contains other documents relating to incidents that have occurred in the school, and to his imprisonment, which might have an interest as enabling one to judge my son as a citizen, that is to say, as a man. I am collecting, and shall continue to collect, everything that mentions him, whether it be good or bad, as long as I have knowledge of it. From the reading of all the contents something may be learned of my son's value as an artist and a citizen. Let him who has the patience to read everything judge him with impartiality.

Figueras, December 31, 1925. *Salvador Dali, Notary.*

I left for Madrid with my father and my sister. To be admitted to the School of Fine Arts it was necessary to pass an examination which consisted of making a drawing from the antique. My model was a cast of the *Bacchus* by Jacopo Sansovino, which had to be completed in six days. My work was following its normal and satisfactory course when, on the third day, the janitor (who would often chat with my father while the latter waited impatiently in the court for me to get out of school) revealed his fear that I would not pass the examination.

"I am not discussing the merits of your son's drawing," he said, "but he has not observed the examination rules. In these rules it is clearly stated that the drawing must have the exact measurements of an Ingres sheet of paper, and your son is the only one who has made the figure so small that the surrounding space cannot be considered as margins!"

My father was beside himself from that moment. He did not know what to advise me—whether to start the drawing over again or to finish it as best I could in its present dimensions. The problem troubled him all during our afternoon walk. At the theatre that evening, in the middle of the picture, he made everyone turn round by suddenly exclaiming, "Do you feel you have the courage to start it all over again?" and, after a long silence, "You have three days left!" I derived a certain pleasure from tormenting him on this subject; but I myself was beginning to feel the contagion of his anguish, and I saw that the question was actually becoming serious.

"Sleep well," he advised me before I went to bed, "and don't think about this; tomorrow you must be at your best, and you will decide at the last moment." The next day, filled with great courage and decision, I completely rubbed out my drawing without a moment's hesitation. But no sooner had I completed this operation than I remained paralyzed by fear at what I had just done. I looked, flabbergasted, at my paper which was all white again, while my fellow-competitors all around me, on their fourth day of work, were already beginning to touch up their shadows. The following day all of them would be almost through; and then they would have plenty of time left to check on final corrections, which always require calm and reflection. I looked at the clock with anguish. It had already taken me half an hour just to erase. I thus anxiously began my new figure, trying this time to take measurements so that it would have the dimensions which the regulations required. But so clumsily did I go about these preliminary operations, which any other student would have executed mechanically at a single stroke, that at the end of the session I had once more to rub out the whole thing. When the class was over my father instantly read in the pallor of my face that things were not going well.

"What did you do?"

"I erased it."

"But how is the new one going?"

"I haven't begun it. All I did was to erase and take measurements. I want to be sure this time!"

My father said, "You're right—but two hours to take measurements! Now you have only two days left. I should have advised you not to erase your first drawing."

Neither my father nor I could eat that evening. He kept saying to me, "Eat! Eat! If you don't eat, you won't be able to do anything tomorrow." We fretted the whole time, and my sister, too, looked shaken. My father confessed to me later that he spent the whole night without being able to sleep for one second, assailed by insoluble doubts—I should have erased it, I should not have erased it!

The next day arrived. Sansovino's *Bacchus* was marked and impregnated so deeply in my memory that I threw myself into the work like a starving wolf. But this time I made it too large. There was nothing to be done—it was impossible to cheat! His feet extended entirely beyond the paper. This was worse than anything, a much worse fault than to have left immense margins. Again I erased it completely.

When I got out of class my father was livid with impatience. With an unconvincing smile and trying to encourage me he said, "Well?"

"Too big," I answered.

"And what do you intend to do?"

"I've already erased it." I saw a tear gleam in my father's eyes.

"Come, come, you still have tomorrow's session. How many times before this you've made a drawing in a single session!"

But I knew that in two hours this was humanly impossible, for it would take at least one day to sketch it out, and another to make the shadows. Besides, my father was saying this only to encourage me. He knew as well as I that I had failed in the examination and that the day after the next we would have to return to Figueras covered with shame— I who was the best of them all back there—and this after the absolute assurances that Señor Nuñez had given him that I could not possibly fail to pass my examinations, even if by chance my drawing should be the poorest that I was capable of making.

"If you don't pass the examinations," he said, trying to continue to console me, "it will be my fault and the fault of that imbecilic janitor. If your drawing was good, which it seemed to be, what would it have mattered whether it was a little smaller or larger?"

Then I whetted my maliciousness and answered, "It's as I've been telling you. If a thing is well drawn, it forces itself upon the professors' esteem!"

My father meditatively rolled one of the strands of white hair that grew on each side of his venerable skull, bitten to the quick by remorse.

"But you yourself told me," he said "that it was very, very small."

"Never," I answered. "I said it was small, but not very *very* small!"

"I thought you had told me it was very very small," he insisted. "Then perhaps it would have passed, if it wasn't small-small! Tell me exactly how it was, so that I can at least form an opinion."

Then I began one of the most refined tortures. "Now that we have spoken so much about it, I can't exactly remember its dimensions; it was average, rather small, but not exaggeratedly small."

"But try to remember. Look, was it about like this?" showing me a dimension with his thumb and his fork.

"With the twisted form of the fork," I said, "I can't tell."

Then patiently he resumed his questioning. "Imagine that it was this knife; it has no curve. Tell me if it was as small as that?"

"I don't think so," I answered, pretending to search my memory, "but perhaps it was."

Then my father began to get impatient and exclaimed furiously, "It's either yes or no!"

"It's neither yes nor no," I answered, "for I can't remember!"

Then my father paced back and forth in the room in absolute consternation. Suddenly he took a crumb of bread, and put one knee on the floor. "Was it as small as this," he asked, in a theatrical pleading tone, showing me the crumb with one hand, "or as big as that?" pointing to the cupboard with the other hand. My sister wept, and we went to the cinema. It was a popular type of motion picture, and in the intermission everyone turned round to look at me as though I were a very rare object. With my velvet jacket, my hair which I wore like a girl's, my gilded cane and my sideburns reaching more than halfway down my cheeks, my appearance was in truth so outlandish and unusual that I was taken for

an actor. There were two little girls, in particular, who looked at me ecstatically, with their mouths open. My father grew impatient. "Soon we won't be able to go out with you. We're made a show of every time. All that hair, and those long side-burns—and anyway we'll damn well have to go back to Figueras like beaten dogs with our tails between our legs."

An expression of infinite bitterness had come over my father's bluish gaze in the last two days, and the white strand of hair which he was in the habit of fingering in his moments of cruelest doubt and anxiety now stood out stiff, like a horn of white hair into which was condensed all the torment and all the yellowish and menacing bile of my problematic future.

The following day dawn broke dismally, with lurid flashes of capital punishment. I was ready for anything. I was no longer afraid, for my sense of impending catastrophe had reached its peak in the infernal atmosphere of the previous day. I set to work, and in exactly one hour I had completely finished the drawing, with all the shading. I spent the remaining hour doing nothing but admiring my drawing, which was remarkable—never had I done anything so precise. But suddenly I became terrified as I noticed one thing: the figure was still small, even smaller than the first one.

When I got out my father was reading the newspaper. He did not have the courage to ask any questions; he waited for me to speak.

"I did wonderfully well," I said calmly. And then I added, "But the drawing is even smaller than the first one I made!"

This remark came like a bomb-shell. So did the result of my examination. I was admitted as a student to the School of Fine Arts of Madrid, with this mention, "In spite of the fact that it does not have the dimensions prescribed by the regulations, the drawing is so perfect that it is considered approved by the examining committee."

My father and sister went back to Figueras, and I remained alone, settled in a very comfortable room in the Students' Residence, an exclusive place to which it required a certain influence to be admitted, and where the sons of the best Spanish families lived. I launched upon my studies at the Academy with the greatest determination. My life reduced itself strictly to my studies. No longer did I loiter in the streets, or go to the cinema. I stirred only to go from the Students' Residence to the Academy and back again. Avoiding the groups who foregathered in the Residence I would go straight to my room where I locked myself in and continued my studies. Sunday mornings I went to the Prado and made cubist sketch-plans of the composition of various paintings. The trip from the Academy to the Students' Residence I always made by streetcar. Thus I spent about one peseta per day, and I stuck to this schedule for several months on end. My relatives, informed of my way of

living by the Director and by the poet Marquina, under whose guardianship I had been left, became worried over my ascetic conduct, which everyone considered monstrous. My father wrote me on several occasions that at my age it was necessary to have some recreation, to take trips, go to the theatre, take walks about town with friends. Nothing availed. From the Academy to my room, from my room to the Academy, and I never exceeded the budget of one peseta per day. My inner life needed nothing else; rather, anything more would have embarrassed me by the intrusion of an unendurable element of displeasure.

In my room I was beginning to paint my first cubist paintings, which were directly and intentionally influenced by Juan Gris. They were almost monochromes. As a reaction against my previous colorist and impressionist periods, the only colors in my palette were white, black, sienna and olive green.

I bought a large black felt hat, and a pipe which I did not smoke and never lighted, but which I kept constantly hanging from the corner of my mouth. I loathed long trousers, and decided to wear short pants with stockings, and sometimes puttees. On rainy days I wore a waterproof cape which I had brought from Figueras, but which was so long that it almost reached the ground. With this waterproof cape I wore the large black hat, from which my hair stuck out like a mane on each side. I realize today that those who knew me at that time do not at all exaggerate when they say that my appearance "was fantastic." It truly was. Each time I went out or returned to my room, curious groups would form to watch me pass. And I would go my way with head held high, full of pride.

In spite of my generous initial enthusiasm, I was quickly disappointed in the professorial staff of the School of Fine Arts. I immediately understood that those old professors covered with honors and decorations could

teach me nothing. This was not due to their academicism or to their philistine spirit but on the contrary to their progressive spirit, hospitable to every novelty. I was expecting to find limits, rigor, science. I was offered liberty, laziness, approximations! These old professors had recently glimpsed French impressionism through national examples that were chock-full of *tipicismo* (local color)—Sorolla was their god. Thus all was lost.

I was already in full reaction against cubism. They, in order to reach cubism, would have had to live several lives! I would ask anxious, desperate questions of my professor of painting: how to mix my oil and with what, how to obtain a continuous and compact matter, what method to follow to obtain a given effect. My professor would look at me, stupefied by my questions, and answer me with evasive phrases, empty of all meaning.

"My friend," he would say, "everyone must find his own manner; there are no laws in painting. Interpret—interpret everything, and paint exactly what you see, and above all put your soul into it; it's temperament, temperament that counts!"

"Temperament," I thought to myself, sadly, "I could spare you some, my dear professor; but how, in what proportion, should I mix my oil with varnish?"

"Courage, courage," the professor would repeat. "No details—go to the core of the thing—simplify, simplify—no rules, no constraints. In my class each pupil must work according to his own temperament!"

Professor of painting—professor! Fool that you were. How much time, how many revolutions, how many wars would be needed to bring people back to the supreme reactionary truth that "rigor" is the prime condition of every hierarchy, and that constraint is the very mold of form. Professor of painting—professor! Fool that you were! Always in life my position has been objectively paradoxical—I, who at this time was the only painter in Madrid to understand and execute cubist paintings, was asking the professors for rigor, knowledge, and the most exact science of draughtsmanship, of perspective, of color.

The students considered me a reactionary, an enemy of progress and of liberty. They called themselves revolutionaries and innovators, because all of a sudden they were allowed to paint as they pleased, and because they had just eliminated black from their palettes, calling it dirt, and replacing it with purple! Their most recent discovery was this: everything is made iridescent by light—no black; shadows are purple. But this revolution of impressionism was one which I had thoroughly gone through at the age of twelve, and even at that time I had not committed the elementary error of suppressing black from my palette. A single glance at a small Renoir which I had seen in Barcelona would have been ample for me to understand all this in a second. They would mark time in their dirty, ill digested rainbows for years and years. My God, how stupid people can be!

Everyone made fun of an old professor who was the only one to understand his calling thoroughly, and the only one, besides, possessing a true professional science and conscience. I myself have often regretted not having been sufficiently attentive to his counsels. He was very famous in Spain, and his name was José Moreno Carbonero. Certain paintings of his, with scenes drawn from *Don Quixote,* I still enjoy today, even more than before. Don José Moreno Carbonero would come to class wearing a frock coat, a black pearl in his necktie, and would correct our works with white gloves on so as not to dirty his hands. He had only to make two or three rapid strokes with a piece of charcoal to bring a drawing miraculously back on its feet, into composition; he had a pair of sensationally penetrating, photographic little eyes, like Meissonier's, that are so rare. All the students would wait for him to leave in order to erase his corrections and do the thing over again in their own manner, which was naturally that of "temperament," of laziness and of pretentiousness without object or glory—mediocre pretentiousness, incapable of stooping to the level of common sense, and equally incapable of rising to the summits of delirious pride. Students of the School of Fine Arts! Fools that you were!

One day I brought to school a little monograph on Georges Braque. No one had ever seen any cubist paintings, and not a single one of my classmates envisaged the possibility of taking that kind of painting seriously. The professor of anatomy, who was much more given to the discipline of scientific methods, heard mention of the book in question, and asked me for it. He confessed that he had never seen paintings of this kind, but he said that one must respect everything one does not understand. Since this has been published in a book, it means that there is something to it. The following morning he had read the preface, and had understood it pretty well; he quoted to me several types of non-figurative and eminently geometrical representations in the past I told him that this was not exactly the idea, for in cubism there was a very manifest element of representation. The professor spoke to the other professors and all of them began to look upon me as a supernatural being. This kind of attention threatened to reawaken my old childhood exhibitionism, and since they could teach me nothing I was tempted to demonstrate to them in flesh and blood what "personality" is. But in spite of such temptations my conduct continued to be exemplary: never absent from class, always respectful, always working ten times faster and ten times harder at every subject than the best in the class.

But the professors could not bring themselves to look upon me as a "born artist." "He is very serious," they said, "he is clever, successful in whatever he sets out to do. But he is cold as ice, his work lacks emotion, he has no personality, he is too cerebral. An intellectual perhaps, but art must come from the heart!" Wait, wait, I always thought deep down within myself, you will soon see what personality is!

The first spark of my personality manifested itself on the day when

King Alfonso XIII came to pay an official visit to the Royal Academy of Fine Art. Already then the popularity of our monarch was in decline, and the news of his coming visit divided my fellow-students into two camps. Many spoke of not appearing on that day, but the faculty, to forestall any sabotage of the splendor of the occasion, had bluntly announced severe penalties for any failure to be present on that day. One

"Cubist" portrait of King Alfonso XIII. Sketch made immediately after our meeting.

week beforehand there began a thoroughgoing house-cleaning of the Academy, which was transformed from a frightfully run-down state to one that was almost normal. A carefully planned organization was set up to change the aspect of the Royal Academy, and several clever ruses were tried out. In the course of the King's visit to the different classes the students were to run from one room to the next by some inner stairways and take their places before the King arrived, keeping their backs

to the door, so that he would have the impression that there were many more students than there really were. At that time the school had a very small attendance, and the large rooms always had a deserted look. The authorities also changed the nude models in the life classes—young but very poor creatures, and not much to look at, who were paid starvation wages—for very lovely girls who, I am sure, habitually exercised much more voluptuous professions. They varnished the old paintings, they hung curtains, and decorated the place with many trimmings and green plants.

When everything had been made ready for the comedy that was to be played, the official escort arrived with the King. Instinctively—and were it only to contradict public opinion—I found the figure of our King extremely appealing. His face, which was commonly called degenerate, appeared to me on the contrary to have an authentic aristocratic balance which, with his truculently bred nobility, eclipsed the mediocrity of all his following. He had such a perfect and measured ease in all his movements that one might have taken him for one of Velásquez's noble figures just come to life.

I felt that he had instantly noticed me among my fellow-students. Because of my hair, my sideburns, and my unique appearance this was not hard to imagine; but something more decisive had just flashed through our two souls. I was considered a representative student and, with some ten of my school-mates who had also been chosen, I was accompanying the King from one class to another. Each time I entered a new class and recognized the backs of the students whom we had just left and who were now busily working I was devoured by a mortal shame at the thought that the King might discover the comedy that was being played for his benefit. I saw these students laugh while they were still buttoning up their jackets, into which they had hurriedly changed while the Director of the School detained the King for a moment to have him admire an old picture and thereby gain a little time. Several times I was tempted to cry out and denounce the deception that was being practiced on him, but I managed to control my impulse. Nevertheless my agitation kept growing as we visited one room after another, and knowing myself as I did, I kept constantly repeating to myself, "Look out, Dali, look out! Something phenomenal is about to happen!"

When the inspection was over preparations were made for taking group pictures with the King. An armchair was ordered for the King to sit in, but instead he seated himself on the floor with the most irresistibly natural movement. Thereupon he took the butt of the cigarette he had been smoking, wedged it between his thumb and forefinger and gave it a flick, making it describe a perfect curve and fall exactly into the hole of a spittoon standing more than two metres away. An outburst of friendly laughter greeted this gesture, a peculiar and characteristic stunt of the "Chulos"—that is, the common people of Madrid. It was a graceful way of flattering the feelings of the students, and especially of the domestics who were present. They had seen executed to perfection a

"feat" which was familiar to them and which they would not have dared to perform in the presence of the professors or of the well-bred young gentlemen.

It was at this precise moment that I had proof that the King had singled me out among all the others. No sooner had the cigarette dropped into the hole of the spittoon than the King cast a quick glance at me, with the obvious idea of observing my reaction. But there was something more in this incisive glance; there was something like the fear lest some-one discover the flattery he had just proffered to the people—and this someone could be none other than I. I blushed, and when the King looked at me again he must necessarily have noticed it.

After the picture-taking, the King bade each one of us goodbye. I was the last to shake his hand, but I was also the only one who bowed with respect in doing so, even going to the extent of placing one knee on the ground. When I raised my head I perceived a faint quiver of emotion pass across his famous Bourbon lower lip. There can be no doubt that we recognized each other! Nevertheless when, two years later, the same King Alfonso XIII signed the order for my permanent expulsion from the School of Fine Arts of Madrid, he would never have believed that I was the expelled student. Or perhaps, yes—he would have believed it!

The consequences of this royal visit did not end for me that day. My emotion and my repressed tension remained unable to find any outlet; and with my feeling of discomfort further augmented, after the King had left, by the regret at not having denounced the whole farce to him, I continued to hear that inner voice repeat to me, "Dali, Dali! You must do something phenomenal." I did. And I chose the sculpture class in which to do it. This, then, is what I did. I shall tell you about it, for I am sure it cannot fail to please you.

I happened to choose the sculpture class because in this class there was an abundance of plaster, and I needed a great deal of plaster for what I wanted to do. There were in fact several sacks of it, of the finest sculptor's plaster. The time I had chosen for this was exactly half past twelve, when everyone would be gone. Thus I would not be bothered by anyone's presence, and I could do as I pleased. I went into the sculpture class and locked the door behind me. There was a large basin where old pieces of dried clay were usually being softened. I removed the largest pieces, and opened the faucet above it full force. In a few minutes the basin was almost full. Then I emptied one of the sacks of plaster into it, and waited for the resulting milk-white liquid to begin to overflow. My idea was very simple: to cause a great inundation of plaster. I accomplished this without difficulty. I used all the four sacks of plaster that were in the room with this intent, about one sack for every basinful spilled over the floor-tiles. The whole class was inundated with the plaster. As it was greatly diluted with water, the plaster took a long time to dry, and thus was able to flow under the doors. Soon I

could hear the sound of the cascade which my inundation was producing, flowing from the top of the stairway all the way down to the entrance hall. The great well of the stairway began to reverberate with such cataclysmic sounds that I suddenly realized the magnitude of the catastrophe I was producing. Seized with panic I dropped everything and left, ploughing my way through the plaster and getting frightfully bespattered. Everything was unexpectedly deserted, and no one had yet discovered what had happened. The effect of that whole great stairway inundated by a river of plaster majestically pouring down was most startling, and in spite of my fear I was forced to stop to admire this sight, which I mentally compared with something as epic as the burning of Rome, though on a smaller scale. Just as I was about to leave the inner court of the school I ran into a model, called El Segoviano (because he was from Segovia), coming in the opposite direction. As he saw the approaching avalanche of plaster he raised his arms to heaven.

"What in God's name is that?" he exclaimed in his burly peasant voice.

At this a little spark of humor flashed through my brain. Going over to him I whispered into his ear,

"At least it can't possibly all be milk!"

I reached the Students' Residence more daubed with plaster than any mason. I took a shower, changed all my clothes and stretched out on the bed, seized with a mad laughter which gave way little by little to a growing uneasiness. Because of El Segoviano who had seen me leave, it would inevitably be found out that I was the guilty one. However, from the moment I had decided to create the inundation I had not cared whether I was caught or not. This in fact was what I had wanted. I was already pondering the explanation I would give for my action, which was an oblique kind of protest against the disloyal attitude that had been shown toward our King by deceiving him. I had even had the idea of threatening to make a written declaration to this effect, thinking that this would strengthen my position to the point of making me invulnerable. But all these explanations remained vague, imprecise, and dissatisfying to my mind, which was becoming more and more rigorously attached to intelligence. All that could not be resolved in my mind in a lucid and rapid fashion created in me a feeling of deep oppression which often became a real waking nightmare. The motives and the meaning of an action as considerable as the plaster inundation which I had just produced escaped me and continued to resist my attempts at interpretation. This made me more and more uneasy, subjecting my spirit to a frightful moral torture. Was I really mad? I knew that I certainly was not. But then, why had I done this?

Suddenly I solved the enigma. And the solution to the enigma was there before me on an easel, entirely contained within the limits of an absolutely immaculate canvas which I had prepared for painting, and on which my eyes had been riveted since the beginning of this whole

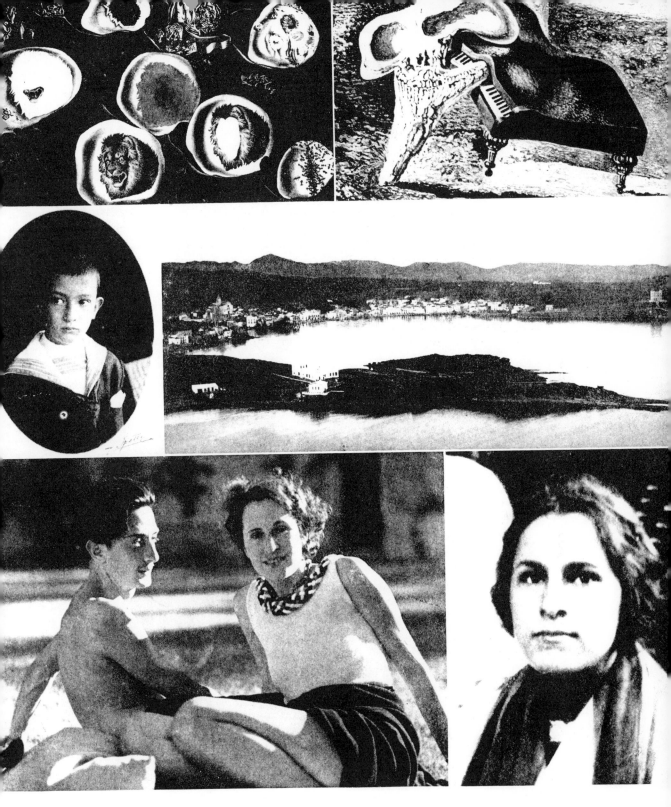

V. Cadaques : An Enchanted Village

"Accomodation of Desires," painted in 1929, recording visions inspired by a contemplation of pebbles on the beach at Cadaques.

"Sodomy Committed by a Skull with a Grand Piano," inspired by a dream at Cadaques in the summer of 1987.

Time exposure, during the taking of which I remember having held my breath while gazing out the window at the view of Cadaques.

General view of Cadaques, which I consider by far the most beautiful place in the world.

Idyll: with Gala at Cadaques.

Gala's face in this photo, taken in her youth, seems to me to have the same aura of eternity which glows about Cadaques.

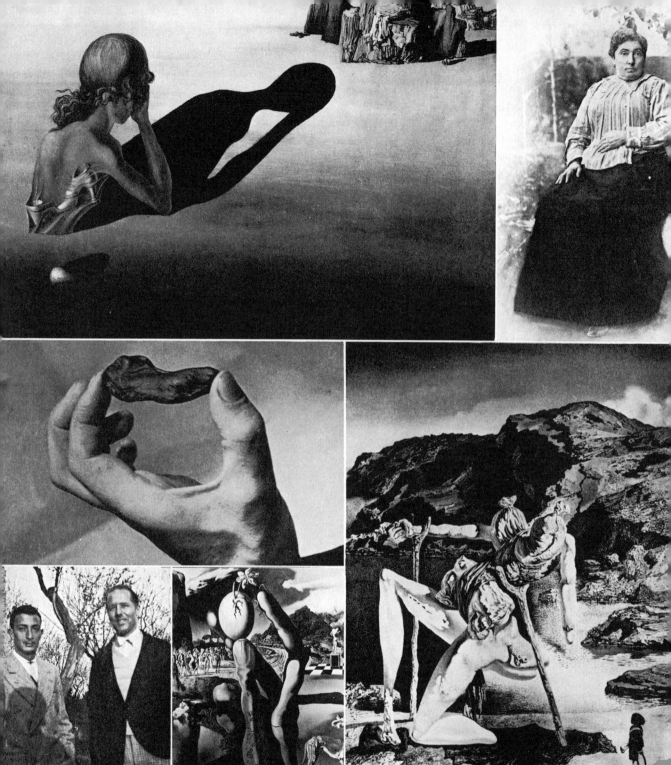

VI. Personal Magic : My Principal Fetiches

"Sphinx Embedded in the Sand," with a woman's slipper and a glass of warm milk underneath the skin of her back—the most active fetiches in my life.

Lidia, "la bien plantée," of Cadaques, godmother to my madness.

My most effective talisman, a piece of wood found in extraordinary circumstances at Cap de Creus in 1933. (Courtesy Eric Schaal-Pix)

Photo of me with the Vicomte de Noailles, my first "Maecenas."

"Metamorphosis of Narcissus"—my favorite magic flower.

"The Spectre of Sex Appeal," 1936, erotic bogie of the first order.

imaginative disturbance. As soon as I understood, I got up. I went over and took my large black felt hat, put it resolutely on my head, and placed myself before the wardrobe mirror. Then, with ceremonious gestures imbued with an extreme dignity, I saluted myself; I saluted my intelligence with the maximum of respect. But, finding that my bow was not sufficient, I humbly stooped before my own reflection, modestly lowering my head. Finally I put one knee to the floor, imitating as closely as possible the genuflection I had made that very morning before my own King.

I realized that I had been the plaything of a dream, and that this whole episode of the plaster inundation was but an illusion. The remarkable stroke of genius, however, was not this discovery itself, but its interpretation,[1] which sprang to my mind in an almost instantaneous way! Now I remembered everything.

This is what had happened.

After His Majesty the King had left the Academy of Fine Arts I took my street-car and went back to the Students' Residence. When I got to my room I lay down on the bed, exhausted by the nervous tension in which the royal ceremony had kept me during the whole morning. I remembered very well having looked with pleasure at the two white canvases all prepared and ready to be painted, placed on an easel just at the foot of the bed. After this I had fallen asleep and my sleep, according to my calculations, could have lasted at the most one hour (from half past twelve to half past one), during which I dreamed, with an intensity of realism one rarely experiences, all the vicissitudes of my plaster inundation.

I have noted down several dreams I have experienced in the course of my life which present the same typical development. They always begin by being linked to an actual event. Their argumental vicissitudes culminate exactly at the spot and in the situation in which the sleeper finds himself at the moment of awakening. This fact, greatly augmenting the dream's verisimilitude, creates a factor that is highly propitious to its confusion with reality, especially when the "manifest content" of the dream does not present (as is the case for the one I shall attempt to analyze) flagrant absurdities, always maintaining itself within the strict limits of the possible. In my own case such dreams have always come during sleep accidentally occurring at unaccustomed hours in the daytime. I believe it is also true as a general rule, as far as my own experience is concerned, that an intense light in the place where sleep occurs is favorable to dreams of a heightened visual intensity. On several occasions I have also been able to observe that sunlight beating directly on my shut eyelids has produced colored dreams.

[1] At this period I had just begun to read Sigmund Freud's *Interpretation of Dreams.* This book presented itself to me as one of the capital discoveries in my life, and I was seized with a real vice of self-interpretation, not only of my dreams but of everything that happened to me, however accidental it might seem at first glance.

To return to the analysis of the dream of the plaster inundation, here are some preliminary data for determining the intentional role of certain elements of the preceding waking period—a symbolic role of the first order. *First of all, the two prepared canvases which I have at the foot of my bed and which I look at with self-satisfaction before going to sleep:* these two canvases had previously been two studies executed in the class in what was called "drapery," which was under the auspices of the painter Cordova Julio Romero de Torres. These studies had been made in very painful circumstances in which my work, encountering the constant obstacles of incomprehension, finally sank into complete failure. The two canvases represented exactly the same subject—a little naked girl covered with a very new and shiny white silk fabric which fell from her shoulders in the form of a cape. The principal subject was this fabric. But it was impossible for me to paint it, for the model not only posed very badly, moving constantly—which made the shadows and the high-lights change—but also the little girl would rest every half hour, after-wards attempting to replace the folds in something like the original arrangement, which made it practically impossible for me to go on with my work. For the other pupils who merely derived from the model a very vague general impression, corresponding (as the habitual phrase went) rather to the folds of their temperament than to those of the white silk fabric, which they pretended nonchalantly to look at, these changes were not of the slightest importance. For me, on the contrary, who with my dilated pupils was trying to clutch everything I could of what I saw before me, each of the model's little movements, even the most imper-ceptible, glued itself to my attentive impatience like real arrows of torture. My two attempts failed. Discouraged, I left them unfinished and took them home with me, intending to paint something else over them.

But a new and even more anguishing factor appeared, weighting those two ill-fated canvases with an admixture of horror and displeasure such that I could no longer look at them. I had been forced from the beginning, not only to turn them against the wall but to shut them up in the wardrobe so as not to see them. And even so their invisible presence continued to annoy me! The second factor of anguish was the follow-ing: The little girl who served as a model had a very perfect face and a delightful pink body, like a lovely porcelain. While I was painting her she suddenly evoked for me the image of myself when as a child I would stand naked before a mirror, with my king's ermine cape over my shoulders. As I have already related at the beginning of my childhood memories, I would sometimes conceal my sexual parts by holding them between my thighs so as to look as much as possible like a little girl. During the whole painful process of working on those two uncom-pleted canvases, executed from the model of that disquieting double of myself as a child-king, I would spend my whole time mentally evaluating the relative beauty of these two kings, the one in the memories of the

past, the other in actuality, posed before me on a platform, the two bitterly struggling in jealous competition. In this competition I felt that the real absence of the male sex organs in the idealized Dali (whom I

130. Le lion rugit.

131. Le bœuf mugit.

132. Le chien aboie.

133. L'agneau bêle.

134. Le rossignol chante.

135. La grenouille coasse.

saw come to life again before me) constituted one of his most advantageous attributes, for I have desired ever since to be "like a beautiful woman," and this in spite of the fact that since my first disappointed love for Buchaques I have continued to feel a complete sexual indifference toward men. (No! Let there be no misunderstanding on this point—I am not a homosexual.) But where the rivalry between the two kings reached its peak, as an esthetic revenge to which I was entitled, was in the white satin fabric, taken from the stock-room, which I compared to the ermine the little model ought to have worn. That naked and hairless little body, had it been draped in ermine, would have appeared to me as one of the most desirable and most truly exquisite things that one could have "seen." I suggested this to the professor, who shrugged his shoulders and declared that fur was not pictorial!

I thereupon began to build the fantasy of hiring the little model for myself and going to look for an ermine cape in the shops supplying theatrical costumes. No, two ermine capes! And I began an exhausting and persevering revery which it seemed to me that nothing could stop or deflect from its course. Two ermine capes, one for her and the other for me! At the beginning I would have her hold a normal pose. But for this I needed a studio, for I could not bring her to the Students' Residence—I would not have dared—and besides, the atmosphere of my room did not lend itself to the mood of my incipient revery. Hence I had to imagine exactly how the studio in which all this was to take place "would be." I was already beginning to see it. It was very large, it looked a little like...

But suddenly I felt that I could not go any further, could not continue to imagine. There was in fact something that did not work, for naturally it would be necessary to find money for this. How could I explain to my father the sudden expense of renting a large studio, a model, ermine capes? I was marking time in my revery, and I felt that I could not advance a single step without having first solved this grave financial question which had interrupted everything. And above all I was feverishly looking forward to the erotic scenes that my reveries had made me glimpse, flashing before me in lightning succession samples of vivid images, each more desirable than the last, like the previews of films calculated by a series of brief, incoherent shots selected from the whole to give you an irresistible desire to plunge yourself into the complete contemplation of something that makes your mouth water in mere anticipation.

But as method is everything in life, so it is in revery, and I said to myself, "Salvador, do begin at the beginning. If you go step by step without haste, everything will come in due time. If you do otherwise, if you rush in and start snatching and gluttonously peeling the images which seem the most captivating at first sight, you will find that these images, not having a solid basis, not possessing a tradition, will be mere copies; they will be forced, like slaves, to resort to other similar situations in your memory that you have already exhausted. It will be a

pathetic plagiarism,[1] and not 'invention,' 'novelty'—which is after all
what you are after. But what will happen to you will be worse than this:
your little bits of images, though flashing, will not be able to resist that
constant need of 'fetishistic verification'; when you ask for it they will
not be able to show you that passport which you yourself, the supreme
chief of the police of your spirit, have constantly given and checked for
each of those short little voyages—not possessing the complete *dossier* of
their public and secret life they will be unable to produce it. You will
no longer be able to give them your confidence, and either you will
banish them as intruders and agents of disorder, paid by the propaganda
of the external world, who come and disturb the peace and prosperity
of the imaginative climate in which you live, or else you will simply
throw them into the prison of your subconscious. Therefore, if you want
to follow the course of your revery through to the end, go back a little,
and before minutely imaging the neurotic setting of your studio, where
you will see your little model with her hairless body come in every
evening, undress and afterward drape herself with malicious modesty
in her ermine cape—before all this find the money you need to make the
adventure of your studio plausible, to make you believe it!"

In order to bring all this about I had to find a friendly painter
who was already in possession of that studio. He had to have unquali-
fied admiration for me, and be about to leave for Catalonia...No, Paris
would be better—he would leave for Paris. Then he would say to me,
"Come to the studio whenever you want, here is the key; and no one
needs to know anything about what goes on here." I knew no one in
Madrid, and the course of my revery was becoming unsatisfactory, when
all at once I remembered the photograph of a well-known painter in

[1] Eugenio d'Ors once made the profound observation that "everything that is not tra-
dition is plagiarism." Everything that is not tradition is plagiarism, Salvador Dali
repeats. The most exemplary case that one can give of this to a young student of the
history of art is that of Perugino and Raphael. Raphael, while still a very young
student, found himself almost without realizing it incorporating and possessing the
whole tradition of his master, Perugino: drawing, chiaroscuro, matter, myth, subject,
composition, architecture—all this was "given" to him. Hence he was lord and master.
He was free. He could work within such narrow limits that he could give his whole
mind to doing it. If he decided to suppress a few columns or to add a few steps to
the stairway; if he thought the head of the Madonna should lean forward a little
more, that the shadow of the orbits of her eyes should have a more melancholy accent,
with what luxury, what intensity, what liberty of invention he could do this. The
complete opposite is Picasso, as great as Raphael, but damned. Damned and condemned
to eternal plagiarism; for, having fought, broken and smashed tradition, his work has
the dazzle of lightning and the anger of the slave. Like a slave he is chained hand
and foot by the chains of his own inventions. Having reinvented everything, he is
tyrannized by everything. In each of his works Picasso struggles like a convict; he is
tyrannized, reduced to slavery by the drawing, the color, the perspective, the composi-
tion, by each of these things. Instead of leaning upon the immediate past which is their
source, upon the "blood of reality" which is tradition, he must lean upon the
"memory" of all that he has seen—plagiarism of the Etruscan vases, plagiarism of
Toulouse-Lautrec, plagiarism of Africa, plagiarism of Ingres. THE POVERTY OF
REVOLUTION. Nothing is truer: "The more one tries to revolutionize, the more
one does the same thing."

Barcelona. At this moment my revery was brusquely interrupted by the professor's arrival. I got up. He simply said to me, "Don't disturb yourself, I'll come back later." But he had already disturbed me, and how! I felt that I was in the midst of thinking about something highly desirable, the only thing I would like to be able to think about again. But I tried in vain!

There is no greater anguish and bitterness than to run madly from one idea to another without being able to find again that most magic of all spots "where you were so comfortable" before you were interrupted. Everything is insipid, everything around you is worthless. But suddenly you find it again! Then you feel that the rediscovered train of thought, though agreeable enough, is not so marvelous as you had thought before you found that "thing," so greatly desired.

Nevertheless I have found it again, and I can continue my revery. Let's go ahead; it will last four or five hours. And perhaps I can continue it the next day, and at the same time perfect it. Good heavens, what a prodigious worker you are, Salvador Dali! But I overcome my temptations, and right here I shall stop describing my revery, for even though it is one of the strangest my brain has produced, it would make us lose the thread of the interpretation of the dream of the "plaster inundation," which we were discussing before we were distracted by these general considerations on the course of the river of "Revery," always so instructive.

So let the reader try to remember (by going back a little) that I had more than sufficient reasons to detest the two abortive paintings of the young girl. These canvases which I had temporarily hidden I intended, as I have already said, to paint over. As soon as this was possible I decided one morning to prepare the two canvases together, and I put them next to each other on the floor so that I could paint them both together, covering them with a coat of white color diluted with glue. This coat dried fast, but I was very much dissatisfied with the result, for the two frightful botched pictures of the little girl-model could be seen standing out very sharply through the transparent color. Then, deciding to resort to desperate measures, I prepared a large pot of white paint and poured it over the two canvases. The paint flowed over the edges and spread on the floor, but, as usual in such circumstances, far from being discouraged or stopping because of this incident, I decided that the damage was already done, and that a little more or less no longer made the slightest difference. I would clean it all up later. But for the moment I wanted to take advantage of the "inundation" to pour still another pot of paint over the canvas, this time making the paint even thicker. It would cover the two coats that were already there and would form a new one that not only would make the two detested pictures completely disappear but also and especially would cause my two canvases to acquire very thick and smooth surfaces, as though they were "covered with plaster." I poured out the second pot of paint with such lack of concern

over spilling it that it was now spreading across the floor of the room like a flood. The sun poured in through the windows, and the dazzling white consciously reminded me of the town of Figueras covered with snow, at the period of my false memories.

Having finished the story of my canvases, let us now undertake the analysis of the dream of the plaster-flood which, as we shall see, is a dream which by its blinding symbols betrays my ambitious autocratic desires of "absolute monarchy" to which I have already alluded, and which constituted the continuous desire of my whole early childhood. What did these two paintings represent for me? First of all, the double and jealous image of myself as king and as young girl. This is even illustrated materially by the fact that the two paintings representing the same subject are considered by me as two kings. This conflict of the two kings broke out on the occasion of His Majesty's visit to the Academy of Fine Arts. In fact I immediately noticed that he had singled me out among all the others. This distinction, in the unconscious, meant: he had recognized that I was a king. It is quite natural that the effect produced on my imagination by the real encounter with His Majesty Alfonso XIII should have awakened in my mind the violent royal feelings with which I had lived during my whole childhood. The King's presence revived in my mind the King I bore within my skin! During the entire visit to the school I had this impression, which did not leave me a single moment, that the two of us were uniquely and continually isolated from all the rest.

But this dualism finally disappeared, for at the moment when I made my genuflection before him I felt myself agreeably but totally depersonalized: I was completely identified with him! I was he, and since he was the real thing, all my autocracy was directed against the false one. The false king was the one I had painted on the two canvases. There the rivalry was flagrant because of the desire to have the sex organs that were the contrary of my own. When I spilled the plaster and inundated the sculpture class I realized the same symbol as I had realized in pouring the paint over my two canvases. "I effaced the rival false king." This plaster, and this paint, of an immaculate white, was the ermine mantle of the absolute monarchy which unifies all, covers, makes occult, and dominates all "majestically." It was exactly the same ermine mantle which in my memories covered the hostile reality of the town of Figueras with a shroud of snow. It was the same purifying mantle which, as it covered and hid the Academy of Fine Arts, also covered the two paintings made in this Academy, representing for me the sum of the most painful experiences suffered in this place of spiritual degradation. The plaster flood was thus nothing other than the ermine mantle of my absolute monarchy solemnly spreading from above, from the summit of the tower of the sculpture class, over everything that was "below."

Misunderstood king! Dali, for your twenty-one years you were assimilating your readings wonderfully well! I congratulate you! And now, con-

tinue, go right on telling us things and things about yourself; it fascinates us more and more! Go to it! Here we are, listening to you. Wait, wait, let me drink a glass of water!...

Four months had passed since my arrival in Madrid, and my life continued to be as methodical, sober and studious as on the first day. I am not altogether telling the truth when I say this—for in reality as my sobriety, my capacity for study, and the minute rigor to which I subjected my spirit, grew from week to week, I felt myself reaching that limit of daily discipline composed of the ritualized perfecting of each moment which leads by a direct short-cut to the very border of asceticism. I should have liked to live in a prison! I was sure that if I had lived in one I should not have regretted a single iota of my liberty. Everything in my paintings took on a more and more severe and monastic flavor, and it was on the plaster-like surface of the canvases which I had unhappily prepared with such a thick coat of paint mixed with glue that I painted these things.

I say "unhappily," because the two cubist paintings which I executed during those first four months of my stay in Madrid were two capital works, as impressive as an *auto-da-fé* [1]—which is what they were. The excessively thick preparation caused them to crack, they began to fall to pieces, and the two paintings were thus totally destroyed.

But before this, one day, they were discovered, and I with them. The Students' Residence where I lived was divided into quantities of groups and sub-groups. One of these groups was that of the artistic-literary advance guard, the non-conformist group, strident and revolutionary, from which the catastrophic miasmas of the post-war period were

[1] Act of faith—the name given to the ceremony of burning alleged heretics by the Holy Spanish Inquisition.—*Translator's note.*

already emanating. This group had recently inherited a narrow
negativistic and paradoxical tradition deriving from a group
of "ultra" *littérateurs* and painters—one of those indigenous "isms" born

of the confused impulses created by European advance guard move-
ments, and more or less related to the Dadaists. This group was com-
posed of Pepin Bello, Luis Bunuel, Garcia Lorca, Pedro Garfias, Eugenio
Montes, R. Barrades and many others. But of all the youths I was to
meet at this period only two were destined to attain the dizzy heights
of the upper hierarchies of the spirit—Garcia Lorca, in the biological,
seething and dazzling substance of the post-Gongorist poetic rhetoric, and
Eugenio Montes, in the stairways of the soul and the stone-canticles of
intelligence. The former was from Granada, and the latter from Santiago
de Compostela.

One day when I was out, the chamber maid had left my door open,
and Pepin Bello happening to pass by saw my two cubist paintings. He
could not wait to divulge this discovery to the members of the group.
These knew me by sight, and I was even the butt of their caustic humor.
They called me "the musician," or "the artist," or "the Pole." My
anti-European way of dressing had made them judge me unfavorably, as
a rather commonplace, more or less hairy romantic residue. My serious,
studious air, totally lacking in humor, made me appear to their sarcastic
eyes a lamentable being, stigmatized with mental deficiency, and at best
picturesque. Nothing indeed could contrast more violently with their
British-style tailored suits and golf jackets than my velvet jackets and
my flowing bow ties; nothing could be more diametrically opposed than
my long tangled hair falling down to my shoulders and their smartly
trimmed hair, regularly worked over by the barbers of the Ritz or the
Palace. At the time I became acquainted with the group, particularly,
they were all possessed by a complex of dandyism combined with cyni-
cism, which they displayed with accomplished worldliness. This inspired

me at first with such great awe that each time they came to fetch me in my room I thought I would faint.

They came all in a group to look at my paintings, and with the snobbishness which they already wore clutched to their hearts, greatly amplifying their admiration, their surprise knew no limits. That I should be a cubist painter was the last thing they would have thought of! They frankly admitted their former opinion of me, and unconditionally offered me their friendship. Much less generous, I still kept a speculative distance. I wondered what benefit I could derive from them, and whether they really had anything to offer me.

They literally drank my ideas, and in a week the hegemony of my thought began to make itself felt. Wherever members of the group were present the conversation was sprinkled with, "Dali said..." "Dali answered..." "Dali thinks..." "How did Dali like this?" "It looks like Dali." "It's Dalinian..." "Dali must see that..." "Dali ought to do that..." And Dali this, and Dali that, and Dali everything!

Although I realized at once that my new friends were going to take everything from me without being able to give me anything in return—for in reality of truth they possessed nothing of which I did not possess twice, three times, a hundred times as much—on the other hand, the personality of Federico Garcia Lorca produced an immense impression upon me. The poetic phenomenon in its entirety and "in the raw" presented itself before me suddenly in flesh and bone, confused, blood-red, viscous and sublime, quivering with a thousand fires of darkness and of subterranean biology, like all matter endowed with the originality of its own form.[1] I reacted, and immediately I adopted a rigorous attitude *against* the "poetic cosmos." I would say nothing that was indefinable, nothing of which a "contour" or a "law" could not be established, nothing that one could not "eat" (this was even then my favorite expression). And when I felt the incendiary and communicative fire of the poetry of the great Federico rise in wild, dishevelled flames I tried to beat them down with the olive branch of my premature anti-Faustian old age, while already preparing the grill of my transcendental prosaism on which, when the day came, when only glowing embers remained of Lorca's initial fire, I would come and fry the mushrooms, the chops and the sardines of my thought (which I knew were destined to be served some day—fried to a turn, and good and hot—on the clean cloth of the table of the book which you are in the midst of reading) in order to appease for some hundred years the spiritual, imaginative, moral and ideological hunger of our epoch.

Our group was taking on a more and more anti-intellectual color; hence we began to frequent intellectuals of every sort, and to haunt the cafés of Madrid in which the whole artistic, literary and political future of Spain was beginning to cook with a strong odor of burning oil. The

[1] Form presents itself as the result of elementary physical modifications. Among these are the reactions of matter (general morphology).

double vermouths with olives contributed generously to crystallize this budding "post-war" confusion, by bringing a dose of poorly dissimulated sentimentalism which was the element most propitious to the elusive transmutations of heroism, bad faith, coarse elegance and hyperchloridic digestions, all mixed up with anti-patriotism; and from this whole amal-

"Head molested by flies"

gam a hatred rooted in bourgeois mentality which was destined to make headway grew, waxed rich, opening up new branches daily, backed by unlimited credit, until the day of the famous crash of the then distant Civil War.

I said a moment ago that the group which had just taken me so generously to its bosom was incapable of teaching me anything, and even as I said this I knew that it was not altogether true, since the group nevertheless taught me one thing, and it was precisely because of this thing that I remained in the group, and that I was going to continue to remain. They taught me how to go on a bender. I spent about three days at it: two days for the barber, one morning for the tailor, one afternoon for money, fifteen minutes to get drunk, and until six o'clock the next morning to go on the "bender." I must relate all this in detail.

One afternoon the whole group of us were having tea in one of the fashionable spots in Madrid, which naturally was called the Crystal Palace. No sooner did I enter it than everything became clear to me. I had radically to change my appearance. My friends, who took a much more decided pride in my person than I (since my immeasurable arrogance always immunized me against being affected by anything), were eager to defend my truculent appearance, and even to force its acceptance, with an energetic and resolute courage. They were ready to sacrifice everything for this, and their vehement non-conformism tended to make a veritable battle-flag of my preposterous get-up. By their offended air they seemed to want to answer the furtive, discreet, though insistent glances from the elegant throng that surrounded us by saying, "Well! Our friend looks like a gutter rat, to be sure, but he is the most important personage you have ever met, and at the slightest incivility on your

part we'll knock you down." Bunuel especially, who was the huskiest and most daring among us, would survey the room to discover the slightest occasion to pick a fight. For that matter, he would seize on any pretext that promised to end in a free-for-all. But nothing happened. When we got outside I said to the bodyguards of my outlandishness, "You've been very decent with me. But I'm not at all anxious to keep this up. Tomorrow I'm going to dress like everyone else!"

This decision, made on the spur of the moment, impressed everyone deeply, for they had all become terribly "conservative" about my appearance. My decision was discussed endlessly and with the same kind of emotion that must have possessed Socrates' disciples when he stoically announced that he was going to drink the hemlock. They tried to make me go back on my decision—as though my personality were attached to my clothes, my hair and my sideburns, and ran the risk of being destroyed and of disappearing along with the paralyzing aspect of my amazing capillary and sartorial emblems. But my decision was irrevocable. The principal and secret reason was that I was bent on something which suddenly appeared to me as of capital importance. I wanted to be attractive to elegant women. And what is an elegant woman? I had found out just now, in the tea-room, by observing one sitting at the opposite table. An elegant woman is a woman who despises you and who has no hair under her arms. On her for the first time I had discovered a depilated armpit, and its color, so finely and delicately blue-tinged, appeared to me as something extremely luxurious and perverse. I made up my mind to study "all these questions," and to do so—as I did everything—thoroughly!

The next morning I began at the beginning—with my head. However, I did not dare go directly to the Ritz barbershop, as my friends had recommended. I therefore went in search of an ordinary barber. I thought I would have him do it just "roughly," and have the rest of my hair properly cut at the Ritz in the afternoon. But each time I reached the door of a barbershop I would suddenly be seized with timidity and decide to go elsewhere. The time it would take to say "Cut my hair" was really a difficult moment to get across.

Toward the end of that afternoon, after a thousand hesitations, I finally made up my mind to it. But as soon as I saw the white towel in which the barber had enveloped me become covered with my ebony-black strands I was seized for a moment with a Samson complex. What if the story about Samson were true? I looked at myself in the mirror in front of me, and I thought I saw a king on his throne. But this produced in me a great uneasiness. Nothing, in fact, more resembles the grotesque parody of a royal ermine cape than the large and solemn white towel sprinkled with the black tails of our own hair that are being snipped off our heads. It is curious, but that is how it is. It was the first and the last time in my life that for several minutes I lost faith in myself. My image of a king-child appeared to me suddenly as a painful case of bio-

logical deficiency, the product of a catastrophic disequilibrium between my sickly, feeble, backward constitution and a precocious but sterile intelligence incapable of functioning in the realm of action, with nothing to look forward to but the degeneration of the terribly incomplete and spiritually aged freak that I was.

I was thinking all these things while the hair fell in shreds on my knees and on the tiled floor—which I remember very well having been of yellow, white and blue porcelain representing a kind of dragon-fish biting its tail. Was I perhaps an imbecile like all the others? I paid, gave the tip and headed toward the Ritz where the barber would put the finishing touches on the work.

As soon as I was in the street, with the barber's door shut behind me, I felt myself a different man, and all my recent scruples and fears melted in an instant like a soap bubble. I knew that the slamming of that door had separated me forever from the swampy blackness of my hair which they must now be sweeping up. I no longer regretted anything, anything, and with the allegorical, age-avid mouth of the Medusa of my anti-sentimentalism, of my anti-Faust, I spat the last unprepossessing hair of my adolescence upon the pavement of time. Instead of going to the barber's when I reached the Ritz, I headed for the bar and asked for "a cocktail."

"What kind will you have?" asked the bartender.

"Make it a good one!" I said, not knowing there were several kinds.

It tasted horrible to me, but at the end of five minutes it began to feel good inside my spirit. I definitely dropped the idea of the barber for the afternoon and asked for another cocktail. I then became aware of this astonishing fact: in four months this was the first day I had missed school, and the most stupefying part of it was that this did not give me the slightest feeling of guilt. On the contrary, I had a vague impression that this period was ended, and that I would never return. Something very different was going to come into my life.

In my second cocktail I found a white hair. This moved me to tears, in the euphemistic intoxication produced by the first two cocktails I had drunk in my life. This apparition of a white hair at the bottom of my glass appeared to me to be a good omen. I felt ideas and ideas being born and vanishing, succeeding one another within my head with an unusual speed—as if, by virtue of the drink, my life had suddenly begun to run faster. I said to myself, "This is my first white hair!" And again I sipped that fiery liquid which I had to swallow with my eyes shut, because of its violence. This perhaps was the "elixir of long life," the elixir of old age, the elixir of the anti-Faust.

I was sitting in a dark corner from which I could easily observe everything, without being observed—which I was able to verify, as I had just said "elixir of the Anti-Faust" aloud and no one had noticed it. Besides, there were only two persons in the bar in addition to myself—the bartender, who had white hair but seemed very young, and an extremely

emaciated gentleman, who also had white hair, and who seemed very old, for when he lifted his glass to his lips he trembled so much that he had to take great precautions not to spill everything on the floor. I found this gesture, betraying a long habit, altogether admirable and of supreme elegance; I would so much have liked to be able to tremble like that! And my eyes fastened themselves once more on the bottom of my glass, hypnotized by the gleam of that silver hair. "Naturally I'm going to look at you close," I seemed to say to it with my glance, "for never yet in my life have I had the occasion, the leisure, to take a white hair between my fingers, to be able to examine it with my avid and inquisitorial eyes, capable of squeezing out the secret and tearing out the soul of all things."

I was about to plunge my fingers into the cocktail with the intention of pulling out the hair when the bartender came over to my table to place two small dishes on it, the one containing olives stuffed with anchovies, the other *pommes soufflées.*

"Another?" he asked with a glance, seeing that my glass was less than half full.

"No thanks!"

With a ceremonious gesture he then wiped up a few drops that I had spilled on the table and went back to his post behind the bar. Then I plunged my forefinger and my thumb into my glass. But as my nails were cut very, very short it was impossible for me to catch it. In spite of this I could feel its relief; it seemed hard and as if glued to the bottom of the glass. While I was immersed in this operation an elegant woman had come in, dressed in an extremely light costume with a heavy fur hanging around her neck. She spoke familiarly, lazily to the bartender. Full of respectful solicitude, the latter was preparing for her something that required a great din of cracking ice. I immediately understood the subject of their conversation, for an imperceptible glance cast by the bartender toward the spot where I was sitting was followed after a short interval by a long scrutinizing gaze from the lady. Before fixing her eyes on me with an insistent curiosity she let her eyes wander lazily around the entire room, resting them on me for a mere moment, meaning in this clumsy way to make me believe it was by pure chance that her gaze settled on me. With his eyes glued to the metal counter, the bartender waited for his companion to have time to examine me at her leisure, and then, with rapid words and an ironic though kindly smile, he told her something about me which had exactly the effect of making the woman's face turn in my direction a second time. This time she did it with the same slowness, but without taking any precautions. At this moment, exasperated as much by this scrutinizing gaze as by my clumsiness in not being able to get out the white hair, I pressed my finger hard against the glass and slowly pulled it up, slipping it along the crystal with all my might. This I could do without being seen, for a column concealed half of my table from the lady and the bartender just at the spot where my hand and my glass happened to be.

I did not succeed in detaching the white hair, but suddenly a burning pain awakened in my finger. I looked, and saw a long cut that was beginning to bleed copiously. Out of my wits, I put my finger back into the glass so as not to spatter blood all over my table. I instantly recognized my error. There was no hair at the bottom of my glass. It was simply a very fine crack that shone through the liquid of my accursed cocktail. I had cut myself by mistake in sliding the flesh of my finger hard along this crack, with the impulsive pressure which the lady's second glance had increased in intensity. My cut was at least three centimetres long and it bled uniformly and without interruption. My cocktail became almost instantly colored a bright red and began to rise in the glass.

I was sure I knew what the bartender had said to the lady. He had told her that I was most likely a provincial who had dropped in here by chance, and that not knowing what kind of cocktail to order I had naïvely asked him to "make it a good one." In spite of the distance I could have sworn that I had seen exactly these syllables emerge from between the bartender's lips. At the moment when he finished telling his anecdote my blood had begun to color my drink, making it rise, and my hemorrhage continued. Then I decided to tie a handkerchief round my finger. The blood immediately went through it. I put my second and last handkerchief over it, making it tighter. This time the spot of blood which appeared grew much more slowly, and seemed to stop spreading.

I put my hand in my pocket and was about to leave, when a Dalinian idea assailed me. I went up to the bar and paid with a twenty-five peseta bill. The bartender hastened to give me my change—my drink was not more than three pesetas. "That's all right," I said with a gesture of great naturalness, leaving him the whole balance as a tip. I have never seen a face so authentically stupefied. Yet I was already familiar with this expression; it was the same that I had so often observed with delight on the faces of my schoolmates when as a boy I had exchanged the famous ten-centimo pieces for fives. This time I understood that it worked "exactly" the same way for grown-ups and I at once realized the supremacy of the power of money. It was as if by leaving on the bar the modest sum of my disproportionate tip I had "broken the bank" of the Hotel Ritz.

But the effect I had produced did not yet satisfy me, and all this was but the preamble to that Dalinian idea which I announced to you a while ago. The two cocktails I had just drunk had dissipated every vestige of my timidity, all the more so as I felt after my tip that the roles were reversed and that I had become the author of intimidation. An assurance and perfect poise now presided over the slightest of my gestures, and I must say that everything I did from this moment until I reached the doorstep was marked by a stupefying ease. I could read this constantly on the face of the bartender as in an open book.

"And now I should like to buy one of those cherries you have there," I said pointing to a silver dish full of the candied fruit.

He respectfully put the dish before me. "Help yourself, Señor, take all you want."

I took one and placed it on the bar.

"How much is it?"

"Why, nothing, Señor. It's worth nothing."

I pulled out another twenty-five peseta bill and gave it to him.

Scandalized, he refused to take it.

"Then I give you back your cherry!"

I put it back into the silver dish. He reached the dish over to me, beseeching me to put an end to this joking. But my face became so severe and contracted, so offended, so stony, that the bartender, completely bewildered, said in a voice touched with emotion,

"If the Señor absolutely insists on making me this further present..."

"I insist," I answered in a tone which admitted of no argument.

He took my twenty-five pesetas, but then I saw a rapid gleam of fear flash across his face. Perhaps I was a madman? He cast a quick glance at the lady seated beside me at the bar whom I could feel staring at me hypnotically. I had not looked at her for a single second, as though I had been completely unaware of her presence. But now it was to be her turn. I turned toward her and said,

"Señora, I beg you to make me a present of one of the cherries on your hat!"

"Why, gladly," she said with agile coquettishness, and bent her head a little in my direction. I took hold of one of the cherries and began to pull it. But I saw immediately that this was not the way to do it, and remembered my long experience with such things. My aunt was a hatmaker, and artificial cherries had no secrets for me. So instead of pulling, I bent the stem back and forth until the very slender wire that served as its stem broke with a snap, and I had my cherry. I performed this operation with a prodigious dexterity and with a single hand, having kept my other, wounded, hand buried in the pocket of my coat.

When I had obtained my new artificial cherry I bit it, and a small tear revealed the white cotton of its stuffing. Having done this, I placed it beside the real cherry, and fastened the two together by their stems, winding the wire stalk of the false one around the tail of the real one. Then, to complete my operation, I picked off with a cocktail straw a little of the whipped cream that covered the lady's drink and applied it to the real cherry, so that now the real and the false both had a white spot, the one of cream and the other of cotton.

My two spectators followed the precise course of all these operations breathlessly, as if their lives had hung on each of my minute manipulations.

"And now," I said, solemnly raising my finger, "you will see the most important thing of all."

Turning round, I went over to the table I had just occupied and, taking the cocktail glass filled with my blood, and holding my hand

Symbol of my speculating days during the war.

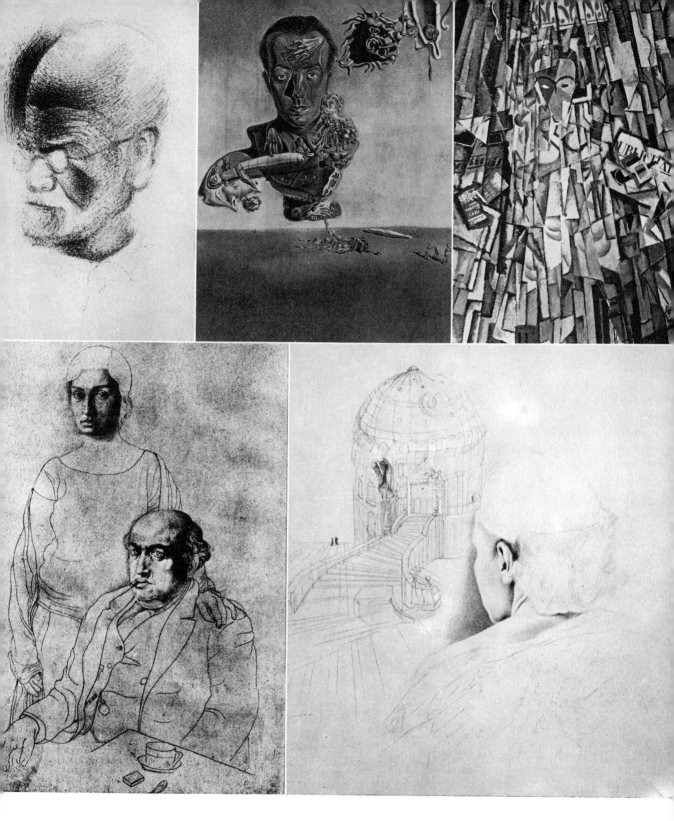

VII. My Rare Works

Portrait of Sigmund Freud, done on blotting paper in London a year before his death.

My first Surrealist portrait: Paul Eluard, at Cadaques in 1929.

Self Portrait, my first Cubist painting, done in 1920.

Portrait of my Father and Sister, my first pencil drawing.

My first "architectural drawing," inspired by the contours of Gala's head.

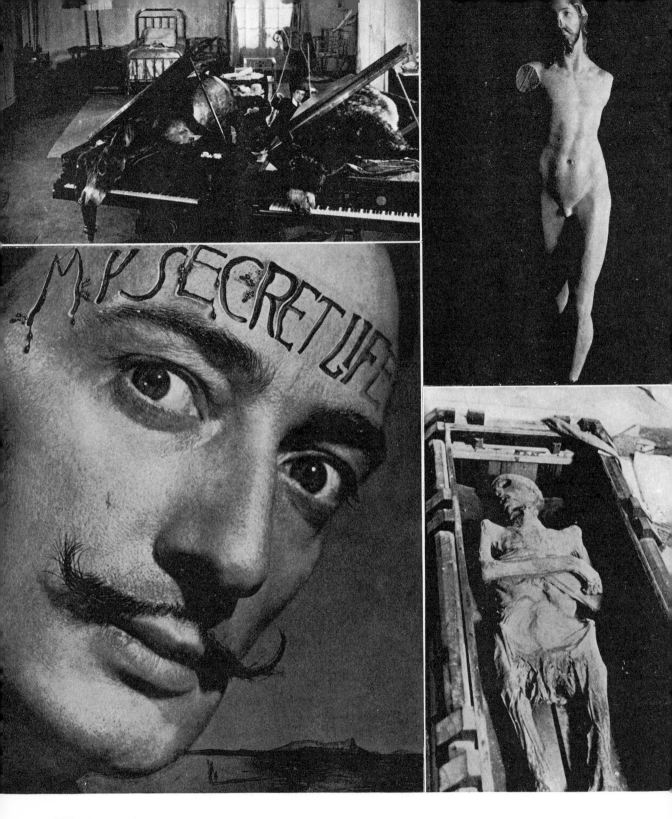

VIII. The Tragic Implications of Spain

"Le Chien Andalu," first Surrealist film by Dali and Bunuel: asses putrefying on pianos.

El Greco's statue of Christ. The Loyalists called it "El Rey de los Maricones."

"My Secret Life," engraved on my forehead. (Courtesy Halsman)

One of the famous "Lovers of Teruel," disinterred at the outset of the Civil War.

around it, carried it cautiously and daintily put it down on the metal top of the bar; after which, quickly removing my hand from it and picking up the two cherries by their joined stems I plunged them into the glass.

"Observe this cocktail carefully," I said to the bartender. "This is one you don't know!"

Then I turned on my heels and calmly left the Ritz Hotel.

I thought over what I had just done, and I felt as greatly moved as Jesus must have felt when he invented Holy Communion. How would the bartender's brain solve the phenomenon of the apparition, in a glass which he had observed with his own eyes to be half empty a moment before, of the red liquid which now filled it to the brim? Would he understand that it was blood? Would he taste it? What would they say to each other, the lady and the bartender, after my departure?

From these absorbing meditations I passed abruptly and without transition to a mood of joyous exaltation. The sky over Madrid was a shattering blue and the brick houses were pale rose, like a sigh filled with glorious promises. I was phenomenal. I was phenomenal. The distance which separated the Ritz Hotel from my street-car stop was rather long and I was hungry as a wolf. I began to run through the streets as fast as my legs would carry me. It astonished me that the people I passed were not more surprised at my running. They barely turned their heads in my direction and continued about their business in the most natural way in the world. Peeved by this indifference, I embellished my run with more and more exalted leaps. I had always been very adept at high-jumping, and I tried to make each of my leaps more sensational than the last. If my running, unusual and violent though it was, had not succeeded in attracting much attention, the height of my leaps surprised all passers-by, imparting an expression of fearful astonishment to their faces which delighted me. I further complicated my run with a marvelous cry. "Blood is sweeter than honey," I repeated to myself over and over again. But the word "honey" I shouted at the top of my lungs, and I pushed my leap as high and hard as I could. "Blood is sweeter than HONEY." And I leaped. In one of these mad leaps I landed right beside a fellow-student of the School of Fine Arts, who had never known me otherwise than in my studious, taciturn and ascetic aspect. Seeing him so surprised I decided to astonish him even further. Making as if to whisper an explanation of my incomprehensible leaps, I brought my lips close to his ear. "Honey!" I shouted with all my might. Then I ran toward my streetcar which was approaching and jumped aboard, leaving my co-religionist in study glued to the sidewalk and looking after me till I lost sight of him. The next day this student told everyone, "Dali is crazy as a goat!"

That next morning I arrived at the Academy immediately before the end of classes. I had just bought the most expensive sport suit in the most expensive shop I could find in Madrid, and I wore a sky-blue silk shirt with sapphire cuff-links. I had spent three hours slicking down my

hair, which I had soaked in a very sticky brilliantine and set by means of a special hairnet I had just bought, after which I had further varnished my hair with real picture varnish.[1] My hair no longer looked like hair. It had become a smooth, homogeneous, hard paste shaped to my head. If I struck my hair with my comb it made a "tock" as though it were wood.

My complete transformation, effected in a single day, created a sensation among all the students of the School of Fine Arts, and I immediately realized that, far from getting to look like everybody else as I had tried to, and in spite of having bought everything in the most exclusive and fashionable shops, I had succeeded in bringing these things together in such an unusual way that people still turned round to look at me as I went by exactly as they had before.

Picassos influence

Nevertheless my potentialities as a dandy were now definitely established. My grubby and anachronistic appearance was replaced by a contradictory and fanciful amalgam which at least produced the effect of being expensive. Instead of inspiring sarcasm, I now released an admiring and intimidated curiosity. On coming out from the School of Fine Arts I ecstatically savored the homage of that street, so intelligent and full of wit, in which spring was already seething. I stopped to buy a very flexible bamboo cane from whose leather-sheathed handle dangled a shiny strap of folded leather. After which, sitting down at the terrace of the Café-Bar Regina, and drinking three Cinzano vermouths with olives, I contemplated in the compact crowd of my spectators passing before me the whole future that the anonymous public already held in reserve for me in the bustle of their daily activities—activities that left no trace, activities devoid of anguish and of glory.

At one o'clock I met my group in the bar of an Italian restaurant called "Los Italianos," where I had two vermouths and some clams, after which we went over to occupy a table which was reserved for us. The story of the tip I had given the bartender had spread like wildfire into

[1] Removing this varnish from my head was a whole drama. The only way to dissolve it was by dipping it in turpentine, which was dangerous for the eyes. After this (except on one occasion that I shall describe in its proper place) I never used picture varnish again, but I achieved almost the same effect by adding white-of-egg to the brilliantine.

the dining-room, and when we got there all the waiters saw us coming and stood at attention. I remember perfectly the menu that I selected on that first day at the restaurant—assorted hors-d'oeuvres, jellied madrilene, macaroni au gratin, and a squab, all this sprinkled with authentic red Chianti. The coffee and the cognac served as a further stimulant to the continuance of the principal theme of our conversations, which was none other than the initial theme of the vermouth developed in the course of the meal and which, naturally, was "anarchy."

There were about half a dozen of us at that dinner, all members of the group, but already it was apparent that a large majority tended vaguely toward the kind of liberal socialism which would some day become a fertile pasture for the extreme left. My position was that happiness or unhappiness is an ultra-individual matter having nothing to do with the structure of society, the standard of living or the political rights of the people. The thing to do was to increase the collective danger and insecurity by total systematic disorganization in order to enhance the possibilities of anguish which, according to psychoanalysis, condition the very principle of pleasure. If happiness was anyone's concern it was that of religion! Rulers should limit themselves to exercising their power with the maximum of authority; and the people should either overthrow these rulers or submit to them. From this action and reaction can arise a spiritual form or structure—and not a rational, mechanical and bureaucratic organization. The latter will lead directly to depersonalization and to mediocrity. But also, I added, there is a utopian but tempting possibility—an anarchistic absolute king. Ludwig II of Bavaria was after all not so bad!

Polemics gave an increasingly sharp form to my ideas. (Never has it served to modify my ideas, but on the contrary to strengthen them.)

Let us examine, if you will, the case of Wagner. Consider the Parsifal myth impartially from the social-political point of view... I reflected for a moment and, as if overcoming my doubts, turned to the waiter who had quickly become corrupted by our intellectualism and never missed a word of our discussions.

"Waiter, please..." I said, and he stepped forward respectfully, "on thinking it over I think I'd like a little more toast and sausage."

He went immediately. I called after him,

"And another drop of wine!"

The case of the Parsifal myth, considered from the political and social point of view, did in fact require still further reinforcements...

Leaving the Italian restaurant I went back to the Students' Residence to get some more money. What I had taken in the morning had been incomprehensibly spent. Getting money was simple. I went to the Residence office, I asked for the sum I wished, and I signed a receipt.

When I had finished my business at the Residence our group reconstituted itself at the table of a German beer-house where authentic brown beer could be had. With it, by way of accompaniment, we ate some hun-

dred cooked crabs, the shelling and sucking of whose legs was most pro-
pitious to the continued development of the Parsifal theme.

Evening fell very fast, as if by miracle, and we were obliged to move
to the Palace in order to drink our *apéritif,* which this time consisted of
just two Martinis. These were my first dry Martinis, and I was to remain
pretty faithful to them from then on. The *soufflées* potatoes disappeared
dizzily from our table, but immediately a swift and willing hand brought
new ones in their place.

The question soon arose as to where we should eat! For the idea of
returning to the clean and sober refectory of the Students' Residence did
not occur to me for a moment. I have always adored habits, and when
something has succeeded I am capable of adopting it for the whole rest
of my life.

"Suppose we return to The Italians?"

Everyone acclaimed this suggestion; we telephoned to Los Italianos
to reserve a small dining-room, and we patiently directed our footsteps
toward this spot, with a growing famine devouring our entrails.

The dining-room was small but charming. There was a black piano
with lighted pink candles on it, and a winestain on the wall, as visible
as a decoration. What shall we eat? I should be lying if I were to tell
you that I can remember. I know only that there was white wine and red
wine in abundance, and that the conversation became so stormy, every-
one shouted so loudly, that I ceased to take part in it. Sitting down to
the piano I tried to play Beethoven's Moonlight Sonata with one finger.
I even succeeded in inventing an accompaniment for my left hand, and
they had to tear me from the piano by main force in order to take me
along to the Rector's Club at the Palace (which was one of the smartest
places) to drink a little champagne. This "little" I knew was a good
deal, for after all the hour was approaching at which I had already
planned to get drunk. Once we were seated Bunuel, who was more or
less our master of ceremonies, suggested,

"Let's begin by drinking some whiskéy, and later on we'll eat a few
tidbits before going to bed—and then we'll take some champagne."

Everyone thought this idea excellent, and we set to work. All of us
agreed that a revolution was necessary. This point was not arguable.
But how was it to be made, who was to make it, and why did it have
to be made? This was not so clear as it had seemed at first. Meanwhile,
as the revolution was not going to break out this very night, and as it
would serve no good purpose to become too much absorbed in this ques-
tion, we ordered a round of iced mint to fill in between whiskeys, for
after all we had to rest from time to time. At the end of the fourth
whiskey everyone began to get impatient, and ask Bunuel anxiously,
"What about that champagne?"

With all this it was getting to be two o'clock in the morning and our
wolfish hunger made it a foregone conclusion that the champagne would
have to be accompanied by something. I took a plate of hot spaghetti

and the others a cold chicken. Toward the end of my spaghetti I began to regret my choice and to look more and more longingly at the cold chicken. I had been offered some several times, and as I had refused I did not want to go back on my decision. The talk now revolved about the theme imposed by the lyricism of the champagne which had been flowing for several minutes. This theme, as you have already guessed, was "love and friendship." Love, I said, strangely resembled certain gastric sensations at the first signs of seasickness, producing an uneasiness and shudders so delicate that one is not sure whether one is in love or feels like vomiting.

"But I'm sure that if we went back to the subject of Parsifal it might still throw some light."

Everyone uttered cries of protest. They wanted to hear no more of that!

"Well, then we will come back to it another day. But anyway, save me a chicken wing for later on, for just before we leave."

It was five o'clock, and the last minute was approaching. It was a cruel thing to have to go to bed just when everything was beginning to go better. With a sense of bitterness we uncorked a fresh bottle of champagne. My friends' eyes were moist with tears. The Negro orchestra was excellent and stirred the depths of our bowels with the spoon and fork of its syncopated rhythm which gave us no respite. The pianist played with a divine incontinence, and in the high lyrical moments, during his accompaniments composed of expectations, one could hear the sound of his panting rise above the noises; and the saxophone player, having blown out all the blood of his passion, collapsed with exhaustion never to rise again. It was our discovery of jazz, and I must say in all honesty that it made a certain impression upon me at the time. In the course of the night we sent up several sizable tips, discreetly folding the bills into an envelope, and this was so unusual that all the Negroes, at the order of the pianist who conducted them, got up in unison and bowed, machine-gunning us with the dazzling fire of all their teeth laughing at once. Bunuel proposed that we serve them a bottle of champagne, and because of this we ordered still another one so as to be able to clink glasses at a discreet distance with the musicians, for the Negroes would never have been allowed to approach our table. For us money did not count. We were really of a limitless magnificence and generosity with the money earned by our parents' labors.

The fresh bottle of champagne inspired my friends to a vow which was to join all of us together in a solemn pact. We pledged ourselves on our "word of honor" that whatever happened to us in life, whatever might be our political convictions, and whatever might be the difficulties—even if we should find ourselves in the most distant countries and a long voyage should be required—we pledged ourselves, as I said, to meet in the same spot in exactly fifteen years; and if the hotel had been destroyed, then in the spot which it had occupied. The possibility of

being able to find again the exact spot where we were in case the hotel and its surroundings had by chance suffered an intense bombardment shortly before, or in case this should happen at the very time when, fifteen years later, we were about to appear at our pledged meeting, started a discussion that got endlessly complicated, and I lost all interest in it.

I began to let my glance stray over that elegant jewel-besprinkled flesh that surrounded us and that seemed to clutch at my heart. Was it really this, or a slight urge to vomit, as I had said a while ago to be cynical? With a dubious appetite I ate the chicken leg that someone had saved for me.

Another bottle of champagne proved indispensable to enable us to reach an agreement. There were six of us, and we divided into six parts the card on which the Rector's Club and the table number were printed (I think I remember that the number was 8, because of a discussion on the symbolic significance of that number), and on each part we wrote the date and other data on one side, and on the other, the six signatures. I called attention to the symbolic significance—since we were talking precisely about symbols—of our signing a pact on a piece of paper that we had immediately before torn up several times. But no one would take this into consideration, and we signed on the six pieces as we had agreed. After which each one of us kept his piece.[1]

The pact having been religiously signed, a last bottle was absolutely required to enable us to celebrate the happy conclusion of our agreement with due ceremony.

At about the time when the meeting stipulated in our pact was to have taken place, civil war raged in Spain. Imagine the Palace Hotel of Madrid, where we had lived our golden youth, transformed into a blood transfusion hospital and bombed. What a fine subject for Hollywood could be made of the heroic Odyssey of those six friends—separated for so long, separated, too, or united, by irreducible hatreds or the unanimous fervor of their fanatical opinions—repressing for a moment their tumultuous passions, temporarily putting aside their disagreements, in a dramatic, lugubrious and ceremonious meal, as a noble tribute to the honor of a word! I do not know whether this chimerical meal took place or not. All I can tell you, and I whisper this into your ear, is that I was not present.

As all things in the world must have an end, so did our night at the Rector's Club. But we found yet another *bistrot* which was open till dawn, frequented by carters and night-watchmen and the kind of people who take trains at impossible hours. There we gathered for a last round of *anis del Mono*. Dawn was already pecking, with the crowing of the

[1] When, nine years later, I met one of these friends again in Paris who admitted to me that he still preciously preserved his piece of this pact, I was once more stupefied by the endemic childishness of humanity. Of all animals, of all plants, of all architectures, of all rocks, it is man who finds it hardest to age.

first cocks, at the windows of the *bistrot*. Come on! Come on, let's get some sleep! Enough for today. Tomorrow is another day.

Tomorrow I was going to begin my new Parsifal! My Parsifal of the morrow was as follows. Up at noon. From noon to two o'clock, five vermouths with olives. At two o'clock, a dry Martini with very fine slices of "Serrano" ham and anchovies, for I had to pass the time before the arrival of the group. I have no recollection of the lunch, except that at the end of it I had the whim of drinking several glasses of chartreuse, in memory of the end of certain Sunday dinners at my parents' in Cadaques —which made me weep.

At five or six o'clock in the afternoon we found ourselves once more seated around a table, this time in a farm on the outskirts of Madrid. It was a small patio with a magnificent view overlooking the Sierra del Guadarrama, spotted with very black oak trees. We decided it was time to have a bite to eat. I had a large plate of cod with tomato sauce. Some carters at an adjoining table were eating it with their knives, and the idea of combining the taste of the metal directly with that of the cod struck me as extremely delicate and aristocratic.

After the cod I asked for a partridge, but there were none at this season. I wanted by all means to eat something succulent. The proprietress suggested either warmed-over rabbit with onions, or a squab. I said I did not want anything warmed-over, and decided on the squab. The proprietress, a little annoyed, called my attention to the fact that sometimes warmed-over things are the best. I hesitated for a moment, but persisted in ordering the squab. The trouble was that it was already so late that in not more than two hours we would have to eat dinner in earnest. We therefore decided that it was better to eat now, and later on, around midnight, we would just have something cold. So I said to the proprietress,

"All right, bring me the rabbit you speak so well about, too."

How right she was! With the sensual intelligence that I possess in the sacred tabernacle of the palate I understood in a moment the mysteries and the secrets of the warmed-over dish. The sauce had attained a suggestion of elasticity peculiar to the warmed-over dish which made it adhere delicately to the inside of the mouth, seeming to distribute the taste uniformly and making one click one's tongue. And believe me, that prosaic sound, which so much resembles the horror of hearing a cork pop, is the very sound of that thing so rarely understood—even more rarely understood when it is not accompanied by this sound—"satisfaction." In short, that modest rabbit gave me a great deal of satisfaction.

We left, and at this moment I realized that we had come in two luxurious cars. No sooner had we returned to Madrid than our plan for a small cold supper at midnight vanished, and once more the spectre of food placed itself before us with its terrible and inevitable reality.

"Let's begin by drinking something," I suggested. "We are not in a hurry. After that we will see."

This was necessary and reasonable, for the wine at the farm was poor, and I had eaten my rabbit to the sole accompaniment of water. I had three Martinis, and toward the end of the third I distinctly felt that my Parsifal was about to begin.

I had my plan. I got up, on the pretext of having to go to the toilet, and quietly left by another door. Breathing deeply the air of freedom, which was for me that of the entire sky, I was stirred by the joyful thrill of feeling myself suddenly alone once more. I had a fantastic plan for this night, and this plan I called my "Parsifal." I took a taxi that brought me to the Students' Residence, and had it wait. It would take me just an hour. My "Parsifal" required that I make myself very handsome. I took a long shower, gave myself a very close shave, glued down my hair as much as possible, putting paint-varnish on it again! I knew the serious inconveniences of this, and even that it would spoil my hair a little, but my Parsifal was worth this sacrifice, and more! I applied powdered lead around my eyes; this made me look particularly devastating in the "Argentine tango" manner. Rudolph Valentino seemed to me at that time to be the prototype of masculine beauty. I put on very pale cream-colored trousers, and an oxford-gray coat. As for the shirt, I had an idea that appeared to me to put the definitive touch of elegance to my outfit. The shirt was of écru silk, a silk fine as onion-skin and so transparent that on looking attentively one could see through it the rather well-defined black imperial eagle of the hair in the middle of my chest. But the outline was too clear. So I took off the shirt, which had been freshly ironed, and squeezed it between my two hands, folding and pressing it into a bunch between my closed fists. I put this bundle of wrinkled silk under my trunk and got on top of it so as to crush it even more. The crumpled effect that resulted was ravishing, especially when I put it on and fastened a stiff smooth collar of immaculate whiteness to it.

Having finished dressing I jumped into the taxi again, stopped to buy a gardenia which the florist pinned to my lapel, and then gave the driver the address of the Florida, a fashionable ball-room where I had never yet been, but which I knew was patronized by the most exclusive crowd in Madrid. I intended to have supper there all alone, and to choose with scrupulous care the necessary feminine material among the most beautiful, the most luxuriously dressed women, in order to carry out, come what may, that mad, irresistible thing, that thing almost without sensation and yet oppressive with pent-up eroticism, that maddening thing which since the day before I had named my Parsifal!

I had no idea where the Florida was, and each time the taxi slowed down, I thought I had arrived, and my anxiety grew so anguishing that it made me shut my eyes. I sang Parsifal at the top of my lungs. Good heavens, what a night it was going to be! I knew it. It was going to age me by ten years.

The effect of the three Martinis had totally vanished, and my brain was turning toward grave and severe thoughts. My wickedness was losing

its edge with the alcohol, which I was already theoretically "against." Alcohol confuses everything, gives free rein to the most pitiful subjectivism and sentimentalism. And afterwards one remembers nothing— and if one does, it is worse! Everything that one thinks while in a state of intoxication appears to one to have the touch of genius: and afterwards one is ashamed of it. Drunkenness equalizes, makes uniform, and depersonalizes. Only beings composed of nothingness and mediocrity are capable of elevating themselves a little with alcohol. The man of evil and of genius bears the alcohol of his old age already absorbed in his own brain.

I hesitated. Was I going to excute my Parsifal with or without alcohol? The pre-nocturnal sky of Madrid knows clouds of a fantastic and poisoned mineral blue that can be found only in the paintings of Patinir, and to the warmed-over rabbit that I had eaten at the farm was now added the venom of that delicately blue-tinged color of depilated armpits toward which I was going to direct my activity that evening, with very definite ideas on the subject in the back of my head. I took advantage of the little clearings which intoxication left for brief moments in my mind to organize the details that would enable me to execute this sublime and absolutely original erotic fantasy which made my heart beat like hammer blows every time I thought about it.

To realize satisfactorily what I wanted to do (and what nothing would prevent me from doing), to realize my Parsifal, I needed five very elegant women and a sixth who would help us with everything. None of them needed to get undressed, and neither did I. It would even be desirable to have these women keep their hats on. The important thing was for all but two of them to have depilated armpits. I had brought a considerable amount of money even though I believed my powers of seduction already to be considerable.

I arrived at the Florida—arrived there much too early. I settled myself before a table, and looked around. I was well placed to see everything, and had my back to a wall, which was indispensable.[1] I came back immediately to the same question: did I have to get drunk or not to carry out my adventure? For all the practical preliminaries—establishing contact with the women, putting them at ease with one another, finding "where" the thing was to take place (perhaps inviting a couple of them into a private room and having them take charge of everything, as well-remunerated accomplices?)—for all these preliminary steps alcohol would obviously be a precious means of overcoming the timidity of the first moments. But afterwards—afterwards it would be exactly the contrary. What I would need afterwards was a sharp eye to see everything at once. Afterwards, from the moment my Parsifal began, no lucidity would be

[1] An area of empty space behind my head has always created in me a sense of anxiety so painful that it makes it impossible for me to work. A screen is not enough for me, I need a real wall. If the wall is very thick I know beforehand that my work is already well on the way to success.

too great, no inquisitor's glance sufficiently severe and perfidious to judge condemn and decide between the hell and the glory of the scenes and situations, verging on disgust and yet so desired, so beautiful, so frightfully humiliating for the seven protagonists of the Parsifal that I was going to direct (and how!) before the cocks of dawn, with the agonized and rusty notes of their first crowing, were capable of raising the festooned, red and abominable cockscomb of remorse in our seven imaginations exhausted from the acutest pleasures.

The head waiter was standing in front of me, waiting for me to end my day-dreaming.

"What will the Señor have?"

Without a moment's hesitation I answered, "Bring me a rabbit with onions—warmed-over!"

But instead of warmed-over rabbit I simply ate a quarter of a chicken, infinitely sad and insipid, accompanied by a bottle of champagne, which was followed by a second one. While I was eating the chicken wing people began to arrive. Until then the large *boîte de nuit* had been empty except for myself, the waiters, the orchestra and a couple of professional dancers who as they danced were putting on an act of quarreling. With a quick glance I eliminated the possibility of using this dancing girl, recognizing that she did not offer the slightest interest for me. She was out of the question for the "Parsifal": she was too beautiful, terribly and disagreeably healthy, and totally devoid of "elegance."

I have never in my life met a very beautiful woman who was at the same time very elegant, these two things excluding each other by definition. In the elegant woman there is always a studied compromise between her ugliness, which must be moderate, and her beauty which must be "evident," but simply evident and without going beyond this exact measure. The elegant woman can and must get along without that beauty of face whose continuous flashing is like a persistent trumpet-call. On the other hand, if the elegant woman's face must possess its exact quota of the stigmas of ugliness, fatigue and disequilibrium (which with the arrogance of her "elegance" will acquire the intriguing and imposing category of carnal cynicism), the elegant woman will necessarily and inevitably have to have hands, arms, feet and under-arms of an exaggerated beauty and as exhibitionistic as possible.

The breasts are of absolutely no importance in an elegant woman. They do not count. If they are good, so much the better; if they are bad, so much the worse! In the rest of her body I exact only one thing for her to be able to attain this category of elegance which we are considering—this single thing is a special conformation of the hip bones, which absolutely must be very prominent—pointed, so to speak—so that one knows they are there, under no matter what dress: present and aggressive. You think that the line of the shoulders is of prime importance? This is not true. I grant all freedom to this line, and no matter how much or in what way it might disconcert me, I should be grateful to it.

The expression of the eyes, yes—very, very important; it must be very, very intelligent, or look as if it were. An elegant woman with a stupid expression is inconceivable; on the other hand, nothing is more appropriate to a perfect beauty than a stupid expression. The *Venus of Milo* is the most obvious example of this.

The mouth of the elegant woman should by preference be "disagreeable" and antipathetic. But suddenly and as if by miracle, either at the approach of ecstacy or as it half-opens in response to a choice and infrequent impulse of her soul, it must be capable of acquiring an angelic expression which makes her momentarily unrecognizable to you.

The elegant woman's nose... Elegant women have no noses! It is beautiful women who have noses. The hair of the elegant woman must be healthy; it is the only thing about the elegant woman that must be healthy. The elegant woman, morever, must be totally tyrannized by her elegance, and her dresses and her jewels, while they are her chief *raison d'être,* must also constitute the chief reason for her exhaustion and her wasting away.

"Projet de robe du soir" (1939)
"Elegant woman?"

This is why the elegant woman is hard in her sentimental passions and only faintly aroused in her loves, this is precisely why bold, avid, refined and unsentimental eroticism is the only kind of eroticism to cling with luxury to her luxury, just as the luxury of her dresses and her jewels clings exhaustingly to the luxurious body which is made only to mistreat them and to wear them with the supreme luxury of disdain.

And this is what I was getting at—blasé, rich and luxurious disdain; for in order to carry through my "Parsifal" I had to find, this very evening, exactly six disdainful elegant women, who could obey me to the letter without losing their glacial manners and without letting the mists or erotic emotion come and befog the continual luxury of their faces, six faces capable of experiencing pleasure ferociously, but with disdain.

With my eyes open, my pupils dilated, I looked around me impatiently without being able to attach my attention to anything decisive, for there was not a single really elegant woman present, and far too many beautiful ones. I was becoming impatient. But understanding that I could not count too much on people's continuing to arrive in any considerable number, since the *boîte* was already crowded, I began to make concessions and to establish comparisons in order to make a choice among possibilities. For this first time I could always content myself with an "approximate" Parsifal. But I knew at the same time that there is nothing worse than the "approximately elegant." Does it even exist? It is as if someone tells you, to encourage you ιo take medicine, that it's "almost" a sweet! Suddenly two elegant women came in together, and by good fortune they sat down all by themselves at a table not far from mine that had just been left vacant. They were just what I wanted. I was still lacking four! But not finding them, I returned to the observation of my two protagonists. The only thing I could not judge was their feet, which could not but be divine, unless there were an absence of conformity about their anatomies which struck me as inconceivable. Their hands rivalled one another in beauty and all four of them were interlaced in a tangled knot which their owners had formed with a cynical coldness that made me shudder.

My second bottle of champagne had just made me moderately drunk, and my thoughts skipped beyond the grooves that I had laid out with my plan and into which I vainly tried to force them back and make them stay. Revolted by my own mental dispersion which was beginning to vex my sense of order and continuity, I said to myself,

"Look here! Either you are Dali or you are not Dali. Come! Be serious. You risk spoiling your 'Parsifal.' Look over there. Is that an elegant wrist? Yes, but it would be necessary to combine it with a different mouth. There it is! A mouth you would like to match it to. Wrist, mouth, mouth, wrist...if one could put beings together in this way—as a matter of fact, one *could* put them together...Why don't you try! Choose carefully before you begin. Pull yourself together. Let's see how you'll like it. You've already found three elegant armpits. Look at them well, at all three successively, and after that, without looking at anything else, you run with your glance and you pounce on that cold expression; then on the mouth, on the more contemptuous of the two I have already chosen...

"Let's proceed in order: have an armpit, another armpit, now quickly the mouth—but you've forgotten the second armpit, so start over again and pay attention... You see it clearly, don't you, the armpit?...Oh yes, how elegant and fine it is! Here, then, is the armpit, the armpit, the fine armpit. Now look at the expression—expression...mouth... Now go back again, more slowly—mouth, expression, armpit, armpit...once more, and dwell longer on the expression—armpit, expression, expression, expression, expression, expression, go back to the armpit, go back to the expression... A little longer on the armpit this time, and now faster...

Armpit, expression, expression, armpit, armpit, armpit, armpit, armpit, expression, mouth, expression, mouth, expression, expression, mouth, expression, mouth, expression, mouth, expression, mouth..."

My head was reeling and a desire to vomit which this time could no longer be confused with the delicate and uncertain sensation of "feeling oneself fall in love" made me get up with a disciplined sequence of movements. I politely asked a cigarette girl dressed as a Louis XIV page where the dressing room was. She made me a sign which I did not see, and I went into a room where there was a desk covered with letters and typewritten sheets of paper. I braced myself with the palms of both hands on this table and vomited copiously. After this I had a breathing spell, knowing that it was not over with, that my almost liturgical labor of "throwing up everything" had just begun. The cigarette girl dressed as a Louis XIV page who had followed me remained motionless in the doorway watching me. I turned to her and, putting fifty pesetas in her cigarette tray, said to her beseechingly, "Let me finish!" And locking the door behind me I turned toward the table with the solemn and resolute step of one who is about to commit hara-kiri, and again placing my two palms on its surface in an attitude identical to that of a while ago, I vomited again with an increased intensity. I was half conscious, and all the tastes of my soul, mingled with all those of my entrails, were coming out of my mouth.

vermouths, olives, clams ect ect.

During the time that this lasted, I relived the experience of these two days of orgy, only backwards and all scrambled together, as though I had begun these two days over again but in reverse, experiencing in a practical way the Christian maxim, that "the last shall be first." Everything was there: the warmed-over rabbit, the two delicate armpits, the wrists, the Patinir clouds, and again a piece of delicate armpit, and again a piece of chicken leg, and the cold expression, and again the warmed-over rabbit, expression, cold expression, warmed-over rabbit, delicate armpit,

warmed-over rabbit, mushrooms, olives, monarchy, anarchy, anchovy, spaghetti, chartreuse, spaghetti, warmed-over clams, warmed-over rabbit, chartreuse, warmed-over clams, chartreuse, warmed-over rabbit, clams, armpits, spaghetti, vermouth, warmed-over, vermouth, warmed-over warmed-over vermouth, vermouth, bile, warmed-over, vermouth, bile, warmed-over, vermouth, bile, bile, clams, bile, clams, warmed-over, bile, warmed-over, bile, warmed-over, bile, bile, bile, bile, bile, warmed-over rabbit, warmed-over rabbit, bile, bile, bile, bile, bile, bile, bile, warmed-over rabbit, vermouth, bile, bile, bile, spaghetti, bile, clams, bile! Warmed-over rabbit, bile! Bile, bile, clams, bile!

I wiped the sweat from my brow and the tears that I shed without weeping, and that flowed down my cheeks—everything had come up. Everything from the absolute anarchic monarchy to the last propellers of my nostalgic, sublime and lamented "Parsifal."

I spent the next day in bed drinking lemon-juice, and the day after I went to the Academy of Fine Arts at the usual hour, only to be expelled from school the following afternoon. When I arrived I found a group of students gesticulating and shouting, and I was seized with a feeling of impending disaster. If I could have remembered the scene of the burning of the flag in Figueras I should have been suspicious of the turn matters took, for I was once more to be the victim of the myth that spread its halo around me. Indeed the attentive reader of this book, who seeks to draw analytical conclusions from it, will have noticed what I myself have often had forced upon my attention only in writing it— namely, that as the development of my mind and character can always be summarized in a few essential myths that are peculiar to me, so the events of my life repeat themselves and develop a few rather limited, but terribly characteristic and unmistakable themes. Whenever in my life something happens to me with a cherry, or with a crutch, you can be sure that it will not stop there. Incidents, ever new, more or less truculent, mediocre or sublime, will occur in connection with cherries and with crutches my whole life long until I die.

If I had known this I could have foreseen, the very first time I was expelled from school, that it would not be a simple and vulgar isolated incident as would have been the case for spirits who, lacking paranoiac inspiration, escape without grief or glory the systematic principles which must govern every destiny worthy of greatness. But to return to the insurgent group that I ran into in the yard of the Academy of Fine Arts— this very group, when it saw me coming, surrounded me and took me automatically as witness, partisan and flag of its rebellion.

What was the occasion of this rebellion? I had already been informed that there was to be an examination to fill the vacant post of teacher of painting at the Academy, and that several renowned painters were coming to compete in it, this being one of the most important classes. The paintings that constituted the practical part of the examination had just been exhibited, each participant having had to execute one painting on

a subject of his own choice and one on a prescribed theme. It appeared that all the paintings were utterly mediocre, with the exception of those of Daniel Vásquez Díaz, which corresponded exactly to what was at that time called "post-impressionism." The seed which I had nonchalantly let drop among the students of the School was in germination and a minority of them—the most active and the most gifted—had suddenly become enthusiastic over Vásquez Díaz, who without having gone as far as cubism was influenced by it, so that through him people were able to swallow what they would not even consider when it came from me.

Thus, according to the insurgents, I must of necessity be a partisan of Vásquez Díaz, and my friends were aroused because they were sure that an injustice was about to be committed and influence and intrigue used to give the post to someone who in no way deserved it. I went with my fellow-students to look at the exhibition, and for once I agreed with them. Doubt was impossible, even though in my heart I should have wanted none of these as professor of painting. I should have preferred a real old academician. But this was a category of people that had disappeared, that had been totally exterminated. Since I had to choose, I gave my vote to Vásquez Díaz without any reservations.

That afternoon, after each of the competitors had briefly expounded his pedagogical ideas (the only intelligent one being Vásquez Díaz) the academicians retired to deliberate. When they reconvened on the platform, and when they pronounced the verdict that we had been expecting, thus consummating one of the thousand injustices and unedifying episodes of which the tapestry of this period of Spanish history was woven, I rose in sign of protest and without saying a word I left the hall before the President of the tribunal, one of the most eminent of the academicians, had finished his closing speech. I was awaited by my group in a gathering of republican writers that was held every afternoon at the Café-Bar Regina, and that was more or less under the influence of Manuel Azaña, who a few years later was to become the President of the Spanish Republic.

The following day when I returned to the school an atmosphere of panic reigned among my co-disciples, and they told me that I was going to be expelled for the incident of the previous day. I did not take the matter seriously, for I knew that it was impossible to take such a measure in retaliation for the mere act of having walked out in the middle of the President's speech. My gesture, though clearly one of protest, had remained strictly within the limits of politeness, since I had not interrupted the President or slammed the door as I left. But in my innocence I was not at all aware that this was not what the stir was about. It appeared that after I left, the students who supported Vásquez Díaz began to interrupt the academician's speech with insults and imprecations, and passing from words to deeds, persecuted the academicians till they were forced to make their escape and lock themselves up in the drawing-class. The students were on the point of breaking in the door

by using a bench as a battering ram when the mounted police rode into the yard and shortly succeeded in rescuing the trembling academicians.

The morally visible leader of this state of mind was myself. And in spite of the fact that I had not been present at the disturbance, I was put down on the list of the rebels as having actively cooperated with them from the moment of my exit, which was interpreted as a signal for the demonstration to begin. It was in vain that I attempted to plead my innocence. I was suspended for a year from the Academy of Fine Arts, and after the disciplinary council had confirmed my suspension I returned to Figueras.

I had been home but a short time when I was taken into custody by the Civil Guard and locked up in the prison of Figueras. At the end of a month I was transported to the prison of Gerona, and was finally set free when no adequate charges could be found on which to try me. I had arrived in Catalonia at a bad moment. A very determined revolutionary upsurge had just been energetically repressed by General Primo de Rivera, who was the father of José Antonio, the future founder of the Spanish Falange. Elections had just taken place, and an effervescent political agitation absorbed all activities. My best childhood friends of Figueras had all become revolutionaries, and my father, accomplishing his strict notarial functions, had had to testify to abuses committed by certain elements of the right during the elections. I had just arrived, and this was remarked even more than formerly. I was always talking about anarchy and monarchy, deliberately linking them together. It was from this whole amalgam of circumstances, which only my father could adequately and accurately relate, that my arbitrary imprisonment resulted, without any other consequence than to add a lively color to the already highly colored sequence of the anecdotic episodes of my life.

This period of imprisonment pleased me immeasurably. I was naturally among the political prisoners, all of whose friends, co-religionists and relatives showered us with gifts. Every evening we drank very bad native champagne. I had resumed writing the "Tower of Babel" and was reliving the experience of Madrid, drawing philosophic consequences from each incident and each detail. I was happy, for I had just rediscovered the landscape of the Ampurdán plain, and it was while looking at this landscape through the bars of the prison of Gerona that I came to realize that at last I had succeeded in aging a little. This was all I wished, and it was all that for several days I had wanted to tear out and squeeze from my experience in Madrid. It was fine to feel a little older, and to be within a "real prison" for the first time. And finally, as long as it lasted, it would be possible for me to let my mind relax.

CHAPTER NINE

"Tristan and Isolde"

Return to Madrid

Permanent Expulsion from the
 School of Fine Arts

Voyage to Paris

Meeting With Gala

Beginnings of the Difficult
 Idyll of My Sole and
 Only Love Affair

I am Disowned by My Family

The afternoon that I was released from the prison of Gerona I reached Figueras just at dinner time and I remember that I ate eggplant as a vegetable. Immediately after, I went to the movies. The news of my liberation had spread through the town, and when they saw me come in I received a veritable ovation.

A few days later we left for Cadaques, where I became an "ascetic" once more, and where I literally gave myself over body and soul to painting and to my philosophic research. The memory of my beginnings of debauchery in Madrid accentuated the severity of my new habits, while giving them that touch of grace appropriate to one who for a moment has held in his own hand the panting bird of a recent and exotic vital experience. I knew, moreover, that I was going to return to Madrid, once my probationary period was over. I should then have a chance to continue experiments of that kind there. But now, the earlier I got up in the morning, the more vigorously I streaked my paper with the hard point of my pencil to transmit to it the fundamental flow of my thoughts, the more capable I was of resisting all the temptations of my body, the more I could canalize the forces of my libido and let them swell the combative forces that struggle, remain and triumph in the crusade of intelligence that should lead me some day to the conquest of the kingdom of my own soul; the more capable I was of impoverishing myself and renouncing my body, the more quickly I would age.

At the end of that summer, which was extremely hot, I had grown thin as a skeleton. My body was absent from my personality, so to speak, and I felt myself turning into one of those fantastic figures of Hieronymus Bosch, of whom Philip II was so passionately fond. I was in fact a

kind of monster whose sole anatomical parts were an eye, a hand and a brain.

In my family it was a long-established Sunday habit to drink coffee after the mid-day meal, and to take *half* a tiny glass of chartreuse. I always respected this limit. But once, on one of those very calm afternoons

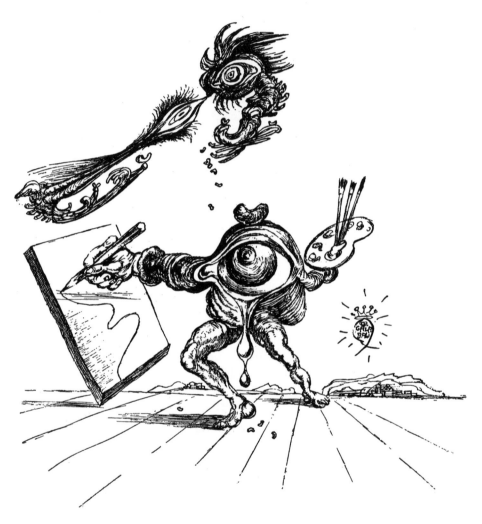

of Cadaques when the sky and the sea intermingle in what the natives call a "white calm," I mechanically filled my small glass to the edge, and the chartreuse even overflowed a little onto the tablecloth. "What are you doing?" my father exclaimed with alarm. "Don't you know that that's a very strong drink?" Pretending that I recognized the imprudence I had just committed, I poured half my glass back into the bottle.

My father settled down to enjoy the sleep of the just. As for me—who knows what I was thinking?... But, as in the case of my "Parsifal," it

is better that there should still remain some impenetrable secrets for my readers, for such secrets will be very useful to me for future editions of this book—corrected and augmented. And if it is meritorious on my part to offer myself body and soul, torn into shreds, for the curiosity of my contemporaries by giving them a unique document for scientific investigation, it is also perfectly legitimate, it seems to me, that I should anticipate the future commercial problems inherent in this question, while incidentally taking advantage of the present occasion tactfully and prudently to begin to give it publicity.

When my disciplinary period had expired, I returned to Madrid where I was awaited with delirious impatience by my group, who confessed that without me "things had not been the same." They were all disoriented, lost and dead of an imaginative famine which I alone was capable of placating. I was acclaimed, I was looked after, I was coddled. I became their divinity. They did everything for me, they bought me shoes, ordered special neckties, reserved seats for me at the theatre, packed my suitcases, watched over my health, my moods, submitted to all my whims, went forth like squadrons of cavalry to overcome the practical dragons that stood in the way of the realization of my most impossible fantasies.

My father, since the experience of the first year, now gave me no more than a modest monthly sum, ludicrously inadequate to the style of living which my orgiastic recrudescence was going to require. But he continued innocently to pay all my bills as in the past. It will not be difficult for my readers, however, to understand that as far as I was concerned this amounted to the same thing. Moreover, my group at that moment helped me financially. Each one had his own way of getting hold of a considerable sum of money when the situation demanded. One would pawn a ring with a magnificent diamond which had been a family gift; another would manage, by a miracle, to mortgage a large piece of property which he had not yet inherited; a third would sell his car to defray the expenses of two or three days of our existence. We also took advantage of the halo of "rich men's sons" which surrounded us to borrow money from the most unbelievable people. We would make up a detailed list of them, after which we would draw lots. Each of us was supposed to call upon a different person. We would take two taxis. One of us would go into the café that our victim frequented or climb up to his apartment. Sometimes we would have no success, and then we would go on and try the next one. By the end of the day we actually managed to get together a considerable sum, often beyond all our hopes. And this is saying a good deal, in view of our insatiable cupidity. From time to time we would return the money to the persons who had lent us the most substantial sums, and this made it easy for us to ask them for some again. We thus created the habit of confidence which, sooner or later, was in turn to fail. For the most part the large loans were in time reimbursed by our parents, who eventually, after our creditors' patient waiting had been hopelessly exhausted, re-

ceived on their heads a shower of demands for payment. But our real victims were our most modest and generous friends, who lent us money not because of the confidence with which we inspired them, but through sympathy, affection, and especially admiration, which we aroused in them through our feats of intelligence. For the sole sake of making them pay dearly for a moment of our conversation we would put on an act in which we were not above resorting to cheap histrionic effects. "We've been robbed!" I would cynically exclaim after receiving the loan of a sum of money. "That remark I made about realism and Catholicism alone is worth five times this amount!" The worst of it was that I really believed our behavior was honorable, and we had absolutely no scruples about it.

One evening I was the victim of the confidences of an artist who expressed the most complete admiration for my work. Naïvely and without the slightest reticence, he poured out his heart to me, revealing in the details of his story a case of spiritual poverty which rivalled his pecuniary poverty. He seemed to believe that after having told his story he would be able to achieve, if not a perfect communion of souls, at least a communication of ideas, an interchange of feelings which might not perhaps bring much light to his troubled spirit but which would at least console him, through my comprehension of his multiple torments, and that if my commiseration became propitious, he might even ask me for a little financial aid.

"Well," he said, when he came at last to the end of his story, with tears in his eyes and depressed by my long and expressionless silence, "that's how it is with me! How is it with you?"

"With me? I command a very high price," I answered slowly, and as I did so I was looking across at one of the towers of the Palace of Communications in which I remember that a window opened at that very moment, letting fall from its height a whitish object which I watched as it fell.

Receiving no answer to my remark I turned my head to look at the man. His face was hidden in a dubiously clean handkerchief and he was weeping. I had sacrificed him! Yet another victim to the growing dandyism of my mind. I felt a burst of pity, and was about to make a move toward him and console him in a brotherly way. But the esthetics of my attitude commanded me to act in just the opposite way. To make matters worse, the wretched state of his person communicated to me a physical repugnance which would have cut short any attempt at a warm effusion.

I said to him then, after having placed a friendly hand on one of his sunken shoulders, covered with dandruff from his rat's hair,

"Why don't you try to hang yourself? . . . Or throw yourself from the top of a tower?"

And as I left him standing there I thought of that whitish bundle that had just fallen from one of the windows of the Palace of Communications. Was it Maldoror? [1] The shadow of Maldoror hovered over my

[1] See footnote to page 209.

life, and it was just at this period that for the duration of an eclipse precisely another shadow, that of Federico Garcia Lorca, came and darkened the virginal originality of my spirit and of my flesh.

During this time I knew several elegant women on whom my hateful cynicism desperately grazed for moral and erotic fodder. I avoided Lorca and the group, which grew to be his group more and more. This was the culminating moment of his irresistible personal influence—and the only moment in my life when I thought I glimpsed the torture that jealousy can be. Sometimes we would be walking, the whole group of us, along El Paseo de la Castellana on our way to the café where we held our usual literary meetings and where I knew Lorca would shine like a mad and fiery diamond. Suddenly I would set off at a run, and no one would see me for three days... No one has ever been able to tear from me the secret of these flights, and I don't intend to unveil it now—at least not yet...

I shall only tell you that one of my favorite games at this time was to dip bank notes into my whiskey until they began to disintegrate. This involved a long ceremonial which would dumfound those who happened to witness it. I loved to practice this trick while I argued, with a refined avarice, about the price of one of those modest *demi-mondaines* who offer themselves to you body and soul, saying "Give me whatever you like!"

At the end of a year of libertinism I received notice of my permanent expulsion from the Academy of Fine Arts. This time the matter appeared in an official announcement in *La Gaceta*, as an order signed by the king, on October 20th, 1926. The story of this incident has been faithfully re-

ported in one of the anecdotes which I have chosen for my anecdotic self-portrait.

This time my "expulsion" in no way astonished me. Any committee of professors, in any country in the world, would have done the same on feeling themselves thus insulted. The motives for my action were simple: I wanted to have done with the School of Fine Arts and with the orgiastic life of Madrid once and for all; I wanted to be forced to escape all that and come back to Figueras to work for a year, after which I would try to convince my father that my studies should be continued in Paris. Once there, with the work that I would bring, I would definitely seize power!

But before leaving Madrid I wanted to savor that last evening alone. I ambled through hundreds of streets that I had never seen. In one afternoon I squeezed out to the last drop the whole substance of that city, where the people, the aristocracy and pre-history know no transition. It shone beneath the concise and limpid October light, like an immense peeled bone faintly tinted with blood-pink. In the evening I went and sat down in my favorite corner of the Rector's Club, and contrary to my habit I drank just two sober whiskeys. Nevertheless I was one of the last to leave, and I was assailed by a trembling little old woman in rags who persecuted me with her insistent begging. I paid no attention to her and continued on my way. When I got as far as the Bank of Spain, with the beggar-woman still trailing me, I ran into a very beautiful young woman who offered me gardenias. I gave her a hundred pesetas and took all she had. Then, turning round, I made a present of them to the old beggar-woman. She remained for a long time glued to the spot like a statue of salt. I walked on slowly for several minutes, and when I again turned round I could barely make out in the moonlight a little black mass with a white smudge in the middle which was all I could see of the basket filled with flowers which I had left in her hands—hands gnarled like vine-stalks and covered with sores.

The following day I was too lazy to pack my suitcases, and left with all my luggage empty. My arrival in Figueras caused a general consternation in my family: expelled, and without even a clean shirt to change into! Good heavens, what would happen to my future! To console them all, I kept telling them,

"I swear to you I was convinced I had packed all my suitcases, but I must have confused it with the last time"—I was referring to my return home two years before.

On my arrival in Figueras I found my father thunderstruck by the catastrophe of my expulsion, which had shattered all his hopes that I might succeed in an official career. With my sister, he posed for a pencil drawing which was one of my most successful of this period. In the expression of my father's face can be seen the mark of the pathetic bitterness which my expulsion from the Academy had produced on him.

At the same time that I was doing these more and more rigorous

drawings, I executed a series of mythological paintings in which I tried to draw positive conclusions from my cubist experience by linking its lesson of geometric order to the eternal principles of tradition. I took part in several collective expositions in Madrid and in Barcelona, and had a one-man exposition in the Gallery of Dalmau, who was the Barcelonian patriarch of advance-guardism and who looked as though he might have just stepped out of a painting by El Greco.

All this activity, which I carried on without stirring from my studio in Figueras for one second, produced a profound commotion, and the polemics aroused by my works reached the attentive ears of Paris. Picasso had seen my *Girl's Back* in Barcelona, and praised it. I received on this subject a letter from Paul Rosenberg asking for photographs, which I failed to send, out of sheer negligence. I knew that the day I arrived in Paris I would put them all in my bag with one sweep. One day I received a telegram from Juan Miro, who at this period was already quite famous in Paris, announcing that he would come and visit me in Figueras, accompanied by his dealer, Pierre Loeb. This event made quite an impression on my father and began to put him on the path of consenting to my going to Paris some day to make a start. Miro liked my things very much, and generously took me under his protection. Pierre Loeb, on the other hand, remained frankly sceptical before my works. On one occasion, while my sister was talking with Pierre Loeb, Miro took me aside and said in a whisper, squeezing my arm,

"Between you and me, these people of Paris are greater donkeys than we imagine. You'll see when you get there. It's not so easy as it seems!"

Before a week was over, in fact, I received a letter from Pierre Loeb in which, instead of offering me a splendid contract as I had thought he would when I received Miro's telegram, he said something to this effect,

"Do not fail to keep me in touch with your work. But for the moment what you are doing is too confused and lacks personality. You must be patient. Work, work; we must wait for the development of your undeniable gifts. And I hope that some day I shall be able to handle your work."

Almost at the same time my father received a letter from Juan Miro in which he explained to him the advisability of my coming to spend some time in Paris. And he ended his letter with these very words, "I am absolutely convinced that your son's future will be brilliant!"

It was at about this period that Luis Bunuel one day outlined to me an idea he had for a motion picture that he wanted to make, for which his mother was going to lend him the money. His idea for a film struck me as extremely mediocre. It was advance-guard in an incredibly naïve sort of way, and the scenario consisted of the editing of a newspaper which became animated, with the visualization of its news-items, comic strips, etc. At the end one saw the newspaper in question tossed on the sidewalk, and swept out into the gutter by a waiter. This ending, so banal and cheap in its sentimentality, revolted me, and I told him that this

film story of his did not have the slightest interest, but that I on the other hand, had just written a very short scenario which had the touch of genius, and which went completely counter to the contemporary cinema.

This was true. The scenario was written. I received a telegram from Bunuel announcing that he was coming to Figueras. He was immediately enthusiastic over my scenario, and we decided to work in collaboration to put it into shape. Together we worked out several secondary ideas, and also the title—it was going to be called *Le Chien Andalou*. Bunuel left, taking with him all the necessary material. He undertook, moreover, to take charge of the directing, the casting, the staging, etc... But some time later I went to Paris myself and was able to keep in close touch with the progress of the film and take part in the directing through conversations we held every evening. Bunuel automatically and without question accepted the slightest of my suggestions; he knew by experience that I was never wrong in such matters.

To go back a little, I spent another two months in Figueras making my last preparations before pouncing on Paris. I have forgotten to mention that before Pierre Loeb's arrival I had already made a trip to Paris which lasted just a week, in the company of my aunt and my sister. During this brief sojourn I did only three important things. I visited Versailles, the Musée Grevin, and Picasso. I was introduced to the latter by Manuel Angelo Ortiz, a cubist painter of Granada, who followed Picasso's work to within a centimetre. Ortiz was a friend of Lorca's and this is how I happened to know him.

When I arrived at Picasso's on Rue de La Boétie I was as deeply moved and as full of respect as though I were having an audience with the Pope.

"I have come to see you," I said, "before visiting the Louvre."

"You're quite right," he answered.

I brought a small painting, carefully packed, which was called *The Girl of Figueras*. He looked at it for at least fifteen minutes, and made no comment whatever. After which we went up to the next story, where for two hours Picasso showed me quantities of his paintings. He kept going back and forth, dragging out great canvases which he placed against the easel. Then he went to fetch others among an infinity of canvases stacked in rows against the wall. I could see that he was going to enormous trouble. At each new canvas he cast me a glance filled with a vivacity and an intelligence so violent that it made me tremble. I left without in turn having made the slightest comment.

At the end, on the landing of the stairs, just as I was about to leave we exchanged a glance which meant exactly,

"You get the idea?"

"I get it!"

It was after this ephemeral voyage that I held my second and third exhibits, at the Dalmau Gallery and at the Salon of Iberian Artists of Madrid. These two shows definitely consecrated my popularity in Spain.

Now, then—to return to the point I had reached before I filled in that oversight which I hope will quickly heal in your memory—I am in Figueras and am preparing, as I have already said, to pounce on Paris. During these two months I trained myself, I sharpened all my doctrinal means of action at a distance, and I did so by making use of a small coterie of intellectuals of Barcelona grouped around a review called *The Friend of the Arts*. This group I manipulated as I wished, and used as a convenient platform for revolutionizing the artistic ambiance of Barcelona. I did this all by myself, without stirring from Figueras, and its sole interest for me, naturally, was that of a preliminary experiment before Paris, an experiment that would be useful in giving me an exact sense of the degree of effectiveness of what I already at that time called my "tricks." These tricks were various, and even contradictory, and were merely terroristic and paralyzing devices for imposing the ferociously authentic essence of my irrepressible ideas, by which I lived and thanks to which my "tricks" not only became dazzlingly effective, but emerged from the category of the episode and became incorporated into that of history. I have always had the gift of manipulating and of dominating with ease the slightest reaction of people who surround me, and it is always a voluptuous pleasure to feel at constant "attention" to my capricious orders all those who, in obeying me to the letter,[1] will most likely go down into their own purgatory, without even suspecting their faithful and involuntary subordination.

I arrived in Paris saying to myself, quoting the title of a novel I had read in Spain, "Caesar or Nothing!" I took a taxi and asked the chauffeur,

"Do you know any good whorehouses?"

"Get in, Monsieur," he answered, with somewhat wounded pride, though in a fatherly way. "Don't worry. I know them all."

I did not visit all of them, but I saw many, and certain ones pleased me immeasurably. The "Chabanais" on Rue Chabanais was naturally the most atmospheric of all, with the armchair for diverse erotic uses that Francis Joseph had had built for his own sexual needs, the bathtubs sculptured with gilded bronze swans, and that stairway constructed with grottoes of pumice stone, with mirrors and plump brasses adorned with red Napoleon III trimmings.

Here I must shut my eyes for a moment in order to select for you the three spots which, while they are the most diverse and dissimilar, have produced upon me the deepest impression of mystery. The stairway of the "Chabanais" is for me the most mysterious and the ugliest "erotic"

[1] Just recently, in writing the preface to the catalogue of my last New York exhibit, which I signed with my pseudonym Jacinto Felipe, I felt that I needed, among other things, to have someone write a pamphlet on me bearing a title something like "Anti-Surrealist Dali." For various reasons I needed this type of "passport," for I am myself too much of a diplomat to be the first to pronounce such a judgment. The article was not long in appearing (the title was approximately the one I had chosen), and it appeared in a modest but attractive review edited by the young poet Charles Henri Ford.

spot, the Theatre of Palladio in Vicenza is the most mysterious and divine "esthetic" spot, and the entrance to the tombs of the Kings of the Escorial is the most mysterious and beautiful mortuary spot that exists in the world. So true it is that for me eroticism must always be ugly, the esthetic always divine, and death beautiful.

If the interior decoration of the brothels pleased me beyond measure, the girls that were offered in them all struck me as inadequate. Their vulgarity and their prosaic character were exactly the contrary of that prototype of elegance which constitutes the initial condition of my libidinous fantasies. I drew the cross of exclusion over those girls, who were so common that though they were possibly beautiful they always, at no matter what hour, appeared in the parlor with an air of having just regretfully left an interrupted repose which they were still chewing between their teeth. Thus the only possible thing to do would be to utilize the atmosphere and, by the utmost concession, take one of those regulation Creoles, with a perpetual animal smile upon their lips, as an "aid." But the women would have to be looked for elsewhere and brought here. In any case, with the brothels I had just visited, I had enough to last me for the rest of my life in the way of accessories to furnish in less than a minute no matter what erotic revery, even the most exacting.

After the houses of prostitution, I paid a visit to Juan Miro[1]. We had lunch together, but he did not talk, or at least talked very little.

"And tonight," he confided to me, "I'm going to introduce you to Marguerite."

I was sure he was referring to the Belgian painter René Magritte, whom I considered one of the most "mysteriously equivocal" painters of the moment. The idea that this painter should be a woman and not a man, as I had always supposed, bowled me over completely, and I decided beforehand that even if she was not very, very beautiful, I would surely fall in love with her.

"Is she elegant?" I asked Miro.

"Oh, no," said Miro. "She is very simple."

My impatience became impossible to contain. Simple or not simple, I must take her to the Chabanais, with a few black and white aigrettes on her head—I would manage to work something out.

In the evening Marguerite came to fetch us at Miro's studio on Rue Tourlaque. Marguerite was a very slender girl, with a mobile little face like a nervous death's head. I immediately put aside all thought of erotic experiments with her, but I was fascinated by her. What a strange creature. And to put a final touch to my bewilderment, she did not speak either.

[1] Miro, I remember, told me the *marseillais* story of the owl. Someone had promised to bring his friend a parrot on his return from America. Back in Marseilles he suddenly realized that he had forgotten his promise. He caught an owl, painted it green and presented it to his friend. After some time the two friends met. The returned traveler slyly asked, "How is the parrot I gave you? Does he talk yet?" And the other answered, "Talk, no. But he thinks a great deal."

We went out to have dinner. A meal with a rather good *foie gras* and a very passable wine in a restaurant on the Place Pigalle. It was beyond doubt the most silent and the most intriguing meal I had ever had in my life, since neither of my friends spoke a word. Almost the only thing Miro said to me was, "Have you a dinner-jacket?" This in a very preoccupied tone of voice.

I not only tried, by visualizing their paintings, to reconstruct hypothetically what they must be thinking from their tics and each of their movements, that all seemed to me unfathomable mysteries, but moreover I was anxious to guess, by piercing through their double silence, the intimate ideological relationship which unquestionably existed between them. I was unable to advance a single step in my hypotheses. When I at last took leave of them Miro said to me,

"You must get yourself a dinner-jacket. We'll have to go out in society." It was only a few days later that I learned that there was no connection between Marguerite and the painter René Magritte.

The following day I went and ordered a dinner-jacket at a tailor's on the corner of Rue Vivienne, which I later learned was the street where Lautréamont [1] had lived.

When my dinner-jacket was made, Miro took me to dinner at the Duchesse de Dato's, the widow of the conservative minister who had been assassinated in the Rue de Madrid. There were many people present, but the only one I remember was the Comtesse Cuevas de Vera, who was to become a friend of mine a few years later. She was in close touch with the intellectual movement in Madrid, and we spoke of a number of questions which had the virtue of visibly annoying everyone. Miro, imprisoned in a swelling shirt, stiff as armor, continued not to talk, but to observe everything and to think—like the owl in my anecdote.

After dinner we went and had a bottle of champagne at the Bateau Ivre. It was here that I discovered that phantasmal, superlatively phosphorescent and integrally nocturnal being called Jacoby, whom I was to run into intermittently the whole rest of my life in the same propitious penumbra of ever-changing night clubs. Jacoby's pale face was one of my Parisian obsessions, and I have never been able to understand exactly the reason for this. He was a regular firefly, that confounded Jacoby!

Miro paid the check at the Bateau Ivre with an ease that I envied, and presently we were walking home, just the two of us.

"It's going to be hard for you," he said to me, "but don't get discouraged. Don't talk too much [I then understood that perhaps his silence was a tactic] and try to do some physical culture. I have a boxing instructor, and I train every evening."

Between sentences he would contract his mouth into an expression full of energy.

[1] The Comte de Lautréamont, whose real name was Isidore Ducasse (1846-1870). His *Chants de Maldoror,* a fantastic, poetic, and highly neurotic novel, has had an enormous influence on surrealism.—Translator's Note.

"Tomorrow we'll go and visit Tristan Tzara, who was the leader of the Dadaists. He is influential. He'll perhaps invite us to go to a concert. We must refuse. We must keep away from music as from the plague."

After a silence he spoke again.

"The important thing in life is to be stubborn. When what I'm looking for doesn't come out in my paintings I knock my head furiously against the wall till it's bloody."

And he left, shouting *"Salud!"* across his shoulder.

For a moment I had a vision of that bloody wall. It was the same blood as my own. Already at this period Miro's work was beginning to be the contrary of everything that I believed in and of everything that I was to worship. But no matter—the coagulated blood was there, vividly present.

The following day we dined at Pierre Loeb's with half a dozen of his "colts."[1] All of them already had their signed contracts, and had managed to attain a small and befitting glory, which had lasted only a short time, which had never been too hot and which was already beginning to cool.

These artists, most of them, already had the sneer of bitter mouths that see before them the unencouraging prospect of having to eat an eternally warmed-over glory for the rest of their lives. And they also had that pale greenish complexion which is but the consequence of the excesses that are paid in bile, the product of all the visceral ravages to which the system has been subjected.

The only personality among that group of faces absolutely effaced from my memory was that of the painter Pavlik Tchelitchev, who when we left was the person who put me in the first *Métro* that I took in my life. For nothing in the world would I enter it. My terror made him laugh so heartily that his eyes were drowned in tears. When he announced to me that he had to get off at the station before mine I clutched at his overcoat, terrified. "You get out at the next stop," he repeated to me several times. "You'll see 'Exit' in large letters. Then you go up a few steps and you go out. Besides, all you have to do is to follow the people who get off."

And suppose nobody got off?

I arrived, I went up, I got out. After this horrible oppression of the *Métro* everything struck me as easy. Tchelitchev had just shown me the underground way, and the exact formula for my success. For the rest of my life I was always to make use of the occult and esoteric subways of the spirit.

Even my closest friends would wonder for long periods, which sometimes lasted four or five months, "But where is Dali? What is he doing?" Dali was simply traveling by subway, and suddenly, when people least expected it, I arrived, I went up, I got out! I would withdraw again, and again I would arrive, go up, get out. And the half asphyxiated noise

[1] A word in artists' slang to refer to painters under contract with a dealer.

of the *Métro* starting off at a furious rate kept repeating with its mon-
otonous and Caesarian voice (for I did not give it a minute's rest), "Veni,
vidi, vici—veni, vidi, vici—veni, vidi, vici—veni, vidi, vici—veni, vidi, vici!"

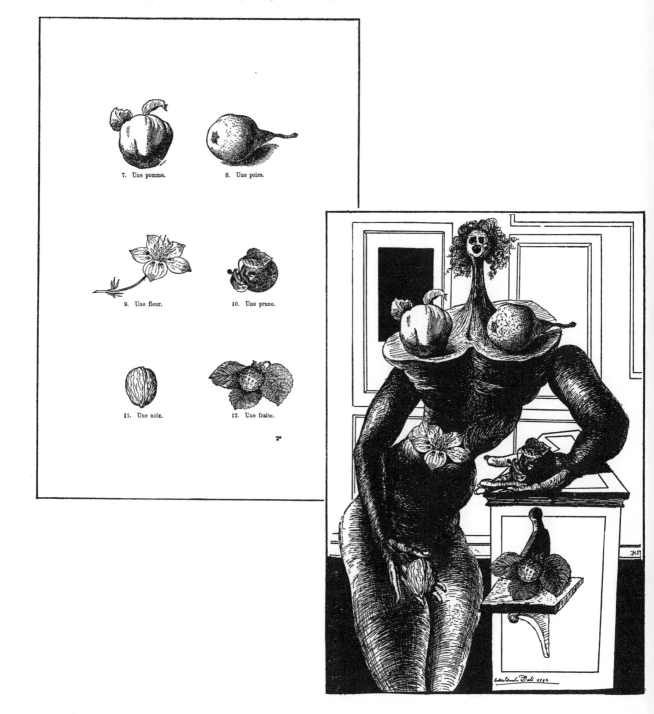

In spite of the success of the first "Exit" from the *Métro* I was careful not to repeat the experience, and took taxis that I ordered to wait wherever I went, and to whose drivers I gave fantastic tips that were ruining me.

I'm coming! I'm coming! I came in time. *Chien Andalou* was going into production. Pierre Bacheff had exactly the physical appearance of the adolescent I had dreamed of for the hero. Already at this time he had begun to take drugs, and continually smelled of ether. Barely was our film completed when he committed suicide.

Le Chien Andalou was the film of adolescence and death which I was going to plunge right into the heart of witty, elegant and intellectualized Paris with all the reality and all the weight of the Iberian dagger, whose holt is made of the blood-red and petrified soil of our pre-history, and whose blade is made of the inquisitorial flames of the Holy Catholic Inquisition mingled with the canticles of turgescent and red-hot steel of the resurrection of the flesh.

Here is an extract from what Eugenio Montes wrote at the time (1928) about *Le Chien Andalou:*

"Bunuel and Dali have just placed themselves resolutely beyond the pale of what is called good taste, beyond the pale of the pretty, the agreeable, the epidermal, the frivolous, the French. One passage of the film was synchronized with the playing of *Tristan.* They should have played the Jota [1] of La Pilórica, of her who would not be French, who wanted to be Aragonese, of the Spain of Aragon, of the Ebro—the Iberian Nile (Aragon, you are an Egypt, you erect pyramids of Jotas to death!).

"Barbarous, elementary beauty, the moon and the earth of the desert, in which 'blood is sweeter than honey,' reappear before the world. No! No! Do not look for the roses of France. Spain is not a garden, nor the Spaniard a gardener. Spain is a planet and the roses of the desert are rotten donkeys. Hence no wit, no decorativism. The Spaniard is essence, not refinement. Spain does not refine, it cannot falsify. Spain cannot paint turtles or disguise donkeys with crystals instead of their skin. The sculptured Christs in Spain bleed, and when they are brought out into the streets they march between two rows of civil guards."

And he concludes by saying,

"A date in the history of the cinema, a date marked with blood, as Nietzsche liked, as has always been Spain's way."

The film produced the effect that I wanted, and it plunged like a dagger into the heart of Paris as I had foretold. Our film ruined in a single evening ten years of pseudo-intellectual post-war advance-guardism.

That foul thing which is figuratively called abstract art fell at our feet, wounded to the death, never to rise again, after having seen "a girl's eye cut by a razor blade"—this was how the film began. There was no longer room in Europe for the little maniacal lozenges of Monsieur Mondrian.

[1] Popular song of Aragon of exemplary racial violence.

Cinema property-men are usually hardboiled fellows who think that they have seen it all and that nothing one could ask them would astonish them. In spite of this, and in spite of the fact that our film was short and required little in the way of properties, our property-man confessed to us that he thought he was dreaming. These were some of the things we asked for: a nude model, for whom he had to find some way of wearing a live sea-urchin under each arm; a makeup for Bacheff in which he would have no mouth, and a second one in which his mouth would be replaced by hairs which by their arrangement would recall as much as possible those of the underarms; four donkeys in a state of decomposition, each of which had to be placed on a grand piano; a cut-off hand, looking as natural as possible, a cow's eye, and three nests of ants.

The shooting of the scene of the rotten donkeys and the pianos was a rather fine sight, I must say. I "made up" the putrefaction of the donkeys with great pots of sticky glue which I poured over them. Also I emptied their eye-sockets and made them larger by hacking them out with scissors. In the same way I furiously cut their mouths open to make the white rows of their teeth show to better advantage, and I added several jaws to each mouth so that it would appear that although the donkeys were already rotting they were still vomiting up a little more of their own death, above those other rows of teeth formed by the keys of the black pianos. The whole effect was as lugubrious as fifty coffins piled into a single room.

The *Chien Andalou* distracted me from my society career to which Juan Miro would have liked to initiate me.

"I prefer to begin with rotten donkeys," I told him. "This is the most urgent; the other things will come by themselves."

I was not mistaken.

Meanwhile I met Robert Desnos one evening at the Coupole, and afterwards he invited me up to his place. I always carried a painting under my arm as a sample. He wanted to buy the one I had, but he had no money. He certainly understood the originality of my painting, which was called *The First Day of Spring,* and in which libidinous pleasure was described in symbols of a surprising objectivity. He said, "It's like nothing that is being done in Paris." After which he began to talk endlessly about Robespierre with a nightmarish and automatic nervousness, a tense, inexhaustible lyricism. It gave me an irresistible desire to go away and sleep.

It is a curious thing that each time I heard people talk too long about the French Revolution I fell ill the following day. I did in fact fall ill the following day with a violent inflammation of my tonsils, which was followed by angina. I spent this period of illness alone in my hotel room, utterly dejected, accustomed as I was to being always cared for with the most exaggerated ritual. I began to find the hotel where I was abominable, and its cleanliness more than dubious.

The day before I was going to get up from my bed for the first time I discovered two or three insects on the ceiling. Were they small cock-

roaches or lice? The ceiling was high, and I tossed cushions up to try to bring them down. But my efforts, in view of my state of extreme feebleness, made my head begin to spin, and I dropped back heavily on my bed, where I fell asleep, all the while knowing that those little insects were there above me sticking to the ceiling. When I awoke, the first thing I did was to look up at that ceiling. There was only one insect. The other one had probably dropped on me during the night. The thought of this gave me a sickening feeling, and I began to look all over myself and shake all the sheets. Suddenly I made a discovery that congealed me with horror. In passing my hands all over my naked body on a tour of inspection I had just felt something caught on my back, just at a point that the tips of my fingers could barely reach. I tried to pull it loose, but it resisted, as though clinging to my body all the harder.

Then I made one leap from my bed over to the wardrobe mirror and looked. There could be no further doubt. The insect, the cockroach, was there, stuck, clutching my flesh pitilessly, and I could see its rounded, smooth back, swollen with my very own blood. This insect must belong to the foul family of ticks which, when they attach themselves to the ear of a dog, cannot be pulled out without drawing blood. I shut my eyes, I gritted my teeth, prepared to endure anything if only I could get rid of that minute nightmare which was paralyzing me. I took the tick between my thumb and forefinger and squeezed the point where it joined my skin with the cutting pincer of my fingernails. I squeezed furiously without paying any attention to the pain, and pulled. The tick was so solidly attached to me that I did not succeed in loosening it even a little. It was as if it was formed of my own flesh, as if it constituted an inherent and already inseparable part of my own body; as if, suddenly, instead of an insect it had become a terrifying germ of a tiny embryo of a Siamese twin-brother that was in the process of growing out of my back, like the most apocalyptic and infernal disease.

I made a drastic decision, and with a savagery proportionate to my frantic condition and my horror I seized a razor blade, held the tick tightly imprisoned between my nails and began to cut the interstice between the tick and the skin, which offered an unbelievable resistance. But in a frenzy I cut and cut and cut, blinded by the blood which was already streaming. The tick finally yielded, and half-fainting, I fell to the floor in my own blood. The pool of blood grew terrifyingly. I had just provoked a violent hemorrhage, which seemed to be merely beginning. I dragged myself across on the floor as far as to the bell to call the chambermaid. When I turned round I saw that I had left behind me a solid trail of blood. I was alarmed to see the large pool that had formed by the wardrobe.

I climbed back into bed and tried to make a bandage with the sheets, but the blood immediately oozed through it, like the impetuous waters of a growing flood that nothing can stem. Then I lunged toward the washstand, but by this time I felt so feeble that I had to brace myself

against the wall. Thus, terribly unsteady and faint, I stumbled in the direction of the washstand, which immediately became red with my blood. It was as if the water that I poured on my wound only intensified the bleeding. I decided to ring once more, but the moment I turned round the sight of the room made me shudder. The bed was completely bespattered with blood, and the wall covered with smears from the clawing of my hands. On the floor the blood had spread under the wardrobe. I seized the bell and did not stop ringing till the chamber-maid arrived.

She opened the door, and on seeing the room covered with blood she let out a scream and shut the door again. After a few minutes I heard a hurried shuffling of many feet out in the hallway. A queer assortment of people, with the hotel manager in the lead, broke into my room and all looked at me breathlessly, expecting at the very least to learn that I had been the victim of a murderous assault.

"It's nothing," was all I said to them. "It's a... It's a..." I could not think of the word for "tick" in French.

The manager gave me a prompting glance, as if to reassure me, conveying that he was a fellow-human, that they were prepared to hear the worst.

"It's a bedbug that has just bitten me."

The doctor arrived. But everything had become clear to me before he came. It was neither a bedbug nor a tick nor a cockroach nor a Siamese-twin that had been stuck to my skin—all this had existed only in my imagination. It was simply a small birthmark that I had seen a hundred times before. The doctor told me that it was very dangerous to perform such an operation, and that it was revolting madness for me to have done it on myself. I explained that I had thought it was a bedbug that had fastened itself on me which I could not wait to get rid of. He did not believe a word of this.

"I can understand," he said, wiping his glasses, "someone wanting to get rid of such a blemish when it happens to be in an awkward place on the face—and even so it's absurd to touch it. But on the back!" And he puffed with indignation.

This orgy of blood, my confinement to this room which evoked the painful memories of my recent illness, and an extreme feebleness made everything begin to look black to me. *Le Chien Andalou,* which had not yet been performed publicly, now seemed to me to be a complete failure, and if I had owned it and had had it in my possession at this moment I would have suppressed it without a moment's hesitation. It seemed to me that it needed at least half a dozen more rotten donkeys, that the roles of the actors were lamentable, and that the scenario itself was full of poetic weaknesses.

Aside from the making of this film, what had I done? The few times I had gone out into society had remained isolated episodes, completely useless. My timidity had prevented me from "shining" in these circles, so that each occasion had left me with a disagreeable feeling of dissatis-

faction. Camille Goemans, the art dealer, had promised me a contract, to be sure, but this contract kept being put off from day to day, and was evaporating into very vague promises conditioned upon the work I would do the following summer at Cadaques.

I had not succeeded in finding an elegant woman to take an interest in my erotic fantasies—even any kind of woman, elegant or not elegant! I had walked the streets like a dog, "seeking," dead with desire, but I had never been able to find anything, and if for a second the miracle occurred, my timidity prevented me from approaching the woman I should have liked to know. How many afternoons I spent running about, going up and down the boulevards, sitting at the terraces of cafés to give the glad eye to the right woman if I saw her! It seemed to me so natural that all women should rush out into the street every afternoon with their brain tormented by the same idea, by the same erotic fantasies as mine. But no! Sometimes, just to try myself out, when I was in the depths of discouragement, I would undertake the persecution of an ugly woman. I would flash on her my most passionate glances, not averting my eyes from her for a second, I would follow her in the street, get into the same streetcar and sit down opposite or beside her, and try with the utmost gentleness and prudent politeness to press her knee. She would always get up with a dignified air and change places. I would get off the streetcar and watch the throng of women (for I saw only them) flow past me along the hostile boulevard, shimmering and inaccessible, utterly ignoring me.

"Well," I asked myself, my throat parched with unsatisfied desire, "where is that bag you were going to put 'all Paris' into? You miserable creature! You see, not even the ugly ones will have anything to do with you!"

And coming back to my immeasurably prosaic hotel room, my legs aching with fatigue from my fruitless comings and goings, I felt the bitterness of frustration fill my heart. Mortification at not having been able to attain the inaccessible beings whom I had grazed with my glance filled my imagination. With my hand, before my wardrobe mirror, I accomplished the rhythmic and solitary sacrifice in which I was going to prolong as much as possible the incipient pleasure looked forward to and contained in all the feminine forms I had looked at longingly that afternoon, whose images, now commanded by the magic of my gesture, reappeared one after another by turn, coming by force to show me of themselves what I had desired in each one! At the end of a long, exhausting and mortal fifteen minutes, having reached the limit of my strength, I wrenched out the ultimate pleasure with all the animal force of my clenched hand, a pleasure mingled as always with the bitter and burning release of my tears—this in the heart of Paris, where I sensed all about me the gleaming foam of the thighs of feminine beds. Salvador Dali lay down alone in his bed on Rue Vivienne, without the foam of thighs and without even having the courage to think of women again. He would meditate a little on Catholicism before going to sleep...

I often went to the Luxembourg garden, sat down on a bench and wept.

One evening Goemans, my future dealer, took me to the Bal Tabarin. We had settled down at a table on the second floor when he pointed out a man who was just coming in with a lady dressed in black spangles.

"That's Paul Eluard, the surrealist poet," he said. "He is very important, and what's more he buys paintings. His wife is in Switzerland, and the woman with him is a friend of his."

We went down to join him, and we had several bottles of champagne together.

Eluard struck me as a legendary being. He drank calmly, and appeared completely absorbed in looking at the beautiful women. Before we took leave of each other, he promised to come to see me the next summer at Cadaques.

The following evening I took the train for Spain, and before I left I ate a vermicelli soup in the Gare d'Orsay which to me was like a dream in which all the angels of heaven sang. It was the first time since my illness that I was hungry again. Each of those slippery vermicelli seemed to whisper to me, "You don't need to be sick any more, since you don't have to 'put Paris in the bag'." And since then my personal experience has proved to me that it is invariably when one has to and wants to put something in the bag and does not succeed that one gets sick. People who actually dominate a situation never get sick, even if their organism becomes increasingly feeble, run down and susceptible.[1] The boundaries between the physical and the moral are again tending to disappear, and the adage according to which the body's life is the reflecton of the soul's seems to reassume all its realistic and Catholic prestige.

I thus hung my illness on the coathanger of the Gare d'Orsay, as though it had been an old coat which could no longer be of the slightest use for the summer on which I was embarking. If, another winter, I should again need an illness to shelter me from the inclemencies of my bad luck I prefer to buy a brand-new coat. Goodbye! And I retired to my berth on the train which was going directly to Spain, and which would deposit me in Figueras.

The next morning I awoke to the view of the sunswept landscape of the Ampurdán plain. We were just passing the Muli de la Torre, and the train was already whistling to announce that we were approaching the station of Figueras.

Just as the purest skies appear after a storm, so in my case after that illness in Paris I experienced the most "transparent" health that I had

[1] When a war breaks out, especially a civil war, it would be possible to foresee almost immediately which side will win and which side lose. Those who will win have an iron health from the beginning, and the others become more and more sick. The ones can eat anything, and they always have magnificent digestions. The others, on the other hand, become deaf or covered with boils, get elephantiasis, and in short are unable to benefit by anything they eat. A rigorously controlled statistical study along this line could not fail to be of the highest scientific interest.

ever "seen," for I actually felt a kind of transparency, as though I could see and hear all the delightful little viscous mechanisms of my reflowering physiology. I had the illusion of having an exact consciousness of the circulation of my hard blood through the tender and ramified tubes which I felt covering the euphoric curve of each of my shoulders, like epaulettes of living and subcutaneous coral imbedded in my flesh.

All at once I cast a quick glance at the tips of my finger-nails, with the sudden terror of seeing a white cat-hair growing out of them. I had a vague presentiment, which grew and became increasingly precise, that all these signs were the visceral portents of love—I was going to know love this summer! And my hands explored upon the body of the terribly precise noon of Cadaques the absence of a feminine face which from afar was already coming toward me. This could be none other than

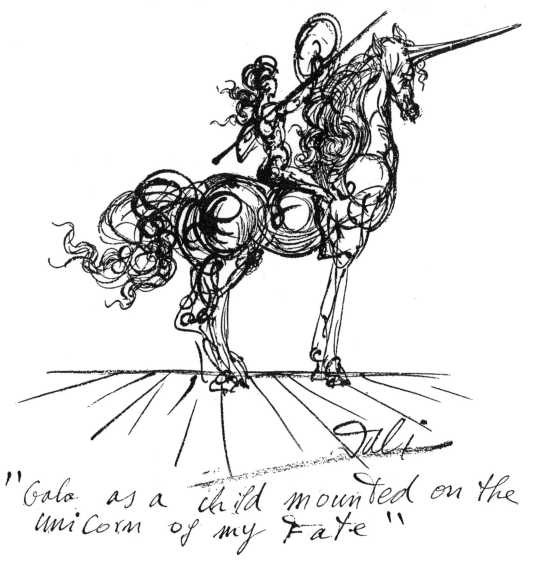

"Gala as a child mounted on the unicorn of my Fate"

Galuchka, resuscitated by growth, and with a new woman's body—advancing, for I saw her always walking, always advancing.

From the moment of my arrival at Cadaques I was assailed by a recrudescence of my childhood period. The six years of the baccalaureate, the three years of Madrid, and the voyage I had just made to Paris—all receded into the background, becoming blotted out until they totally disappeared, whereas all the fantasies and representations of my childhood period again victoriously took possession of my brain. Again I saw passing before my ecstatic and wondering eyes infinite images which I could not localize precisely in time or space but which I knew with certainty that I had seen when I was little. I saw some small deer, all green except for their horns which were sienna-colored. Surely they were reminiscences of decalcomanias. But their contours were so precise that it was easy for me to reproduce them in painting, as though I were copying them from a visual image.

I also saw other more complicated and condensed images: the profile of a rabbit's head, whose eye also served as the eye of a parrot, which was larger and vividly colored. And the eye served still another head, that of a fish enfolding the other two. This fish I sometimes saw with a grasshopper clinging to its mouth. Another image which often came into my head, especially when I was rowing, was that of a multitude of little parasols of all the colors in the world. I saw this image several times while engaging in other forms of violent exercise. And the multiplicity of colors of all those parasols left with me for the whole rest of the day an impression of ineffable joy.

After some time spent wholly in indulging in this kind of fancy summoned up out of childhood reminiscences, I finally decided to undertake a picture [1] in which I would limit myself exclusively to reproducing each of these images as scrupulously as it was possible for me to do accord-

[1] This work, unusual and disconcerting in the highest degree, was by the very physiology of its elaboration far removed from the "Dadaist *collage*," which is always a poetic and a *posteriori* arrangement. It was also the contrary of Chirico's metaphysical painting, for here the spectator had perforce to believe in the earthy reality of the subject, which was of an elementary and frenzied biological nature. And it was furthermore the contrary of the poetic softening of certain abstract paintings which continue stupidly, like blind moths, to bump into the extinguished lamps of the neo-Platonic light.

I, then, and only I was the true surrealist painter, at least according to the definition which its chief, André Breton, gave of surrealism. Nevertheless, when Breton saw this painting he hesitated for a long time before its scatological elements—for in the picture appeared a figure seen from behind whose drawers were bespattered with excrement. The involuntary aspect of this element, so characteristic in psychopathological iconography, should have sufficed to enlighten him. But I was obliged to justify myself by saying that it was merely a simulacrum. No further questions were asked. But had I been pressed I should certainly have had to answer that it was the simulacrum of the excrement itself. This idealistic narrowness was from my point of view the fundamental "intellectual vice" of the early period of surrealism. Hierarchies were established where there was no need for any. Between the excrement and a piece of rock crystal, by the very fact that they both sprang from the common basis of the unconscious, there could and should be no difference in category. And these were the men who denied the hierarchies of tradition!

ing to the order and intensity of their impact, and following as a criterion and norm of their arrangement only the most automatic feelings that their sentimental proximity and linking would dictate. And, it goes without saying, there would be no intervention of my own personal taste. I would follow only my pleasure, my most uncontrollably biological desire. This work was one of the most authentic and fundamental to which surrealism could rightly lay claim.

I would awake at sunrise, and without washing or dressing sit down before the easel which stood right beside my bed. Thus the first image I saw on awakening was the painting I had begun, as it was the last I saw in the evening when I retired. And I tried to go to sleep while looking at it fixedly, as though by endeavoring to link it to my sleep I could succeed in not separating myself from it. Sometimes I would awake in the middle of the night and turn on the light to see my painting again for a moment. At times again between slumbers I would observe it in the solitary gay light of the waxing moon. Thus I spent the whole day seated before my easel, my eyes staring fixedly, trying to "see," like a medium (very much so indeed), the images that would spring up in my imagination. Often I saw these images exactly situated in the painting. Then, at the point commanded by them, I would paint, paint with the hot taste in my mouth that panting hunting dogs must have at the moment when they fasten their teeth into the game killed that very instant by a well-aimed shot.

At times I would wait whole hours without any such images occurring. Then, not painting, I would remain in suspense, holding up one paw, from which the brush hung motionless, ready to pounce again upon the oneiric landscape of my canvas the moment the next explosion of my brain brought a new victim of my imagination bleeding to the ground. Sometimes the explosion occurred and nothing fell. Sometimes I would dash off in a mad and fruitless chase, for what I had thought was a partridge turned out to be just a leaf that the shock of the bullet had shaken from a branch. To win forgiveness for my mistake I came back hanging my head and humiliated myself before my master. Then I would feel the protective fingers of my imagination scratch me reassuringly between my two eyebrows, and I would close my eyes with fawning voluptuousness.

A violent pecking would occur inside my brow, and sometimes I would have to scratch myself with my two hands. One would have said that the colored parasols, the little parrots' heads and the grasshoppers formed a seething mass just back of the skin, like a gay nest of worms and ants. When the pecking was over, I felt anew the calm severity of Minerva pass the cool hand of intelligence over my brow, and I said to myself, "Let's go for a swim." I would climb over the rocks and find a spot completely sheltered from the wind. There I would bask in the stifling heat, waiting till the last moment to dip into the icy water, plunging from the jutting rocks straight down into the Prussian blue

depths, even more unfathomable than those of the Muli de la Torre. My naked body embraced my soul caressingly, and said to it, "Wait—she is coming." My soul did not like these embraces and tried to elude the too violent impulses of my youth.

"Do not press me so," said my soul, "you know perfectly well she is coming for you."

After which my soul, who never bathed, went and sat down in the shade.

"Go—go and play!" she said, exactly as my nurse had done when I was little. "When you are tired come and get me and we will return home."

In the afternoon, again, bent before my picture, I would paint with my body and soul until there was no more light in my room. The full moon caused the maternal tide of my soul to rise, and shed its insipid light over the very real full-blown feminine body, covered by sheer summer dresses, of the Galuchka of my "false memories" which had continually grown with the years. With all my soul I wanted her. But feeling her to be already very close I now wished the pleasures and tortures of expectation to be further prolonged. And while I yearned for the moment when she would come, more intensely than for anything in the world, I said to myself, "Make the most, make the most of this wonderful occasion. She is not yet here!" And with a delirious delight I dug my nails into each precious moment that remained to me to continue to be alone. Once more I wrenched from my body that familiar solitary pleasure, sweeter than honey, while biting the corner of my pillow lighted by a moonbeam, sinking my teeth into it till they cut through the saliva-drenched fabric. "Ay, ay!" cried my soul. After which I went to sleep beside her without daring to touch her.

She always awoke before I did, and when at sunrise I opened my eyes I found her already up standing beside my picture, watching. Did she never sleep?

I excuse myself for the crudeness I am about to commit by stating that everything I have just been saying about my "soul" is allegorical. But it was a familiar allegory, which occupied a quite definite place in my fantasies of that time. I make this remark because the story that I am about to tell, far from being an allegory, constitutes a true "hallucination," the only one I have experienced in my life, and for this very reason it is necessary that I tell it scrupulously, while taking precautions lest it be confused with the rest of my fantasies or images. These, while sometimes endowed with a great visual intensity, never attain the degree of being hallucinatory.

It was on a Sunday, and as usual on that day I got up very late. It must have been about half past twelve. I was awakened by an immediate urge to relieve myself. I got up and went to the bathroom, which was down on the second floor. I had a bit of conversation with my father after leaving the toilet, where I had stayed about fifteen minutes, which he himself subsequently confirmed. (This eliminates the possibility that

I may have dreamed that I went down to the bathroom—I was thus awake, and well awake.) I went upstairs again to my room, and barely had I opened the door when I saw sitting before the window, in three-quarter view, a rather tall woman wearing a kind of nightgown. In spite of the "absolute reality" and the normal corporeality of this being, I immediately realized that I was the victim of an hallucination,[1] and contrary to everything I had anticipated I was in no way impressed. I said to myself, "Get back into your bed so that you can observe this astonishing phenomenon completely at your ease." I got back into bed, but without lying down. However, during the moment that I stopped looking at the apparition to put my two pillows behind my back she disappeared. I did not see her gradually melt away, but when I looked again in her direction she had simply disappeared.

The incontrovertible fact of this apparition made me anticipate the possibility that others would follow. And from this time on, in spite of the fact that it was never repeated, each time I open a door I am aware of the possibility that I may see something that is not normal. In any case I myself at that time "was not normal." The limits of the normal and the abnormal are perhaps possible to define, and probably impossible to delimit in a living being. But when I say that at this period I was abnormal I mean as compared to the moment I am writing this book. For since the period of which I am speaking I have made bewildering progress in this direction of normality, and in the direction not only of passive but even and especially of active adaptation to reality.

At the time when I had my first and only hallucination I derived satisfaction from each of the phenomena of my growing psychic abnormality, to such a point that everything served to stimulate them. I made desperate efforts to repeat each of these, adding each morning a little fuel to my folly. Later, when I saw the fruits of this folly threatening to clutter up my life, becoming so vigorous that it seemed as though they

After this "hallucination" which I can completely vouch for on my own testimony, here are two further incidents of the same nature, which I have on authority which I consider as good as my own, for they were related to me by my father, who is the last person in the world to be given to this kind of thing. He explained to me that when I was barely three years old I happened to be sitting and playing on a large, completely deserted terrace. Several members of my family observed the interest and satisfaction I showed in my game, which consisted in piling together and tapping little clods of dirt. Suddenly it appears that I stopped my game and looked in front of me, where there was nothing but empty space, and drew back seized with such a violent fright that I did not stop weeping the rest of the morning. All those who witnessed this scene were convinced that I had had a terrifying apparition. The other incident occurred in our house in Cadaques. We were getting ready to go out on a boat ride one day. At the last moment my father went back into the house to get a handkerchief. He had only been inside the house a few moments when he came out again, pale and upset, and explained to us that just as he came into the dining room he heard little footsteps of someone coming down the stairs. He immediately recognized these steps by their characteristic slow, light tread. He looked toward the door and there on the threshold he did in fact see my grandmother (who had been dead for eight years), carrying a little basket with clothes to be mended. She went down the remaining three steps and disappeared from sight without vanishing into thin air.

might deprive me of all the air I needed, then I rejected folly with violent kicks, and undertook a crusade to recover my "living-space"; and the slogan of this first moment—"The irrational for the sake of the irrational" —was one which I was to transform and canalize at the end of a year into that other slogan, which was already of Catholic essence—"The Conquest of the Irrational." So that the "Irrational" which, at the moment of which I am speaking, I was treating with all the honors and ceremonials due to a true divinity was a thing which I already completely rejected at the end of a year. And while profiting by the secrets I had torn from it, and which it had yielded to me, during the promiscuity of our relations, I set out with fury, stubbornness and heroism to try to conquer it, destroying it pitilessly as I progressed, and at the same time trying to pull the entire surrealist group along with me.[1]

1929. I am, then, in the white-washed Cadaques of my childhood and my adolescence. Grown to manhood, and trying by every possible means to go mad—or rather, doing everything in my conscious power to welcome and help that madness which I felt clearly intended to take up its abode in my spirit. "Ay! Ay!" my soul would cry.

At this point I began to have fits of laughter. I would laugh so much that often I was obliged to lie down on the bed to rest. These fits gave me violent pains in my sides. What did I laugh at? At almost anything. I would imagine, for instance, three tiny curates running very fast in single file across a little Japanese gangplank, like the ones in the Tsarskoe Selo. Just at the moment when the last of the small curates, who was much smaller than the others, was about to leave the gangplank, I would kick him hard in the behind. I saw him stop like a hunted mouse, and take to his legs, recross the gangplank and run off in the opposite direction from that in which the others were going.

The little curate's terror the moment I kicked him struck me as the most comical thing in the world, and I had only to imagine this scene to myself again to writhe with laughter, unable to stop, to hold myself in, no matter under what circumstances I happened to find myself.

Another example, among innumerable ones of this kind, was that of imagining certain people I knew with a little owl perched on their heads, which in turn carried an excrement on its own head. This owl was carved, and I had imagined it to the minutest detail. The excrement always had to be a bit of my own excrement. But the efficacy of this little excrement-bearing owl was not uniform. It varied according to the individuals on whose heads I tried to balance it by turns in my imagination. For certain ones the comic effect was such as to provoke me to a paroxysm of laughter; for others it was completely inoperative. Then I would remove it from this head and try it on another one. And suddenly I would

[1] I did not succeed in this. Political preoccupations almost immediately ruined the activity of the surrealists like a cancer. They adopted my slogans, for they were the only clairvoyant ones, but this did not suffice to inject vigor into the movement. I saw that henceforth I would have to conquer or die without being helped by anyone.

find the head, the exact expression of the face to go with my owl. And once it was in place I would contemplate the hilarious, infinite and instantaneous relationship which established itself magically between the face of the person I knew, who was completely unaware of what I had just put on his head, and the fixed stare of the owl balancing his excrement, and which provoked me to such spasmodic explosions of laughter that my family hearing from below the noise I was making wondered, "What's going on?" "That child laughing again!" [1] my father would say, amused and preoccupied as he watered a skeletal rosebush wilting in the heat.

It was under these circumstances that I received a telegram from my dealer Camille Goemans. Aided and counseled by my father, I had in a series of letters reached a basis of agreement, by the terms of which I was to receive three thousand francs and he was to handle all the pictures I should paint during the summer, which would be exhibited in his gallery in Paris at the beginning of winter. He would have a percentage on the sale of each painting and would keep, besides, three canvases of his choosing. My father found these conditions honorable, and

My relatives still call me a child.

I did not give this matter a moment's reflection. For that matter I had
not yet acquired a precise notion of the value of money. I still had the
impression that five hundred francs in small bills ought to "last" infi-
nitely longer than a single bill of a thousand. I know that this will seem
improbable to my readers, and only the testimony of my friends who
knew me at this time could banish their doubts, which as a matter of
fact are quite unfounded, for I am myself always the first to let them
in on my mystifications.

Termite (Névroptère)

Goemans arrived and was enthusiastic over *Le Jeu Lugubre* (The
Lugubrious Game), which was not yet altogether completed. A few days
later René Magritte arrived with his wife, and Eluard had just written
that he would come later. Luis Bunuel also arrived at about the same
time.

Thus within four days I was surrounded for the first time by sur-
realists who, when one came right down to it, had been attracted here
by the unusual personality they had discovered in me. For Cadaques
offered none of the comforts and conveniences indispensable to a resort,
if one did not have one's own house.

My fits surprised everyone, and this surprise which I observed on all
their faces each time I burst out laughing only aggravated the intensity
of my fits. Sometimes, stretched out on the beach of an evening to enjoy
the coolness, everyone would be deep in a philosophic conversation,
when suddenly I would interrupt them, showing that I wished to say
something. But the moment I opened my mouth I would again explode
with laughter. I finally gave up talking entirely, for instead of talking
I could only laugh. My surrealist friends accepted my laughter with
resignation, considering it to be one of the drawbacks of possessing a
genius so manifest as mine. "Don't ask Dali what he thinks about this,"
they would say, "for naturally he will laugh, and we will be in for a
good ten minutes of it."

From hour to hour my fits of laughter grew more violent, and I
caught in passing certain glances and certain whisperings about me by
which I learned in spite of myself the anxiety which my state was
beginning to cause. This appeared to me as comical as everything else,
for I knew perfectly well that I was laughing because of the images that
came into my mind. "If you could see what I imagine," I would say to
them, "you would all laugh even more than I do." Finally I could no
longer resist the avid curiosity which I saw reflected on all the faces.

"Imagine to yourselves, for instance," I began, "that you see in your
own mind a certain very respectable person. All right. Now go on and
imagine a little sculptured owl perched on his head—a rather stylized
owl, except for his face which must be quite realistic. You see what I
mean." Everyone, very serious, tried to represent to himself the image
I had just described, and they said, "Yes, yes!"

"Well, then, imagine on the owl's head a piece of my excrement!"
I repeated, "Of my own excrement!"

Everyone still waited, and no one laughed.

"That's it!" I said.

Then everyone laughed very feebly, as if to humor me.

"No, no," I said, "I see it doesn't make you laugh at all. For if you could see all this as I do you would be rolling on the floor."

I was writhing with laughter in this way one morning when a car stopped in front of our house. It was the surrealist poet Paul Eluard, accompanied by his wife. They were tired from a long trip, having arrived from Switzerland, where they had been visiting René Crevel. They left us almost immediately to go and rest, and we arranged to meet at five o'clock at their hotel, the Miramar.

Eluard's wife, Gala, struck me as having a very intelligent face, but she seemed to be in very bad humor, and rather annoyed at having come. At five o'clock our whole little surrealist group went to look up the Eluards. We drank in the shadow of the plane trees. I took a Pernod and had a little fit of laughter. My "case" was explained to Eluard, who seemed to be very much interested. But all the others, who were used to my fits, seemed by their expressions to say, "It's nothing yet, wait a little and you'll see!"

That evening, during the walk, I spoke with Gala of intellectual questions, and she was immediately surprised by the rigor which I displayed in the realm of ideas. She even admitted to me that earlier, as we were drinking in the shade of the plane trees, she had thought me an unbearably obnoxious creature because of my pommaded hair and my elegance, which she thought had a "professional Argentine tango slickness." My Madrid period had in truth left its imprint on me in love of adornment. In my room I was always completely naked, but as soon as I had to go into the village I would spend an hour in fixing myself up, plastering down my hair, shaving with maniacal care, always wearing freshly creased white trousers, fancy sandals and pure silk shirts. I also wore a necklace of imitation pearls, and a metal cloth ribbon tied to one of my wrists. For evening I had had made shirts in a heavier material with low necks and very full sleeves, which I had designed myself and which gave me a completely feminine appearance.

Walking back, I spoke with Eluard. I saw immediately that he was a poet of the category of Lorca—that is to say, among the greatest and most authentic. I waited impatiently to hear him praise the landscape of Cadaques; but he "did not see it yet." Then I tried to put a little owl on his head to see what effect it would produce. It did not make me laugh. I tried it on Lorca—this had no effect either. I tried it then on other poets. But no. It was as though the hilarity-provoking virtue of my owl had disappeared. I tried again and again; and even on those on whom it had formerly produced the most efficacious results—nothing. Then suddenly I imagined my owl upside down, with his head stuck to the sidewalk by my excrement. This provoked such a violent fit that I had to roll on the ground before I could continue my walk.

We accompanied the Eluards back to the Hotel Miramar, and we agreed to meet, all of us, on the beach in front of our house the next day at eleven o'clock and go swimming.

The following day I awoke well before sunrise, in the throes of a great anxiety. The idea that my friends, and especially the Eluards, would be there already at eleven o'clock, on the beach in front of my window, and that since I wanted to be polite I would have to go out, stopping my work an hour earlier than usual, greatly exasperated me, ruining my whole morning in advance. In the framework of my window the morning sang the song of my impatience, and the pebbles stirred by a early fisherman sent a shudder through me. I should have liked to stop the rising course of the sun that was implacably advancing, so that in plunging back into the sea from which it came it would leave unbegun the uncertain battle that my presentiments announced to me.

But of what battle was I thinking? The morning shone like every other morning, perhaps with a little more of that utter foreboding calm which habitually precedes momentous events. After that "morning void" that kept my heart in suspense the myriad forms of life were stirring and awakening, with the daily noises a thousand times heard—the kitchen door just opened by the maid, struck several times with a closed fist before the key was turned and it made up its mind to open with a sandy crunching; the shepherd passing by with his tinkling flock. At this moment I shut my eyes to get the full impact of it, and to greet with dignity that troubling, intoxicating and symphonic odor of the sheep, in the midst of which the virile and arrogant odor of the ram resounded in my sniffing nostrils like a dominant genital note. I also made out, among a hundred others, the characteristic rhythm of the fisherman Enrique's oar, coming always about ten minutes later than the passing of the flock. All this was repeating itself chronologically, and with the same accent as on other days. And yet... What was going to happen?

I would frequently get up from my easel on the most varied pretexts. I tried on my sister's ear-rings several times. I liked them on myself, but decided they would be a nuisance for the swim. Nevertheless I put on my pearl necklace. I made up my mind to get myself up very elaborately for the Eluards. It would be much better, without any clothes on, to have my hair tousled rather than plastered down as usual. I decided that they had already seen me with my hair slicked down yesterday, and I would grease it again in the evening. When they come, I thought, I will go down with the pearl necklace, my hair very tousled, and with my palette in my hand filled with brushes. This, combined with the blackness of my skin, darkened by the sun like an Arab's, might produce a rather interesting effect on them. Nevertheless I was not satisfied with my attire. Definitely giving up attempting to paint any more, I took my finest shirt and cut it irregularly at the bottom, making it so short that it did not quite reach my navel. After which, putting it on me, I began to tear it artfully: one hole, baring my left shoulder, another, the

black hairs on my chest, and a large square tear on the left side exposing my nipple that was nearly black.

Once I had torn the shirt in all the appropriate places the great problem that confronted me was that of the collar of the shirt: should I leave it open or closed? Neither the one nor the other. I buttoned the top button, but cut off the collar entirely with a pair of scissors. But the most difficult problem was the trunks, which struck me as too sporty, impossible to fit into that composite of beggarly painter and exotic Arab which I was trying to make myself into. Then I had the idea of turning the trunks inside out. They were lined in white cotton, which was discolored with rust stains from the oxidation of my belt.

What else could I do on the necessarily limited "theme" of a swimming costume? But this had but just begun. I now shaved the hairs under my arms. But failing to achieve the ideal bluish effect I had observed for the first time on the elegant ladies of Madrid, I went and got some laundry bluing, mixed it with some powder, and dyed my armpits with this. The effect was very fine for a moment, but immediately my sweat caused this makeup to begin to run, leaving bluish streaks that ran down my sides. I then wiped my armpits, and the skin, already chafed, became quite red from the rubbing. Then I had a new idea which this time struck me as fine and worthy of me. I understood that the artificial bluing was not the thing, and neither was the present bright pink. On the other hand dried and coagulated blood on this part of the body ought to make an extraordinary impression. There was already a small bloodstain where I had cut myself in shaving, which gave me the proof and sample of what I contemplated. So without more ado I took my Gillette and began to shave again, pressing harder so as to make myself bleed. In a few seconds my armpits were all bloody. I now had only to let the blood coagulate, and I daintily began putting some everywhere, especially on the knees. The blood on the knees pleased me beyond measure, and I could not resist the temptation to make a small cut on one of them. What a work! And it was not yet finished. My transformation appeared to me more and more desirable, and each moment I fell more in love with my new appearance. Adroitly I stuck a fiery-red geranium behind my ear.

I should have liked some kind of perfume, but I had only Eau de Cologne, which made me sick to my stomach. I would therefore have to invent something else for this. Oh, if I could only perfume myself with the odor of that ram that passed every morning! I sat down and meditated deeply on this question of a perfume, but could not find the solution. But wait! Salvador Dali has just sprung to his feet, and his attitude is resolute. This means that something very unusual has just passed through his mind, for what could otherwise be the cause of his new agitation?

I got up and ran to fetch some matches. I lighted a small alcohol burner that I used for my etchings, and I began to boil some

water in which I dissolved some fish glue. While waiting for this to boil I ran out in back of the house where I knew several sacks of goat manure had been delivered. I had often smelled it after dark in damp weather, when the smell became stronger. It pleased me very much, but it was not complete. Back in my studio, I threw a handful of this manure, and then another, into the dissolved glue. With a large brush I stirred and stirred it until it formed a homogeneous paste. For the moment the stench of the fish glue eclipsed that of the goat dung, but I foresaw that when it "jelled" it would be the goat smell that would have the best of it. But the secret of this strong odor that was already beginning to fill the whole house was a bottle of aspic oil which I also used for my etchings, a drop of which was enough to cling to a material with a tenacity that lasted several days. I poured out half the bottle, and—miracle of miracles! —the "exact" odor of the ram which I was seeking emerged as if by a veritable magic operation. I let the whole thing jell, and when it was cold I took a fragment of the paste that I had made and rubbed my whole body with it.

Thus I was ready. Ready for what? Eleven o'clock rang out from the bell-tower of Cadaques. I went over to the window. She was already there. Who, she? Don't interrupt me. I say that she was there and that ought to suffice! Gala, Eluard's wife. It was she! Galuchka Rediviva! I had just recognized her by her bare back. Her body still had the complexion of a child's. Her shoulder blades and the sub-renal muscles had that somewhat sudden athletic tension of an adolescent's. But the small of her back, on the other hand, was extremely feminine and pronounced, and served as an infinitely svelte hyphen between the willful, energetic and proud leanness of her torso and her very delicate buttocks which the exaggerated slenderness of her waist enhanced and rendered greatly more desirable.

How had I been able to spend the whole previous day with her without recognizing her, without suspecting anything? But was this true, and if so what was the meaning of the inconceivable rig I had just got myself into if it was not a veritable nuptial costume? No, no! It was not true! It was for her that I had just smeared myself with goat dung and aspic, for her that I had torn my best silk shirt to shreds, and for her that I had bloodied my armpits! But now that she was below, I no longer dared to appear thus. I looked at myself in the mirror, and I found the whole thing lamentable. I said to myself, "You look like a regular savage, and you detest that."

This was true—so true it is that the "savage state" is none other than that of the depth of atavistic and common folly of humanity! I quickly removed all my adornments and washed my body as best I could to get rid of the stifling stench which I gave off. However, I kept the pearl necklace and the immense red geranium, which I reduced to less than half.

I ran out to meet Gala, but when I was about to greet her I was

seized with hysterical laughter, which recurred each time I tried to answer any question she would ask me. I could not utter a word to her. My surrealist friends, who were resigned to this, seemed to say to themselves, "Now we're in for another whole day of it," and nonchalantly cast pebbles into the sea. Bunuel especially was terribly disappointed, for he had come to Cadaques with the idea of collaborating with me on the scenario for a new film, whereas I was more and more absorbed in nursing my personal madness, and had thoughts only for this and for Gala.

Since I was unable to talk to her, I tried at least to surround her with all manner of little attentions. I would run to fetch her some cushions, or a glass of water, or make her move to a place where she would have a better view of the landscape. I should have loved to help her on with her shoes a thousand times. If in the course of the walk I happened by chance to brush against her hand all my nerves quivered, and immediately I heard the rain of half-ripe fruit of my erotic illusion falling about me, as if instead of my touching Gala's hand, a real giant had savagely and prematurely shaken the still frail tree of my desire.

But Gala, who with a vital intuition unique in the world perceived my reactions in every detail, was miles from thinking that I was already madly in love with her. I could see that her curiosity progressed in an unequivocally practical direction. She considered me a genius—half mad but capable of great moral courage. And she wanted something—something which would be the fulfillment of her own myth. And this thing that she wanted was something that she was beginning to think perhaps only I could give her!

The painting *Le Jeu Lugubre* (it was Paul Eluard who gave it this name, with my full approval) was becoming with each passing day a source of increasing concern to every one. The drawers bespattered with excrement were painted with such minute and realistic complacency that the whole little surrealist group was anguished by the question: Is he coprophagic or not? The possibility that I might constitute a case of this repulsive aberration was beginning to create an increasingly marked uneasiness among them. It was Gala who decided to put an end to this doubt, and she took me aside one day and said she had something very serious to talk to me about and begged me to arrange a time when we could meet and talk without having to contend with my laughing fits. I told her that this was something over which I had no control, but that even if I laughed during our discussion it would not prevent me from listening to everything attentively and answering her consequentially.

This occurred at the door of the Hotel Miramar. We made an appointment for the following evening. I would fetch her at the hotel, and we would go for a walk alone among the rocks, where we would be able to talk freely. The preoccupied air with which Gala received the answer that I "had no control" over these laughing fits gave me a mad urge to laugh. I was on the verge of a fit, but with superhuman effort

I was able to control it for an instant. I kissed her hand and rushed away. As soon as I felt the door shut behind Gala I burst into a convulsive laugh that did not cease till I reached my house. From time to time I had to sit down on a bench or a door-step before I could continue to walk. On my way I came upon Camille Goemans and his wife who had been observing me for a long time. They stopped to talk to me. "You must be careful. You have been excessively nervous for some time. You work much too hard."

The following day I went to fetch Gala at the Hotel Miramar, and we went walking toward the rocks of (The Molars), a spot imbued with a "planetary melancholy." I waited for Gala to start the conversation in her own way, since it was she who had wanted it, but as the moments passed and she failed to come to the point I began to fear that she could not make up her mind how to begin. Thinking that this might be painful for her, I took the initiative myself and alluded to it. She was grateful to me for this, and at the same time conveyed by her firm tone that she did not need my help. I shall now attempt to write down one of my first conversations with Gala.

"It's about your picture *Le Jeu Lugubre*."

She relapsed into a silence during which I had time to work the whole thing out. I was tempted immediately to answer the question she was going to ask me, but I preferred to wait to hear what she had to say, for this might perhaps enable me to infer other things.

"It's a very important work, and it is precisely for this reason that Paul and I and all your friends would like to know what certain elements, to which you seem to attach a special importance, refer to. If those 'things' refer to your life we can have nothing in common, because that sort of thing appears loathsome to me, and hostile to my kind of life. But this concerns only your own life, and has nothing to do with mine. On the other hand, if you intend to use your pictures as a means of proselytism and propaganda—even in the service of what you may consider an inspired idea—we believe you run the risk of weakening your work considerably, and reducing it to a mere psychopathological document."

I was suddenly tempted to answer her with a lie. If I admitted to her that I was coprophagic, as they had suspected, it would make me even more interesting and phenomenal in everybody's eyes. But Gala's tone was so clear, and the expression of her face, exalted by the purity of an entire and lofty honesty, was so tense that I was moved to tell her the truth.

"I swear to you that I am not 'coprophagic.' I consciously loathe that type of aberration as much as you can possibly loathe it. But I consider scatology as a terrorizing element, just as I do blood, or my phobia for grasshoppers."

I waited for my answer to relax Gala's intense, preoccupied air. On the contrary, she registered my answer as something reassuring but instantaneously assimilated, and I guessed then that there was still

another, even more important, question behind that of the coprophagia
—her real reason for talking to me, the one that tormented her little
face. A fine and communicative anguish ruffled the delicate surface of her
olive skin, and I could hear it murmuring as though it had been a
twilight breeze suddenly awakened. I was on the point of saying to her,

"What about you? What is on your mind? Let's have it out, and
then say no more about it!"

Instead of which I remained silent, overwhelmed by the reality of
her flesh. What need was there of all these avowals? Did not the fragile
beauty of her face of itself vouch for the body's elegance? I looked at
her proud carriage as she strode forward with the intimidating gait of
victory, and I said to myself, with a touch of my budding humor, "From,
the esthetic point of view victories, too, have faces darkened by frowns.
So I had better not try to change anything!"

I was about to touch her, I was about to put my arm around her
waist, when with a feeble little grasp that tried to squeeze with the
utmost strength of her soul, Gala's hand took hold of mine. This was
the time to laugh, and I laughed with a nervousness heightened by the
remorse which I knew beforehand the vexing inopportuneness of my
reaction would cause me. But instead of being wounded by my laughter,
Gala felt elated by it. For, with an effort which must have been super-
human, she succeeded in again pressing my hand, even harder than
before, instead of dropping it with disdain as anyone else would have
done. With her medium-like intuition she had understood the exact
meaning of my laughter, so inexplicable to everyone else. She knew that
my laughter was altogether different from the usual "gay" laughter. No,
my laughter was not scepticism; it was fanaticism. My laughter was not
frivolity; it was cataclysm, abyss, and terror. And of all the terrifying
outbursts of laughter that she had already heard from me this, which
I offered her in homage, was the most catastrophic, the one in which I

threw myself to the ground at her feet, and from the greatest height!

She said to me, "My little boy! We shall never leave each other."

She was destined to be my Gradiva,[1] "she who advances," my victory, my wife. But for this she had to cure me, and she did cure me!

Here now is the story of this cure, which was accomplished solely through the heterogeneous, indomitable and unfathomable power of the love of a woman, canalized with a biological clairvoyance so refined and miraculous, exceeding in depth of thought and in practical results the most ambitious outcome of psychoanalytical methods.

The beginnings of my sentimental relationship with Gala were marked by permanent character of diseased abnormality, and by very distinct and pronounced psychopathological symptoms. My laughing fits, from having been euphoric, became more and more painful, spastic, and symptomatic of a pre-hysterical state which already alarmed me in spite of the manifest self-satisfaction which I continued to derive from all these symptoms. My regression to the infantile period became accentuated by the fact of the delirious illusion which I was under that Gala was the same person, grown to womanhood, as the little girl of my "false memories," and whom, in narrating these, I called Galuchka, the diminutive of the name Gala. The phantasms and representations of vertigo (heights, the desire to throw someone, or perhaps myself, from a cliff) reappeared with increased intensity. In an excursion to the rocks of Cape Creus, I insisted pitilessly on Gala's climbing to the top of all the most dangerous summits, which reached great heights. These ascents involved obvious criminal intentions on my part, especially when we reached the highest point of a gigantic pink granite block called The Eagle, which leans like an eagle with outspread wings over a sheer drop. On this height, I invented a game which I got Gala to participate in, which consisted in starting large granite blocks rolling down the ledge and into space, and watching them crash far down on the rocks below or into the sea. I should never have tired of this, and only the fear of accidentally pushing Gala, instead of one of these rocks, forced me to avoid these heights where I felt myself continually in danger and possessed by a joyous, quivering excitement which made a destructive drain on my energy.

The same rancor that I had felt toward Dullita was beginning to make its way into my heart in respect to Gala. She too had come to destroy and annihilate my solitude, and I began to overwhelm her with absolutely unjust reproaches: she prevented me from working, she insinuated herself surreptitiously into my brain, she "depersonalized" me. Moreover I was convinced that she was going to do me harm. I often said to her, as if bitten in the nape of the neck by a sudden fear,

[1] *Gradiva*, the novel by W. Jensen, interpreted by Sigmund Freud (*Der Wahn und die Träume*). Gradiva is the heroine of this novel, and she effects the psychological cure of the other, the male protagonist. When I began to read this novel, even before coming upon Freud's interpretation, I exclaimed, "Gala, my wife, is essentially a Gradiva."

"Above all don't, please don't hurt me. And I mustn't hurt you either. We must never hurt each other!"

And then I would suggest to her a walk at sunset to some geological height from which we would get a fine view.

I propose now to take advantage of the fact that we have reached this spot where we overlook a fine view and to allow you, my readers, and myself to rest after this walk over many abrupt slopes that I have forced you to make in order to reach this culminating point on the road of my life as quickly as possible. You and I are tired, and we are a little more than half way through this book. And so we need a little time before we begin—in a little while, after we are well rested—the downward climb along another, more elegiac path, with that more leisurely and philosophic pace appropriate to the experience of the road we have just travelled, back to the reassuring familiarity of our respective abodes.

So, my readers, you who have kept me company thus far, let us sit down. Let your glance stray over the panoramic precision of this landscape of Cadaques which you now have before your eyes, and while our bodies rest let me once more agitate your souls by telling you, and interpreting for you, a tale, both distracting and sublime, which was told me in my infancy by Llucia, my nurse. And while it diverts you you will presently recognize in the feminine protagonist, whom I shall call Gradiva, the personality of Gala, but also you will immediately recognize myself in the person of the king who is the other protagonist of this medieval Catalonian popular tale, which I have baptized with the suggestive name of

The Manikin With the Sugar Nose

And now click your tongues with satisfaction against your palates, producing that sound of the uncorking of a bottle, so agreeable to the ears, for I myself am about to uncork the full bottles that you all are, and I intend this evening to get completely drunk on the avid alcohol of your curiosity.

I am about to begin...I begin...We have begun!

Once upon a time there was a king whose manner of life was very strange. Each day there were brought to him three of the most beautiful girls in the kingdom who had to come and water the sweet-williams in his garden. From the top of his tower he would look down upon them, and hesitate long before choosing her who should spend the night in the royal bed, around which perfumed oils burned. She would be adorned with the most precious robes and jewels, and would have to sleep, or feign to sleep, through the whole night. The king never touched her, only looked at her. But when dawn rose, he would cut off her head with a single blow of his sabre.

To designate his choice, the king would address her whom he singled out to be the victim of his night of "unfulfilled love," and leaning over the rampart of the tower he invariably asked her this same question,

"How many sweet-williams are there in my garden?"

And the girl, who by this question learned her death sentence, had to lower her eyes in shame, and invariably answer him with malice this other question,

"How many stars are there in the sky?"

After which the king would disappear. The chosen girl would run to her house, where her weeping parents adorned her with her richest garments in preparation for her macabre nuptial night.

One day the king's choice fell on a girl whose beauty and intelligence were renowned throughout the kingdom. Now this girl, whose intelligence was as resplendent as her beauty, when she learned that she had been chosen, made a wax manikin to which she glued a sugar nose.

When night arrived she draped herself in a white sheet, and, hiding the manikin within it, went up into the nuptial chamber in which all the candles were lit. She placed the wax manikin with the sugar nose on the bed, covering it with her most beautiful jewels. After which she lay down under the bed, and waited.

When the king entered he stripped himself naked, and lay down beside her whom he thought he had chosen. He spent the whole night in looking at her, but as usual he did not touch her. Also, as usual, the moment he sensed the coming dawn he unsheathed his sword and with a single blow cut off the head of the wax manikin. With the blow the sugar nose broke off and flew right into the king's mouth. Surprised by the sweetness of the sugar nose the king dolefully cried,

Dulcetta en vida,
Dulcetta en mor,
S t'agues coneguda
No t'auria mort!

Which means literally,

Sweet in life,
Sweet in death,
If I had known you
I should not have given you death!

At this moment the wily beauty, who had heard everything from beneath the bed, quickly came forth, presenting herself to the king and unveiling her stratagem to him.

The king, suddenly and miraculously cured of his criminal aberration, married her, and they lived happily for many long years.

And there the tale ends.

INTERPRETATION OF THE TALE OF THE WAX MANIKIN WITH THE SUGAR NOSE

Narcisse.

Let us try now to interpret this story in the light that psychoanalysis by my own original methods of investigation can shed upon it.

We shall begin with the generating element of the stratagem, the wax manikin with the sugar nose, and first of all, with the wax itself as a clearly characteristic and determining element.

I shall first recall to your mind its livid color, as evidenced in the expression "wan, or pale, as wax," and the current assimilation of this pallor to that of death; also its ductile consistency (a kind of imitation flesh). Wax is furthermore not only the matter that lends itself best to the imitation of living forms and figures, but also that which succeeds in imitating them in the most anguishing fashion—that is to say, the one which, while being the most life-like, is at the same time the most inert, the most spectral, and in short the most macabre (witness the artificial cemeteries which the morbid museums of wax figures constitute, especially the Musée Grevin in Paris). The non-repugnant character of wax, which is further augmented by an attractive softness, has a variety of reasons far more direct and less intellectual than that of its consubstantiality with the honey from which it originally derives. This softness of wax, moreover, is partially due to its extreme ductility, reaching the state of liquefaction upon exposure to heat—which is not a property of so many other malleable substances (clay, etc.) which on the contrary have a tendency to dry and harden. This liquefaction, with the defiguration which it entails, may easily appear as characteristic of the decomposition of corpses.

We shall furthermore observe that even when wax most obviously evokes decomposition, as would be the case of a wax manikin if it should

melt, this would nevertheless always occur without provoking repugnance, in place of which one would be conscious of a gentle anguish, owing to the fact that this would constitute the most pleasant and attenuated fashion of representing such a state. It is as if on every occasion and under all circumstances the evocation of death transmitted by the mediation and vehicle of wax were able to affect us in the gentlest fashion and constituted a pseudo-sweet used to make us "swallow" a great terror. Throughout all anecdotology of the macabre and funereal rites wax does not cease for a moment to play this constant deceptive and attenuating role to which we have just called attention, shedding light upon the dead with a false and attractive light of desirable life beneath the quivering flames of the candles that are being consumed.

Still upon this vertiginous slope of my hypothesis, it is necessary to imagine the necrophile madly troubled by the odor of burning wax which, replacing that of the sweat of the loved being lying inert, without sweat, without odor of life, would serve to render more desirable the blended, incipient and real odor of death, by attenuating it and providing it with that substitute and euphemistic illusion necessary to the nostalgic pleasure of the necrophilic "passional aberration."

The wax, then, by its softening and idealized representation of death, would serve to prepare the short-cut to necrophilic impulses and desires. Furthermore it would act as a sentinel to the mechanism of repression, keeping out of the sphere of consciousness the coprophagic phantasms which in a more or less veiled fashion commonly coexist with the "desire for waste matter." Thus the hypocritical warmth of the wax in a symbolic situation would replace the atrocious crudity of the real intention of these phantasms, with all the candles of copro-necrophilic consummation already lighted for the nuptial feast which would couple these two passions that together constitute the peak of aberration and perversity.[1]

Returning to our tale, we must observe that the extremely flagrant necrophilic sentiments of the king led him to anticipate his final and decisive act by a whole appropriate ritual destined to envelop the "expectant and unfulfilled" love which was to precede the fatal *dénouement*. It was necessary—as we learned—for the king's victim to spend the night in a state of immobility; she had to sleep or feign to sleep—in short, she had to play dead. The king's fantasy further commanded that the sleeping girl remain prone *on* the sheets, adorned with rare and dazzling robes, like a corpse. Also it is specified that perfumed oils would be burning in the nuptial chamber and that "all the candles" must be lighted (as for the dead). All this neurotic preamble obviously had no other aim than to furnish, by a series of mortuary simulacra, idealized repre-

[1] A very precise study of the wax candle, written in 1929, led me to the conclusion that this object lends itself to a whole series of symbolic situations in which non-terrorizing unconscious representations of intestinal and digestive metaphors lead to the apotheosis of human waste matter—the turd.

sentations of his pathological case, in order that the victim be imagined as having already expired, well before the culminating moment in which, as in a definitive and material "realization of desire the king reached the point of really killing the desired dead woman with his weapon, and this in the finally consummated paroxysm of his pleasure—which, in his aberration, coincided with the very moment of ejaculation.

But just at this supreme moment the tale tells us that the wily beauty who had substituted the wax manikin for herself behaved intuitively like a refined and extremely skilful expert in the most modern psychological sciences. What she did was to effect the miraculous cure of her husband-to-be by a substitutive operation which could be regarded only as magical. The wax manikin must have appeared to the king as the deadest of all his beautiful girls, and at the same time the most special, the most life-like, the most softened, desired and "metaphysical" of all. The nose falling off, a defiguration genuinely evocative of death, must also by its possible links with and recalls of the castration complex have reactualized his fears of punishment, while at the same time preparing an ambiance of remorse which by the tension of guilt feelings was propitious to an imminent repentance. The king, a probably cannibalistic copro-necrophile, was at bottom only seeking to savor the true hidden taste of death, his censor allowing him to achieve this only through the appearance of a false life composed of the pseudo-sleep of the wax with its macabre ornamentation and display. The sugared taste of the nose, falling unexpectedly into his mouth, can only have been a startling anticlimax, something incongruously inadequate and paradoxical, causing him to react in the same way as, in the inverse case, the nursing child reacts when he is being weaned.[1] The child finds his mother's nipple suddenly offering a bitter, disagreeable and nauseating taste instead of the agreeable one of the milk he was expecting. He does not want to repeat this experience; after the cruel disappointment he no longer wants to suck his mother's breast.

The king wanted to eat corpse, and instead of the taste of corpse he found that of sugar, after which he no longer wanted to eat corpse. But in addition to this the "sugar nose" of our tale played a much more subtle and decisive role than that of having succeeded in weaning our king from death. It did not indeed correspond to the secretly desired taste of death, but this disappointment was only partially and relatively disagreeable. For it did not only become a lucid element of cannibalistic consciousness. Most important of all, the fact that this disappointment was experienced at the very moment of pleasure (as is the case in hysterical fits) operated in such a way as to re-evaluate instantaneously and with the maximum of violence the reality of a sweetness unexpected and unknown, "effective" and "sensible" in reality, in life—

[1] The author is here referring to the formerly very wide-spread method of weaning children by coating the nursing mother's nipples with a substance of disagreeable taste.—*Translator's note.*

a sweetness which could suddenly appear and become desirable, precisely because the sugar nose had just served as a "bridge" to desire, enabling it to pass from death to life. Thus the king's whole libidinous discharge formed an unfaithful fixation upon life, since this real sweetness was that which by surprise happened to occupy the expected place which the fictive sweetness of death was to occupy.

> *Sweet in life,*
> *Sweet in death,*
> *If I had known you*
> *I should not have given you death . . .*

A wholly spontaneous way (since involuntarily the word "life" occurs in the first line, in spite of being but a consequence of and a deduction from the second line) of expressing the regret at "having killed her," which confirms the prevision of the cure of the king's psychic disturbances.

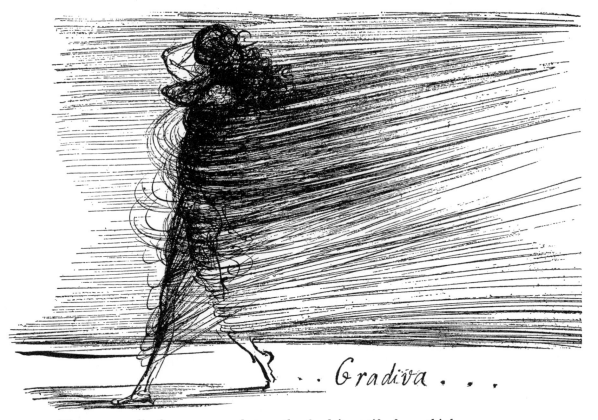

. . Gradiva . . .

Thus was realized once more that myth, the leit-motif of my thinking, of my esthetic, and of my life: death and resurrection! The wax manikin with the sugar nose, then, is only an "object-being" of delirium, invented by the passion of one of those women who, like the heroine

of the tale, like Gradiva, or like Gala, are able, by virtue of the skilful simulacrum of their love, to illuminate moral darknesses with the sharp lucidity of "living madmen." For me the great problem of madness and of lucidity was that of the limits between the Galuchka of my false memories, who had become chimerical and dead a hundred times through my subconscious pulsions and my desire for utter solitude, and the real Gala whose corporeality it was impossible for me to resolve in the pathological aberration of my spirit. And it is these very limits, which were peculiar to me, which are defined with a materialized symbolism in the form of a veritable "surrealist object" [1] in the tale I have just told—where the wax manikin ends, where the sugar nose begins, where Gradiva ends, and where Zoe Bertrand begins in Jensen's *Delirium and Dream*.[2] That is the question! we might repeat, parodying Hamlet.

Now that my readers know the tale, and also its interpretation, I think the moment has come for us to continue on our way, and, as we go back down the opposite slope from that by which we came, for me to try now to establish for you a parallel between my own case and that of the king, so that the continuation of the story of Gala and myself may appear to you comprehensible in every way.

I too, as you all know, was a king. Not only had I lived my whole childhood disguised in a king's costume (and adolescence and the rest of my life had only accentuated and developed my spirit in ever the same direction—that of absolute autocracy), but also I had decided that the image of my love must continually "feign to sleep," for I have already explained throughout the preceding reminiscences that each time this image tried to "stir too much" on the adorned bed of my solitude, I cried "Dead!" to it. And the chimerical and invisible image of my love resumed its immobility on the authority of my order and continued to "play dead." We have also seen that the few times when Galuchka's image assumed a real form (in the person of the Dullita of my true memories, for instance) things ran the risk of turning out badly. Not only did I feel the constant breath of danger at my side, but I came to the verge of committing a crime! I too, like the king in the story, loved perversely to prolong beyond measure, beyond the frontier of the pathological, the anxious expectation in which reposed the whole tormented voluptuousness of that grandiose myth of "unfulfilled love." I too . . .

But this summer, I knew, the revived and hitherto obedient image

[1] Indeed, the heroine who invented the wax manikin with the sugar nose glued on it created a surprising "surrealist object functioning symbolically" (of the type of those I myself was to reinvent in 1930 in Paris). This anthropomorphic object was destined to be "activated" by the blow of a sword and, by the leap of the nose into the mouth of the necrophile who was to operate it, to release phantasms and representations of life among the nostalgic sentiments of unconscious copro-necrophilism.

[2] Zoe Bertrand is the real protagonist, the double of the mythological image of Gradiva, in the novel by Jensen referred to in a previous note (p. 233).

of the chimerical Galuchka of my false memories, now incarnated in Gala's stubborn body, would no longer obey a simple commanding gesture of my hand, and come as before to "play dead" at my feet. I knew that I was approaching the "great trial" of my life, the trial of love; and my love, the love of a man half-mad, could not either be like that of others! The closer the hour of the "sacrifice" came, the less I dared think about it. Time after time, having just left Gala at the entrance to the Hotel Miramar, I would utter a long, deep sigh, and exclaim, "It's awful!" What is awful? I would ask myself, not understanding my sudden state of mind. Your whole life has been spent longing only for what is about to happen, and what is more, "It is she!" But now that the moment approaches you feel yourself dying of fear, Dali! As my laughing fits and my hysterical state became more acute, my spirit acquired that suppleness and agility peculiar to defense mechanisms. Indeed, with my flights and my *capeas*[1] worthy of a *torrero*, I was "fighting" this central problem of my life, this bull of my desire who, I knew, would at a given moment be there immobile and menacing a few centimetres from my own immobility, confronting me with the sole and only choice: either to kill him or be killed by him.

Gala was beginning to make repeated allusions to "something" which would have to happen "inevitably" between us, something "very important," decisive in our "relationship." But could she depend on me in my present overwrought state which, far from growing more normal, on the contrary bedecked itself with all the showiest tinsel of madness, and gathered behind itself the more and more spectacular procession of "symptoms?" Besides, my psychic state seemed to become contagious and to threaten Gala's initial equilibrium.

We would walk for long periods among the olive trees and the vines, without saying anything to each other, in a painful, tense state of mutual restraint in which all our twisted, repressed and tightly knotted feelings seemed to want to be subdued by the physical violence of our long walks. But one does not tire the spirit at will! No weariness or truce, no exhaustion either for the body or for the soul while the instincts remain cruelly unsatisfied. What a sight we must have been during those walks, the two of us, both mad! Sometimes I would throw myself to the ground and passionately kiss Gala's shoes. What must have transpired in my soul a moment before to unleash the remorse implied by such lively effusions? One evening Gala vomited twice in the course of our walk and was seized with painful convulsions. These vomitings were neurogenic and, she explained to me, had been familiar symptoms of a long psychic illness that had absorbed a great part of her adolescence. Gala had vomited just a few drops of bile, clean as her soul, and the color of honey.

At this period I began to paint *The Accommodation of Desires,* a

[1] The manner in which the torrero dodges the bull with feints which he makes with his cape.

painting in which desires were always represented by the terrorizing images of lions' heads.

"Soon you will know what I want of you," Gala would say to me.

This could not be very different from my lions' heads, I thought, trying to accustom myself in advance to the impending revelation by the most frightening representations.

I never pressed Gala to tell me the things she had on her mind before she was ready. On the contrary I would wait for these as for an inevitable sentence before which, once pronounced, we could no longer draw back. Never in my life had I yet "made love," and I represented this act to myself as terribly violent and disproportionate to my physical vigor—"this was not for me." I took advantage of all occasions to repeat to Gala, in an obsessive tone which visibly irritated her, "Above all, remember we promised each other that we would never hurt each other!"

At this point in our idyll we had reached the month of September. All my friends of the little surrealist group had left for Paris, and Eluard too. Thus Gala alone remained in Cadaques. At each new encounter we seemed to say to each other, "We must have it over with!" One could

"You must have it over with!"
"white or black?"

already hear the intermittent shots of the hunters resound amid the solitary echoes of the hills, and the August skies, smooth and serene to the point of exasperation, were followed now by those twilights charged with the ripening clouds of autumn which began already to become feverish with the approaching juicy grape-harvest of our passion. Seated on a dry-rock wall Gala ate black grapes. It was as if she were growing brighter and more beautiful with each new grape. And with each new silence-rounded afternoon of our idyll I felt Gala sweeten in unison with the grapes on the vines. Even Gala's body seemed to the touch to be made

of the "flesh-heaven" of a golden muscat. Tomorrow? we both thought. And as I brought her two new clusters of grapes I gave her the choice— white or black?

She was dressed in white on the day we had finally set. It was a very light dress that trembled so shudderingly as we climbed up the slope that she "made me cold." The wind became too violent as we went up, and I used this as a pretext for turning our walk away from the heights.

We climbed down again and went and sat down facing the sea on a slate bench cut into the rocks, which sheltered us from the slightest gust of wind. It was one of the most truculently deserted and mineral spots of Cadaques, and the month of September held over us the "dying silver" garlic-clove of the incipient crescent moon, haloed by the primitive taste of tears that painfully knotted Gala's throat and mine. But we did not want to weep, we wanted to have it over with.

Gala's face wore a resolute expression.

"What do you want me to do to you?" I said to her, putting my arms around her.

She was speechless with emotion. She made several attempts to speak, and finally she shook her head abruptly, while tears flowed down her cheeks. I kept insisting. Then, with a decisive effort, she unsealed her lips at last to tell me, in a plaintive little child's voice,

"If you won't do it, you promise not to tell anyone?"

I kissed her on the mouth, inside her mouth. It was the first time I did this. I had not suspected until then that one could kiss in this way. With a single leap all the Parsifals of my long bridled and tyrannized erotic desires rose, awakened by the shocks of the flesh. And this first kiss, mixed with tears and saliva, punctuated by the audible contact of our teeth and furiously working tongues, touched only the fringe of the libidinous famine that made us want to bite and eat everything to the last! Meanwhile I was eating that mouth, whose blood already mingled with mine. I depersonalized and annihilated myself in this bottomless kiss which had just opened beneath my spirit like the dizzy gulf into which I had always wanted to hurl all my crimes and in which I felt myself now ready to sink.

I threw back Gala's head, pulling it by the hair, and, trembling with complete hysteria, I commanded,

"Now tell me what you want me to do to you! But tell me slowly, looking me in the eye, with the crudest, the most ferociously obscene words that can make both of us feel the greatest shame!"

Breathless, ready to drink in all the details of this revelation, I opened my eyes wide the better to hear, the better to feel myself dying with desire. Then, with the most beautiful expression that a human being is capable of, Gala prepared to tell me, giving me to understand that nothing would be spared me. My erotic passion had by now reached the limits of dementia and, knowing that I still had just enough time, I repeated to her in a more tyrannical, deliberate way,

"What do you want me to do to you?"

Then Gala, transforming the last glimmer of her expression of pleasure into the hard light of her own tyranny, answered,

"I want you to croak me!"

No interpretation in the world could modify the meaning of this answer, which meant exactly what she said.

"Are you going to do it?" she asked.

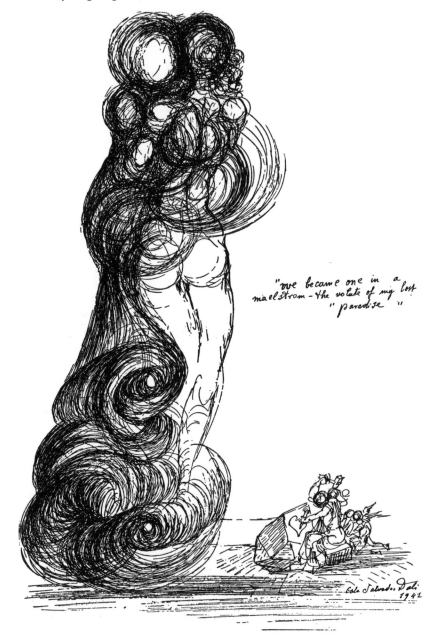

"we became one in a maelstrom – the volute of my lost "paradise""

I was so astonished and disappointed at having "my own secret" offered me as a present instead of the ardent erotic proposal I had expected that I was slow in answering her, lost in a whirl of undefinable perplexity.

"Are you going to do it?" I heard her repeat again.

Already the tone of her voice betrayed the disdain of doubt. I pulled myself together again, goaded by pride. I was suddenly afraid of destroying the faith Gala had had until then in my potentialities of moral courage and madness. Again I seized her in my arms, and in the most solemn manner of which I was capable I answered,

"YES!"

And I kissed her again, hard, on the mouth, while I repeated deep within myself, "No! I shall not kill her!"

And my second kiss to Gala, while it was a Judas kiss by virtue of the hypocrisy of my tenderness, simultaneously consummated the act of saving her life and resuscitated my own soul.

Gala had begun to explain to me minutely the reasons for her wish, and it suddenly occurred to me that she, too, had an inner world of desires and frustrations, and moved with a rhythm of her own between the poles of lucidity and madness. As she spoke I began by degrees to take "her case" into consideration. I kept saying to myself that it was by no means a foregone conclusion that I would not end up by doing what she asked me—by killing her! Certainly no scruple of a moral nature could prevent me from committing such an act. With our perfect agreement on this question as a starting point, the incident of her death could easily have been turned into a suicide. All that would be needed would be that I should have a letter from Gala confirming this hypothesis.

Gala now described her insurmountable horror of the "hour of her death," which had tortured her since childhood. She wanted it to happen without her knowing it, "cleanly," and without experiencing the fear of the last moments.

One of the lightning-ideas that flashed into my mind was to throw Gala from the top of the bell-tower of the Cathedral of Toledo, a place where I had already had similar temptations once when I had climbed up there in the company of a very beautiful girl I had known during my stay in Madrid. But this idea did not suit Gala's ideas, for during the fall she would have had a moment of fearful terror. For a host of other reasons the Toledo bell-tower idea immediately struck me as completely out of the question—how, indeed, was I to justify my presence in the tower at the same time? The simple procedure of poison, however, did not interest me, and I always came back to my "vicious precipices." In this connection I launched upon a revery unfolding in Africa, a place that seemed propitious to me for a moment because of the atmosphere. But I immediately gave up this idea too. It was too hot! And besides it did not appeal to me.

I therefore gave up looking for ideas, since they all died before they were even born, and concentrated my whole attention on what Gala was saying with such inspired eloquence in her delivery and her gestures that I could not make up my mind whether to look at her or listen to her. Gala's fantasy of seeking death at an unplanned and happy moment of her life was not simply a childish and romantic urge, as it might seem to someone who unlike myself did not immediately realize the vital importance of such a representation, as I did by the very "tone" of conscious exaltation in which she made her request. Gala's idea constituted indeed the very basis of her psychic life, and in the lovely expression of her face at the moment she made her avowal I saw all the fibres of her flayed sensibility converge into a pyramid—saw them converge toward the point of a single inacceptable representation: the hour of death with the procession of signs of old age which precede and prepare its approach.

Only Gala's secret life, however, could unveil the real reasons for her resolve. But although she has authorized me to write of this, I refuse to do so. In this book I want to dissect one and only one person—

myself!—and this living dissection of myself I am performing, not through sadism, or through masochism. I do so through narcissism. I do so as a matter of taste—my own taste—and jesuitically. Besides, a total dissection has no eroticizable meaning; it becomes as secret and dressed as before the skin and flesh were removed. The same is true for the total skeleton. My method is to conceal and to reveal, delicately to suggest the possibilites of certain visceral lesions, while at the same time strumming elsewhere the exposed tendons of the human guitar in parts completely torn away, all without ever forgetting that it is more desirable to strike the physiological resonances of the preludes than the ultimate and melancholy ones of accomplished fact.

Therefore let the Dalinian dissection be effected esthetically and artfully, and let the bones gleam with sobriety, just where they can produce the most harrowing effect. "The bone you could see on him! The bone you could see on him! The bone you could see on the tip of his big toe!" [1]

I had just heard Gala dissect herself alive before me. Yet she was but all the more precise and reblooming with multiple new muscles, which seemed to incarnate the lofty, proud and anatomic figure of her spirit. Surely she is right, I repeated to myself again, and it is not yet decided that I shall not do it...

September "septembered" wine and moons of May; the moons of September vinegared the May of my old age, old age harvested the grapes of passion...In the young rock of my heart adolescent bitterness, seated in the shadow of the tower of Cadaques, engraved these words: Take advantage of her and kill her! ... I thought: she will teach me love, and after that, as I have always wished, I shall come back alone. She wants it, she wants it, and she has asked it of me!

[1] A Catalonian song.

But something limped in my enthusiasm, and the conviction of my resounding resolve to murder, instead of resounding within the armors of my Machiavellism with the sonorous prestige of fine bronze, rang only with the defective noise of tin! What is wrong with you, Dali? Can't you see that now, when your crime is being offered to you as a present, you don't want it any longer! Yes! Gala, the wily beauty, Gradiva of my life, with the sabre-stroke of her avowal had just cut off the head of that wax manikin which I had watched since childhood on the bedecked bed of my solitude, that wax manikin of her double, the chimerical Galuchka of my false memories, whose dead nose had just jumped into the delirious sugar of my first kiss!

Gala thus weaned me from my crime, and cured my madness. Thank you! I want to love you! I was to marry her.[1]

My hysterical symptoms disappeared one by one, as by enchantment. I became master again of my laughter, of my smile, and of my gestures. A new health, fresh as a rose, began to grow in the centre of my spirit.

On the day when I returned from the station of Figueras after seeing Gala off to Paris, I rubbed my hands, exclaiming, "Alone at last!" For if the vertiginous twists and turns of the murderous impulses of my childhood had in fact disappeared from my imagination forever, my desires and my need for solitude would be long and stubborn to heal. "Gala, you are reality," I would often say, opposing the tangible experience of her flesh to the virtual and idealized images of my chimerical pseudo-loves. And I would bury my nose in a knitted wool bathing suit of hers which kept something of her odor. I wanted to know that she was alive and real, but also I had to remain alone from time to time.

My new solitude appeared to me truer than the old, and I loved it all the more. I shut myself up for a month in my studio in Figueras, and I immediately returned to my familiar monastic life. I finished painting Paul Eluard's portrait, begun in the course of the summer, and two large canvases, one of which was to become famous.

It represented a large head, livid as wax, the cheeks very pink, the eyelashes long, and the impressive nose pressed against the earth. This face

[1] I call my wife: Gala, Galuchka, Gradiva (because she has been my Gradiva), Olive (because of the oval of her face and the color of her skin), Olivette, the Catalonian diminutive of olive; and its delirious derivatives, Olihuette, Orihuette, Buribette, Burihueteta, Sulihueta, Solibubulete, Oliburibuleta, Cihueta, Lihuetta. I also call her Lionete (little lion), because she roars like the Metro-Goldwyn-Mayer lion when she gets angry; Squirrel, Tapir, Little Negus (because she resembles a lively little forest animal); Bee (because she discovers and brings me all the essences that become converted into the honey of my thought in the busy hive of my brain). She brought me the rare book on magic that was to nourish my magic, the historic document irrefutably proving my thesis as it was in the process of elaboration, the paranoiac image that my subconscious wished for, the photograph of an unknown painting destined to reveal a new esthetic enigma, the advice that would save one of my too subjective images from romanticism. I also call Gala Noisette Poilue—Hairy Hazlenut (because of the very fine down that covers the hazlenut of her cheeks); and also "Fur Bell" (because she reads to me aloud during my long sessions of painting, making a murmur as of a fur bell by virtue of which I learn all the things that but for her I should never know).

had no mouth, and in its place was stuck an enormous grasshopper. The grasshopper's belly was decomposed, and full of ants. Several of these ants scurried across the space that should have been filled by the non-existent mouth of the great anguishing face, whose head terminated in architecture and ornamentations of the style of 1900. The painting was called *The Great Masturbator*.

My works once finished, they were packed with the "maniacal care" which I had succeeded in communicating to a cabinet-maker of Figueras, whom I must count among the endless list of my anonymous martyrs. The works were shipped to Paris for the exposition which was to take place from November 20th to December 5th at the Goemans Gallery.

I went to Paris. The first thing I did upon arriving was to go and buy flowers for Gala. I naturally went to one of the best florists, and asked for the best they had. They recommended red roses, which it seems were un-usually fine. I pointed to a large mass of these and asked the price. "Three francs." I ordered ten such bouquets. The salesman seemed panic-stricken by my purchase, and showed no intention of carrying out my order. He was not even sure he would be able to furnish me such a quan-tity. I wrote a word or two on a card addressed to Gala, and as I went to pay the bill I read the figure of 3000 francs. I did not have this amount on hand and I asked to have the mystery of the price explained to me. It was simply that the bunch that I had pointed to contained one hundred roses, and that they were three francs each. I had thought it was three francs for the whole bunch! Then I told him to give me 250 francs' worth, which was all I had on me.

I spent the whole morning roaming through the streets, and at noon I had two Pernods. In the afternoon I went to visit the Goemans Gallery where I met Paul Eluard. He told me that Gala was very much surprised that I had not paid her a visit, nor even let her know when I would meet her. This astonished me greatly, for I had a vague intention of drift-ing along for several days in this state of waiting, which appeared to me filled with all manner of delights.

I finally went to call on her in the evening, and stayed for dinner. Gala showed her anger only for a moment, which stimulated everyone's hunger, and we sat down to the table which was filled with an innumer-able procession of bottles of all kinds, containing the most varied Russian alcoholic drinks. The alcohol I had drunk in Madrid rose in the tomb of my palate like the mummy of Lazarus. "Walk!" I commanded. And it walked. This was the only mummy capable of inspiring fear in every-one. Indeed, the inaugural and living alcohol of Madrid had been dead in my spirit for the whole last summer. But its resurrection made me eloquent again. Thereupon I said to this mummy, "Speak!" And it spoke. It was a discovery to discover that besides painting what I was painting I was not an utter cretin. I also knew how to talk, and Gala with her devoted and pressing fanaticism furthermore undertook to convince the surrealist group that besides talking I was capable of "writing," and of

writing documents whose philosophic scope went beyond all the group's previsions.

Gala had in fact gathered together the mass of disorganized and unintelligible scribblings that I had made throughout the whole summer at Cadaques, and with her unflinching scrupulousness she had succeeded in giving these a "syntactic form" that was more or less communicable. These formed fairly well-developed notes which on Gala's advice I took up again and recast into a theoretical and poetic work which was to appear under the title, *The Visible Woman*. It was my first book, and "the visible woman" was Gala. The ideas which were to be developed in this book were those for which I was soon to begin my battle in the very heart of the hostility and constant suspicion of the surrealist group itself.

Gala, moreover, had first of all to win her own battle in order that the ideas I expressed in my work could be taken half-way seriously even if only by the group of friends most prepared to admire me. As we shall see in the beginning of the third part of this book, a primordial fact, which everyone already unconsciously guessed, was that I had come to destroy their revolutionary work, using the same weapons, only much sharper and more formidable than theirs.

Already in 1929 I was in reaction against the "integral revolution" released by the post-war dilettante anxiety. And even while I hurled myself with greater violence than any of them into demential and subversive speculations just to see what the heart of revolutions in the making carried in its belly, with the half-conscious Machiavellism in my scepticism I was already preparing the structural bases of the next historic level— that of eternal tradition.

The surrealist group appeared to me the sole one offering me an adequate outlet for my activity. Its chief, André Breton, seemed to me irreplaceable in his role of visible chief. I was going to make a bid for power, and for this my influence had to remain occult, opportunistic, and par-

adoxical. I took definite stock of my positions, of my strongholds, of my inadequacies and of the weaknesses and resources of my friends—for they were my friends. One maxim became axiomatic for my spirit: If you decide to wage a war for the total triumph of your individuality, you must begin by inexorably destroying those who have the greatest affinity with you. All alliance depersonalizes; everything that tends to the collective is your death; use the collective, therefore, as an experiment, after which strike hard, and remain alone!

I remained constantly with Gala, and my love made me generous and disdainful. But suddenly this whole ideological battle, already crowding my brain with the incessant movement of troops which my philosophy-in-chief zealously sent forth to protect all the frontiers of my brain against aggression, appeared to me premature. And I, the most ambitious of all contemporary painters, decided to leave with Gala on a voyage of love two days before the opening of my first painting exhibit in Paris, the artistic capital of the world. Thus I did not even see how the paintings in this first exhibit of my work were hung, and I confess that during our voyage Gala and I were so much occupied by our two bodies that we hardly for a single moment thought about my exhibit, which I already looked upon as "ours."

Our idyll had its setting in Barcelona, and then in Sitges, a little village close to the Catalonian capital, which offered us the desolation of its beaches attenuated by the sparkling Mediterranean winter sun. For a month I had not written a word to my parents, and a slight sense of guilt would assail me every morning. And so I said to Gala,

"This can't last forever. You know that I must live alone!"

Gala left me at Figueras and continued her voyage to Paris.

In my father's dining-room the storm broke—a storm created wholly by myself over the slightest of my father's complaints. He was broken-hearted at the more and more lofty and inconsiderate way I had of treating my family. The question of money was brought up. I had in fact signed a two-year contract with the Goemans Gallery, but I could not manage to remember what the terms were, and in thinking it over more carefully, I could not even say whether the contract was for two or three years, or perhaps for one! My father begged me to try to find it. I said that I did not know where I had put it, and that I wanted to put off looking for it for three days, when I would be going to Cadaques, and that there I would have plenty of time to do it. I said also that I had spent all the money Geomans had advanced me. This bowled my family over

completely. I then began to rummage in my pockets, and pulled out a bank note here and another there, half torn and so crumpled and bedraggled that they were certainly not usable. Everything in the way of small change I had thrown into the garden of a square before the station, not to be burdened by it. In a few moments of ransacking my pockets I had managed to gather together three thousand francs, which were left over from my trip.

The following day Luis Bunuel arrived in Figueras, having just received an order from the Vicomte de Noailles to make a film exactly according to our two fancies. I learned also that the same Vicomte de Noailles had bought *Le Jeu Lugubre,* and that almost all the rest of the paintings of my exhibit had been sold at prices that ranged between six and twelve thousand francs.

I left for Cadaques dizzy with my success, and began the film *L'Age d'Or* (The Golden Age). My mind was already set on doing something that would translate all the violence of love, impregnated with the splendor of the creations of Catholic myths. Even at this period I was wonderstruck and dazzled and obsessed by the grandeur and the sumptuousness of Catholicism. I said to Bunuel,

"For this film I want a lot of archbishops, bones and monstrances. I want especially archbishops with their embroidered tiaras bathing amid the rocky cataclysms of Cape Creus."

Bunuel, with his naïveté and his Aragonese stubbornness, deflected all this toward an elementary anti-clericalism. I had always to stop him and say,

"No, no! No comedy. I like all this business of the archbishops; in fact, I like it enormously. Let's have a few blasphematory scenes, if you will, but it must be done with the utmost fanaticism to achieve the grandeur of a true and authentic sacrilege!"

Bunuel left, taking with him the notes on which we had collaborated. He was going to begin to get *L'Age d'Or* into production so that it could start simmering, and I would come later.

I thus remained all alone in the house in Cadaques. In the winter sun I would eat at one sitting three dozen sea-urchins with wine, or five or six chops fried on a fire of vinestalks. In the evening a fish soup and cod with tomato, or else a good big fried sea-perch with fennel. One noonday while I was opening an urchin I saw before me a white cat. He had something coming out of one eye which flashed like quicksilver in the sun at each of its movements. I stopped eating my urchin and approached the cat. The cat did not move; on the contrary it continued to look at me all the more intently. Then I saw what it was: the cat's eye was completely pierced through with a large fishhook, the point of which emerged from one side of its dilated and blood-shot pupil. It was frightful to see, and especially to imagine the impossibility of extracting this fish-hook without emptying the eye itself. I threw rocks at it to rid myself of the sight that filled me with an unspeakable horror. But the following days

just at the moments of my greatest enjoyment [1] and when it was most intolerable—as with a piece of well-toasted bread I was getting ready to empty an urchin shell of its palpitating coral—the apparition of the white cat with its eye pierced through with the silvery hook stopped my gluttonous gesture in an attitude of anguished paralysis. I finally became convinced that this cat was an omen.

A few days later I received a letter from my father notifying me of my irrevocable banishment from the bosom of my family. I do not wish to unveil here the secret which was at the root of such a decision, for this secret concerns only my father and myself, and I have no intention of reopening a wound which kept us apart for six long years and made both of us suffer so greatly. When I received this letter, my first reaction was to cut off all my hair. But I did more than this—I had my head completely shaved. I went and buried the pile of my black hair in a hole I had dug

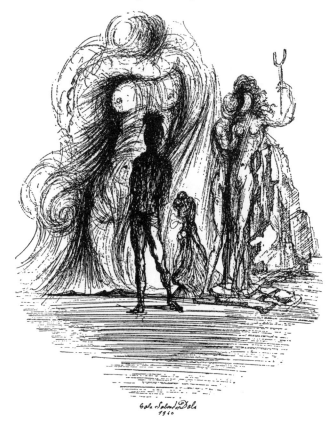

on the beach for this purpose, and in which I interred at the same time the pile of empty shells of the urchins I had eaten at noon. Having done this I climbed up on a small hill from which one overlooks the whole

[1] The taste that I like best in the world is that of the very red and full rock-urchins that are to be found during the May moon in the Mediterranean. My father too loves this food, in an even more exaggerated way than I.

village of Cadaques, and there, sitting under the olive trees, I spent two long hours contemplating that panorama of my childhood, of my adolescence, and of my present.

The same evening I ordered a taxi which would fetch me the next day and take me to the frontier where I would board a train straight for Paris. I had a breakfast composed of sea-urchins, toast and a little very bitter red wine. While waiting for the taxi, which was late in coming, I observed the shadow of my profile that fell on a white-washed wall. I took a sea-urchin, placed it on my head, and stood at attention before my shadow—William Tell.

The road that goes from Cadaques and leads toward the mountain pass of Peni makes a series of twists and turns, from each of which the village of Cadaques can be seen, receding farther into the distance. One of these turns is the last from which one can still see Cadaques, which has become a tiny speck. The traveler who loves this village then involuntarily looks back, to cast upon it a last friendly glance of leave-taking filled with a sober and effusive promise of return. Never had I neglected to turn around for this last glance at Cadaques. But on this day, when the taxi came to the bend in the road, instead of turning my head I continued to look straight before me.

PART III

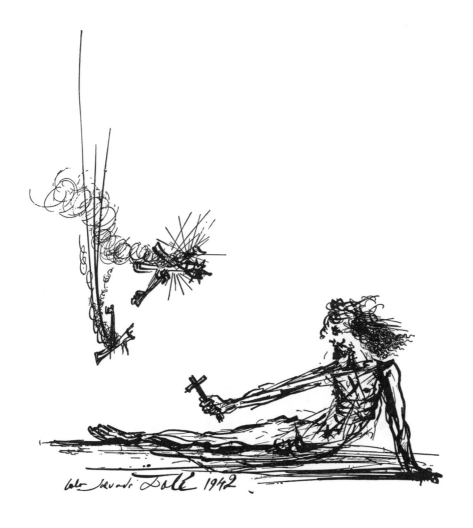

CHAPTER TEN

No sooner had I arrived in Paris than I was in a great hurry to leave again. I wanted to begin as soon as possible the pictorial investigations of which I had conceived the idea in Cadaques just at the time when my repudiation by my family occurred, paralyzing the course of my projects.

I wanted to paint nothing less than an "invisible man," but to do this I wanted to go away somewhere to the country again. But also I definitely wanted to take Gala along. The idea that in my own room where I was going to work there might be a woman, a real woman who moved, with senses, body hair and gums, suddenly struck me as so seductive that it was difficult for me to believe this could be realized. However, Gala was quite ready to go with me, and we were in the midst of deciding where we should go. Meanwhile—timidly and as if by chance—I tossed a certain number of bold slogans into the bosom of the surrealist group in order to test their demoralizing effect during my absence. I upheld "Raymond Roussel as against Rimbaud; the modern-style object as against the African object; still-life deception as against plastic art; imitation as against interpretation."

All this, I knew, would suffice for several years, and I purposely gave very few explanations. At this time I had not yet become a "talker," and I uttered only the strictly necessary words, words intended solely to annoy everyone. The remnants of my pathological timidity edged my character with extremely uncommunicative features, features so abrupt that I was in effect conscious that people would look forward nervously to the infrequent occasions when I would open my mouth. Then, with a remark that was terribly crude and charged with Spanish fanaticism, I

would express all that my pent-up eloquence had accumulated during the painful and prolonged silences, when my polemic impatience would undergo the hundred and one martyrdoms of that French conversation, so sprinkled with *"esprit"* and good sense that it often manages to conceal its lack of bony structure and of substance.

On one occasion I had to listen to an art critic who was constantly talking about matter—the "matter" of Courbet, how he spread out his "matter," how he felt at home in handling his "matter."

"Have you ever tried to eat it?" I finally asked.

Becoming wittily French, I added, "When it comes to s—t, I still prefer Chardin's."

One evening I was having dinner at the Vicomte de Noailles'. Their house intimidated me, and I was extremely flattered to see my painting *The Lugubrious Game* hung between a Cranach and a Watteau. At this dinner there were artists and society people, and I immediately realized that I was the chief object of attraction. I believe that the Noailles were deeply touched by my timidity. Each time the wine-butler came and whispered the name and the year of the wine into my ear with an air of great secretiveness, I thought it was something very serious that he had come discreetly to tell me—Gala run over by a taxi, or a furious surrealist who was coming to beat me up—and I would turn livid, leap up and prepare to leave the table. Then, in a louder voice so as to reassure me, and looking with the utmost dignified intentness at the bottle lying prone in the little basket, the butler would repeat "Romanée 1923." At one gulp I would drink down this wine that had just so terrified me and thanks to which I recovered my hope of overcoming my timidity and of being able to talk.

I have always admired—and I did so particularly at this time—the person who, without having anything really sensational or important to say, manages throughout a whole dinner of twenty people to steer the conversation in whatever direction he chooses, to make himself heard in the midst of a general silence at the right moments without having to stop eating—in fact, eating more than the next fellow—and still has time for an occasional slyly calculated pause during which he gracefully and self-confidently stops the flow of his conversation just long enough to brush aside the danger of anyone's taking advantage of his absorption to kindle fresh hearths of conversation, or—in the extreme case in which this should occur—is able to extinguish them at the desired moment without seeming to make the slightest effort, and at the same time give the recalcitrant ones the impression, when he interrupts their incipient conversation against their will, that it is they who are interrupting by asking him in a voice that verges on the impolite to repeat his last remarks so that they can follow the course of his argument in which they have not the slightest interest.

In the course of this first dinner at the Noailles' I discovered two things. First, that the aristocracy—what was then called "society"—was

infinitely more vulnerable to my system of ideas than the artists, and especially the intellectuals. Indeed "society people" still wore clinging to their personalities the dose of atavism, of civilization, of refinement which the generation of the middle class with advanced social ideas had just joyfully sacrificed as a holocaust to the "young" ideologies with col-

"Bonjour chère amie!"
"Project for special costumes, for afternoon strolls.
The inside of the pockets light up at night."

lectivist tendencies. The second thing I discovered was the climbers, those little sharks frantically scrambling for success, who with their assiduous flattery, their intriguing and competitive gossiping anxiety crowd around all the tables covered with the best crystals and the best silverware. I decided that I would thenceforth have to make use of these two kinds of

discoveries—of society people to keep me, and of the climbers to open a way of prestige for me with the blundering calumnies of their jealousy. I have never feared gossip. I let it build up. All climbers work and sweat at it. When finally they hand it to me as complete, I look at it, I examine it, and I always end by finding a way to turn it to my advantage. The activity of the malicious creatures who surround one is a force capable by itself alone of launching the vessel of one's glory. The important thing is never to relinquish the wheel for a moment. Climber-ism is not interesting. The interesting thing is to arrive—just as looking for a watch is not interesting—the interesting thing is to find it

That I had reached fame I felt and knew the moment I landed at the Gare d'Orsay in Paris. But I had reached it without realizing it, and so quickly that I found myself all alone, without being known to anyone and without passport or baggage. I would therefore have to go back and fetch them, and hire porters. I would have to go and have my documents visaed, and I realized that with all this bureaucratic red tape I risked wasting the rest of my life. I therefore began to look around me, and from then on I regarded most of the people I met solely and exclusively as creatures I could use as porters in my voyages of ambition. Almost all these porters sooner or later became exhausted. Unable to endure the long marches that I forced on them at top speed and under all climatic conditions they died on the way. I took others. To attach them to my service, I promised to get them to where I myself was going, to that end-station of glory which climbers desperately want to reach. But as I have already said, I did not want to arrive, "I was going there."

How was I going to succeed in making society people come to my support? It was childishly simple. I was going to succeed by having them come and lean on me. What are society people? Society people are people who, instead of standing on the world with both feet, balance themselves on a single foot, like storks. This involves an aristocratic attitude by which they wish to show that, while having to remain standing in order to continue to see everything from above, they like to touch the common base of the world only by what is strictly necessary in order to continue to maintain their equilibrium. This exhaustingly egocentric posture often needs support, and it is because of this that society people habitually surround themselves with a crowd of "unijambists" to lean on, who, assuming the diverse forms of pederastic and drug-addicted artists, come by turns and serve as support for the untenable attitude of an aristocracy which at this time was already beginning to feel the first jostlings of the "People's Front."

Such being the case, I decided to join forces with the group of invalids whose snobbism propped up a decadent aristocracy which still stuck to its traditional attitude. But I had the original idea of not coming with empty hands, like all the rest. I arrived, in fact, with my arms loaded with crutches! One thing I realized immediately. It would take quan-

tities and quantities of crutches to give a semblance of solidity to all that. And I inaugurated the "pathetic crutch," the prop of the first crime of my childhood, as the all-powerful and exclusivist post-war symbol—crutches to support the monstrous development of certain atmospheric-cephalic skulls, crutches immobilize the ecstasy of certain attitudes of rare elegance, crutches to make architectural and durable the fugitive pose of a choreographic leap, to pin the ephemeral butterfly of the dancer with pins that would keep her poised for eternity. Crutches, crutches, crutches, crutches.

I even invented a tiny facial crutch of gold and rubies. Its bifurcated part was flexible and was intended to hold up and fit the tip of the nose. The other end was softly rounded and was designed to lean on the central hollow above the upper lip. It was therefore a nose crutch, an absolutely useless kind of object to appeal to the snobbism of certain criminally elegant women, just as some beings wear monocles without having any other need of them than to feel the sacred tug of their exhibitionism incrusted in the flesh of their own face.

My symbol of the crutch so adequately fitted and continues to fit into the unconscious myths of our epoch that, far from tiring us, this fetish has come to please everyone more and more. And curiously enough, the more crutches I put everywhere, so that one would have thought people had at last become bored by or inured to this object, the more everyone wondered with whetted curiosity, "Why so many crutches?" When I had made my first attempt at keeping the aristocracy standing upright by propping it with a thousand crutches, I looked it in the face and said to it honestly,

"Now I am going to give you a terrible kick in the leg."

The aristocracy drew up a little more the leg that it kept lifted, like a stork.

"Go ahead," it answered, and gritted its teeth to endure the pain stoically, without a cry.

Then, using all my might, I gave it a terrific kick right in the shin. It did not budge. I had therefore propped it well.

"Thank you," it said to me.

"Never fear," I answered as I left, kissing its hand, "I'll be back. With the pride of your one leg and the crutches of my intelligence, you are stronger than the revolution that is being prepared by the intellectuals, whom I know intimately. You are old, and dead with fatigue, and you have fallen from your high place, but the spot where your foot is soldered to the earth is tradition. If you should happen to die, I would come at once and place my own foot in that very imprint of tradition which has been yours, and immediately I would curl up my other leg like a stork. I am ready and able to grow old in this attitude, without tiring."

The aristocratic regime has in fact been one of my passions, and already at that period I thought a great deal about the possibility of giving back to this class of the elite a historic consciousness of the role which it would inevitably be called upon to play in the ultra-individualist Europe that would emerge from the present war. For had I written down all my previsions of the events which were to overwhelm the world during the following years, people would indeed have been obliged to acknowledge my prophetic gift. At any rate, all my friends of good faith who since 1929 have followed and been able to verify the accuracy of most of my predictions are ready to testify to the almost literal fulfillment of events which, at the moment they were announced, were always considered as paradoxical, without real basis, and indicative only of a sense of humor of the most sombre kind.

In 1929 I predicted things which, to be sure, are still far from having been realized: that the period of the "masses," of "collectivism" and of mechanism which would be unleashed by the post-war revolutionary ideologies after these had devoured the democracies with their new totalitarian life, must lead to a European war out of which, after a thousand miseries and vicissitudes, only an individualist tradition that would be Catholic, aristocratic, and probably monarchic could arise anew from the bosom of an impoverished society. These things were listened to by no one, and I must say that I myself did not pay too much attention to them, letting them drop at random, rather through love of adventure than for any other reason.

While waiting for the fulfillment of all these prophecies, while waiting for the surrealists to begin to digest the short sentences that I had tossed them, while waiting for the climbers to busy themselves about doing me injury, while waiting for society people to begin to want me, I left

IX. Dalinian Eccentricities Not to be Further Imitated

Mannequin rotting in a taxicab, where an interior rainfall had been installed. Three hundred Burgundy snails lived for a month in the "rainy taxi."

Dali disguised as the "Angelus" of Millet.

A woman walking through London wearing a mask made of roses, as shown in one of Dali's paintings.

Image shown by Dali in a Congress of Architects, as a prototype of the soft architecture of the future.

Mannequin with a real loaf of bread on her head. Picasso visited the exhibition, and his dog leaped at the loaf of bread and devoured it.

Beginning in 1940, Dali came to consider the eccentric period as closed, and thought it time for the world to enter upon an era of fasting and austerity.

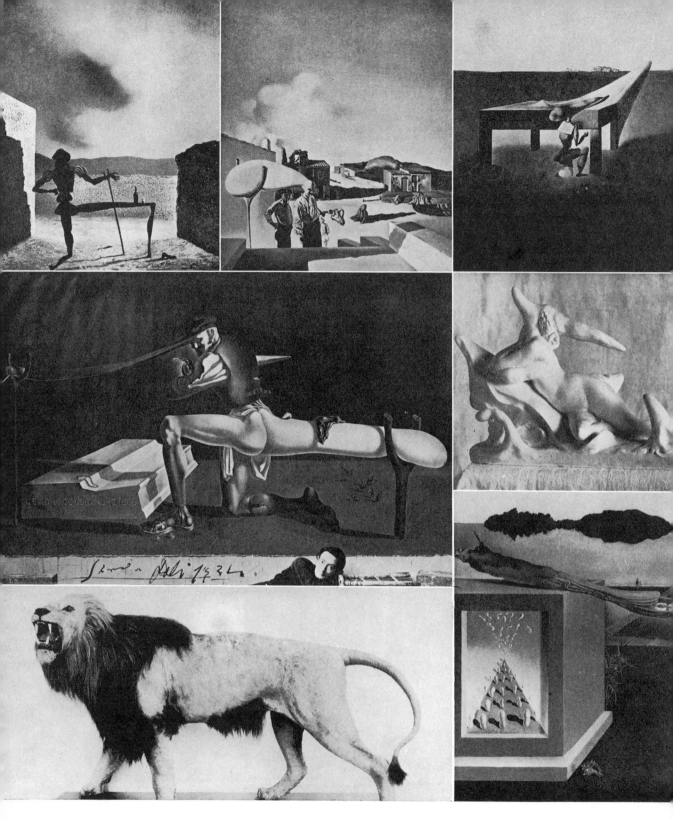

X. The Strangest Distortions in the Whole History of Art

"The Ghost of Vermeer"—which may be used as a table.

"The Cranial Harp."

"Myself at the Age of Ten, when I was the Grasshopper Child."

"The Enigma of William Tell."

Sculpture of an "Aerodynamic Woman."

"Incomprehensible Object."

African Lion. It was in hearing a lion roar at the Zoo in Barcelona that I conceived these distortions whose prolonged appendix forms represent in my aesthetic system something like the "cavernous roarings of form." (Courtesy: American Museum of Natural History, N. Y.)

for the Côte d'Azur. Gala knew a solitary hotel where no one could come and ferret us out. It was the Hôtel du Château at Carry-le-Rouet. We took two large rooms there, in one of which I set up my studio. We had the hallway stacked with wood, so that our fireplace would never for a moment be without a fire—and so that no one could come and disturb us on the pretext of bringing us wood. I set up an electric light which lighted just my painting, leaving the rest of the room almost in darkness, and I had given orders never to open the shutters. We often had our meals brought up to the room; at other times we would go down into the dining room; but for two months we did not once go outdoors!

This period has remained engraved in Gala's and my memory as one of the most active, exciting and frenzied periods of our lives. And several times, during those long reveries which come over one on train-trips, just at the moment when each of us seemed to be wandering in the most distant of his memories, it has happened that both of us would exclaim at once, "You remember the time at Carry-le-Rouet?"

remember Hôtel du Château at Carry-le-Rouet

After two months of voluntary confinement, during which I knew and consummated love with the same speculative fanaticism that I put into my work, *The Invisible Man* was only half completed. But in his smile Gala already saw the same road full of difficulties leading to success that the cards predicted each time she consulted them. I believed blindly in

the cards that Gala interpreted. Every evening I asked her to read them, and after this the slightest spells of anxiety which occasionally came and gnawed at my happiness vanished instantly.

For several days the cards had announced a letter from a dark man, and money. The letter arrived, and it was from the Vicomte de Noailles. The Goemans Gallery was on the verge of bankruptcy, and he offered to help me financially to free me from the least uneasiness on this score. He suggested that I pay him a visit; his car would come and fetch me on a day that I was to set. It was just two months to the day since we had come to the Hôtel du Château, and we decided to go out for a little walk, during which we would examine the situation. I remember that we were overwhelmed by the dazzling brilliance of a sunny winter morning. Our complexions were cadaverous, and we had great difficulty in getting used to the light after our two months of almost continuous darkness. The heat of the sun seemed a delight such as we had never experienced, and we decided to eat outside. For the first time, too, we took wine with our meals. By the time we got to the coffee our decision had been made. Gala would go to Paris to try to get some money that the gallery owed us. I would go and visit the Vicomte de Noailles in his Château de Saint Bernard at Hyères. I would offer to do an important picture for him for which he would pay me twenty-nine thousand francs in advance. With this, and the money Gala had at her disposal, we would go to Cadaques and build a small house just big enough for the two of us. This would permit us to work and to escape Paris from time to time. I like only the landscape of Cadaques, and I would not even look at any other.

Gala left for Paris, and I for the Noailles', who were enchanted by my proposal. On the same day that Gala returned from Paris, I got back from Hyères. She brought the money, and I had received the check. I spent the whole afternoon looking at the check, and for the first time I had the suspicion that money was a rather important thing. We started off again for Spain, and there began the period of my life which I consider the most romantic, the hardest, the most intense, the most breathless, and also the one that "surprised" me most, for favorable hazards have always seemed to me to be my due—and suddenly it looked as though my good luck were going to end, to spoil.

Now began the brutal battle that I was to wage against life, and which until then I had always thought I would be able to elude. I had in fact until then known no other obstacles or constraints than those of my own imagination. All the odds had been on my side. Love too had served me —it had cured me of my approaching madness, and I adored it to the point of driving it mad. But suddenly I was going to return to Cadaques where, instead of being the son of Dali the notary, I would be the disgraced son, disowned by his family, and living with a Russian woman to whom I was not married!

How were we going to organize our life in Cadaques? There was only

one person on whom we could count—Lydia, "La Ben Plantada." [1] Lydia was a woman of the village, the widow of Nando, "the good sailor with the blue eyes and the serene look." Her age was about fifty. The writer Eugenio d'Ors had spent the summer once, when he was twenty, in the house that Lydia owned at that time. Lydia had a mind predisposed to poetry, and had been struck with wonder at the unintelligible conversations of the young Catalonian intellectuals. Sometimes when d'Ors was about to start out on a boat trip, accompanied by Lydia's husband, he would shout to Lydia to bring him a glass of water, and in thanking her d'Ors had several times exclaimed,

"Just look at Lydia, how well planted she is!"

The following winter d'Ors published his famous book, *La Ben Plantada,* which was steeped in neo-Platonism, and Lydia immediately said, "That's me." She learned the book by heart, and began to write letters to d'Ors, in which symbols presently appeared with alarming abundance. D'Ors never answered these letters. But he was at this time writing his daily column in the *Veu de Catalunya,* and Lydia came to believe that this column of d'Ors's was the detailed, though figurative, answer to her letters. She explained that this was d'Ors's only recourse, for a lady whom Lydia had nicknamed "Mother of God of August," and certain other ladies whom she had her reasons for considering her rivals, would with their perfidy have managed to intercept the correspondence. This obliged d'Ors to speak in a veiled manner and, like herself, to express all his sentiments in a more and more figurative way. Lydia possessed the most marvelously paranoiac brain aside from my own that I have ever known. She was capable of establishing completely coherent relations between any subject whatsoever and her obsession of the moment with sublime disregard of everything else, and with a choice of detail and a play of wit so subtle and so calculatingly resourceful that

[1] This was the second time in my life that I encountered the incarnated myth of "La Ben Plantada," in the person of Lydia, who resuscitated in my childhood memories that of Ursulita Matas.

it was often difficult not to agree with her on questions which one knew to be utterly absurd. She would interpret d'Ors's articles as she went along with such felicitous discoveries of coincidence and plays on words that one could not fail to wonder at the bewildering imaginative violence with which the paranoiac spirit can project the image of our inner world upon the outer world, no matter where or in what form or on what pretext. The most unbelievable coincidences would arise in the course of this amorous correspondence, which I have several times used as a model for my own writings.

On one occasion d'Ors wrote an ultra-intellectual critical article entitled *Poussin and El Greco*. That evening Lydia arrived, triumphantly waving from afar the newspaper in which the article had just appeared. She adjusted the folds of her skirt and sat down with that ceremonial air by which she indicated that there was a great deal to talk about, and that it was going to take a long time. Then, putting her hand up to her mouth confidentially, she said in a low voice,

"He begins his article with the end of my letter!"

It so happened that in her last letter she had alluded to two popular characters in Cadaques. One of them was called Pusa, and the other was a Greek deep-sea diver, who was surnamed "El Greco." Hence the analogy was quite obvious, at least phonetically: Pusa and "El Greco"—Poussin and El Greco! But this was just the beginning, for Lydia took the esthetic and philosophic parallel which d'Ors established between the two painters as being the comparison she herself had made between Pusa and the Greek diver, elucidating it word by word in an interpretive delirium so systematic, coherent and dumfounding that she often verged on genius!

Later that evening she went home and put on her glasses. Her two sons, humble and taciturn fishermen of Cape Creus, watched her while they prepared their lines and their nets for the next day's fishing. Lydia uncorked the ink-bottle and, on the best ruled paper that was sold at the village post office, she began her new letter to the "master," as she called him. She liked to begin directly with sentences like this:

"The seven wars and the seven martyrologies have left the village of Cadaques with its two fountains dry! La Ben Plantada is dead. She was killed by Pusa, El Greco, and also by a society of 'goats and anarchists' recently founded. The day you decide to come here on an excursion, be sure to make it clearly known to me in your daily article. For I have to know a day in advance so as to go and fetch meat in Figueras. In this summer season, with all the people there are here, it is impossible to find anything good at the last moment . . ."

One day she said to me, "D'Ors was at a banquet in Figueras the day before yesterday!" I knew positively that this was not true, but I asked her how she could have found out. She said, "It was written in the menu that the paper published," and she showed me the menu, pointing with her finger to *"Hors d'oeuvres."* I answered her,

"The *'Hors'* is all right. But what does *'oeuvres'* mean?"

She thought for a moment. " *'Oeuvres'*—it's as if you were to say 'Incognito.' D'Ors incognito—he didn't want anyone to know it!"

Such was Lydia of Cadaques who, if she lived as she did in a world of her own which was very superior, spiritually speaking, to that of the rest of the village, did not on this account fail to have her feet firmly planted on the ground—with a sense of reality which the people of Cadaques were as ready to recognize as her folly whenever she got on the subject of "Master d'Ors and La Ben Plantada."

"Lydia isn't crazy," people would say, "just try to sell her a bad weight of fish or to put your finger in her mouth!"

Lydia could make *riz de langouste* like no one else, and *dentos*[1] *a la marinesca*—really Homeric dishes. For this last dish she had found a culinary formula worthy of Aristophanes. She would say,

"To make a good *dento a la marinesca* it takes three different people— a madman, a miser, and a prodigal. The madman must tend the fire, the miser add the water, and the prodigal add the oil." For the success of this dish in fact required a violent fire and a great deal of oil, while the water had to be used very sparingly.

But if Lydia was linked to reality, and of the most substantial kind, by multiple terrestrial and maritime ties, her sons on the other hand were really mad, and ended much later by being committed to an asylum. They thought they had discovered at Cape Creus several square kilo-metres of precious mineral. They would spend the moonlit nights haul-ing dirt in wheelbarrows from a great distance to bury the vein of the mineral so that no one might discover it. I was the only one who inspired them with confidence, because of my long conversations with their mother on the subject of the "master" and La Ben Plantada. They arrived one evening at my family's house, the summer before I met Gala, to inform me of their discovery. We shut ourselves up in my room. I asked what the mineral was that they had discovered. Then they insisted on my closing the shutters on the windows: there might be spies listening to us from outside. I shut the two windows and drew close to them, putting my hands on their shoulders in order to inspire them again with con-fidence.

"Well, what is it?"

They looked at each other again, as if to say, "Shall we tell him or shall we not?" But finally one of them was unable to hold it back any longer.

"RADIUM!" he whispered hoarsely.

"But is there much of it?" I asked .

And he answered, indicating with his hands a volume twice the size of his head, "Pieces like that, and as many as you like!" . . .

Lydia's two sons owned a miserable shack with a caved-in roof which they used to keep their fishing tackle. This shack stood in a small port,

[1] *Dentos,* a fish so succulent that fishermen consider it the pork of the sea.

Port Lligat, which was a fifteen minutes' distance from Cadaques, beyond the cemetery. Port Lligat is one of the most arid, mineral and planetary spots on the earth. The mornings are of a savage and bitter, ferociously analytical and structural gayety; the evenings often become morbidly melancholy, and the olive trees, bright and animated in the morning, are metamorphosed into motionless gray, like lead. The morning breeze writes smiles of joyous little waves on its waters; in the evening very often, because of the offshore islands that make of Port Lligat a kind of lake, the water becomes so calm that it mirrors the dramas of the early twilight sky.

During the two months that I spent with Gala at Carry-le-Rouet, almost the only correspondence I received from Spain was Lydia's letters, which I collected and analyzed as paranoiac documents of the first order, and when I received the letter from the Vicomte de Noailles I immediately thought of buying the shack belonging to Lydia's sons at Port Lligat and of fixing it up to make it habitable. This shack happened to be set exactly in the spot which I liked best in all the world. With the capriciousness which always characterizes my decisions, it became in a moment the only spot where I would, where I could, live. Gala wanted only what I wished, and we wrote to Lydia offering to buy her sons' shack. She answered that they agreed to this, and that they awaited our coming.

Thus we arrived in Cadaques in the dead of winter. The Hotel Miramar, taking my father's side, used the fact that they were remodeling as a pretext for not receiving us, and we had to go to a tiny boarding house, where one of our former maids did everything she could to make our stay bearable. The only people with whom I was interested in keeping on good terms were the dozen fishermen of Port Lligat who, being more independent of the opinions of Cadaques, received us at first with reserve, but were quickly captivated by Gala's irresistibly winning nature and by the aureole of my prestige. They knew that the papers were writing about me. "He's young," they said. "He doesn't need his father's money. He's free to do what he likes with his youth."

We hired a carpenter, and together Gala and I worked out all the details, from the number of steps there were to be in the stairway to the dimensions of the smallest window. None of the palaces of Ludwig II of Bavaria aroused one half the anxiety in his heart that this little shack kindled in ours.

The shack was to be composed of one room about four metres square, which was to serve as dining-room, bedroom, studio and entrance hall. One went up a few steps, and on a little hallway opened three doors leading to a shower, a toilet and a kitchen hardly big enough to move around in. I wanted it to be very small—the smaller, the more intra-uterine. We had brought the nickel and glass furniture from our Paris apartment, and we covered the walls with several coats of enamel. Not being in a position to carry out any of my delirious decorative ideas, I

wanted only the exact proportions required by the two of us and the two of us alone. The only extravagant ornament which I planned to use was a very, very small milk tooth of mine which had never been replaced, and which I had just lost. It was white and transparent like a rice-grain, and I wanted to pierce a hole in it and hang it by a thread from the mathematical center of the ceiling.

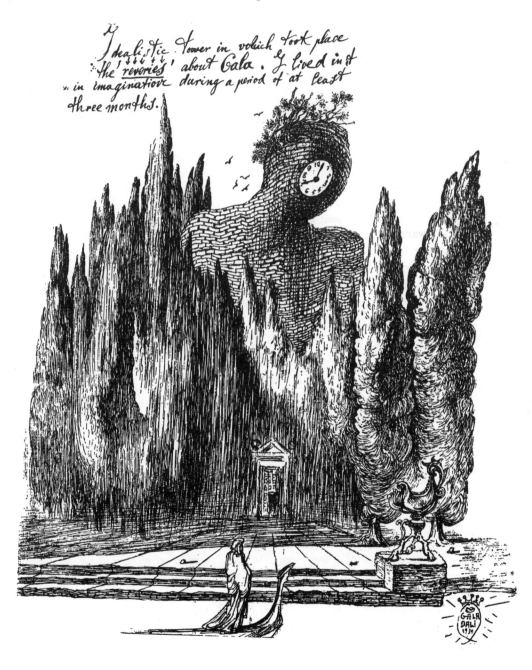

Idealistic tower in which took place the 'reveries' about Gala. I lived in it in imagination during a period of at least three months.

The idea of hanging my milk tooth from the ceiling of my house made me forget all kinds of practical difficulties which began to gather round Gala's worried face. "Don't think about those problems any more," I would say to her then, " . . . the water, the lighting, the difficulty of deciding where to have the maid sleep. The day you see my milk tooth hanging from its thread, reigning in the center of our house, you will be as enthusiastic as I at having undertaken all this. And we'll never have any flowers, or a dog—only aridity around our passion! And intelligence will age us quickly, and together! One day I shall write a book about you, and you will become one of those mythological Beatrices that history is forced to carry on its back, lashed by the fury of my whip and spitting fire in the rage of its resentment."

Once we had decided on all the details for the construction of our house in Port Lligat, we went to Barcelona. The peasants of the region around Barcelona like to repeat this adage, "Barcelona is good if your purse rings." With the deposit we had given the carpenter of Cadaques, we had gone through all our money. I prepared to make my purse ring We went to the bank to cash the Vicomte de Noailles' check for twenty-nine thousand francs. At the bank I was surprised that the gentleman at the cashier's window deferentially called me by my name. I was not aware of my already great popularity in Barcelona, and this familiarity of the bank employee, instead of flattering me, filled me with suspicion. I said to Gala,

"He knows me, but I don't know him!"

Gala was furious at such survivals of childishness and told me I would always remain a Catalonian peasant. I signed my name on the back of the check, but when the employee was about to take it I refused to give it to him.

"I should say not!" I said to Gala. "I'll let him have my check when he brings me the money."

"But what do you expect him to do with your check?" said Gala, trying to convince me.

"He might eat it!" I answered.

"But why would he eat it?"

"If I were in his place I would certainly eat it!"

"But even if he ate it you would not lose your money."

"I know, but then we would not be able to go and eat *torts* and *rubellons a la llauna* this evening.[1]"

The bank clerk looked at us blankly, unable to follow our conversation, for I had purposely dragged Gala out of earshot. She finally convinced me, and I went back to the cashier's window full of resolution. I said to the clerk, disdainfully throwing down my check, "All right, go ahead!"

Throughout my life it has in fact been very difficult for me to get

[1] *Torts,* a variety of small bird, and *rubellons a la llauna,* a kind of mushroom fried on a thin sheet of metal: two of my favorite Catalonian dishes.

used to the disconcerting and flabbergasting "normality" of the beings who surround me and who people the world. I always say to myself, "Nothing of what *might* happen ever happens!" I cannot understand why human beings should be so little individualized, why they should behave with such great collective uniformity. Take such a simple thing as amusing oneself by derailing trains! Think of the thousands of kilometres of railroad tracks that cover the earth, in Europe, America and Asia! And what a negligible percentage of those who have a passion for derailing trains ever put it into practice, as compared to the number who have a passion for traveling! When the train wrecker Marouchka was caught in Hungary this was regarded as a sensational and unique event.

I cannot understand why man should be capable of so little fantasy. I cannot understand why bus drivers should not have a desire once in a while to crash into a five-and-ten-cent store window and catch a few toys on the fly for their wives, and amuse the children who happened to be around.

I do not understand, I cannot understand why toilet manufacturers do not put concealed bombs in the flushing compartment of their products which would burst the moment certain politicians pulled the chain.

I cannot understand why bath-tubs are always made in approximately the same shape; why no one invents taxi-cabs more expensive than the others fitted inside with a device for making artificial rain which would oblige the passenger to wear his rain coat when he got in while the weather was fine and sunny outside.

I do not understand why, when I ask for a grilled lobster in a restaurant, I am never served a cooked telephone; I do not understand why champagne is always chilled and why on the other hand telephones, which are habitually so frightfully warm and disagreeably sticky to the touch, are not also put in silver buckets with crushed ice around them.

Telephone frappé, mint-colored telephone, aphrodisiac telephone, lobster-telephone, telephone sheathed in sable for the boudoirs of sirens with fingernails protected with ermine, Edgar Allan Poe telephones with a dead rat concealed within, Boecklin telephones installed inside a cypress tree (and with an allegory of death in inlayed silver on their backs), telephones on the leash which would walk about, screwed to the back of a living turtle . . . telephones . . . telephones . . . telephones . . .

I was always astonished to observe all the beings around me who were quite content in their various specialties to do again and repeat blindly and wearilessly always the same thing! And just as it astonished me that a bank clerk never had the simple idea of swallowing the check confided to him by his client, so it astonished me that no painter had ever yet had the idea of painting a "soft watch."

Naturally I was able to cash the Vicomte de Noailles' check without incident, and that evening we sat endlessly over a repast in which I ate two dozen small birds, with champagne, and during which we did not stop talking for a moment about our house in Port Lligat. The following day Gala fell ill of pleurisy, and I was plunged into such anxieties that for the first time in my life I felt the massive architecture of my egoism shaken to its foundations by that subterranean earthquake of sentimental altruism. Was I really going to end by loving her?

During Gala's illness I accepted the invitation of a friend of my Madrid days who asked me to come and visit him in Málaga. He would pay for my stay there, and promised to buy a picture from me. We accordingly planned to go to Málaga as soon as Gala was well again, but we promised ourselves not to spend a centime of Noailles' money, which we would leave in a safe at the Hotel de Barcelona, for this money was to be put aside for Port Lligat, which had become something sacred. I spent hours thinking up gifts and plans for Gala's convalescence. Her illness had given her such a fragile look that when one saw her in her tea-rose pink night gown she looked like one of those fairies drawn by Raphael Kishner that seemed on the point of dying from the mere effort of smelling one of the decorative gardenias twice as large and heavy as their heads. A feeling of tenderness toward Gala that was quite new in my life took a hegemonic hold of my spirit. Each of her movements made me feel like weeping, a feeling sweet as honey. This fondness was accompanied by slight sadistic impulses. I would get up excitedly, full of loving care, and say to her, "You are too pretty!" while I began to kiss her everywhere. But I would squeeze her tighter and tighter, and the more I squeezed and felt her weakly try to resist my too energetically passionate embraces, the more irresistible was my desire to grind her, so to speak, between my arms. I felt Gala become exhausted by my effusions, and this only stimulated, in a more and more delirious way, my desire not to stop my "games" of compression and asphyxiation the whole afternoon. At last Gala, unable to stand any more in her state of weakness, began to weep. Then I would attack her face. I began by gently kissing it a hundred times all over. Then I began to squeeze her cheeks, to flatten her nose, to suck her lips which I obliged to contract in a snoutish grimace which appeared to me irresistible; I sucked her nose, and then her nose and her mouth at the same time while I flattened her ears toward her cheeks with both hands. All these squeezings became more and more frenzied, and finally I was grinding that little fairy face with a force that I felt to be dangerous, as though I were pulling, kneeding,

folding over and patting a piece of dough to make a loaf of bread. In trying to console her I had just made her weep again.

"Let's go out! Let's go out!"

I put her in a car and took her to the International Exposition of Barcelona. I forced her to walk up a long flight of stairs with her eyes shut. I helped her to go up, holding her by the waist; she was so feeble that we had to rest every four of five steps. I led her thus to the top of a terrace from which one saw the whole exposition, and in the foreground the luminous, monumental fountains which were the most beautiful I have ever seen in my life. They rose to great heights, spreading fanwise, changing their form and color with combinations of a disconcerting magic effect. The sky too exploded with sheafs of fireworks. And Gala, her livid head leaning on my chest, asked,

"What have you prepared for me to see?"

"Now look!" I said.

No child has ever been so wonderstruck. The *sardanas* shed their melancholy rhythm around us. She said,

"You know how to do everything for me! You make me weep all the time!"

The anonymous crowd dragged its lazily stupid feet along the lanes of the fiasco that an international exposition always is. Misery of miseries! None of them wept!

Two days later we left for Málaga. The long three-day voyage was undertaken too soon after Gala's illness. In our second-class compartment she remained for hours with her cheek glued against my chest, and I was astonished that her small head, which seemed to be composed wholly of expression, should be so heavy. It was as if the whole little cranium were filled with lead. And I fell to meditating about her skull. I saw it very white and clean, with those teeth of hers that are so perfect, so well-shaped, regular and categorical, brilliant and glorious as though each of them had been the mirror of the truth of her red tongue emerging from the salivary well of her larynx. I compared her skull, without tongue, saliva or larynx, just armed with the truth of its teeth, with the lie of the teeth of my skull. I really had the mouth of an old man. No dentist has ever been able to fathom the mystery of my dental structure,[1] which always causes them to burst out in astonishment— I do not know whether from terror or admiration; for once the dentist who was examining them could not help congratulating me on the incomparable disaster of my dentition which, according to him, was something unique. Not a single tooth was where it should be. I lacked two molars that had never grown, and the two incisors of the lower jaw, which were

Dents de l'homme:
1. Incisive; 2. Canine; 3. Molaire.

[1] The correspondence—a symbolic one, at any rate—between the teeth and the sexual organs has been well established. In dreams the losing of teeth, which is popularly interpreted as a death omen, is supposedly a very clear allusion to onanism. Also among certain African tribes the ceremony of circumcision is replaced by that of pulling out a tooth.

milk teeth and which I had lost, did not grow out again (in fact they never have); still other teeth grew where they were not supposed to . . .

Thus I imagined my skull next to Gala's, and I saw it as a veritable cataclysm, for aside from the chaos of my teeth, my extremely underdeveloped chin would offer a violent contrast to the decisive development of my superciliary arches, which would be monstrously avid of sight once sight was absent. Moreover I could not imagine my own skull as white—it would always be ochre and putrefying, the color of earth saturated with manure. Gala's—as I have already said—was white, and even sky-blue-tinged, like those smooth, translucid and semi-precious pebbles that Gala's mother had gathered on the shores of the Black Sea and given her as a present, and which were kept in a cotton-lined box. I thought of the burial of Gala and myself together, holding each other's hand . . .

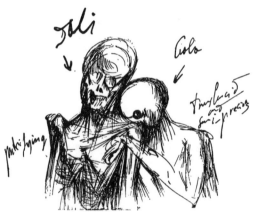

Gala's skull, overflowing with sleep, dropped into my lap. I put it back in place, on my shoulder that already ached from its weight. Opposite me other skulls, attached to anonymous travelers, swayed inertly with the jolts of the train. The flies walked about freely on all these faces. It was in a train wholly occupied by people "dead with sleep" that we reached Málaga.

An African heat already hovered at this season over the country of Andalusia with a phantasmal, royal and supreme majesty. Inscribed in letters of fire on the smooth, outstretched field of the sky without a single cloud, I read this heraldic device, "Here Heat Is King." The taxi driver went up to a porter sleeping in a shaded corner and tried to wake him up by rolling his body over with his foot. He did this twice, pausing in between. After the second rolling the porter finally made a gesture with his hand which seemed to belong to a ritual of ancient Egypt and by which he gave to understand, "Certainly not today!"

Preparations were in full swing for the Festival of the Dead, with orgiastic processions of Easter flowers. A streetcar conductor stopped his tram before a bar. He was brought a glass of *anis del mono*. He gulped

it down and started off again, singing. In the streets one saw many Picassos[1] with a carnation stuck over one ear, watching the passing throngs with eyes of a criminal, intense and graceful intelligence. Great bullfights were scheduled, and in the evenings after the implacable sunset, instead of a "lovely" breeze a hot, often burning wind would sweep in, the wind of the African desert just across the strait.

We Spaniards loved it! And this was the hour that we chose to make love! The hour when the fields of carnations and sweat smelled strongest, while the African lion of Spanish civilization roared! In a tiny village a few kilometres from Málaga, Torremolinos, we rented a fisherman's cottage which overlooked a field of carnations on the edge of a cliff falling abruptly into the sea. This was our honeymoon of fire! Our skins became dark as those of the fisher folk, who were brown as Arabs. The bed of our house was so hard that the mattresses seemed, instead of wool, to contain pieces of dry bread. It was uncomfortable to sleep on, but afterwards one's body was completely covered with gentle bruises and aches which, when one gets used to them, become extremely agreeable, for then one perceives that one has a body, and that one is naked.

[1] Málaga is Picasso's native town, and Picasso's morphological type is very common there, with the same bull-like expression of intelligence and vivacity.

Gala, with a build like a boy's, burned by the sun, would walk about the village with her breasts bare, and I had taken to wearing my necklace again. The fishermen of this region had no modesty of any kind, and would drop their pants a few metres from us to perform their physical functions. One could see that it was one of the most pleasurably anticipated moments of the day, and sometimes there was a whole string of them doing it together along the beach beneath a relentless sun. They would take their time about it, all the while tossing epic obscenities back and forth. At other times they would egg their children on with guttural cries as they fought with sling-shots in pitched battles. These stone-fights often ended with a few cracked skulls. The sight of their children's blood would awaken a little the personal hostilities among the defecators and, quickly pulling up their trousers and carefully readjusting their genital parts, which were always of handsome and well-developed proportions, they would start arguing among themselves about their children's battles and would in turn end the polemic with one or two knife jabs, accompanied and embellished by the unimportant tears which their wives, in perpetual mourning, would shed as they came running with hair dishevelled and arms raised to heaven, imploring Jesus and the Immaculate Virgin. There was not a shadow of sadness or of sordidness about all this. Their outbursts of anger were gay, biological, like a fish-bone drying in the sun. And their excrements were extremely clean and inlayed with a few undigested muscat grapes, as fresh as before they were swallowed.

At this period I developed a passion for olive oil. I would put it into everything. I would begin early in the morning by dipping my toast in oil with anchovies swimming in it. The considerable amount that remained in the dish I drank directly as though it were a precious liquid. Finally I poured the last drops on my head and my chest. I rubbed my hair and my body with it. My hair grew out again with renewed vigor, and so thickly that I broke all my combs. I continued to paint *The Invisible Man* begun at Carry-le-Rouet, and wrote the definitive version of *The Visible Woman*.

From time to time we received the visit of a small group of intellectual surrealist friends who all hated one another passionately and who were beginning to be gnawed by the canker of left and right ideologies. I saw at once that the day these cankers reached the stature of real serpents the civil war in Spain would be something ferocious and grandiose, a kind of monumental head of Medusa which instead of having a face in its head would have a face in its belly in which instead of intestines there would be serpents mutually strangulating one another in a continual iliac passion of death and of erection.

One day we received a batch of mail with several items of bad news. The Goemans Gallery, which owed us almost a month in arrears, had just gone into bankruptcy; Bunuel was going ahead all by himself with the production of *L'Age d'Or*—thus the film would be executed without

my collaboration; the carpenter of Cadaques, who claimed to have nearly completed our house at Port Lligat, was asking for the balance of his bill, augmented by a series of supplementary expenses which made it amount to more than twice what we had originally contemplated. At the same moment our rich Málaga friend went off without leaving his address, saying he would be back in twenty days! The money we had brought to Málaga was spent. We had enough to live on for another three or four days. Gala suggested that we send for the money in Barcelona. I did not want to touch this money, which for that matter was no longer enough to pay the carpenter's bill. The house at Port Lligat was sacred! So we decided to send telegrams to Paris asking friends to advance us money on the paintings I would bring them. But none of these friends answered, and the three days went by.

In the evening we requisitioned all the small change that always lay scattered in the pockets of my suits, and succeeded in collecting two pesetas. That very evening we received the visit of a surrealist who was a Communist sympathizer. I begged him to send a telegram for me, which I drafted, to our hotel in Barcelona to have our money sent to us. We would reimburse him the cost of the telegram as soon as we received our money. He left promising to do this. But the whole next day passed without any answer, and the following day likewise. To cap our misfortune, we were without a maid, and the empty house was without a single crumb of food. I knew moreover that our condition of sudden distress was solely due to my stubbornness in not having wanted to follow Gala's advice to send for the Barcelona money, which I had at first refused to touch out of superstition in regard to the Port Lligat house. This whole situation assumed in my brain the proportions of an incipient tragedy.

The intense African heat which had been beating on my body for a long month was making me see everything in red and black. In the morning, in an adjoining house, a crazed youth had just half-killed his mother with a pair of tongs. In the evening the customs-officer amused himself by shooting swallows with his rifle. Gala tried to convince me that our situation was annoying but far from tragic. All we had to do was to go and settle comfortably in a hotel in Málaga and wait there for the Barcelona money which could not fail shortly to arrive. There were several reasons why the money might have been delayed. We had telegraphed on a Saturday, and because of the English week the banks were closed that day. Perhaps our friend had neglected to send the telegram.

But I would not listen to all these arguments. I wanted to take advantage of the occasion to play out the drama of my anger once and for all, after having held it in leash ever since I had encountered my first economic difficulties. I would not admit the affront, the injustice, the monstrousness of the fact that I, Salvador Dali, should have to interrupt the writing of *The Visible Woman* because I, Salvador Dali, found myself without money, and the fact that my Galuchka should be dragged into the same

degrading situation was the last drop to make the already full cup of my patience overflow.

I left the house, slamming the door, and with the remorse of leaving Gala there in anguish, in the midst of packing our baggage. I picked up a stick from the ground and stalked through the fields of red carnations down toward the sea. As I went I furiously mowed the heads of the carnations, which shot into the air like the spurting blood of the decapitations so savagely painted by Carpaccio.

The seashore was hollowed out by grottos in which lived olive-complexioned gypsies, who were cooking fish in boiling oil that hissed in the frying pans like the very vipers of my own anger. For a second I thought of the absurd possibility of bringing down Gala's fitted trunk and coming to live among them. The thought of this promiscuous contact with the very beautiful gypsy women who were there half naked suckling their babies was a powerful aphrodisiac, to which the tenacious dirtiness of these women contributed. I fled to a solitary cove, my imagination whirling with the memory of those nursing breasts mingled with the vision of the glistening rump—like a black horse's—of one of the women puttering over the fire. My legs gave way and, falling to my knees on the jagged rocks, I felt like one of those anchorites in the throes of ecstasy painted by Rivera. With my free hand I caressed and scratched the calcinated skin of my body. I wanted to touch it everywhere at the same time. And I riveted my half-shut eyes upon a shred of cloud from which the scatological golden rain of Danaë fell in oblique rays. My whole fury had now taken hold of the jerks and trembling of my flesh. All my pockets were empty. No more gold, eh? But I could still spend this! And I spilled upon the ground the large and the small coin of my precious life, which seemed to me this time to be extracted from the deepest and darkest recesses of my bones.

This new and unnecessary "expense," the moment the pleasure it afforded me was over, only accentuated for me with an intensified feeling of discouragement the intolerable reality of my financial situation. Then all my impulsive anger turned toward myself. To punish myself for having done "that," I looked at my closed fist, the recent instrument of my enjoyment, and with it I pitilessly struck my face. I hit it several times in succession, harder and harder, and suddenly I felt that I had broken a tooth. I spat blood on the ground, on the very spot where a moment before I had squandered my treasure of pleasure. It was written: a tooth for a tooth!

I returned to our cottage, in a fever of excitement, but radiant. Victoriously I showed Gala my fist:

"Guess!"

"A glow-worm," she said, knowing that I was fond of gathering them.

"No! My tooth—I broke my little tooth; we must by all means go and put it in Cadaques, hang it by a thread in the centre of our house at Port Lligat."

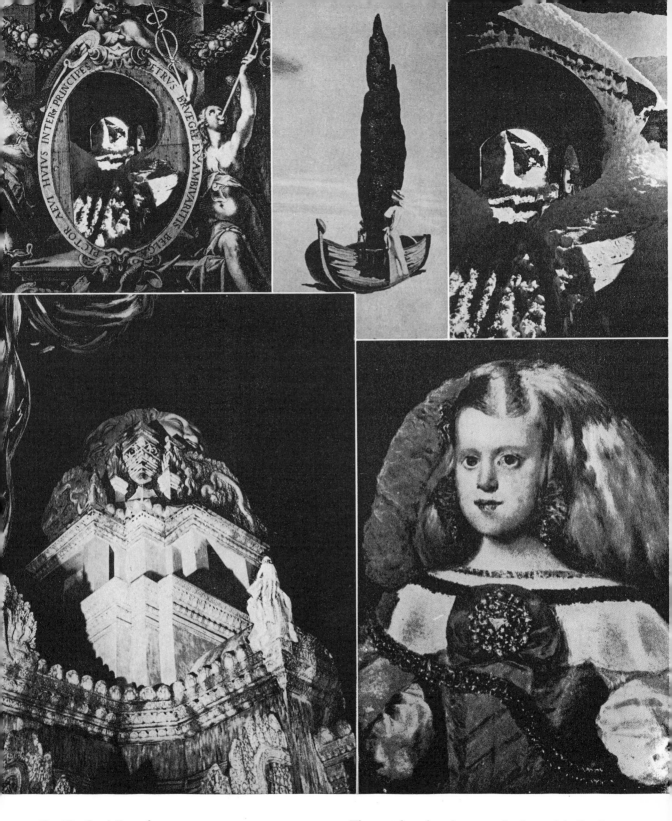

XI. The Great Paranoiac
Apparition of the head of Don Quixote in an Austrian postal card.
Under this cypress, which figures in my early memories, I first read Don Quixote.

The postal card as it appeared when originally discovered by Gala.
Apparition of Velasquez' Infanta in the summit of a piece of Hindu architecture.
Velasquez' painting of the Infanta.

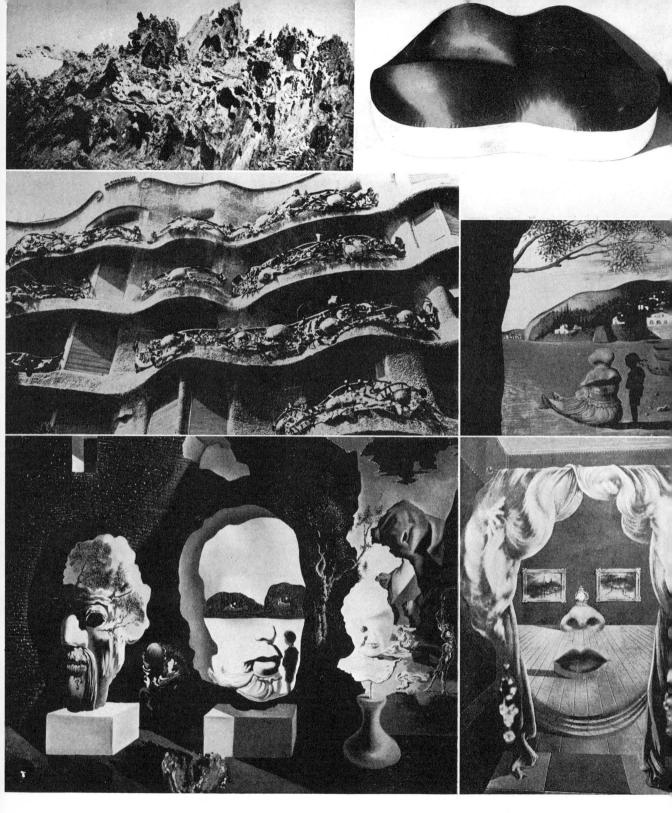

XII. The Mouth of an Aesthetic Form

The exact spot at Cadaques, where the jagged rocks made it uncomfortable to sit, which inspired the famous Divan in the Shape of a Mouth.

My idea as realized by the decorator, Jean-Michel Frank, one of my great friends during the Paris period, who was to commit suicide almost immediately after his arrival in America.

The mouth, the sea, and its foam treated as aesthetic forms in wrought iron by the architect Gaudi of Barcelona.

Mysterious Mouth appearing in the back of my nurse.

Four Mouths or "Age, Adolescence, and Youth."

The Face of Mae West, which might be used as an apartment.

This little tooth inspired in me a great tenderness and pity. It was tiny, so thin that it was translucid. It was like a small fossilized rice-grain, with an infinitesimal fragment of a daisy-petal caught within it. For one could in fact see a tiny whiter point at the center. Perhaps if one could have microscopically enlarged this little white spot one might have seen the aureole of a tiny Virgin of Lourdes appear. I have always had a precise consciousness of the advantage of my infirmities. In deficiencies, as a consequence of the laws of compensation, of disequilibrium and of heterogeneity, there are created breaks out of which new hierarchies of the normal coefficients of elasticity are created. I am quite aware that the Argonauts were supposed to have aggressive and well-stocked jaws, and we are told a great deal about the will logically directed toward success. But within my own experience I have never seen these strong faces with flawless porcelain teeth—prototypes of mordant tenacity—except among the anonymous crowds, capable at best of climbing to the most average situation in life. The rich, on the contrary, always have bad teeth. Money ages and wrinkles the man who is going to be rich, even before he succeeds in becoming so, just as the effluvia of certain malefic and carnivorous flowers intoxicate in advance the insect that comes to rest upon its fatal pistils. "My beloved, impoverished, uneven, decal-cified teeth, stigmas of my old age, henceforth I shall have only you to bite at money!"

The following day we went to Málaga to ask for a little money of our communistically inclined surrealist friend. We took the bus, with just enough money for the one-way trip. Thus, if we did not get hold of any it would be impossible for us to come home. After looking for him every-where we finally caught him. I said to him, "We need at least fifty pesetas to keep us for three or four days more till our money comes." Our friend assured us that he had sent our telegram the very evening we wrote it. He had no money of his own, but he promised me that he would imme-diately look up the various people from whom he might borrow this sum, and that I could surely count on it. He made us sit on the terrace of a café, and while Gala had an *horchta* and I a vermouth with olives he went on his pilgrimage to find money to lend us.

It was getting close to the time our bus was to leave, and there was still no sign of our savior. We began to despair of ever seeing him again when, just at the last moment, he came running.

"Run over and get seats on the bus!" he said. "Everything is arranged. I'll see you off."

He saw us to our seats, and while he wiped the sweat from his face with one hand, he shook my hand with the other, in which a piece of paper was discreetly folded, and said goodbye. I thanked him with all my heart, saying, "It won't be long now."

He smiled to indicate that we could in any case count on him, the ous started off, and for the first time the contact with a fifty-peseta bill within my hand seemed to be imbued with all the white magic of the

earth combined. Here I held three days of the life of Gala and of Salvador Dali which I savored in advance as the most magnificent in our existence. I relaxed my hand with the deliberation of one who wants to prolong the pleasure of anticipation indefinitely, able at last to observe with his own eyes the symbol of a happiness awaited with too much anguish.

But a chill came over me when I discovered that what I had in my hand was not a fifty-peseta bill but that my friend, apparently in sarcasm and derision, had simply left me the crumpled blue receipt of the telegram which he had sent for me two days before, thus not only giving me to understand that he was not disposed to lend me the sum I had asked him for, but cynically reminding me of the debt I owed him for the telegram. We had no money to pay our bus fare, and if the conductor had asked me at that moment for the price of my ticket, I should probably have tried to kick him off the bus. Gala was aware of the danger of such fits of anger which, when they take hold of me, can lead to the most unforseen, but always catastrophic solutions. She clutched my arm, begging me not to do anything. But I had got to my feet and was looking about for some pretext to perpetrate one of my phenomenal acts. As if in mechanical obedience to my sudden anxiety the conductor rang the bell and the bus stopped. I thought for a moment that my aggressive intentions had somehow been divined and that I was going to be thrown out of the bus. With both hands I clutched one of the nickel bars, prepared for a desperate resistance. But at this moment I saw our surrealist friend come rushing toward me, looking very unhappy, and waving in his hand what this time was visibly a fifty-peseta bill. In the last-minute confusion of leave-taking he had given me the wrong piece of paper and he had followed our bus in a taxi to catch up with us. We continued on our way.

When we reached home a stack of letters bearing good news awaited us, and among them was a check from Barcelona for our money which had been transferred to a Málaga bank. I ate a couple of anchovies with tomatoes and slept the whole afternoon with a sleep as heavy as the somnambulist noon-day bus that had brought us back. When I awoke, a moon that was red as a slice of watermelon rested on the fruit-dish of the bay of Torremolinos cut off by the window-frame and seemingly standing right on the table. My sudden awakening gave to this combination of images a confused synthesis in which the real spatial relationships began only gradually to organize themselves. I could not tell *a priori* what was near and what was far, what was flat and what was in perspective. I had just seen photographically a picture of the type of Picasso's cubist windows, a picture which, evolving in my brain, was to

become the key to the mimetic and paranoiac images I was later to produce, like my bust of Voltaire. While I lay on my bed reflecting upon all these complicated problems of vision, which are essentially philosophical problems, my finger was pleasurably exploring the inside of my nose, and I pulled out a little pellet which struck me as too large to be a piece of dry mucus. And upon examining and compressing it with delicate attention I discovered that it was in fact a piece of the telegram receipt which I must have pressed, rubbed and rolled into a ball with the sweat of my hand and absentmindedly stuck in one of my nostrils, an automatic bit of play which was characteristic of me at that period.

Gala was again unpacking our baggage, with the evident intention of staying, since we had received the money. But I said,

"We're leaving for Paris!"

"Why? We can have the benefit of another two weeks here."

"No! The other evening when I left slamming the door, I saw a slanting ray of sunlight pierce through a shred of cloud. Just at that moment I was in the act of 'spending' my vital fluid. It was after this that I broke my small tooth. You understand? I had just discovered in my own flesh the 'grandiose myth' of Danaë. I want to go to Paris, and I want to make thunder and rain. But this time it's going to be gold! We must go to Paris and get our hands on the money we need to finish the work on our Port Lligat house!"

We went back to Paris, stopping only as long as we had to in Madrid and Barcelona, and two hours in Cadaques to go and look at the effect of our house for a moment. This effect was even poorer and more cramped than we had expected—it was practically nothing. But already in this almost nothing there was the mark of the fanaticism of the two of us, and for the first time I was able to observe a structural reality in which Gala's clear, concrete and trenchant personality pierced through the defective delirium of my own. There were only the proportions of a door, a window and the four walls, and already it was heroic.

But true heroism awaited us in Paris, where Gala and I were to endure the hardest, tensest and proudest effort in the day-to-day defense of our personality. Everyone around us betrayed without greatness, the anecdote devoured the category, and as my name progressively affirmed itself with the indestructible grip of a cancer in the bosom of a society that did not want to hear about it, our practical life grew increasingly difficult. It was as if people were reacting to the horrible disease of my intellectual prestige, which was demolishing and destroying them, by communicating to me that disease of which they alone possessed the germs —the continual gnawing of "financial worries." I preferred this disease to theirs. I knew it was curable.

Bunuel had just finished *L'Age d'Or*. I was terribly disappointed, for it was but a caricature of my ideas. The "Catholic" side of it had become crudely anticlerical, and without the biological poetry that I had desired. Nevertheless the film produced a considerable impression, especially the scene of unfulfilled love in which one saw the hero, in a state of collapse from unsatisfied desire, erotically sucking the marble big toe of an Apollo. Bunuel left post-haste for Hollywood with dreams of conquest, and the *première* of the film was performed without his presence.

The audience was almost wholly sympathetic to surrealism and the performance passed without notable incident. Only a few noisy laughs and a few protests, quickly drowned out by the frenzied applause of the majority of the hall, marked the passionate tension with which our work was received. But two days later there was a different story. At one point in the film there was a scene showing a luxurious car coming to a stop, a liveried servant opening the door and taking out a monstrance, which one saw, in a close-up, deposited on the edge of the sidewalk. A pair of

very beautiful woman's legs then appeared coming out of the car. At this moment, at a pre-arranged signal, an organized group of the "King's Henchmen"[1] proceeded to toss bottles full of black ink that went crashing into the screen. Simultaneously, to the cries of "Down with the Boches!" they fired their revolvers in the air, at the same time throwing stench and tear-gas bombs. The film had shortly to be stopped, while the audience was beaten with blackjacks by the *Action Française* demonstrators. The glass panes of all the doors of the theatre were smashed, the surrealist books and paintings exhibited in the lobby of the theatre (Studio 28) were completely wrecked. One of my canvases was miraculously saved by an usher, who when the fracas began, had seized it and thrown it into the lavatory. But the rest were mercilessly torn to shreds after the glass protecting them had been crushed by heels. When the police appeared the wreckage was complete.

The following day the scandal burst in all the papers, and it became one of the most sensational events of the Paris season. Fiery polemics broke out everywhere, leading to the complete banning of the film by special order of the police commissariat. For some time I had occasion to fear that I would be banished from France, but almost immediately there was a reaction of public opinion in favor of *L'Age d'Or*. Nevertheless everyone preserved a holy fear of undertaking anything with me. "With Dali you never know. Might as well not start an *Age d'Or* all over again."

i Scandal!

The scandal of *L'Age d'Or* thus remained suspended over my head like a sword of Damocles, and also, like this sword, prevented me later from stammering, "I'll never collaborate with anyone again!" I accepted the responsibility for the sacrilegious scandal, though I had had no such ambition. I should have been willing to cause a scandal a hundred times greater, but for "important reasons"—subversive rather through excess of Catholic fanaticism than through naïve anticlericalism. Nevertheless I realized that in spite of everything the film possessed an undeniable evocative strength, and that my disavowal of the film would have been understood by no one. I therefore resolved to accept all the consequences

[1] *Les Camelots du Roi,* an organization of nationalistic, Catholic and royalist youths belonging to the *Action Française.*

of this incident,[1] while I planned to deflect its subversive side in the direction of my budding reactionary theories.

I had just made *L'Age d'Or*. I was going to be allowed to make *The Apology of Meissonier in Painting*. With me no one could ever tell where humor ended and my congenital fanaticism began, so that people soon got used to letting me do whatever I wanted, without discussion: "That's just Dali!" they would say, shrugging their shoulders. But meanwhile Dali had said what he wanted to say, and this thing that he had just said would quickly devour all the things that were not said or that even though they were said remained as though they had not been said, for most of them were already dead letters before they were even formulated. I was considered the maddest, the most subversive, the most violent, the most surrealistic, the most revolutionary of them all. What a power of darkness behind me, therefore, for the radiance of the day when I would build the whirling sky of the Catholic and luminous geometry of all the hierarchic flesh of the angels and the archangels of classicism!

Besides, my own heaven would always remain more violent and real than the ideal hell of *L'Age d'Or*, just as my classicism would one day be more surrealist than their romanticism! And my reactionary traditionalism more subversive than their abortive revolution.

[1] Later on, when Bunuel abandoned surrealism, he expurgated *L'Age d'Or* of its frenzied passages and made a number of other alterations without asking me my opinion. This altered version I have never seen.

The whole modern effort that had been accomplished during the Post-War period was false, and would have to be destroyed. Inescapably there must be a return to tradition in painting and in everything. Otherwise spiritual activity would quickly become nothingness. No one knew how to draw any more, or how to paint, or how to write. Everything was on the same level, everything was becoming uniform as it became internationalized. The formless and the ugly became the supreme goddesses of laziness. The empty and pseudo-philosophic gossip of café tables was increasingly encroaching upon honest work in studio and workshop. And the goddesses of inspiration, instead of continuing to occupy their Parnassus imagined and painted by Raphael and Poussin, were expected to come down into the street and ply the sidewalk trade and give themselves over to the libertinism of all the more or less popular assemblages. Artists fraternized with bureaucrats, spoke the language of the most vulgarly opportunistic demagogues, and impudently joined in the ambitions and frenzies of bourgeoisification of the masses who, bursting with scepticism and mechanical progress, waxed fat in the nauseating well-being of a life without rigor, without form, without tragedy and without soul! All this was hostile to me, and did not cease to work like a dog!

C H A P T E R E L E V E N

My Battle

My Participation and
My Position in the
Surrealist Revolution

''Surrealist Object'' versus
''Narrated Dream''

Critical-Paranoiac Activity
Versus Automatism

MY BATTLE

Against Simplicity	For Complexity
Against Uniformity	For Diversification
Against Equalitarianism	For Hierarchization
Against the Collective	For the Individual
Against Politics	For Metaphysics
Against Music	For Architecture
Against Nature	For Esthetics
Against Progress	For Perenniality
Against Mechanism	For the Dream
Against Abstraction	For the Concrete
Against Youth	For Maturity
Against Opportunism	For Machiavellian Fanaticism
Against Spinach	For Snails
Against the Cinema	For the Theatre
Against Buddha	For the Marquis de Sade
Against the Orient	For the Occident
Against the Sun	For the Moon
Against Revolution	For Tradition
Against Michelangelo	For Raphael
Against Rembrandt	For Vermeer
Against Savage Objects	For Ultra-Civilized 1900 Objects
Against African-Modern Art	For the Art of the Renaissance
Against Philosophy	For Religion
Against Medicine	For Magic
Against Mountains	For the Coast Line
Against Phantoms	For Spectres
Against Women	For Gala
Against Men	For Myself
Against Time	For Soft Watches
Against Scepticism	For Faith

Already upon my arrival in Paris I realized that the conspicuous success of my exhibition at Goeman's had had as its chief result the provoking of a regular mobilization of hostilities around myself and my incipient appearance upon the scene. It was as though the unexpected downpour of my imagination, aggravated by the hail-storm of *L'Age d'Or,* had caused the innumerable mushrooms of my enemies to sprout on all sides, while at the same time destroying their crop of fruit.

Who were my enemies? Everyone, or almost everyone, except Gala. What could be called Modern Art, even in surrealist circles, had risen to arms, alarmed by the demoralizing and destructive power which I came to represent. In the first place, my work was violent and audacious, incomprehensible, disconcerting, subversive. In the second, it was not "young" modern art. This much was understood and taken for granted: I had a horror of my epoch! Indeed my anti-Faustian spirit was exactly the contrary of that of the snotty apologists of youth, of dynamism, of the instincts of spontaneity and of laziness, incarnated in the degrading residues of poetic cubism and of the more or less pure plastic art that ravaged the nauseating and sterile terraces of Montparnasse. That gay and modern enterprise, *Cahiers d'Art,* was to remain serenely ignorant of me till the last minute, while old gentlemen with gaiters woven by the mites and the dust of tradition, with white moustaches stained with snuff, with the ribbon of the Legion of Honor in their buttonholes, would pull out their lorgnettes to look closely at a painting of mine and be tempted to walk off with it under their arm, to hang it in their dining-room next to a Meissonier! The oldsters who after fifty years have not become tired of looking, have always liked and understood me. They felt that I was there to defend them. They did not need it; strength was already on their side; and I took my position beside them, knowing that victory would be on the side of tradition. My crusade was for the defense of Greco-Roman civilization.

At the moment when I arrived in Paris, the intellectual elements were rotten with the nefarious and already declining influence of Bergsonism which, with its apology of instinct and of *l'élan vital* (the life urge), had led to the crudest esthetic revaluations. Indeed an influence blown over from Africa swept over the Parisian mind with a savage-intellectual frenzy that was enough to make one weep. People adored the lamentable instinctive products of real savages! Negro art had just been enthroned, and this was accomplished with the aid of Picasso and the surrealists! When I reflected that the heirs of the intelligence of a Raphael Sanzio had fallen into such an aberration, I blushed with shame and rage. I had to find the antidote, the banner with which to challenge these blind and immediate products of fear, of absence of intelligence and of spiritual enslavement; and against the African "savage objects" I upheld the ultra-decadent, civilized and European "Modern Style" objects. I have always considered the 1900 period as the psycho-pathological end-product of the Greco-Roman decadence. I said to myself: since these people will

not hear of esthetics and are capable of becoming excited only over "vital agitations," I shall show them how in the tiniest ornamental detail of an object of 1900 there is more mystery, more poetry, more eroticism, more madness, perversity, torment, pathos, grandeur and biological depth than in their innumerable stock of truculently ugly fetishes possessing bodies and souls of a stupidity that is simply and uniquely savage!

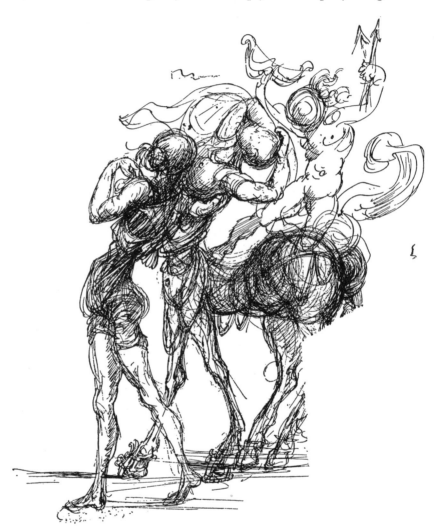

And one day, in the very heart of Paris, I made the discovery of the 1900 subway entrances, which unfortunately were already in the course of being demolished and replaced by horrible modern and "functional" constructions. The photographer Brassai made a series of pictures of the ornamental elements of these entrances, and people simply could not believe their eyes, so "surrealistic" was the Modern Style becoming at the dictate of my imagination. People began to look for 1900 objects at the

flea market, and one would occasionally see, timidly rising beside a grimacing mask from New Guinea, the face of one of those beautiful ecstatic women in terra cotta tinted in verdigris and moon-green. The fact is that the influence of the 1900 period was beginning to make itself felt in the form of a steadily growing encroachment. The modernizing of Chez Maxim's, which was becoming increasingly popular again, was interrupted; reviews of the 1900 epoch were revived, and the songs of this same epoch returned to favor. People speculated on the gamey and anachronistic side of 1900 in serving us literature and films in which sentimentalism and humor were combined with naïve malice. This was to culminate a few years later in the collections of the *couturière*, Elsa Schiaparelli, who succeeded in partially imposing the terribly inconvenient fashion of wearing the hair up in back—completely in accord with the 1900 type of morphology, which I had been the first to preach.

I thus saw Paris become transformed before my eyes, in obedience to the order I had given at the moment of my arrival. But my own influence has always outdistanced me to such a point that it has been impossible for me to convince anyone that this influence came from me. It was a phenomenon similar to the one I experienced on my second arrival in New York, upon observing that the window-displays of the great majority of shops in the town were visibly under the surrealist influence, and yet at the same time definitely under my personal influence. But the constant drama of my influence lies in the fact that once launched it escapes from my hands, and I can no longer canalize it, or even profit by it.

I found myself in a Paris which I felt was beginning to be dominated by my invisible influence. When someone, who until then had been very modern, spoke disdainfully of functional architecture, I knew that this came from me. If someone said in any connection, "I'm afraid it will look modern," this came from me. People could not make up their minds to follow me, but I had ruined their convictions! And the modern artists had plenty of reason to hate me. I myself, however, was never able to profit by my discoveries, and in this connection no one has been more constantly robbed than I. Here is a typical example of the drama of my influence. The moment I arrived in Paris, I launched the "Modern Style" in the midst of the most hilarious hostility. Nevertheless the

prestige of my intelligence was gradually imposing itself. After a certain time it began to take, and I was able to perceive my imprint here and there merely in walking about the streets: laces, night clubs, shoes, films—hundreds of people were working and earning an honest living as a result of my influence, while I myself continued to pace the streets of Paris without being able to "do anything." Everyone managed to carry out my ideas, though in a mediocre way. I was unable to carry them out in any way at all! I should not even have known how or where to turn to find the last and most modest place in one of those 1900 films that were about to be produced with a prodigality of means and stars, and that but for me would never have been made.

This was the discouraging period of my inventions. More and more the sale of my paintings was coming up against the freemasonry of modern art. I received a letter from the Vicomte de Noailles which made me foresee the worst difficulties. I therefore had to make up my mind to earn money in another way. I drew up a list of the most varied inventions, which I considered infallible. I invented artificial fingernails made of little reducing mirrors in which one could see oneself. Transparent manikins for the show-windows, whose bodies could be filled with water in which one would put live gold fish to imitate the circulation of the blood. Furniture in bakelite molded to fit the contours of the buyer. Ventilator sculptures modeled by forms in rotation. Camera masks for news reporters. Zootropes with animated sculpture. Kaleidoscopic and spectral spectacles through which one would see everything transformed, to be used on automobile rides when the scenery became too boring. Cleverly combined makeup to eliminate shadows and make them invisible. Shoes provided with springs to augment the pleasure of walking. I had invented and worked out to the last detail the tactile cinema which would enable the spectator by an extremely simple mechanism to touch everything in synchronism with what he saw: silk fabrics, fur, oysters, flesh, sand, dog, etc. Objects destined for the most secret physical and psychological pleasures. Among the latter were distasteful objects intended to be thrown at the wall when one was in a rage, and that would break into a thousand pieces. Others were built entirely of hard points and were intended by their jagged appearance to provoke feelings of exasperation, grinding of teeth, etc., such as one experiences in spite of oneself at the noise made by a fork rubbed hard against the marble top of a table. These objects were made to exasperate the nerves to the limit, while preparing the agreeable discharge which the mind would experience at the moment of throwing the other kind of object that breaks so gratifyingly with the pleasant noise of a bottle being opened—plop! [1] I had also invented objects which one never knew where

[1] Recently in thumbing through *Life* magazine I came upon photographs of similar objects that are now on the market and can be bought at the five-and-ten-cent stores, and that are, I believe, called "whackaroos."

to put (every place one chooses immediately appearing unsatisfactory), intended to create anxieties that would cease only the moment one got rid of them. It was my contention that these objects would have a great

re, with live jewels provided with reflectors for alternative and decreasing lighting . Salvador Dali 1937

commercial success, for everyone underestimated the unconscious masochistic buyer who was avidly looking for the object capable of making him suffer in the most indefinite and least obvious way. I invented dresses with false insets and anatomical paddings calculatingly and strategically disposed in such a way as to create a type of feminine beauty corresponding to man's erotic imagination; I had invented false supplementary

breasts budding from the back—this could have revolutionized fashion for a hundred years, and still might. I had invented a whole series of absolutely unexpected shapes for bath-tubs, of bizarre elegance and surprising comfort—even a bath-tub without a bath-tub made of a waterspout of artificial water which one would step into and emerge from bathed. I had made a whole catalogue of streamlined designs for automobiles, which were those that would be called streamlined ten years later.

These inventions were our martyrdom, and especially Gala's. Gala, with her fanatical devotion, convinced of the soundness of my inventions, would start out every day after lunch with my projects under her arm, and begin a crusade on which she displayed an endurance that exceeded all human limits. She would come home in the evening, green in the face, dead tired, and beautified by the sacrifice of her passion. "No luck?" I would say. And she would tell me everything, patiently and in the smallest details, and I have the remorse of not always having been just in appreciating her unsparing and limitless devotion. Often we would have to weep, before going to appease our worries and the epilogue of our reconciliation in the stupefying darkness of a neighborhood cinema.

It was always the same story. They would begin by saying that the idea was mad and without commercial value. Then, when Gala with all the efforts and the ruses of her eloquence had in the course of several insistent visits succeeded in convincing them of the practical interest of my invention they would inevitably tell her that the thing was interesting in theory but impossible to carry out practically, or else, in case it happened to be possible to carry out, it would be so expensive that it would be madness to market it. In one way or another the word "mad" always cropped up. Discouraged, we would definitely abandon one of our projects, which had already cost Gala so much perseverance, and with fresh courage we would launch another of my inventions. The false fingernails did not go; let us now try the kaleidoscopic spectacles, the tactile cinema, or the new automobile design. And Gala, hurrying to finish her lunch, would give me a kiss before starting out on the pilgrimage of the buses, kissing me very hard on the mouth, which was her way of saying "Courage!" And I remained the whole afternoon painting the picture I happened to be working on, of an untimely and anti-modern character, while the uninterrupted cavalcade of unrealizable projects passed through my head.

And yet all my projects were realized, sooner or later, by others; but invariably so badly that their execution would sink into anonymity, the disgust which they created making it impossible to do them over again. One day we learned that false fingernails for evening wear had just become the fashion. Another day someone came bringing the news, "I've just seen a new type of car-body"—whose lines were exactly in the spirit of the models I had designed. Another time I read, "Display windows have recently been featuring transparent manikins filled with live fish.

They remind one of Dali." This was the best that could happen to me, for at other times it was claimed that it was I who in my paintings imitated ideas which had in fact been stolen from me! Everyone preferred my ideas when, after having been progressively shorn of their virtues by several other persons, they began to appear unrecognizable to myself. For once having got hold of an idea of mine, the first comer immediately believed himself capable of improving on it.

The more proofs I had of my influence the less capable I became of acting. I was beginning to be known, but this was worse, for then French good sense seized upon my name as a bugaboo. "Dali, yes—it's very 'extraordinary,' but it's mad and it can't live." Nevertheless it had at all costs to be made to live. I wanted to tear from this admirative and timorous society a minimum of its gold, which would permit Gala and me to live without that exhausting phantom, the constant worry about money, which we had seen rise for the first time on the African shores of Málaga.

But if I did not succeed in earning money, Gala achieved the miracle of making the little we had do—everything. Never did the dirty ears of Bohemianism enter our domicile, walking on the long staggering legs of an anemic frog, dressed in a cape made of soiled bedsheets with rice and fried potatoes stuck to them, glued and hardened by sweet champagne that has dried for two long months. Never have we been exposed to the degrading insistence of the shadows of utilities, employees, who stand leaning nervously against the doors of kitchens convulsively empty, though stored with a whole year's famine. Never have either Gala or I yielded a single inch to the defeats of the prosaic that monetary difficulties drag in their wake, to the inertia of not being aware of anything, and of shutting one's eyes to the morrow by telling oneself that the little that remains will not be able to alter the situation. Thanks to the strategist that Gala became on these occasions, external difficulties made us on the contrary harden our two souls even more. If we had little money, we ate soberly but well, at home. We did not go out. I worked a hundred times harder than any mediocre painter, preparing new exhibits. For the smallest order I put all my blood into my work. Gala would often reproach me for putting such great effort into the execution of insignificant and miserably remunerated orders. I would answer that inasmuch as I was a genius it was a veritable miracle that I got any orders at all. Our fate would be literally to die of hunger. "If we manage to live modestly it is because you and I at each moment of the day make a continuous and superhuman effort—and thanks to which we shall pierce through in the end."

All around us artists, who today are annihilated by oblivion, were living handsomely on the adaption and mediocritization of Dalinian ideas. If Dali, the authentic king, was inacceptable and unassimilable, like a too violently seasoned food, on the other hand the formula of

putting a little Dali here and a little there made the most insipid left-over dishes suddenly appetizing. A bit of Dali in the landscape, a bit of Dali in the cloud, a bit of Dali in the melancholy, a bit of Dali in the fantasy, a bit of Dali in the conversation, but just a bit, gave a piquant and tantalizing savor to everything. And everything became readily more commercial as Dali himself, while becoming more and more integrally and violently Dali, frightened people and decommercialized himself more and more. I said to myself: patience—the thing is to last. And with my

Project for an ultra-sophisticated oil lamp for the exclusive use of the aristocracy

stubbornness and my fanaticism, aided and encouraged by Gala's, instead of taking a step backward, as good sense commanded us to do, I would take five steps forward in the intransigence of my opinions and of my works. It would be longer and more difficult, but the day we "came through," we would have all the rats and all the dirty ears of Bohemianism, and all the pink cheeks of the easy life, at our feet. As our life became shaped beneath the pitiless constraints of rigor, of severity, and of passion, the others around us were dissolving in facility. Cocaine here, heroin there, opium galore, alcohol and pederasty everywhere. Heroin, cocaine, drunkography, opium and pederasty were sure vehicles to ephemeral success. The freemasonry of vice buoyed all its members with sentimental devotion against the common fear of solitude. All lived together, sweated together, took shots together, watching one another to see which one would croak first in order to plant a friendly dagger in his back at the last moment. Gala's and my strength was that we always lived a healthy life in the midst of all this physical and moral promiscuity, taking no part in it, without smoking, without taking dope, without sleeping around. Gala and I continued to live as much alone as I had lived during my childhood and adolescence. Not only did we remain distant, but we remained equidistant—at equal distance from the artists of Montparnasse, from the drug-addicts, from society people, from the surrealists, from the communists, from the monarchists, from the parachutists, from the madmen, from the bourgeois. We were at the centre, and to remain at the centre, to preserve that equilibrium of lucidity and be able to play all the notes, by virtue of which you feel yourself dominating the situation—like an organist sitting in the center of a semicircular organ, I wrung every sound as from an organ—it was necessary to leave an area of free space around one, to be able to run away from time to time and settle down.

This free space, for us, was Cadaques, our retreat in Spain for months on end, during which we left Paris as one leaves a kettle full of tripe which to be properly done, as is well known, must cook for several days.

While the kettle of Paris was cooking the *tripes à la mode de Caen* of my gluey imagination, we would be away. But before our departure we would prepare the dishes that we would leave cooking for two or three months. I would sow among the surrealist group the necessary ideological slogans against subjectivity and the marvelous. For the pederasts the problem was simple: I reactualized the classic romanticism of Palladio. For the drug-addicts I furnished a complete theory of hypnagogic images, and I spoke of masks of my invention for seeing dreams in color. For the society people I set up the fashion of sentimental conflicts of the Stendhalian type and polished the forbidden fruit of the revolution. The pederasts I coyly introduced to surrealism. To the surrealists I held up another forbidden fruit, that of tradition.

We were to leave the following morning. After a thousand efforts we had managed to scrape together a little money. I had hurriedly to set up the secret links of my influence, and I drew up the list of the last visits I must make: in the morning, a cubist, a monarchist, and a com-

"Gala à Paris"

munist; in the afternoon, society people, selected among those who detested one another most; and the evening, for Gala and myself. For the two of us to achieve this was the greatest triumph. The other couples were never together, or when they were their respective minds were elsewhere. They were horrified to discover us together in a corner of one of the best restaurants, before a good vintage wine, talking to each other with the avidity of a fresh idyll which was only in its first or second day! What did we talk about? We talked about being alone, about that magic prospect of going to Cadaques to be alone, to see what was going to happen between the two of us. Down there we were going to build walls in the sun to protect us against the wind, wells to catch springs of water, stone benches to sit on. We were going to build the first steps of the critical-paranoiac method; we were going to continue that tragic and beautiful labor of living together, of living for the reality of just the two of us!

We took the train at the Gared'Orsay, loaded as bees. Ever since I can remember I have wanted to travel with my documents—that is to say, with some ten suitcases stuffed with books, photographs of morphology, insects, architecture, texts, endless notes. This time, moreover, we brought a few pieces of furniture from our Paris apartment, and a whole collection of butterflies and leaf-insects mounted under crystal, with which we planned to decorate the house; also gasoline lamps and heaters, for in Port Lligat there was no electricity. The instruments for my painting made a whole pile of baggage by themselves, among which a large revolving easel stood out.

From Cadaques to Port Lligat the road leads between abrupt rocks, where no car can get through. So it was necessary to carry everything on a donkey's back. It took us two days to get settled, and during these two days we lived in a continual fever. The walls were still all damp, and we tried to dry them a little at a time by turning the heat of our gasoline lamps on them. At the end of the second day Gala and I were lying on the great divan which at night became our bed. The *tramontana* [1] was blowing outside like a madwoman. Lydia "La Ben Plantada," was seated on a little chromium stool in front of us. She spoke to us about mystery, about the "master," about an article on William Tell that d'Ors had just written. "William and Tell," she said, "are two different people. One of them is from Cadaques, the other from Rosas..." She had come to make our supper, and as the conversation on William and Tell was sure to develop methodically, she went to the kitchen to fetch the chicken, and what she needed to kill it with. Lydia this time sat on the floor, and while continuing to interpret Eugenio d'Ors's last article she adroitly plunged her scissors into the chicken's neck, and held its bleeding head in a deep glazed terra-cotta vessel.

[1] An extremely violent wind, the equivalent of the *mistral* in Southern France. It usually blows for three or four days in succession, lasting sometimes as long as two weeks.

"No one will believe I am 'La Ben Plantada.' I can understand that. People don't have strong minds like the three of us—no spirituality! They don't see farther than the mark of the letters on the paper. Now Picasso did not talk much, but he was very fond of me; he would have given his blood for me. One day he lent me a book by Goethe..."[1]

The chicken was in the last extremity of its agony, and remained with its legs stiff and motionless, like vinestalks hemmed in by winter. Lydia began to pluck it, and soon the whole room was covered with feathers. When this operation was over she cleaned the chicken, and with her fingers dripping with blood she began to pull out its viscera which she arranged neatly on a separate dish on the crystal table, where I had laid a very expensive book of facsimiles of the drawings of Giovanni Bellini. Observing that I jumped up anxiously to remove the book against the possibility of splashing, Lydia smiled bitterly, and said, "Blood does not spot," and then she immediately added this sentence, which a malicious expression in her eyes charged with erotic hidden meanings, "Blood is sweeter than honey. I," she went on, "am blood, and honey is all the other women! My sons..." (this she added in a low voice) "at this moment are against blood and are running after honey."

At this very moment the door opened, and the two sons appeared, the one very sombre with his red moustache, the other smiling constantly in an anxious and disturbing manner. The latter said, "She is coming now." "She" was the maid whom Lydia had picked out for us, and who would begin to take care of the house the following day. She arrived a few minutes later. She was a woman of about forty, with black shiny hair, like a horse's mane. She had a Leonardesque facial structure, and a passion in her eyes which denoted insanity. She was really insane, and we were to have dramatic proof of this later. I have several times observed, by my own experience, that a violent abnormality of mind mysteriously attracts madness to the point of grouping it protectively around itself. No matter where I go, madmen and suicides are there waiting for me, forming a guard of honor. They know obscurely and intuitively that I am one of them, although they know as well as I that the only difference between me and the insane is that I am not insane. Nevertheless my "effluvia" attract them irresistibly. I remember the chrysalis cocoon that Fabre transported, as an experiment, several hundred kilometers from the spot where this species was exclusively to be found. He put it on a table, and at the end of the time necessary for butterflies of the same species to arrive the room was invaded by a swarm of them. They had come as with one mind at the tyrannical call of an effluvium so immaterial that one could not even detect it by smell. It was enough for this chrysalis to have been for one moment in contact

[1] Picasso had spent a summer in Cadaques with Derain; Ramon Pitchot had brought them here. They had interested themselves in Lydia's case, and lent her two books by the same author, but different books. Lydia succeeded in interpreting them in such a way as to make one the continuation of the other.

with a piece of cotton for this cotton to acquire its attractive power and cause hundreds of frenzied butterflies to fly through space, rushing in answer to the call.

Two days after my arrival in solitary Port Lligat, my little room was already swarming with madmen. I realized the unlivableness of this, and took necessary measures. Every day I was going to get up at seven o'clock to work. A door opening inopportunely was enough to disturb my work for hours. No one must ever remain in the house. I would see him outside. And from then on the madmen would prowl outside the house, and only exceptionally came in on Sundays.

Another of our importunate Lligat friends was Ramon de Hermosa. He was a man of about fifty, very hale and hearty, with a coquettish moustache *à la* Adolphe Menjou—he even looked a little like him. He was probably the laziest man in the world. He liked to repeat the phrase, "There are years when you don't feel like doing anything." In his case this phenomenal kind of year had occurred without interruption since his childhood. The sight of other people working filled him with admiration. "I can't understand how they don't get tired out doing all that!" he would say. His case of do-nothingness was so proverbial that it had been accepted, with a touch of pride even, by the fishermen. There was a tinge of admiration in the contempt with which they would say, "Don't you worry about Ramon's being willing to do that!" And if Ramon had been willing, everyone would have been disappointed, and he would have lost his prestige forever. His do-nothingness was a kind of institution, a rarity, a phenomenon, something unique, which did not exist anywhere else. His total and parasitic inactivity was a source of pride in which everyone had a small share. Nevertheless when the fishermen would be dragging their heavy burden of fishing tackle under the relentless afternoon sun and would pass the casino and see Ramon savoring a coffee, a cigar and a glass of brandy, their anger would often break loose in the crudest insults, which provoked on Ramon's part only the most comprehensible, bitter and comprehensive of smiles. Knowing that he was incapable of earning his living, the gentlemen gave him their old suits and a few centimos on which he lived with the miracle of each moment. It was because of this that he was always dressed as a gentleman. For years he wore an English-cut sport jacket. The mayoralty lent him a large house in which he had to cohabit with the vagrants who passed through the town, of whom there were very few, and whom he somehow managed to have keep house for him and even to fetch his water. I had been several times to see Ramon in his house. There were two fig trees in front of it full of rotting figs, but which he never touched—out of sheer laziness, of course, but offering the pretext that he did not like them. The house was infested with fleas. The rain leaked in everywhere, and one witnessed bloody battles between cats and rats. Once Gala made an arrangement with Ramon to have him pump water for us once a day, just enough to fill the wash-tub. It would take him only a few minutes, and he could

do it at sundown, when it was cool. Ramon started off to perform this little job. On the second day there was still not a drop of water in the tub, and yet one heard the intermittent sound of the pump. I went to see what was going on, and found Ramon lying under an olive tree, in the act of skilfully imitating the sound of the pump by rhythmically striking two irons (with the aid of strings, which enabled him to do this with the minimum of effort), each iron having a different pitch, which from afar resembled the sound of the pump—tock, tock, tock, tock . . . Every day when I saw him come and try to coax some of the kitchen left-overs out of me I would ask him,

"Well, Ramon, how goes it?"

"Badly, very badly, Señor Salvador," he would invariably repeat, "worse and worse!" After which he would let slip out a sly little smile that scurried under his moustache.

Ramon had the virtue of telling the least interesting things in the world with a minuteness and an epic tone worthy of the *Iliad*. His best story was about a three-day trip he had made in which he had had the duty of carrying a small suitcase for a billiard champion. It was told with all the minute-to-minute details and was a masterpiece of build-up without suspense. After the tense, agitated conversations of Paris, swarming with double meanings, maliciousness and diplomacy, the conversations with Ramon induced a serenity of soul and achieved an elevation of boring anecdotism that were incomparable. And the gossip of the fishermen of Port Lligat, with their completely Homeric spirit, was of a corporeal and solid substance of reality for my brain weary of "wit" and *chichi*.

Gala and I spent whole months without any other personal contacts than Lydia, her two sons, our maid, Ramon de Hermosa, and the handful of fishermen who kept their equipment in their shacks in Port Lligat.

In the evening everyone left for Cadaques, even the maid, and Port Lligat remained absolutely deserted, inhabited solely by the two of us. Often at five o'clock in the morning our light was still lit. Just as the moon would be melting in the sky. We would begin to look for something a knock at the door. It was one of the fishermen.

"I saw the light on, and I thought I would come in for a moment to bring you this sea perch. It will be good and fresh for tomorrow morning. And this stone. I picked it up for Madame Gala. I know she likes strange stones. Señor works too hard. The day before yesterday too he went to bed very late." And, speaking to Gala, "Señor Salvador should take a purge. That insomnia he complains about comes from his stomach. He ought to clean it out once and for all, and have it over with. The sky is clear as a fish eye. That moon—we'll have good weather. Good night."

When the fisherman had gone I would look at Gala, begging her, "Go to bed. You're dead tired. I *have to* paint for another half hour."

"No, I'll wait for you. I have a thousand things to classify before I go to bed."

Gala wove unwearyingly the Penelope's cloth of my disorder. As soon as she had succeeded in organizing the documents and notes necessary for the methodical course of my work I would begin, in a frenzy of impatience, to mix them all up to find some unnecessary thing which, for that matter, I was almost sure to have left on purpose in Paris and which Gala had advised me to take. For Gala has always known better than I what I needed for my work. Five o'clock would ring, and the moon would be melting in the sky. We would begin to look for something which had appeared to me for a moment with the flash of a caprice. Gala tirelessly undid the valises, without laziness and without hope, and knowing that we would not sleep. If I did not sleep, she would not go to bed. She followed the anguish of my picture with more intensity even than myself, for I would often cheat, in order to derive pleasure from my drama, and even to see Gala suffer.

"It is mostly with *your* blood, Gala, that I paint my pictures," I said to her one day, and since then I have always used her name with mine in signing my work.

Gala and I lived for three months steadily in Port Lligat, stuck like two cancers, one in the stomach, the other in the throat, of time. We did not want a fraction of an hour to flow by without having consumed the life of all its tissues in our devouring embrace. We obliged time to heed us by torturing it. There was not an hour of the day that could escape appearing and rendering account before the inquisitorial judgment of our two souls. Around us gray, cutting rocks, aridity, famished cats, wind, sickly vinestalks, exalted madmen in rags, Ramon—dressed as a gentleman, cynical, and covered with fleas—a dozen or so fishermen nobly reserved, unflinchingly awaiting the hour of their death, their finger-nails crammed with fish-guts and the soles of their feet hardened by absinthe-colored callouses. In Cadaques, at a quarter of an hour's distance,

my father's hostility, whose passion I could feel at a distance, localized behind the mountain that separated us, in the exact spot of my parents' house where I had lived my childhood and adolescence, and from which I had been evicted. This house of my father's I saw at a distance in the course of my walks; it seemed to me like a piece of sugar—a piece of sugar soaked in gall.

Port Lligat: a life of asceticism, of isolation. It was there that I learned to impoverish myself, to limit and file down my thinking in order that it might become effective as an ax, where blood had the taste of blood, and honey the taste of honey. A life that was hard, without metaphor or wine, a life with the light of eternity. The lucubrations of Paris, the lights of the city, and of the jewels of the Rue de la Paix, could not resist this other light—total, centuries-old, poor, serene and fearless as the concise brow of Minerva. At the end of two months at Port Lligat I saw rising day after day before my mind the perennial solidity of the architectural constructions of Catholicism. And as we remained alone—Gala and I, the landscape and our souls—the ancient brows of the Minervas came more and more to resemble those of the Madonnas of Raphael, bathed in a light of oval silk.

Every evening we took a walk and would sit down in our favorite parts of the landscape. "We shall have to have the well dug five metres deep to try to find more water...At the new moon we will go to the *encessa*[1] and fish sardines . . . We will plant two orange trees beside the well . . ." These were the kinds of things I would say to Gala to relax us from a long day of spiritual work. But my eyes remained fixed on those smooth and immaculate skies of the serene winter days. Those skies were great and rounded like the intact cupola that awaited the painting of an allegory of glory—the triumph and the glory of the critical-paranoiac method, perhaps?

Oh, nostalgia of the Renaissance, the sole period that had been able to meet the challenge of the cupola of the sky by raising cupolas of architecture painted with the unique splendor of the Catholic faith. What has become, in our day, of the cupolas of religion, of esthetics, and of ethics which for centuries sheltered the soul, the brain and the conscience of man? The soul of man, in our day, dwells out in the cold, like beggars, like dogs! Our age has invented mechanical brains, that degrading and horrible "apparatus of slowness," the radio. What does it matter to us if we can hear the wretched noises that reach us from Europe or China? What is this compared to the "speed" of the Egyptian astrologers, of Paracelsus or of Nostradamus, who could hear the breathing of the future three thousand years ahead! What does it matter that man can hear the World War communiqués and the "congas" sung from one hemisphere to the other—man, whose ears were made to hear the sound of the battles of archangels, and the canticles of the angels of heaven?

[1] The night fishing of sardines.

What is a television apparatus to man, who has only to shut his eyes to see the most inaccessible regions of the seen and the never seen, who has only to imagine in order to pierce through walls and cause all the planetary Baghdads of his dreams to rise from the dust. What is the socialist ideal of a "higher living standard" for man, who is capable of believing in the resurrection of his own flesh? If a donkey should suddenly begin to fly, or a fig sprout wings and take to the sky, this might astonish us and distract us for a moment. But why be astonished at a flying machine? It is more meritorious for a laundry iron to fly than for a plane, even though if you throw an iron into the air it will fly too, while it is up, like any plane. What is it for a machine to fly? And what is it for man to fly, he who has a soul?

"September"

Our epoch is dying of moral scepticism and spiritual nothingness. Imaginative slothfulness, entrusting itself to the mechanical, momentary and material pseudo-progress of the post-war period, has de-hierarchized the spirit. It has disarmed it, dishonored it before death and eternity. Mechanical civilization will be destroyed by war. The machine is doomed to crumble and rust, gutted on the battle fields, and the youthful, energetic masses that have constructed them are doomed to serve as cannon-fodder.

Yes! I am thinking of you, enthusiastic and devoted youth; youth with flushed, heroic faces, with your teeth holding trophies snatched in world contests held in concrete stadiums. I am thinking of you, the generation of youth, you who have been raised on athletic feats in the unbroken roar of planes and the radio. I am thinking of you, youth exuberant with gay generosities, youth of neo-paganism guided by a

monstrous utopian idea bloody and sacrilegious. I am thinking of you, companions, comrades of nothingness! . . .

"Gala, give me your hand. I'm afraid of falling, it's dark. I'm all worn out by this walk. You think the maid will have found some sardines at the last moment for this evening? If it's still as warm as this tomorrow, perhaps I can take off one of my wool sweaters. We'll take some drops to sleep well tonight. Tomorrow I have lots and lots of things to do before it gets to be this time."

We were returning home. A faint smoke rose from the chimney of our roof. It was the fish soup that was cooking and taking its time about it. Let us hope she has put a few crabs into it. We walked and walked, locked in each other's arms, and we felt like making love.

Suddenly I was seized with a joy that made me tremble. "My God, what a stroke of luck that we are not Rodin, you or I!"

As a special treat, to celebrate the completion of a painting, we went with the fishermen for a feast of fried sardines and chops on Cape Creus, which is exactly the epic spot where the mountains of the Pyrenees come down into the sea, in a grandiose geological delirium. There, no more olive trees or vines. Only the elementary and planetary violence of the most diverse and the most paradoxically assembled rocks. The long meditative contemplation of these rocks has contributed powerfully to the flowering of the "morphological esthetics of the soft and the hard" which is that of the Mediterranean Gothic of Gaudi—to such an extent that one is tempted to believe that Gaudi must, at a decisive moment of his youth, have seen these rocks which were so greatly to influence me.

But aside from the esthetics of this grandiose landscape, there was also materialized, in the very corporeity of the granite, that principle of paranoiac metamorphosis which I have already several times called attention to in the course of this book. Indeed if there is anything to which one must compare these rocks, from the point of view of form, it is clouds, a mass of catastrophic petrified cumuli in ruins. All the images capable of being suggested by the complexity of their innumerable irregularities appear successively and by turn as you change your position. This was so objectifiable that the fishermen of the region had since time immemorial baptized each of these imposing conglomerations—the camel, the eagle, the anvil, the monk, the dead woman, the lion's head. But as we moved forward with the characteristic slowness of a row-boat (the sole agreeable means of navigation), all these images became transfigured, and I had no need to remark upon this, for the fishermen themselves called it to my attention.

"Look, Señor Salvador, now instead of a camel one would say it had become a rooster."

What had been the camel's head now formed the comb, and the camel's lower lip which was already prominent had lengthened to become the beak. The hump, which before had been in the middle of its back, was now all the way back and formed the rooster's tail. As we came

nearer, the tips of the anvil had become rounded, and it was exactly like a woman's two breasts . . .

While the fishermen rowed, and one saw these rocks at each monotonous stroke of the oars continually become metamorphosed, "become uninterruptedly something else," "change simulacra," as though they had been phantasmal quick-change artists of stone, I discovered in this perpetual disguise the profound meaning of that modesty of nature which Heraclitus referred to in his enigmatic phrase, "Nature likes to conceal herself." And in this modesty of nature I divined the very principle of irony. Watching the "stirring" of the forms of those motionless rocks, I meditated on my own rocks, those of my thought. I should have liked them to be like those outside—relativistic, changing at the slightest displacement in the space of the spirit, becoming constantly their own opposite, dissembling, ambivalent, hypocritical, disguised, vague and concrete, without dream, without "mist of wonder," measurable, observable, physical, objective, material and hard as granite.

In the past there had been three philosophic antecedents of what I aspired to build in my own brain: the Greek Sophists, the Jesuitical thought of Spain, founded by Saint Ignatius of Loyola, and the dialectics of Hegel in Germany—the latter, unfortunately, lacked irony, which is the essentially esthetic element of thought; moreover it "threatened revolution". . .

In the lazy way in which the fishermen of Cadaques rowed there was concealed a quality of patience and of inaction which, too, was a form of irony. And I said to myself that if I really wanted to return to Paris as a conqueror I ought to arrive there rowing a boat, I ought not even to get out of this boat, but go there directly, bringing this light of Lligat clinging to my brow, which two months of decantation of the spirit had settled and clarified—for the spirit, like wine, cannot be transported without peril; it must not be shaken too much, or it will spoil on the way. It is to the rhythmic beat of the lazy and ironic oars that one should transport the rare wines of tradition on days of great calm, in order that these should be as little aware as possible of the voyage, even though the voyage should be "as long as possible." For nothing in fact is more cretinizing for the spirit of man than the speed of modern means of locomotion, nothing more discouraging than those "speed records" that are announced with weariless periodicity. I am willing, for that matter, to grant anything one likes in this realm, and I will even ask the reader to accept with me for a moment the hypothesis that it may be possible to go around the world in a single day. How boring that would be! Imagine this to be still further perfected until one could do it in ten minutes—in one minute. But this would be frightful! On the other hand, suppose that, by a miraculous stroke of luck emanating from heaven, one should suddenly succeed in making the trip between Paris and Madrid last three hundred years. What mystery then, what speed! What vertigo

for the imagination! Immediately, instead of the train, one would go back to horoscopes. Instead of traveling on the back of an airplane's carcass oozing with gasoline, one would again travel on that of the stars! But this too is romanticism *à la Méliès*.[1] Three hundred years is too long to go from Madrid to Paris. Let us then take the ironic average, that of the stage-coach, that of Stendhal's and Goethe's voyages to Italy. At that time distances still "counted," and gave time to the intelligence to be able to measure all spaces and all forms, and all the states of the soul and of the landscape and of the architecture. At that time the slowness and lack of mechanical perfection were still among the prime conditions for the easy and savory development of the intelligence. Row, Dali, row! Or rather, let the others, those worthy fishermen of Cadaques, row. You know where you want to go; they are taking you there, and one might almost say that it was by rowing, surrounded by fine paranoiac fellows, that Columbus discovered the Americas!

It became necessary to return to Paris once more. Our money was practically exhausted. Thus we were leaving "to make a few more pennies," as I called it, in order to be able to come back to Port Lligat as soon as possible. But the soonest would be in no less than three or four months. I therefore pressed against my palate the corporeity of these last days tinted and impregnated with the light and the already somewhat elegiac savor of our imminent departure. Spring, feeble and bruised, like an autumn coming to birth again backwards, was beginning to make itself felt, and the tips of the fig-tree branches which had just been lighted with little green flames of young leaves, seemed like candelabra of tarnished silver lighted for the Easter festivals.

It was the season for lima beans. I was finishing a long meal of which the principal dish had been precisely this extraordinary vegetable which so greatly resembles a prepuce. The Catalonians have a way of flavoring beans which makes this one of my favorite dishes. For this they have to be cooked with bacon and very fat Catalonian *butifarra*[2], and the secret consists in putting into the mixture a little chocolate and some laurel leaves. I had eaten my fill and was looking absentmindedly, though fixedly, at a piece of bread. It was the heel of a long loaf, lying on its belly, and I could not cease looking at it. Finally I took it and kissed the very tip of it, then with my tongue I sucked it a little to soften it, after which I struck the softened part on the table, where it remained standing. I had just reinvented Columbus's egg: the bread of Salvador Dali. I had discovered the enigma of bread: it could stand up without having to be eaten! This thing so atavistically and consubstantially welded to the idea of "primary utility," the elementary basis of continuity, the symbol of "nutrition," of sacred "subsistence," this thing, I repeat, tyrannically inherent in the "necessary," I was going to render useless

[1] Georges Méliès (1861-1938), one of the pioneers in motion pictures.
[2] A native blood sausage.

and esthetic. I was going to make surrealist objects with bread. Nothing could be simpler than to cut out two neat, regular holes on the back of the loaf and insert an inkwell in each one. What could be more degrading and esthetic than to see this bread-ink-stand become gradually stained in the course of use with the involuntary spatterings of "Pelican" ink? A little rectangle of the bread-inkstand would be just the thing to stick the pens into when one was through writing. And if one wanted always to have fresh crumbs, fine pen-wiper-crumbs, one had only to have one's bread-inkwell-carrier changed every morning, just as one changes one's sheets . . .

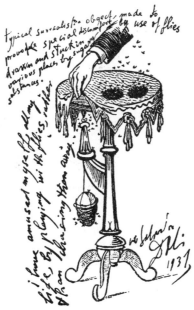

Upon arriving in Paris, I said to everyone who cared to listen, "Bread, bread and more bread. Nothing but bread." This they regarded as the new enigma which I was bringing them from Port Lligat. Has he become a Communist? they would wonder jokingly. For they had guessed that my bread, the bread I had invented, was not precisely intended for the succor and sustenance of large families. My bread was a ferociously anti-humanitarian bread, it was the bread of the revenge of imaginative luxury on the utilitarianism of the rational practical world, it was the aristocratic, esthetic, paranoiac, sophisticated, jesuitical, phenomenal, paralyzing, hyper-evident bread which the hands of my brain had kneaded during the two months in Port Lligat. During two months, in fact, I had subjected my spirit to the tortures of the most infinitesimal doubts, to the rigorous exactions of my slightest intellectual explorations. I had painted, I had loved, I had written and studied, and in the last moment, on the eve of leaving, I had summarized, in the apparently insignificant gesture of putting the end of a loaf of bread upright on a table, the whole spiritual experience of this period.

This is my originality. One day I said, "There is a crutch!" Everybody thought it was an arbitrary gesture, a stroke of humor. After five years they began to discover that "it was important." Then I said, "There is a crust of bread!" And immediately it began in turn to assume importance. For I have always had the gift of objectifying my thought concretely, to the point of giving a magic character to the objects which, after a thousand reflections, studies and inspirations, I decided to point to with my finger.

A month after my return to Paris I signed a contract with George Keller and Pierre Colle, and I exhibited in the latter's gallery my *Sleeping Woman-Horse-Invisible Lion,* which was the fruit of my contemplations of the rocks of Cape Creus; also a painting of Catholic essence which was called *The Profanation of the Eucharistic Host,* and *The Dream,* and *William Tell. The Profanation of the Host* was bought by Jean Cocteau, *William Tell* by André Breton; *The Dream* and *Sleeping Woman-Horse-Invisible Lion* by the Vicomte de Noailles. The art critics began to be more seriously interested in my art, but only the surrealists and society people seemed to be really touched to the quick. After a certain time the Prince de Faucigny-Lucinge bought *The Tower of Desire,* a painting which represented a naked man and woman at the top of a tower, beside a lion's head, caught in a "fixed" embrace charged with crime and eroticism.

I began at about this period to appear assiduously at a few society dinners where I was welcomed, together with Gala, with mingled fear and respectful admiration. I took advantage of this reaction at the first opportunity to bring in my bread. One evening during a concert at the home of the Princesse de Polignac, I surrounded myself with a group of elegant ladies, the ones most vulnerable to my kind of lucubrations. My obsession with bread had led me to a revery which became crystallized in the plan of founding a secret society of bread, which would have as its aim the systematic cretinization of the masses. That evening,

Fig. 16. — Nubiens tirant de la fronde
pour chasser les oiseaux.

between glasses of champagne, I expounded the general plan. The weather was mild, and the sky was full of shooting stars, and I could see the souls of these charming ladies reflected in their sparkling jewels. The laughter with which they greeted the lamentable apparition of my project flashed with the same diversity. Some of the laughs came from

blasé and very beautiful mouths, which had not laughed thus for three years; others set their teeth to control their laughter, knowing that all this was dangerous, for they found me handsome; still other laughs were those of hundred per cent French scepticism, yielding nothing before a demonstration of false reasoning. These laughs, opening into a fan of nacre and pearl, wafted voluptuous gusts upon my conversation, which tactfully utilized the variegated sparkle of all those rows of teeth in order skillfully and prudently to add or subtract just the gram or the centigram of levity necessary to the equilibrium of attention, which I brilliantly succeeded in maintaining at this already brilliant initiation of my gifts as a conversationalist. Just at the moment when I believed I had managed to bring the attention of each of the women in my circle to a dead center with an erudite exposition of my idea of "secret societies" sprinkled with whimsicalities, I stopped talking. I knew perfectly well that the idea was a childish one. But I was not only thinking of this. What is all this about the bread? What can Dali have invented with this bread of his? And they laughed again, with a little touch of unwholesome frenzy.

They implored me to reveal to them the secret of the bread. I then confided to them that the principal act of the bread, the first thing to be done, was to bake a loaf fifteen metres in length. Nothing was more feasible on condition that one go about it seriously. First one would build an oven large enough to bake it in. This loaf of bread was not to be unusual in any way, and was to be exactly like any other loaf of French bread, except in its dimensions. When the bread was baked one would have to find a place to put it. I was in favor of choosing a spot not too conspicuous or too frequented, so that its apparition would be all the more inexplicable, for only the insoluble character and cretinizing purpose of the act counted under the circumstances. I suggested the inner gardens of the Palais Royal. The bread would be brought in two trucks and placed at the designated spot by a gang of members of the secret society disguised as workers, who would seem to be bringing a pipe to be laid down as a water main. The bread would be wrapped in newspapers tied with string.

Once the bread was in place some members of the society, who would previously have rented an apartment overlooking the spot, would come and take their posts in order to be able to make a first detailed report of the various reactions which the discovery of the bread would occasion. It was easy enough to foresee the highly demoralizing effect which such an act, perpetrated in the heart of a city like Paris, would have. In the course of the morning the loaf of bread would inevitably be discovered for what it was. The first question would be what to do with it—the occurrence was utterly without precedent, and the enormousness of the object would dictate acting with circumspection. Before doing anything further, the bread would be taken, intact, to a place where it could be examined. Does it contain explosives? No! Is it poisoned? No! Is it, in

other words, a loaf of bread possessing any peculiarities whatever aside from its inordinate size? No. Is it an advertisement, and if so, for what bakery and to what purpose? No, surely not, it is not an advertisement either.

Then the newspapers avid of insoluble facts would take hold of this act, and the bread would become food for the unbridled zeal of born controversialists. The hypothesis of madness would very likely be among the first to be suggested, but here the theories and differences of opinion would multiply to infinity. For a madman alone, or even a sane man alone, would not be up to kneading, baking and placing the loaf of bread where it had been found. The hypothetical madman would have been obliged to depend upon the complicity of several persons with a sufficiently coordinated practical sense to carry the idea into effect. Thus the hypothesis of a madman or of a group of madmen did not rest on solid foundations.

It must therefore be concluded that the act was in the nature of a demonstration of a probably political character, the enigma of which would perhaps presently be explained. But how to interpret even symbolically such a demonstration, which after costing an unusual effort remained without a possibility of effectiveness because of the obscurity of its intentions? To attribute it to the Communist party was out of the question. This was the very contrary of their conventional and bureaucratic spirit. Besides, what could they have wanted to demonstrate by

this means? That it took a lot of bread to feed everyone? That bread was sacred? No, no, all this was stupid. It might be suspected that the whole thing was a joke perpetrated by students or the surrealist group, but this supposition, I knew, would not fully have convinced anyone. Those who knew the disorganization and the incapacity of the surrealist group to carry through anything requiring a minimum of practical effort directed to no matter what end knew them beforehand to be incapable

of seriously undertaking the building of the fifteen-metre oven indispensable for the baking of the bread. As for the students, it was even more childish to suspect them, since the means at their disposal would be even more limited. People might have thought of Dali—of Dali's secret society! But this was still too much to ask.

All these hypotheses formed at haphazard around the cooling excitement of the event would, however, be swept aside by the brutal shock of a new act, doubly, triply more sensational than the first—the apparition in the court of Versailles of a loaf twenty metres in length. The existence of a secret society now became flagrant to everyone's eyes, and from the more or less flabbergasting anecdote of the first apparition of the bread the public, just at the moment when it was beginning to forget it, was suddenly plunged into the palpitating moral category of this second apparition. At the breakfast table the avid eyes of readers were inevitably drawn to look for the headlines and the photographs announcing the apparition of the third loaf which, it was sensed, would appear before long, so that these Dalinian loaves of bread were already beginning to "eat" the other news, of politics, world events and sex, making these insipid and reducing them to a secondary rank of interest.

But instead of the third loaf of bread which was expected, an event exceeding all the limits of plausibility would occur. On the same day, at the same hour, thirty-metre loaves would appear in public places of the various capitals of Europe. The following day a cable from America would announce the apparition of a new loaf of French bread forty-five metres long lying on the sidewalk and reaching from the Savoy-Plaza to the end of the block where the Hotel St. Moritz stands. If such an act could be successfully carried through with the rigorous attention to all the relevant detail that I had planned, no one would be able to question the poetic efficacy of such an act which in itself would be capable of creating a state of confusion, of panic and of collective hysteria extremely instructive from an experimental point of view and capable of becoming the point of departure from which, in accordance with my principles of the imaginative hierarchical monarchy, one could subsequently try to ruin systematically the logical meaning of all the mechanisms of the rational practical world.

The account of this wild scheme was assimilated as lightly as the champagne we were drinking, and these haughty women, the most elegant in Europe at the time, made my terminology their own—"My dear, I have a phenomenal desire to cretinize you!" "For two days I haven't been able to localize my libido!" "How was Stravinsky's concert?" "It was beautiful—it was gluey! It was ignominious!" Things were or were not "edible." Braque's recent paintings, for instance, were "merely sublime"! Etc., etc. This whole exuberant and crudely Catalonian phraseology which was peculiar to me, and which people humorously borrowed from me, was in effect extremely suited, as it spread by contagion, to filling in the gaps between bits of "real society gossip."

But, beneath the very sure snobbism of these bewildered females, the pincers of my mystification had clutched their magnificently clad breasts, within which the cancer of my brain was already silently growing. They would ask me, "But look here, Dali, what is all this about 'bread'?" I then feigned a thoughtful air. "That is something you should ask of the critical-paranoiac method, my dear." Some actually asked me to enlighten them on the "critical-paranoiac method," and read my articles in which this was all beginning to be more or less hermetically explained. But I confess that I myself at this period did not know exactly whereof this famous critical-paranoiac method which I had invented consisted. It "exceeded" me, and like all the important things which I have "committed," I was to begin to understand it only a few years after I had laid its foundations.

People were constantly asking me, "What does that mean? What does that mean?"

One day I hollowed out entirely an end of a loaf of bread, and what do you think I put inside it? I put a bronze Buddha, whose metallic surface I completely covered with dead fleas which I wedged against one another so tightly that the Buddha appeared to be made entirely of fleas. What does that mean, eh? After putting the Buddha inside the bread I closed the opening with a little piece of wood, and I cemented the whole, including the bread, sealing it hermetically in such a way as to form a homogeneous whole which looked like a little urn, on which I wrote "Horse Jam." [1] What does that mean, eh?

One day I received a present from my very good friend Jean-Michel Frank, the decorator: two chairs in the purest 1900 style. I immediately transformed one of them in the following fashion. I changed its leather seat for one made of chocolate; then I had a golden Louis XV door-knob screwed under one of the feet, thus extending it and making the chair lean far over to its right, and giving it an unstable balance so calculated that it was only necessary to walk heavily or to bang the door to make the chair topple over. One of the legs of the chair was to repose continuously in a glass of beer, which also would spill each time the chair keeled over. I called this dreadfully uncomfortable chair, which produced a profound uneasiness in all who saw it, the "atmospheric chair." And what does that mean, eh?

I was determined to carry out and transform into reality my slogan of the "surrealist object"—the irrational object, the object with a symbolic function—which I set up against narrated dreams, automatic writing, etc. . . . And to achieve this I decided to create the fashion of surrealist objects. The surrealist object is one that is absolutely useless from the practical and rational point of view, created wholly for the purpose of materializing in a fetishistic way, with the maximum of tangible reality, ideas and fantasies having a delirious character. The existence

[1] Name suggested by an idea of René Magritte's.

and circulation of this kind of mad object began to compete so violently with the useful and practical object that one would have thought one was witnessing a regular fight of blood-crazed cocks, from which the reality of the normal object frequently emerged with a good many of its feathers savagely torn out. The apartments in Paris that were vulnerable to surrealism soon became cluttered with this kind of object, disconcerting at first glance, but by virtue of which people were no longer limited to talking about their phobias, manias, feelings and desires, but could now touch them, manipulate and operate them with their own hands. And, remembering that the landscape is a "state of the soul," these people were now able to stroke the naked body of another truth of Catholic essence, which had sprung from my well—that the object is a "state of grace."

The vogue of surrealist objects[1] discredited and buried the one which had preceded it, the period called "of dreams." Nothing now appeared more boring, more out of place and anachronistic, than to relate one's

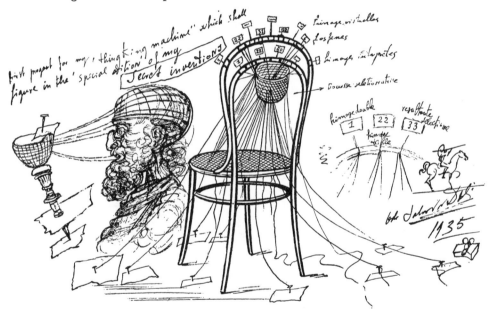

dreams or to write fantastic and incongruous tales at the automatic dictate of the unconscious. The surrealist object had created a new need of reality. People no longer wanted to hear the "potential marvelous" talked about. They wanted to touch the "marvelous" with their hands, see it with their eyes, and have proof of it in reality. Living and decapitated figures, beings formed of the most diverse zoological and botanical juxtapositions, the Martian and abysmal landscapes of the subconscious, and flying viscera persecuting decahedrons in flames already at this time

[1] One of the most typical surrealist objects was the cup, saucer and spoon made of fur imagined by Meret Oppenheim, which is now in the possession of the Museum of Modern Art in New York.

appeared intolerably monotonous, exorbitantly and anachronistically romantic. The surrealists of Central Europe, the Japanese, and the late-comers of all nations took hold of these facile formulae of the never seen in order to astonish their fellow-citizens. This kind of fantasy, combined with a certain sense of fashion, could also become a rich field for the effective decoration of up-to-date shops that know their business.

With the surrealist object I thus killed elementary surrealist painting, and modern painting in general. Miro had said, "I want to assassinate painting!" And he assassinated it—skilfully and slyly abetted by me, who was the one to give it its death-blow, fastening my matador' sword between its shoulder-blades. But I do not think Miro quite realized that the painting that we were going to assassinate together was "modern painting." For I have just recently met the older painting at the opening of the Mellon collection, and I assure you it does not yet seem at all aware that anything untoward has happened to it.

At the height of the frenzy over surrealist objects I painted a few apparently very normal paintings, inspired by the congealed and minute enigma of certain snapshots, to which I added a Dalinian touch of Meissonier. I felt the public, which was beginning to grow weary of the continuous cult of strangeness, instantly nibble at the bait. Within myself I said, addressing the public, "I'll give it to you, I'll give you reality and classicism. Wait, wait a little, don't be afraid."

This new period in Paris was coming to a close. We had the wherewithal to spend two and a half months in Cadaques, and we were getting ready to leave very shortly. My reputation in Paris had become considerably more solid. Surrealism was already being considered as before Dali and after Dali. People saw and judged only in terms of Dali; all the forms offering characteristic of the 1900 period—the soft, deliquescent

ornamentation, the ecstatic sculpture of Bernini, the gluey, the biological, putrefaction—was Dalinian. The strange medieval object, of unknown use, was Dalinian. A bizarre anguishing glance discovered in a painting by Le Nain was Dalinian. An "impossible" film with harpists and adulterers and orchestra conductors—this ought to please Dali.

A group of friends were having dinner out in the open in front of a corner *bistrot* at the Place des Victoires. No one was thinking about anything in particular. Suddenly the waiter skillfully placed a loaf of bread in the center of the table, and everyone exclaimed in astonishment, "It's like Dali!" The bread of Paris was no longer the bread of Paris. It was my bread, Dali's bread, Salvador's bread. The bakers were already beginning to imitate me!

If the secret of my influence has always been that it remained secret, the secret of Gala's influence has been to remain in turn doubly secret. I had the secret of remaining secret. Gala had the secret of remaining secret within my secret. Often people thought they had discovered my secret, but this was impossible, because it was not my secret but Gala's. Gala's secret and my secret formed the two evenly balanced scales of our justice, but the indicator of these scales was formed by Gala, standing erect, sculptured in gold; she held a sword, and it was with this that she pointed. People in Paris were afraid of being pointed to with this sword. Often the injustice of the absence of money-weight made one of the scales tip inordinately, threatening to spill the sperm of Dalinian philosophy which filled the other scale to the edge. Then the gold sword indicator of the Galadian scales would point without equivocation to a person who had betrayed us through avarice. This person needed to wait for no sign of our hostility—he felt himself sufficiently dishonored.

Our lack of money was another of Gala's and my secrets. We still had almost nothing. We were living constantly among the richest people, and were constantly anguished over money. But we knew that our strength was never to show it. For the pity of the neighbor kills. Strength, said Gala, lay in inspiring, not pity but shame. We could have died of hunger, and no one would ever have known it. We made it a *pundonor* never to let our material difficulties be known.

This Spanish *pundonor* is well illustrated by the anecdote of the Spanish knight who has nothing to eat. When the noonday bell sounds he goes home. He sits down before his empty table, without bread and without wine. He waits—he waits until the others have finished eating. The square, on which all the houses look out, is deserted and slumbering beneath an implacable sun. When he thinks the opportune moment has come, the knight who has not eaten gets up, puts a tooth-pick in his mouth, and proudly crosses the square picking his teeth so that everyone can see him. They had to think he had eaten so they would still be afraid of his bite!

As soon as the money began to diminish the first precautionary

measure we took was to give bigger tips wherever we went—we never yielded an inch to mediocrity. We got along without things, but we did not resign ourselves, we did not adapt ourselves to things. We could go without eating, if need be, but we were not willing to eat poorly.

Since Málaga I had become Gala's pupil. She had revealed to me the principle of pleasure. She taught me also the meaning of the principle of reality in all things. She taught me how to dress, how to go down a stairway without falling thirty-six times, how not to be continually losing the money we had, how to eat without tossing the chicken bone at the ceiling, how to recognize our enemies. She also taught me the "principle of proportion" which slumbered in my intelligence. She was the Angel

of Equilibrium, the precursor of my classicism. Far from becoming depersonalized, I got rid of the cumbersome, sterile and dusty tyranny of symptoms and of tics, tics, tics. I felt myself becoming master of the new and more and more conscious violence of my acts. And if the chicken bones of my eccentricity were going to continue to fly to the ceilings of my Amphitryonic hostesses, they would not be flying up there of their own accord and without knowing why. On the contrary it would be I, with the sling-shot of my own hand, who would toss them there. Instead of hardening me, as life had planned, Gala, with the petrifying saliva of her fanatical devotion, succeeded in building for me a shell to protect the tender nakedness of the Bernard the Hermit that I was, so that while in relation to the outside world I assumed more and more the appearance of a fortress, within myself I could continue to grow old in the soft, and in the supersoft. And the day I decided to paint watches, I painted them soft.

It was on an evening when I felt tired, and had a slight head-ache, which is extremely rare with me. We were to go to a moving picture with some friends, and at the last moment I decided not to go. Gala would go with them, and I would stay home and go to bed early. We had topped off our meal with a very strong Camembert, and after every-one had gone I remained for a long time seated at the table meditating on the philosophic problems of the "super-soft" which the cheese presented to my mind. I got up and went into my studio, where I lit the light in order to cast a final glance, as is my habit, at the picture I was in the midst of painting. This picture represented a landscape near Port Lligat, whose rocks were lighted by a transparent and melancholy twilight; in the foreground an olive tree with its branches cut, and without leaves. I knew that the atmosphere which I had succeeded in creating with this landscape was to serve as a setting for some idea, for some surprising image, but I did not in the least know what it was going to be. I was about to turn out the light, when instantaneously I "saw" the solution. I saw two soft watches, one of them hanging lamentably on the branch of the olive tree. In spite of the fact that my head-ache had increased to the point of becoming very painful, I avidly prepared my palette and set to work. When Gala returned from the theatre two hours later the picture, which was to be one of my most famous, was completed. I made her sit down in front of it with her eyes shut: "One, two, three, open your eyes!" I looked intently at Gala's face, and I saw upon it the unmistakable contraction of wonder and astonishment. This convinced me of the effectiveness of my new image, for Gala never errs in judging the authenticity of an enigma. I asked her, "Do you think that in three years you will have forgotten this image?"

"No one can forget it once he has seen it."

"Then let's go and sleep. I have a severe head-ache. I'm going to take a little aspirin. What film did you see? Was it good?"

"I don't know . . . I can't remember it any more!"

That same morning I had received from a moving-picture studio a rejection of a short scenario for a film that I had laboriously prepared, and that was the profoundest possible summary of all my ideas. Having seen at a glance the negative contents of the letter I had not had the courage to read in detail the reasons for the refusal, but the bad humor into which my head-ache had put me and the satisfaction at having completed my picture in such an unhoped-for way had worked me into a state of anxiety which led me to reread it carefully after I was in bed. Having granted that the ideas in my scenario were very interesting—too interesting—the author of the letter declared categorically that the film I had in mind was not of "general" interest, that it was impossible to commercialize, that the public did not like to have its habits so violently jolted, that my images were so strange that no one would be able to remember afterwards what he had seen!

A few days later a bird flown from America bought my picture of "soft watches" which I had baptized *The Persistence of Memory*. This bird had large black wings like those of El Greco's angels, and which one did not see, and was dressed in a white duck suit and a Panama hat which were quite visible. It was Julien Levy, who was subsequently to be the one to make my art known to the United States. He confessed to me that he considered my work very extraordinary, but that he was buying it to use as propaganda, and to show it in his own house, for he considered it non-public and "unsalable." It was nevertheless sold and resold until finally it was hung on the walls of the Museum of Modern Art, and was without a doubt the picture which had the most complete "public success." I saw it recopied several times in the provinces by amateur painters from photographs in black and white—hence with the most fanciful colors. It was also used to attract attention in the windows of vegetable and furniture shops!

Some time later I was present by chance at the shooting of a lamentable comic film in which, without advising me, they were utilizing most of my rejected ideas. It was idiotic, badly done, and completely pointless —a disaster. "Ideas," I thought, "are made to be squandered, but it is always the profiteers who croak on them! For they often explode in their own hands even before their 'first appearance.' And the day they finally come and ask me to light the fuse of my integral spectacle myself, I can count on the prestige of the heroes who have died for me, and who in reality only wanted to starve me." Like the Modern-Style woman on the cover of the *Petit Larousse* dictionary, I could say as I blew on the dandelion-seeds of my dangerous ideas, "I sow with every wind," but my generosity was that of virulent germs. No one imitates Savador Dali with impunity, for he who tries to be Dali dies!

Robbed, cheated, plagiarized though I was, my reputation was steadily rising and my influence spreading, while the state of my pocket-book

remained precarious. After so many efforts, Gala and I were going to
return to our Port Lligat with just enough money to spend two and a
half months and then to return to Paris with enough to last us for the
two weeks that we might be kept waiting. Since I had been banished
from my home I had received nothing but persecution from my family.
My father would have liked to make it impossible for me to live in Port
Lligat, for he considered my nearness a disgrace. Since then I had bal-
anced on my head William Tell's apple, which is the symbol of the

passionate cannibalistic ambivalence which sooner or later ends with the
drawing of the atavistic and ritualistic fury of the bow of paternal venge-
ance that shoots the final arrow of the expiatory sacrifice—the eternal
theme of the father sacrificing his son: Saturn devouring his sons with his
own jaws; God the Father sacrificing Jesus Christ; Abraham immolating
Isaac; Guzmán el Bueno lending his son his own dagger; and William
Tell aiming his arrow at the apple on the head of his own son.

As soon as we had got settled in Port Lligat I painted a portrait of
Gala with a pair of raw chops poised on her shoulder. The meaning of
this, as I later learned, was that instead of eating *her,* I had decided to
eat a pair of raw chops instead. The chops were in effect the expiatory
victims of abortive sacrifice—like Abraham's ram, and William Tell's
apple. Ram and apple, like the sons of Saturn and Jesus Christ on the
cross, were raw—this being the prime condition for the cannibalistic
sacrifice.[1] In the same vein I painted a picture of myself as a child at
about the age of eight, with a raw chop on my head. I was trying thus
symbolically to tempt my father to come and eat this chop instead of me.
My edible, intestinal and digestive representations at this period assumed
an increasingly insistent character. I wanted to eat everything, and I
planned the building of a large table made entirely of hard-boiled egg
so that it could be eaten.

This hard-boiled-egg table was perfectly feasible, and I herewith give
the recipe, for anyone who would like to try to make one. The first thing
to do is to make the mold of a table out of celluloid (preferably a Louis
XIV table), exactly as if one were going to make a cast. Instead of pouring

[1] Freud relates a desert sacrifice of totemic character, in which the entire tribe in a few
hours devoured a raw camel, of which only the bones remained at sunrise.

plaster into the mold, one pours the necessary quantity of white of egg. Then one dips the whole into a bath of hot water, and as soon as the white begins to harden one introduces the yolks into the mass of egg-whites by means of tubes. Once the whole has hardened, the celluloid mold can be broken and be replaced by a coating of pulverized egg-shell mixed with a resinous or sticky substance. Finally this surface can be polished with ground pummice until it acquires the texture of egg-shell. By the same process one can make a life-size *Venus of Milo,* who would likewise be made integrally of hard-boiled egg. You would then be able to break the egg-shell of the Venus, and inside you would find the hard white of egg really made of white of egg, and by digging deeper you would find the hard egg-yolk, really made of egg-yolk.[1] Imagine the delightful thirst which such a Venus of solid hard-boiled egg could produce in a victim of the perversion of "retention of thirst," when this pervert after a long summer day of waiting, in order to work himself into a paroxysm, would dip a blue silver spoon into one of the breasts of the Venus, exposing the egg-yolk of her insides to the light of the setting sun, which would thus make it yellow, red, and fire of thirst!

That summer I was very thirsty. I think that the alcohol which I had been obliged to swallow in Paris to overcome the reapparition of my fits of timidity had its share in the kind of voluptuous irritation to which my stomach was subject, which caused me to feel an Arab thirst rising from the visceral depths of my North-African atavisms, a thirst which had come on horse-back to civilize Spain and immediately invent shade and water fountains. When I shut my eyes to hear what went on within me, it was as if in the burning desert of my skin I could feel the murmur of the whole Alhambra of Granada sounding in the very centre of the cypress-shaded patio of my stomach plastered with the whitewash and the bismuth of the medicines with which I had to plaster its walls and partitions.[2]

But if I was thirsty as an Arab, I also felt as combative as one. One evening in early fall, Gala and I left to go to Barcelona. I had been invited to give a lecture, and I had decided to try out my oratorical talents and test once and for all my ability to stir an audience. My lecture took place in the *Ateneo Barcelonés,* which was the most traditional and impressive intellectual centre in the town, and I decided to attack with the utmost violence the native intellectuals who were vegetating at this period in a kind of local patriotism of a boundless philistinism. I arrived on purpose a half hour late, and found myself at once facing a public at the height of excitement from waiting and curiosity, at just the right point of readiness.

[1] Della Porta, a Neapolitan of Catalonian origin who lived in the thirteenth century, gives in his *Natural Magic* (previously referred to, p. 9) the recipe for making an egg as large as one wishes.
[2] I was at this time taking a medicine which, according to the physician who prescribed it, was intended to plaster my stomach walls.

I immediately entered upon the theme of my speech with a short and vibrant apology of the Marquis de Sade, whom I held up in contrast to the degrading intellectual ignominy of Ángel Guimerá[1], who had died a few years before, and who was the most venerated and respected of patriotic Catalonian *littérateurs*. Coming to one of the climaxes of my speech I said, with dramatic emphasis, "That great pederast, that immense hairy putrefaction, Ángel Guimerá . . ." At this moment I realized that my lecture was over. The audience was seized with complete hysteria. Chairs were thrown at me and I would surely have been beaten to a pulp if the assault guards had not come to protect me from the fury of the crowd. I had to be surrounded by the guards and escorted out to the middle of the street, where they put me into a taxi. "You are very courageous," one of them said to me. I think that on this occasion I behaved in fact quite coolly, but the real courage was displayed by the guards who actually received the few blows that were intended for me.

This incident had considerable repercussions. A short time later I received another invitation to give a speech, this time before a revolutionary group with predominantly anarchist leanings. "At our meeting," their president said to me, "you can say anything you like—and the stronger it is, the better." I accepted, and merely asked the organizers to get me a large loaf of bread, as long as possible, and straps to tie it with. On the evening of the lecture I arrived ten minutes early to give instructions about the props I had asked for. In the small office adjoining the lecture hall a large loaf of bread lay on the desk, and with it some leather straps. They asked me if this was what I wanted. "It's perfect. Now listen to me carefully. At a certain point in my speech I shall make a gesture with my hand and say, 'Bring it!' Then two of you must come up on the stage while I am talking and tie the loaf of bread to my head with the straps, which are to be passed under each arm. Be sure to keep the loaf horizontal. This operation must be performed with utmost seriousness, and even with a touch of the sinister."

I was dressed with provocative elegance, and when I appeared I was given a stormy reception. Nevertheless the catcalls and jeers were gradually drowned out by an "organized" applause, and then by a voice shouting, "Let him speak first!"

I spoke. It was not a dithyrambic apology of the Marquis de Sade that I offered this time, but simply a speech of the irrational and poetic type, in which the crudest obscenities occasionally flashed. These enormities which no one had ever heard uttered in public I delivered in the most matter-of-fact and casual way, which only augmented their truculent and disconcertingly pornographic character. An insurmountable uneasiness took hold of this audience of sentimental and humanitarian anarchists, most of whom had brought their wives and daughters

[1] Angel Guimerá had been (without my knowing it) the very founder of the society under whose auspices I was speaking. This amplified the scandal to such a point that the president of the society in question had to hand in his resignation the following day.

—having said to themselves, today we're going to amuse ourselves by listening to the eccentricities of Dali, that amiable petty-bourgeois ideologist whom we've heard so much about, and who has the gift of making the bourgeoisie itself howl.

196

Suddenly a lean, severe-looking anarchist, handsome as a Saint Jerome, interrupted me in a loud voice and with great dignity reminded me that the place where we were was not a brothel and that "their womenfolk" were among the audience. I answered him that an anarchist centre was not exactly a church. I said, furthermore, that the person I esteemed most highly in the world was my wife, and that since she was present and was listening, I saw no reason why their wives could not perfectly well listen too. My answer reestablished my authority for a moment, but a string of fresh obscenities, this time enhanced by my own type of realism, and which were blasphematory to boot, made the hall roar like a lion, and I could not make out whether it was with pleasure or with fury.

I now judged that the moment was psychologically ripe, and making an impatient movement with my hand I gave the pre-arranged signal to "have it brought to me." All eyes turned in the direction in which I had waved my hand, and the surprise at the apparition of two persons carrying the bread and the straps exceeded all my hopes. While the bread was being fastened to my head the tumult increased, showing all the preliminary symptoms of a general fracas. When the bread was finally secured on my head I suddenly felt myself infected by the general hysteria, and with all the strength of my lungs I began to shout my famous poem on the "Rotten Donkey." At this moment an anarchist doctor with a face as red as if it had been boiled, and a white beard which made him look for all the world like a Boecklinian allegory, was

seized with a real fit of madness. I was told later that this man, who besides being mad was also an alcoholic, frequently had such fits, though nothing like the one he had that evening. Everyone tried, unsuccessfully, to control him. One man would clutch his legs while others would hold his head and arms. It was of no avail. With a supreme convulsion, and the indomitable strength of his delirium, he would always manage to free one of his legs and with a fantastic kick knock over a whole group of those black and sweating anarchists struggling to reestablish order. After the tirade of my obscenities, which still rang in everyone's ears, the apparition of the loaf of bread on my head, and the fit of delirium tremens of the old doctor, the evening ended in an unimaginable general confusion.

The organizers of this meeting were well pleased. "You went a little far," they told me, "but it was very good."

The meeting had broken up, and the people were leaving. Suddenly a man came up to me, who seemed perfectly well balanced, though his eyes twitched with cynicism. He was vigorously chewing a sprig of mint-leaves as though he were a goat. When he had finished it he pulled out others which he kept wrapped up in a newspaper. The blackness of his fingernails was so intense that I could look at nothing else.

"I've been an anarchist all my life," he said to me, "and I eat only herbs, and a rabbit from time to time. I like you, but there is another man I like better, and if I tell you who it is you won't believe me. You see, I've never been sold on Joseph [by Joseph he meant Stalin]. But Hitler, on the other hand, if you just scratch him till you get under the surface you'll find Nietzsche. And that fellow [still referring to Hitler] is a *morros de con* who can blow up all of Europe with one foot. And I've no use for Europe, you understand?"

So saying, he showed me his package of mint leaves and winked maliciously. And then he left. *"Salud!"* he said, "and don't forget— 'direct action.'"

The political ideology of Barcelona at this period was reaching a degree of confusion which verged on the Biblical apotheosis of the Tower of Babel. Political parties were born, became subdivided, fought among one another, were born again, split up into a thousand and one schisms each of which, in spite of its theoretical insignificance, immediately created distances and abysses of hatred. There were three communist parties claiming to be the true official party, three or four shades of Trotskyists, the political syndicalists, the socialist syndicalists, the pure anarchists of the Iberian Anarchist Federation, the separatists who called themselves "we alone," the republican left, etc., etc., etc. So much for the left, for the parties of the centre and those of the right were as numerous, active and agitated. Everyone felt that something phenomenal was going to happen in Spain, something like a universal deluge in which, instead of a simple downpour of water, there would rain archbishops, grand pianos and rotten donkeys. A peasant of the vicinity of

Figueras found the exact phrase to sum up the anarchic state of the country, "If politics continue in this way we'll come to a point where even if Jesus Christ in person were to come down to earth with a clock in his hand he would not be able to tell what time it was!"

On our return to Paris we moved from 7 Rue Becquerel to 7 Rue Gauguet. This was a modern functionalist building. I considered this kind of architecture to be auto-punitive architecture, the architecture of poor people—and we were poor. So, not being able to have Louis XIV bureaus, we decided to live with immense windows and chromium tables with a lot of glass and mirrors. Gala had the gift of making everything "shine," and the moment she entered a place everything began furiously to sparkle. This almost monastic rigidity, meanwhile, excited my thirst for luxury even more. I felt like a cypress growing in a bathtub.

For the first time I realized that people had been waiting for me in Paris, and that my absence had left "desert emptinesses" impossible to fill without me. They were counting on me to show them how to "continue," but this time I would refuse. I preferred to leave them to themselves, to let them go their own way and get over their illusions once and for all.

My two lectures in Barcelona had cured me of my pathological residues of timidity. I knew that I was capable of arousing the passion and frenzy of the public, in the way I wanted, by the sole efficacy of certain images which I alone could invent and manipulate. I had a growing desire to feel myself in contact with a "new flesh," with a new country, that had not yet been touched by the decomposition of Post-War Europe. America! I wanted to go over there and see what it was like, to bring my bread, place my bread over there; say to the Americans, "What does that mean, eh?"

I had just received some newspaper clippings from New York about a small exhibition that Julien Levy had organized during the summer, with the picture of the soft watches and others which I had lent him. The exhibition had been a success, in spite of the fact that not much had been sold. But the articles which I got translated revealed a comprehension a hundred times more objective and better informed of my intentions, and of the case which I constituted, than most of the commentaries on my work that had appeared in Europe, where my work was judged only in relation to the "vested interests" which the writers of articles had in their platforms. In Paris, in fact, everyone judges things from the esthetic point of view of his own intellectual interests. A certain critic had fought, continues to fight, and would have sacrificed his life for cubism and non-figurative art. When I arrived upon the scene, reactualizing anecdotism in the illusion-creating and ultra-blatant manner that Meissonier had used in his epoch, these worthy defenders of pure plastics received me with the fiery barrage of their neo-Platonic batteries. Nor were those who defended the opposite extreme, pure and absolute autom-

atism, able to accept my hegemony composed of rigor and systematization. In Europe, in short, I was surrounded solely by partisans.

America was different. Our kind of esthetic civil war had not yet touched that country except in a purely informative way. And often what with us had tragic undertones assumed at most an aspect of entertainment in America. Cubism had never had a real influence, and in America it had been rightly considered as an indispensable experiment which should properly be filed among the official archives of history. Thus, taking no sides, far from the battle, having nothing to gain and nothing to lose or to combat, they could be lucid and see spontaneously what made the most impression upon them among all the things that were happening in Europe. And what was going to make the most impression on them was precisely myself, the most partisan, the most violent, the most imperialistic, the most delirious, the most fanatical of all. Europeans are mistaken in considering America incapable of poetic and intellectual intuition. It is obviously not by tradition that they are able to avoid mistakes, or by a perpetual sharpening of "taste." No, America does not choose with the atavistic prudence of an experience which she has not had, or with the refined speculation of a decadent brain which it does not possess, or even with the sentimental effusion of its heart which is too young . . .

No, America chooses better and more surely than it would with all these things combined. America chooses with all the unfathomable and elementary force of her unique and intact biology. She knows, as does no one else, what she lacks, what she does not have. And all that America "did not have" on the spiritual plane I was going to bring her, materialized in the integral and delirious mixture of my paranoiac work, in order that she might thus see and touch everything with the hands of liberty. Yes, what America did not have was precisely the horror of my rotten donkeys from Spain, of the spectral aspect of the Christs of El Greco, of the whirling of the fiery sunflowers of Van Gogh, of the airy quality of Chanel's *décolletés,* of the oddness of fur cups, of the metaphysics of the surrealist manikins of Paris, of the apotheosis of the

symphonic and Wagnerian architecture of Gaudi, of Rome, Toledo and Mediterranean Catholicism...

The idea I was beginning to form of America was corroborated by the impression produced upon me by a personal meeting with Alfred H. Barr, Jr., the director of the Museum of Modern Art of New York. I met him at a dinner at the Vicomte de Noailles'. He was young, pale, and very sickly-looking; he had stiff and rectilinear gestures like those of pecking birds—in reality he was pecking at contemporary values, and one felt that he had the knack of picking just the full grains, never the chaff. His information on the subject of modern art was enormous. By contrast with our European directors of modern museums, most of whom still had not heard of Picasso, Alfred Barr's erudition verged on the monstrous. Mrs. Barr, who spoke French, prophesied that I would have a dazzling future in America, and encouraged me to go there.

Gala and I had already decided to take a trip to America, but we had no money . . . At about this time we became acquainted with an American lady who had bought Le Moulin du Soleil in the Forest of Ermenonville. It was the surrealist writer René Crevel who introduced us to her, taking us to lunch at her Paris apartment one summer day. At this luncheon everything was white, except the table cloth and the china, so that if one had taken a picture of it it would be the negative that appeared to be the positive. Everything that we ate was white. We drank milk. The curtains were white, the telephone white, the rug white. She

was dressed in white, wore white ear-rings, shoes and bracelets. This American lady became interested in my secret society. We decided to begin to build a fifteen-metre oven in the Forest of Ermenonville in order to bake my famous loaf of bread. We would try to get the baker

of Ermenonville to become our accomplice, as she had already observed that he had rather marked tendencies toward the "bizarre." This so white American lady who would have made such a black negative was Caresse Crosby.

Every week-end we went to the Moulin du Soleil. We ate in the horse-stable, filled with tiger skins and stuffed parrots. There was a sensational library on the second floor, and also an enormous quantity of champagne cooling, with sprigs of mint, in all the corners, and many friends, a mixture of surrealists and society people who came there because they sensed from afar that it was in this Moulin du Soleil that "things were happening." At this period the phonograph never stopped sighing Cole Porter's *Night and Day,* and for the first time in my life I thumbed through *The New Yorker* and *Town and Country.* Each image that came from America I would sniff, so to speak, with the voluptuousness with which one welcomes the first whiffs of the inaugural fragrances of a sensational meal of which one is about to partake.

I want to go to America, I want to go to America...This was assuming the form of a childish caprice. Gala would console me: as soon as we could scrape together enough money we would go! But just at this time everything was going from bad to worse. My contract with Pierre Colle was ended and his financial situation did not enable him to renew it. Money worries thus loomed before us again with an endemic and aggravated aspect. By the fact that collectors likely to buy Dalis already had some, our possibilities of making sales became increasingly few and precarious. Moreover we had spent all our small savings in Port Lligat, and whenever an unexpected sale occurred, Gala took advantage of it to publish my books, which reached only the same small group of society people who bought my pictures. I thus found myself at a moment when I was simultaneously at the height of my reputation and influence and at the low point of my financial resources.

I was not of those who resign themselves to adversity, and my reaction was one of anger. I developed a restrained, barely visible but continual fury. Since Málaga, when I had decided to make money, I had not yet succeeded. We would see! I stormed and fumed. As I paced the streets I would tear the buttons from my overcoat and bite them. I would tap the ground with my feet and it seemed to me as if I were sinking into it.

One evening on my way home from a day of fruitless attempts I met at the foot of the Boulevard Edgar-Quinet a legless blind man sitting in his little cart. Rolling his rubber wheels with his hands, he was pushing himself along with an extremely perky and coquettish air. When he came to the edge of the sidewalk to cross the avenue, he stopped short, took out a small cane from under his cushion and began impertinently to tap the sidewalk, with a boundless self-assurance which struck me as utterly

repugnant. With an intolerable insistence he was calling upon the casual passerby to interrupt his walk in order to extend him a brotherly hand and help him across the avenue to protect him from the traffic.

The street was deserted. There were no other passersby besides myself—only a blonde girl in the distance, who was walking the street, and who seemed to be looking at me. I went up to the blind man and with a thrust of my foot against the back of his cart I gave him a kick that sent him scooting all the way across the Boulevard Edgar-Quinet. His cart struck the opposite sidewalk, and he would have fallen forward from the impact, except for the fact that with his blind man's williness he had prudently and solidly clutched the arms of his cart with both hands. He remained stiff with outraged dignity and as motionless as the lamp post beside him. Now I in turn crossed the avenue, and looked as I passed at the face of the blind man. He evidently was not deaf, for on hearing my approaching footsteps, which he recognized as mine, his erect attitude became suddenly more humble and in keeping with the modesty which his state of physical degradation dictated. I saw the lemon-colored spider of cowardice cross his absent gaze. I then understood that if I had asked this blind man for money, in spite of the terrible avarice which must undoubtedly be his, he would have relinquished it to me.

It was thus that I discovered how I was going to go about crossing the Atlantic. For I was not legless; for I was not blind, degraded, and pitiful. For I did not tap impertinently with an altruistic cane in order to make that noise of pity which would bring some anonymous person gratuitously to help me across the ocean separating me from America. No, I was not plunged in abjection. On the contrary, I was radiant with glory. No help for me, therefore—just as one does not come to the aid of a tiger even if he is starving. Therefore, if I could not make use of the magic gift of the percussion of the blind man's cane to get people to help me, I could at least wrench this cane from the blind man's hands and strike about me. I could also, as I had just done, rid myself pitilessly of the conventional paralysis that cluttered my footsteps.

With the little money that we had left I made reservations on the next steamer to New York, the *Champlain,* which was leaving in three days. We thus had to find the rest of the sum that would enable us to complete the payment of our passage, and a little more besides, at least for the first two weeks of our stay over there. For three days I ran all over Paris, armed with the symbolic cane of the blind man, which in my hands had become the magic wand of my anger. I struck right and left, caring not where the blows fell. I beat and shook that shriveled and knotty trunk of money, which let fall a few scattered coins only at the moment when it felt the avarice of its own soul falter beneath the impetuous rage of my frenzied flagellation. Again, again, again—you will get as many blows, as many shakings, as you need to make you let go; give, give, give, now, give now, give all, give all! The myth of Danaë was realized, and after three days of furiously

jerking fortune's cock it ejaculated in a spasm of gold! After this I
felt as exhausted as if I had made love six times in succession.

My fear of missing the boat made me get to the station three hours
ahead of time. I kept my eyes riveted on the clock and on our porter
who kept going off every moment and who I was afraid would betray us
at the last minute. Gala held my hand to calm my nervousness. I said
to her, "Only when I am on the boat will I feel calm." At the moment
of boarding the train the news-cameramen wanted me to get down again
to pose in front of the locomotive. They had to be satisfied with taking
my picture through the window of my compartment. I was actually
afraid the train might get away from us while we went to take the
pictures, and so I told the reporters, to give them an explanation of
my refusal,

"Locomotives are not in scale with me—either I am too big or
they are too small."

My fear of missing the trip to America was not wholly dissipated
by our boarding the *Champlain*. As soon as I felt myself on the high
seas a great fear of the "ocean space" took hold of me. I had never
yet in my life sailed out of sight of land, and the creakings of the ship
appeared to me more and more suspect. I felt that the boat was too
large and too complex to be able to make the crossing without a
catastrophe. I attended all the life-saving drills and I was always on the
spot minutes ahead of time, my life-belt attached with all the regula-
tion straps. I made Gala take the same interest as myself in all these
annoying precautions, which either disgusted her or made her laugh
till the tears rolled down her cheeks. Each time she came into our
cabin she found me lying on my bunk reading, with my life-belt strapped
on. I expected every moment in fact to hear the decisive whistle of
a real alarm. The thought that I might be the victim of a "mechanical"
catastrophe made me shudder, and I looked upon the officers of the ship,
who were carefree and pleasant, as my executioners.

I continually drank champagne, to give myself courage and in anticipa-
tion of seasickness, which, however, did not occur. Caresse Crosby was
traveling on the same boat. Disappointed by the failure of the project of
baking a fifteen-metre loaf of bread, which had never got beyond the pre-
liminary stage, she spoke to the captain about getting the longest possible
loaf of French bread that could be baked in the ship's ovens. We were
put in touch with the baker on board, who promised to make us one that
would be two and a half metres long, but he would have to put a wood
armature inside it so that it would not break in two the moment it
began to dry. The baker kept his word, and I received this bread in my
cabin luxuriously enveloped in cellophane.

I thought that it would be an intriguing object for the reporters who
would probably come on board to interview me when we landed. Every-
one spoke of these reporters with horror and contempt. "Those awful

uneducated people," they said, "who never stop chewing their gum while they ask you endless indiscreet questions." Everyone had invented private tricks for evading them, but beneath this puerile hypocrisy, it was very easy to see that everyone desired and thought of only one thing—the opportunity to be interviewed. Only they defended themselves in advance against possible disappointment by the well-known reaction of "not wanting it"—because the "grapes were too sour." I, however, affected the opposite position, and often said, "I love getting publicity, and if I am lucky enough to have the reporters know who I am, I will give them some of my own bread to eat, just as Saint Francis did with his birds." My shamelessness in this regard struck everyone as in such bad taste that they could not help twisting their mouths into a suggestion of a sneer.

"What do you think I can do to have my bread make the greatest impression on the reporters?" I would unsparingly ask all my acquaintances on the ship. I decided in the end to change its cellophane envelope for another made of simple newspaper tied with strings in the middle and leaving both ends sticking out: I wanted the fact that it was really a loaf of bread to be unmistakable, and I would be able to unwrap it myself before everyone's eyes.

We reached New York, and while we were going through the formalities of having our visas checked for the landing I got word that the reporters wanted to talk to me. I ran to my cabin to fetch my loaf of bread, and appeared in another cabin where a group of reporters were waiting for me.

Then there happened to me an utterly disconcerting thing, and I felt as Diogenes, that king of the cynics, would have felt if on the day when he went forth naked with a tub around his middle and a lighted candle in his hand he had met no one in his way who would ask him, "What are you looking for?" It may appear astonishing, but it is a fact that not one of the reporters asked me a single question about the loaf of bread which I held conspicuously during the whole interview either in my arm or resting on the ground as though it had been a large cane.

On the other hand, all these reporters were amazingly well informed as to who I was. Not only this. They knew stupefying details about my life. They immediately asked me if it was true that I had just painted a portrait of my wife with a pair of fried chops balanced on her shoulder. I answered yes, except that they were not fried, but raw. Why raw? they immediately asked me. I told them that it was because my wife was raw too. But why the chops together with your wife? I answered that I liked my wife, and that I liked chops, and that I saw no reason why I should not paint them together.

These reporters were unquestionably far superior to European reporters. They had an acute sense of "non-sense," and one felt, moreover, that they knew their job dreadfully well. They knew in advance exactly the kind of things that would give them a "story." They had a merciless flair for the sensational which made them pounce immediately upon the

kernel of every question and which enabled them, in the midst of the swarming and indistinguishable confusion, to choose unerringly just the daily events possessing the vitamin content necessary for the journalistic diet that was to nourish the casual curiosity of millions of psychologies in a state of inanition. In Europe reporters start out on their interviews with their finished article already in their pockets, composed in advance on the basis of circumstances and coincidences of all sorts, and addressed to a reader who will read it only in order to judge whether what he is told is exactly what he already knew. Europe has the sense of history, but not that of journalism. The American journalist, on the other hand, starts from a criterion based on instantaneity, in which his all-powerful instinct of biological competition comes first and foremost, enabling him to shoot on the fly those rare and fleeting birds of actuality which he will bring back still warm and bleeding and toss on the desk of his editor-in-chief—a desk covered by the pallor of expectation of the white sheets of paper awaiting news, and by the blackness of the black hope of the news locked up within his black telephone.

The day I arrived in America the reporters returned from their morning hunt and triumphantly tossed into the air a pair of raw chops. Already that evening all New York was eating these chops, and even today in the remote corners of the continent I know that people are still gnawing at the last substance of their bones . . .

I went out on the deck of the *Champlain,* and suddenly I beheld New York. It rose before me, verdigris, pink and creamy-white. It looked like an immense Gothic Roquefort cheese. I love Roquefort, and I exclaimed, "New York salutes me!" But immediately the pride of the Catalonian blood of Christopher Columbus which flows in my veins cried to me, "Present!" and I in turn saluted the cosmic grandeur and the virgin originality of the American flag.

New York, you are an Egypt! But an Egypt turned inside out. For

she erected pyramids of slavery to death, and you erect pyramids of democracy with the vertical organ-pipes of your skyscrapers all meeting at the point of infinity of liberty! New York, granite sentinel facing Asia, resurrection of the Atlantic dream, Atlantis of the subconscious. New York, the stark folly of whose historic wardrobes gnaws away at the earth around the foundations and swells the inverted cupolas of your thousand new religions. What Piranesi invented the ornamental rites of your Roxy Theatre? And what Gustave Moreau apoplectic with Prometheus lighted the venomous colors that flutter at the summit of the Chrysler Building?

New York, your cathedrals sit knitting stockings in the shadow of gigantic banks, stockings and mittens for the Negro quintuplets who will be born in Virginia, stockings and mittens for the swallows, drunk and drenched with Coca-Cola, who have strayed into the dirty kitchens of the Italian quarter and hang over the edge of tables like black Jewish neckties soaked in the rain and waiting for the snappy, sizzling stroke of the iron of the coming elections to make them edible, crisp as a charred slice of bacon.

New York, your beheaded manikins are already asleep, spilling all their "perpetual blood" which flows like the "surgical fountains of publicity" within the display-windows dazzling with electricity, contaminated with "lethargic surrealism." And on Fifth Avenue Harpo Marx has just lighted the fuse that projects from the behinds of a flock of explosive giraffes stuffed with dynamite. They run in all directions, sowing panic and obliging everyone to seek refuge pell-mell within the shops. All the fire-alarms of the city have just been turned on, but it is already too late. Boom! Boom! Boom! Boom! I salute you, explosive giraffes of New York, and all you forerunners of the irrational—Mack Sennett, Harry Langdon, and you too, unforgettable Buster Keaton, tragic and delirious like my rotten and mystic donkeys, desert roses of Spain!

I awoke in New York at six in the morning on the seventh story of the Hotel St. Moritz, after a long dream involving eroticism and lions. After I was fully awake I was surprised by the persistence of the lions' roars that I had just heard in my sleep. These roars were mingled with the cries of ducks and other animals more difficult to differentiate. This was followed by almost complete silence. This silence, broken only by roars and savage cries, was so unlike the din I had expected—that of an immense "modern and mechanical" city—that I felt completely lost, and for some time I thought my waking imagination continued to be under the influence of my dream. Nevertheless I had actually heard lions' roars, for the waiter who brought me breakfast, a Canadian who spoke French perfectly, informed me that there was a zoo just across the avenue in Central Park. And when I looked out of my window I could make out the cages, and even the seals splashing in the tank.

But all my experiences during the rest of the day only continued systematically to give the lie to the stereotype of the "modern and mechan-

ical city" which the estheticians of the European advance guard, the apologists of the aseptic beauty of functionalism, had tried to impose upon us as an example of anti-artistic virginity. No, New York was not a modern city. For, having been so at the beginning, before any other city, it now on the contrary already had a horror of this. I began my succession of afternoon cocktail parties at a house on Park Avenue in which fierce anti-modernism manifested itself in the most spectacular fashion, beginning with the very façade. A crew of workers armed with implements projecting black smoke that whistled like apocalyptic dragons were in the act of patining the outer walls of the building in order to "age" this excessively new skyscraper by means of that blackish smoke characteristic of the old houses of Paris. In Paris, on the other hand, the modern architects à la Corbusier were racking their brains to find new and flashy, utterly anti-Parisian materials which would not turn black, so as to imitate the supposed "modern sparkle" of New York. As soon as I entered the elevator I was surprised by the fact that instead of electricity it was lighted by a large candle. On the wall of the elevator there was a copy of a painting by El Greco hung from heavily ornamented Spanish red velvet strips—the velvet was authentic and probably of the fifteenth century. After the smoked façade and the Toledo-chapel elevator I do not think it is necessary to continue with the description of the apartment, of which I shall only tell you in passing that it contained Gothic, Persian, Spanish Renaissance, Dalis and two organs.

The whole rest of the afternoon I visited an unbroken succession of other apartments and hotel rooms. We went from one cocktail party to another; sometimes several occurred in the same building; this gave rise to a complete confusion which my absolute ignorance of the English language made all the more vague and agreeable. But of all the fleeting visions the sole clear impression that remained in my mind was that of New York as a city without electricity. The elevator lighted by a candle was not an isolated case; it was typical. Everywhere the electric light was choked by Louis XVI skirts, by Gothic polychrome parchment manuscripts, by manuscript partitions of Beethoven serving as lampshades. One had the impression that artificial ivy grew in all the corners of the woodwork, and that bats, equally artificial, and invisible, were constantly flitting through the propitious darkness of the halls. In the evening I visited an astonishing motion-picture temple. It was decorated with the most diverse artistic bronzes, from the *Victory of Samothrace* to Carpeaux; with ultra-anecdotic pictures really painted in oil, framed with an oppressive fantasy of gold molding; and in the midst of all this one suddenly perceived the plumes of a playing fountain illuminated with the whole iridescent rainbow of bad taste. And again, organs—organs everywhere, organs and organs, more and more monumental.

That evening before going to bed I took a last Scotch and soda at the bar of the Hotel St. Moritz in the company of a very ceremonious Quaker in a top hat whom I had met discreetly dissipating in a sordid

Harlem night club and who, since we had been introduced, seemed not to want to leave us. He spoke enough French to enable me to guess that he wanted to tell or confess something to us. Gala must have had the same impression, for finally she said in the most provocative way, "I am sure you live in a state of mind quite close to that of the surrealists." This was all that was needed to make him reveal his secret to us. He was a Quaker, and in addition he belonged to an altogether original spiritualist sect. None of his friends, even the most intimate, knew this. But I, a surrealist, who painted grand pianos hanging from the tops of cypress trees, inspired him with confidence. He knew I would understand. The members of this sect, by virtue of a recent secret invention, were able to hold conversations with the dead, though only for the four months following their decease, during which period the spirit does not yet leave for good the familiar haunts of the defunct. Gala discreetly asked for more detailed information. This was all the spiritualist Quaker was waiting for, and all in one breath he said, "It's a kind of little brass trumpet that you attach to the wall by means of a rubber suction-grip. Every night before going to bed I talk to my father, who died two months ago." At which point I suggested that this was probably the propitious hour for his conversation, and that it would be a good idea for all of us to go to bed. And we almost immediately took leave of one another.

Before going to sleep on this my second night in New York I went over in my mind, as it became steeped in a haze of drowsiness, the incongruous contours of the images seen in the course of my first day. No, a thousand times no—the poetry of New York was not what they had tried in Europe to tell us it was. The poetry of New York does not lie in the pseudo-esthetics of the rectilinear and sterilized rigidity of Rockefeller Center. The poetry of New York is not that of a lamentable frigidaire in which the abominable European esthetes would have liked to shut up the inedible remains of their young and modern plastics! No!

The poetry of New York is old and violent as the world; it is the poetry that has always been. Its strength, like that of all other existing poetry, lies in the most gelatinous and paradoxical aspects of the delirious flesh of its own reality. Each evening the skyscrapers of New York assume the anthropomorphic shapes of multiple gigantic Millet's *Angeluses* of the tertiary period, motionless and ready to perform the sexual act and to devour one another, like swarms of praying mantes before copulation. It is the unspent sanguinary desire that illuminates them and makes all the central heating and the central poetry circulate within their ferruginous bone-structure of vegetable diplococcus.

The poetry of New York is not serene esthetics; it is seething biology. The poetry of New York is not nickel; it is calves' lungs. And the subways of New York do not run on iron rails; they run on rails of calves' lungs! [1]

[1] Rails of calves' lungs—an idea borrowed from Raymond Roussel, the greatest French imaginative writer.

The poetry of New York is not pseudo-poetry; it is true poetry. The poetry of New York is not mechanical rhythm; the poetry of New York is the lions' roar that awakened me the first morning. The poetry of New York is an organ, Gothic neurosis, nostalgia of the Orient and the Occi-

dent, parchment lampshade in the form of a musical partition, smoked façade, artificial vampire, artificial armchair.[1] The poetry of New York is Persian digestion, sneezing golden bronze, organ, suction-grip trumpet for death, gums of thighs of glamor girls with hard cowrie-shell vulvas. The poetry of New York is organ, organ, organ, organ of calves' lungs, organ of nationalities, organ of Babel, organ of bad taste,[2] of actuality; organ of virginal and history-less abyss. The poetry of New York is not that of a practical concrete building that scrapes the sky; the poetry of

[1] An armchair that "breathes" by means of a mechanical pump and cushions that can be blown up. This armchair I call artificial by contrast with the "naturalness" of common armchairs. The artificial armchair is very useful for putting to sleep old people, children and snobs of every kind.

[2] I have always considered "good taste" to be one of the principal causes of the growing sterility of the French mind; I have always defended, as against French good taste, the fertile and biological bad taste of Wagner, Gaudi and Boecklin.

New York is that of a giant many-piped organ of red ivory—it does not scrape the sky, it resounds in it, and it resounds in it with the compass of the systole and the diastole of the visceral canticles of elementary biology. New York is not prismatic; New York it not white. New York is all round; New York is vivid red. New York is a round pyramid. New York is a ball of flesh a little pointed toward the top, a ball of millennial and crystallized entrails; a monumental ruby in the rough—with the organ-point of its flashes directed toward heaven, somewhat like the form of an inverted heart—before being polished!

On certain very bright mornings filled with the dazzling sun of early November, I would go walking all alone in the heart of New York with my bread under my arm. Once I went into a drug store on 57th Street and asked for a fried egg which I ate with a small piece of my large loaf of bread which I cut off to the stupefaction of everyone who gathered round me to watch me and ask me questions. I answered all these questioners with shrugs of my shoulders and with timid smiles.

One day when I was walking thus, my bread, which had become entirely dry and had for some time betrayed marked tendencies to crumble, broke into two pieces, and I decided then that the moment had come to get rid of it. I happened to be on the sidewalk just in front of the Hotel Waldorf Astoria. It was exactly twelve o'clock, the hour of the noon-day phantoms, and I decided to go and eat in the Sert Room. But just at the moment of crossing the street I slipped and fell. In my fall the two pieces of bread were tossed violently against the pavement and scooted off some considerable distance. A policeman came and helped me up. I thanked him and began to limp away. But after taking a dozen steps I turned round, curious to observe what had finally happened to the two parts of my bread. They had simply disappeared without leaving the slightest trace, and the manner in which they were spirited away is still an enigma to me. Neither the policeman nor any of the other people on the street had the two large pieces of bread about them. I definitely had the bewildering and disquieting impression that this was a delirious and subjective phenomenon, and that the bread was there somewhere before my eyes, but that I did not see it for affective reasons that I would subsequently discover and that were connected with a whole long history involving the bread.

This became the point of departure for a very important discovery which I decided to communicate to the Sorbonne in Paris under the evocative name of *The Invisible Bread*. In this paper I presented and explained the phenomenon of sudden invisibility of certain objects, a kind of negative hallucination, much more frequent than true hallucinations, but very difficult to recognize because of its amnesic character. One does not immediately see what one is looking at, and this is not a vulgar phenomenon of attention, but very frequently a clearly hallucinatory phenomenon. The power to provoke this kind of hallucination at will

would pose possibilities of invisibility within the framework of real phenomena, becoming one of the most effective weapons of paranoiac magic. One recalls the "involuntary" element which is at the basis of all discoveries. Columbus discovered America while he was looking for the Antipodes. In the Middle Ages, metals like lead and antimony were discovered in the search for the philosopher's stone. And I, while I had been looking for the most directly exhibitionistic way of showing my obsession with bread, had just discovered its invisibility. It was the very invisibility which I had not been able to solve in a satisfactory manner in my *Invisible Man*. What man cannot do, bread can.

My exhibit at Julien Levy's was a great success. Most of the paintings were sold, and critical reaction, while keeping its polemic tone, was unanimous in recognizing my imaginative and pictorial gifts.

I was to leave again for Europe on the *Normandie,* which was sailing at ten o'clock the next morning. For the last night of our stay Caresse Crosby and a group of friends had arranged to give an "oneiric" ball in my honor, at the Coq Rouge. This party, which was got up in one after-

Project for an ashtray and cigarette holder mounted on the back of a live turtle

noon, remained a kind of "historic institution" in the United States, for it was subsequently repeated and imitated in most American cities. This first "surrealist ball" exceeded in strangeness everything that its organizers had desired and imagined. Indeed the "surrealist dream" brought out the germs of mad fantasy that slumbered in the depths of everyone's brains and desires with the maximum of violence. I myself, though I may be considered to be fairly inured to eccentricity, was surprised at the truculent aspect of the witches' sabbath, at the frenzy of imagination in which that night at the Coq Rouge was plunged. Society

women appeared with their heads in bird cages and their bodies practically naked. Others had painted on their bodies frightful wounds and mutilations, cynically slashing their beauties and transpiercing their flesh with a profusion of safety pins. An extremely slender, pale spiritual woman had a "living" mouth in the middle of her stomach gaping through the satin of her dress. Eyes grew on cheeks, backs, under-arms, like horrible tumors. A man in a bloody night shirt carried a bedside table balanced on his head, from which a flock of multi-colored humming birds flew out at a given moment. In the center of the stairway a bath-tub full of water had been hung, which threatened every moment to fall and empty its contents on the heads of the guests, and in a corner of the ballroom a whole skinned beef had been hooked up, its yawning belly supported by crutches, and its insides stuffed with a half-dozen phonographs. Gala appeared at the ball dressed as an "exquisite corpse." On her head she had fastened a very realistic doll representing a child devoured by ants, whose skull was caught between the claws of a phosphorescent lobster.

The following day we innocently left for Europe. I say "innocently," for on our arrival in Paris we were to learn the scandal of the "oneiric" ball. At this time the feverish excitement over the Lindbergh-baby trial was at its height. The French correspondent of the *Petit Parisien*,[1] along with the usual chronicle of this trial, cabled the sensational news that the wife of the famous surrealist painter, Salvador Dali, had appeared at a ball with the bloody replica of the Lindbergh baby fastened to her head, and thereby provoked "a great scandal." The only person in New York who was aware of this scandal was the French correspondent of the *Petit Parisien*, who had not even been at the ball. In Paris, however, the news spread like wildfire, and our arrival was greeted with stupefaction.

I was no longer master of my legend, and henceforth surrealism was to be more and more identified with me, and with me only. Much water had passed under the bridge, and I found upon my return that the group I had known—both surrealists and society people—was in a state of complete disintegration. Preoccupations of a political nature had turned a great number of them toward the left, and a whole surrealist faction, obeying the slogans of Louis Aragon, a nervous little Robespierre, was rapidly evolving toward a complete acceptance of the communist cultural platform. This inner crisis of surrealism came to a head the day when, upon my suggesting the building of a "thinking-machine," consisting of a rocking chair from which would hang numerous goblets of warm milk, Aragon flared up with indignation. "Enough of Dali's fantasies!" he exclaimed. "Warm milk for the children of the unemployed!"

Breton, thinking he saw a danger of obscurantism in the communist-sympathizing faction, decided to expel Aragon and his adherents—

[1] M. de Roussy de Sales.

Bunuel, Unic, Sadoul, and others—from the surrealist group. I considered René Crevel the only completely sincere communist among those I knew at the time, yet he decided not to follow Aragon along what he termed "the path of intellectual mediocrity." Nevertheless he remained distant from our group, and shortly afterward committed suicide, despairing of the possibility of solving the dramatic contradictions of the ideological and intellectual problems confronting the Post-War generation. Crevel was the third surrealist who committed suicide, thus corroborating their affirmative answer to a questionnaire that had been circulated in one of its first issues by the magazine *La Révolution Surréaliste,* in which it was asked, "Is suicide a solution?" I had answered no, supporting this negation with the affirmation of my ceaseless individual activity. The remaining surrealists were in the process of committing suicide gradually, sinking into the growing obscurity of the lethargic and political tittle-tattle of the collective café terraces.

Personally, politics have never interested me, and at that moment less than ever, for they were becoming day by day more wretchedly anecdotic and threatened ruin. On the other hand I undertook the systematic study of the history of religions, especially the Catholic religion, which appeared to me more and more as the "perfect architecture." I began to isolate myself from the group, and to travel constantly: Paris, Port Lligat, New York, back to Port Lligat, London, Paris, Port Lligat. I took advantage of my appearances in Paris to go out into society. Very rich people have always impressed me; very poor people, like the fishermen of Port Lligat, have likewise impressed me; average people, not at all. Around the real surrealist personalities were beginning to gather average people, a whole fauna of misfit and unwashed petty bourgeois. I ran away from them as from the cholera. I went to see André Breton three times a month, Picasso and Eluard twice a week, their disciples never; society people every day and almost every night.

Most society people were unintelligent, but their wives had jewels that were hard as my heart, wore extraordinary perfumes, and adored the music that I detested. I remained always the Catalonian peasant, naïve and cunning, with a king in my body. I was bumptious, and I could not get out of my mind the troubling image, post-card style, of a naked society woman loaded with jewels, wearing a sumptuous hat, prostrating herself at my dirty feet...[1] My mania for wearing elegant clothes, harking back to the period of Madrid, took up its abode again in my brain, and I then understood that "elegance" was the materialization of the material refinement of an epoch, being for that very reason only the tangible, acute simulacrum, the clarion-call of religion.

Nothing is in fact more tragic and vain than fashion, and just as for an intelligence of the first order, like my own, the war of 1914 was

[1] I have heard a Catalonian painter say of someone very dirty, "Imagine how dirty he was—that black stuff we all have between our toes he has between his fingers!"

fetishistically represented by Mademoiselle Chanel, the war which was soon to break out and which was going to liquidate the post-war revolutions was symbolized, not by the surrealist polemics in the café on the Place Blanche, or by the suicide of my great friend René Crevel, but by the dressmaking establishment which Elsa Schiaparelli was about to open on the Place Vendôme. Here new morphological phenomena occurred; here the essence of things was to become transubstantiated; here the tongues of fire of the Holy Ghost of Dali were going to descend. And (since unfortunately I am always right) the German troops were to swoop down on Biarritz, just a few years later, camouflaged in the Schiaparelli and Dali manner, wearing cynical and mimetic costumes, with branches of leaves freshly torn from the soil of France bursting from their sandy animal hair like the Nordic buds of a crucified Daphne. But the soul and the biology of the Schiaparelli establishment was Bettina Bergery, one of the women of Paris most highly endowed with fantasy. She exactly resembled a praying mantis, and she knew it. Bettina and Roussie Sert (née Princess Mdivani), fairy skeletons of sveltest poetry, with Chanel *France de France,* head the procession of those who continue in spite of separations and death to be my best friends.

London brought to Paris a gleam of Pre-Raphaelism which I was the only one to understand and to savor. Peter Watson had a sure taste for architecture and furniture, and bought the Picassos which, without his knowing it, most resembled Rossettis. And Edward James, hummingbird poet, ordered aphrodisiac lobster-telephones, bought the best Dalis, and was naturally the richest. Lord Berners was impassively present, within the diving-suit of his humor, at the concerts, always of a high quality, given by the Princess de Polignac in the large drawing-room decorated by José-María Sert with tempests of embryo elephants prophetic of the Europe of the League of Nations which one day was going to blow up.

At Missia Sert's, Sert's first wife, the most substantial gossip of Paris was concocted. At Marie-Louise Bousquets one smacked the left-overs of these in her social-literary salon where she received on Thursdays, a salon at the bottom of the serene gray stone lake of the Place Palais-Bourbon, a salon in which I saw the most spectacular short-circuits between real cherries and the luminous ones of the cherry-colored rays of the setting sun which, so to speak, crept in in order to settle on the nose of the bone of this salon, the soft and phantasmal nose, of Ambroise Vollard, and sometimes even on Paul Poiret. Across the square from Marie-Louise, Emilio Terry kept new Dalis amid the finest spiderwebs in Paris.

In the spring it was very pleasant at the Comtesse Marie Blanche de Polignac's, where from the garden one listened to string quartets played in the interior all aflame with candles and Renoir paintings and with the malefic coprophagia of an unsurpassable pastel by Fantin-Latour—all this accompanied by *petits-fours* and much candy and other sweets.

At the Vicomtesse de Noailles's it was just the opposite, the counter-point in painting and literature. It was the tradition of Hegel, Ludwig II of Bavaria, Gustave Doré, Robespierre, de Sade and Dali and a touch of Serge Lifar.

There were also the balls and the dinners of Mrs. Reginald Fellowes. There one could count on the disappointment of not seeing her wear a dress designed by Jean Cocteau, and hear a speech by Gertrude Stein, all of which was fortunately accompanied by a snobbery and an elegance of the first quality.

The principle of stilts applied to the building of a "Mediterranean hammock"

The Prince and Princesse de Faucigny-Lucinge had an indisputable sense of "tone." Their "tone" was almost as violent and sustained as the "*figura*" of the Spaniards. It was the slightly gamy residue of the super-elegant and exotic pictures of Aubrey Beardsley. This princess always

had a touch of the "outmoded" that was capable of tyrannizing fashion. Her anachronism was always up-to-date; she was unquestionably one of the women possessing the most precise sense of "Parisian elegance."

The Comte and the Comtesse Etienne de Beaumont constituted the theatrical key to all this. To enter their house was to enter the theatre. All that was needed to recognize this was to see a cubist Picasso of the gray period hung on the silvery tubes of an organ. Etienne de Beaumont spoke exactly like people born to the theatre, and wore fancy kid shoes. All the more or less criminal intrigues between the various companies of Ballets Russes that Diaghilev had left in his wake germinated, grew and invariably exploded in his garden, on whose trees artificial flowers were sometimes hung. At his house, too, one could with impunity meet Marie Laurencin, Cardinal Verdier, Colonel de La Roque, Leonid Massine, Serge Lifar (dead tired and cadaverous), the Maharajah of Kapurthala, the Spanish ambassador, and a sprinkling of surrealists.

The "society" of Paris was becoming unrestrainedly promiscuous, and the spectre of the defeat of 1940 was already rising in the Bordeaux clouds of the horizon of France, with that catastrophic bitter-sweet which was incarnated in the popular, realistic and gluey gums of Fernandel,[1] which offered a ravishing effect of contrast to the racy and spectral pallor of the Russian princess, Natalie Paley, dressed in the finest Lelong dress, her silhouette covered with all the powder of the stage of 1900. Another touch was added by the inimitable phiz of Henry Bernstein in the midst of telling the cynical-sentimental *dénouement* of a prophetic bit of gossip before a plate of spaghetti—all this drowned in the penumbra of the gallant Parmesan cheese which illuminated the Casanova night club and which awaited only the propitious moment to burst into flame like a *crêpe suzette*. The beard of Bébé Bérard, which, after the hairs of my own moustache, was that of the most intelligent painter in Paris, would saunter about, reeking of opium and Le Nain-Roman decadence, in this Paris ripe for Rasputinism, for Bébé-dandyism and for Gala-Dalinism, with a suspicious, flattering assurance, as architectonically romantic as that of a glance of Piero della Francesca. Aside from his paintings, Bérard had three things which I thought very fine and touching—his dirtiness, his glance, and his intelligence. As for Boris Kochno, he had a beard that was always savagely shaved, that grew with the perseverance and the courage of a Cossack. He "lighted" the Russian ballets, ate rapidly and often left in a great hurry, excusing himself immediately after the dessert (he was running to another dessert). Sometimes his flesh would become red and congested: then the blue of his shaved and stubborn beard would contrast with the white of his shirt-front, and if one did not look too carefully he gave the effect of a French flag, all red, white and blue.

[1] A comic actor of the French cinema, discovered by Jean Renoir, rightly considered by Salvador Dali to be the most realistic and the best. The war prevented Dali from executing the portrait of Fernandel disguised as a Velásquez *menino* (dwarf).

The painter José-María Sert, a man possessing a true Spanish jesu-itical imagination—a splendid sheath that enveloped him, like a golden diving-suit—had a house three hours from Port Lligat, the Mas Juny, the poorest and most luxurious spot in Europe. With Gala I would often go and spend weeks there. To the Mas Juny the whole group that I knew in Paris found its way, and there toward the end of summer, the last happy days of post-war Europe were lived—happy, and at the same time of intelligent "quality." All this today is but the nostalgic memory of a time that is gone.

This period of summer enchantment in the setting of the Catalonian *sardanas* and the provincial festivals of the Costa Brava ended with the accident of Prince Alexis Mdivani and Baroness von Thyssen, killed in a Rolls-Royce on the road from Palamos to Figueras. Roussie, Alexis Mdivani's sister, was to die of grief over this four years later. To tell you how much I loved this being I shall tell you only that she resembled— as two "pearls of death" resemble each other—the portrait of the young girl by Vermeer of Delft in The Hague Museum.

One must not judge the protagonists of this "insoluble" and super-romantic Europe too frivolously. One may wait a century for such beings to be produced anew. Surrealists, and society ladies too, died for the sake of sentiments! Certain professional politicians were not to do as much in the coming trials. And out of this helter-skelter of luxury, moral confu-sion, sentimental promiscuity and ideological experi-ments stretched to the point of tearing all the viscera of elegance and race of each one of us, very few were des-tined to survive, for the Europe that we loved was sinking amid the ruins of contemporary history—ruins without memory and without glory, the enemy of all of us, who were supremely—and heroically—anti-his-toric!

CHAPTER TWELVE

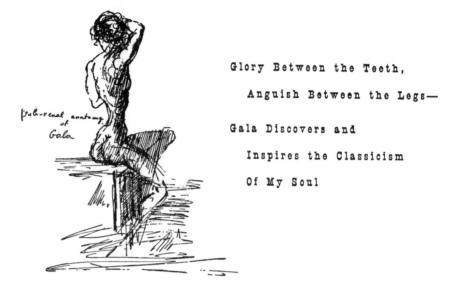

Glory Between the Teeth,

 Anguish Between the Legs—

Gala Discovers and

 Inspires the Classicism

Of My Soul

My second voyage to America had just been what one may call the official beginning of "my glory." All my paintings were sold at the opening of the exhibit. *Time* magazine published on its cover the photograph of me done by Man Ray with this sub-title: "SURREALIST SALVADOR DALI: A blazing pine, an archbishop, a giraffe, and a cloud of feathers went out of the window." I had learned from several sources about its having appeared, and when I received a copy of the magazine I was very disappointed, for I thought it was a "little" magazine. I subsequently learned that it was one of the best and most important put out in America.

I have never understood the rapidity with which I became popular. I was frequently recognized on the street, and asked to give autographs. Great quantities of flabbergasting letters came to me from the most varied and remote parts of the country. And I received a shower of extravagant offers, each more unexpected than the last.

By way of demonstration, I accepted an offer to dress one of the windows of Bonwit-Teller's shop with a surrealist display. I used a manikin whose head was made of red roses and who had fingernails of ermine fur. On a table, a telephone transformed into a lobster; hanging on a chair, my famous "aphrodisiac coat" consisting of a black dinner jacket to which were attached one beside another, so as entirely to cover it, eighty-eight liqueur glasses filled to the edge with green *crême de menthe,* with a dead fly and a cocktail straw in each glass.

This same aphrodisiac coat had just been shown with great success in a surrealist exhibit in London, at which I gave a lecture from inside a diving suit. Lord Berners was in charge of renting the diving suit in question, and over the telephone they asked him to specify exactly to what depth Mr. Dali wished to descend. Lord Berners replied that I

was going to descend to the subconscious, after which I would immediately come up again. With equal seriousness the voice answered that in this case they would replace the helmet with a special one.

I got into the diving suit, and the mechanic from the diving-suit establishment bolted my helmet on tight. The diving suit had extremely heavy lead shoes which I could barely lift. I therefore had to walk very slowly, leaning on friends who helped to move me, as though I were completely paralyzed, and thus I appeared before the audience holding two luxurious white Russian wolf hounds on a leash. My apparition in a diving suit must have had a very anguishing effect, for a great silence fell over the audience. My assistants managed to get me to my seat behind the microphone. It was only at this moment that I realized that it would be impossible for me to deliver my speech through the glass window of my helmet. Moreover, I had been shut up in this thing for ten minutes and became heated from the exertions I had made in walking across the stage to reach my chair, so that I was dripping with perspiration, and felt faint and on the point of suffocating.

I made the most energetic gestures I could to have the helmet of my diving suit removed. Gala and Edward James, immediately understanding my painful situation, came running to take off my helmet. But it was solidly bolted on, and there was nothing to be done, for the worker who had put it on me had disappeared. They tried to open a slit between the helmet and the suit with a billiard cue so that I would be able to breathe. Finally they brought a hammer and began to strike the bolts energetically to make them turn. At each blow I thought I would faint. The audience for the most part was convinced that all this was part of the show, and was loudly applauding, extremely amused at the pantomime that we were playing so realistically. When I at last got out of the diving suit everyone was impressed by my really deathly pallor, which constituted the accurate gauge of that Dalinian dramatic element which never fails to attend my most trivial acts and undertakings. I believe the Dalinian mythology which was already so crystallized upon my return to New York owed a great deal to the violent eccentricity of this lecture in a diving suit, as well as to the distinction of the exhibit of my paintings which Mr. MacDonald had held in his London Gallery in conjunction with that of two illustrious predecessors, under the title *Cézanne—Corot—Dali*.

But just as everything seemed to be going better and better for me, I suddenly felt myself in the grip of a depression which I was unable to define. I wanted to return to Spain as soon as possible! A kind of insurmountable fatigue weighed on my ever-alert imaginative hysteria. I had had enough of all this! Enough diving suits, lobster-telephones, jewel-clips, soft pianos, archbishops, and blazing pines thrown from windows, enough of publicity and cocktail parties. I wanted to return to Port Lligat as soon as possible. There, now at last, in the solitude which Gala and I had won through our common effort of six years spent in

striking, without impatience but with unwearying persistence, the hammer-blows of our personality on the red-hot anvil of the sooty Vulcan of actuality—at last, I said to Gala, I would be able to begin to do "important" things.

We arrived in Port Lligat toward the end of a very bright December afternoon. Never had I understood so well how beautiful the landscape of Port Lligat was! I wanted desperately to be happy, to enjoy the minutest chink of the life that I was about to begin. But an unknown anguish held me by the solar plexus, and it obliged me continually to utter deep sighs. At night I could not sleep. And when dawn came I would walk along the seashore. The memories of the extravagant and brilliant life I had been leading these last years, in Paris, London and New York, struck me now as remote and without reality, and only my more and more pervasive and inexplicable anguish filled each present moment with its oppressive and corporeal weight.

What is the matter with me? You have what you have been wanting for six years. You are in your Port Lligat, which is the spot you love best in the world. You are with Gala, who is the being you love best in the world. You no longer suffer the degradation of money worries. With the greatest luxury of time you can begin the important works you desired most in the world to undertake. You have never enjoyed such good health as you do now. Plans for theatrical and motion-picture ventures beckon to you, and you are free to choose... Gala would be happy if she did not worry about your unexpected anxiety that screws up your eyes into that cowardly squint, which betrays your fear . . . your fear of what?

I would heave a sigh of rage against my own anguish that thus annihilated all my illusions, and the sea air that filled my lungs seemed to me bitter as gall and tears intermingled. I said to myself that this was idiotic, but in spite of all the reassuring arguments which I resorted to to overcome it, I was sure that in the past hour my anguish had grown all the more. This mere supposition released a flood of anguish which for a moment paralyzed my whole body, plunging it into a horrible sweat. If it continued at this rate I would soon break down and weep . . . I must react against my stupidity. Gala had sometimes advised me to take a shower to calm my nerves. I would plunge into the calm and icy water of the solitary beach wrapped in winter sleep.

I undressed and remained for a long time standing naked. The sun was burning as in summer, but I did not have the courage to go into the water. Then I heard anguish ascend the stairway of flesh of my naked body step by step. It reminded me of the paralyzing tale which had so frightened me when I was a little boy—the tale of the dead Marieta who, on the very night of her burial, returns to her house to frighten her husband.

"Ay, ay!" she cries lugubriously as she climbs the stairway, "I am on the first step!"

"Marieta! Marieta!" cries the husband beseechingly. "Don't come and get me! Go back to your grave!"

"Ay, ay!" answers Marieta, "Ay, ay, I am on the second step!"

"Marieta! Marieta! . . ."

"Ay, ay! Now I am on the third step!"

"Marieta! . . ."

"New Flesh"

In the end, when Marieta, the dead woman, had reached the last step, my nurse Llucia who was telling me the story would pause to create the most hair-raising suspense, after which she would scream with unexpected violence, clutching my shoulder with her hand, "I've got you!"

Far behind me I heard Gala call me to lunch, and I trembled hysterically, instinctively bringing one hand to my heart and the other to my penis. A bland odor rose from my body, seeming to me to be the very odor of my own death. And from that moment I felt the whole weight of my anguish bear down between my legs like the cut-off and dirty hand of my already rotting destiny. As I returned to the house I tried to explain my mood to Gala.

"There is nothing the matter with me. I know that my glory is there, within reach, ripe as an Olympian fig; I have only to clench my hand and my teeth to feel the juice of its materiality flow. There is nothing the matter with me, there is nothing to produce this anguish. And yet I feel myself the slave of a growing anguish—I don't know where it comes from or where it is going! But it is so powerful that it frightens me! That is exactly what is the matter with me: there is nothing wrong, absolutely nothing that can frighten me, but I am afraid of being afraid, and the fear that I may be afraid frightens me!"

Already from afar we perceived the figure of Lydia "La Ben Plantada," dressed in black and seated on the threshold of the door to our house, awaiting our return. When we got close, Lydia got up and came to meet us. She was weeping. We went inside, and she confided to us that her life with her two sons had become unbearable. Her sons no longer went fishing; they spoke only of their radium mines; they spent most of the time lying on their pallets. Sometimes they would weep; sometimes, taken with dreadful fits, they would beat her. She showed us a scar on her head, pulling aside two strands of her white hair, and let us see the blue

marks all over her body. A week later her two sons were sent to the mad-house in Gerona. In the afternoons Lydia would come to the house and weep. Port Lligat was solitary. A violent and persistent wind prevented the fishermen from going out to fish, and only the famished cats would skulk around our little house. Ramon de Hermosa was perpetually coughing, and was so completely covered with lice that I forbade him to come near us. Lydia would bring him left-overs every evening. Our maid spoke to herself endlessly in the kitchen. One morning she went up on the roof with her breasts bare and a strange hat made out of newspaper and pieces of string perched on her head. She had gone mad, and we had to get a new maid.

My fear of being afraid had by now become a single very precise fear—that of going mad and dying! One of Lydia's sons died of hunger. Immediately I became a prey to the fear of not being able to swallow my food. One evening it happened: I could no longer swallow! I hardly slept at night any longer, and during the long hours of darkness my anguish did not relinquish its grip on me for a single moment. In the daytime I would run out abjectly and sit with the fishermen who came to chat in a spot sheltered from the wind and warmed by the sun, out of the *tramontana*[1] which did not relax its unleashed violence. The talk about the troubles and hardships that were the daily lot of the fishermen succeeded in distracting me a little from my obsessions. I would ask them questions of all sorts, for I should have liked to tear from them living bits of their own anguish to be able to hold them up against my own. But they were not anguished; they were not afraid of death. "We," they said, "are already more than half dead, you might say." One of them would sit and slowly cut away with a fish-knife pieces of dead skin from the yellow thickness under his feet, another would pick off scabs covering the backs of his hands where the blue veins swollen by arterio-sclerosis followed their hardening course between the hair bristles. Bits of scabs would cling to these hairs, and sometimes a gust of wind would blow some of these over the copy of *Vogue* magazine that I was thumbing through. Gala would come eagerly running with the bundles of American and Parisian magazines which she knew sometimes distracted me for brief moments. There was a photograph of an ultra-sophisticate wearing jewel clips combined with flowers—she had appeared at a garden party wearing a diamond in the shape of a large drop of water dripping from a natural rose. There was an advertisement of a new lipstick which was said to be the real Dali red, which had to be applied over two liquid layers.

Batu, the old fisherman, would break wind in slow, deliberate blasts, after which he exclaimed, "I'm not going to eat any more octopus; my wife she has a whorish mania for putting too much garlic in it, and then I get belly-gripes!" "That isn't it," another fisherman answered,

[1] The spells of the *tramontana* last sometimes for three weeks uninterruptedly, during which the sky is always serene, but the fishermen cannot put out to sea.

"it's the beans you ate two days ago. Beans can make you f—t two days after."

At the stroke of noon the beating sun would kindle the slumbering fire of everyone's hunger. I would send for a few bottles of champagne that we drank to wash down a mess of sea-urchins. We were in for three more days of wind!

"Gala, come here, bring me the cushion, and hold my hand tight; I think I'll go to sleep. I feel less anguish. It's pleasant here now."

A small lizard with a quick-moving head and a triangular face darted alertly to catch a fly absorbed in sucking the juice from a crushed sea-urchin. But a gust of wind blew over a page of one of my magazines, making him scurry back under a crevice of the dilapidated wall from which he had crept. Around me I felt the conversations of the fishermen gradually die down. Dragging the weight of the voluptuous chains of digestion they were falling off one by one into dreams. We were all sheltered as if in the furnace of the afternoon, and the furious whistling of the wind which could not reach us was all the more agreeable. And this whole conglomeration of poor fishermen with clothes woven of patches, with Homeric souls and with essential odors would mingle as I sensed the approach of sleep, so painfully desired, in a blend of "reality" which in the end outweighed that of my anguish and of my imagination.

Not one day goes by that I don't ride; 'til the infinite, the horse of my imagination.

When I awoke, all the fishermen had left; the wind had stopped blowing, and Gala [1] was bowed over my slumber, like the divine animal of anxiety over the body of the "chrysalis Lazarus" that I was. For like a chrysalis, I had wrapped myself in the silk shroud of my imagination,

[1] Once already Gala Gradiva had cured me of madness with the corporeal reality of her love. Having become practical, I had been able to achieve my surrealist "glory." But this success threatened a relapse into madness, for I was shutting myself up in the world of my realized image. It was necessary to break this cocoon. It was necessary for me really to believe in my work, in its importance outside of myself! She had taught me to walk; I had to advance like a Gradiva, in my turn. I had to pierce the cocoon of my anguish. Mad or living! I have said again and again: living, aging until death, the sole difference between myself and a madman is the fact that I am not mad!

and this had to be pierced and torn to enable the paranoiac butterfly of my spirit to emerge, transformed—living and real. My "prisons" were the condition of my metamorphosis, but without Gala they threatened to become my coffins, and again it was Gala who with her very teeth came to tear away the wrappings patiently woven by the secretion of my anguish, and within which I was beginning to decompose.

"Arise and walk!"

I obeyed her. For the first time I experienced the "savor" of tradition upon feeling myself touching the earth with the soles of my feet.

"You have accomplished nothing yet! It is not time for you to die!"

My surrealist glory was worthless. I must incorporate surrealism in tradition. My imagination must become classic again. I had before me a work to accomplish for which the rest of my life would not suffice. Gala made me believe in this mission. Instead of stagnating in the anecdotic mirage of my success, I had now to begin to fight for a thing that was "important." This important thing was to render the experience of my life "classic," to endow it with a form, a cosmogony, a synthesis, an architecture of eternity.

Metamorphosis

Death

Resurrection

Dingdong, Dingdong, Dingdong, Dingdong . . .

What is it?

It is the clock of history that has rung.

What does the clock of history say, Gala?

On the dial of the clock of history, after the quarter-hour of the "isms," [1] the hour of the individual is about to sound! Your hour, Salvador!

Dingdong, dingdong, dingdong, dingdong! Post-war Europe was about to croak of the anarchy of "isms"; of the absence of political, esthetic, ideological and moral rigor. Europe was about to croak of scepticism, arbitrariness, drabness, lack of form, lack of synthesis, lack of cosmogony. Post-war Europe was about to croak of lack of faith. It thought it knew everything from having tasted the forbidden fruit of specialization. But it believed in nothing and trusted in everything, even in morality and esthetics, in the anonymous flaccidity of the "Collective."

Excrements always depend more or less on what one has eaten. Post-war Europe had continually eaten "isms" and revolution. Its excrements

[1] The whole pre-war and post-war period is characterized by the germination of "isms": Cubism, Dadaism, Simultaneism, Purism, Vibrationism, Orpheism, Futurism, Surrealism, Communism, National-Socialism, among a thousand others. Each has had its leaders, its partisans, its heroes. Each claims the truth, but the sole "truth" which they have demonstrated is that once these "isms" are forgotten (and how quickly they are forgotten!) there remains among their anachronistic ruins only the reality of a few authentic individuals.

would henceforth be war and death. The collective sufferings of the war of 1914 had led to the childish illusion of "collective well-being" based on the revolutionary abolition of all constraints. What had been forgotten was the morphological truth that is the very condition of well-being, which can only be ultra-individualistic and built on the rigor of hyper-individualistic laws and constraints, capable of producing a "form of reaction" original and peculiar to each spirit. Oh, the spiritual poverty of the Post-War era, the poverty of individual formlessness swallowed up in the formlessness of the masses! The poverty of a civilization which, avowedly destroying every kind of constraint, becomes the slave of the scepticism of its new liberty, constrained to the most practical and the basest necessities, those of the mechanical and industrial type! The poverty of a period that replaces the divine luxury of architecture, the highest crystallization of the material liberty of intelligence, by "engineering," the most degrading product of necessity! The poverty of a period which has replaced the unique liberty of faith by the tyranny of monetary utopias! . . . The responsibility for the war which was to break out would lie solely on the ideological poverty, the spiritual famine of this Post-War period, which had mortgaged all its hope on bankrupt materialistic and mechanical speculations.

For there is no materialistic thought that is not basely mechanical; and even the dialectic of Engels has only a metaphysical value. There can be no intellectual greatness outside the tragic and transcendental sense of life: religion. Karl Marx wrote, "Religion is the opium of the people." But history would demonstrate that his materialism would be the poison of "concentrated hatred" on which the people would really croak, suffocated in the sordid, stinking, and bombarded subways of modern life. Whereas "the religious illusion" had made the contemporaries of Leonardo, of Raphael and of Mozart thrill beneath the perfection of the architectonic and divine cupolas of the human soul!

Gala was beginning to interest me in a voyage to Italy. The architecture of the Renaissance, Palladio and Bramante impressed me more and more as being the startling and perfect achievement of the human spirit in the realm of esthetics, and I was beginning to feel the desire to go and see and touch these unique phenomena, these products of materialized intelligence that were concrete, measurable and supremely non-necessary. Also, Gala had decided to undertake some further building in our little house in Port Lligat—a new floor. She knew that this would distract me from my spells of anguish, and would canalize my attention on small immediate problems.

From day to day Gala was reviving my faith in myself. I would say, "It is impossible, even astrologically, to learn again, like the ancients, all the vestiges of technique that have disappeared. I no longer have time even to learn how to draw as they did before! I could never improve on the technique of a Boecklin!" Gala demonstrated to me by a thousand inspired arguments, burning with faith, that I could become something

other than "the most famous surrealist" that I was. We were consumed with admiration over reproductions of Raphael. There one could find everything—everything that we surrealists have invented constituted in Raphael only a tiny fragment of his latent but conscious content of unsuspected, hidden and manifest things. But all this was so complete,

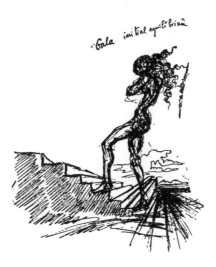

so synthetic, so "one," that for this very reason he eludes our contemporaries. The analytical and mechanical short-sightedness of the Post-War period had in fact specialized in the thousand parts of which all "classic work" is composed, making of each part analyzed an end in itself which was erected as a banner to the exclusion of all the rest, and which was blasted forth like a cannon-shot.[1]

War had transformed men into savages. Their sensibility had become degraded. One could see only things that were terribly enlarged and unbalanced. After a long diet of nitro-glycerine, everything that did not explode went unperceived. The metaphysical melancholy inherent in perspective could be understood only in the pamphleteering schemata of Chirico, when in reality this same sentiment was present, among a thousand other things, in Perugino, Raphael or Piero della Francesca. And in these painters, among a thousand other things, there were also

[1] The cannon-shot of composition, old as the world—cubism
The cannon-shot of automatism—surrealism
The cannon-shot of ... etc., etc.
All "isms" were only cannon-shots, each one over a problem existing in any classic work. It is true that cannon-shots were the only means of making anything heard after the war, and all will have served for the classic works to come. For example, it is probable that in ornamental elements—reliefs, mouldings, acanthuses, friezes, and other architectual parts of a painting—a certain influence of surrealist automatism will be felt in future styles. But it would be naïve to pose the problem of style the other way round and derive a painting from a Louis XIV ornamental motif! A painting is a much more complete and complex phenomenon than the inspiration that one can put into drawing an acanthus leaf!

to be found the problems of composition raised by cubism, etc., etc.; and from the point of view of sentiment—the sense of death, the sense of the libido materialized in each colored fragment, the sense of the instantaneity of the moral "commonplace"—what could one invent that Vermeer of Delft had not already lived with an optical hyper-lucidity exceeding in objective poetry, in felt originality, the gigantic and metaphorical labor of all the poets combined! To be classic meant that there must be so much of "everything," and of everything so perfectly in place and hierarchically organized, that the infinite parts of the work would be all the less visible. Classicism thus meant integration, synthesis, cosmogony, faith, instead of fragmentation, experimentation, scepticism.

All these ideas were crystallized in a lecture which I was preparing to deliver in Barcelona and which would have had historic repercussions. Mine was not a case of the periodic imitative and discouraged "return to tradition"—the neo-classicism, the neo-Thomism which one heard about everywhere, symptomatically arising out of the fatigue and the nausea over "isms." On the contrary it was the combative affirmation of my whole experience in the spirit of synthesis of the "Conquest of the Irrational" and the affirmation of the esthetic faith to which Gala had just restored me.

We were thus preparing to leave for Barcelona, and before leaving Port Lligat we went to take a glass of wine with the masons who were working on the new story to our house, to say goodbye to them. They were in the midst of discussing politics.

"The finest thing in the world," one of them said, "—I mean finest, and I don't care what anybody says—is anarchy, what you might call libertarian communism. And when I say fine I mean it's a very fine idea, but you can't put it into practice. So I'm satisfied with a good liberal socialism, with a few variations that I've thought up myself."

"The only thing that appeals to me about all that," said another, "is integral free love; everything bad comes from people not having their fill of love." So saying, he dug his teeth with conviction into the leg of a chicken.

Another said, "I'm for syndicalism—clean and stripped and no politics mixed up in it, and for this idea I wouldn't stop at anything, I'd even overturn all the streetcars that were necessary." And he went through a pantomime suggesting that he knew by experience how this was done.

Another said, "Neither syndicalism nor socialism. Communism is the only thing, communism as Stalin understands it. It's the only realistic way out."

"Communism, sure," said another, "but you've got to know what kind you mean, because there are five different kinds, not counting my own, which is the right kind. It's been proved and demonstrated that the Stalinists are murderers of free men, just as criminal as the fascists." The problem of Trotskyism was an acute one at that time.

But the important thing for all of them was to bring about the revo-

lution. After that one would see. The master mason listened with consternation to all this debate over various "isms"; then, nodding his head he said to them,

"Do you want me to tell you how all this is going to end? It's going to end with a military dictatorship that will make all of us shrivel up and won't allow any of us to breathe . . ."

On my arrival in Barcelona the "isms" began to burst in the form of real bombs set off by the *Federación Anarquista Ibérica* that were beginning to explode all around. That same afternoon a general strike was declared, and Barcelona suddenly took on a sinister aspect. Dalmau, the old picture-dealer who had been the first to introduce modern art to Barcelona, and who had organized my present lecture, rang the bell at about five o'clock at the door of our hotel room on Carmen Street with a twice-repeated lugubrious pressure of his bony hand.

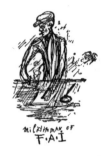

Militiaman of
F·A·I

"Come in," I cried. The door opened, and the sight of Dalmau was something unforgettable. His white beard was unkempt, his hair bristling, and by his hurried breathing I could guess that he had come in all haste to tell us something urgent. Nevertheless he remained motionless on the threshold. His fly was wide open and within it he had placed a number of a review that I had asked him to get for me. On the cover of this review I read a title, *La Révolution Surréaliste*. After remaining motionless for some time to enjoy the effect that his unbuttoned appearance produced on us, he said,

"You must get away to Paris as soon as possible. Hell is about to break loose here."

We spent the whole afternoon looking for a chauffeur who would be willing to take us to the frontier, and going through the red tape necessary to obtain an official permit of exit and circulation. The streets of Barcelona were filling more and more with groups of civilians armed with guns whom no one interfered with. Sometimes they would meet sombre mounted civil guards coming in the opposite direction. All would pretend not to see one another, and each group would go on its way; "Bye and bye!" they seemed to say to each other tacitly. At the *Ministerio de la Gobernación* I had to wait two long hours. The personnel would stop tapping at their typewriters to help set up the machine-guns that were calmly being installed at every window. And everyone had a thread in his mouth, for everyone was sewing—they were sewing armbands with the Catalonian flag and the separatist star on their sleeves. And word passed from mouth to mouth that Companys was going to proclaim the Catalonian Republic. The storm announced by Dalmau was thus going to beat down on Barcelona in perhaps an hour or less, if the army should decide to take matters into its own hands. I was less and less sure of being able to get to the frontier in time. While I was waiting for my interminable exit visa, I recognized the two leaders of Catalonian separatism as being the Badia brothers. They looked exactly like two Buster Keatons; they had the same tragic gestures and

a predestined pallor; I immediately realized that they were about to die—the anarchists were in fact to kill them a few days later.

When I finally obtained my exit visa, Dalmau reappeared, bringing us an anarchist chauffeur who was willing to compromise himself, for a rather considerable sum, by taking us to the frontier. Gala, Dalmau, the anarchist and I went and shut ourselves up in a men's lavatory to discuss the price and the conditions of our trip. Once everything had been settled the anarchist winked at us, and said, "I have foreseen everything," and pulled a Catalonian flag out of his pocket. "This I put on the car to get there," and, pulling a Spanish flag out of the other, he added, "and this one will get me back in case they lose their revolution, which they almost certainly will. But this quarrel between Spain and Catalonia doesn't concern us anarchists. Besides, 'our moment' hasn't come yet. All these bombs you hear exploding are our bombs all right, but they're just to make a few casualties and keep up appearances. Whenever there are people killed we have to be in on it—it's up to us to make the most noise. But that's all. The day hasn't come yet for us to blow the lid off."

We got into the car and started on our way. It took us no less than twelve hours to make the trip that usually can be made in two. Our car was stopped every moment by groups of the armed populace who demanded to see our safe-conduct. The mood of these groups varied in the extreme, like their state of sobriety, and on several occasions we were allowed to continue on our way only thanks to the eloquence of our anarchist driver who invariably was able to convince these people of the validity and legality of our document.

Midway we stopped in a little sea-side resort town to fill our gasoline tank. Inside a large "envelat" [1] a crowd was madly dancing to the sound of *The Beautiful Blue Danube*. Outside, boys and girls were walking arm in arm. On the dusty white road lighted by the October moon a barrel of black wine had been spilled. Within a tavern whose doors were swung wide open one saw two grown men playing ping-pong. When we had filled our tank our anarchist driver said to us, "Now you will excuse me a moment. I have to go and change the olive water, and then we'll start off again." He disappeared in the rear of the tavern, and he emerged buttoning himself with one hand while with the back of the other he wiped his chin which was dripping with a hurriedly swallowed *anis del mono*. He started round the table, catching a ping-pong ball on the bounce as it fell to the floor. He asked one of the players for a racket and played one or two rallies very skilfully. Suddenly he dropped the racket, ran out and jumped into the driver's seat of our car. "We have to hurry," he shouted. "The radio has just announced that Companys has proclaimed the Catalonian Republic and they're already fighting in the streets of Barcelona." Inside the "envelat" *The Beautiful Blue Danube* was playing for the third time. Everything seemed perfectly

[1] An elaborately decorated tent put up for dancing during village festivals.

normal, except that for a moment a group of armed men discussed discreetly among themselves, in a low voice but loud enough for us to hear, whether or not it would be proper to shoot us. They were all particularly concerned over Gala's numerous suitcases, which impressed them as provocative evidence of luxury. Finally our driver, growing impatient, began to blaspheme with such inspiration and violence that he aroused a sudden respect in all of them, and we continued on our way.

The following day we awoke in a small hotel in the frontier town of Cerbère, and we learned from the newspapers that the uprising had been put down, and the leaders killed or arrested. The Catalonian Republic had thus lasted only a few hours. We had lived through the "historic night" of October 6th, and since that night I have always had the same picture of a historic night. A historic night to me is a perfectly idiotic night like any other, in which people play *The Beautiful Blue Danube* a great deal, a little ping-pong, and in which you risk getting shot. We were to learn a few days later in a letter which we received from Dalmau that our driver was caught by a spray of machine-gun bullets coming back through the suburbs of Barcelona and was killed. They had thus definitely changed the water of the white ping-pong balls of his black olives into fresh blood.

I was definitely not a historic man. On the contrary I felt myself essentially anti-historic and a-political. Either I was too much ahead of my time or much too far behind, but never contemporaneous with ping-pong-playing men. The disagreeable memory of having seen two Spaniards capable of indulging in that imbecile game filled me with shame. It was a dreadful omen: the ping-pong ball appeared to me as a little death's-head—empty, without weight, and catastrophic in its frivolity—the real death's head, personifying politics completely skinned. And in the menacing silence that surrounded the tock, tock, tock, tock of the light skull of the ping-pong ball bouncing back and forth across the table I sensed the approach of the great armed cannibalism of our history, that of our coming Civil War, and the mere memory of the sound of the ping-pong ball heard on the historic night of October 6th was enough to set my teeth on edge in anticipation.

When I arrived in Paris I painted a large picture which I entitled *Premonition of Civil War*. In this picture I showed a vast human body breaking out into monstrous excrescences of arms and legs tearing at one another in a delirium of autostrangulation. As a background to this architecture of frenzied flesh devoured by a narcissistic and biological cataclysm, I painted a geological landscape, that had been uselessly revolutionized for thousands of years, congealed in its "normal course." The soft structure of that great mass of flesh in civil war I embellished with a few boiled beans, for one could not imagine swallowing all that unconscious meat without the presence (however uninspiring) of some mealy and melancholy vegetable.

The first news of the Spanish Civil War that I had prophesied in my

painting were not long in coming. I learned it in London, at a supper at the Savoy, after attending a concert of chamber music. I had asked for a poached egg, and this immediately brought up in my mind that ping-pong ball which had, in fact, been haunting me intermittently. It had, so to speak, just had time to mature. I communicated to the composer Igor Markevitch my idea of the lamentable and highly demoralizing effect that playing a game of ping-pong with a poached egg could produce—it would be almost worse than playing tennis with a dead bird. This poached egg set my teeth on edge, for I discovered, incomprehensibly, that it contained sand. I am sure that it was not the fault of the chef of the Savoy, but that it was the African sand of the history of Spain which had just risen to my mouth. Against sand, champagne! But I did not drink any. A period of ascetic rigor and of a quintessential violence of style was going to dominate my thinking and my tormented life, illuminated solely by the fires of faith of the Spanish Civil War and the esthetic fires of the Renaissance—in which intelligence was one day to be reborn.

The Civil War had broken out! I knew it, I was sure of it, I had foreseen it! And Spain, spared by the other war, was to be the first country in which all the ideological and insoluble dramas of Post-War Europe, all the moral and esthetic anxiety of the "isms" polarized in those two words "revolution" and "tradition," were now to be solved in the crude reality of violence and of blood The Spanish anarchists took to the streets of total subversion with black banners, on which were inscribed the words, VIVA LA MUERTE! (Long live death!). The others, with the flag of tradition, red and gold, of immemorial Spain bearing that other inscription which needed only two letters, FE (faith). And all at once, in the middle of the cadaverous body of Spain half devoured by the vermin and the worms of exotic and materialistic ideologies, one saw the enormous Iberian erection, like an immense cathedral filled with the white dynamite of hatred. To bury and to unbury! To unbury and to bury! To bury in order to unbury anew! Therein lay the whole carnal desire of the civil war of that land of Spain, too long passive and unsated, too long patient in suffering others to play the humiliating game of the vile and anecdotic ping-pong of politics on the aristocratic nobility of its back. Land of Spain, you who had been capable of fecundating religion itself! And this was what we were now to witness—what the land of Spain was capable of—a planetary capacity for suffering and inflicting suffering, for burying and unburying, for killing and resuscitating. For it was going to be necessary for the jackal claws of the revolution to scratch down to the atavistic layers of tradition in order that, as they became savagely ground and mutilated against the granitic hardness of the bones of this tradition they were profaning, one might in the end be dazzled anew by that hard light of the treasures of "ardent death" and of putrefying and resurrected splendors that this earth of Spain held hidden in the depths of its entrails. The past was unearthed,

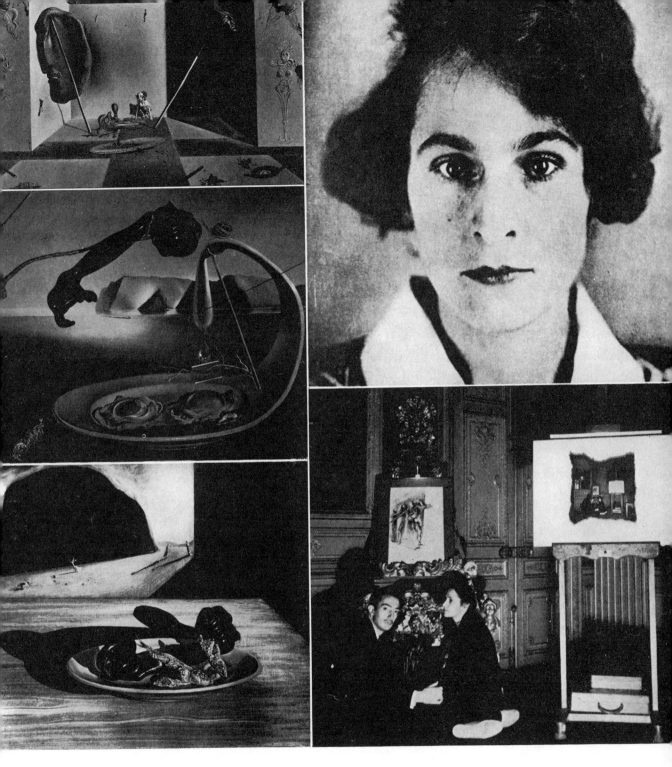

XIII. Tyranny and Liberty of the Human Gaze

"Herodiade," 1936, painted under the influence of the look in Gala's eyes.

"The Sublime Moment," influenced by Gala's gaze.

Telephone Grilled Sardines at the End of September," influenced by Gala's gaze.

Gala's gaze, characterized by Paul Eluard as "the look that pierces walls."

The dark apartment at 88, rue de l'Université in Paris, where I first discovered the phenomenal intensity of Gala's gaze.

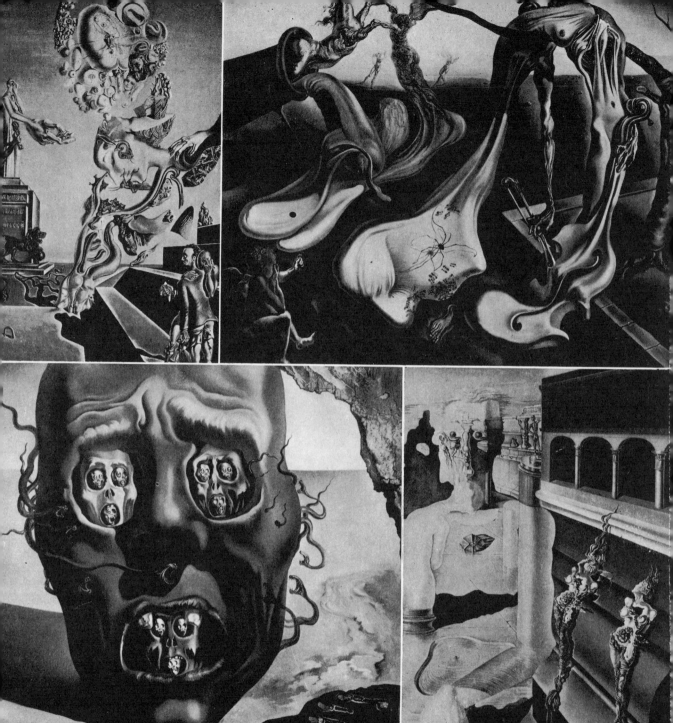

XIV. Exorcism

"Ominous Pastimes," a terror picture.

"Soft Violincello, Spider, Great Masturbator," etc.—type of waking nightmare.

"The Face of War," the eyes stuffed with infinite death.

"The Invisible Man," personage with benevolent smile, painted in 1930, which still serves to exorcise all my terrors.

lifted to its feet, and the past walked among the living-dead, was armed—the flesh was resuscitated in the disinterment of the lovers of Teruel, people learned to love one another in killing one another. For nothing is closer to an embrace than a death-grapple. The militiaman of Faith would come to the café carrying on his arm the mummy of a twelfth-century nun whom he had just unearthed; he would not leave

her! He wanted to bring her with him, fastened to his *correajes* as his "mascot," to the trenches on the Aragon front and die with her if need be. An old friend of the architect Gaudi claims to have seen the unearthed body of that architect of genius dragged through the streets of Barcelona by a rope that the children had fastened around his neck. He told me that Gaudi had been very well embalmed, and that he looked "exactly" as he had in the life, except that he did not look very well. This was after all only natural, considering the fact that Gaudi had been buried for some twenty years. In Vic the soldiers played football every afternoon with the head of the archbishop of Vic, in Vic . . .

From all parts of martyred Spain rose a smell of incense, of chasubles, of burned curates' fat and of quartered spiritual flesh, which mingled

with the smell of hair dripping with the sweat of promiscuity from that other flesh, concupiscent and as paroxysmally quartèred, of the mobs fornicating among themselves and with death. And all this rose toward heaven like the very odor of ecstasy of the orgasm of revolution.

The anarchists lived their dream in which they had never wholly believed. Now they did in fact enter the office of the notary public and perform their intimate functions right on his desk, which stood as the symbol of property. In several villages in which integral libertarianism was set up, all the bank notes were burned.

The Spanish Civil War changed none of my ideas. On the contrary it endowed their evolution with a decisive rigor. Horror and aversion for every kind of revolution assumed in me an almost pathological form. Nor did I want to be called a reactionary. This I was not: I did not "react"—which is an attribute of unthinking matter. For I simply continued to think, and I did not want to be called anything but Dali. But already the hyena of public opinion was slinking around me, demanding of me with the drooling menace of its expectant teeth that I make up my mind at last, that I become Stalinist or Hitlerite. No! No! No! and a thousand times no! I was going to continue to be as always and until I died, Dalinian and only Dalinian! I believed neither in the communist revolution nor in the national-socialist revolution, nor in any other kind of revolution. I believed only in the supreme reality of tradition.

Besides, revolutions have never interested me by what they "revolutionize," which is always perishable and constantly threatened with becoming the opposite of what it was at the beginning. If revolutions are interesting it is solely because in revolutionizing they disinter and recover fragments of the tradition that was believed dead because it had been forgotten, and that needed simply the spasm of revolutionary convulsions to make them emerge, so that they might live anew. And through the revolution of the Spanish Civil War there was going to be rediscovered nothing less than the authentic catholic tradition peculiar to Spain, that wholly categorical and fanatical catholicism, that passion built of stone, massive with granitic and calcareous reality which is Spain.[1] In the Spanish Civil War the Spanish people, the aristocracy of peoples, even while they were devouring one another, were obscurely and unknowingly fighting unanimously for one thing, for that thing which is Spain—ardent tradition. All—atheists, believers, saints, criminals, grave-openers and grave-diggers, executioners and martyrs—all fought with the unique courage and pride of the crusaders of faith. For all were Spaniards, and even the most ferocious sacrileges and manifestations of atheism abounded in faith, illuminating the dark dementia of unleashed and omnipotent passion with flashes of heaven.

[1] "Spain is a granitic or calcareous plateau with a mean altitude of 700 metres." (*Petit Larousse*.)

The story has often been told of the Andalusian anarchist who during the Civil War walked up the steps of a gutted and profaned church with the grace of a torrero, drew himself up to his full height before a crucifix whose Christ wore long natural hair, and after having insulted Him with the most atrocious blasphemies, spat into His face while with one hand he brutally seized the long hair which he was about to tear out. At this moment the Christ's hand became detached from the cross and His arm, which was articulated, fell on the shoulder of the Andalusian soldier, who dropped dead on the spot. What a believer! . . .

At the very outbreak of the revolution my great friend, the poet of *la mala muerte*, Federico Garcia Lorca, died before a firing squad in Granada, occupied by the fascists. His death was exploited for propaganda purposes. This was ignoble, for they knew as well as I that Lorca was by essence the most a-political person on earth. Lorca did not die as a symbol of one or another political ideology, he died as the propitiatory victim of that total and integral phenomenon that was the revolutionary confusion in which the Civil War unfolded. For that matter, in the civil war people killed one another not even for ideas, but for "personal reasons," for reasons of personality; and like myself, Lorca had personality and to spare, and with it a better right than most Spaniards to be shot by Spaniards. Lorca's tragic sense of life was marked by the same tragic constant as that of the destiny of the whole Spanish people.

Lorca's death, and the repercussions of the civil war which had begun to create a suffocating atmosphere of partisanship in the heart of Paris, made me decide to leave this city to go and dedicate the whole energy of my thinking to my work of esthetic cosmogony and synthesis which Gala had "inspired" in me at the time of my mortal anguish in Port Lligat. I set off on a voyage through Italy.

The disasters of war and revolution in which my country was plunged only intensified the wholly initial violence of my esthetic passion, and while my country was interrogating death and destruction, I was interrogating that other sphinx, of the imminent European "becoming," that of the RENAISSANCE. I knew that after Spain, all Europe would sink into war as a consequence of the communist and fascist revolutions, and from the poverty and collapse of collectivist doctrines would arise a medieval period of reactualization of individual, spiritual and religious values. Of these imminent Middle Ages I wanted to be the first, with a full understanding of the laws of the life and death of esthetics, to be able to utter the word "renaissance."

My voyage to Italy was generally interpreted as the symbol of my reputed lightness and frivolity of spirit. Only the few friends who closely followed my work could observe that it was precisely in the course of this voyage to Italy that the hardest and most decisive combats of my soul took place. I would walk through Rome with a volume of Stendhal in my hand. On my own and Stendhal's behalf I grew indignant over the

bourgeois mediocrity of the conception of "modern Rome" which, claiming to revive the Rome of the Caesars while adapting it to the urban necessities of a modern city, by that very fact destroyed the divine myth, that other Rome of all time, the real and living Rome, that anarchic and often paradoxical conglomeration which had been and should continue to be—and will continue to be, in spite of everything—the true Rome, Catholic in essence and in substance. The splendors of Rome are not the peeled bones of the old columns of Caesar, but the teeming and triumphant flesh of the spirit with which Catholicism had ended by covering the barbarian carcasses of architecture of territorial victories. A broad modern avenue had just been cut through which gave access to the Vatican, and instead of arriving suddenly, after a labyrinthian series of narrow streets of an irreplaceable and savory sordidness, and being struck to the heart by the sublime proportions, one now saw the Vatican fifteen minutes sooner, placed at the end of an avenue which seemed to have been conceived by the brain of one of those lamentable organizers of international expositions. Saint Peter's of Rome, you who were built for the sole and unique space between the two open arms of Bernini's colonnade, or for that of the whole of heaven and earth! . . .

"Mad Tristan" Project-costumes never executed masquerade because is was "too mad"

I spent a long season in the villa Cimbrone near Amalfi, to which I was invited by the poet Edward James, within a stone's throw of the garden where it appears that Wagner found his inspiration for his

Parsifal. It was just at this period that I conceived my integrally Wagnerian spectacle, *Tristan Fou.* Later I set up my studio in the Roman Forum, at Lord Berners', where I spent two months and painted *Impressions of Africa,* which was the consequence of a brief excursion to Sicily, where I found mingled reminiscences of Catalonia and of Africa. I had no contact with the social life of Rome. My solitude with Gala was almost complete. I saw only a very few English friends.

A famous actress was traveling in Italy at the time, in the company of a well-known musician, and one evening I met her all alone in the museum of Etruscan jewelry in Pope Julius' villa. I was surprised by her inelegant appearance and her shabby coat. However, there had been talk the day before, at the Berners', of her lack of style. I did not know her personally, and I did not greet her. Nevertheless she took the initiative of greeting me with a smile so charming that I bowed politely, and continued my tour of the museum. As I left the museum I became definitely aware that she was following me. Purposely I took an irregular course through a number of side streets in order to test my impression, and I noticed that she was indeed still behind me at a distance of some six or seven metres. This incredible situation struck me as more and more ridiculous. Should I turn round and face her, or continue to run away?

There was a great crowd converging toward the Piazza Venezia, where Mussolini was delivering a speech, and in a moment we were caught in the flood of people coming between and around us, who increased the distance separating us. Reaching the Piazza Venezia we could no longer move either forward or back. Mussolini was reaching the end of his speech, and on several occasions as he was being applauded I was startled to observe the enthusiam with which she raised her arm in the fascist salute. She kept her eyes almost constantly on me, and seemed to be reproaching me with her glance for not doing as everyone else did. What a fuss-budget, she seemed to say, what difference does it make whether you salute this way on any other way? Suddenly abandoning her initial ill-temper indicated by the contraction of her extremely mobile brows, so characteristic of her, she looked straight at me with an irresistible friendliness and burst into a peal of laughter, while she began energetically to squeeze her way toward me through the dense crowd and succeeded in getting to within a metre from where I was standing. There she got wedged again, surrounded by a phalanx of pot-bellied Romans who formed an impassable barrier. Nevertheless I saw very clearly the gestures she was making to me with her hand. She was obviously drawing my attention to a stack of postcards of Roman scenes which she was holding up for me to see between all the upraised arms. All this appeared to me to be more and more abnormal and anguishing. I looked stupidly at these views of Rome that she slowly unfolded before me, spreading them out fanwise, and suddenly I shuddered. Among the views of the

Eternal City I had caught a glimpse of an erotic picture, which was followed by another. With a coy gesture she quickly flicked these two pictures out of sight, again concealing them among the other, conventional, picture postcards, emphasizing her gesture of precocious immodesty with an attitude of feigned innocence by which she wished to make the sudden and incomprehensible exhibitionistic act comical.

Then I looked her straight in the eye and scrutinized her closely, and the veil of error vanished from before my eyes. She was not the famous actress at all, except in my wandering imagination. I then instantly recognized that her physical resemblance to the movie star was actually very slight. She was simply an artist's model, a friend of one of the models I had used in my work. Her friend had pointed me out to her in the street, and had told her that I collected obscene photographs. She was referring to a collection of very fine photographic nudes that I had bought in Taormina, and that were pinned up on the walls of my studio. When she had met me in the museum of Etruscan jewels in Pope Julius' villa it had occurred to her to offer to sell me her collection, and this was why she had pursued me, hoping to catch my eye and surreptitiously show me her forbidden wares.

POPE JULIO'S VILLA

This crude misapprehension that I had been led to worried me for several days, for it seemed to me to be the symptom of some mental disturbance. I had in fact experienced in the last few months a regular epidemic of more and more alarming errors and confusions. I felt myself to be overtaxed, and Gala took me off into the mountains, close to the Austrian frontier. We settled down in Tre Croci near Cortina, in a lonely hotel. Gala had to go to Paris for twelve days, and I remained there all alone.

Just at this time I received tragic news from Cadaques. The anarchists had shot about thirty people, all of them friends of mine, and among them three fishermen of Port Lligat to whom we were very close. Would I finally have to make up my mind to return to Spain, and share the fate of those who were close to me?

I remained constantly in my room, with a real terror of catching a cold and falling ill up there all alone, without Gala. Moreover, the landscape of high mountains has never pleased me, and I developed a growing resentment against the Alpine outdoors: too many summits around me! Perhaps I would have to return to Spain. In that case I must take care of myself! For if this should happen I would want to have the maximum of my life at my disposal for the sacrifice. I set myself to watching over my health with a maniacal rigor. When I noticed an ever so slightly abnormal mucosity in my respiratory regions I would rush for the electargol and put drops in my nose. I would gargle with disinfectants after every meal. I would become alarmed over the least sign of a skin irritation, and was constantly putting salves on almost imperceptible pimples which I feared would develop malignantly in the course of the night.

During my returning insomnia I would listen for the non-existent pains that I was expecting and for the diseases that must be about to pounce on me. I would feel around my appendix for the slightest sign of sensitiveness. I scrupulously examined my stools, which I would wait for with my heart in my throat. Actually my bowel movements were regular as clockwork.

FROM HESSE, "TIERBAU UND TIERLEBEN" (TUEBNER)
DRAWINGS SHOWING THE MOVEMENTS OF A LEECH

For some five or six days I had noticed while I was in the very clean toilet a large piece of nasal mucus stuck to the white majolica wall close to where I sat. It was extremely repugnant to me, though I tried not to see it and to look elsewhere. But day after day the personality of this piece of mucus became more and more impossible to ignore. It was fastened to the white majolica with such exhibitionism, with such coyness, I might even say, that it was impossible not to see it and even not to look at it constantly. It seemed to be quite a clean piece of mucus, a very pretty, slightly greenish pearl gray, browner toward the centre.

This mucus ended in a rather sharp point, and stood out from the wall with a gesture that called stridently and with the trumpet-call of its insignificance for an act of intervention. It seemed to say to me, "All you have to do is to touch me, and I will let go and drop to the floor: that will put an end to your disgust."

But, armed with patience, I would get up impatiently from the toilet without touching the mucus's intact virginity, slamming the door in a fit of rancor and spite.

One day I could no longer stand it, and I decided to have done once and for all with the obsessing presence of this anonymous piece of mucus which with its loathsome presence was increasingly spoiling the satisfaction I derived from my personal stools. Screwing up my courage, I decided finally and irrevocably to wipe the mucus from the wall. In order to do this I wrapped up the forefinger of my right hand in toilet paper and, shutting my eyes and furiously biting my lower lip, with a gesture of savage violence into which I put the whole force of my soul exacerbated by disgust I tore the mucus from the wall.

But against my expectation this mucus was as hard as a tempered steel needle; and like a needle, it penetrated between the nail and the flesh of my forefinger, right to the bone! Almost immediately my hand became blood-soaked, and a violent, burning pain brought involuntary tears to my eyes. I went back to my room to disinfect my wounded finger with hydrogen peroxide, but the worst of it was that the lower and pointed part of the mucus had remained down inside my nail, so deep that I saw no way of getting it out. The sharp initial pain dwindled away, but soon it was replaced by that sub-sub-sub-rhythmic throbbing which I knew to be the perfidious and characteristic music of infection! Once the bleeding had stopped I went down into the dining room, pale as a ghost, and I explained the matter to the head waiter, who was always trying to engage me in conversation—which I habitually avoided by a dry and disagreeable tone of voice which admitted of no other response than silence. That day, on the other hand, my cowardice made me so human and communicative that he took advantage of it to pour himself out with all his stored-up effusiveness. He examined my finger closely.

"Don't touch it!" I cried. "Look at it without touching it. What do you think? Is it serious?"

"It seems to have gone quite deep, but it all depends on what it is— a splinter, a needle, what is it?" I did not answer. I could not tell him the frightful truth. I could not tell him,

"That blackish thing which has pierced the forefinger of my right hand is a piece of snot!"

No, no one would have believed that. That kind of thing happens to no one but Dali. What was the use of explaining, when the reality was verily that of a purple-tinged hand that was clearly beginning to swell? The whole hand of the painter Salvador Dali, which it would be necessary to cut off, infected by a piece of mucus—if indeed it did not

devour me entirely, after first reducing me to nothingness amid the spasmodic and abominable convulsions of tetanus.

I went up into my room and lay down on the bed, ready for every martyrdom. I spent one of the blackest and most sinister hours of my life. None of the tortures of the civil war could be compared in intensity with the imaginative torment which I endured during that frightful early Alpine afternoon. I felt death weigh within my hand like two ignominious kilos of gesticulating worms. I imagined my hand already separated from my arm, a prey to the livid first symptoms of decomposition. What would they do with my cut-off hand? Would they bury it? Are there coffins for a hand? It would be necessary to bury it, for it had already that "foul look" of corpses in an advanced stage of decomposition, looked at too often for the "last time," so that even those who are most loving and closest to the deceased have no other thought but to hide it with horror—for it is no longer he! It begins to frighten! It threatens to begin to move! One can't bear to look at it any longer! It is the imperialist unsepulchered cadaver which threatens one every moment with its tenacious swollen apparition, worse than anything one can imagine!

But even though it might be rotting, I did not want to separate myself from my hand! I could not resign myself to imagining it, when night had risen, far from me, finally shut up in the recipient in which struggled fetid gases corresponding to the progressive stages of decomposition of a corpse. I brought my hand to my mouth, and it was worse than if on the same spot someone had crushed the body of a monstrously heavy headless grasshopper!

I got up, maddened with moral suffering, drenched in the perspiration of death-agony, and I dashed to the toilet, where I got down on the floor on my knees to examine the rest of the mucus that ought to be still there. I did find it, and minutely examined it. No! It was not a piece of mucus! It was simply a drop of glue that must have fallen there, clinging to the majolica of the wall, at the time the painters had done over the ceiling of the toilet. The moment this was cleared up, my terror disappeared. I dug out the barb of hardened glue that had remained inside my fingernail with that strange attentive and voluptuous vertigo that had been masterfully immortalized in the famous piece of sculpture of the *Boy Extracting Thorn from His Foot*. Once I had removed the remnant of the "false mucus" from my finger, I immediately sank into a blissful heavy slumber.

When I awoke I knew that I should not leave for Spain.

I had already been there. And just as des Esseintes, the hero of Huysmans' *A Rebours,* had experienced the fatigue and the reality of his voyage to London before even beginning it, without moving from the station *bistrot* where he had imagined all the experiences of the travel and of his stay in London so powerfully that he could return home with the impression that he had made the whole journey,

just so I had just experienced a "civil war" in my own body, from which I had cut the very substantial piece of my own right hand.

Beings without imagination wearilessly undertake travels round the world; they will all need a whole European war in order to obtain a very vague idea of hell. All that I had needed, in order to descend into "hell," was a piece of mucus, and furthermore a piece of mucus that was not even real—a piece of false mucus! Besides, Spain that knew me and that knows me knows it: were I to die, and no matter how I died, even if I should die of a piece of mucus or of false mucus, I should always die for her, for her glory. For unlike Attila under whose footsteps the grass no longer grew, each bit of earth on which I set my feet is a field of honor.

CHAPTER FOURTEEN

"ornamental inquisition"

Paul Eluard had formulated the heraldic device, "To Live by Errors and Perfumes." After my "error" with the false actress, and the error with my false mucus, I experienced the imponderable perfume of clairvoyance It was as though by a curious law of psychic compensation the more I was mistaken in the world of immediate things that surrounded my daily and practical life, the more I "saw" at a distance and even into the future.

We had just rented a villa surrounded by cypresses, near Florence, where I had recovered a relative calm. Mademoiselle Chanel, who was my best friend, was at this time travelling in Sicily. One evening I had the sudden and gratuitous idea that Chanel had been stricken with fever. I immediately wrote her saying, "I have a terrible fear that you are suffering from typhus." The following day I received a telegram from Missia Sert informing me that Chanel was seriously ill in Venice. I rushed to see her! It was indeed a paratyphoid V, with high steady fevers which stubbornly resisted treatment. In these circumstances the memory of Diaghilev's death in Venice terrified us all.

On her night-table was a large painted shell which had been given her in Capri as a present. I had always associated the island of Capri with a "great fever." Often I had said, "In Capri the landscape always suffers from 'horse fever.' Capri should be cured of its grottoes." I ordered the Capri shell to be immediately removed from the room, and then made the experiment of taking Chanel's temperature. It had gone down to almost normal. Since then I have always been obsessed by this question: was there a Capri shell on the night-table when Diaghilev died?

I believe in magic, and am convinced that all new efforts at cosmogony and even metaphysics should be based on magic, and should recapture the state of mind that had guided brains like those of Paracelsus and Raymond Lully. The critical-paranoiac interpretation of the images that involuntarily strike my perception, of the fortuitous events that occur in the course of my days, of the so frequent and so violent phenomena of "objective hazard" that cast enigmatic rays of light over the most insignificant of my acts—the interpretation of all this, I repeat, is nothing other than the interpretative reading, which is capable of giving an objective coherence to the signs, omens, avatars, divinations, presentiments and superstitions which are the very sustenance of all "personal magic."

But if I myself am able during short periods to read quite clearly the exact outcome of certain nearby events, Gala on the other hand is a true medium in the scientific sense of the word. Gala is never, never, never wrong. She reads cards with a paralyzing sureness. She predicted to my father the exact course of my life up to the present moment. She foretold the illness and suicide of René Crevel, and the very day of the declaration of war on Germany.

She believes in my wood—a piece of wood that I found at the beginning of our acquaintance among the rocks of Cape Creus, under extraordinary circumstances. Since then we have never been without this "pure Dalinian fetish," though we have lost it on several occasions. Once we lost it in Covent Garden in London, and found in again the next day. Another time it had been taken out with the bed sheets. It was necessary to go minutely over the whole laundry of the Hotel St. Moritz, yet we finally found it. This piece of wood has assumed in my mind the form of a compulsive maniacal neurosis. When I get the idea that I ought to go and touch it, I cannot resist doing it. At this very moment I am forced to get up to go and touch it . . .

There! I have just touched it, and with this my anxiety, which other-
wise would only have grown agonizingly, has been calmed. Before the
compulsive maniacal psychosis that now is exercised exclusively in con-
nection with my piece of wood, I was full of manias, tics, and neurotic
rituals that were extremely cumbersome. My ritual for going to bed,
for instance, was very long and minute. Everything in my room had to
be placed in a certain pre-determined way—the door opened at just a
certain angle, my socks symmetrically arranged on a certain exact part
of the armchair, always the same. The slightest infraction of these rituals
would make it necessary for me to get up out of bed to rectify it, even if
this was extremely disagreeable to me, and if I had to get up several
times. Since I found my piece of wood in 1931 I have been freed of all
my manias and rituals. I have been able to do everything as I have wished,
provided only that each time I think of it my wood-fetish[1] is there with
me. In any case my piece of wood is there, there, and there! It is my
prayer . . .

The September equinox was going to bring us the Munich crisis. In
spite of the fact that Gala's cards had predicted that war would not "yet"
come this time, we prudently left Italy and spent the Munich crisis in La
Posa, on the hills of Monte Carlo, with Mademoiselle Chanel, constantly
glued to the radio. This "equinox" was to last four months, during
which I remained at Chanel's in the company of the great French poet,
Pierre Reverdy, whose terribly elemental and biological Catholicism made
a deep impression on me. Reverdy is the integral poet of the generation
of cubists. He is the soul possessing the most violent and finest set of
teeth I have ever known, and has that gift, which is so rare, of spiritual
anger and rage. He was "massive," anti-intellectual, and the opposite of
myself in everything, and provided me a magnificent occasion to
strengthen my ideas. We fought dialetically like two Catholic cocks, and
we called this "examining the question."
During this period I was preparing my forthcoming exhibit in New
York, writing the general plan of my "secret life" and painting *The
Enigma of Hitler*, a very difficult painting to interpret, whose meaning
still eludes me. It constituted a condensed reportage of a series of dreams
obviously occasioned by the events of Munich. This picture appeared
to me to be charged with a prophetic value, as announcing the medieval
period which was going to spread its shadow over Europe. Chamber-
lain's umbrella appeared in this painting in a sinister aspect, identified
with the bat, and affected me as extremely anguishing at the very time
I was painting it . . .

On my arrival in New York I was astonished by the window displays
on Fifth Avenue, which all were trying more or less to ape Dali. I

[1] Fetish: a tangible, objective and symbolic materialization of desire; by sublimation,
a wish, a "prayer."

immediately received another proposal from Bonwit-Teller's shop asking me to dress two of their windows. I accepted, for I thought it would be interesting to make a public demonstration of the difference between the true and the false Dali manner. I laid down only one condition: that I be allowed to do exactly what came into my head. This condition was accepted, and I was put in touch with the man who was in charge of their window displays, a Mr. Lee, who was at all times extremely obliging.

I detested modern manikins, those horrible creatures, so hard, so inedible, with their idiotically turned-up noses. This time I wanted flesh, artificial flesh, as anachronistic as possible. We went and unearthed in the attic of an old shop some frightful wax manikins of the 1900 period with long natural dead women's hair. These manikins were marvelously covered with several years' dust and cobwebs. I said to Lee, "Be sure not to let anyone touch that dust, it's their chief beauty. I'm going to serve these manikins to the Fifth Avenue public as one serves an old bottle of Armagnac that has just been brought up from the cellar with infinite precautions." With great care we succeeded in transporting them almost in the state in which we had found them. I knew that their state was going to make a startling contrast with the frame of padded satin and mirrors that I had thought up.

The theme of the display was intentionally banal. One of the displays symbolized Day, and the other, Night. In the "Day" display one of these manikins was stepping into a "hairy bathtub" lined with astrakhan. It was filled with water up to the edge, and a pair of beautiful wax arms holding up a mirror evoked the Narcissus myth; natural narcissi grew directly out of the floor of the bedroom and out of the furniture. "Night" was symbolized by a bed whose canopy was composed of the black and sleepy head of a buffalo carrying a bloody pidgeon in its mouth; the feet of the bed were made of the four feet of the buffalo. The bedsheets of black satin were visibly burnt, and through the holes could be seen artificial live coals. The pillow on which the manikin rested her dreamy head was composed entirely of live coals. Beside the bed was seated the phantom of sleep, conceived in the metaphysical style of Chirico. It was bedecked in all the sparkling jewels of desire of which the sleeping wax woman was dreaming. This manifesto of elementary surrealist poetry right out in the street would inevitably arrest the anguished attention of passers-by with stupor when the morrow, amid so much surrealist decorativism, lifted the curtain on an authentic Dalinian vision.

On leaving the Metropolitan Opera, where we had attended a performance of *Lohengrin*, Gala and I went to Bonwit-Teller's, where my two displays were being set up. I thought up on the spot a whole series of new lyric inventions, and we stayed to put the finishing touches to the two displays till six o'clock in the morning. Gala had completely torn her dress in the ardor of nailing and hanging false jewels everywhere. Dead tired, we went to bed.

The following day we had a large luncheon affair to attend, and it was only around five o'clock that we decided to go and see the effect of my displays. Imagine my anger when we discovered that everything, absolutely everything, had been changed, without my even having been accorded the courtesy of being informed of it! The wax manikins had been replaced by the shop's conventional manikins; the bed and its sleeping occupant had been removed! Of my idea there remained only the satin-padded walls—in other words, what I had put in as a joke! Gala understood by my pallor and by the sobriety of my reaction that I had suddenly become dangerous.

"Go and talk to them," she begged me, "but be reasonable; let them remove all that rubbish, and let's forget about it!"

She went back to the hotel, for she felt that any kind of advice at this moment would only exasperate me. I went up to the management of Bonwit-Teller's where, after having been made to wait in a corridor a good fifteen minutes, I was received by a gentleman who expressed his happiness at knowing such a great artist as myself. I then told him, through an interpreter, and with the greatest politeness, that I had just observed on passing by in the street that my work had been changed without my being advised, that I therefore wished my name to be removed from the display and this display completely changed, for the adulteration of my work could only harm my reputation. The gentleman answered that they had the right to keep "what they had liked" of my ideas, and that it would be awkward for the store to lower the shades in broad daylight to make the changes that I requested. These changes actually would not have required more than ten minutes, and I was about to give a practical demonstration of the fact that the whole thing could be done in one second. The rude manner in which my reasonable and legitimate request was answered instantly led me to deliver an ultimatum, and I announced to the gentleman that I *demanded* the removal of my name and of the parts of my display that still remained in the windows. "If this is not done within ten minutes," I said, "I shall take drastic action."

I had just decided exactly what I would do. I was going to go down, enter the display room, and upset the bathtub filled with water. With

the place inundated, they would certainly be forced to lower the shade and take everything out. This appeared as the sole solution, for the idea of starting a suit against Bonwit-Teller struck me as childish.

The gentleman explained to me that they had changed my displays because they had been too successful; that there had been a constant crowd gathered around them which blocked the traffic; and that now they were just right, and that he would not for the world remove them after all the expense they had gone to.

I bowed my head with the utmost correctness and walked out, leaving each of the two gentlemen wearing a smile expressive of the most complete scepticism. I went down to the main floor and very calmly headed for the display-window where the bath-tub stood and stepped inside. I paused for a moment to savor the act I was about to commit, and looked through the window at the bizarre crowd which at this hour literally inundated the sidewalks of Fifth Avenue. There must have been something very unusual about my apparition in the window, for a large crowd gathered to watch me.

I took hold of the bath-tub with both hands, and tried to lift it so as to turn it over. I felt like the Biblical Samson between the pillars of the temple. The bath-tub was much heavier than I had calculated, and before I could raise one side it slipped right up against the window so that at the moment when with a supreme effort I finally succeeded in turning it over it crashed into the plate glass, shattering it into a thousand pieces. The crowd immediately fell back in a wide semicircle with a movement of instinctive terror, dodging the glass-splinters and the water from the bath-tub which now was spilling onto the sidewalk. Then I coolly appraised the situation and judged it much more reasonable to leave by the hole in the window bristling with the stalactites and

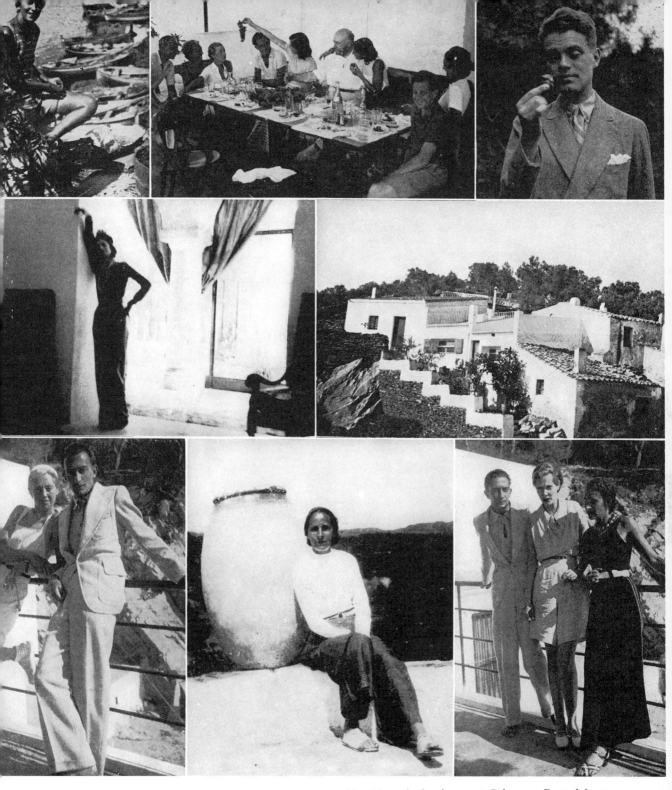

XV. Last Days of Happiness in Europe

The Homeric luncheons at Palamos. From left to right: Charlie Bestegui, Roussie Sert, Bettina Bergery, Salvador Dali, Countess Madina Visconti, Jose-Maria Sert, Gala Dali, Baroness von Thyssen, Prince Alexis Mdivani.

René Crevel, observing a snail, foreshadows the distress felt in Europe when he committed suicide.

My best friend, Mademoiselle Chanel, at Rochebrune.

House of Salvador and Gala Dali at Port Lligat.

Roussie Sert and Dali at Palamos.

Gala: The Olive.

Dali, Princess Nathalie Paley, and Gala at Palamos.

Gala in sailor costume at Cadaques, the day she caught 15 lobsters in a single morning.

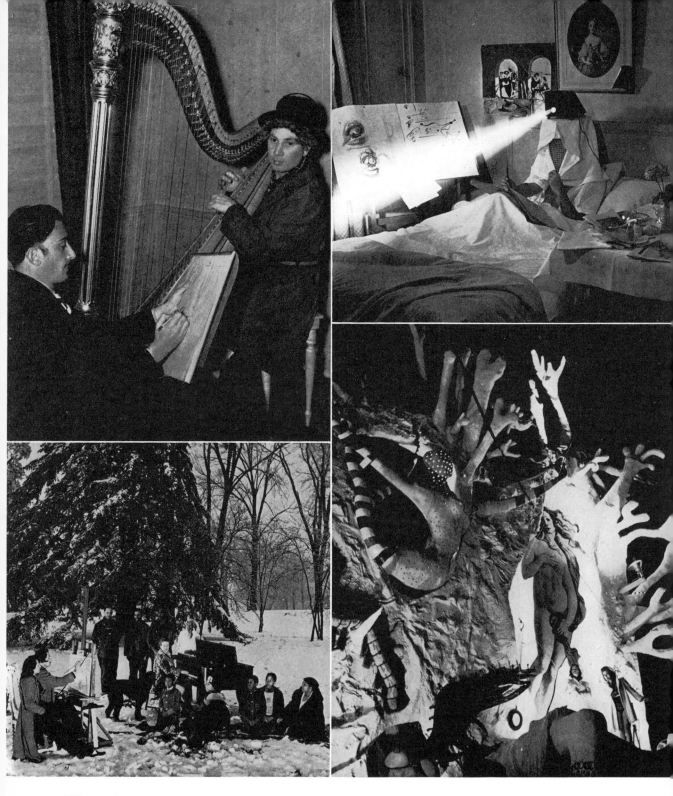

XVI. My Heteroclite Life in America

I draw Harpo Marx in Hollywood.
I invent a hallucinatory mask, during breakfast in bed
at the Hotel St. Regis in New York.

At Caresse Crosby's place in Virginia, a black piano,
black dogs, and black pigs are assembled on the snow,
and negroes sing while I work. Caresse is at the
piano. (Courtesy Eric Schaal-Pix.)
Based on my plans, "The Dream of Venus" is con-
structed at the Amusement Park of the World's fair
in New York. (Courtesy Eric Schaal-Pix.)

the stalagmites of my anger than to go back through the door in the rear of the shop window. Barely had I jumped through the frame and landed on the sidewalk than a large piece of glass which must have held up by a miracle became detached and cut down across the space I had just passed through—and it was another miracle that I was not guillotined by it, for judging by its dimensions and weight it might very easily have split my head wide open.

Having reached the sidewalk, I slipped on the coat that I was carrying over my arm, for the air was sharp and cool and I was afraid of catching cold. With a slow step I headed for my hotel. I had only gone some ten paces when an extremely polite plainclothesman delicately placed his hand on my shoulder, and explained apologetically that he had to arrest me.

Gala and my friends came running to the station to which I was taken, and my lawyer presented me with two alternatives: I could either be immediately released on bail, and the trial would take place much later; or if I preferred, I could remain for a short time in jail, together with the other people who were being held, and then my case would come up within a few hours. I was anxious to have this matter over with as soon as possible, and decided on the second alternative.

The promiscuity in which I was forced to live with the other prisoners terrorized me. Most of them were drunks and professional bums, who vomited and fought among themselves with an admirable optimism. I kept running from one corner to another to escape the spatterings of all that swarming ignominy, and my distress must have been noticed by a small gentleman loaded with rings and gold chains which hung ostentatiously from all his pockets, and whom in spite of his slight stature and his effeminate look all those brawny, two-fisted fellows seemed to respect.

"You're Spanish," he said to me, "I can see that right off. I'm from Puerto Rico. Why are you here?"

"I broke a window," I answered.

"That's nothing. They'll fine you a few dollars, and that's all. It was a saloon, wasn't it? In what part of town did you break the window?"

"It wasn't a saloon, it was a shop on Fifth Avenue."

"Fifth Avenue!" exclaimed the small gentleman from Puerto Rico, in a manner indicating that I had suddenly risen in his estimation. Immediately taking me under his protection he added, "You can tell me all about it later. Right now stay close to me and don't be afraid of anything. Nobody'll touch you while you're here."

He must certainly have been an important figure in these circles.

The judge who tried my case betrayed upon his severe features the amusement that my story afforded him. He ruled that my act was "excessively violent" and that since I had broken a window I would have to pay for it, but he made a point of adding emphatically that every artist has a right to defend his "work" to the limit.

The following day the press reacted, giving me a warm and moving proof of its sympathy, and I received a shower of telegrams and letters from artists and private individuals all over the country, telling me that by my act I had not only defended my "personal case" but also that of the independence of American art, too often subjected to the incompetence of intermediaries of an industrial and commercial type. I had thus unintentionally touched one of the country's open wounds.

Immediately after I had broken my Bonwit-Teller window, I received an offer to do "another one," entirely to my taste—a monumental one, that would not have to be broken, in the New York World's Fair which was to open in another month and a half, and I signed a contract with a corporation,[1] a contract which appeared to me unequivocally to guarantee my "complete imaginative freedom."

This pavilion was to be called *The Dream of Venus,* but in reality it was a frightful nightmare, for after some time I realized that the corporation in question intended to make *The Dream of Venus* with its own

... *Furniture* .

imagination, and that what it wanted of me was my name, which had become dazzling from the publicity point of view. I still did not speak a word of English, and the whole struggle to impose the least of my ideas had to be carried out through my secretary, who sweated blood! Each day there was a new explosion. I had designed costumes for my swimming girls executed after ideas of Leonardo da Vinci's, and instead of this they constantly kept bringing me horrible costumes of sirens with rubber fish-tails! I realized that all this was going to end up in a fish-tail—that is, badly. I explicitly stated a thousand times that I would not hear of those sirens' tails that the corporation wanted at all costs to impose on me, claiming that I did not know the psychology of the

[1] In French, *société anonyme,* which explains Dali's subsequent play on the word "anonymous."—*Translator's note.*

American public. I shouted, I lost my temper—all through my secretary. The sirens' tails would disappear for a while and suddenly they would reappear, like the bitter after-taste of some greasy and indigestible foods.

Realizing that the explanations and the letters of protest that my secretary typed every evening to the point of exhaustion were becoming more and more ineffective, I told him to stop all these explanations, and to buy me a large pair of scissors. I appeared the following morning in the workshop where *The Dream of Venus* was being set up. My contract granted me the supreme right of supervision, and I was going to use and abuse this right with the challenging force of my scissors. The first thing I did was to cut open, one after another, the dozen sirens' tails intended for the swimming girls, thus making them totally unusable. After this I attacked the fluorescent gold and silver wigs which I had not called for either—a wholly gratuitous and anonymous fantasy of the corporation's. I cut them into braids which I dipped in tar, to be stuck to umbrellas turned inside out which were to line the ceiling of the pavilion. Thus these umbrellas appeared as if covered with a lugubrious Spanish moss in mourning. After having transformed the wigs of the sirens into Spanish moss, I used my scissors, which were but the cutting symbol of the vengeance of my personality, to cut, snip, puncture and annihilate everything, sticking them finally right into the heart of the "anonymous" corporation, which in the end cried "Ay!" and raised its arms in sign of surrender.

Resigned, they agreed to do whatever my royal will commanded them. But my struggles were not over, for sabotage was about to begin. They did "approximately" what I ordered, but so badly and with such bad faith that the pavilion turned out to be a lamentable caricature of my ideas and of my projects. I published on this subject a manifesto: *Declaration of Independence of the Imagination and of the Rights of Man to His Own Madness* (New York, 1939), to rid myself of the moral responsibility for such an adulterated work, for it was not possible to break the windows a second time (in spite of the fact that, given the dimensions of the swimming pool in which my exhibit was placed, this was tempting, and would have produced a fine effect, with the flooding of the entire pavilion).

I left for Europe, disgusted with *The Dream of Venus,* long before it was finished—so that I never did see my work completed. I was to learn subsequently that no sooner had I left than the corporation took advantage of my absence to fill *The Nightmare of Venus* with the anonymous tails of anonymous sirens, thus making what little was left of Dali perfectly anonymous.

On the *Champlain* that took me back to Europe I had time to revise and situate more philosophically my feelings of admiration for the elementary and biologically intact force of "American democracy," an admiration often expressed in a fervent and lyrical form in the course

of this book, and which the unfortunate circumstances of my recent voyage had in no way affected. On the contrary, for where one may dialogue with open scissors in one's hand there is healthy flesh to cut and liberty for all sorts of famines. Unfortunately Europe, to which I was returning, was already exhausted with its masturbatory and sterile self-refinement; and the failure to synthesize the ideological contradictions of which it had become the speculative grazing-ground already predisposed it to the unique solution of war and defeat.

On my return trip to France on the *Champlain* I had time, besides, to reflect on that other, more hidden, America—that of certain solitary and lucid intelligences who had already given us Europeans repeated lessons of "transcendent didacticism." The discrimination revealed by certain museums and certain private collections was in effect a decisive proof that, far from the sceptical eclecticism of Europe, there is already forming in America, as in no other country, a fore-air of thesis and synthesis. James Thrall Soby, with whom I had just tightened the intellectual bonds that had joined us on my first voyage to America, had as it happened been the first to make an ideological grouping of esthetic values according to Picasso, under the manifest sign of the pitiless exclusion of abstractionism and of non-figurative art, fusing in a desire for integration and interpretive synthesis the aspirations toward a "renaissance" latent in the ultra-figurative sector of paranoiac surrealism and neo-romanticism. It was obvious, but it had to be "classified." The Bérard-Dali axis was infinitely more "real," spiritually speaking, than that of the superficially surrealist affinities which linked surrealist individualities among themselves by the conventional links of the sect. And Eugene Behrman's paintings, "romantic with classicism," [1] became authentically mysterious and had a quality of imagination infinitely superior to that of my literal followers, the "official surrealists." Soby's intellectual platform was very similar to that which Julien Levy, in a parallel way, with the weapons of action in his hands, had resolutely adopted, evident in the spiritual direction toward which he guided the activity of his gallery from the beginning—that of hierarchy and synthesis. Soby had also been among the first to consider "critical paranoiac activity" as destined to succeed the excitement over automatic experiments which was wearing itself out in a boring repetitiveness and in an exasperating and interminable marking of time.

I had a sad confirmation of this interminable marking of time when upon my arrival in Paris I learned that the surrealist group had found nothing better to do during my absence than to set up the weariless continuation of the more or less flying small beans of pure automatism in opposition to my new search for the esthetic hierarchization of irrational imagination. The answer to my hierarchization was a surrealist exhibition in which the entries were arranged according to the perfectly collectivist criterion of the order of the alphabet! It really was not neces-

[1] Or "romantically classic."

sary to have gone to such lengths to revolutionize everything from top to bottom in order at last to come to the point of adopting such an arrangement! I have never succeeded in learning the alphabet by heart, and when I need to look up something in the dictionary all I have to do is to open it at random, and I always find what I am looking for. The order of the alphabet is not my specialty, and I have had the gift of always being outside it. I was going, then, to put myself outside the order of the alphabet of surrealism, since, whether I wished it or not, "I was surrealism."

As with everything else, my *Mad Tristan,* which was my best theatrical work, "could not be played," and became transformed into the *Venusberg,* and the *Venusberg* into the *Bacchanale,* which became its definitive version. This was a ballet that I had invented for the Monte Carlo Russian Ballet. I got along very well with Leonid Massine, who had been a hundred per cent Dalinian for a long time—it was precisely he who was predestined to do the choreography of the *Dance of the Crutches.* Prince Chervachidze, who with the Vicomte de Noailles is the purest representative of the authentic aristocracy of Europe, executed my stage sets with a professional conscience hardly deserved by our gimcrack modern epoch, always in a hurry and lacking in scrupulousness, in which everything is half done and badly done. I also had the good fortune to have Chanel take upon herself the designing of the costumes. Chanel worked on my show with a wholehearted enthusiasm and created the most luxurious costumes that have ever been conceived for the theatre. She used real ermine, real jewels, and the gloves of Ludwig II of Bavaria were so heavily embroidered that we felt some anxiety as to whether the dancer would be able to dance with them on.

But once more the work was to fail. The moment the war broke out the ballet company hurriedly left for America before Chanel and I had finished our work. In spite of the cables we sent to try to delay the performance the *Bacchanale* appeared at the Metropolitan with improvised costumes, and without my having seen even a single rehearsal! Nevertheless it was, it appears, an immense success.

l'unique chose qui: est
de ce projet est la petite
montagne du fond!

First project for the decor of
"Venusberg" — never realized
because of its high cost, and turned
later, into a decor for "BACCHANALE"

The European war was approaching. The enervating adventures of our recent voyage to America had exhausted Gala and myself, and we decided to go off for a rest to the Pyrenees, close to the Spanish frontier, where we stopped at the Grand Hotel in Font-Romeu. "To rest," for me, meant to begin immediately to paint twelve hours a day instead of resting. The apartment for which I had made a reservation, and in which I planned to set up my studio, as it was the best in the hotel, had just been occupied by the Chief of Staff of the French army, General Gamelin, who had arrived unexpectedly on an inspection tour of the frontier fortifications. We therefore had to wait impatiently for Gamelin to leave before we could occupy his room, which we did without a moment's delay. The evening when I got into General Gamelin's bed with Gala, she read the cards before we went to sleep, and saw the exact date of the declaration of war. The clothes that we had left on the armchair in disorder cast upon the wall the shadow of an impressive silhouette, which was exactly the profile of General Gamelin. A bad omen!

The mobilization occurred, and the Grand Hotel was shut down.

Back in Paris I examined the map of France, I studied my winter campaign, trying to plan it in such a way as to combine the possibility of a Nazi invasion with gastronomical possibilities, for in Font-Romeu the food was rather bad, and I was possessed by a frenzy for appetizing dishes. I finally put my finger as close as possible to the Spanish frontier and at the same time on a neuralgic point of French cooking: Bordeaux. That would be one of the last places the Germans reached if, as seemed to me highly improbable, they should win. Moreover Bordeaux naturally meant Bordeaux wine, jugged hare, duck liver *aux raisins,* duck *aux oranges,* Arcachon claire-oysters . . . Arcachon! I've got it! That is exactly the spot, a few kilometres from Bordeaux, to spend the war-days.

Three days after our arrival in Arcachon the war was declared, and I began to set up my studio in a large colonial-style villa, overlooking the famous Arcachon ornamental lake, which we rented from Monsieur Colbet.

Monsieur Colbet had what was probably the world's greatest capacity for talking. I had proof of this during the period when Mademoiselle Chanel came to visit us, for until then I thought it was Chanel who was the most tireless talker. One evening, before a dish of fried sardines and a glass of Medoc, I got little "Coco" (which is what her intimate friends call Mademoiselle Chanel) and Monsieur Colbet together to see which could outdo the other. The struggle lasted, and remained undecisive, for over three long hours, but toward the end of the fourth hour Monsieur Colbet began to get the upper hand, and finally triumphed. His victory was due chiefly to his respiratory technique. His way of breathing while he talked was simply astonishing, for even in the most heated

moments he did not for a second abandon that even and unalterable rhythm of inhaling and exhaling characteristic of those who are determined to go a long way. **Coco**, on the other hand, would from time to time let herself be caught in the trap of her own eloquence and have to stop for a second or two to take a deep breath—aaahhh! It was then that Monsieur Colbet would perfidiously push home his advantage and continue imperturbably the thread of his story, somewhat frayed up to that point, and at the same time veer the conversation in the direction of themes and questions in which he felt that Mademoiselle Chanel was growing increasingly unsteady. When termites came up for discussion, for instance, Chanel lost her footing, not having sufficiently definite opinions on the subject. Then Monsieur Colbet would go boldly ahead and pour forth tons of anecdotes drawn from personal experiences during his African travels. One felt that he was capable of pursuing this theme for the whole rest of the night.

Vertical Infantry, as against horizontal infantry; means of winning a battle by the unexpected use of stilts of the Landes country
Salvador Dalí

With all this, the German troops were opening up one front after another. Coco was like a white swan, her thoughtful brow slightly bowed, moving forward on the water of history which was beginning to flood everything, with the unique elegance and grace of French intelligence. All that is best in what France possesses in the way of "race" can be found in Coco. She could speak of France as no one else could; she loved it body and soul, and I knew that no matter what befell her country she would never leave it. Coco was, like myself, one of the living incarnations of Post-War Europe, and the evolution of our two spirits had been very similar. During the fortnight that Mademoiselle Chanel spent with us at Arcachon all the themes, human and divine, were again gone over in the course of our interminable conversations which the war had

invested with a new rigor of exacting originality, for one would have to begin to look upon form in a wholly different way.

But her originality was the opposite of mine. I have always either shamelessly "exhibited" my ideas, or else hidden them with a refined jesuitical hypocrisy. Not she: she does not exhibit them, nor does she hide them. She dresses them. The sense of clothes had in her a biological significance of self-modesty of a mortal and fatal violence. What Ludwig II of Bavaria dresses Chanel must have designed to "dress," for formal occasions and for street-wear, the young and hard bitterness of her unavowed sentiments! Her sense of fashion and of costume was "tragic" —as in others it is "cynical." Above all Chanel was the being possessing the best dressed "body and soul" on earth.

After Coco, Marcel Duchamp came to see us. He was terrorized by those bombardments of Paris that had never yet taken place. Duchamp is an even more anti-historic being than I; he continued to give himself over to his marvelous and hermetic life, the contact with whose inactivity was for me a paroxysmal stimulant for my work. Never had I worked so hard, or with such a burning sense of intellectual responsibility, as during this war, at Arcachon. I delivered myself over body and soul to the struggle of technique and of matter. It became alchemy. I was seeking that unfindable thing, the medium to paint in, the exact mixture of amber oil, of gum, of varnish, of imponderable ductility and of super-sensitive materiality by virtue of which the very sensibility of my spirit could at last materialize itself. How many times I have spent a sleepless night because of two drops too many erroneously poured into my painting medium! Gala alone was a witness to my furies, my despairs, my fugitive ecstasies, and my relapses into the bitterest pessimism. She alone knows to what point painting became for me at this period a ferocious reason for living, while at the same time it became an even more ferocious and unsatisfied reason for loving her, Gala, for she and she alone was reality; and all that my eyes were capable of seeing was "she," and it was the portrait of her that would be my work, my idea, my reality.

But in order to achieve this portrait of my Galarine, as I called her, I would perhaps have to die of fatigue like a real Catholic donkey, and half rotten—as I already was—a donkey on his last legs from carrying alone on his back covered with sores bronzed with imitative flies the whole weight of deficiencies, nothingnesses and revolutions of our sceptical, formless and traditionless epoch!

And from the problems of the physical kitchen of technique, I fell back into that "all" that was the spirit of Leonardo—all, all, all. Cosmogony, cosmogony, cosmogony! The conquest of all, the systematic interpretation of all metaphysics, of all philosophy, and of all science, according to the fund of Catholic tradition which alone the rigor of the critical-paranoiac method would be capable of reviving. Everything remained to be integrated, to be architectonized, to be morphologized. It was kill-

ing! And Gala alone enabled me to live. She collected Bordeaux wines; she took me in the company of the painter Leonor Fini, whose esthetic torments gave me a little relief, to dine at the Château Trompette of Bordeaux or to the Chapon Fin. She would put a mushroom *à la Bordelaise* fragrant with garlic on the tip of my tongue, and say to me, "Eat!" "It's good!" I would exclaim, while my brain did not cease to hammer, Cosmogony, cosmogony, cosmogony! And at times a tear would well into my eye, the product of just the right mixture of cosmogony and garlic.

Beside all this the European war appeared to me like an episodic children's fight on a street-corner. One day, nevertheless, this fight began to make too much of an uproar and became too real because of those big, happy and taciturn children of the German troops who were already very close, and who arrived in fairy-tale armored carriages covered with childish drawings and camouflaged with branches. I said to myself, this it getting too historical for me; and in a rage I stopped painting the picture I was in the midst of, and we left.

In Bordeaux we spent a sinister day, that of its first bombardment, and we entered Spain two days before the Germans occupied the international bridge of Hendaye. Gala left directly for Lisbon, where I was to meet her as soon as my documents were in order, in order to arrange our trip to America, which appeared to bristle with red tape of a superhuman refinement.

From Irún I went to Figueras—that is to say, I crossed the whole of Spain. I found my country covered with ruins, nobly impoverished, with faith in its destiny revived, and with mourning engraved with a diamond in every heart.

"Knock, knock!"

"Who goes there? Who is knocking?"

"It is I."

"Who?"

"I, Salvador Dali, your son."

That is how I knocked at my father's door in his house of Cadaques, at 2 o'clock one morning. I embraced my family—my father, my aunt, and my sister. They prepared anchovies, sausage, and tomatoes sprinkled with oil for me. I chewed my food, stupefied and terrorized: for I saw no traces of the revolution.

"Nothing had changed" in eleven years, and everything had remained the same in spite of the three years of civil war and revolution! Oh, the perennity, the force, the indestructibility of the real object! The unfathomable violence of tangible and formal things, to the detriment of history; the terrorizing and permanent power of the "material concrete" over the vain ephemeral of ideological revolutionism!

The night that I spent in Figueras I thought I was dreaming wide awake. Before going to sleep I walked for a long time back and forth in

my room, the one I had lived in before I was banished from my house, which was the same one that I had lived in as a child. There, too, everything was exactly as it had been before. Moved to tears, I went over to a little secretary-cabinet in cherry wood that I knew by heart. I touched its heart. Its heart, let me explain, was a little system of pigeon-holes which was probably intended for writing-paper and envelopes, but as this cabinet was never used to write on, these pigeon-holes always remained empty except for a bottom compartment, where the hand could barely reach with the tips of its fingers. There one could always find the same kinds of objects—one or two indeterminate keys, buttons, a five-*centimo* piece that was indented, as if it had received a blow (the convexity thus created having formed a hump on the other side that was pointed and shiny like an incipient metal boil), safety pins, purplish wads of dust, and perhaps a tiny ivory rabbit or some other small carved object, preferably of ivory and always broken, with a bit of the glue used to mend it covering and going beyond the edge of the mutilated surface, which bristled with tiny very black and shiny hairs, all sticky, giving to the ivory object an appalling appearance of dirtiness and of irremediable repugnance. I knew from experience that even when my mother, who had a passion for cleanliness, managed to empty and remove even the last speck of dust from the bottom of that little grilled balcony other objects, but always of the same kind, and the same kind of purplish wads of dust, would immediately reappear in the same place. Thus it was with a beating heart that I slipped my hand into the depth of the mysterious heart of this secretary-cabinet, and with the tips of my fingers I immediately felt the exact contact of everything I expected. Everything was there: the two or three keys, one of them rusty, the other smaller, very shiny; the safety pins. With the tips of my fingers I successfully caressed the buttons, the little conical relief of the humped five-*centimo* coin, the broken ivory carving which I felt to be sticky at the point of its regulation scar, dirty as it should be with little black and shiny hairs. I pressed between my fingers several of those little wads of dust, of a deep purplish color, and taking them close to the light which continued to shine on them with the same wanness as during the convalescences of my childhood, I examined them attentively. This wad of dust was stronger than anything, because it was outside of history; it was the very dynamite of time, capable of making history itself blow up, the violet flower of tradition!

I turned round. I knew that behind me a reproduction in a round frame, above the bed, concealed a round moisture stain in this same spot. When I was small I would sometimes lift up this painting, and almost always a little spider would come running out. I tried this now. The spot had disappeared, but a little spider scurried out, exactly as when I was a small boy.

It is true that my sister had been tortured by the C.I.M.[1] and driven

[1] A military intelligence committee that functioned during the terror in Barcelona.

to insanity, but she was already completely cured. It is true that a bomb had ripped a balcony from our house, but no one had ever looked precisely at that balcony before. It is true that the floor tiling in our dining room was all blackened by the fire that the anarchists had made when they would cook their meals right in the middle of the room, but this was just the spot where the large dining table stood, and to see this damage it was necessary to move the table which, though it vanished for two months, was found again twenty kilometres from Figueras, at a dentist's. Like the film of a destructive catastrophe run in reverse, after the revolutionary explosion everything, as by enchantment, returned to its original and traditional place. The piano, which was thought to have disappeared forever, "existed." And little by little it returned to the place of its origin. One morning it was back once more where it belonged! Everything became again as before! It was as if the process of "becoming" obeyed the physical laws of the serene traditional surfaces of the metaphysical lakes of history, which after each upheaval resumed their identity, thus contradicting the very principles of the Hegelian dialectic, while the concentric circles of the illusory waves of human progress, though appearing to grow, were in reality only consummating their own oblivion upon the far-flung shores of human destiny, making the territorial and mechanical eye forget the traceless traumatism of the stone of the invisible and already forgotten revolution which when it was thrown seemed capable of splashing heaven itself with its heterogeneous agitation. And if Heraclitus was right in claiming that one cannot bathe twice in the same stream, Dali is just as right in claiming

Fig. 1. — La crevette-cythèle.

that the stagnant water of the lakes of tradition, unlike a river, does not have the slightest need to stir or to run anywhere in order to reflect the eternal originality of heaven, or to rot with dignity and without heaven, if need be . . .

Before leaving Paris I met a childhood friend, who had been a revolutionary all his life. For years he had bitterly struggled as a fervent terrorist to establish the Spanish Republic. During the Civil War he fought like a lion without respite up to the last moment among the anti-fascist

militias. A refugee in Paris, without money, hovering on the edge of ill-health, he was relinquishing his non-conformist canon. He had not yet lost hope for Spain. He said to me, lowering his voice confidentially as if under the painful constraint of a confession that cost him dearly and that he had paid for with blood which did not belong to him,

"What our country needs is to do away with Franco and become a constitutional monarchy again!—A king!" exclaimed this man who had been a sincere revolutionary during his whole life.

I also knew some painters who were terribly revolutionary, smashers of all the plaster moulds of academic tradition, who in the more reflective age of their graying hairs were beginning—too late—to apply themselves shamefully and secretively to drawing as academically as they were capable of doing, from the plaster molds broken during the irresponsible iconoclasm of their youth.

But Dali is not of those either. Dali is not returning to anything, he does not renounce anything, for instead of denying even that Revolutionary Post-war Period which he denounces, which he hates and fights, he wants to affirm and "sublimate" it, because it was reality and because the very lack of tradition of that period is in itself a tradition to be integrated into the period that will follow. For Cosmogony is an "exclusive whole." Cosmogony is neither Reaction nor Revolution—Cosmogony is Renaissance, hierarchized and exclusive knowledge of everything.

The day after my return to Cadaques I embraced the heroic Lydia, "a Ben Plantada," who had survived everything. Her old age was still "well planted." I went with her to pay a visit to our house in Port Lligat. Ramon de Hermosa had died during the civil war in an old people's home in Gerona. He had been confined there by the decision of the local Committee. Ramon was a "Mal Plantado," and the tree of his laziness had not been able to resist the ordeal of transplantation. Lydia said to me,

"During the revolution everybody loved me. In those moments when one is about to die one sees clearly where spirituality is to be found."

"But how did you manage to live, without your sons, without men to help you, at your age?" I asked her.

She smiled before my innocence.

"Never have I lived better; I had everything and more than I wanted; my spirituality, you understand?"

"But what does this spirituality consist of, for the time comes when one jolly well has to go and eat!"

"Precisely, precisely—you see, my spirituality functioned precisely at the meal hour. Those militiamen of faith would come in trucks. It was very hot, and they would camp on the beach. They were constantly arguing and quarrelling among themselves. I never said a word to anybody. I would pick out the best spot, and I would calmly go ahead and make one of those good fires that promise a lot of coals, that only 'La Ben Plantada'

knows how to make. The meal hour would gradually come round, and after a while I would hear one of the militiamen exclaim, 'Who is that woman over there?' 'I don't know,' another would say, 'she's been preparing a fire for a long time!' And they would continue their endless discussions—whether they ought to kill all the people of the village, because they were all sons of whores; whether they should definitely seize power before the end of the week; whether they should burn the church and the curate that very afternoon.

"Meanwhile I continued to feed my fire well with fresh vinestalks that crackled like the hairs of angels. And now one and now another

of the militiamen would begin, sure as fate, to come close to my fire. One of them at last would say, 'We'll have to think about dinner.' I would say nothing, and throw another handful of wood on the fire, the smell of which was like a whiff of balsam to the peeled souls of that handful of criminals. 'Come,' said another, 'we've got to go and get something to eat.' And one after another, a chop, a rabbit's leg, a pigeon would appear and begin to cook, to turn a golden brown, to sizzle, and to glaze.

And as they ate they all became gentle as lambs, and insisted on my sharing everything with them. By being nice to me they tried to make up for all the bad they had done. Nothing was good enough for Lydia, and they began to show me all kinds of attentions. When I discovered someone among them who was capable of understanding me, I would tell them the story of the secret of the Master, the secret of 'La Ben Plantada.' It was the life of Cockaigne. Always they went to fetch new chinaware in the gentlemen's houses, because they would never wash them, and once they had finished a meal they would throw everything, dishes, cups, spoons, into the sea.

"But all this did not last very long, for those of the opposing party would get the upper hand sooner or later. While we would be eating, one of the anarchists would come running, with the face of an exhumed corpse, bringing bad news. The left republicans had repressed the anarchist movement and trucks loaded with assault guards and machine-guns were already on their way from Cadaques. Everyone would get up, tossing the half-finished chop into the air, and prepare to leave. One would leave me a pair of shoes, another a wool blanket, another a stolen phonograph, another a down cushion. 'Come on! Let's go! The good life is over! Everybody up! The time has come to run. Ay, Ay, they're already coming! Ay, Ay, Ay! we've got to go and die!'

"And the beach became deserted again, without a living soul. But about the middle of the afternoon would come the assault troops of the separatists. They would shout, insult each other and blaspheme like the others, and like the others, no one yet thought of supper, or of dying. But I had already brought a little fresh wood and began to light the fire. Someone would say, 'Who is that woman over there, dressed in black?' 'I don't know. She's making a fire.'...One of them would come round, then another. They would watch me silently. And I wouldn't say a word, and I would throw on a fresh handful of vinestalks that would crackle so pleasantly that it was good to hear. Someone would exclaim, 'We've got to think of supper.' Others would then shout, 'Let's go and find something.'

"Then in turn another kind of soldiers would come and chase them away. In short I got in this way everything I needed, and finally came the "Tercio de Santiago', and even the Arabs. The Arabs were very well planted. All would come and sit in a circle around my fire, and they loved me like a mother. For, good or bad, when meal-time comes round one must eat, and preferably eat hot, and I myself could not starve to death. They would all have time to eat cold in the cemetery, for I was pretty sure most of them would be killed, so young though they were! As for me—what little time I still have to live...*Que odiosea*,[1] *Señor Dios!* You can't explain it in words!"

I found again the good fishermen of Port Lligat. All of them had preserved a nightmarish memory of the anarchist period. "No, no, never

[1] Involuntary neologism, composed of the word *odio* (hatred) and *Odisea* (Odyssey).

again. That was worse than anything: stealing, murdering, and nothing more. Now things are once more the way they've always been: you go home, and you're your own master!"

I opened the door of my house. Everything had disappeared. Nothing left of my library, not a single thing; only the walls covered with obscene drawings and contradictory political emblems. Under all these inscriptions, most of them in pencil and denoting the successive passage of anarchists, Communists, separatists, republicans, Trotskyists, etc., large letters painted with tar: "Viva la Anarquia! F. A. I.! Tercio de Santiago—Arriba España!"

After a week spent in Madrid I flew to Lisbon where Gala awaited me to continue our trip to America. In Madrid I stumbled by chance upon the sculptor Aladreu, one of the youngest members of the group of my adolescent days in Madrid. I found at the home of the poet Marquina one of my paintings of my first classic period of Cadaques. I established contact with the intellectuals, among them Eugenio Montes, with whom I had had twelve years before very close spiritual affinities, and who is the most severe and the most lyrical of our philosophers of today. Effusively I embraced the Master, the "Petronius of the Baroque" and the inventor of the Mediterranean "Ben Plantada," and brought him messages from the ever well-planted Lydia of Cadaques. Eugenio d'Ors's bushy and remarkably long eyebrows, with the silver price of his age, already bore a remarkable resemblance to Plato's. I met Dyonisio Ruidejo, who is the youngest poet of the most ardent and vigorous lyric style. As for the anti-Gongorist Raphael Sanchez Moros, by his Catholic respiratory morphology and by the Machiavellism of his glance, I understood with a single glance of my own that he was initiated into all the secrets of the Italian Renaissance, and even a little more so into those of the coming Occidental renaissance.

But before giving birth to this cosmogony which for nine years I had felt pressing and growing and giving me kicks in the depths of my logical bowels I would have to continue on the road of my life, which the war of Europe might even involuntarily bar, in order to be able to continue to attend to my moral, material and capricious "needs," as for a pregnant woman—which I was and which I continually am for the honor and glory of everyone. I needed, in fact, immediately to get away from the blind and tumultuous collective jostlings of history, otherwise the antique and half-divine embryo of my originality would risk suffering injury and dying before birth in the degrading circumstances of a philosophic miscarriage occurring on the very sidewalks of anecdote. No, I am not of those who make children by halves. Ritual first and foremost! Already I am concerning myself with its future, with the sheets and the pillows of its cradle. I had to return to America to make fresh money for Gala, him and myself...

So I arrived in Lisbon. Lisbon beneath the frenzied song of the

crickets at that torrid period of the dogdays was a kind of gigantic fry-
ing-pan bubbling over with all the boiling oil of circumstances, in which
was being cooked the future of thousands of migratory and fleeing fish,
which the thousands of refugees of all sorts and all nationalities and all
races had become. In that historic Place del Rossio which had once been
fragrant with the stench of the burning flesh of the victims of the Inquisi-
tion, now again rose the ardent smoke of the new martyrs immolated by
the red-hot iron pincers of visas and passports, with a smell which choked
respiration and which was the very smell of the nauseating fried fish
of destiny. Of the fish of that destiny I had to taste a piece of the tail,
which the European actuality put perforce into my mouth. I chewed and
rechewed it, but I did not swallow it, and the moment I felt my two
feet solidly braced on the deck of the *Excambion* which was to take me to
America I spat it with enraged repugnance and spite into that hand
which I was going to abandon. It was in that right shoulder of the Iberian
peninsula weighted down with the monumental sack of atavistic and
pointless melancholy of the marvelous city of Lisbon that was per-
formed the authentic and the most pitilessly sad drama of the European
war (with the theatre empty of spectators, and with neither glory nor
pleasure). It was a solitary drama, without effusion, that was being
played in the oozing effusion of those hotel rooms where the refugees
slept crowded together like rotting sardines, to which they returned every
evening after a day of fruitless efforts, no longer discouraged, smiling
with hatred and with the gangrene of hopeless bureaucratic proceedings
already devouring the tissues, blue-tinged with death, of their donkeys'
patience! It was the drama of those who were going to take advantage
of the small comfort offered by the sole comfort station of the ignomini-
ously bespattered watercloset for which they also had to stand in line
in order at last basely to open the veins of their sole and ultimate liberty
with a razor blade!

My sojourn in Lisbon still continues to appear to me as some-
thing utterly unreal. One had always the impression of meeting familiar
faces in the street. One turned round, and so they were. "Say, doesn't
she look like Schiaparelli?" It was she. "He's the spitting image of René
Clair!" It *was* René Clair! The painter Sert would be leaving the Zoologi-
cal Park by streetcar just as the Duke of Windsor crossed the street and
Paderewski sat down on a bench opposite to enjoy the sun. On the edge
of the sidewalk, sitting on a newspaper, the famous banker, king of the
bankers, would listen to the song of a cricket shut up in a golden cage,
which he had just bought, and next to him the legless man who was
observing him you would have sworn was Napoleon Bonaparte in person,
so greatly did the bitter brow and the triangular nose resemble those
of the Emperor. At the far end of the square, standing in line before the
Navigation Company offices, the one you see from behind, wearing a
brown suit, looks like Salvador Dali...

On arriving in America I almost immediately went to the home of

our friend of the period of the Moulin du Soleil, Caresse Crosby, at Hampton Manor. We were going to try all together to revive a little of that sun of France which had just set, far away, beyond Ermenonville. I shut myself up for five months, spending my time working, writing my book and painting—hidden away in the heart of that idyllic Virginia which constantly makes me think of Touraine, which I have never seen in my life. Gala reread Balzac to me, and on certain nights the spectre of Edgar Allan Poe would come from Richmond to see me, in a very pretty convertible car all spattered with ink. One black night he made me a present of a black telephone truffled with black pieces of black noses of black dogs, inside which he had fastened with black strings a dead black rat and a black sock, the whole soaked in India ink. It was snowing. I placed the telephone on the snow, and the effect was simply and above all that of black on white.

I began to believe more and more in the good sense of that miraculous thing, the eye! In pre-sleep, with my eyes shut, I would look at my eye, with my eye from the depth of my eye, and I began to "see" my eye and to consider it as a veritable soft photographic apparatus, not of the objective world but of my hard thought and of thought in general. I immediately reached conclusions which enabled me to affirm that one can photograph thought and began the theoretical bases for my invention. This invention is today an accomplished fact, and as soon as it is mechanically perfected I shall offer it for the scientific consideration of the United States.

It will in fact become possible to obtain what has always appeared to be miraculous: the objective visualization of the virtual images of the thought and imagination of each individual. This is the true future of the cinema, that unknown and long-sought-for thing which every man at birth bears latently enfolded in the histological complexity of his brain, and which since the beginning of time and in all epochs humanity has tried to materialize by the approximate means peculiar to artistic activity, which has always been the privilege of an extremely limited number of mortals.

All the rest of my life will now be devoted to the realization and the perfecting of my invention, with the aid of the men of science with whom I shall of necessity have to collaborate. The sudden idea of my discovery occurred exactly on the night of the 8th of May in New York, in my room in the Hotel St. Regis, during an awakening of a half hour between six and half past six in the morning. When I awoke I noted down the sensational conclusions of my conception, in which I hardly dared to believe. Nevertheless my long reflections on the original plan of these notes, jotted down in haste and with anxious fear lest I forget something, have only become more and more systematically consolidated, to the point of reaching the present certainty that my invention is not a figment of my imagination, and even that the realization of the first apparatus of this kind is a not remote possibility, if I can succeed in rapidly gather-

ing around myself the technicians and specialists whom I will of course
need in order to succeed in giving a concrete form to the reality of my
discovery...

This book is about to end.

Customarily writers begin to write their memoirs "after their life is
over," toward the end of their life, in their old age. But with my vice
of doing everything differently from others, of doing the contrary of what
others do, I thought that it was more intelligent to begin by writing
my memoirs, and to live them afterwards. To live! To liquidate half of
life in order to live the other half enriched by experience, freed from the
chains of the past. For this it was necessary for me to kill my past with-
out pity or scruple, I had to rid myself of my own skin, that initial skin
of my formless and revolutionary life during the Post-War Epoch. It was
necessary at all costs that I change skins, that I trade this worn epidermis
with which I have dressed, hidden, shown myself, struggled, fought and
triumphed, for that other new skin, the flesh of my desire, of my imminent
renaissance which will be dated from the very morrow of the day this
book appears. I am at this moment, as I write these lines, in the midst of
making the last convulsions, which are in reality the end of this chapter,
which will allow me to shuffle off and completely detach myself from the
prison of my old skin, exactly as snakes do, and as those flexible pianos
imagined by Dali also do, when toward the end of certain transparent
October days they leave hanging all along the rocks of the beach of
Monterey the torn shreds of their old lyrical epidermis which the seals
—who in turn so much resemble soft pianos—believe, when they see them
drying, to be the sacred remains of their polar ancestors, because of the
respect with which the even and regular superiority of the ivory of the
teeth of soft pianos inspires them, when they compare them with their
own maritime and unsuccessful elephants' teeth.

New skin, a new land! And a land of liberty, if that is possible! I
chose the geology of a land that was new to me, and that was young,
virgin, and without drama, that of America. I traveled in America, but
instead of romantically and directly rubbing the snakeskin of my body
against the asperities of its terrain, I preferred to peel protected within
the armor of the gleaming black crustacean of a Cadillac which I gave
Gala as a present. Nevertheless all the men who admire and the women
who are in love with my old skin will easily be able to find its remnants
in shredded pieces of various sizes scattered to the winds along the road
from New York via Pittsburgh to California. I have peeled with every
wind; pieces of my skin have remained caught here and there along my
way, scattered through that "promised land" which is America; certain
pieces of this skin have remained hanging in the spiny vegetation of the
Arizona desert, along the trails where I galloped on horseback, where I
got rid of all my former Aristotelian "planetary notions." Other pieces

of my skin have remained spread out like tablecloths without food on the summits of the rocky masses by which one reaches the Salt Lake, in which the hard passion of the Mormons saluted in me the European phantom of Apollinaire. Still other pieces have remained suspended along the "antediluvian" bridge of San Francisco, where I saw in passing the ten thousand most beautiful virgins in America, completely naked, standing in line on each side of me as I passed, like two rows of organ-pipes of angelic flesh with cowrie-shell sea vulvas. Other pieces still have remained lost in the folds of that night of the future illuminated by fifteen stars large as closed fists filled with seeds of liberty, and stirred by the patriotic wind which, coming from the fifteen states, makes the erect, fecundating and immobile serenity of the banners even more glorious...

My metamorphosis is tradition, for tradition is precisely this—change of skin, reinvention of a new original skin which is precisely the inevitable consequence of the biological mold of that which preceded it. It is neither surgery nor mutilation, nor is it revolution—it is renaissance. I renounce nothing; I continue. And I continue by beginning, since I had begun by finishing, in order that my end may be again a beginning, a renaissance.

Will I now at last age? I have always begun by death in order to avoid death. Death and resurrection, revolution and renaissance—these are the Dalinian myths of my tradition. I began my idyll with Gala with the intention of killing her. Today, at the end of my "biography," after seven years of living with her, and at the moment of my metamorphosis into the Dali of tomorrow, I decide to marry again, concluding the romantic portion of my book by a true marriage. But instead of remarrying in a "revolutionary" way with another, I want to do it again with the same one, with Gala, my wife, and this time I want it to be affirmed and made sacred by the Catholic Church.

On my arrival in Paris I too, with Miro, wanted to assassinate painting. Today it is painting that assassinates me, for I only want to save it, and no technique in the world appears to me sufficient to make it live again! Thus it is proved that Dali is equal to Dali, that I am always the same, that my paradoxical tradition is the real force of my originality.

I continue...

Europe too...

From the thousand-faceted light-house of liberty I look at Europe. The whole confused experience of my life, my surrealist revolution in Paris, my ascetic and tormented retreats in Spain, my esthetic voyages to Italy, all becomes clarified and assumes the objective lucidity that comes with distance and with the sentimental wisdom of tragic perspectives. Not only do I understand what has happened, but also I see the future.

The old Greco-Roman civilization, after the experience of all those vain revolutions, and beneath the inquisition and the distress into which war has plunged it, it too is painfully changing its skin, dramatically finding its new skin, the skin of its tradition, still buried under chaotic hell. Post-War Europe was dying of its political, esthetic and moral

revolutionary experiments which have progressively devoured, weakened and reduced it. It was dying of lack of rigor, lack of form; it was dying, asphyxiated by the materialist scepticism of negativistic, nihilistic theories, of "isms" of all kinds. It was dying of arbitrariness, indolence, gratuity, psychological orgy, moral irresponsibility and promiscuity, the dehier-archization, the uniformization of the socializing tendencies. It was dying of the monstrous error of specialization and analysis, of lack of synthesis, lack of cosmogony, lack of faith.

Europe awakened from the sufferings of the last war with the mes-sianic and chimerical mirage of the "revolution" which was going to change everything in the world. Its hopes have again become war. Europe will awaken from the nightmare of the atrocious torture of the present war, disillusioned by the "goodness" of the revolutionaries for which it will have paid too monstrously dear. It will awaken, I repeat, with its eyes at last opened and dry, from having exhausted its tears, upon the reality of the holy resuscitated continuity of its tradition. The present war only confirms, before all else, the bankruptcy of revolutions. Indeed, the col-lectivist, atheistic or neo-pagan utopias of Communism or of National-Socialism, whether they mutually aid each other or devour each other, are destined at last to be annihilated and vanquished, both of them, by the individualist reactualization of the Catholic, European, Mediter-ranean tradition. I believe above all in the real and unfathomable force of the philosophic Catholicism of France and in that of the militant Catholicism of Spain. Europe, after the present catastrophe of its experi-ence of the post-machinist and materialist civilization of the Post-War, will sink into a kind of medieval period, during which it will again come to lean upon the eternal foundations of the religious and moral values and forces of its past of spiritual civilization. Out of the imminent spiritual crisis of those ephemeral Middle Ages will arise individuals of the coming renaissance.

Let me be the first fore-precursor of that renaissance! No unity of Europe could be more solid, tenacious, and menacing than that of its common distress, and even if Russian atheism be annihilated by the neo-paganism of the Nazi ideologist Rosenberg, this neo-paganism can in its turn already be considered as absorbed and annihilated in advance pre-cisely by that "unity of Europe" which, while being a consequence and an ambition of the conqueror, paradoxically but inevitably assumes the annihilation of the latter's neo-pagan and pan-Germanic ideology.[1] For the unity of Europe will be made, and can only be made, under the sign of the triumph of Catholicism. And if I am asked again today where the real force of Europe is to be found, I shall answer again that in spite of all immediate appearances it resides more than ever in the indivisibility of its spirit, in that indivisibility which is materialized in Bernini's two rows

[1] To Tristan Bernard is attributed the witty remark, on the day of occupation of Paris: "We spent the whole period of the war exclaiming, about the Germans, 'We'll get them! We'll get them!' Well, we've got them!"

of columns,[1] the open arms of the occident, the arms of St. Peter's in Rome, the cupola of man, the Vatican.

When, in the beginnings of the history of culture, the men who were to found the eternal bases of Occidental esthetics chose, among the form-less multiplicity of existing foliages, the unique and shining outline of the acanthus leaf, they materialized, in so doing, the immortal morpho-logical symbol which was destined to become nothing less than the cosmogonic constant of Greco-Roman civilization, opposing that of Asia and the Orient, the lotus-blossom. The "plant-dream whirl" of the acanthus leaf hardened into the luminous concisions of the first Corin thian capitals, and since then it has not ceased to be the tradition of esthetic intelligence, the continuous force of Minerva through the vicissi-tudes of blind and obscure forces of history. The acanthus leaf, become divine through the force of the conception of its first ornamental concre-tions, was destined not to die. It was to live in all the future architec-tures of the spirit, and while changing the skin of its dreams of growth, it was throughout the convulsive events of the Occident to roll, curl, grow heavy, furl and unfurl, live and live again, sprout and sprout again. Often it would disappear beneath the revolutionary storms, only to reap-pear more esthetically perfected than before, in the serene calms of the renaissances...

Men kill one another; peoples bite the dust beneath the yoke of the victors; others swell like elephant lice with the bloody geography of terri-torial ccnquests. Revolution and middle-ages seem then to have destroyed that anti-historic "little life" of the acanthus leaf about which no one was thinking. But precisely while no one was thinking about it, behold, this leaf is born anew, green, tender and shiny, between the cracks of a brand-new ruin. And it is as though all the historic catas-trophes, all the suffering of man, all the upheavals, hail-storms, deluges, and chaos of the Occidental soul are destined, with their transitory, stormy apparition and disparition, only to come at all times to feed the perennity of the acanthus leaf, only to maintain the ever-renascent immortality of tradition ever green, new, virginal and original...

The end of a war, the crumbling of an empire, and a hundred years of disorder have served only slightly to modify the tilt, the outline, the ornamental figure of the acanthus leaf, immediately reappearing in the first, still tender moldings of the budding new flesh of civilization. The acanthus leaf continues. From the Corinthian capitals, what life of tradi-tion is that of the acanthus leaf, dying under the Christ, born again heavy and fecund with classicism with Palladio, nuptial in Rome, apotheotic in style under Louis XIV, hysterical under Louis XV, orgiastic

[1] It has been demonstrated that one does not defend the country with Maginot lines constructed with false material and false politics, undermined by revolution. But the French soldier who comes from the concentration camp and who weeps already becomes once more a "Catholic stone," a stone of the Cathedral of Chartres, a tradi-tion and a force.

and aphrodisiac in the Baroque, guillotined by the French Revolution, modest and haughty under the Napoleonic Empire, neurotic and mad in the Modern Style, confined to an insane asylum throughout the Post-War, forgotten by all today during the present new war!

But it is not dead! For it lives somewhere, for it is unfurling its new bloom of spiny beauty in the shelter of the barbed wires of daily events, and more precisely within the brain of Salvador Dali. Yes! I announce its life, I announce the future birth of a Style...

All those who continue to imitate me by redoing "primary surrealism" are doomed to the limbo of lack of style, for to arrive at the creation of a style, instead of continuing to disintegrate, it is necessary to integrate, and instead of stubbornly attempting to use surrealism for purposes of subversion, it is necessary to try to make of surrealism something as solid, complete and classic as the works of museums.

Finished, finished, finished, finished, finished, finished, finished, finished—what is finished!

The day I went to visit Sigmund Freud in his London exile, on the eve of his death, I understood by the lesson of classic tradition of his old age how many things were at last ended in Europe with the imminent end of his life. He said to me,

"In classic paintings, I look for the sub-conscious—in a surrealist painting, for the conscious."

This was the pronouncement of a death sentence on surrealism as a doctrine, as a sect, as an "ism." But it confirmed the reality of its tradition as a "state of the spirit"; it was the same as in Leonardo—a "drama of style," a tragic sense of life and of esthetics. At this moment Freud was occupying himself mainly with "religious phenomena and Moses."

And I remember with what fervor he uttered the word "sublimation" on several occasions. "Moses is flesh of sublimation." The individual sciences of our epoch have become specialized in these three eternal vital constants—the sexual instinct, the sense of death, and the space-time anguish. After their analysis, after the experimental speculation, it again becomes necessary to sublimate them. The sexual instinct must be sublimated in esthetics; the sense of death in love; and the space-time anguish in metaphysics and religion. Enough of denying; one must affirm. Enough of trying to cure; one must sublimate! Enough of disintegration; one must integrate, integrate, integrate. Instead of automatism, style; instead of nihilism, technique; instead of scepticism, faith; instead of promiscuity, rigor; instead of collectivism and uniformization—individualism, differentiation, and hierarchization; instead of experimentation, tradition. Instead of Reaction or Revolution, RENAISSANCE!

I am thirty-seven years old. It is July 30th, 1941, the day I promised my publisher I would finish this manuscript.

I am completely naked and alone in my room at Hampton Manor. I approach the wardrobe mirror and look at myself; my hair is still black as ebony, my feet have not yet known the degrading stigma of a single corn; my body exactly resembles that of my adolescence, except for my stomach which has grown bigger. I am not on the eve of a voyage to China, nor am I about to get a divorce; neither am I thinking of committing suicide, nor of jumping over a cliff clutching the warm placenta of a silk parachute to attempt to be reborn; I have no desire to fight a duel with anyone or with anything; I want only two things: first, to love Gala, my wife; and second, that other inescapable thing, so difficult and so little desired—to grow old.

And you too, Europe, may I find you on my return a little more aged by all "that." As a child I was wicked, I grew up under the shadow of evil, and I still continue to cause suffering. But since a year ago I know that I have begun to love the being who has been married to me for seven years; and I am beginning to love her as the Catholic, Apostolic and Roman Church demands, according to its conception of love. Catholic love, said Unamuno, is, "If your wife has a pain in her left leg, you shall feel that same pain in your left leg."

I have just finished writing this long book of the secrets of my life, for this life that I have lived, this alone, gives me authority to be heard. And I want to be heard. I am the most representative incarnation of postwar Europe; I have lived all its adventures, all its experiments, all its dramas. As a protagonist of the surrealist revolution I have known from day to day the slightest intellectual incidents and repercussions in the practical evolution of dialetical materialism and of the pseudo-philosophical doctrines based on the myths of blood and race of National-Socialism; I

have long studied theology. And in each of the ideological short-cuts which my brain had to take so as always to be the first I have had to pay dear, with the black coin of my sweat and passion. But if I have participated, with the lucid fanaticism characteristic of the Spaniard that I am, in all the speculative searches, even the most contradictory, I have never in my life been willing, on the other hand, to belong to any political party whatsoever. And how should I be willing to do so now, today, when politics is already in the process of being devoured by religion?

Since 1929 I have ceaselessly studied the processes, the discoveries of the special sciences of the last hundred years. If it has not been possible for me to explore all corners of these because of their monstrous specialization, I have understood their meaning as well as the best! One thing is certain: nothing, absolutely nothing, in the philosophic, esthetic, morphological, biological or moral discoveries of our epoch denies religion. On the contrary, the architecture of the temple of the special sciences has all its windows open to heaven.

Heaven is what I have been seeking all along and through the density of confused and demoniac flesh of my life—heaven! Alas for him who has not yet understood that! The first time I saw a woman's depilated armpit I was seeking heaven. When with my crutch I stirred the putrefied and worm-eaten mass of my dead hedgehog, it was heaven I was seeking. When from the summit of the Muli de la Torre I looked far down into the black emptiness, I was also and still seeking heaven!

Gala, you are reality!

And what is heaven? Where is it to be found? "Heaven is to be found, neither above nor below, neither to the right nor to the left, heaven is to be found exactly in the center of the bosom of the man who has faith!"

THE END

At this moment I do not yet have faith, and I fear I shall die without heaven.

Hampton Manor
Twelve o'clock noon.